THE PELICAN HISTORY OF ART
Founding Editor: Nikolaus Pevsner
Joint Editors: Peter Lasko and Judy Nairn

Anthony Blunt
ART AND ARCHITECTURE IN FRANCE 1500 TO 1700

Anthony Blunt was educated at Marlborough College and Trinity College, Cambridge, where he was a Fellow from 1932 to 1936. After working on the staff of the Warburg Institute he was appointed in 1939 to the Courtauld Institute of which he was Director from 1947 to 1974. He was also Professor of the History of Art in the University of London and Surveyor of The Queen's Pictures, and the author of various works on French art of the sixteenth and seventeenth centuries, including monographs on Philibert de l'Orme, François Mansart, and Nicolas Poussin.

Penguin Books

ART AND ARCHITECTURE IN FRANCE 1500 TO 1700

Anthony Blunt

PENGUIN BOOKS

Published by the Penguin Group
27 Wrights Lane, London w8 5TZ, England
Viking Penguin, a division of Penguin Books USA Inc.,
375 Hudson Street, New York, New York 10014, USA
Penguin Books Australia Ltd, Ringwood, Victoria, Australia
Penguin Books Canada Ltd, 2801 John Street, Markham, Ontario, Canada L3R 1B4
Penguin Books (NZ) Ltd, 182–190 Wairau Road, Auckland 10, New Zealand

Penguin Books Ltd, Registered Offices: Harmondsworth, Middlesex, England

First published 1953
Second edition (previously described as second rearranged impression) 1957
Third edition (previously described as second edition) 1970
First integrated edition, based on third hardback edition, with revisions, 1973
Reprinted 1977
Fourth edition 1980
Reprinted with revisions and additional bibliography 1982
Reprinted 1986, 1988, 1991

Library of Congress Catalog Card Number: 70-521859

ISBN 0 14 0560.04 1 (UK hardback)
ISBN 0 14 0561.04 8 (UK and USA paperback)

Made and printed in Great Britain
by Butler & Tanner Ltd, Frome and London

Designed by Gerald Cinamon and Veronica Loveless

CONTENTS

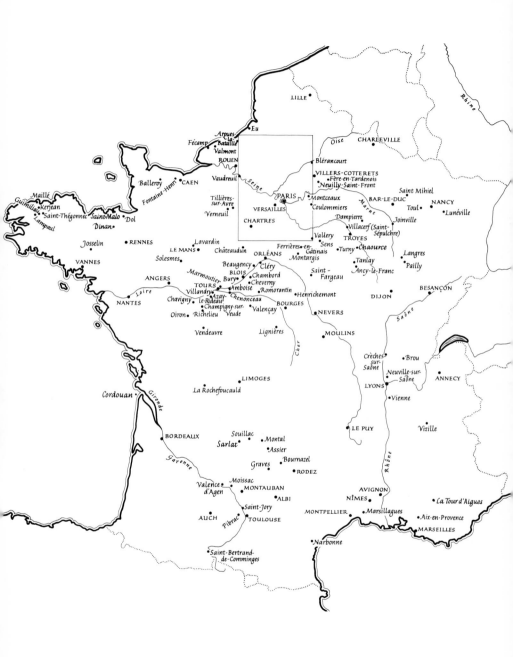

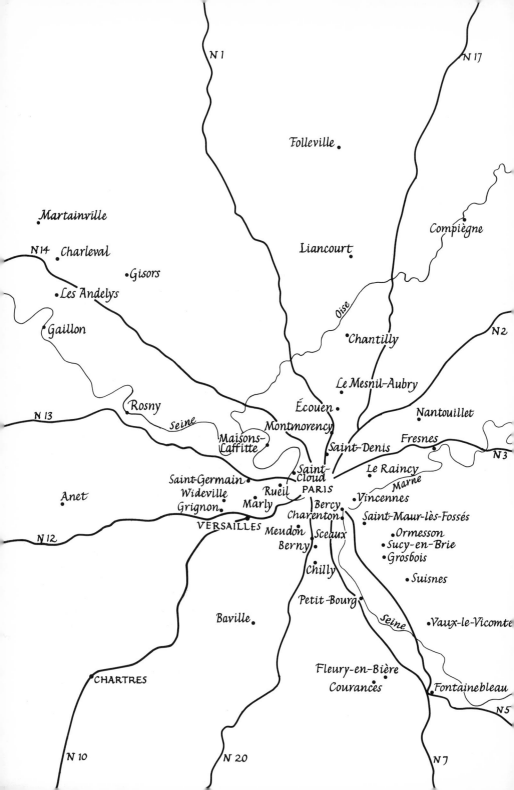

PREFACE TO THE FOURTH EDITION

On rereading this book thirty years after it was written I became aware of the fact that it is based on the use of certain stylistic terms – particularly 'Mannerist', 'Baroque', and 'Classical' – which are not defined and the meanings of which are not so obvious now as they seemed to be in the 1940s. Fortunately 'Mannerism' has been given a precise meaning by Professor John Shearman,[1] and his definition fits exactly with the way in which I use the word here: an elegant, refined, artificial, courtly style having its origin in the art of Parmigianino and reaching a high point in France in the work of Primaticcio, Goujon, and Pilon.

'Baroque' I have tried myself to define elsewhere[2] – rather by example than by abstract principles – as the art which was created in Rome roughly in the period 1620–1680 (and then spread to other countries, including France) in which artists used means which can be summed up in the term 'rhetorical', the aim of which was to strike astonishment and admiration in the spectator: in painting dynamic composition, irrational lighting and chiaroscuro, dramatic gestures, ecstatic poses, miraculous effects, often contrary to the laws of nature; in sculpture the same kinds of poses and gestures, sometimes combined with the use of coloured marbles and *trompe l'œil* imitations of other materials; in architecture creating effects of movement by means of curving walls and by the use of incomplete spaces leading one into another, a preference for ovals or polygons rather than circles and squares, dramatic and concealed lighting, effects of false perspective, the lavish introduction of coloured marbles and gilding, and the skilful use of siting.

The word 'classical' is much harder to define, and the problem has been made more difficult by the indiscriminate use which has been made of the term in the past, particularly by French literary historians for whom the whole period from Malherbe to Voltaire was *l'âge classique*. Then it was noticed that there were some writers in the early part of the period – such as Rotron, Racan, and Mairet – who could not be called classical,[3] and that even in Corneille there were features which were quite contrary to what had been regarded as the principles of 'classicism'.

In the visual arts painters such as Vignon and architects like Antoine Le Pautre at the beginning of the period could not really qualify as classical; Mazarin launched a campaign in favour of Roman Baroque or near-Baroque artists which for a time looked like succeeding; Lebrun and his colleagues working for Louis XIV borrowed from Baroque artists and even from Rubens, whatever they may have said about them in their theoretical writings; and even that paradigm of 'classical' architecture, François Mansart, was found, on close inspection, to reveal some surprising Baroque tendencies. At the same time supposedly pure 'Baroque' architects, such as Bernini and Borromini, were found to have equally unexpected 'classical' features. It was therefore realized that the crude opposition of Baroque and classical was a serious over-simplification, and that French art and literature, even of the supposedly most classical periods, were much more heterogeneous than had been thought to be the case.

It still seems to me, however, that the term 'classical' has its utility, if used with caution,

and I shall attempt to show how it can, in my opinion, be applied to French art of the sixteenth and seventeenth centuries.

In architecture I take the word 'classical' to imply the correct employment of the Orders according to the practice of the Ancients – in effect the Romans – but at the same time the pursuit of certain qualities of clarity and simplicity, a preference for regular forms (circle and square), for plane surfaces, clearly defined masses, and simple materials such as stone and stucco rather than marbles and gilding, the result being a static and monumental style related to certain familiar types of ancient Roman buildings, such as the Pantheon or the Maison Carrée at Nîmes, and to the work of Italian architects of the High Renaissance, such as Bramante or Antonio da Sangallo the Younger.

In sculpture the most obvious hallmark of classicism is a direct imitation of Roman models either in the types of figures or the forms of the drapery, but these features are usually accompanied by a preference for frontal views or low relief, as opposed to the three-dimensional movement and high relief with deep undercutting loved by Bernini.

In the most purely 'classical' works in the painting of this period, such as Poussin's second series of 'Sacraments', the figures are based on ancient sculpture, both in their types and in the treatment of their drapery, and the designs are sometimes taken from ancient reliefs, but these direct imitations of antiquity are accompanied by symmetry in the disposition of the figures and clarity in the construction of the space in which they exist, a preference for static rather than violent poses, explicit rather than evocative expressions and gestures, generally a use of clear daylight rather than dramatic or supernatural lighting, and an emphasis on the idea of decorum; that is to say making the style of the painting suitable to its theme. All these features

bring the art in question near to that of the Italian High Renaissance, above all to the painting of Raphael, the god not only of Poussin but of all those painters normally associated with the French classical tradition.

On these standards it seems to me to have some meaning to describe Philibert de l'Orme and Lescot as more classical than their predecessors of the reign of Francis I who worked in a mixed Italianate–Gothic style or than the architects of the next generation of Mannerists centred on the du Cerceau family, or to say that Poussin in his middle years was more classical than Vouet; and I think it is not too fanciful to see the calm, monumental clarity of Georges de la Tour [220] or of Champaigne's votive picture [213] as being connected with classicism in its broader sense in spite of the absence of explicitly antique features, and in the case of La Tour, in spite of his use of Caravaggesque chiaroscuro.

*

Changes made for the fourth edition include a complete rewriting of the section on the Le Nains, a thorough overhaul of the account of architecture in the late sixteenth and early seventeenth centuries (with particular reference to the du Cerceau family), and extensive revision of the Notes in order to bring the literature and references up to date.

ANTHONY BLUNT
London, 1979

Illustrations 49, 50, 52, 124, 136, and 168 were specially prepared for this book by Mr P. J. Darvall, A.R.I.B.A. The maps were drawn by Mr Paul White and executed by Mrs Sheila Waters and Mr Reginald Piggott. In a few cases, despite all efforts, it has been impossible to discover the owner of the copyright of photographs.

FROM THE INVASION OF ITALY TO THE BATTLE OF PAVIA

1494-1525

HISTORICAL BACKGROUND

From the point of view of French art the most important historical events of the years 1494–1525 were the campaigns of Charles VIII (reigned 1483–98), Louis XII (1498–1515), and Francis I (1515–47) in Italy, which produced as a direct result a reverse invasion of France by Italian taste.

From a strictly historical point of view, however, other developments of greater significance were taking place; for these years mark an important stage in the evolution of France as a modern state. During the following period the French monarchy which had been no more than the nominal head of a feudal agglomeration of territories was to become the effective controller of a relatively centralized nation. Louis XI had done much to break down the strength of the feudal nobility and to concentrate the effective power of government in his own hands, and Louis XII and Francis I were to continue the process. At the same time they strove to break the spirit of the États and the Parlements, which were another source of resistance to complete centralization. Here their task was harder, because these bodies, representing the new aristocracy of the towns, had a solid basis of power in their wealth, and could always resist the collection of taxes. In the end, however, by an ingenious combination of compromise and economy under Louis XII and a skilful development by Francis I of the authority of the provincial governors appointed by the Crown, the Parlements found themselves unable seriously to resist the wishes of the central power and,

except in the matter of taxation, usually in agreement with its policy. Finally the Concordat of 1515 had provided the King with an almost endless supply of rewards for his servants in the form of bishoprics and abbeys which not only depended on his personal gift but had the added advantage of not being hereditary, thus binding each recipient to him afresh. In this way Francis I, having reduced the independence of the feudal nobles and centralized a great part of the power and wealth of the kingdom in his own hands, had gone far towards the construction of that personal absolutism which was to be the characteristic of the French constitution for the next two hundred years.

In foreign policy a parallel change had taken place. At the beginning of the period with which we are here concerned, Charles VIII invaded Italy primarily with the intention of satisfying dynastic claims on the kingdom of Naples. But by the time of the disaster of Pavia, with which the period ends, the Italian campaigns had taken on an entirely different character. They had developed into a struggle between the growing power of France, relatively small but united and organized on modern principles, and the vast agglomeration of the Habsburg territories, Spain, and the Empire, still broken up by feudal separatism and weakened by out-of-date administration.

As the Crown became the centre of French administration, the Court became the focal point of culture in the kingdom. Under Louis XII it was possible for a great minister like Cardinal Amboise to be the leader of taste, far in advance of the King. But in the following

reign everything centred on the group round the King and his sister, Margaret of Navarre, and the most important works in the arts and in literature were executed under their direct patronage.

From the first years of his reign Francis I made it plain that he intended to form a court which could rival those of Italy in culture and would be a fair setting for a great king. For this reason he collected round him men of letters, thinkers, humanists, painters, and architects, each of whom had a part to play in building up the setting against which the King wished to be seen and the reputation of a great patron which he aimed at leaving to posterity. It was as a result of this policy that there arose the new wing of the château of Blois and the château of Chambord, the first of the royal buildings; and it was as part of the same plan that Francis tried to lure to France the greatest artists of Italy, failing in the case of Michelangelo but succeeding in that of Leonardo.

The great noble families were also active as patrons, particularly in architecture, but they were equalled in importance by the newly enriched *bourgeois* servants of the Crown. Whereas under Louis XI there had been but one Jacques Cœur, there was now a host of such patrons – Semblançay, Bohier, Briçonnet, to mention a few – who built town and country houses and encouraged all the arts.

Centralization was, however, far from complete. The Court was still mobile, and Paris had not yet attained its position as the political and cultural centre of the country. Before 1525 the region of the Loire valley was in advance of the capital in architecture and the allied arts. The Court spent much time there on account of the hunting; the aristocracy remodelled its castles in the district; the valley was rich in agriculture; and towns like Tours and Orléans were rapidly developing as centres of trade.

The direction taken by artistic life under Louis XII and Francis I was, as has already

been said, fixed by the influence of Italian culture. Before the invasion of Charles VIII French writers and artists had, of course, already been conscious of what was happening on the other side of the Alps, and in the field of pure classical learning it can even be said that the Italian campaigns did not exercise a very serious influence, since humanist studies were well established in Paris before 1494. But in most other fields Italian taste began to flood into the country as Frenchmen came back from Naples or Milan. However, as has often been pointed out, their understanding of the Italian Renaissance was in many ways superficial. What attracted them above all was the luxurious manner of living displayed at the Italian courts. Italian gardens, Italian dress, Italian manners were for them the real discoveries. Platonic philosophy, Florentine painting, monumental architecture do not seem to have impressed them deeply; nor do they seem to have shown any great interest in the works of antiquity, which they must have seen in Italy. It is, however, recorded that in 1498 the Maréchal de Gié asked the Signoria of Florence for seven Roman busts which had belonged to Lorenzo de' Medici. Gié's taste must have been in advance of that of his compatriots, for a little later he also begged for a copy of Donatello's bronze David. Instead, Michelangelo was commissioned to make a work of the same subject to his own design; but owing to the disgrace of the Marshal, the Signoria eventually sent the statue to his successor in the favour of Louis XII, Florimond Robertet, who built the château of Bury, where the statue stood for many years.[1]

The character of the first invasion of Italian taste can be clearly seen in French literature of the early years of the reign of Francis I. The most successful poet of the time was Lemaire de Belges, who still belongs to the late medieval school of tortuous poetry practised by the Grands Rhétoriqueurs. If he occasionally turns to Petrarch for an idea, the influence of the great

Italian poet never penetrated below the surface of his art. Even Clément Marot in his early works still writes in the same manner. He was better versed in Italian literature than Lemaire, but he only absorbed such elements as would not conflict with his playful and ingenious conception of poetry.

Parallel with this court-poetry and independent of it a tradition of learned humanism was being built up. The pioneer work of men like Robert Gaguin had prepared the way for the colossal learning of Guillaume Budé, but his scholarship was so academic that it never came into contact with the real literary movements of the time. Even with the more likable Lefèvre d'Étaples, whose humanist studies were for a moment flavoured with Platonism, the effect of his work was more apparent in the field of religion than of literature. It was, however, men like Budé and Lefèvre who founded in France those Greek studies which were to have such revolutionary effects in the next generation, when classical scholarship was to be fused with a great literary movement.

The period up to 1525 was one of transition. Francis I himself reflects both the past and the future. In one way he was the last product of chivalry; in another the first modern King of France. In culture Italy was the rage, but was understood only as a mode of manners or a source of conceits imposed on medieval traditions. We shall see that in the visual arts Italian forms were at first used in an equally superficial way.

ARCHITECTURE

The Introduction of Renaissance Motives from Northern Italy: The first Châteaux of Francis I

The earliest traces of Italian Renaissance influence on France appear several decades before the invasion of 1494, but they are spasmodic. The painter Jean Fouquet had visited Rome in the middle of the fifteenth century, and the miniatures of the Hours of Étienne Chevalier show that he understood not only the decorative detail of Italian Quattrocento art but also to a remarkable degree the problems of perspective, in which, in some respects, he was actually in advance of his Italian contemporaries.[2] A little later René of Anjou had attracted many Italian craftsmen to his Court in Provence, and one of them, Francesco Laurana, had built what was probably the earliest purely Italian work on French soil, the chapel of St Lazare in the church of La Major at Marseilles (1475–81) [1].[3] But this model was too far away from the

1. Francesco Laurana: Marseilles, La Major, Chapel of St Lazare. 1475–81

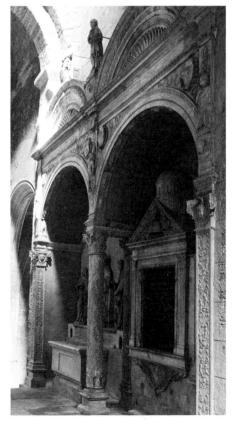

main centres of artistic activity in France to bear any fruit.

More important was the arrival in France of Italian engravings and illustrated books towards the end of the fifteenth century. Through them French engravers and publishers became acquainted with Italian decoration and in due course came to imitate it. In the *Terence* printed in Lyons in 1493 we see a crude attempt to render the *putti*, the fruit-swags, and the shell-niches of the Quattrocento. But in the *Roman Hours* published in Paris in 1502 the detail is much finer and better understood, though still mixed with Gothic elements. By the time of the Paris *Origen* of 1512 the transformation is complete, at any rate as far as the decorative parts of the wood-cuts are concerned.[4]

If the style of the *Origen* differs so much from that of the *Terence*, the change is no doubt due to the campaigns in Italy and the arrival in France of Italian craftsmen. Even Charles VIII, after the short and disastrous campaigns of 1494, brought back with him from Italy a band of artists who introduced the ideas and methods of their country to France. On the whole it was the architects among these foreigners who exerted the least permanent influence on France. The two most important – Fra Giocondo, who stayed from 1495 to 1505, and Giuliano da Sangallo, who came on a short visit in 1495 with Cardinal Giuliano della Rovere – left no traceable works. The third – Domenico da Cortona, a man of much more slender talent – only established himself as a recognized architect about 1519, that is to say twenty-four years after his arrival and at a time when the manner of the Italian Renaissance was well known through other channels. The sculptors were of greater importance, and some, such as Guido Mazzoni, exercised an influence on architectural decoration; but they will be considered in a later section.

The effect of the campaigns of Louis XII and Francis I (1500–25) was naturally more pro-found. As a result of them Milan was a French dependency almost continuously for twenty-five years and Genoa for a shorter period. French soldiers and statesmen were constantly visiting these cities, sometimes accompanied by French artists. They commissioned works from local craftsmen, whom they sometimes brought back with them on their return to France so that they might continue to decorate their châteaux, an abbey in which they were interested, or the tomb which they were building for themselves.

Very soon French artists began to learn from the Italian visitors, and trained themselves to copy the new style. They rapidly became competent at this imitation, and generally speaking it is impossible to disentangle the exact shares of Italian and French craftsmen in the work before 1525. The documents are rarely explicit, and though they often mention a number of names, Italian and French, they hardly ever define the exact function of any one craftsman. Moreover, not only did the French imitate the Italians, but the latter also adapted themselves in certain respects to the demands of local traditions and materials, so that in the end there is no firm basis for distinguishing the shares of the two groups, and those who claim to do so are often actuated more by a spirit of national pride than by one of genuine criticism.

The fact that French contacts with Italy were with the northern provinces, above all with Milan, was perhaps lucky, because in Milan French patrons found the kind of architecture to appeal to them. The seigneur of the time of Louis XII and Francis I had been brought up surrounded by Flamboyant Gothic, a style notable for the ingenuity of its forms and the elaboration of its decoration. With this training they would hardly have taken to the cold intellectualism of Florentine Quattrocento architecture, which in their eyes would have been merely bleak. Their taste is clearly shown by the few comments which Philippe de Commines makes on the buildings which he saw. In Venice

he was deeply impressed by all the palaces because of the richness of their materials on the outside and of their decoration within. In the Certosa of Pavia he becomes ecstatic and calls it 'the finest church I ever saw, and all of fine marble'. Now, on Florentine principles both the fifteenth-century palaces of Venice and the Certosa would have been almost barbarous in their profusion of ornament and marbles and in the survival of Gothic elements; but to Commines and to his French companions these were precisely the objectives sought.

It was actually more from the Certosa than from any other building that French decoration of the early sixteenth century derived. Lying within easy reach of Milan, it provided an accessible model, and the façade of the church, of which the lower part was built between 1490 and 1498, is perhaps the most remarkable piece of fantasy in north Italian architecture of this period. With its profusion of coloured marbles, its surface fretted into reliefs, decorative or representational, and its every pilaster carved into a candelabrum, it presented a whole nearer in its lavishness to the spirit of Late Gothic than to that of Brunelleschi. In the cloisters the French would have found the same type of decoration executed in terra-cotta, a technique which was also to be imported to France. The style had, moreover, already been married with Gothic in Milan, and in buildings such as Filarete's Ospedale Maggiore the French could see pointed arches accompanied by classical ornament, precisely the combination which they were themselves to produce in their own châteaux.

The French seem actually to have turned their backs, as it were, on the examples of purer Renaissance style, even when these were presented to them. For in Milan itself the tradition of Florentine Quattrocento architecture was to be seen in Michelozzo's Portinari Chapel in the church of S. Eustorgio, a direct descendant of Brunelleschi's Pazzi Chapel; and, further,

between 1482 and 1499 Bramante was building in Milan two works which laid the foundation of sixteenth-century classicism: the churches of S. Maria presso S. Satiro and S. Maria delle Grazie. But, for all the French cared, Bramante might almost not have existed.

An exception to this rule must be made for a group of Frenchmen who became members of the Papal court.[5] The first of these was Cardinal Guillaume d'Estouteville (1403–83), who held important positions under Eugenius IV and his successors and was responsible for the rebuilding of S. Agostino in Rome and for the first Italianate work at Gaillon,[6] but more important were those prelates and soldiers who were imposed on the papal court by Charles VIII at the time of his invasion of Italy. They included Cardinal Jean de Billières de la Groslaye, who commissioned Michelangelo to make the *Pietà* for St Peter's in 1498, Guillaume Pérès, who was responsible for various altarpieces in the style of the Bregno family, and Pierre Amiette and Giraud d'Ancézune, whose tombs are to be seen in S. Luigi dei Francesi and SS. Apostoli. In architecture the most important works produced by this group were the original circular church of S. Luigi dei Francesi, of which the reliefs are incorporated in the façade of the existing church,[7] the little chapel of S. Giovanni in Oleo, commissioned by Benoît Adam in 1508, and the palace built for Thomas Le Roy in 1523, probably by Antonio da Sangallo the Younger in 1523. All these buildings are in the Roman taste of the day, but the influence of these patrons does not seem to have spread to France. The only exception is the chapel added to the cathedral of Vannes in 1537 by Jean Danielo.[8]

Generally speaking, it was the decoration and not the forms of Milanese architecture that the French took home with them. And at first they applied this decoration almost without change to the forms traditional in their own country. This produced that strangely hybrid quality

which characterizes the architecture of the period up to 1525. An Italianate door will be applied to the round tower of a château still wholly medieval in feeling; a low relief candelabrum will decorate the jamb of a Gothic door; the space between the ribs of Flamboyant vaulting will be covered with classical carving. On Italian standards the result is of course barbarous; and yet the style of these early years of Francis I has its own quality. The Gothic structural tradition was still vigorous enough to carry off the union with Milanese ornament.

During the greater part of the sixteenth century the Kings of France were the most important patrons of architecture; but they were far from being the only ones, and they were not always ahead of their subjects. The earliest example of architectural decoration in the Italian taste is probably the decoration of the pilasters of the Easter Sepulchre in the abbey church at Solesmes (1496),[9] and the form in which it appears is typical. The Entombment group itself is a piece of Late Gothic naturalistic sculpture, and its architectural setting is of Flamboyant design except for the two side pilasters, which are decorated with rich Italianate candelabra, imitated from the type to be found in the Certosa. The sculptor of these pilasters was very probably one of the Italians brought back by Charles VIII, who is believed to have contributed to the payment for the work at Solesmes.[10]

Hardly anything survives of the work executed for the royal châteaux by the craftsmen brought back from Italy by Charles VIII and Louis XII, although it is known that they were widely employed at Amboise and Blois. Their influence is, however, attested by other activities. They settled in Tours, and from there the new style spread in all directions: up and down the Loire valley to Orléans and Nantes; to Bourges and other towns in Berri; farther south to Limoges[11] and to Quercy, where the

châteaux of Assier (1526–35) and Montal (1523–34) are late examples of the manner; north-east to Champagne; and northwards to Normandy. Paris itself seems to have been relatively little affected, and the fragments of the chapel built by Philippe de Commines in the Grands-Augustins,[12] now in the Louvre and the École des Beaux-Arts, are the only examples of importance still traceable. The absence of such work is no doubt due in part to later destruction, but it must also be remembered that Paris had not yet regained its position as the real capital of France and the Court spent more time in the Loire valley than in the Île-de-France.

Normandy became a centre of the new style, second only to the Loire valley, owing to the activities of one man, Cardinal Georges d'Amboise, Archbishop of Rouen, chief minister to Louis XII and viceroy of Milan. Between the beginning of the century and his death in 1510 his château of Gaillon, standing on a ridge over the Seine above Rouen, was extended and decorated partly by craftsmen from Tours, and partly by artists brought back from Italy. It was further embellished with sculpture commissioned in Milan or Genoa and sent back to be set up in the gardens or courtyards of the palace.[13]

The Cardinal's taste was spread over other parts of France through members of his family: a brother and a nephew were in succession bishops of Albi and were responsible for the decoration of the cathedral; another nephew, Artus Gouffier (d. 1519), built the earliest wing of the great house of Oiron with fine Italian decorative detail;[14] and a third, Guillaume Bonnivet, began the château of the same name near Vendeuvre (Vienne) (between 1513 and 1516) completely in the new manner.[15]

Other less distinguished families also played their part in the diffusion of Italianism in France. A typical example is the Bohier family. One brother, Thomas, a rich financier, was the

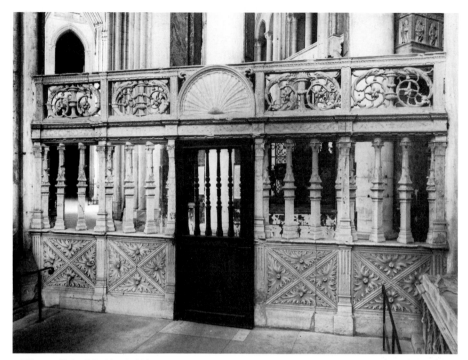

2. Fécamp (Seine Maritime), Abbey,
choir chapel screen. Before 1519

builder in 1515 of the earlier parts of Chenon-
ceau. He was related through his wife, Catherine
Briçonnet, to Duprat, the builder of Nantouillet,
and Gilles Berthelot, who constructed Azay-le-
Rideau. The other brother, Antoine Bohier, had
visited Italy in 1507, brought back Italian sculp-
tures, and later employed Italian craftsmen on
the redecoration of the church at Fécamp, of
which he was abbot.

Fécamp is the most important ensemble of
ecclesiastical decoration carried out in the first
decade of the sixteenth century. Antoine Bo-
hier's first action was to commission from Gero-
lamo Viscardi (b. 1467), whom he had no doubt
met on his visit to Genoa in 1507, the taber-
nacle, the sarcophagus, and the reliefs now

grouped above the high altar of the church.
These, though strictly speaking works of sculp-
ture, must have acted as useful models for local
architects interested in the new style of decor-
ation. Secondly he caused stone screens to be
made to enclose all the chapels round the choir
of the church [2]. We do not know the exact date
at which they were undertaken, but it must in
any case have been well before the abbot's death
in 1519. In their general conception the screens
follow a Late Gothic type to be found, for in-
stance, not far away at Eu, but the decoration is
purely Italian.[16] It is generally believed that
these screens were carved by Italian craftsmen
working in Normandy, and this is highly prob-
able. They must have been executed on the spot,

but the detail is too accurate for a Frenchman at this date. The same sculptors no doubt also executed the door to the sacristy, but here the French influence is stronger, for though the pilasters are Italianate, the form of the arch is Late Gothic.

Gothic and Italian elements can be seen more sharply juxtaposed in the tomb of Raoul de Lannoy and his wife in the church of Folleville

3. Antonio della Porta and Pace Gaggini: Folleville (Somme), tomb of Raoul de Lannoy. Begun 1507–8

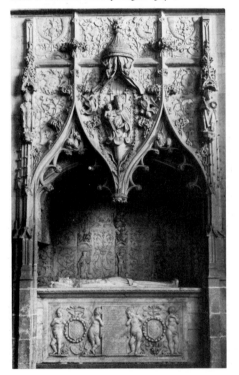

[3].[17] The tomb itself with the recumbent figures and the inscription supported by *putti* was not originally designed to stand in a niche, but was intended to be placed with one side along the wall of the chapel. It is of pure north Italian design, and is signed by Antonio della Porta,

called Tamagnino, and his nephew Pace Gaggini, who worked on the Certosa of Pavia and later set up a studio in Genoa. Lannoy was governor of that town during the years 1507–8, and it was no doubt then that he ordered the tomb. At his death in 1513, however, it had not been set up, and it was his widow and his son who built the chapel and gave the tomb its present setting, probably before 1524.

The contrast between tomb and setting is remarkable. The former is purely classical; the latter consists of two rich Flamboyant ogee arches, above which the wall is carved in low relief with a pattern Italian in style, but entirely different from the work of the two Genoese sculptors. It was probably executed by a Frenchman trained in the workshop of Gaillon or Fécamp, the latter being perhaps the more likely origin, since Lannoy was a friend of Antoine Bohier and no doubt in contact with him in Genoa and when both men were back in France. In this monument all three components of the art of Louis XII can be seen: pure Italian classicism, Flamboyant Gothic, and a local imitation of motives imported from south of the Alps.

In contrast to this composite work there are examples of wholly Italian tombs, such as that of Bishop Thomas James in the cathedral of Dol (1507)[18] by Antonio Giusti and that of Cardinal Briçonnet (d. 1514), father-in-law of Thomas Bohier, in Narbonne Cathedral, the author of which is not known, but was probably Italian.

Of later examples still mixed in style the most remarkable is to be found in the church of St Pierre at Caen, of which the east end was built by Hector Sohier between 1528 and 1545 [4]. Structurally it is a Late Gothic building, and internally the vaulting goes through every convolution known to Flamboyant builders, particularly in the lady-chapel, which rises to double the height of the ambulatory [5]. But from the ribs and bosses hang, as it were, stalactites of pierced Italianate decoration. On the outside the effect is more sober. The form of the chapels

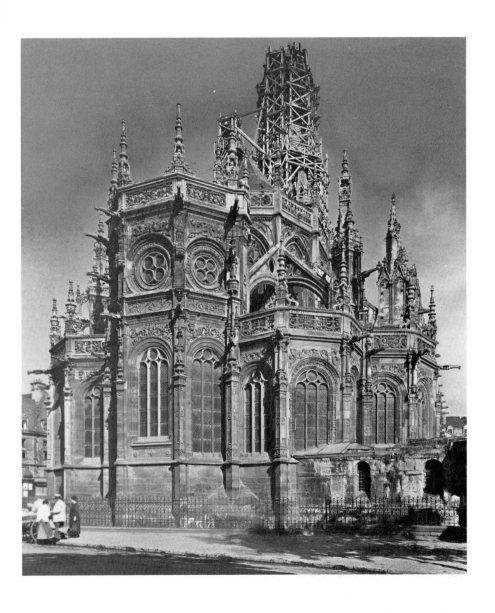

4. Hector Sohier: Caen, St Pierre, apse. 1528–45

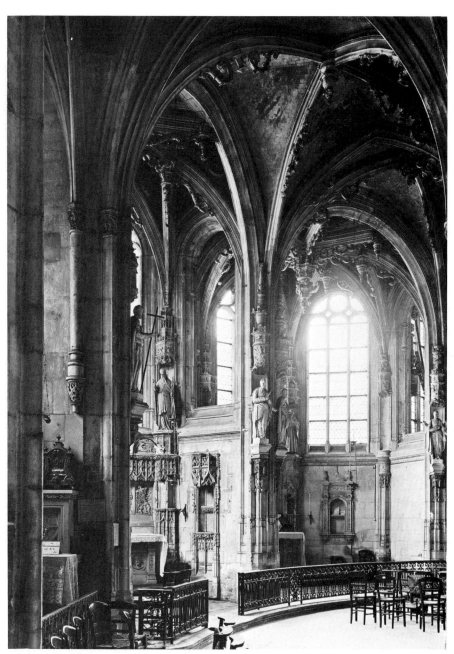

5. Hector Sohier: Caen, St Pierre, ambulatory. 1528–45

is still Gothic, and the windows, though round-headed, still have Gothic tracery. The pierced balustrade, however, is more fanciful, and the artist has given free rein to his imagination in the candelabra which replace the finials. The two elements, French medieval and north Italian Quattrocento, here stand clearly distinguishable, and yet the result is not discordant.[19]

In secular architecture the vital steps towards Italianism can be seen taking place at Gaillon. Cardinal Amboise began the rebuilding of the château in 1502, and it was nearly completed at the time of his death in 1510.[20] The first wings, constructed between 1502 and 1508, were still in the Flamboyant style, without any trace of the new manner, but in the latter year foreign work-

men began to arrive and a change of style becomes apparent. Among the first artists was a Genoese sculptor referred to as Bertrand de Meynal. In 1508 he brought to Gaillon the great fountain sent from Genoa and commissioned from Pace Gaggini and Antonio della Porta in 1506 [6].[21] In the same year another Italian, called in the accounts Jérôme Pacherot (perhaps Girolamo Pacchiarotti),[22] carved the frame for Colombe's St George [22] which formed the altarpiece of the chapel, in which Andrea Solario was decorating the walls with frescoes, including portraits of the Cardinal and his family.[23] As at Fécamp, this first phase, the importation of Italian works, was the prelude to setting Italian sculptors to work on the building itself, and in

6. Pace Gaggini and Antonio della Porta: La Rochefoucauld (Charente), fountain from Gaillon. 1508

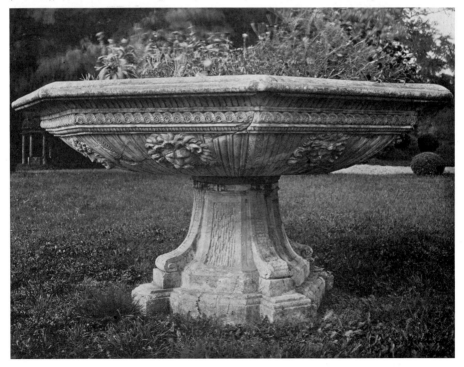

7. Gaillon (Eure), château, entrance. 1508

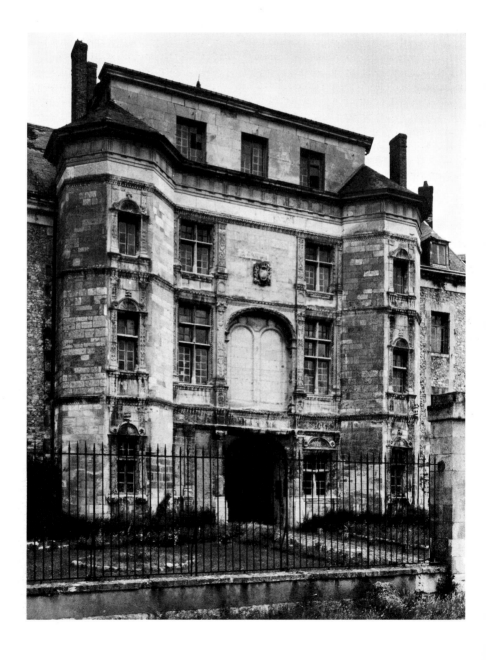

those parts of the château erected from 1508 onwards Italian decoration can be seen. The most important is the entrance gate [7], the decoration of which probably dates from 1508. In structure this is still the fortified entrance to a medieval château, but the decorative elements are Italian, with Lombard pilasters, grotesque friezes, and shell-heads to the windows. But the disposition of this ornament is in accordance with Gothic methods. Notice, for instance, how the windows on the three floors are linked together by the flanking pilasters to form a vertical panel such as is found on a Flamboyant château like Josselin. The windows themselves are still mullioned, for it was not till many years later that the French abandoned this practice. The

interior of Gaillon seems to have been decorated in the same style, as we can judge from the chapel stalls, now at St Denis, which are covered with fine relief grotesques;[24] and the château was surrounded by gardens made probably by the Italian designers at Amboise and Blois.

Before discussing the first royal building schemes, mention must be made of a group of small châteaux built for private individuals, most of which preceded them. These are Le Verger, built for the maréchal de Gié (c. 1500), Bury commissioned by his successor Florimond Robertet (1511–24), Chenonceau (begun 1515), and Azay-le-Rideau (1518–27), the last two built for wealthy financiers. They are marked by a completely new regularity of plan. Gaillon had been

8. Chenonceau (Indre-et-Loire), château. Begun 1515

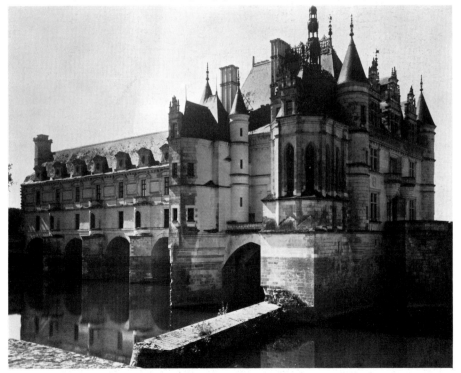

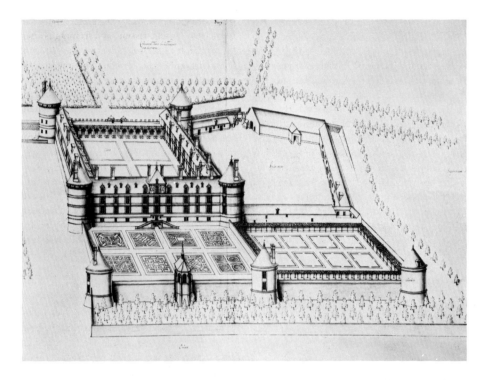

built on the site of an earlier castle, and the cardinal had largely accepted the irregularities of the older foundations; but the châteaux under consideration are planned on a strictly rectangular system. The part of Chenonceau built at this period is the simplest [8] and consists of a square block with a turret at each corner and a corridor through the middle [106], a plan which repeats fifteenth-century models, such as Martainville. An Italian feature is the single straight staircase, doubling back on itself, which replaces the usual French spiral. Azay is more unusual in its L-shaped plan, but it presents symmetrical views from almost every direction. Le Verger and Bury are more revolutionary, and indeed set the type for French château design for more than a century. The buildings are grouped round a nearly square court, of which one end is occupied by a *corps-de-logis* containing the principal

rooms and rising in the middle to a higher pavilion [9]. Along the sides of the court stretch wings which contain lesser rooms and perhaps a gallery (as at Oiron). The fourth side is filled by a lower range of buildings which at Bury included an arcaded cloister. In the middle of this side was the main entrance to the château. In one respect Le Verger and Bury were more medieval than Chenonceau and Azay, because they retained round towers at the corners; in the two smaller châteaux these are reduced to turrets, which are more easily absorbed into the Renaissance character of the building.

The four châteaux are, however, similar in their treatment of the elevation. Each storey is ornamented with very flat pilasters, and is bounded by strong horizontal string-courses above and below it. The result is that the wall is divided up by a network of lines crossing at right

9 *(opposite)*. Bury (Loir-et-Cher), château. 1511–24. Drawing by du Cerceau. *London, British Museum*

10. Azay-le-Rideau (Indre-et-Loire), château, entrance. 1518–27

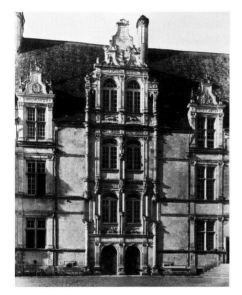

angles, which pattern out the surface but hardly disturb its flatness. It is, in fact, a completely non-plastic wall treatment. In all three buildings the dormers are a prominent feature and are early examples of the type to be found in all the Loire châteaux, still medieval in form but decorated with dolphins and candelabra in the new manner. At Azay a prominent feature is the main entrance to the *corps-de-logis* [10], a tall, narrow, four-storeyed pavilion in which the Orders are applied one above the other but are sometimes interrupted by the insertion of a niche in the middle of a pilaster. Once again the vertical emphasis is strong, not only in the entrance pavilion but also in the arrangement of the windows, which, as at Gaillon, are linked to form vertical strips.

When we come to the châteaux of Blois and Chambord the scale of work changes; we move

from the country house to the palace. Blois was Francis I's earliest passion, and six months after his accession in 1515 we find him giving orders for extensive building operations there.[25] During the following nine years there rose the wing which bears his name and which stands to-day, slightly truncated on the court side and heavily restored, as the first great monument of the reign. In plan it has nothing novel to offer, for, in spite of the grandeur of his ideas, the King allowed himself to be tied by the remains of surviving medieval buildings. The court façade [11] and the flight of rooms behind, which were the first to be built, are constructed on old foundations, and even the great staircase replaces a tower of roughly the same shape. On the opposite front overlooking the town [12] the new *logge* and the rooms which they veil, probably built after 1520, are constructed between three medieval round towers, one of which is clearly visible at the extreme right, while the other two have their foundations incorporated in the new structure. This economical use of existing foundations accounts for certain irregularities in the design of the wing. Neither façade is symmetrical; on the court side the staircase was roughly central before the seventeenth-century reconstruction cut off the end bays, but the arrangement of windows was always irregular, as we can see from du Cerceau's engravings. On the outer front the aberrations are even more marked; some bays are separated by single pilasters, others by double, others by double pilasters enclosing a niche, all apparently without rhyme or reason.

This irregularity proves that although French builders had learnt the idiom of Italian decoration, they had not yet absorbed the basic principles of Renaissance architecture. It does not, however, alter the fact that the Francis I wing is an effective and original building. Of the two façades, that on the court is the less remarkable. Its general disposition is in line with what we have seen at Bury and Azay, and the only novel

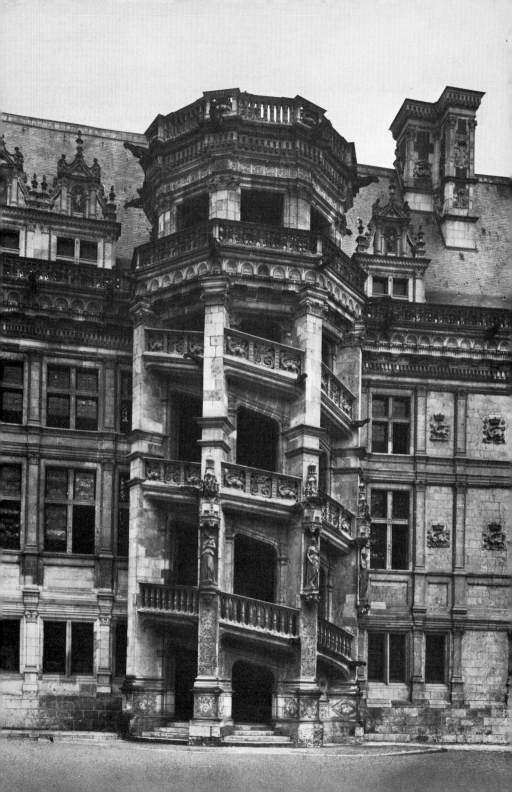

element is the staircase. This is an admirable example of the attitude of French architects of this period towards tradition. In its general principle the staircase is only the last of a long line of spiral staircases to be found in France throughout the fifteenth century. Often, as at Châteaudun, it is incorporated in the main block of the building, but in many cases – for instance in the house of Jacques Cœur at Bourges – it stands out from the façade in a polygonal pavilion, and in some examples it is open. In many respects therefore the Blois staircase is traditional, but the old type is translated into a

11 *(opposite)*. Blois, château, staircase. 1515–24

12 *(below)*. Blois, château, north-west façade. 1520–4

completely new idiom. Here it is no longer merely a question of the decorative detail, most of which incidentally dates from the nineteenth-century restoration. For the first time one can speak of a feeling of monumentality in French Renaissance architecture. Compared with the light surface patterning of Azay or of the façade itself at Blois, we have here the impression that the architect has thought in three dimensions. The ramp carves out a definable space, and both it and the piers create emphatically the impression of weight. The play is in depth, in a series of planes in the thickness of the polygonal drum of the tower. On the outer surface are the verticals of the piers, decorated with niches below and pilasters above. Across these run the three bands of open-work balustrade, sloping and set slightly back; and behind them again in a third

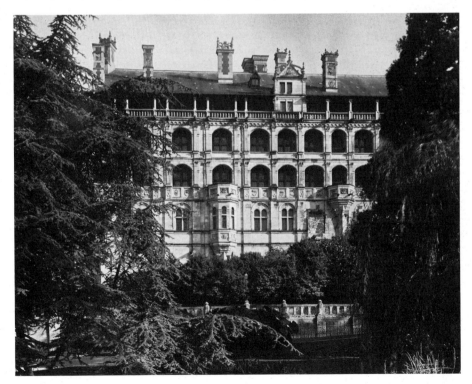

plane are the lines of the ramp itself, sloping a little more steeply than the balustrade. Inside the staircase tradition reigns unchallenged except for decorative detail; for the structure and vaulting are purely Gothic.

The façade over the town is an altogether original conception. The sharp cliff on this side seems to have held an irresistible attraction for architects. The medieval castle had been built along the edge of the flat area at its top, with only the three round towers projecting and built up from the lower level. Francis I, however, boldly set the façade forward some twenty feet, to the outer points of the towers, and was therefore forced to build a vast substructure to support the *logge* above. For the right-hand half the rock was still relatively near, but on the left it ran sharply back, so that a whole extra floor could be inserted between the substructure and the normal ground floor of the main building. As we shall see later, in the seventeenth century François Mansart was tempted to be even bolder, and his final design would have carried the front another thirty feet into space.[26]

The idea of an arcaded *loggia* on the outside of a château was not altogether new in France. It had already been used in Gothic form at Amboise and in the earlier wing at Gaillon, built between 1502 and 1506, but at Blois the scheme is grander in conception. There are two sets of *logge* one above the other, and over them a third floor of flat-headed openings separated by free-standing columns. The source of this design is evidently the *Logge* of the Vatican, in which two floors of round-headed and one of flat-headed *logge* rest on a solid ground floor. We must suppose that the French builders were fairly well up to date in their information about building in Rome, for the *Logge* were not finished till 1519. On the other hand, the drawings or description of the *Logge* from which they worked cannot have been very accurate, for nothing could be less like them in feeling than the Blois façade. The irregularity in the

elevation has already been pointed out, but there are other differences of importance. The arches are slightly flattened, instead of having the pure semicircle of Bramante, and, except on the top floor, the galleries at Blois are not properly speaking *logge* at all, since they are merely very deep recesses closed by glazed windows. These differences effectively destroy the essential qualities of Bramante's design: regularity, mathematical perfection, and lightness.[27]

At Blois are summed up the strength and weakness of French architecture in the earlier years of Francis I. The strength consists of imaginative inventiveness and structural skill, both qualities resulting from the medieval tradition, and of a certain *finesse* in the adaptation of Italian ornament. The weakness lies in the naïve and often clumsy imitation of Italian design, imperfectly understood. The impression made by the château on a strictly classical mind is well conveyed by La Fontaine's description of it, though he must have been alone at his time in preferring the sixteenth-century wing to that of François Mansart: 'The part built by Francis I, seen from the outside, pleased me more than anything else. There are many little galleries, little windows, little balconies, little ornaments without regularity or order; these make up a whole which is big and rather pleasing.'[28]

Up to this stage in the development of French sixteenth-century architecture the buildings were to all intents and purposes anonymous. We often know the names of master masons involved, but in no case, except that of St Pierre at Caen, is there any reason to suppose that they were responsible for the design of the building. Further, the arguments about the shares of French and Italian craftsmen are, as has been said, futile. The only clear fact is that in planning and structure the French mind dominates, and in decoration the Italian; the nationality of the executants is of purely academic interest.

But in the case of Chambord [13] both these problems are posed in a new and more definite

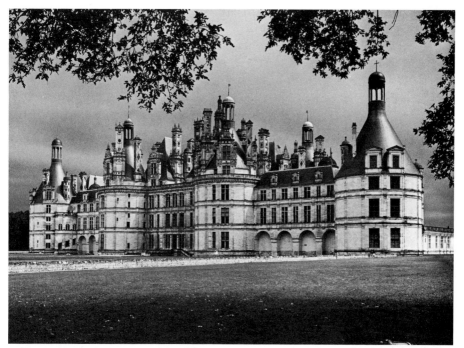

13. Chambord, château, north front. Begun 1519

manner: there is every probability that the original designer was an Italian, Domenico da Cortona, but on the other hand his plans seem to have been modified in the course of execution by French masons.[29]

The known facts are as follows. Francis I, attracted by the site of Chambord as a hunting lodge, first caused plans to be drawn up for a château there in 1519. Work was probably begun soon afterwards, but was interrupted from 1524 to 1526 by the Italian campaign and the King's captivity. It was then actively continued, and the main keep was being roofed in 1537; the east wing was being constructed in 1539 and the west in 1550, that is to say, after the death of the King.[30] As it stands to-day Chambord is essentially a French medieval château with square keep flanked by round towers from which run

ranges of lower buildings, again with towers at the corners, the whole being surrounded by a moat.[31] In one respect, however, the planning is unusual, namely, in the keep itself, which is divided into four parts by a Greek cross, the arms of which lead from the entrances to the central staircase [14]. This arrangement leaves in each corner a square space divided into a large room, two smaller ones, and a closet, that is to say, into the *appartement*, which was to be the regular unit of French domestic planning for the next two centuries. This seems to be its first appearance in France, and its origin is worth investigating. It appears in the original wooden model designed and executed almost certainly by Domenico da Cortona and known to us through the drawings made by Félibien in the seventeenth century.[32] According to tra-

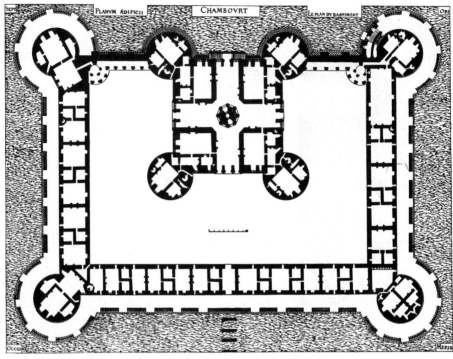

14. Chambord, château. Plan,
from du Cerceau, *Les plus excellents Bastiments*

dition, Domenico da Cortona was a pupil of
Giuliano da Sangallo, whom he accompanied to
France on his visit in 1495, the master soon
returning and the pupil remaining. Now we find
an arrangement closely similar to the Chambord
plan in the villa built by Giuliano for Lorenzo
de' Medici at Poggio a Caiano.[33] Here are the
four groups of rooms arranged in the corners of
a square, and although the intervening spaces
are filled in a slightly different way, they are
occupied on two sides by vestibules, as at Cham-
bord. In fact, it seems almost certain that
Domenico borrowed this disposition from his
master, and so set a fashion which was to be-
come purely French; for in Italy this particular
design was not followed up.

Apart from this important detail of planning,
little of Domenico's original design survived in
the executed building. Even the plan was altered
in one respect, for Domenico had proposed a
straight staircase doubling back on itself in one
arm of the Greek cross, an arrangement remi-
niscent of Chenonceu. In the building itself
this disposition was changed, and the double
spiral staircase was inserted at the central point
of the Greek cross. This staircase derives partly
from a French tradition, represented by the
staircase at Blois, but it may also have been
influenced by Sangallo's double spiral at the
Well of St Patrick at Orvieto (1528). In elevation
the alterations made to the Italian model were
much more drastic. Domenico's keep was to be

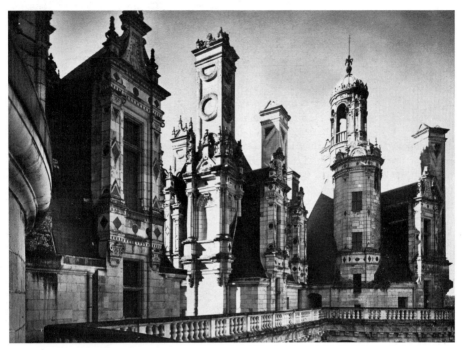

15. Chambord, château, roof. After 1537

surrounded on the ground floor by an open *loggia* of round-headed arches, and on the upper floors the windows, though themselves mostly square-headed, were to be enclosed in blind arcades. In the actual building these Italian elements have disappeared, and the elevation is treated in the manner which we have noticed at Azay and on the court façade at Blois, with string courses and flat pilasters.

In its general appearance Chambord is entirely French and still largely medieval. The massive round towers with their conical tops could be matched in any fifteenth-century château. What is original is the treatment of the roof [15]. Standing on the flat terrace of which it consists, the spectator has the impression of

being surrounded by a forest of chimneys, turrets, and dormers, all different and all of the most complex form. The fantasy of the design brings this roof into line with the strangest inventions of Flamboyant Gothic. The detail, however, is not only Italian, but of purer Italian design than had so far been seen in France. Some of the dormers are like those at Blois or Azay, except that they have panels of coloured marble let into their surface; but others are altogether new in their plastic conception. The niche decorating the chimney in the middle of illustration 15, for instance, is hollowed almost into a half-cylinder, topped by a shell half-dome and flanked not by pilasters but by free-standing columns. We have already noticed this sense of

spatial design in the staircase at Blois, though there it was expressed in a more strictly French idiom. In both, however, it prepares the way for what was to come in the next period.

We have already seen that the richer *bourgeois* played an important part in the evolution of the château, and naturally their share is even greater in town houses. In their corporate activities they were responsible for the rebuilding of many town-halls in the new manner, and the changes which they introduced can be seen by the comparison of two almost contemporary examples, at Compiègne (1502-10) and Orléans (1503-13) [16]. The Compiègne Hôtel de Ville is still a Franco-Flemish Flamboyant building with a belfry in the middle and, between the windows, niches with statues of kings of France. At Orléans the fifteenth-century belfry was preserved and the new town-hall built separately in front of it. The general design is like that of Compiègne, and even incorporates the same niches and statues, but the decoration is Italian, with pilasters partly fluted and partly decorated with candelabra and with a shell cornice of a kind to be found later on the court façade at Blois. Below each window is a pair of *putti* supporting the arms of the town, an unusually advanced conception for such an early date.[34]

The same development can be seen in the private houses built by the wealthier financiers in the towns. The great model of these, and one which for long was not to be surpassed in splendour, was the house of Jacques Cœur at Bourges, built in the Late Gothic style between 1445 and 1451. The arrangement round a partly arcaded court was generally followed in the sixteenth century, for instance in the transitional example of the Hôtel d'Alluye at Blois, built before 1508 by Florimond Robertet, the creator of Bury. Here we find the usual mixture of elements, Late Gothic arches with Italianate capitals and a pierced balustrade of dolphins running above the upper arcade. The Hôtel Lallemant at Bourges, mainly completed by 1518, is still

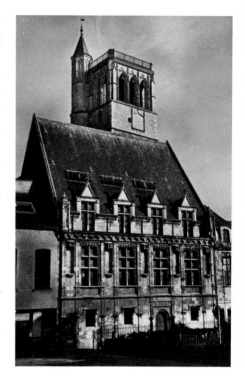

16 *(above)*. Orléans, Old Town Hall. 1503-13

17 *(opposite)*. Angers, Hôtel Pincé. 1523-33

Gothic in its design, but has fine and relatively pure Italianate detail.[35] Fully in the style of Francis I is the Hôtel Pincé at Angers [17],

built on an L-shaped plan, of which the left-hand wing and the staircase tower date from 1523-33. Here are still the mullioned windows, the turrets, and the high-pitched roofs of a medieval building, but dormers and windows are all ornamented with rich decoration in the style of the Loire châteaux.

In many towns, notably Lyons,[36] Le Mans, Orléans, and Toulouse, smaller houses survive, which follow in plan a medieval pattern: an arched opening for the shop on one side and a passage beside it leading to a small court and to the spiral staircase which gives access to the private rooms on the upper floors. The design of town houses is often affected by climate and local building materials. South of the Loire, for instance, much greater play is made with open *logge* than in the north, and in Toulouse and

the neighbouring towns the houses, both great and small, take on a special character from the fine local brick of which they are built. This allows of rich moulded decoration and has the further advantage of being much less inflammable than the timber and plaster construction used in most other districts; it is no doubt for this reason that so many sixteenth-century houses have survived in this area.[37]

In some of the more remote provinces, particularly in the south-west, the fusion of Italianate and Gothic elements takes on forms unknown in the Loire valley or the north of France. At Albi, for instance, where the decoration of the cathedral was carried out within a relatively short period (1499-1514), the choir stalls are in the most elaborate Flamboyant style, with figures of prophets and sibyls deriving from late fifteenth-century Burgundian sculpture, whereas the walls and vaults are covered with frescoes by artists working in the style of the Emilian Renaissance.[38] This iconographical scheme with prophets and sibyls seems to have been much favoured in this district. It is to be found earlier in the late fifteenth-century statues which surrounded the choir of St Sernin at Toulouse and are now in the Musée des Augustins, and later at Auch in the stained-glass windows and in the magnificent stalls (bearing the dates 1526 and 1529), where the figures, apparently based on north Italian models, are carved in low relief under Flamboyant canopies and supported on Italianate consoles. Finally, the same iconography appears in fully Italian form in the choir of the cathedral of St Bertrand-de-Comminges.

Occasionally an individual patron indulged in a purely personal decorative scheme. At Assier, for instance, where both château and church were built by Galiot de Genouillac, who was Grand Master of the Artillery, allusions to his position are to be seen not only in the cannons and bombs which ornament the exterior of the house but, even more explicitly, in a long frieze

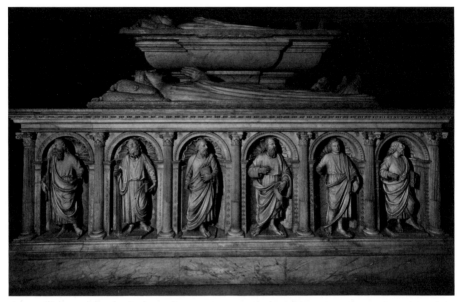

18. Gerolamo Viscardi and assistants: St Denis, tomb of the Dukes of Orleans, 1502

which runs the whole way round the outside of the church and is decorated not only with symbols of artillery but with scenes from the campaigns of the patron.[39]

The period of French architecture from 1494 to 1525 was a transitional phase in which Italian ideas were grafted on a very lively medieval tradition, the two elements still remaining distinct. In the next period they become more closely fused, and architects, while remaining distinctively French, show a greater understanding of Italian principles and skill in adapting them to their needs, instead of copying blindly and often inappropriately.

SCULPTURE

Guido Mazzoni, the Giusti, Michel Colombe

In sculpture as in architecture a strong Gothic tradition still flourished at the end of the fifteenth century, and well into the sixteenth century we find works of high quality produced in this style all over France.[40] Examples of Italian work had begun to arrive in France long before the Italian campaigns, but, as in the case of architecture, without exercising any perceptible influence.[41]

At the turn of the century, however, a more consistent Italian influence begins to be felt. In 1502 Louis XII commissioned a tomb in honour of his ancestors, the Dukes of Orleans, which was originally set up in the church of the Célestins in Paris, but is now at St Denis [18]. The contract of 1502 mentions the Genoese sculptors, Michele d'Aria and Gerolamo Viscardi, and the two Florentines, Donato di Battista Benti and Benedetto da Rovezzano, who had settled in Genoa. This tomb shows a compromise scheme which was to become common in the next decades, consisting of a purely Italian sarcophagus supporting a recumbent

figure, or *gisant*, in the traditional French manner. In this case the style of the drapery suggests that the *gisant* was actually executed by the Italian sculptors, probably on a French design; but we shall see later that sometimes the two parts were by artists of different nationalities. The novelty of this tomb, apart from the strictly classical arcade round the sarcophagus, lies in the introduction in this arcade of the figures of the twelve apostles, which replace the *pleurants* usual in French tombs.[42]

There is no reason to believe that any of the artists involved in the Orleans tomb actually came to France; and the first sculptor who can be traced there is Guido Mazzoni, who was brought back by Charles VIII from Naples in 1495. He was born in Modena and had worked for some years in his native district, but moved to Naples in 1489. His works in Italy consist mainly of terra-cotta groups, usually of the Entombment, marked by an extreme naturalism of style which derives largely from northern Gothic sources.[43]

Such groups were already popular in France in the late fifteenth century, and Mazzoni's skill in them would no doubt have been welcomed by his new patrons. We have no proof that he executed works of this type in France, but Vitry is probably right in attributing to him the 'Death of the Virgin' in painted stone at Fécamp.[44]

The only work by Mazzoni for which we have documentary evidence is the tomb of Charles VIII at St Denis, now destroyed, but known from engravings.[45] It consisted of a rectangular sarcophagus on which was the figure of the King kneeling at a prie-Dieu, surrounded by four angels. This arrangement was more French than Italian and was probably derived from the tomb of Louis XI at Cléry, but the figure had greater freedom of movement than would have been possible in a French tomb. The sarcophagus was decorated with roundels in which were half-figures of the Virtues, or possibly of *pleurants*, an arrangement new in France, and probably inspired by reliefs to be seen on the façades of certain north Italian buildings.[46] We know little more of Mazzoni's activities in France, beyond that he supplied medallions for Gaillon. In 1507 he went back to Modena, returning to France for the years 1509-11, but without apparently undertaking any important work.

Mazzoni was soon followed by the Giusti brothers, who settled in Tours, changed their name to Juste, and formed a dynasty of sculptors lasting till after the middle of the century. The two of importance are Antonio (1479-1519) and Giovanni (1485-1549), who came to France together probably in 1504 or 1505. Antonio is known to have revisited Italy between 1508 and 1516, during which period he owned a house in Carrara where Michelangelo sometimes stayed when supervising the quarrying of marble.[47] He may therefore have brought back to France information about artistic events in Italy which had taken place since the brothers had left the country, and it was probably he who introduced certain influences from Italy which appear in the later French sculpture of the Giusti.

The first work which can be connected with the family is the tomb of Thomas James in the cathedral of Dol, finished in 1507, which has already been mentioned as an early example of Italian decoration in France.

Much more important and original is the tomb of Louis XII at St Denis [19], commissioned by his successor Francis I, probably in 1515, and finished in 1531. It bears the name of Giovanni only, but is often said to be a work of both brothers working in collaboration. The arrangement with the kneeling figures above links the design with the tomb of Charles VIII, and the placing of the *gisants* in an arcaded enclosure below follows the usual fifteenth-century disposition. In all other respects, however, the tomb marks an innovation in French practice. First of all, the enclosure of the *gisants*

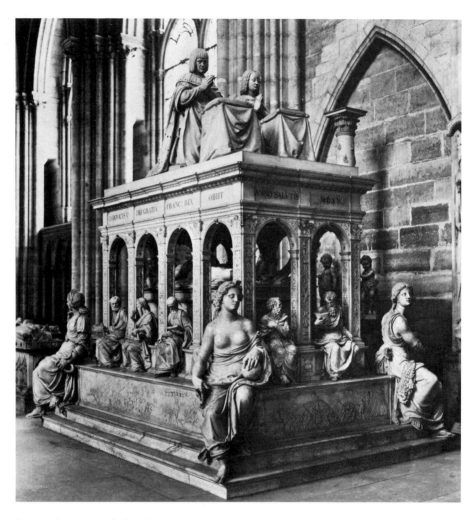

is now almost a small chapel open at the sides and the ends. This feature, combined with the allegorical figures of the Virtues at the corners and the apostles in front of the arcade, suggests that we may have here a remote echo of Michelangelo's first scheme for the tomb of Julius II. But the actual form is different, in that the 'chapel' is opened by arcades, and for this the Giusti probably followed another model, the tomb of Gian Galeazzo Visconti, which Com-

mines had admired in the Certosa at Pavia.[48] In the sculpture several different hands can be distinguished. Two groups – the apostles and the Virtues – seem to be Florentine in derivation and apparently connected with the style of Andrea Sansovino. The apostles are dull but competent imitations of his statues in the chapel of S. Giovanni in the cathedral of Genoa (finished in 1503), the Virtues very coarse versions of his later manner in the tombs in S.

19 *(opposite)*. Antonio and Giovanni Giusti and assistants: St Denis, tomb of Louis XII. 1515-31

20 *(below)*. St Denis, head of the recumbent figure of Louis XII. Between 1515 and 1531

time the most puzzling group consists of the two *gisants*. In certain respects the heads of the two figures are classical; in particular that of Louis XII is like the well-known heads of the Emperor Augustus [20]. But the traces of French Gothic are strong. The lines of the eyes have a sweetness to be found in French fifteenth-century painting; and, by contrast, the grimness of Late Gothic sculpture can be seen in certain naturalistic details, particularly the rendering of the incisions and stitching made in the process of embalming the bodies. The naturalistic treatment of the open mouth showing the teeth,

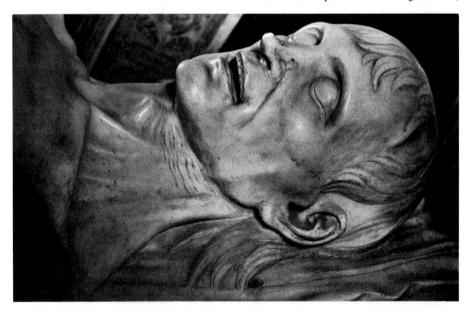

Maria del Popolo, Rome (1505-9). These two groups can almost certainly be attributed to members of the Giusti family. The bas-reliefs round the base seem also Florentine in style and indicate an artist trained in the studio of Bertoldo. On the other hand, as suggested by Vitry and Pradel, the kneeling figures of the King and Queen on the top of the tomb are likely to be by a French artist of the circle of Colombe. The most remarkable and at the same

and the hollowing out of the cheeks reminds one in some respects of French fifteenth-century portraiture as it can be seen in the head of the donor in the Avignon Pietà. On the whole, therefore, it seems likely that these figures are by a French artist with some knowledge of Italian sculpture rather than by an Italian sculptor, who could hardly have absorbed these local elements.[49] But, whoever the artist may have been, the statues are unquestionably among the

most remarkable works of the period. The sensitiveness of their modelling and the liveliness of their conception are shown up by the contrast with the heavy proportions and coarse modelling of the statues round the base of the tomb. The latter are only interesting as being among the few surviving examples of Italian High Renaissance sculpture which reached France at this period, though they cannot have given Frenchmen much idea of what was being produced at the period in Italy.[50]

The works which we have so far considered have been either exclusively or predominantly Italian. But it must be remembered that one French sculptor of great celebrity was still active at this time, namely, Michel Colombe. The greater part of his career falls outside our period, for he was born about 1430–5 and is last recorded in 1512. But we have almost no information about his work till the early years of the

sixteenth century, when his name occurs in connexion with two important works: the tomb of Francis II, Duke of Brittany, in Nantes Cathedral, and the altar-relief of St George at Gaillon.

The tomb of Francis II [21] is a work of collaboration, the story of which is complex and in many points obscure. In 1499 Anne of Brittany was collecting marble for the tomb of her father, and in January 1500 the Italian sculptor Girolamo da Fiesole was commissioned to carry out at any rate some part of the work. At the end of the same year Anne seems to have turned towards French artists, and we find her approaching Colombe and Perréal on the subject. Work seems actually to have been started by these two artists in 1502, apparently with Perréal in charge and supplying the general design and Colombe working out the detail of the sculpture. It is, however, likely that the

21. Girolamo da Fiesole and Michel Colombe: Nantes Cathedral, tomb of Francis II of Brittany. Begun 1499

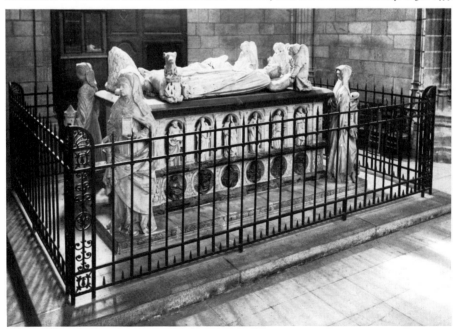

sarcophagus was made by an Italian. The tomb was finally erected in 1507.

The general design with altar-tomb and *gisants* is the usual translation of the Late Gothic tomb into Italian terms, with the small difference that it combines the arches of the Orleans tomb with the roundels of the monument to Charles VIII. At the corner stand four allegorical figures of Virtues, an arrangement which may be regarded as a variation on Burgundian tombs like that of Philippe Pot. Vitry has argued convincingly that these figures and the *gisants* are the work of Colombe and his studio, and that except in certain points of iconography they show little direct Italian influence. They are far from the tortured Burgundian Late Gothic style, and belong in their calm to the style of the Loire, in which Colombe had grown up. They are idealized, but their idealization is different in character from that of the Italian

Renaissance. In fact they belong to a French Late Gothic style, classical in its calm, but not in its forms, more individual and more harmonious than anything produced by the Italian sculptors imported into France.[51]

The altarpiece of St George for Gaillon [22], now in the Louvre, was executed by Colombe in 1508-9, and the frame for it carved by Jérôme Pacherot, the Genoese sculptor whom we have already noticed working at Gaillon. In this relief we find stronger traces of Italian influence than are usual in Colombe. Iconographically it does not go back, as is usually said, to Donatello's relief on Or San Michele, but more directly to various reliefs of the subject produced by the Gaggini family in Genoa.[52] Colombe, however, has not slavishly imitated the Italian work. In the latter the landscape is treated in a schematic manner, with the rocks reduced to geometrical forms, whereas Colombe

22. Michel Colombe and Jérôme Pacherot: St George from the chapel at Gaillon. 1508-9. *Paris, Louvre*

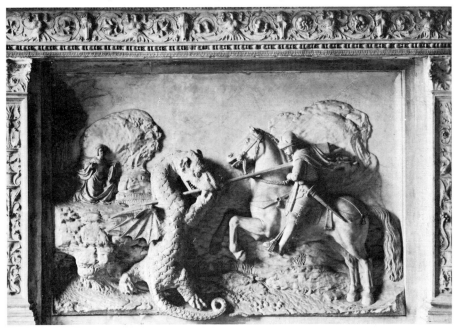

has rendered with great care every incident of rock, pebble, or plant. Moreover, his dragon is entirely his own, with a Gothic combination of imagination and homeliness.

Colombe occupies a unique position among French artists of the early sixteenth century. He rarely borrows directly from Italian models, yet he adapted his art to suit the ideals which were coming into France from the south. His work is always distinguishably French, but it has deeper affinities with the sculpture of the Italian High Renaissance than many works which imitate the forms of the latter.

The monument to the children of Charles VIII in Tours Cathedral is, like that of Francis II of Brittany, a work in which the style of Colombe and that of the Italians can be seen side by side. Girolamo da Fiesole was engaged to execute the tomb in 1499, and he is probably responsible for the sarcophagus, which is of elaborate and original design.[53] Among the acanthus reliefs are scenes from the lives of Samson and Hercules, strangely inappropriate, one would have said, to the tomb of two young children, but to be explained by the fact that both were frequently used as symbols for Christ in the Middle Ages, and that in classical antiquity Hercules is often identified with Cupid.[54] The figures of the children clearly belong to the same school as those on the Nantes tomb and can with great probability be attributed to the studio of Colombe.

The last and most complicated monument of this period is the tomb of the two Cardinals of the Amboise family in Rouen Cathedral [23].[55] The tomb was begun in 1515 under the direction and probably after the design of Roullant le Roux, whose name, however, disappears from the accounts in 1522. In the first stage the tomb was intended to commemorate only the elder Cardinal, whose statue, the left-hand of the two figures, was probably executed by Pierre des Aubeaux. Later the whole design was altered, partly to incorporate the figure of the younger Cardinal, and partly for reasons of economy, both in money and in space. Of the various craftsmen named in the accounts none appears to be Italian, but the decorative detail is clearly southern in style and some of the figures appear to be based on Lombard models. The design of the tomb, however, is certainly French. It derives from the Late Gothic form, with an altar-tomb set in a niche, but in this case the *gisant* has been replaced by a kneeling figure, perhaps in imitation of the tombs of Louis XI and Charles VIII. Much of the detail is evidently French and specifically Norman, for instance the finials and pendentives, which are like those of Hector Sohier at St Pierre at Caen. This tomb is the last expression of the experimental spirit which animated the early years of the sixteenth century in France. In its general form it is Gothic, in its wildness it is Flamboyant, in its detail it is Italianate; and yet as a whole it is unmistakably in the style which we call 'François I'.

Sculpture of the early sixteenth century outside the main centres such as Paris or Rouen is still inadequately studied, but one type, representing the Entombment, usually in the form of an Easter Sepulchre, flourished, particularly in the eastern provinces of Lorraine, Champagne, and Burgundy, but also in central and south-western France, and produced work of high quality in which Renaissance forms gradually overcome those inherited from the late Middle Ages. A particularly fine group of such Entombments is to be found in Champagne and has been ascribed to a single sculptor called the Maître de Chaource, after the village in which his most remarkable Easter Sepulchre is to be found. In their calm, almost classical style they are more akin to the work of Michel Colombe than they are to anything to be found among their immediate predecessors in Champagne or Burgundy.[56]

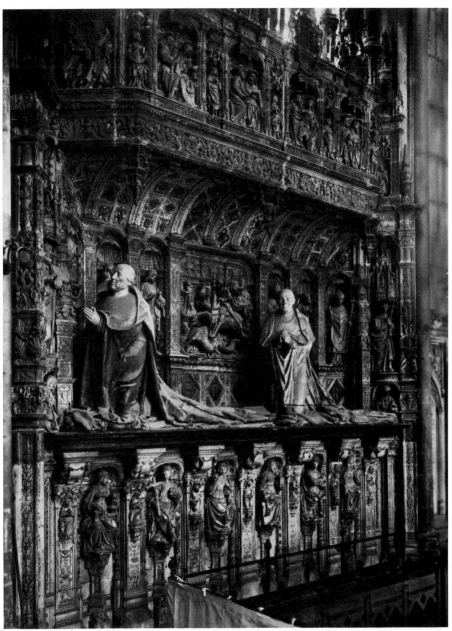

23. Roullant le Roux and assistants: Rouen Cathedral, tomb of the Amboise Cardinals. Begun 1515

PAINTING

Bourdichon, Perréal

The position of painting in France at the beginning of the sixteenth century was very different from that of architecture and sculpture. In the two latter arts a vigorous medieval tradition survived which was capable of absorbing influences from abroad. Painting was, on the other hand, at a much lower ebb, although in the last two decades of the century it had produced a brilliant burst of inspiration in the works of the Maître de Moulins. After 1500, however, there are few signs of real activity in painting proper, though certain works to be found in the eastern provinces of France suggest that there may have existed there a competent school of religious painters yet to be rediscovered and isolated from contemporary Flemish work.[57]

24. Jean Bourdichon: St Sebastian, from the *Hours of Anne of Brittany.* 1508. *Paris, Bibliothèque Nationale*

Only two names of importance survive from this period. With one, Jean Bourdichon, can be connected a number of works; about the other, Jean Perréal, there is much contemporary evidence, but modern scholarship has not reached any agreement about the paintings that can be attributed to him.

Bourdichon was probably born about 1457 and seems to have spent most of his life in Touraine. He worked in turn for Louis XI, Charles VIII, Louis XII, Anne of Brittany, Charles of Angoulême, and his son Francis I, and died in 1521. He is known from records to have painted portraits and religious pictures, but apart from one triptych in Naples generally accepted as his,[58] the only works which can be certainly attributed to him are manuscript illuminations. Of these the most important series and the one of which the authorship is proved beyond doubt is the *Hours of Anne of Brittany* in the Bibliothèque Nationale, finished in 1508. The illuminations of this manuscript allow us to define Bourdichon's position fairly clearly. In many respects he follows the Late Gothic tradition of fifteenth-century illuminators, and the miniatures illustrating the months show no novel features except a curious tendency to allow the figures to be cut off at the waist by the frame, a trick which at a later date we should call Mannerist. Another series of miniatures in the book reveals an astonishing naturalistic power in the rendering of plants and insects, a naturalism still essentially within the Gothic field but carried to a hitherto unknown pitch of perfection [25].

In the paintings representing the scenes from the New Testament and lives of the saints, however, a more mixed style is visible. In many the architectural setting shows unmistakable Italian influence. This was not new in French illumination, for since the time of Fouquet details of Italian decoration had been relatively common. It is, however, of some interest to notice that certain features in Bourdichon's

designs can be traced directly to Bramante's work in S. Maria presso S. Satiro at Milan, particularly the shell-niches which appear in several miniatures, and the coffered vault in the 'Annunciation'. But it is also noticeable that the figure types and compositions are influenced by Italian models. Many of the heads are reminiscent of Milanese painting, notably of Foppa, but more remarkable is the unquestionable influence of Perugino. The miniature of St Sebastian [24] is in almost exactly the pose of Perugino's figure of the saint in the Louvre and other paintings of the 1490s;[59] and in many of Bourdichon's compositions we find heads unmistakably Peruginesque in origin. It is not clear how the influence came to be transmitted,

25. Jean Bourdichon: Page from the *Hours of Anne of Brittany*. 1508. *Paris, Bibliothèque Nationale*

since we have no evidence that Bourdichon visited Italy. But the variety of Italian influences in his work points strongly to a visit, and seems to indicate that he went not only to Milan[60] but to other parts of Italy.[61] It is characteristic of Bourdichon that he should have been primarily influenced by large-scale Italian painting and sculpture rather than by miniatures. Many of his designs look in reproduction like altarpieces rather than miniatures; and in this respect his art marks a complete break with the tradition of illumination as it was conceived in the Middle Ages.

Jean Perréal, or Jean de Paris, seems to have commanded even more than Bourdichon the admiration of his contemporaries. We do not know the date of his birth, but it cannot have been far from that of Bourdichon, that is to say, in the second half of the 1450s. By 1483 he was in the service of the city of Lyons; soon afterwards we find him working for the Duc de Bourbon; and later he was in the service of the Kings of France, Charles VIII, Louis XII, and Francis I, till his death in 1530. He visited Italy on three occasions, accompanying Charles VIII to Naples in 1494, and going on Louis XII's campaigns of 1502 and 1509. On one of these occasions he met Leonardo, who mentions him in his notebooks. His activities were varied: he was a specialist in the preparation of triumphal entries; he was called upon to draw up programmes for big undertakings in sculpture, such as the tomb of Francis II of Brittany at Nantes and those erected by Margaret of Savoy in the church of Brou, though his precise share in each of these is obscure,[62] and he designed the medals struck for the entries of Charles VIII and Louis XII into Lyons in 1494 and 1499, which contain their portraits in profile.[63] We are best able to judge his quality as an artist by his miniatures, of which one [26], illustrating a poem by Jean de Meung, was identified by Charles Sterling on the grounds that it was signed by the artist with an anagram.[64] From

26. Jean Perréal: Illustration to Jean de Meung, *Dialogue de l'Alchimiste.*
Miniature. 1516. *Paris, Bibliothèque Nationale*

this one firm starting-point Professor Sterling was able to go on and confirm the previously tentative attributions to Perréal of three portrait miniatures of Charles VIII, Anne of Brittany, and Pierre Sala, a friend of the artist [27], as well as two portrait drawings and another elaborate miniature showing Louis XII kneeling before an altar. In the portrait miniatures Perréal appears as a master of naturalism – even in the case of Charles VIII's almost grotesque nose he does not flinch before what his eye sees – but with a sculptor's feeling for the hollow forms of the mask. The miniature frontispiece to Jean de Meung's *Complainte de Nature,* datable to 1516, is Perréal's latest surviving work and shows that, although in the head of the alchemist his naturalism is still powerful,

his general conception of his art has been profoundly affected by the Italian fashion which had by then conquered France. One would guess, however, that he did not feel quite at

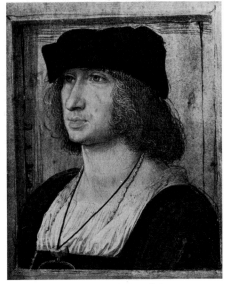

27. Jean Perréal: Portrait of Pierre Sala. Miniature. 1516. *London, British Museum*

home in this new mode, and the painting lacks the nervous quality of the earlier portrait miniatures.

From the beginning of his reign Francis I aimed at collecting Italian paintings and at attracting to his court some of the great masters of Italy. In the former project he was successful, and by the time of his death the royal collection included important paintings by Raphael, Titian, and many other painters of the High Renaissance.[65] But he found it harder to persuade the artists themselves to come to France. Leonardo da Vinci accepted his invitation and

spent the last three years of his life (1516-19) in France. Andrea del Sarto came, but stayed only for one year (1518-19).[66]

Francis I seems, however, to have set his heart above all on obtaining works by Michelangelo. The fame of this artist must have been known early in France, for the 'Pietà' in St Peter's, executed in 1498, was commissioned by a French cardinal, Jean de Villiers de La Groslaye, for the chapel of the King of France, and in 1508 the bronze 'David' was presented to Florimond Robertet. The King sent a message to Michelangelo asking for a work by him, but this desire was not satisfied till 1529, when his agent, Giambattista della Palla, was able to buy the 'Hercules',[67] with which Filippo Strozzi probably parted only in the hope of winning the support of the King for Florence against the Emperor. In the same year Michelangelo fled to Venice to escape from the siege of Florence, apparently with the intention of going on to France. He was, however, prevented from carrying out his plan by the pressure of his Florentine friends, who represented to him that this action would be regarded as treason to his native city. The last chapter of this story brings us to the year 1546, that is to say, nearly to the end of the reign, when Roberto Strozzi presented to Francis I the two 'Slaves' from the tomb of Julius II which the King passed on to Montmorency who set them up at Écouen.

Curiously enough, however, the presence in France of the great masters of the Italian Renaissance or of their works seems to have exercised almost no effect on French art, and it was not till the arrival of Rosso and Primaticcio that Italian influence began to take root in French painting. But then it swept everything aside and founded a totally new school without links with any local tradition.

THE MIDDLE YEARS OF FRANCIS I

1525-1540

HISTORICAL BACKGROUND

The short period with which we are now concerned was one of almost continuous disturbance. Beginning with the defeat of Francis I by Charles V at Pavia (1525) and the captivity of the French King in Spain, it closed inconclusively with the interview of the King and the Emperor at Aigues Mortes (1538) and the curious journey of Charles V through France to suppress the revolt of the burghers of Ghent (1540). The diplomacy of Francis I during these years was notable neither for integrity nor consistency. His immediate repudiation of the Treaty of Madrid, his subsequent reconciliation with the Emperor, the constantly changing alliances between France, the Pope, England, and the smaller European states make up a picture of vacillation and confusion. But in spite of this confusion the decades before the middle of the century were important and productive for France in the political, social, and intellectual fields.

The wars, which mostly took place abroad, only affected the border provinces, and in the rest of France trade, industry, and agriculture continued to develop, bringing increasing prosperity, especially to the middle classes. While the landed aristocracy found itself in financial difficulties owing to the changes in the purchasing power of money, those involved in commerce were able to adapt themselves to these fluctuations and even to derive profit from them. In addition, their position was greatly strengthened by the formal recognition of usury through the establishment in 1522 of *rentes*,

that is to say, loans guaranteed by the city of Paris and paying a high rate of interest, which were to be for several centuries the basis of *bourgeois* investment. At the same time the middle classes consolidated their position by establishing the right to bequeath municipal and legal posts from father to son, so that a new hierarchy sprang up in the towns, the *noblesse de robe*, despised by the *noblesse d'épée* but gaining steadily in real power.

In the administration of the kingdom Francis I pursued after his return from Madrid the policy of centralization which had been sketched out in the preceding decades. The *Conseil des Affaires*, which gradually supplanted the *Conseil Étroit*, depended solely on the King and became the chief weapon of his increasingly autocratic direction of the Government. In finance he gradually replaced the remains of the medieval system with one which depended entirely on the central government. He continued the policy of weakening the power of the nobles by reducing their rights to administer justice and by skilfully enlarging the *domaine royal* at the expense of the other feudal estates.

In fact, from this time onwards the nobility gradually lost the function and position which it had held under the feudal system and began to take up its new status as a court aristocracy. This evolution did not reach its final phase till the reign of Louis XIV, but it can be seen in its early stage under Francis I. In his reign the nobility still took an active part in the government as advisers to the King; the *Conseil des Affaires* consisted mainly of members of the old families; and the most powerful figure in the

middle years of the reign was the Constable Anne de Montmorency. But the primary employment of the nobles grew to be attendance on the person of the King. After the return of Francis from Madrid the Court was reorganized on a grander scale than ever before, and around the Household, properly speaking, the King created a large floating population of nobles attached to his person and living on gifts and pensions from him. Naturally in order to house this increasing Court new and larger palaces were needed, and, as we shall see, the King was active in building them.

In the field of religion there is a sharp difference between the periods before and after Pavia. The Reformation had taken shape as a major European fact on which it was no longer possible to avoid taking sides. The 'liberal' Reformers, such as Lefèvre d'Étaples, found themselves squeezed out by the extremists, just as Contarini and Pole ultimately found themselves impotent in Italy. The spirit of Luther began to dominate French Protestantism, and the Affair of the Placards of 1534 and the persecutions which followed it give the tone of the new period. As early as 1528 at the Council of Sens the Gallican Church organized itself to resist the schismatics, in the spirit which was to be shown by the whole Roman Church nearly two decades later at Trent. The position of Francis himself in these struggles was unsteady. Swayed towards sympathy with the Reformers by his sister Margaret of Navarre, he was sometimes pulled equally strongly in the opposite direction by political necessity, such as a new alliance with the Pope, or by fear, as after the Affair of the Placards. In general, however, he tended more and more to identify himself with the party of orthodoxy, and the persecution of the Protestants grew more violent as the reign went on.

In the literary field no new figure of importance appears in poetry. Marot's style developed under the influence of Italian models in the direction of greater simplicity, and he dropped more and more in his later works the complex poetical tricks which he had inherited from the Rhétoriqueurs. French prose, however, produced at this period one writer of genius in François Rabelais, whose *Pantagruel* appeared in 1532, to be followed by *Gargantua* in 1534, and the *Tiers Livre* in 1546. Here, for the first time in France, humanist erudition is used by a writer who has a positive attitude towards life, even a philosophy, to propose and who, though soaked in the classics and in Italian literature, is original and wholly French.

In the visual arts, as we shall see, the same stage was reached at this time, but unhappily with no figure of the calibre of Rabelais to focus the movement into works of genius.

ARCHITECTURE

The Châteaux built for Francis I in the Île-de-France: Madrid, Fontainebleau, etc.

The fact that on his return from Madrid Francis I made Paris his regular headquarters necessarily brought about a change of centre for artistic activities, and it is notable that whereas before 1525 the Loire valley had been the most advanced region of France, this now drops behind and becomes provincial, while the lead passes to the Île-de-France. In the period with which we are now concerned the major architectural undertakings may be divided into two groups of royal palaces, all of which are within a relatively short distance of Paris. The first consists of the châteaux of Madrid, St Germain, La Muette de St Germain, and Challuau; the second of Fontainebleau and Villers-Cotterets.[1] Of these, only St Germain, Fontainebleau, and Villers-Cotterets survive, and those only in much altered form.

The châteaux of the first group are closely related in style, though it is not possible to say that they are all designed by the same architect. Indeed, it is not certain who was responsible for

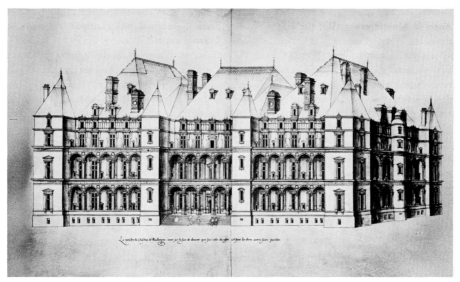

28. Paris, Château de Madrid. Begun 1528.
Drawing by du Cerceau. *London, British Museum*

the plans of any of them. In the Château de Madrid [28], which was begun in 1528, those mentioned as engaged on the building were Pierre Gadier, Gatien François, and the Italian Girolamo della Robbia. The last was responsible for the terra-cotta decoration, but the accounts show that he was also in charge of building operations, and some critics have maintained that he was the designer of the whole château. However, it is too unlike any Italian architecture in its general lay-out and elevation for this to be possible. For St Germain and La Muette we know that the master mason was Pierre Chambiges from the beginning of the work in 1539 till his death in 1544, when Guillaume Guillain and Jean Langeois took over, completing the work in 1549. About Challuau we have no documents, but the name of Chambiges is traditionally and plausibly connected with it. It seems safe to conclude that the original design of each château is due to a Frenchman, probably to Chambiges for St Germain, La Muette,

and Challuau, and perhaps to Gadier or François for Madrid, but in this last case the Italian artist may have modified certain details.

All these buildings are of very singular design, unlike anything else in French architecture. They are all of unusual height, decorated with external galleries running between turrets. In certain features Madrid differs from the others. It has, for instance, a high-pitched roof, whereas all the others had flat terraces.[2] It has true *logge*, while in the others the openings are only deep window bays, as at Blois. In this respect its design is more Italian than the others, and we may well see here a detail of arrangement introduced by Girolamo della Robbia; but the high-pitched roof is essentially French and must be attributed to the local master-masons.

The appearance of Madrid is preserved for us in the engravings of du Cerceau, which may be supplemented by the description of Evelyn, who saw the château in 1650: ''Tis observable onely for its open manner of architecture, being

much of tarraces and galleries one over another to the very roofe, and for the materials, which are most of earth painted like Porcelain or China-ware, whose colours appeare very fresh, but is very fragile. There are whole statues and relievos of this potterie, chimney-pieces and columns both within and without.' This sentence evidently refers to the contribution of Girolamo which can be seen on the outside in the form of medallions and friezes, but which also included mantelpieces like that shown in a more detailed drawing of du Cerceau, which bears the Salamander of Francis I [29]. The

novelty of the latter lay in the combination of painting with high-relief sculptured ornament, and in a sense Girolamo's work may be said to combine the methods of the two arts even more completely, since the reliefs are themselves executed in colour.

The decoration of the interior of Madrid was fantastic in form as well as in colour and material, but in a new way. It is no longer the almost Flamboyant fantasy of the early years of the century but one based on Early Italian Mannerism. The forms are those familiar in the late 1520s in decorative engravings and in

29. Paris, Château de Madrid, mantelpiece. 1530–40. Drawing by du Cerceau. *London, British Museum*

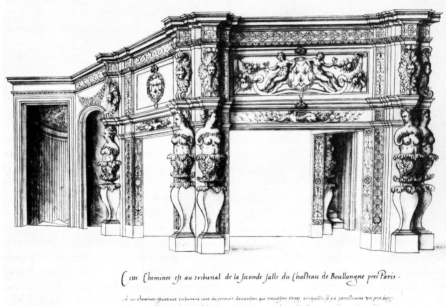

effect of this coloured terra-cotta decoration applied to interior decoration on this scale must have been startling and somewhat barbarous, but it provides an interesting prelude to the decoration which Rosso and Primaticcio were to create at Fontainebleau a few years later. The

Florentine small sculpture in stone or wood,[3] particularly the motive of caryatids which turn into architectural features, such as consoles or foliated balusters. The decoration of this château seems to have been an important source for later French artists, and many motives which

we associate with the second half of the century are already to be seen here. In one respect the decoration is simpler than in the previous period: the dormers no longer have the complicated open-work designs to be found at Blois or Chambord. In general, they are covered by straight pediments, a form so far unknown in France, but connected with the new methods which were being evolved simultaneously by Gilles Le Breton at Fontainebleau.

In plan the Château de Madrid is of importance [30], and, like Chambord, is ultimately connected with Poggio a Caiano. It consists of

coration. St Germain, which survives, though altered by Louis XIV and then put back somewhat ruthlessly to its former state in the nineteenth century, shows certain characteristics which distinguish it from the other members of this group.[5] On both the court and the outside façades it has on one floor a form of window hitherto unknown in France, consisting of a round-headed arched opening over which is a straight pediment; and a similar form, but with a curved pediment, is used in some of the doors in the turrets. This formula is common about 1500 in the architecture of Venice and its terri-

30. Paris, Château de Madrid. Begun 1528.
Plan, from du Cerceau, *Les plus excellents Bastiments*

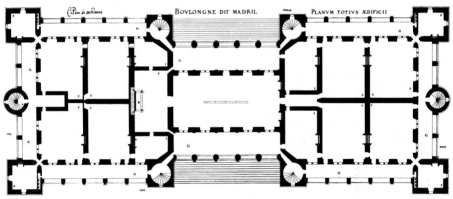

pairs of *appartements* connected by public rooms or *salles*, and du Cerceau explicitly praises the manner in which each *appartement* is arranged to be a self-contained unit with its separate entrance by a spiral staircase. The difference between Chambord and Madrid is that Chambord is the more compact and symmetrical plan, the whole building being contained in a square, whereas at Madrid the design consists of two square blocks linked by the narrower *salles*. La Muette and Challuau are known to us through the engravings of du Cerceau,[4] but they were little more than ingenious variants on the basic theme of Madrid, without the terra-cotta de-

tories on the mainland, but is hardly found in other parts of Italy, and it may not be fanciful to connect its appearance at St Germain with the tradition recorded by Félibien in the seventeenth century that Sebastiano Serlio was responsible for at any rate some work on the château, for he was trained partly on Venetian models, and reproduces in an engraving to his treatise the probable ancient source for the form in the Porta dei Leoni at Verona.

★

There is a striking contrast between the style of the châteaux just discussed and the work carried

out at Fontainebleau between 1528 and 1540. Whereas the former buildings all look back to Blois and Chambord in the complexity of their design and decoration, the architecture of Fontainebleau is marked by great simplicity, which leads the way towards the classicism of the next generation.

In 1528 Francis I decided to make certain improvements in the medieval castle of Fontainebleau, which had up till then been no more than a hunting lodge.[6] Unfortunately, as in so many of his building undertakings, he began with the idea of making small alterations. By the time he had developed a scheme for total transformation, everything had been confused by attempts to incorporate old parts and to add wings here and there. The result is that, though charming and picturesque, Fontainebleau is one of the most inconsequently designed châteaux in France.

The work with which we are now concerned was carried out in almost every case under the master mason Gilles Le Breton (d. 1553).[7] From the uniformity of style in different parts of the building it is reasonable to suppose that he was the designer as well as the executant, though some critics have maintained that another hand, perhaps even an Italian, was responsible for the original conception. The manner is, however, unmistakably French, and, if it is more classical than what went before, this classicism is an evolution within a French idiom, and is not due to the importing of new Italian motives.

From the contract signed by Le Breton in 1528 we know that the first plan of Francis I included the following modifications and additions: the building of a new entrance, the Porte Dorée [31], to the court of the old castle, the Cour de l'Ovale; the addition of a gallery stretching behind the keep, and later called the Galerie François I [39]; and the construction of two short blocks at an obtuse angle to link the new entrance to the keep. In addition, the north side of the Cour du Cheval Blanc or Cour des

Adieux probably dates from this period, though it differs in style from the other buildings. The reason for this difference may be that it was not part of the château proper but housed the monks who served the small church on the site of the present chapel of the Trinity. Of these buildings the Galerie François I has been completely remodelled externally, and the wings facing the Cour de l'Ovale are undistinguished. The most interesting is, therefore, the Porte Dorée, in which the new style of Le Breton appears clearly. Fundamentally it is, like the entrance to Gaillon, the fortified gate to a castle flanked by two towers, translated into a partly Renaissance idiom. But here the idiom is much simpler than at Gaillon. The decoration is limited to the application of flat pilasters on each floor and to the windows, which are topped with straight pediments. This simplicity was no doubt partly imposed on the architect by his material, which is the hard local *grès*, of great beauty and variety in colour but resistant to fine carving.

The most striking feature of the Porte Dorée is the series of three open bays one above the other in the middle [31]. This may be an echo of certain Italian gates, such as Alfonso I's entrance to the Castel Nuovo at Naples, of which drawings might well have been brought back to France, or the same architect's façade to the palace at Urbino. But, if the source is Italian, the treatment is French. First of all, the design is in several respects asymmetrical; the right tower is slightly broader than the left, and the middle peak of the roof is arbitrarily placed, a detail which no Italian architect of this generation would have overlooked. Secondly the windows in each tower are linked up in a vertical strip by the device of making the pediment of one window cut into the support of the one above or into the entablature of the main Order, an arrangement which we have already noticed at Gaillon and elsewhere, and which is still a trace of the Gothic love of the vertical. Finally

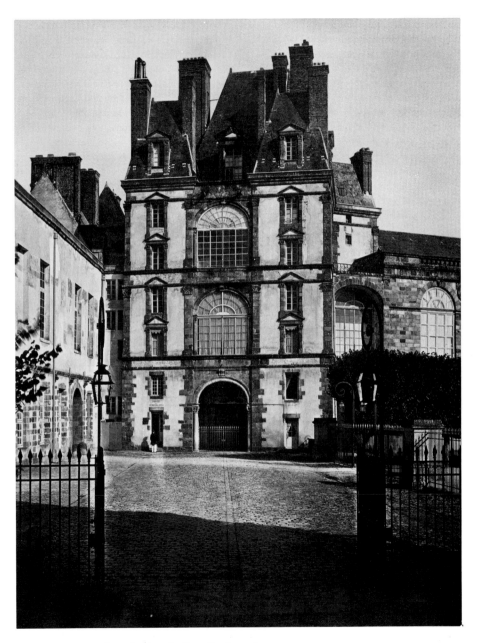

31. Gilles Le Breton: Fontainebleau, La Porte Dorée. 1528–40

the arches over the middle bays are slightly flattened, and the capitals are of a Quattrocento type which was already out of fashion in Italy. The north side of the Cour du Cheval Blanc is even simpler in style and material. It is composed of brick pilasters and mouldings against a white plaster wall, an arrangement which was to be widely followed in châteaux all over

Of the many other works carried out by Le Breton at Fontainebleau almost all have been altered or pulled down; but one must be mentioned, even though as it stands to-day it is only a fragment. This is the portico and staircase in the Cour de l'Ovale, begun in 1531, of which a reconstruction is shown in illustration 33.[8] This design is so original that it is permissible to

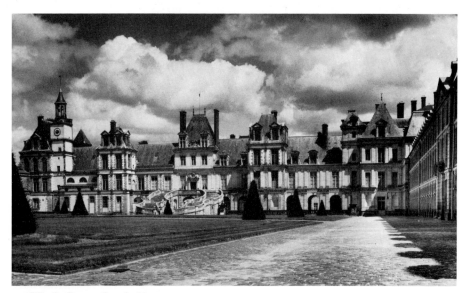

32. Gilles Le Breton: Fontainebleau,
Cour du Cheval Blanc. 1528–40

France. Here again no strict attention is paid to symmetry, for instance in the placing of the windows. The same point might be made about the east side of the court [32], but in this case the irregularities are due to subsequent alteration. The parts due to Le Breton, and built at various dates between 1528 and the death of Francis I, are in general distinguishable by being constructed in plaster with quoins and pilasters of *grès*, whereas the later parts are executed in a finer cream-coloured stone, more like that used in the châteaux of the Loire.

imagine that it may have been partly inspired by an Italian artist, perhaps Rosso,[9] but in many respects it develops out of a French tradition. The form of the staircase with a double flight leading to a single flight bridging an arch to the first floor of the building is in the late medieval French tradition, and follows examples at Montargis and in the Palais of Paris,[10] but a closer parallel for the lower part is found at Bury [9].[11] Le Breton, however, has translated the model into his own terms.[12] The middle arch has exactly the form which we see on the

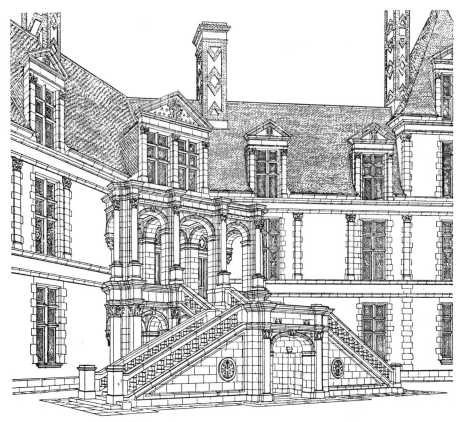

33. Fontainebleau, Cour de l'Ovale, staircase,
after a reconstruction by A. Bray

outer side of the Porte Dorée, and the mould-
ings and capitals are similar. Le Breton is here
more correct in his use of the Orders, especially
in the upper floors, but he could well have
acquired his new erudition from reading one of
the editions of Vitruvius by then available. The
staircase is the first of a great series of similar
schemes, of which the two most celebrated were
also to be built at Fontainebleau: Philibert de
l'Orme's, known to us from du Cerceau's en-
gravings and closely dependent on Le Breton's,
and Jean du Cerceau's, which replaced it and

which still stands to-day in the Cour du Cheval
Blanc.

The tendency towards a more classical style
noticeable in Le Breton was the beginning of a
movement which gathered strength during the
1530s. In various parts of France we find
châteaux and town houses in which simplicity
of form and decoration is accompanied by a
stricter use of the classical Orders. In the Loire
valley the châteaux of Champigny-sur-Veude
(probably finished before 1543), Villandry
(1532) [34], and Valençay (c. 1540) all have

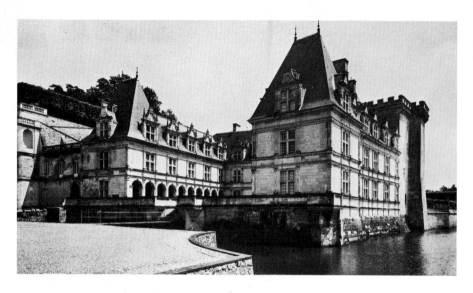

34 *(above)*. Villandry (Indre-et-Loire), château. 1532

35 *(below)*. Blaise Le Prestre: Caen,
Hôtel d'Écoville. 1535-8

36 *(opposite)*. Paris, St Eustache. Begun 1532

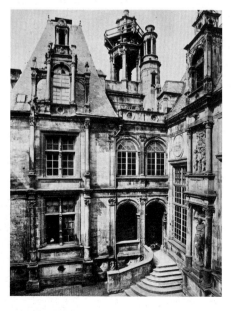

affinities with Le Breton's manner,[13] though the last two still show traces of the earlier style in the use of round towers or fretted dormers. Further south at Assier, in the Lot, the two doors added in 1535 show a better knowledge of the use of the Orders and a more monumental feeling which prepares the way for de l'Orme and Bullant. In Normandy another artistic personality appears in Blaise Le Prestre, who was responsible for the Hôtel d'Écoville at Caen (1535-8) [35] and the north wing of the château of Fontaine-Henri (*c.* 1537-44). These two buildings have in common a new formula for linking superimposed windows or niches into a vertical strip, which is here achieved by the use of full columns carrying the eye emphatically upwards. At the Hôtel d'Écoville the sculpture is also of a much more advanced type, classical in its detail and in its emphasis on the frontal view.[14]

Church architecture during this period was in the main limited to additions and alterations to existing buildings, but it produced one complete work of great interest, the church of St Eustache in Paris [36]. The foundation stone

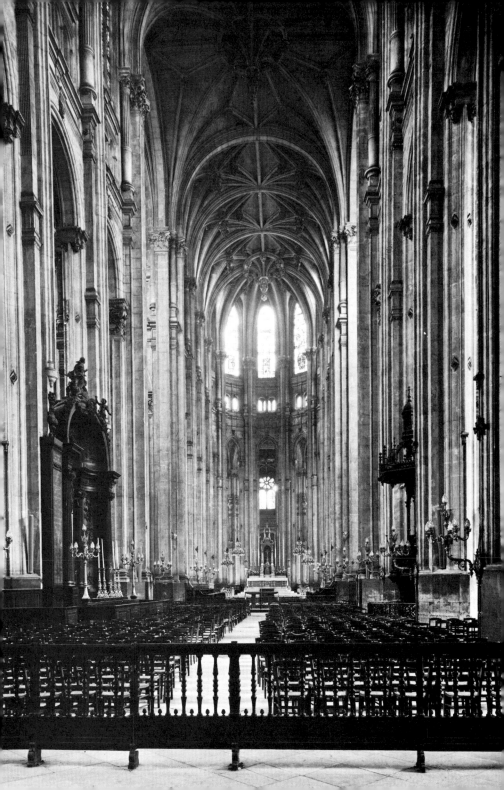

was laid in 1532; but the building was not finished till more than a century later, though the original design seems to have been generally followed. It is to be expected that Gothic tendencies should survive longer in ecclesiastical architecture than in secular, and this is amply borne out by St Eustache. It represents, however, a remarkable compromise between new and old, quite different from St Pierre at Caen. Here the plan, structure, and proportions are nearer to High Gothic than Flamboyant. The plan is almost exactly that of Notre-Dame, with double aisles and chapels running round nave and choir, and transepts which do not project beyond these chapels. In the interior the arches are tall and narrow, and although in general they are round-headed, those in the apse are stilted and pointed. The proportions of the nave again recall the thirteenth rather than the fifteenth century. This Gothic structure is, however, clothed in Renaissance forms, but not, as at St Pierre, covered with Italianate low reliefs. The ornament at St Eustache is, on the contrary, very simple, and the Italian impression depends only on the use of classical pilasters instead of Gothic. The Orders are, it is true, used in a way to horrify any classically trained architect. In some piers, for instance, the four main faces are decorated with Corinthian pilasters, the height of which is perhaps twenty times their breadth, and the corners of the pier are filled by three columns standing one on top of the other, all of somewhat bastard design. And yet, in spite of these eccentricities, the interior of St Eustache has a grandeur of space and proportions not to be found in any other sixteenth-century church in France. It is true that in these features it follows a medieval rather than a contemporary tradition, and it must also be noticed that the church was to have no influence on the general evolution of French architecture; but as an isolated work it remains of great importance.[15]

From the many additions made to existing buildings during this period one curious general feature emerges. Whereas decoration in the style of 1500-25 could be added to a Flamboyant Gothic building without any incongruity, as at St Pierre at Caen, the classical manner of the 1530s falls more readily into place in a context of Romanesque architecture. So, for instance, the strange tower added by Jean de l'Espine just before 1540 to the west front of Angers Cathedral, though it may be unhappy in its overcrowding, does not clash in style with the Romanesque façade. The same feature appears in a different way in the doors of St Michel at Dijon, built between 1537 and 1540 [37]. Seen from a distance these look like Romanesque porches,

37. Dijon, St Michel, façade

although in fact they were begun in the first years of the sixteenth century as deep Late Gothic porches but finished (before 1537) with voussoirs in an advanced Italianate style. The towers were not finished till the mid seventeenth century.

In certain French churches of this time we find additions made in a style directly deriving from Italy and without any real French admixture. Such, for instance, is the façade of the cathedral of Annecy (1535), which follows the style of Biagio Rossetti of Ferrara.[16] Another instance is the cylindrical chapel added to the cathedral of Vannes by Archdeacon Jean Danielo in 1537.[17] Danielo had spent some years in Italy, and probably brought back designs based on the work of Antonio da Sangallo the elder, whose style seems to appear here, though coarsened by the execution of French masons.

After the return of Francis I from captivity French architecture makes a crucial advance towards freeing itself from Gothic influences. Certain medieval elements, such as the high-pitched roof, remain – and were indeed to remain for more than a century longer – but in general French style changes, so that borrowings from Italy can now be absorbed and not merely applied to the surface of what are still fundamentally Late Gothic buildings. A certain degree of simplicity and a respect for the surface of the wall bring French builders closer to their contemporaries in Italy, and, although they still do not seem to have understood the lesson of the High Renaissance in Italy, the way was opened for such an understanding by the next generation.

DECORATIVE SCULPTURE AND PAINTING

Rosso and the early work of Primaticcio

All the works which we have considered up till now, though they may have great charm and inventiveness, have been either hybrid or provincial. And it is not till we come to the style of decoration evolved at Fontainebleau in the 1530s that we find a real contribution being made in France to the main European artistic tradition. One must speak of a contribution made in France rather than a French contri-

bution, for the artists responsible for the new manner are Italian; but the difference is that up till this moment the Italians who had settled in France and established their influence there had all been second-rate figures, whereas now two artists of real merit and of great invention appear on the scene. These are Giovanni Battista Rosso and Francesco Primaticcio.[18]

Much of the work which they carried out at Fontainebleau has been destroyed, but we can still form an idea of their achievement from the Galerie François I, the Chambre de la Duchesse d'Étampes, and the Salle de Bal, which were all skilfully restored in the 1960s and 1970s.[19] In these rooms we see that brilliant combination of painted panels with stucco sculpture in full relief which is the characteristic of Fontaine-bleau decoration.

A word must be said first of the previous training of the two artists. Rosso was the elder and was born in Florence in 1494. In his extreme youth he seems to have been concerned with decorative painting, but his earliest surviving works are a series of religious pictures executed between 1517 and 1523, which express with great intensity the somewhat neurotic religious sentiment prevalent in some Florentine circles at that time. In 1523 he moved to Rome, where he turned to designing compositions of mythological subjects, which were engraved. At the Sack of 1527 he fled from Rome and spent three years moving from place to place, getting apparently into increasing difficulties from which he was saved by the summons to France in 1530. During these last years in Italy he was mainly occupied with paintings for churches, though he designed for Aretino the engraving of Mars and Venus which foreshadows to some extent the style which he was to develop in France.

Primaticcio's career was entirely different.[20] He was born in Bologna in 1504 or 1505, and in 1526 joined the studio of Giulio Romano, who was engaged in decorating for the Gonzagas

the Castello and the newly built Palazzo del Tè in Mantua. He stayed there till his departure for France early in 1532. Mantua was the ideal place for a young artist to receive training in decoration. Giulio Romano had transferred from Rome the tradition of mural painting and stucco work which had been created by Raphael, and he had been given by the Duke an opportunity of displaying his ability on the grand scale. We do not know exactly which rooms Primaticcio helped to decorate, but Vasari tells us that he executed the classical friezes in the Sala degli Stucchi in the Palazzo del Tè, and he may also have worked in the Sala del Sole and the Sala delle Aquile in the same building.[21]

There is much doubt about the origin of the style of decoration employed at Fontainebleau and about the precise shares of Rosso and Primaticcio in the invention of the new manner.[22] Most writers tend to give the credit to Rosso, chiefly on the grounds that he was the older artist, that he arrived first, that he was more highly paid, and that he had more assistants. But Vasari says explicitly, speaking of Primaticcio's arrival: 'And although the year before that the Florentine painter Rosso had gone into the service of the same King, as has been related, and had executed many works there, and in particular the pictures of Bacchus and Venus, Psyche and Cupid, nevertheless the first works in stucco that were done in France, and the first labours in fresco of any account, had their origin, it is said, from Primaticcio'.[23] In some ways Primaticcio might be expected to have played the more important part, since his training at Mantua was in the field of large-scale decoration, but the most important model for the mixture of figure sculpture in the round with panels of painting and decorative stucco was Raphael's Palazzo Branconio dell'Aquila in Rome – destroyed but recorded in a drawing and an engraving – which would have been known in the original to Rosso but not to Primaticcio.[24] A similar technique had also been

used in temporary constructions for the entry of Leo X into Florence in 1515, which Rosso would have seen. The examples of this style which survive in Italy to-day, such as the Sala Regia in the Vatican and the Gallery in the Palazzo Spada, are in fact later than the first work at Fontainebleau and probably influenced by it.

Rosso's main work, the Galerie François I, survives, whereas all the decoration executed by Primaticcio during Rosso's lifetime, that is to say, before 1540,[25] has perished except for the fireplace in the Chambre de la Reine, though we know something of his decoration of the Chambre du Roi and other rooms from his drawings. Probably both these groups of works were begun

38. Primaticcio: Fontainebleau, Chambre de la Reine, mantelpiece, c. 1533-7

about 1533; Primaticcio's two rooms mentioned above were finished by 1537, and the gallery was apparently not quite finished at the time of Rosso's death.

Primaticcio's work shows clear evidence of his training under Giulio Romano at Mantua. Indeed, his first decorative scheme at Fontainebleau, for the Chambre du Roi, was based on a drawing by Giulio.[26] This decoration is lost, and we can best judge of Primaticcio's early style at Fontainebleau from the chimney-piece in the Chambre de la Reine [38], on which the fruit swags recall those in the Sala del Zodiaco in the Palazzo del Tè, and the sphinxes are cousins of those in the Sala di Fetonte. The general design is classical in its emphasis on circular and square panels, but the proportions of the figures are elongated like those in the stuccos on the vault of the Sala degli Stucchi. The whole effect, moreover, is richer than anything to be seen in Mantua, mainly because of the higher relief.

In judging the Galerie François I [39] we must remember that it has been seriously altered though it has recently been brilliantly restored by the removal of the restoration carried out under Louis Philippe. In one important detail, however, the gallery still differs from its original state: it was designed to have windows on both sides, except in the middle bay which opened on each side on to a small projecting *cabinet*.

39. Rosso: Fontainebleau,
Galerie François I. *c.* 1533–40

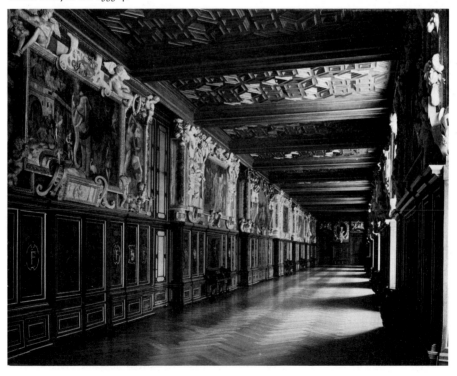

The restoration has revealed once more the full beauty and originality of this remarkable room. In richness, variety, and ingenuity it has no predecessor and few successors. The walls are divided into two more or less equal parts, of which the lower is occupied by panelling elaborately carved by the Italian Scibec de Carpi and the upper by stucco and painting, a novel arrangement, but one which may be regarded as an extension of the deep frieze used in many Italian decorative schemes of the Quattrocento, such as the rooms of Isabella d'Este at Mantua. The spaces between the windows are all treated differently. Each has a central painted panel, but some are flanked by stucco figures, others by painted figures framed in stucco, and others by stucco cartouches. These plaster decorations again show great variety. In some the figures are Michelangelesque nudes [40], in others herms; some are dominated by *putti*, others by fruit garlands. Rosso's invention never flagged in producing new motives. But the hall-mark of the whole decoration is the use of strap-work, that singular form of decoration in which the stucco seems to be copied from pieces of leather rolled and folded and then cut into fantastic shapes. The origin of this device is not altogether clear, but Rosso probably derived it from Italian engravings.[27] But what had been merely a minor incident in a corner of a design is made by Rosso into a recurrent theme, worked into every part of the stucco. The success of this motive was enormous, and it was copied not only by French artists but all over Europe, first in Italy[28] and then in England,[29] Flanders, and Germany, and so became a regular part of the vocabulary of Mannerist decoration.

The decoration of the Galerie François I must be classed as one of the most refined and successful products of Early Mannerism. It differs from the classical decoration of Raphael's *Logge* or the Villa Madama in that at Fontainebleau ingenuity and complexity are sought for their own sake. The wall surface is concealed

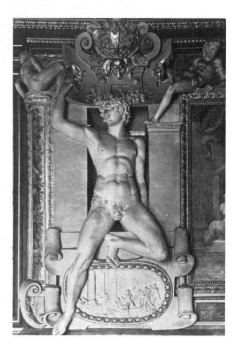

40. Rosso: Fontainebleau, Galerie François I, detail. *c.* 1533-40

behind the varied relief of stuccos; figures break over frames; cartouches disappear behind swags, and this sophisticated use of decorative forms is paralleled by the complexity of the iconography, which combines allusions to history, mythology, and Christian symbolism – all in honour of the King.[30] In fact France has passed from imitating a Late Quattrocento style in the earlier part of the reign to experimenting in Mannerist principles, skipping High Renaissance decoration just as she had skipped Bramante's style in architecture.

The decoration of the Galerie François I is purely Italian, but the room to which it is applied is quite different from the usual Italian form. This is the earliest surviving example of the

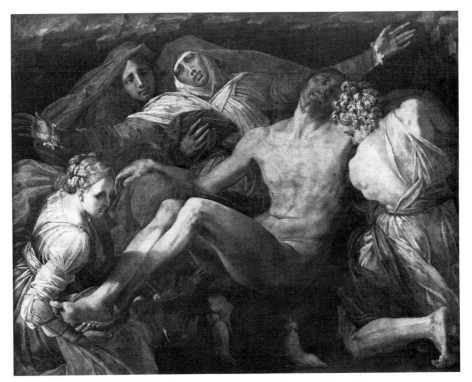

41. Rosso: Pietà. 1530–40. *Paris, Louvre*

Gallery which was to become a regular feature of French châteaux, and was also popular in England,[31] and it is sometimes argued that the Italian decoration is not suited to this essentially northern form. But this argument is fallacious. It might be true that the High Renaissance decoration would not fit a long, narrow gallery of this kind, since it is designed to cover the surface of a classically proportioned room. But the variety of depth and design, which is one of the chief features of the Fontainebleau style, is admirably adapted to a long gallery to be read, so to speak, panel by panel, and to be seen often in sharp perspective.

The later career and works of Primaticcio belong to the next chapter, but Rosso's life closes with the year 1540, and of his other decorative work nothing remains. We need only add that he executed for the Constable Anne de Montmorency the 'Pietà' in the Louvre [41], a profoundly dramatic painting, angular in design and startling in colour, which shows that even at the end of his career Rosso could express the kind of religious emotion which was the hallmark of his early work in Florence.[32]

Many engravings were made of Rosso's designs during his lifetime and the years following his death, mainly by Domenico del Barbiere, Fantuzzi,[33] and Boyvin, and these spread the knowledge of his style throughout France and abroad. It was mainly due to them that the influence of the first Fontainebleau style was so

extensive, not only in painting and engraving, but also in the decorative arts. Tapestries were woven after his designs, the most famous being the series after the panels in the Galerie François I, now in the Kunsthistorisches Museum in Vienna. These give perhaps a more complete idea than the Gallery itself in its damaged state of the original splendour of Fontainebleau.[34]

A discussion of the decoration of this period cannot end without reference to an artist who, though he worked in a minor field, reached the highest degree of skill in it, Geoffroy Tory (*c.* 1480-1533), to whom must go the credit for printing some of the finest illustrated books of the Renaissance. He was a keen humanist and a friend of Robert Étienne; he made more than one journey to Italy and studied Roman antiquities with a care which was new in a Frenchman. It is therefore not surprising that in this humanist atmosphere he should have produced designs which are closer in feeling to Italian High Renaissance work than almost anything else produced in France in the sixteenth century. His reform dealt with typography as well as with the decoration of the page, and he was one of those responsible for the introduction of a good Roman type in France. He was a true humanist turning to Greece as his ultimate inspiration and believing that proportion should be based on the human figure, as can be seen from the title of his treatise printed in 1529: *Le Champfleury, auquel est contenu l'art et la science de la deue et vraye proportion des lettres attiques qu'on dit autrement antiques et vulgairement lettres romaines proportionées selon le corps et visage humain.*[35]

PORTRAIT PAINTING

Jean Clouet

Italian taste swept the board in architecture, sculpture, and decorative painting during the reign of Francis I, but in portrait-painting a different tradition prevailed. We have already seen that Perréal's portraiture, as far as we can judge it, was still deeply rooted in a local tradition; the same is true of the great representative of this art in the next generation, Jean Clouet.

42. Jean Clouet: Madame de Canaples. *Edinburgh, National Gallery of Scotland*

Little is known of his life.[36] He was probably Flemish by birth, but seems to have come to France at a fairly early age. His name appears in the royal accounts from 1516 onwards; at first he is recorded as earning a lower wage than Perréal and Bourdichon, but with the death of the latter in 1523 he appears as the equal of the ageing Perréal. The accounts mention him solely for portraits, but from other documents we know that he also executed religious paintings and even designed embroidery. In 1539 he is praised by Clément Marot in extravagant terms as the equal of Michelangelo. He must have died soon after, for he is referred to as dead in a document of 1541. His position was filled by his son, François.

The works which can be attributed to him with even a reasonable degree of probability are very few. A series of portrait-drawings, mostly at Chantilly, are traditionally attributed to him, and in the case of one there is external evidence to support the tradition. We know that Clouet

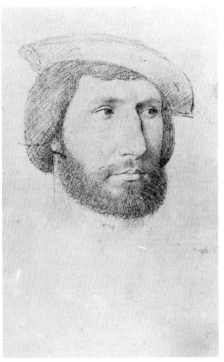

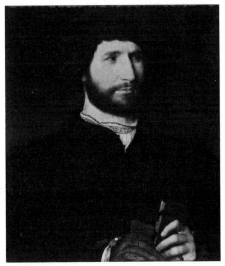

43. Jean Clouet: Man with a Petrarch. *Windsor Castle*

44. Jean Clouet: Man with a Petrarch. Drawing. *Chantilly*

painted the portrait of Guillaume Budé, and among the drawings is one which certainly represents him. A painting now in the Metropolitan Museum is based on this drawing and is therefore presumably by Clouet. Other drawings can be selected which are evidently by the same hand as the Budé, and they can therefore be attributed to the artist with reasonable certainty. One of these again is the basis for a painting, the 'Man with a Petrarch' at Windsor [43], which, though damaged, is perhaps Clouet's most sensitive surviving painting. Other drawings substantiate the attribution to Clouet of the painting at Antwerp of the Dauphin Francis, of the miniature of the Comte de Brissac in the Morgan library, of the portrait of Mme de

Canaples in the National Gallery of Scotland [42], and of the miniatures of the Preux de Marignan in the manuscript of the *Commentaires des Guerres Galliques* (1519) in the Bibliothèque Nationale and the British Museum [47], which are among the earliest portrait miniatures in the modern sense of the word. To these can be added a few further portraits including two of the young daughters of Francis I.

With this relatively small amount of evidence it is difficult to form a clear idea of Jean Clouet's style. The 'Budé', the 'Man with a Petrarch' and the St Louis portrait are largely Flemish in inspiration, whereas the 'Mme de Canaples' and the 'Dauphin Francis' are larger and more abstract in their forms, like the drawings. The

miniatures, owing to the difference of scale and medium, have naturally a character distinct from the other paintings, but they have something of the breadth of the 'Mme de Canaples'.

When, however, we come to study the drawings [44-6], we find marked and consistent expressive of character as it is shown in individual features. Clouet, on the other hand, seems hardly interested in the outline; it is generally softened by being worked over several times and in a drawing like the 'Unknown Man' [45] it has neither decorative nor descriptive quality.

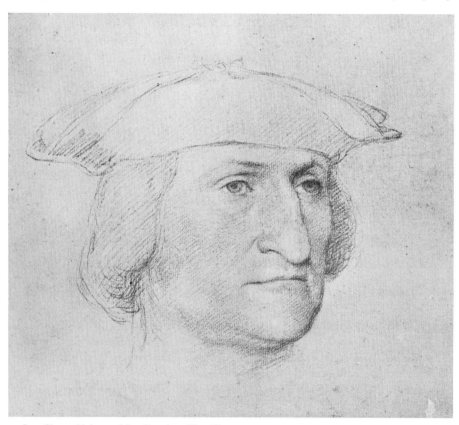

45. Jean Clouet: Unknown Man. Drawing. *Chantilly*

characteristics which are perhaps best brought out by a comparison with Holbein. Both artists are, of course, masters of observation in all that concerns the human face; but their methods of recording what they see could hardly be more different. Holbein relies above all on an outline which is both beautiful in itself and precisely Clouet conceives the head primarily in terms of solid form, and not as a flat pattern on the paper to which modelling is later added. In this way his chalk portraits are nearer to Italian models than to Holbein, and it has been said that there is something almost Raphaelesque in their simplicity. Moreover, there is one tech-

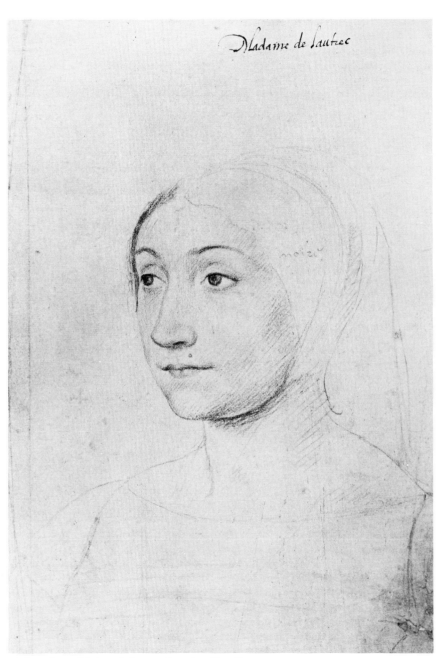

46. Jean Clouet: Madame de Lautrec. Drawing. *Chantilly*

47. Jean Clouet: Le Sire de Tournon. Miniature.
Paris, Bibliothèque Nationale

nical device which serves this plastic conception and which can be directly linked with an Italian source. In all the drawings reproduced the modelling is achieved by a system of parallel diagonal shading strokes which break off where there is a light and begin again when there is a shadow. This simple method, which gives an almost geometrical quality to the modelling, is one used by Florentine artists in the Quattrocento and brought to perfection by Leonardo. The latter, it is true, makes the most effective use of it when he is working in silver point, but

he also shades in this way with chalk. It is quite possible that Clouet would have known drawings by Leonardo who brought with him to France the accumulation of his studio which he bequeathed to his pupil Melzi; but in any case this link with the great Italian master is an indication that Clouet's eyes were not, as is often said, turned entirely north, but that in his grasp of form he is in many ways nearer to Italy than to Flanders, and that he must count as one of the few French artists who understood the aims of the high Renaissance.[37]

THE CLASSICAL PERIOD OF THE SIXTEENTH CENTURY

1540–1565

HISTORICAL BACKGROUND

The middle decades of the sixteenth century in France showed a remarkable flowering in all intellectual fields. Writers and artists began to free themselves from the tutelage of Italy, and individual figures appear whose art is not only classical but genuinely French. Ronsard and the Pléiade on the one hand, Philibert de l'Orme and Goujon on the other, created the first really original and independent movements since the Renaissance had touched France.

All these activities are centred round the Court even more completely than before. In culture as in politics the centralization of France continued during the last years of Francis I and the reign of Henry II. We have already seen the attempts of the former to gather the whole power of the State into his own hands, and though his son was personally less active in this way, and indeed played little visible part in public affairs, the politicians who ruled France for him – Montmorency and the Guises – continued the policy of Francis and carried absolutism to a further point. The same was true of religion. The Crown now firmly identified itself with the cause of Catholicism, and, although the Protestant party grew greater in number and more efficient in organization, repression by the Government also grew in intensity, with the result that more and more supporters of the Reformation left France to take refuge in Geneva.

In literature the years round 1550 are marked by the birth of the new classicism. Du Bellay's *Deffense et Illustration de la langue françoyse*

(1549), the first four books of Ronsard's *Odes* (1550), and Jodelle's tragedy *Cléopâtre* (1552) were the manifestos of the new movement which took the name of the Pléiade. Ronsard is the most typical figure of the period. He was a firm but not a fanatical Catholic, a monarchist, many of whose finest odes glorify the King, and a passionate believer in the glory of his country, which he set forth in his most ambitious, if not his best poem, the *Franciade*. He was soaked in Greek and Latin literature, but was not a pedant; he knew the Italian poets and learnt much from them, but without ever imitating them slavishly, because a vital part of his faith was that the French language was in itself as splendid as Latin or Italian, and that his business was to write essentially French poetry. He created new forms of verse capable of expressing ideas and feelings hitherto untouched by French poets. In his didactic Odes his ideas are clear and nobly expressed; in his shorter lyrics real feeling is compressed into the strictest forms. France had not before him produced a writer of genius who expressed himself within the conventions of classical poetry.

A similar spirit of inventiveness and independence appears in the visual arts. Fontainebleau continued to be the King's favourite residence, and it was there that the new style reached its finest flowering under Primaticcio. It was there also that were displayed the works of art which Francis had obtained from Italy. Among the most important for the future of French art were the bronze casts made from the moulds which Primaticcio brought back from Rome after his journey in 1540. Through these casts

French artists were able for the first time to study such famous ancient statues as the 'Laocoon', the 'Apollo Belvedere', and the 'Marcus Aurelius', as well as the reliefs from Trajan's Column. A few original antiques were at Fontainebleau, and the 'Diana', now in the Louvre, was to be seen in the house of the Duchesse d'Étampes at Meudon. Modern sculpture was also represented, and, in addition to the marble 'Hercules' by Michelangelo already mentioned, there were casts of his 'Pietà' in St Peter's and of his 'Christ' in S. Maria sopra Minerva. Among paintings, the most celebrated were Michelangelo's 'Leda', several works by Raphael and his studio, including the 'Belle Jardinière', the big 'St Michael', the 'Holy Family of Francis I', and the 'Joanna of Aragon', Titian's portrait of the King, and Leonardo's 'Mona Lisa', 'Virgin of the Rocks', and 'Virgin and Child with St Anne'. There was enough, in fact, to make it not unreasonable, allowing for the normal level of court flattery at the time, for Vasari to say that Fontainebleau had become a second Rome.

Under Henry II patronage and collecting continued, but, as in politics, the King himself played little part. He seems to have taken a personal interest in the rebuilding of the Louvre, but the real dictator in this field was Diane de Poitiers, a woman of great intelligence and a good patron of Philibert de l'Orme, who built Anet for her and enlarged Chenonceau. The great nobles who were active in the conduct of government under Henry II also played their part in the arts: Montmorency at Écouen and Chantilly, the Guises at Meudon and in their Paris hôtel, and St André at Vallery. In certain provinces, particularly in the east of France and in the south-west, independent centres of activity sprang up, but in general the style of the Court was accepted as the standard for the whole of France. Henry II was, in fact, inaugurating in the arts the policy which was to be carried to its fullest development by Louis XIV.

ARCHITECTURE

Serlio, Lescot, Philibert de l'Orme, Primaticcio

The years 1540 and 1541 are crucial in the history of French architecture. In the latter year Primaticcio returned from his visit to Rome, bringing Vignola with him; in 1540 or 1541 Sebastiano Serlio was called to France by the King, and about the same time Philibert de l'Orme settled in Paris after his training in Italy. In these two years, therefore, a new wave of Italian influence was felt in France; and, further, the style which was now brought back from the south was very different from that which had come in during the earlier part of the century. For the first time French architects became aware of the achievements of the High Renaissance in Italy, and the examples of Bramante, Peruzzi, and Sansovino were held up to them. Meanwhile the study of Vitruvius had been spreading in France, where editions of his work had become available. These two influences combined to exercise pressure in the direction of classicism and, since the general state of mind among French artists and intellectuals was receptive to such an influence, they took root and produced the first great period of French classical architecture.

Of the artists mentioned above Vignola is the least important in relation to France, since at the time of his visit his career as an architect had not yet begun and he came in the capacity of a technician, principally to help in the casting of bronzes from the moulds after ancient sculpture which Primaticcio had brought from Rome. We have no further record of his activities in France.

As is so often the case with Italian artists abroad, the less talented man exercised the greater influence, and it is to Sebastiano Serlio, not to Vignola, that we must look to find the main channel of Italian influence in France at this time.

Serlio was born at Bologna in 1475.[1] After a preliminary training in this town he moved to Rome, where he is traceable from 1514 till the Sack of 1527 working under Peruzzi, who bequeathed to him all his plans and sketches, of which Serlio later made extensive use. The years 1527-40 seem to have been mainly spent in Venice, partly in actual building, of which little trace remains, and partly in the preparation of the treatise on architecture. The first section to be published was the fourth book, which appeared in 1537. Serlio sent a copy to Francis I through Georges d'Armagnac, Bishop of Rodez and ambassador in Venice, asking at the same time to be taken into the French King's service. The latter promised a gift of 300 crowns, which was slow in arriving, but Serlio dedicated the next section, Book 3, to the King in 1540, and this gesture, combined with support from Aretino, produced the intended effect, and Serlio was called to France and put in charge of the building operations at Fontainebleau.[2] His position in relation to the royal palaces is not altogether clear, but he seems to have acted primarily in an advisory capacity, and none of the executed buildings can be attributed to him. Meanwhile he continued work on his treatise, of which Books 1 and 2 appeared in 1545, Book 5 in 1547, and an *Extraordinario Libro* in 1551. Books 6, 7, and 8 were still unpublished at the time of his death in 1554.

During his time in France Serlio seems to have carried out only two buildings: the house of Ippolito d'Este, Cardinal of Ferrara, at Fontainebleau, known as 'Le Grand Ferrare', of which only the gate survives, and the château of Ancy-le-Franc near Tonnerre in Burgundy. In addition, he made designs, which were not executed, for the rebuilding of the Louvre, for a pavilion and a *loggia* at Fontainebleau, for a merchants' *loggia* or stock-exchange at Lyons, and for a château in Provence.[3]

These works, executed or designed, were of great importance for the later development of French architecture, but Serlio's influence was even greater through his treatise, which was issued in many editions and was translated into most European languages.

Serlio's treatise enjoyed this success because of its entirely new plan. Previous writings on architecture – and they were not many – had been almost purely theoretical. Vitruvius had gone through many editions, some illustrated, and had already been the subject of learned exegesis. Alberti's *Architecture* was lighter reading but still in the first place theoretical, and it was not illustrated till the edition of 1550. Serlio planned to produce for the first time an illustrated handbook for architects. His aim was essentially practical, and the value of the book was to depend more on its plates than on its text. It was to be a pattern book in which the architect could find solutions for all sorts of problems.

Serlio's practical aim appears in every part of the treatise. The first two books deal with geometry and perspective, which are essential to the architect, if he is to be distinguished from the mere builder. On the other hand, Serlio warns the reader that he is going to avoid all theoretical speculation on these two branches of mathematics, and will concentrate instead on their practical application. Book 3 contains plates and descriptions of the finest works of ancient architecture, to which Serlio adds some of the most important modern buildings by Bramante and Raphael. Such models are useful for architects living far from Rome, either in France, which Serlio already had in mind as his goal, or in Venice, where he actually composed this book. Book 4 deals with the five Orders, but without the erudite detail which the commentators on Vitruvius loved. Book 5 shows twelve designs for churches, mostly of ingenious forms, circular, oval, polygonal, or variants of the Latin cross. The real Book 6, which dealt with houses and villas, is known from two manuscripts, one in Munich, the other in Columbia

University, and the old editions put in its place the *Extraordinario Libro*, containing fifty designs for doors.[4] Book 7 is concerned with *Accidenti*, or miscellaneous problems which may present themselves to the architect. These include, for instance, plans for houses on irregular sites, designs for chimneys, schemes for systematizing older and asymmetrical buildings. Finally Book 8 was devoted to military architecture. Each book consists primarily of a series of plates to which the text acts as a commentary. In the early folio editions the woodcuts are of excellent quality, but the later quartos are illustrated with coarse reduced copies, of which the blocks are often ruined by overprinting.

Serlio was not an artistic genius, but he had one quality which must have helped towards his success in France: he was extremely adaptable. In fact he is in this way an exception to most of the Italian artists who went abroad in the sixteenth century, for his style grew more and more French the longer he stayed north of the Alps. This can be seen in his treatise as well as in his executed works.

Naturally the two books published before his removal to France are entirely Italian in character. His main sources are ancient remains and the works of modern Roman architects such as Bramante, but many of the designs are clearly Venetian in origin and show the influence of Sansovino. Books 1 and 2, published in 1545, only deal with architecture incidentally, but the buildings which appear in them are almost all Italianate in feeling, and Book 2 ends with three plates giving Peruzzi's designs for the tragic, comic, and satirical stage. The preface to the *Extraordinario Libro* warns us that we may expect a change, for in it Serlio apologizes for the freedom of the designs which it contains, excusing himself on the grounds that men naturally like novelty and asking the reader to remember in what country he is working. He adds that he purposes not to wander far from the precepts of Vitruvius, to whom be all praise.

But when we look at the plates we cannot help feeling that the Roman architect would hardly have approved the fantastic designs with which we are presented. Some of the doors are still irregular in an Italian way, making play with complicated rustication in the manner of Giulio Romano. Others exploit a broken silhouette in a more Venetian style. But some are altogether personal in their licence as for instance the Ionic door in illustration 48. Instead of columns running up to the entablature supporting the

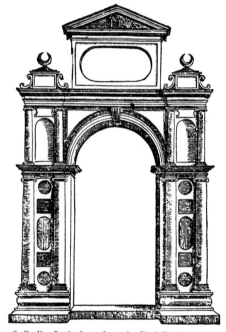

48. Serlio: Ionic door, from the Sixth Book

pediment, this design shows them stopping at the spring of the arch, so that Serlio has to fill in the upper part of the sides with another Order of diminutive columns, in quite incorrect proportion to the Order below. Above this second Order are two decorative panels incorporating the crescent moon of Henry II or

Diane de Poitiers, and in the middle is a simple pediment raised unexpectedly on a rectangular insertion, in which is an oblong panel. The whole door is thus broken up into loosely related fragments in a manner quite contrary to the principles of High Renaissance design. Other plates in the book are even more fanciful, but this one has been chosen because it happens to have been imitated closely by a French architect, Lescot, in the château of Vallery.

In the true sixth and in the seventh book the French influence is more tangibly apparent. In the preface to Book 7 Serlio explicitly states that he is going to present some designs 'in the Italian manner' and others 'according to French custom'. When, for instance, he deals with fireplaces he gives two sets, one in a more or less Venetian style, and the other with picturesque French forms. In the same way the designs for windows include some which are of traditional classical type and others which represent Serlio's version of the French dormer. Many of the elevations of houses include the high-pitched French roof, which the author praises in the text for its practical value.

Serlio's later style as we see it in the illustrations to the last books is a curious mixture. The Italian manner which he brought with him to France was in itself not purely classical. Although he greatly admired Bramante, his real master in Rome was Peruzzi, who was less Vitruvian in outlook, and was notable for the ingenuity of his planning rather than for the correctness of his elevations. Further, Serlio's style was affected by his stay in northern Italy, and in Venice he picked up many tricks which tended to make his manner less Bramantesque, so that he came to France with a style freer and more picturesque than was normal in Rome at this time. This tendency was fortified by the influences to which he was subjected in France, and his later designs mark an important stage in the development towards the style which is commonly called French Mannerism.

Of the two works which he actually carried out in France, the 'Grand Ferrare' (built 1544-6) has disappeared except for the entrance door, but we know its general character from drawings and engravings, most accurately from the drawing in the Columbia manuscript [49].[5] The house consisted of a main block, or *corps-de-logis*, containing a single flight of rooms, from which stretched forwards two narrower wings, one with minor rooms and the other with a gallery. The court thus formed was closed by a wall,

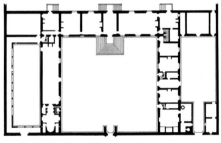

49. Serlio: Le Grand Ferrare.
1544-6. Plan, from the Columbia manuscript

broken in the middle by the door which still stands. This plan was in one sense an adaptation of the design of French châteaux such as Bury or Villesavin to a town house, and it had something of the scale of a château, since its main block measured some 38 metres, but in another way it was an Italianate, regularized version of earlier French town houses, such as the Hôtel de Bernuy at Toulouse or the Hôtel d'Écoville at Caen. It is of great importance since it remained an almost standard form for the hôtel for more than a century. As far as we can judge, the building was simple in appearance, with a single slightly raised floor, covered by a high roof in the French manner. In an ideal variant, recorded in the Munich manuscript, Serlio proposed to add to the *corps-de-logis* an open portico, which would have been less suitable to the climate of Fontainebleau. In front of it

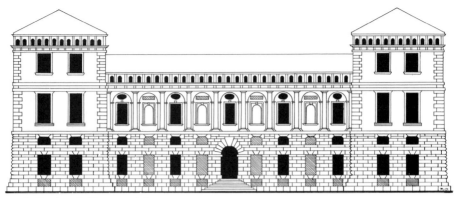

50. Serlio: Ancy-le-Franc, north front.
Elevation, from the Columbia manuscript

was to be a terrace, in the middle of which Serlio introduced Bramante's circular steps for the Belvedere.

The château of Ancy-le-Franc [51, 53] survives complete, though it underwent many alterations during the period when Serlio was in charge of the building and some after his death. The building was probably begun in 1546, the date cut over the door on the south front, and Serlio's original designs are preserved in the Columbia manuscript [50, 52]. These show an entirely Italianate building with rusticated ground floor and four low square towers at the corners, in the manner of early Renais-

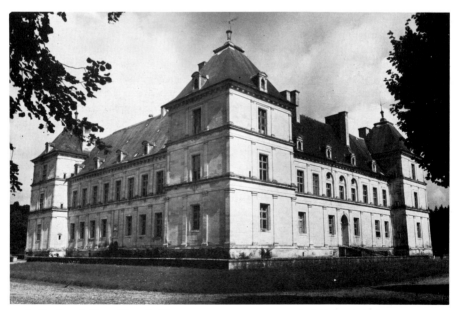

51. Serlio: Ancy-le-Franc (Yonne), château, exterior. *c.* 1546

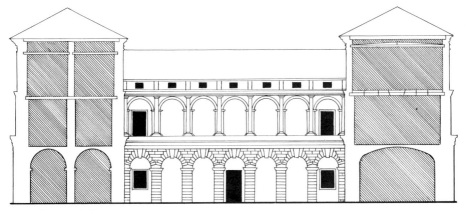

52. Serlio: Ancy-le-Franc.
Section, from the Columbia manuscript

sance villas on the Venetian mainland. Along the middle section of the main storey ran an order of Doric pilasters enclosing an alternating series of windows and niches. Above this and below the low roof was an arcade, almost like a machicolation, which Serlio tells us was the personal invention of the owner, who later gave it up, perhaps under pressure from the architect. Two sides of the court were composed of double *logge*, conspicuously north Italian in character and suggesting models by Falconetto.[6] In the Munich manuscript Serlio tells us that after the building was begun the owner decided to decorate it with pilasters on all the floors, and

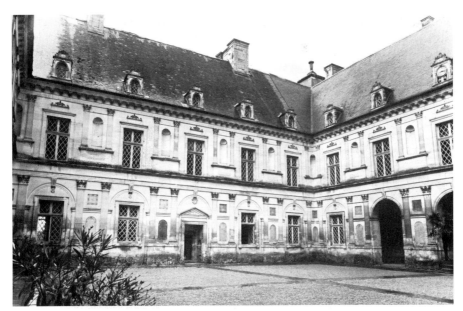

53. Serlio: Ancy-le Franc, château, court. *c.* 1546

we therefore know that this important change was made during the architect's lifetime and under his direction. It was accompanied by other changes for which he is almost certainly also responsible and which appear in the engravings of du Cerceau published in 1576. These include the abandoning of the niches in the bays between the windows. Later these bays were pierced with windows, producing the present arrangement. Another alteration for which Serlio is probably responsible is the addition of the high roof with dormers. At the same time the arrangement of the court was changed, the number of the bays was reduced, and the regular repetition of an arch was replaced by the motif of Bramante's Cortile di Belvedere with its more varied disposition of double pilasters enclosing a niche. The result of these alterations was that the building ceased to be a masculine design, a real Italian *castello,* and became almost effeminate in its delicacy. At the same time it became markedly French, with its high roof and the flat patterning of the walls, which is familiar from châteaux such as Villandry.[7]

Of the various designs made by Serlio for specific buildings but never carried out, one must be mentioned. The Columbia manuscript contains a plan for a palace of the King, and this can be shown to be a project for the rebuilding of the Louvre, which Francis I had been considering since 1527. The plan was apparently rejected in favour of Lescot's, but indirectly it exercised an influence as great as his, because it contains the germs of those ideas for the completion of the building which were to be discussed for several centuries to come, and when we have to consider the various projects put up to Louis XIV we shall find that even then Serlio's plan was not forgotten, and that some architects were ready to borrow from it more than they admitted.

Serlio played an important part in the development of French architecture, because he accustomed the French to the idiom of the early sixteenth-century Italian masters. But his artistic personality was not strong enough to impose a style on the country of his adoption. His treatise was used, so to speak, as a dictionary by many architects, particularly in the provinces, but, though they often copied the individual words, they had no idea how to put them together to form a sentence. For instance, the picturesque screens enclosing the forecourt of the château of Fleury-en-Bière are mainly composed of elements lifted from Serlio's engravings, but nothing could be more provincial or less Italian than the result produced by the French architect.[8] In a town like Toulouse, where the general understanding of architecture was higher, the borrowings are more intelligent, and Bachelier's door to the Capitole, for instance, now in the Jardin des Plantes, is a very competent version of one of Serlio's models.

★

The two great French architects of the middle of the sixteenth century, Pierre Lescot and Philibert de l'Orme, form a remarkable contrast. De l'Orme was primarily an engineer, with a love of ingenious structure and with great inventiveness in plans and architectural forms. Lescot's art was essentially decorative, and it is significant that in all his major works he appears as the close collaborator of the greatest sculptor of the time, Jean Goujon.

Lescot (born between 1500 and 1515, died 1578) was a quite different kind of man from the Le Bretons and the Chambiges, the master masons of the earlier part of the century. He came from a well-to-do legal family, and from his youth gave himself up to the study of mathematics, architecture, and painting,[9] so that, unlike his French predecessors, he was a man of general education and of learning. There is no documentary evidence to show that he visited Italy in his youth, though he seems to have

been sent to Rome on an official mission in 1556, that is to say after the completion of all the buildings which we know to be by him. The style of his work tends to confirm the view that he did not cross the Alps earlier, for though his designs are in many respects classical they show no specific likeness to Italian models, and they lack conspicuously the monumentality which was the mark of Roman architecture in the generation after Bramante. It seems much more likely that Lescot derived his knowledge of architecture from the study of illustrated books on the subject, with perhaps some first-hand contact with Roman remains in France.

Lescot's reputation rests mainly on his rebuilding of the Louvre. Of his other works the screen of St Germain l'Auxerrois (1554) has been destroyed, except for some of Goujon's reliefs preserved in the Louvre; the Hôtel Carnavalet (c. 1545–50) has been altered three times since his death; the Fontaine des Innocents (1547–9) has been totally reconstructed, and the château of Vallery is only a fragment.[10] The façade of the Square Court of the Louvre, on the other hand, survives complete, though many of the decorative reliefs have been recut. The story of this building has been worked out in the greatest detail,[10] but we need only notice here the principal stages of its construction.

In 1527 Francis I declared himself dissatisfied with the medieval palace of the Louvre and announced his intention of rebuilding it on up-to-date lines. He pulled down the keep which blocked a great part of the Square Court of the old château, but for many years nothing more was done. In 1546, however, he commissioned Lescot to erect a new building on the site of the west wing of the old château. Lescot's first project was to build a *corps-de-logis* of two floors only with a projecting central pavilion in which he placed the staircase. On either side of this there was to be a big room for public occasions. During the following five years, however, the plan and elevation were both altered. The staircase was moved to the north end of the wing, leaving space for a single much grander *salle* on each floor; but this move necessitated the addition of two more projecting pavilions at the ends, one of which had to house the new staircase. Finally the façade was heightened by the addition of an extra floor [54], perhaps in order that the wing might not be overpowered in the view from the outside by another new building, the Pavillon du Roi, which had been added in the south-west corner facing the river. Originally the plan had only been to rebuild this one wing or at most to carry on the same scheme round the existing court; but at some date between 1551 and the death of Henry II in 1559 it was almost certainly decided to embark on a more ambitious plan and to build a court enclosed by blocks double the length of Lescot's executed wing. This plan was not carried out till the reigns of Louis XIII and Louis XIV, but all the documents of this later period give the credit of the original idea for the extension to the architect of Henry II, that is to say, Lescot.

In the context of French architecture of the middle of the 1540s the first feature which strikes one about Lescot's façade is its classicism. The Orders are of a correctness undreamt of by Le Breton, and though Serlio was in theory capable of producing such accurate imitations of antiquity, he had not apparently done so in practice. But, having noticed this correctness of detail, we are at once almost equally struck with the un-Italian character of the whole design. If we compare Lescot's front with the closest parallel in contemporary Roman architecture, Sangallo's court of the Palazzo Farnese, the contrast is startling.[11] The Roman building depends for its effect on simple masses of almost undecorated masonry, on the exact repetition of a standard arch along each floor, and on the clear demarcation of one floor from the next by the unbroken horizontal lines of the entabla-

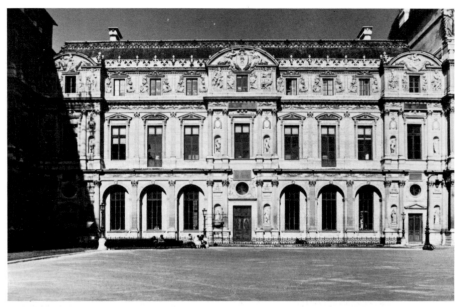

54. Pierre Lescot:
Paris, Louvre, Square Court. Begun 1546

tures. Lescot's design has none of these qualities and in some cases displays their exact opposites. The effect is one of ornamental beauty rather than of monumentality. Apart from the pavilions, the façade is entirely articulated with pilasters and not with half-columns, and these pilasters are of the most decorative Orders, Corinthian and Composite, in contrast to the Doric and Ionic of the Farnese Palace. It would have been even richer if Lescot's design had been completely carried out.

Still more different is the general disposition of the façade. Lescot has carefully avoided the exact repetition on which Sangallo relies. The pavilions differ from the wings joining them, and each pavilion is itself divided into a wide central bay and two narrow flanking ones. Each floor has, further, a different system of fenestration; on the ground floor segment-headed windows[12] set behind round-headed arches; on the first floor pedimented openings; and in the attic

windows crowned with crossed torches. Again, the pavilions have windows different from those in the rest of the façade. Finally notice how deliberately Lescot breaks the horizontals and emphasizes the verticals. Not one of the horizontal mouldings is allowed to run unbroken through the whole width of the front. On the ground floor the base of each pilaster breaks forward, whereas the entablature only does so in the pavilions, where, however, it has a return in the middle bay. On the first floor the pilasters rest on a more or less continuous base, except in the pavilions,[13] and the entablature breaks forward for the pavilions but does not return in the middle, as on the ground floor. On the other hand, the three pavilions form marked vertical elements, emphasized by the lines of the double columns which carry the eye upwards almost as in the façade of Fontaine-Henri.[14] In fact the triple repetition of the pavilion seems to be an echo, probably unconscious, of the late medi-

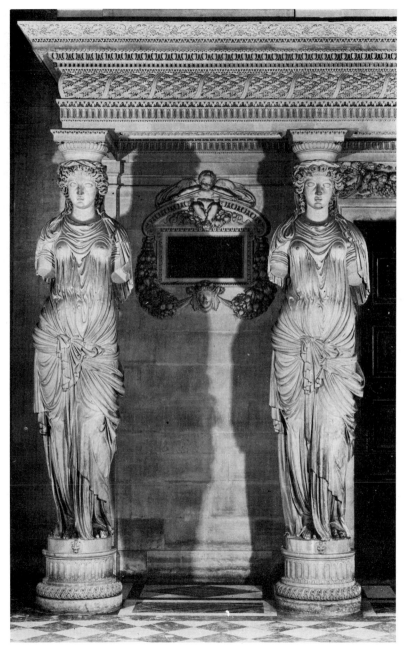

55. Jean Goujon: Caryatids. 1550–1. *Paris, Louvre*

eval château façade divided by three round towers, to be seen for instance at Josselin or Martainville. There is thus in this design a mixture of Italian features with others which derive from the French tradition; but here the two elements are for the first time fused, so that it is possible to talk of Lescot's style as a form of French classicism, having its own principles and its own harmony.

The decoration of the interior of the new wing of the Louvre was also revolutionary. The *salle* on the ground floor was ornamented at one end with a gallery supported by Goujon's four caryatids [55], a form hitherto almost unknown in France and not, so far as I can trace, used on a monumental scale even by Italian Renaissance architects.[15] Lescot was no doubt inspired to use them by the description in Vitruvius, and he may also have seen them either in illustrated editions of his works or in Italian engravings, such as that by Marc' Antonio based on Perino del Vaga's decorations on the lower parts of the walls in the Stanze.[16]

At the south end of the *salle* a bay was cut off and formed into the Tribunal, which was separated from the main room by sixteen Doric columns, arranged in groups of four. As usual with Lescot, these columns are richly decorated, but they have a monumentality rare in his work.[17] In both these designs, as well as in the façade itself, the decoration was executed by Goujon, and there is little doubt that the sculptor must have been a collaborator with the architect on more or less equal terms, so that it is hard to say where the share of one ends and the other begins. The question is, however, hardly a real one; for Lescot's architecture was perfectly conceived to display sculpture, and Goujon's reliefs or caryatids were planned to decorate a building, so that the two men worked in full harmony, almost as one mind.

In one case we find Lescot using another collaborator. This is for the wooden ceiling in the *Chambre* of Henry II, that is to say the King's bedroom in which all State business was carried on. This ceiling survives, though moved to one of the rooms behind Perrault's colonnade, and it marks an epoch in French interior decoration. Previous ceilings had been of the traditional French pattern with beams running across them, decorated usually with painted motives. But in the ceiling for the Louvre Lescot and his Italian wood-carver, Scibec de Carpi, have rivalled the most elaborate southern designs of the period, even those of Venice. We can be certain that the design is here due to Lescot and not to the carver, partly because the documents indicate it,[18] and partly because Scibec de Carpi's other work, such as the panelling in the Galerie François I at Fontainebleau, based on Rosso's patterns, or the ceiling in the Salle de Bal of the same palace designed by Philibert de l'Orme, are entirely different in character.

Lescot is almost certainly responsible for the Hôtel Carnavalet begun *c.* 1545, the only example of a Paris house which survives from the middle of the century [56].[19] The building has been much altered, but certain parts of the original survive: the main façade on the court with the sculptures of the four seasons from the studio of Goujon, the turrets which flank it, and the entrance, also decorated by Goujon. From the contract of 1548 it appears that the gallery along the left-hand side of the court was not built as early as the main block, but it was probably part of the original scheme. It was originally covered by a high-pitched roof with dormers, and the present first floor was added later, in the seventeenth century, by François Mansart.[20]

In its general plan the Carnavalet follows Serlio's 'Grand Ferrare', except that the side towards the street is closed by a block containing stables and kitchen instead of a simple wall. The most interesting feature is the decoration of the façade on the court with Goujon's reliefs. This arrangement, which was to be widely followed later in Paris,[21] was not entirely new,

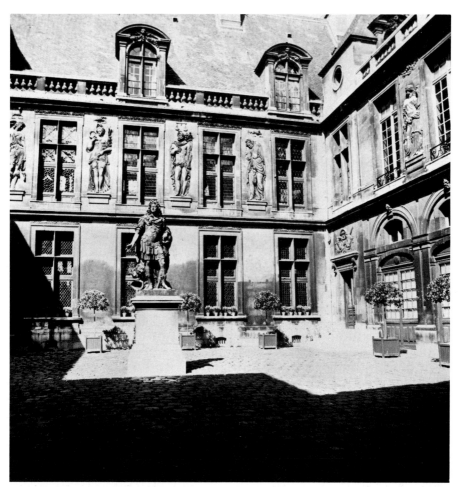

56. Pierre Lescot: Paris, Hôtel Carnavalet.
Begun *c*. 1545

since it is found in the earlier Hôtel d'Écoville at
Caen. Goujon spent his early years in Nor-
mandy, and it may be that he knew this build-
ing and suggested the idea to Lescot.

There are still many points about the career
and achievement of Lescot which need clari-
fying. Of his personality we know almost no-
thing, and even our records of his professional

career are very incomplete. We have no evi-
dence of his activity before 1544, and after the
death of Henry II in 1559 he again disappears,
though he lived nearly twenty years longer. But
his position is assured as one of those who laid
the foundations of the classical tradition of
French architecture which produced its greatest
representatives in the seventeenth century.

Lescot is, however, overshadowed by the figure of Philibert de l'Orme, beside whom he seems no more than a talented amateur. De l'Orme is the first French architect to have something of the universality of the great Italians. He combines the engineering skill of the French mason with the learning of the Renaissance artist. Like Lescot, he is classical without being merely an imitator of the Italians; but whereas Lescot can only play in one key, Philibert is master of a vast range of harmony.[22]

He was born in Lyons, probably between 1505 and 1510, and was the son of a master-mason. About 1533 he visited Rome, where he apparently spent three years. There he was noticed by Marcello Cervini, later Pope Marcellus II, and also by Cardinal du Bellay, who was at that time in Rome, accompanied by his secretary, François Rabelais. De l'Orme became an intimate friend of the great humanist and may well have inspired the description of the abbey of Thélème in *Gargantua*, published in 1534, just after Rabelais' return from Rome. After three years spent in studying, measuring, and even excavating the antiquities of Rome and, we may suppose, enjoying the conversation of the humanists whom he must have met through the Cardinal, we find him back in Lyons in 1536. Here he executed his first known work, the house of Antoine Bullioud. About 1540 he was called to Paris by du Bellay, who commissioned him to build a château at St Maur-lès-Fossés, near Charenton. Through the Cardinal he was introduced to the circle of the Dauphin and Diane de Poitiers, and in 1547 he was commissioned by the latter to build her château at Anet, which was completed about 1552. When the Dauphin ascended the throne as Henry II de l'Orme was immediately appointed superintendent of buildings, and during the whole reign he remained the most powerful figure in the arts in France. For the King he designed the tomb of Francis I at St Denis, a chapel at Villers-Cotterets, and the Château-Neuf at St Germain,

and carried out alterations at other royal châteaux, including Fontainebleau. He was also employed by Diane de Poitiers between 1556 and 1559 to build the bridge at Chenonceau.[23] On the death of Henry II he was immediately dismissed, and seems for a short time to have been exposed to serious maltreatment from his enemies, of whom he had made many by his arrogance. After four or five years, however, he was again taken into favour by the Queen Mother, Catherine de' Medici, who ordered him to build the palace of the Tuileries and to prepare new plans for completing St Maur, which she had bought from the heirs of Cardinal du Bellay. Both before and after the death of Henry II de l'Orme was also concerned with church building. Little of his documented work in this field survives, but there are reasonable grounds for thinking that he designed the celebrated screen in St Étienne-du-Mont [57]. In style the pierced balustrades and the spiral staircases are very close to those at Anet, and in the absence of any other indication of date or author it seems reasonable to suggest that they may be by the same architect.

During his years of disgrace he composed two works on architecture from which we learn much about him as a man and as an architect. The first, entitled *Nouvelles Inventions pour bien bastir et à petits frais* (1561), was a practical treatise on the construction of vaults and roofs and embodied the engineering aspects of Philibert's thought. The other and much more considerable work, the *Architecture*, in nine books, was published in 1567. It was to have been followed by a second volume dealing with Divine Proportion, but Philibert was prevented from publishing this by his death in 1570.

De l'Orme naturally makes use in the composition of his treatise of the obvious models, Vitruvius and Alberti. But his work is original both in plan and in treatment. It is not so speculative as Alberti, nor is it a mere illustrated compendium like Serlio. It combines the theo-

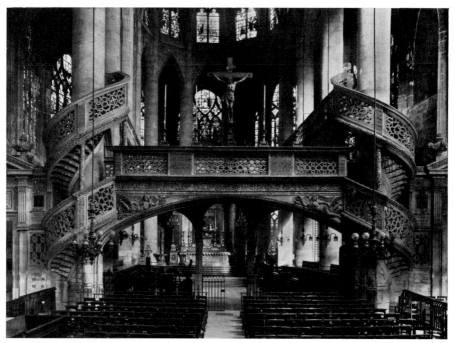

57. Philibert de l'Orme(?):
Paris, St Étienne-du-Mont, screen. *c.* 1545

retical and practical aspects of architecture in a remarkable manner. The main reason for this seems to be that the author writes from his own personal experience. He emphasizes this point explicitly, and throughout the book he quotes in support of his suggestions some work which he has executed or some incident, often disagreeable, which has happened to him in connexion with a patron or a mason. This personal element gives freshness and solidity to his writing and prevents him from ever copying, parrot-like, Vitruvius or any other authority. On the other hand, the book is not solely made up of reminiscences or of practical hints; for Philibert was a man of education, with a desire to find a rational basis for his art. But here again his approach is personal and the theory is deduced from experience and observation.

His attitude appears in the general plan of the treatise. The first two books deal entirely with practical questions, such as the relations of the architect to the patron, the choice of the site, the effect of climate. The third and fourth are concerned with arithmetic and geometry, but again from a strictly practical point of view, to enable the architect to make good plans, to work out the structure of vaults, to use a plumb line, and so on. Books 5 to 7 are devoted to the Orders, and the last two books cover architectural details and decorative features such as doors, windows, and mantelpieces. It is apparent from this arrangement that de l'Orme gives priority to the practical side of architecture, and he tells us this explicitly on several occasions: 'It would be much better, in my opinion, for the architect to fail in the ornamentation of the columns, in

the proportions and in the treatment of façades (to which those who proclaim themselves architects devote most study) rather than that he should desert Nature's excellent rules which concern the comfort, convenience, and advantage of the inhabitants, and not the decoration, beauty, and richness of houses, made only to please the eye, and not for any benefit to the health and life of men.'

But if the architect must bear in mind practical considerations, he should always act according to the dictates of reason, and not blindly without knowing what he is doing. Philibert attacks those who pile up ornament 'without reason, proportion, or measure, and more often by mere chance, without being able to say why they did it'. Therefore the architect must be equipped with some theoretical knowledge. He should know the relevant parts of mathematics, have some notion of natural philosophy or, as we should say, science, and a smattering of music so that he can deal with questions of acoustics. On the other hand, de l'Orme differs from Vitruvius in that he does not consider it necessary for the architect to be versed in law or rhetoric. Here again we see his practical sense leading him to disagree even with the most revered of authorities.

The architect and the patron must plan everything before they actually start building. The patron must consider whether he can afford to erect the projected house, whether it is suitable to his station, and whether its upkeep will ruin him. He must then select his architect with care, but having chosen him he must give him a free hand, not interfere with him at every step, and not change his plans as the building grows. The architect must work out his plans and models in detail before he actually starts, so that the patron may know exactly what is proposed and so that the cost of the building can be accurately estimated. In preparing these models and plans he must beware of using painters who embellish the architect's true plans, and so give a false impression to the patron. As far as possible the architect must lay in a store of materials in advance so that he may not be compelled to change in the middle of the operations. On one point Philibert is very firm, coming back to it continually, namely that the architect must resist if possible the idea of incorporating in his projected building fragments of older work existing on the site. He quotes his own difficulties in this matter at Anet, and he may also have been thinking of the confusion introduced into so many of the buildings of the earlier part of the century, such as Fontainebleau, by the patching up and extension of earlier work. On the other hand, he is not adamant on this point, and in Book 3 puts forward an ingenious plan for regularizing a château of which two older parts survive. But he does this only under protest, again advising the architect to avoid the problem if possible.

After considering these basic practical matters, Philibert goes on to the question of ornament. This he admits is necessary but it must above all be applied properly, 'as is necessary and reasonable', not merely to give an effect of richness. Generally speaking, he is opposed to richness of either decoration or material, except in the case of a royal palace or a public building to which it is appropriate. In particular he is against the reckless use of marble, and laughs at those who think that nothing worth while can be built except in Italian marbles. He maintains, on the contrary, that the different kinds of stone to be found in France are as good as marbles brought from Italy and more suitable to the climate of the country.[24]

This is an instance of de l'Orme's national pride, which is an underlying theme in the whole of his writings. His independence of Italy and even of the ancients is one aspect of this, and he constantly attacks those who blindly follow these models, pointing out incidentally that in so doing they often fall into the trap of copying a good original for use in a different setting or on a different scale, which makes it

look ridiculous.[25] But there is a more positive side to this doctrine. Philibert sets up by implication a standard which was new in France, that of reason as opposed to conformity to a model, classical or Italian. He judges every problem on the basis of his own experience and understanding, learning what he can from his predecessors but not following them blindly. This independence of mind makes him a worthy contemporary to the poets of the Pléiade, and a true representative of the first period in which France may be said to have produced her own classical style. It is as much a characteristic of his buildings as of his writings.

His independence, his national feeling, and his practical sense all appear in their clearest form in the section of the treatise in which de l'Orme puts forward his proposal for a new French Order to be added to the five Orders of Greece and Rome.

His argument is double, theoretical and practical. On the theoretical side he argues that the Greeks and Romans invented Orders which satisfied their particular needs, so why should not the French, an equally great nation, invent an Order in accordance with their problems? The practical argument is also cogent. The Greek and Roman Orders were invented in countries in which marble is the natural material, whereas in France most buildings are made of stone. Now it is difficult to obtain a shaft of stone long enough to make a large column in a single piece, and, further, in a shaft of this length stone will not bear the strain put on it. Therefore, generally speaking, stone columns have to be built in drums laid one on top of the other. The disadvantage of this is that the joints between the drums are visible and are disfiguring to the columns. De l'Orme therefore proposes a French Order in which the column is broken at intervals by bands of horizontal decoration which serve to cover these joints. Finally he extends the idea by applying it to the classical Orders and illustrates French versions of, for

instance, the Doric and Ionic Orders, distinguished from their classical prototypes by the bands of decoration round them.

When we come to examine the works actually carried out by Philibert de l'Orme we find the same qualities as in his writings. Unfortunately almost all that he built has been destroyed, and apart from sections of Anet and the tomb of Francis I, we have to rely on engravings.

The château of St Maur, probably begun in 1541 [58], has not the individuality of his mature works, but taken in its context it is an important, even revolutionary building. Philibert himself boasts, not unreasonably, that it was the first building in France 'to show how the proportions and measures of architecture should be observed', and it is certainly true that it set a new standard of classicism for its date, which was, we must remember, the year of Serlio's arrival in France. The original plan and elevations are given in the treatise, but only the main corps-de-logis was carried out according to them. The design is reminiscent of the Palazzo del Tè, in that it consists of one floor only and that the rooms are arranged in a single suite round a square court. But it follows the French tradition in that the side opposite the main corps-de-logis is lower than the other three and the two wings at right angles to it project beyond it to form pavilions on the main façade. On the garden side de l'Orme planned a horseshoe staircase leading up to the first floor, the earliest example of this form in France. The elevations were simple. Round the court ran a single Order of coupled Corinthian pilasters, and in the middle of each side was a door flanked by columns. The original court front can be seen in illustration 58, since it was embodied in the second scheme there illustrated. The balcony on short pillars was, however, an addition at the second stage. Over the main door to the corps-de-logis were panels with inscriptions and reliefs in honour of Francis I. The main block of the entrance front had an almost similar arrangement, but the corner

pavilions, and probably also the other outside façades, were decorated with rusticated pilasters, as opposed to plain pilasters in the court. This design for St Maur is remarkable in that it is the first attempt in France to decorate a complete building with a single Order of classically regular pilasters, disposed in the manner of the

l'Orme's new conception of classicism. In form it is a development of the medieval French château entrance which had already been modified and Italianized to different degrees at Azay-le-Rideau, Fontainebleau, and Assier. But here the transformation is more fundamental. First of all the Orders are far more correct than in any

Italian architects of the High Renaissance. The result is hardly Italian, partly because of the use of certain French features such as the mullioned windows; but it justifies its author's boast about its novelty.

Though the greater part of Anet has been destroyed, its three essential features have survived: the *avant-corps* or frontispiece from the main block, which now stands sadly in the court of the École des Beaux-Arts [59]; and the chapel [60] and entrance gate [62], which are still *in situ*, though the chapel now stands free instead of being, as it originally was, veiled by the porticoed east wing of the court.

The frontispiece [59], which probably dates from the late forties, is a splendid example of de

of the earlier examples and are applied in their correct sequence – Doric, Ionic, and Corinthian – one above the other, as in the Colosseum in Rome. But, more important, the design has a monumentality which we have seen glimmering in French architecture of about 1540, but never with this grandeur or completeness. This quality is particularly apparent if we compare the fragment with one of Lescot's Louvre pavilions [54]. The choice and the massive proportions of the Orders, the severity of the mouldings, the boldness of the bases for the coupled columns, and the discreet use of the ornament are all in a spirit entirely foreign to Lescot. De l'Orme's design is classical but does not go back directly to any Roman model; it has the gran-

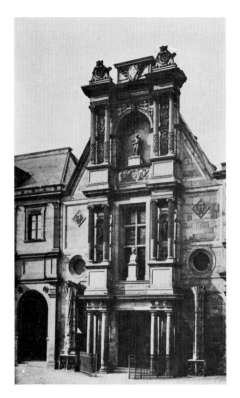

58 *(opposite)*. Philibert de l'Orme:
St Maur, château. 1541–63. Drawing by du Cerceau.
London, British Museum

59 *(above)*. Philibert de l'Orme:
Frontispiece from the château of Anet. Before 1550.
Paris, École des Beaux-Arts

deur of Sangallo but is not copied from him. Not till the time of François Mansart was any further advance to be made in the designing of this favourite motive in French architecture.

The chapel[26] is even more remarkable [60, 61]. Apart from the apparently solitary experiment of the chapel at Vannes,[27] this is the first chapel in France in which is applied the Renaissance principle that the circle is the perfect figure, and therefore suitable for the house of God. It is applied, moreover, with great originality. Not only is the central domed space circular, but the side chapels are so shaped that the outer contour of the whole building is a circle, interrupted only by the right angles of the two sacristies. Further, the marble pavement is made up entirely of arcs of circles, forming a pattern which is the direct projection of the coffering in the dome but which also corresponds to a design frequently found in ancient Roman mosaics.

This emphasis on the circle is in accordance with the practice of Bramante, but Philibert's application of it is quite different from his. In the Tempietto Bramante chooses the simplest combination of the mathematically pure forms of circle, cylinder, and sphere, whereas de l'Orme, with an almost naïve enthusiasm, seeks a much more complex solution. The chapel lacks, therefore, the purity of the Tempietto, but it has its own brilliance. It is also important for one structural innovation. Instead of arches in one plane linked to the circular base of the dome itself through pendentives, the arches in this chapel are inscribed on the surface of a cylinder, not in a plane; that is to say the actual profile of the soffit describes a three-dimensional curve. The only other chapel by de l'Orme of which we have any knowledge, built *c.* 1550 in the park of Villers-Cotterets, also played elaborately on the theme of the circle, but here in the form of a trefoil. It was also important for two novelties: the use of de l'Orme's French Order

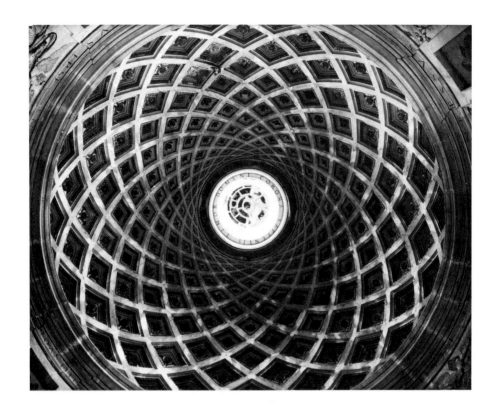

60. Philibert de l'Orme:
Anet (Eure-et-Loir),
château, dome of the chapel.
1549-52

61. Philibert de l'Orme:
Anet, château,
chapel. 1549-52. Plan,
from du Cerceau,
Les plus excellents Bastiments

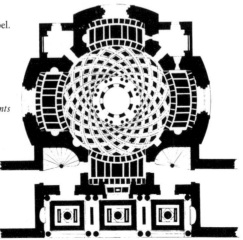

62. Philibert de l'Orme:
Anet, château,
entrance. *c.* 1552

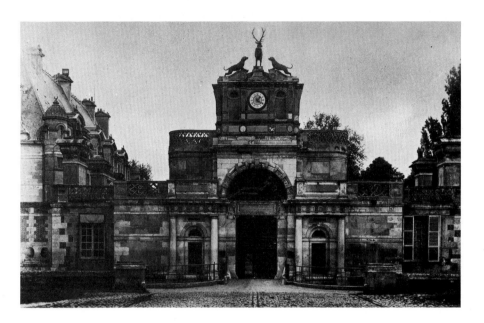

and the addition in front of the main chapel of a free-standing classical portico.

Finally we must consider the entrance, probably built in 1552 [62]. This astonishing structure has, so far as I know, neither predecessor nor successor. It is designed almost without the use of classical elements except for the Doric columns round the actual door, and is thought of as a series of blocks of masonry, playing against each other almost in the manner of functionalist architecture. A sequence of rectangular blocks builds up to the central feature, surrounded by consoles and flanked by two rounded masses which support little terraces. The culmination of the whole design is the clock consisting of a bronze stag surrounded by hounds, which move at the striking of the

hours, a piece of mechanical ingenuity typical of the architect. On each side, at the ends of the lower terrace, are four sarcophagi adding a touch of richness to the design, which, however, is mainly enlivened by the elaborate open-work balustrades running round the whole structure. An element of colour was formerly given by an inlay of black marble in the entablature of the Doric Order and by Cellini's bronze relief of Diana, now replaced by a plaster copy. This entrance is perhaps the most striking example of Philibert's ability to think in monumental terms while at the same time remaining free from any tendency to imitate models of the Italian High Renaissance.[28]

The two works executed for Henry II are rather different in kind. The tomb of Francis I

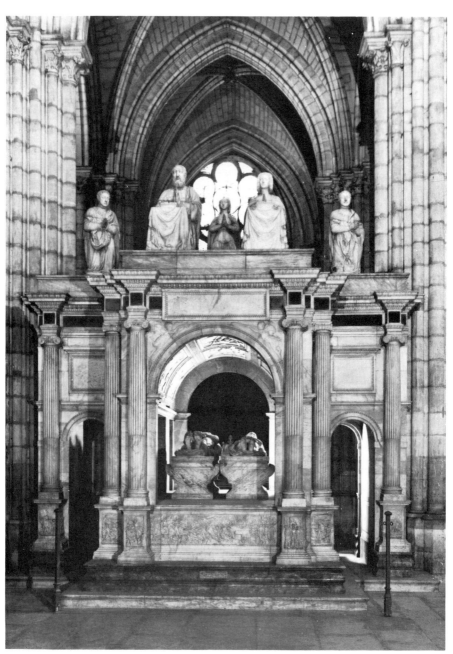

63. Philibert de l'Orme and Bontemps: St Denis, tomb of Francis I. Begun 1547

64. Philibert de l'Orme: St Denis, tomb of Francis I,
detail of entablature. Begun 1547

[63, 64], begun in 1547, is de l'Orme's solution to the problem of producing a classical version of the type of tomb invented by the Giusti for Louis XII. It is in general design a Roman triumphal arch with the side arches set back from the plane of the principal front. The use of coloured marbles is skilful and the decorative detail, for much of which Pierre Bontemps seems to have been responsible, is superb. To a pupil of Bramante it would have seemed overloaded, but de l'Orme shows astonishing skill in making a coherent whole out of such a mass of detail.

The Château-Neuf at St Germain, or, as it was more properly called in the time of Henry II, the *Théâtre*, was begun in 1557. The contract and old engravings prove that it consisted of a *corps-de-logis* to the corners of which were attached four pavilions. It was preceded by a

court, enclosed simply by a wall and intended as a setting for festivities. The unusual form of this court, a square with an apsed bay on each side, seems to be derived from a part of Hadrian's Villa which was being excavated in the sixteenth century and was then thought to have formed a symmetrical open court, though later excavations have shown that it was in reality a covered dining-hall with a strong longitudinal axis. The plan of the principal *corps-de-logis* is of great importance, since it is the first example in France of a château erected as a free-standing symmetrical building, as opposed to the traditional type with four wings enclosing a court. It is the direct model for Salomon de Brosse's Blérancourt and paved the way for Maisons and Vaux-le-Vicomte.

De l'Orme's last two designs were prepared at the request of Catherine de' Medici. In 1563

she acquired the unfinished château of St Maur and ordered the architect to make plans for its completion for her son, Charles IX, on a grander scale than originally proposed. A series of drawings by du Cerceau in the British Museum appear to embody de l'Orme's new project [58]. The main difference from the first design lies in the doubling of the pavilions adjacent to the *corps-de-logis*, thus enabling the architect to put an extra *appartement* in each wing and so to enlarge the accommodation of the château. This arrangement was to be widely followed in the seventeenth century, for instance by Salomon de Brosse at the Luxembourg, although it had the disadvantage of making the side elevation asymmetrical. In spite of this enlargement the château was to remain a one-storey building with a flat roof. Its treatment externally was to consist of a series of rusticated pilasters, which hardly disturbed the simple grouping of the masses.

The second commission for Catherine de' Medici was much more important. In 1563 and 1564 the Queen was acquiring land outside the walls of Paris with the intention of building herself a palace separate from the Louvre but conveniently near to it. This was to be the palace of the Tuileries. Philibert de l'Orme was commissioned to produce the designs, and he refers frequently in his treatise to the work that he was doing there for the Queen Mother. At the time of his death, however, only a very small part of the building had been completed; the lower section of a central pavilion containing an oval staircase without support in the middle, and two wings, one on either side of it. We have little certain evidence about his intentions for completing the palace,[29] but it is clear from what was carried out that it would have been somewhat different in style from his usual work. He himself suggests the reason for this in references to the Tuileries in his treatise, for he labours the point that he followed in every detail the wishes of the Queen, adding that she de-

manded certain rich ornaments and materials and implying that he himself would have preferred to have made them simpler.

In view of the uncertainty which surrounds the designs for the Tuileries and the later plans for St Maur, it is difficult to give any precise characterization of de l'Orme's last style, but it is possible that he may have been moving away from the monumentality of his earlier works towards a more ornamental style. There are details in the elevation of the Tuileries which are certainly due to de l'Orme and which foreshadow the innovations of Bullant. The most significant is the manner in which the dormers are overlapped by the pedimented panels between them, causing a blurring of each unit which would not be found in the architect's more classical works. In fact it seems that de l'Orme, having contributed more than any other architect to the creation of a truly French classical architecture, was towards the end of his life preparing the way for the succeeding generation.

In spite of the fact that he was Italian and senior to the architects whom we have just considered, it is convenient to take the work of Primaticcio in architecture at this late stage, because he did not become active in this field till towards the end of his career. He seems, as we should expect, to have approached architecture through decorative sculpture, and the first works which can plausibly be attributed to him are on the border line between the two arts. These are the grotto of the Jardin des Pins at Fontainebleau (*c.* 1543) [65],[30] the grotto at Meudon (*c.* 1555), and the gate in the Cour du Cheval Blanc at Fontainebleau (after 1561), of which the fragments are now incorporated in the lower storey of the so-called Baptistery. All these show him influenced by the rusticated work of Giulio Romano. The conception of the Grotte des Pins, with its giants emerging from a rocky background, sug-

65. Attributed to Primaticcio: Fontainebleau,
Grotte des Pins. *c*. 1543

gests that Primaticcio knew sketches for Giulio's
frescoes of the Fall of the Giants in the Palazzo
del Tè, although the actual frescoes were exe-
cuted just after he left Mantua.

More important is another addition to Fon-
tainebleau attributed to Primaticcio, the Aile
de la Belle Cheminée, built in 1568 [66]. This
is a colder, more academic work, from which
we may conclude that Primaticcio had been in-
fluenced by the buildings of Vignola which he
must have seen on his visit to Bologna in 1563.
The general lay-out with the double flight of
steps is impressive, but the detail is dry and
strangely in contrast with the picturesque rusti-
cation of his earlier experiments in architec-
ture.

Primaticcio's name must also be closely as-
sociated with the mausoleum which Catherine
de' Medici designed for her husband, Henry II,

herself, and her sons. This was the Chapelle des
Valois, a circular building to be added to the end
of the north transept at St Denis [67]. In the
middle was to stand the tomb of the King and
Queen, which was begun in 1561 on Prima-
ticcio's designs, the sculpture being carried out
by Germain Pilon [68]. The tomb was Prima-
ticcio's solution to the problem tackled by the
Giusti and de l'Orme in the monuments to
Louis XII and Francis I. As in the former of
these, we seem to have here an echo of Michel-
angelo's first design for the tomb of Julius II,
but one which shows at any rate a slightly closer
understanding of the original in the placing of
the columns and statues at the corners of the
whole structure. As a result of this disposition
Primaticcio's tomb seems to be conceived more
completely in the round than de l'Orme's, which
is designed to be seen only from the front or

66. Attributed to Primaticcio: Fontainebleau,
Aile de la Belle Cheminée. 1568

67 *(below)*. Jean Bullant: St Denis, Valois Chapel.
Engraving of plan and elevation by Marot

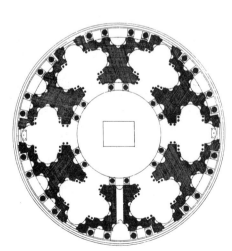

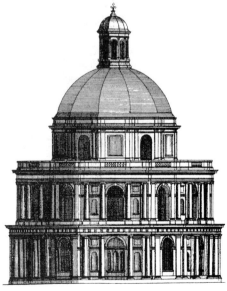

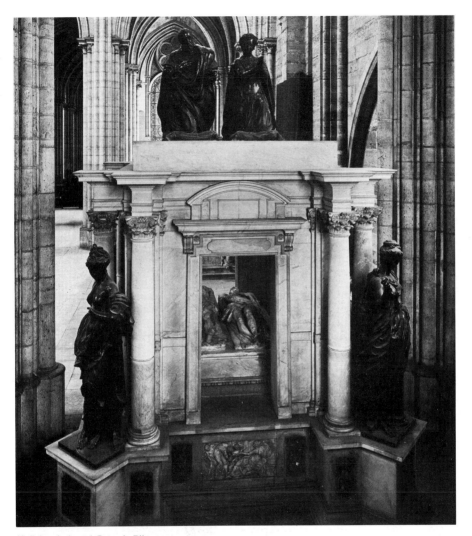

68. Primaticcio and Germain Pilon:
St Denis. tomb of Henry II. Begun 1561

from the side, but not from any intermediate
position. This more plastic conception was no
doubt due in part to the position for which the
tomb of Henry II was destined, that is to say,
the centre of a circular chapel, where it would
have been seen from every angle.

The question of the authorship of the chapel
itself is more complicated. The documents and
the evidence of Vasari prove that a first design,
probably circular, was produced by Prima-
ticcio,[31] but nothing seems to have been actually
erected by the time of his death in 1570. In 1572

Jean Bullant was put in charge of the work, and in the following year presented a model to the king, which was probably the original on which Marot based his engravings [67]. At his death in 1578 he was succeeded by Baptiste du Cerceau who probably made minor alterations to the design and carried the actual building up to the top of the second Order between 1582 and 1585.[32] It fell into decay and was finally pulled down in the early eighteenth century.[33]

In its general design, as we know it from Marot's engravings and by a few views made while it was still standing, the Valois Chapel goes back to Italian models such as Bramante's Tempietto or Michelangelo's plans for S. Giovanni dei Fiorentini, though it differs from any previous buildings of this type in having six chapels instead of the usual four or eight, this number being dictated by the necessity of supplying four chapels for the four sons of Henry II and two more for the altar and the entrance. The division of the chapel externally into two storeys, each with its Order, from which emerges the drum carrying the dome itself, recalls Sangallo's design for St Peter's, which Primaticcio could have seen on his visit to Rome in 1540–1. All these links with Rome tend to show that Primaticcio's basic design was followed by his successors, but it is possible that Bullant made alterations to the Orders in the engraved versions.

★

The four architects so far considered in this chapter all worked primarily in the Île-de-France; but the middle decades of the century were also a time of great activity in the provinces. It would be impossible to give even a brief account of the innumerable châteaux, churches, and town houses which were built or enlarged at this time all over France. But one or two centres call for special mention.

In the south-west of France a group of buildings can be distinguished as showing a style

which is probably connected with the influence of a particular architect, Guillaume Philandrier or Philander. Philander was originally a classical philologist and in architecture was more notable for his learning than for his practical skill. Born about 1505, he accompanied Georges d'Armagnac, Bishop of Rodez, when he went as ambassador to Venice in 1536 and almost certainly went on to Rome. In Venice he became a pupil of Serlio, who probably inspired him with the idea of working on Vitruvius. In 1543 he published a translation of this author and the next year a long and erudite commentary on him. On his return to Rodez in 1544 he was given charge of the structure of the cathedral, and about 1562 added to it the remarkable gable of the west front [69]. Here we see clearly Philander's strength and weakness; for he has simply planted a complete Roman church front on top of a tall plain Gothic façade. In its detail the design is remarkably pure and rather advanced

69 *(below)*. Guillaume Philander: Rodez (Aveyron), cathedral, gable (above the rose window). *c.* 1562

70 *(opposite)*. Guillaume de Lissorgues(?): Bournazel (Aveyron), château. *c.* 1550

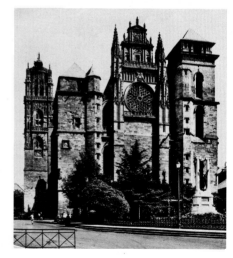

for its date, even on Italian standards. But in its context it is preposterous. All sense of scale and appropriateness seems to have deserted Philander, and he has fallen straight into the trap against which de l'Orme warned architects.

But Philander's knowledge of ancient architecture and his more scholarly attitude towards the use of the Orders seem to have had their effect on architects in the Rouergue, and we find several châteaux in which an interesting kind of classicism is visible, different from that of northern France. The most important of these is Bournazel, of which the earlier and less important north wing was built in 1545 and the impressive double-arcaded screen on the east about 1550 [70].[34] This arcade has something of the monumentality of de l'Orme, but is not imitated from his style. It is actually more Italianate, and it seems likely that this feature is due to the influence of Philander. The design has, on the other hand, several strictly French

characteristics. The decoration, particularly in the metopes, reflects the style of Fontainebleau, and one feature in the application of the Orders is also irregular according to Italian standards but frequently found in France. The entablature of the upper Ionic Order is unbroken in spite of the fact that the columns are full and free-standing. This is a usage hardly ever to be found in Italy and is explicitly condemned by Alberti.[35] It is possible that it was derived by French architects from a celebrated Roman building, the so-called Temple of Diana at Nîmes, which, we shall see, was taken as a model in at least one other work.

Another centre of radiation for the new classicism, though not of quite so pure a kind, was Toulouse, a city proud of its independence in politics through its Parlement and in learning through its university. Humanists like Jean des Pins, Bishop of Rieux, rebuilt their houses there in the new manner as early as 1530. Though

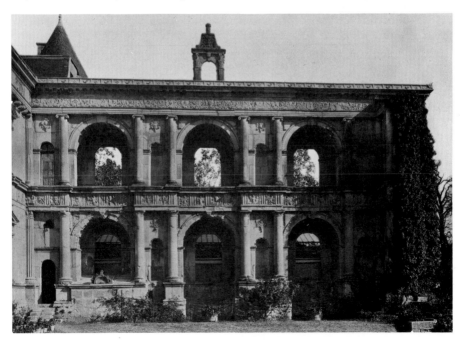

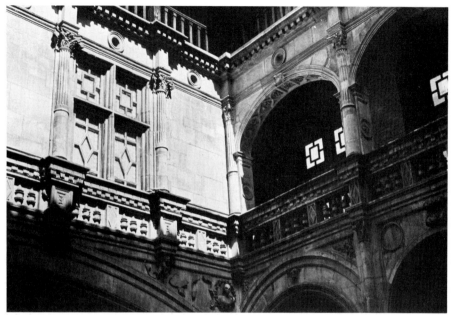

71. Toulouse, Hôtel de Bernuy. 1530

72. Nicolas Bachelier:
Toulouse, Hôtel de Bagis. 1538

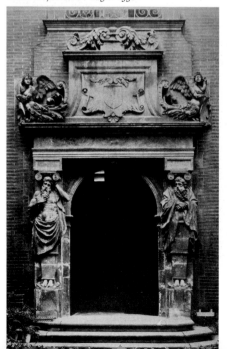

little remains of this work today, we can form some idea of the manner current at that time in Toulouse from the Hôtel de Bernuy of 1530 [71], in which traces of Gothic influences are still visible, but which is strikingly original in its design. The important personality of the middle of the century is Nicolas Bachelier, who built some of the outstanding private houses of the town.[36] He began as a sculptor, and his works in architecture bear the marks of this early training. His door at the Hôtel de Bagis (1538) [72], with its ingeniously arranged supporting herms, is conceived essentially as a work of sculpture. The entrance to the Hôtel d'Assézat (1555) is more the work of an architect, but is still picturesque in its use of rustication and surface decoration. The application of Italian motives in it is quite personal, and the

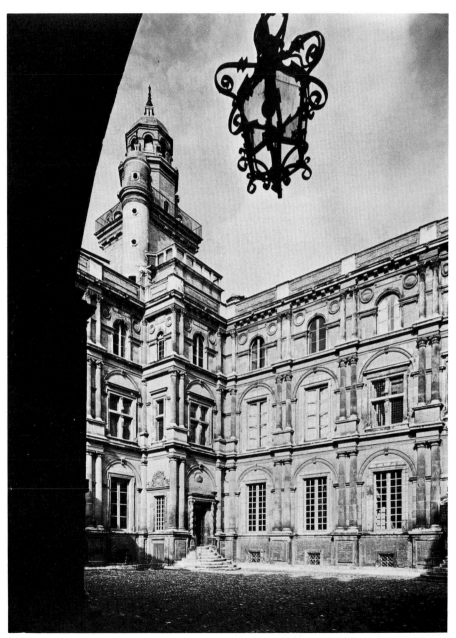

73. Toulouse, Hôtel d'Assézat. 1552–62

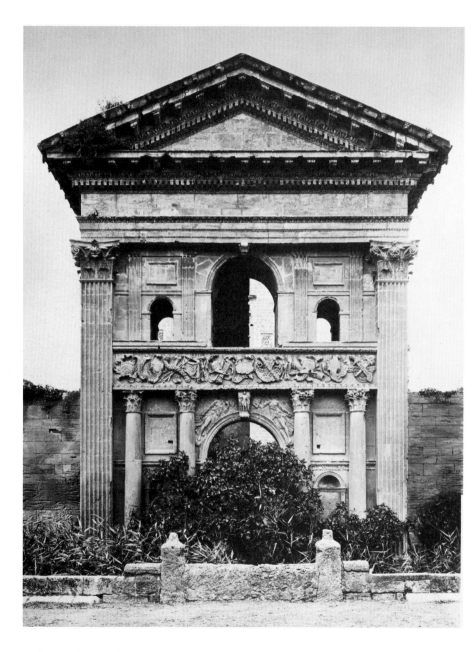

74. La Tour d'Aigues (Vaucluse), château. 1571

design has little in common with what was being produced farther north.

There is no clear evidence about the authorship of the court of this hôtel, the most original work produced in Toulouse at this time (built between 1552 and 1562) [73]. Lavedan[37] argues convincingly that it is too classical for Bachelier, but can make no alternative suggestion. The only point that can be established is that the architect was familiar with the treatise of Serlio, since the elevation is largely composed of elements borrowed from the plates of Book 4. Whoever the architect may be, however, he must rank with Lescot and de l'Orme as one of the creators of the classical style of the middle of the century, and his influence seems to have been wide among architects in Toulouse.

Apart from these centres two single buildings deserve special mention. The first is the château of La Tour d'Aigues near Aix-en-Provence. The main building of the château was put up between 1555 and 1570, and is a direct adaptation of Lescot's Pavillon du Roi at the Louvre. Much more remarkable, however, is the triumphal arch erected as the main entrance to the château and dated 1571 [74]. This displays some of the points which we have seen in the architecture of the south-west, monumentality and the use of the unbroken entablature over full columns. But its general character is quite different. La Tour d'Aigues is within easy reach of the most important Roman remains in Provence, and it is no doubt from the study of these that the architect derived his style. The rich frieze carved with trophies, the exceptionally fine and correct capitals of the Corinthian pilasters, and the elaborate carving of the cornice all suggest a careful study of Roman originals, not merely a casual acquaintance with them through drawings or engravings. La Tour d'Aigues has more than any other French building of the century the character of a real Roman triumphal arch.[38]

The second building, the chapel at Champigny-sur-Veude, is equally remarkable. The chapel itself was begun in the early part of the century, and is an interesting example of Late Gothic with Italianate decoration. But in about 1570 the Duc de Montpensier added at its west end a narthex of very unusual form, built, according to Hautecœur, by Toussaint Chesnau [75]. It consists of a barrel-vaulted porch at right

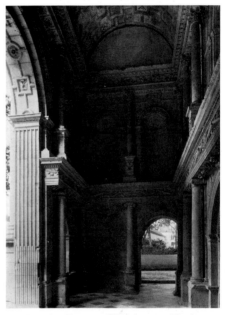

75. Toussaint Chesnau: Champigny-sur-Veude (Indre-et-Loire), chapel, porch. *c.* 1570

angles to the axis of the nave. The walls are decorated with two Orders of full columns, Ionic and Corinthian, each supporting an unbroken entablature. The decoration is fanciful, and entirely French, but the main design of the narthex may go back to the temple of Diana at Nîmes, which has the same form, though the vault is there supported by a single Order.[39]

The same tendencies can be seen in other examples of ecclesiastical architecture of the middle of the century, but generally only in parts added to existing buildings. The appli-

cation of columns and pilasters to doors and porches becomes more and more monumental, as at Le Grand Andely.[40] Towers are decorated with Orders repeated in correct sequence one above the other, as at Gisors and in St Michel at Dijon [37].[41] Screens were added in a strictly classical idiom, one of the finest being that at Arques-la-Bataille.[42] In other cases, for instance Le Mesnil-Aubry, the whole nave is built with classical columns, but the principles of the structure remain medieval and the columns support Flamboyant vaulting.[43] There is only one example of a whole chapel which embodies the principles of the new manner and which can compare in importance with provincial secular work like Bournazel or the Hôtel d'Assézat. This is the chapel of All Saints in the cathedral at Toul, apparently mainly erected before 1549.[44] This chapel is octagonal in plan, with two superimposed Orders supporting a coffered dome. The feeling of the design and detail is entirely Italian, and very advanced for this date, but it is impossible to point to any exact analogy among Italian buildings.

These scattered examples confirm the conclusion which was to be drawn from secular building that the new classicism created by the great architects of the court, Serlio, de l'Orme, Lescot, and Primaticcio, was accompanied by parallel and often independent movements in the provinces, which sometimes, as in the Hôtel d'Assézat and Bournazel and La Tour d'Aigues, produced buildings of real originality.

Reference must be made in this section to a character who, though not a practising architect nor even an original writer on the subject, yet played a part in the development of architectural doctrine and methods in the sixteenth century. This is Jean Martin,[45] a professional translator through whom a number of important architectural writings became widely known in France. From 1545 onwards he was concerned with the French version of Serlio; in 1546 he published a translation of the *Hyp-*

nerotomachia Poliphili, with new engravings by French artists. In 1547 there followed a Vitruvius with plates and commentary by Jean Goujon, and in 1553 Alberti's *Architecture*.

PAINTING AND ENGRAVING

Primaticcio, Nicolò dell' Abate, François Clouet, Jean Duvet

Rosso was responsible for the style of decoration which we connect with the school of Fontainebleau, but it was Primaticcio who created the manner of figure drawing which was to become the most recognizable characteristic of French painting for the rest of the sixteenth century.

76. Primaticcio: Temperance.
Drawing for the Cabinet du Roi, Fontainebleau.
1541-5. *London, British Museum*

77 (*opposite*). Primaticcio:
Fontainebleau, Room of the Duchesse d'Étampes (since restoration). *c.* 1541-5

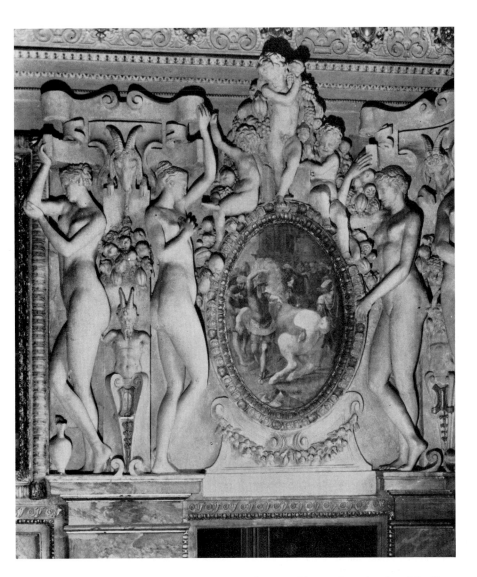

This he achieved during the decade after his visit to Rome and the death of Rosso, in which period he planned some of the most important decorations at Fontainebleau, many of which have unfortunately been destroyed. The panels for the Cabinet du Roi decorated between 1541 and 1545 and known from drawings [cf. 76] are still in the tradition of Giulio Romano, and remind one of the seated allegorical figures in the Stanza di Costantino, but the decoration of the Chambre de la Duchesse d'Étampes [77], planned in the same year, is entirely original.[46]

78. Primaticcio: The Masquerade of Persepolis.
Drawing for the Room of the Duchesse d'Étampes,
Fontainebleau. 1541–5. *Paris, Louvre*

The paintings have suffered severely, but pre-
paratory drawings, for instance for the Mas-
querade [78], show that Primaticcio's style was
undergoing a change. To some extent this trans-
formation can be attributed to the effect which
must have been produced on the artist by his
first sight of ancient sculpture in Rome, and the
nudes in the foreground suggest that something
of the delicacy and softness of Late Hellenistic
work was now qualifying the more masculine
and sometimes inflated manner of Giulio. But
in the Mannerist attitude of the figure bending
down in the right-hand corner of the foreground
and in the types of girls' heads on the right

there is proof of a different influence, that of
Parmigianino, which was to be the essential
factor in transforming Primaticcio's style. Pri-
maticcio must have known his work before he
came to France, but he does not seem to have
realized the significance of his elegant and re-
fined style till a relatively late period. The
change is most clearly visible in the stuccos of
the Chambre de la Duchesse d'Étampes, where
the caryatids have the characteristics of Parmi-
gianino's female figures: long tapering limbs,
thin necks, small heads with exaggeratedly clas-
sical profiles. In the decorative part of the
stuccos the influence of Rosso's Galerie Fran-

79. Primaticcio: Ceres. Drawing for Ballroom, Fontainebleau. 1552–6. *Chantilly*

çois I is still evident, both in the fruit garlands and the strap-work, but the character of the figures is quite different from his. Rosso sometimes elongates his figures, but he does so in order to give them a sort of spiritual intensity, and the elongation is combined with an angular disposition of the limbs which heightens this effect. With Parmigianino and Primaticcio the forms are long and delicate, and are disposed with the utmost ease, never with abruptness. The figures in the Chambre de la Duchesse d'Étampes were the first examples of this formula which was to have such success in France and was to be imitated by other countries during the later sixteenth and early seventeenth centuries.[47]

The most important examples of this style were the two galleries at Fontainebleau which occupied the later part of Primaticcio's career, the Galerie Henri II or Ballroom, and the Galerie d'Ulysse. The former survives, much restored; the latter was destroyed in the eighteenth century, but the style of its decoration is known from drawings and engravings.

The Salle de Bal is not of a form conveniently designed for painted decoration. Built between 1540 and 1550, with immensely thick walls, leaving deep window embrasures, the room was

originally to have been vaulted, and the consoles to support the vaults survive. But under Philibert de l'Orme the plan was changed in favour of the existing coffered wooden ceiling. This left for the main frescoes somewhat awkward spaces composed of spandrels linked together over the slightly flattened arches. These zones and the spaces under the window embrasures were decorated by Primaticcio probably between 1552 and 1556. Owing to the condition of the paintings themselves, we shall form a fairer idea of their qualities from the surviving drawings [79]. Here Primaticcio has been visibly inspired by the example of Raphael's decorations in the Farnesina, the classic models for decoration within the difficult space of the spandrel; but his slightly broader fields have forced him to enlarge the compositions from the two or three figure-groups of Raphael to whole scenes. However, although compositions and many of the figures come from Raphael, all are changed in character and conform to the canons of proportions employed by Parmigianino.[48]

The second great decorative scheme, the Galerie d'Ulysse, was far more complex and took many years to complete. The gallery was

80. Primaticcio: Ulysses and Penelope. c. 1545. *Toledo Museum, Ohio*

of immense length, and filled one whole side of the Cour du Cheval Blanc on the first floor. It was probably begun soon after 1541, and by the death of Henry II the painting of the walls and ceiling was complete. The additions made by Charles IX consisted mainly of the decoration of the window niches and the paintings over the five fireplaces. The walls were decorated with a series of paintings illustrating the story of Ulysses which, as far as we can judge from the drawings[49] and engravings, show Primaticcio as a master of academic design in a style more affected than previously by Michelangelesque

the background, their lean silhouettes forming with the foreground group a contrast which in its dramatic quality recalls Rosso.

The ceiling was decorated with grotesques, among which were interspersed small panels of figures. The general disposition of one bay of this design is recorded in an engraving by du Cerceau [81]. This shows that Primaticcio drew his general idea from the frescoes attributed to Pierino del Vaga in the Salone di Studio of the Cancelleria in Rome, which he could have seen on his visit of 1540. In both decorations the effect depends principally on the great variety

influence, particularly in the scenes of violent action. In the gentler subjects, however, the style of Parmigianino dominates, and we can form some idea of what they must have been like from an oil-painting of Ulysses and Penelope, probably by Primaticcio himself, which is based on one of the panels [80]. A striking feature here is the group of small figures in conversation in

81. Primaticcio:
Ceiling of the Galerie d'Ulysse, Fontainebleau.
c. 1550. Engraving by du Cerceau

of forms given to the panels [50] and on the ingenious way in which they blend with the grotesques surrounding them.

The general plan of the bays seems to have been the same all through the gallery, but a difference is to be traced in the designs of the actual figure panels. In the earlier bays these seem to have been in the style of the Ballroom or the Chambre de la Duchesse d'Étampes. But from the middle of the gallery onwards there is a strong tendency to introduce illusionism. So, for instance, in the octagonal fresco of the fourteenth compartment which shows Jupiter and Juno surrounded by the Olympians, the figures are arranged in a steep perspective system such as Correggio used in his dome designs. In other panels the illusionism is contrived with the help of foreshortened architecture, recalling Tibaldi, as in the panel of Minerva visiting Jupiter and Juno in the thirteenth compartment. In the tenth bay, perhaps the boldest of all, the chariot of Apollo is depicted from exactly below, so that all that can be seen is the bellies of the horses.[51]

This change of conception may have been due to a development in the style of Primaticcio, but it can be more probably explained by the intervention of a new artist in the direction of the gallery. This was Nicolò dell'Abate (c. 1512–71), a painter who was born and trained in Modena and is first traceable at Fontainebleau in 1552.[52] He arrived with a wide experience of north Italian illusionist painting as it had sprung from the experiments of Mantegna and Correggio and been continued by the Mannerists. Nicolò himself had executed illusionist decoration in Italy: a frieze in the Palazzo Poggi in Bologna, an octagonal ceiling design of the Boiardo family now in the museum at Modena, and a complete ceiling in the Municipio of the same town.[53] He was therefore more deeply versed than Primaticcio in the latest devices of this kind of decorative painting, which the latter could not have seen till his visit to Bologna in

1563, when the vault of the gallery was already finished. It is therefore reasonable to suppose that this change is due to Nicolò, though it would not be safe to conclude from this that the drawings for all such illusionist panels in the gallery were prepared by him. Primaticcio, who had shown after his visit to Rome in 1540 that he was capable of absorbing new ideas and putting them to good use, may well have benefited by Nicolò's suggestions and incorporated them in his own designs.[54]

The last decorative work planned by Primaticcio was the chapel for the Hôtel de Guise. From a letter of 1555 we know that he recommended Nicolò to carry out the work, but it is generally assumed that the drawings are from his own hand.[55] In any case the designs show the illusionist methods of Nicolò in a high degree, especially the fresco over the altar which represented the Star of the Magi supported by angels. The general style of this composition recalls Correggio, but the immediate model seems to be the central panel on the ceiling of the Sala dei Pontefici in the Vatican, probably by Perino del Vaga.[56]

Nicolò's personality seems to have been partly submerged in that of Primaticcio after his arrival in France, but the 'Continence of Scipio' (Louvre), which is almost certainly datable to that period, shows him as a quite independent designer of figure compositions. This is a typical work of North Italian Mannerism, not deriving, like Primaticcio, from the Roman tradition of Giulio Romano, but ultimately from Correggio via his imitators in Emilia. In the types, in the non-linear conception, and in the softness of the handling it is characteristically Modenese, and not Mantuan.[57]

In one other field – that of landscape – Nicolò was an innovator in France. He had already evolved in Italy a style of landscape-painting based on that of Dosso, of which typical examples are to be seen in the Borghese Gallery.

82. Nicolò dell'Abate: Orpheus and Eurydice.
1557(?). *London, National Gallery*

The 'Landscape with Orpheus and Eurydice', now in the National Gallery in London [82], and the 'Rape of Persephone' in the Louvre were executed in the same style, certainly in France.[58] Nicolò's style differs from that of Dosso in that it reveals more evident traces of the influence of Flemish landscape as it had been evolved by Patinir and his followers. The panoramic coast view, the fantastic buildings, the artificial disposition of the colour in tones of brown, green, and blue are all marks of the Antwerp school. Nicolò probably first came into close contact with this tendency in France, but its effect is already to some extent evident in the two Borghese landscapes which seem to have been executed in Italy.[59]

★

The Fontainebleau school as it was represented by Primaticcio and Nicolò dell'Abate was the central stream of French painting during the period which we are considering, but there were artists working in Paris and the provinces who stand to some extent aside from the movement. Unfortunately we are very ill-informed about these painters, and till further research is carried out we are only in a position to indicate a few scattered instances of what may have been taking place in many districts in France.

The most important of the painters working independently of the Fontainebleau school is the elder Jean Cousin, whose identity and career as a painter and a draughtsman are beginning to take shape.[60] He was a native of Sens, and is recorded there from 1526 onwards. In about 1538 he moved to Paris, where he evidently made for himself a highly successful career as a painter and designer of stained glass, and died in 1560 or 1561, leaving considerable

of Langres for which they were woven, and one in a private collection.

From these works we can deduce that Cousin, while conscious of contemporary art in Italy, did not draw his knowledge of it entirely from Fontainebleau. The 'Eva Prima Pandora' [83],[61] though it shows the influence of Rosso in the head of the figure and to some extent in the drawing of the nude, differs entirely from anything produced at Fontainebleau in the setting

83. Jean Cousin the Elder: Eva Prima Pandora. Before 1538. *Paris, Louvre*

property. Little work survives which can with any certainty be ascribed to him, but we can safely accept the traditional attribution to him of the 'Eva Prima Pandora', probably executed in Sens before 1538 and now in the Louvre, since the tradition can be traced almost to his own lifetime. Apart from this, the only solid fact is the contract of 1543 which proves his authorship of the tapestries of the life of St Mammès, of which three survive, two still in the cathedral

with its rocky cave and dramatic silhouettes of trees, suggesting a knowledge of Leonardo in the use of light and of Dürer's engravings and woodcuts in the forms of the trees. The St Mammès tapestries suggest different influences. In all of them the decorative borders are strictly in the manner of Rosso and show exceptionally complicated strap-work. The main panels, however, appear to be based largely on a knowledge of Italian engraving of the school of Raphael

84. Charles Dorigny: Lamentation over the dead Christ. *Paris, Ste Marguerite*

and Giulio Romano. Ancient and Renaissance buildings, not always well understood, compose the settings, accompanied in the 'St Mammès preaching to the beasts' by a rather naïve representation of countryside, based on Late Gothic conventions.

It is known that Cousin designed much stained glass, and two windows in the cathedral of Sens are traditionally attributed to him. One, representing Augustus and the sibyl (1530), has

been so much restored that no firm conclusion is possible; the other, of the life of St Eutropius (1536), is quite consistent with his style as far as it is known to us.

A 'Lamentation' in the church of Ste Marguerite, Paris [84], has been identified[62] as the altarpiece painted in 1548 by Charles Dorigny for the Orléans Chapel in the Célestins. It is a splendidly monumental design, deriving largely from Rosso, but having a distinctive

French flavour and probably with, in the head of Joseph of Arimathea, a portrait of Henry II.

One group of provincial work shows direct contact with Italy. This is the series of frescoes illustrating the Trojan War in the château of Oiron (Deux-Sèvres) [85]. The contract for these paintings which was known in the nineteenth century shows them to have been painted in 1549 by Noël Jallier, an artist otherwise unrecorded. These frescoes are damaged but have recently been restored and count among the most impressive decorations of the period.

traced between 1535 and his death in 1561 or 1562. Born at Châlons-sur-Marne, he seems to have been trained in Flanders, for his few certain works show the influence of Antwerp painting of the 1530s. He was, however, also affected by Italian art, and his 'Virgin of Sorrows' in the Borghese Gallery, dated 1543, is a copy of a painting by Solario. He seems to have executed many altarpieces for the churches of Avignon, of which the 'Lamentation over the dead Christ' of 1550 in the Musée Calvet is typical in its mixture of Flemish with Italian elements.[64]

85. Noël Jallier: The Trojan War. 1549. *Château of Oiron (Deux-Sèvres)*

They show many elements of the Fontainebleau style, but they also reveal a knowledge of Roman decoration of the later 1540s, particularly of Daniele da Volterra's stucco frames in the Sala Regia of the Vatican[63] and Salviati's decorations of the Palazzo Sacchetti.

Farther south in Avignon a curious artist, Simon Mailly or Simon de Châlons, can be

By far the most puzzling problem in the painting of this phase is presented by the 'Moses and Aaron before Pharaoh' in the Metropolitan Museum, New York [86].[65] This was commissioned in 1537 by François de Dinteville, Bishop of Auxerre, probably to hang as a pendant to Holbein's 'Ambassadors' ordered by his brother Jean some four years previously. Like

the 'Ambassadors' the 'Moses' is in a sense a portrait group, for the Moses and Aaron are represented with the features of the Dinteville brothers. Till recently the 'Moses' and two other paintings connected with the Dinteville family were attributed to Félix Chrétien, whose name was mentioned as their author by an eighteenth-century historian. It has now been shown, however, that Chrétien was not a painter at all but the secretary to the bishop, who became a canon of Auxerre. Once the name of Chrétien was eliminated it became clear that the paintings of

the group were not all by the same hand, and that the 'Moses', though undoubtedly painted for a French patron, was probably not French at all. It has been suggested that the artist might have been German, but the fact that the inscription in another of the Dinteville paintings is in Dutch shows that the Dinteville family had connexions with the Low Countries. Stylistically the Metropolitan picture might be by an artist trained in Holland, for many of the heads recall the style of Jan van Scorel. Among the most remarkable features of the picture is the aston-

86. Unknown artist: Moses and Aaron before Pharaoh. 1537. *New York, Metropolitan Museum*

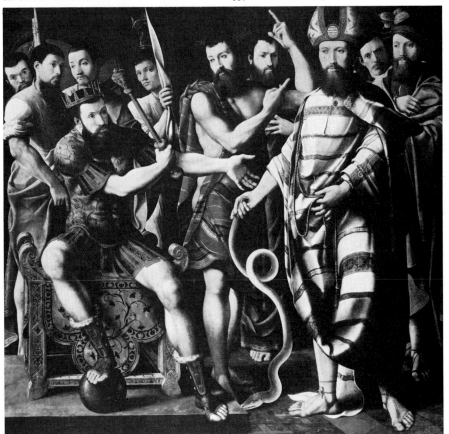

ishing realism used in depicting Aaron's serpent, which is being transformed into transparent glass.

★

Parallel with these schools of decorative painting the art of portraiture continued to flourish in France. Indeed, the middle of the sixteenth century is a period of unusual activity in this field, and the fashion for collecting portrait-drawings led to the setting up of regular factories for supplying them. Various attempts have been made, principally by Dimier and Moreau-Nélaton,[66] to put order into this mass of material, but it must be confessed that the problem is still to a large extent unsolved, and the greater part of the drawn and painted portraits of the middle and second half of the century cannot be attributed with any certainty to named artists. The following summary will give what facts are tolerably certain, and will not include any attempt to deal with the problem of the anonymous works.

Two names occur frequently about the middle of the century in connexion with portraiture: François Clouet and Corneille de Lyon. About the former we have a few solid facts on which to base an account of his works; but in the case of Corneille there is only one work which can be authenticated by anything like contemporary evidence.

François Clouet was the son of Jean and often used his nickname of Janet. In 1541 after the death of his father he was appointed by Francis I to succeed him, and we must therefore suppose that he was already an artist of established reputation. On these grounds the date of his birth must be placed not later than 1510 and probably rather earlier. He died in 1572. His earliest documented work dates from 1562, but in his first years as painter to Francis I he probably executed the famous portrait of the King in the Louvre [87].[67] This portrait is based on a drawing by Jean Clouet, but is quite unlike his

painted works. It has, on the other hand, in a high degree the decorative quality and the love of fine detail which characterize the mature portraits by his son.

The portrait of his friend, the apothecary Pierre Quthe, in the Louvre, dated 1562 [88], is markedly different in style. It indicates that François Clouet must have been familiar with Florentine painting, for the type conforms to one in regular use by painters like Pontormo, Bronzino, and Salviati. The pattern with the figure leaning one arm on a table and a curtain

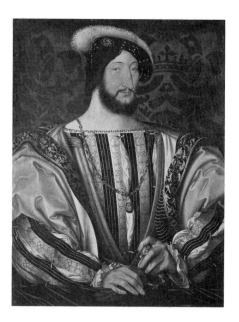

87 *(above)*. François Clouet(?): Francis I.
Paris, Louvre

88 *(right)*. François Clouet: Pierre Quthe. 1562.
Paris, Louvre

89 *(far right)*. François Clouet: Charles IX. 1570.
Vienna, Kunsthistorisches Museum

cutting off the corner of the composition is purely Florentine in origin, and the naturalism in the face and in the treatment of drapery is close to the early work of Bronzino or to the portraits of Salviati. It is an altogether unpredictable work in French painting of this time, and points to the conclusion that the author must have paid a visit to Italy, for models of this type were not, as far as is known, available in France.[68]

A second portrait bearing his name is the life-size full-length of Charles IX in the Vienna

even Bronzino would appear naturalistic beside it. It conforms to a type of international Mannerist portraiture which spread over Europe in the second half of the sixteenth century, producing an exact parallel in Sanchez Coello in Spain and ending with the style of the Pourbus family at the turn of the century.[71]

For this portrait a drawing exists in the Hermitage which provides the basis for attributing to François Clouet a series of similar sketches of which the greater part are in the Musée Condé at Chantilly. These show traces of in-

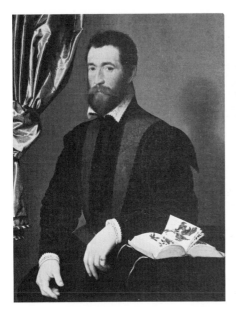

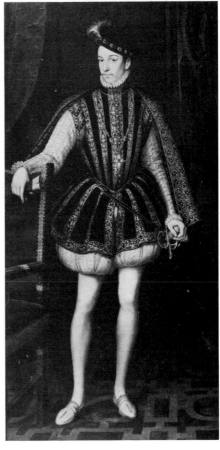

gallery [89].[69] Here the main influence seems to be from Germany. The stance of the figure and the flat, almost heraldic treatment of the elaborately embroidered dress, though they have certain affinities with Florentine portraiture, are closer to portraits by Seisenegger dating from the 1530s.[70] Clouet's 'Charles IX' is more hieratic than contemporary Flemish portraiture, of which the leading exponent was Mor, and

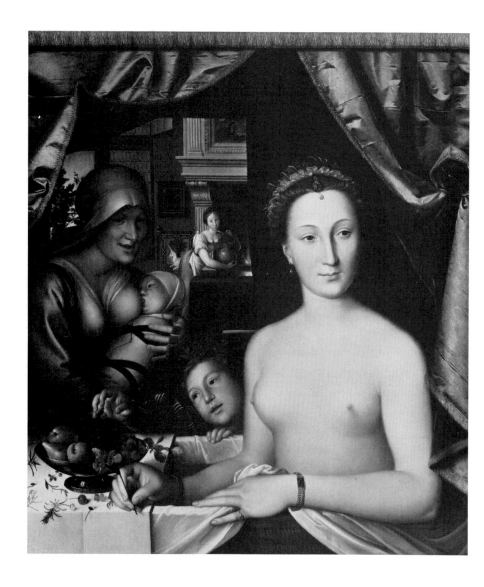

90. François Clouet: Marie Touchet (?). *c.* 1570. *Washington, National Gallery*

fluence from the elder Clouet, but with important differences. The technique is much more meticulous, the attention to accidents of feature and surface is greater, and, as a result, the emphasis on simple geometrical volume is much less apparent. Whereas Jean Clouet's drawings were in the tradition of the Italian High Renaissance, those of his son belong to the world of northern-European naturalism.

One painting signed by François Clouet stands apart from those so far considered. This is the 'Lady in her Bath' [90] in the National Gallery, Washington, traditionally identified as a portrait of Diane de Poitiers, but more probably, as suggested by Irene Adler, of Marie Touchet, the mistress of Charles IX. Here again Italian motives dominate, for the conception and pose of the half-length portrait are taken directly from one of the so-called 'Monna Vanna' portraits emanating from the studio of Leonardo, of which the finest is the cartoon at Chantilly. Clouet may have known one of these Italian originals, but he may equally have come to know the design through the adaptations of it frequently made in the circle of Joos van Cleve.[72] The latter hypothesis is perhaps supported by the somewhat Flemish flavour of the painting and by the resemblance of the composition as a whole to certain paintings by Joos van Cleve representing half-length groups, usually of the Holy Family, behind parapets on which are depicted a dish of fruit and other objects.[73] There may also be a faint echo of Titian in the presence of the maidservant in the background, but there is no stylistic link with Venetian painting.[74]

The problem of Corneille de Lyon is, as has already been said, unusual in that, although we have many contemporary references which show him to have been a portrait painter of great repute, we have only one work which we can attribute to him with certainty. The documents prove that he was of Dutch origin and was born in The Hague, that he was painter to the Dau-

phin, later Henry II, from 1540 onwards, and that he was naturalized French in 1547. In 1551 the Venetian ambassador, Giovanni Capelli, describes a visit to his studio, where he saw little portraits of all the members of the French Court. After the death of Henry II he continued in favour with his successors. He abjured Protestantism and joined the Roman Church in 1569, and the last record of him dates from 1574.

In the absence of any signed work by his hand the safest starting-point is a portrait of Pierre Aymeric, a native of St Flour [91], which has on the back an inscription in the hand of the sitter, saying that it was painted by 'Corneille de la

91. Corneille de Lyon: Pierre Aymeric. 1533.
Paris, Louvre

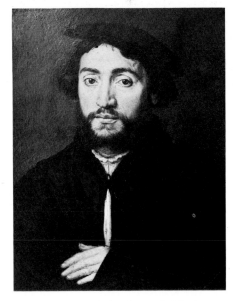

Haye' in 1533 and that it was finished on 11 April, the day when the inscription itself was added.[75] This portrait confirms the attribution to him of a number of portraits which have long gone under his name which are characterized by their small size, their sensitive naturalistic modelling in a northern manner, and usually

by a green background. We have no evidence of the artist's early training, but there is nothing in Dutch portraiture of the time to suggest that he learnt his art in his own country. Closer links can perhaps be seen with Antwerp, more precisely with Joos van Cleve, whose portraits, though larger in scale, have very much the same modelling in thin glazes which give variety of light and texture to the features rather than plasticity. The influence may have been reinforced when the Flemish painter visited the French Court, probably soon after 1530, to paint the portraits of Francis I and his second wife, Eleanor of Portugal.

<center>★</center>

If we turn to engraving we come upon an artist who forms in every respect a contrast to all that we have so far found in France during the sixteenth century. The painting of the period was a court art, almost exclusively associated with the King himself or with the great noble families; and it showed in the most highly developed form the characteristics of such an art: elegance, sophistication, and refinement. With the engravings of Jean Duvet [92, 93], above all with his illustrations to the 'Apocalypse', we are confronted with the works of a religious mystic which sweep us at once into a world which is far removed from the Court of Fontainebleau and carry us back in some ways into the Middle Ages.[76]

We know little of Duvet's life except that he was born in 1485, at either Langres or Dijon, where he spent the early part of his career, but from 1540 onwards he lived in Geneva, where he worked for the city council and might therefore have become a Protestant. He died after 1561. His earliest dated engraving is an 'Annunciation' (R.D.5) of 1520. This does not foreshadow his mature style, but it is a startling work for its date, owing to its pure Italian style. The architectural setting is more accurately classical than anything to be found in contemporary French work; the figure of the Virgin

92. Jean Duvet: Moses and the Patriarchs. 1540–50. *London, British Museum*

has an almost Correggesque sentiment; and the angel reveals a knowledge of current Roman painting. His 'Judgement of Solomon' (R.D.64), undated but probably early, is based on Raphael's cartoon of Elymas the Sorcerer which he may have known from the engraving of Agostino Veneziano, but the real understanding of High Renaissance Italian design displayed in these and other early works leads to the conclusion that he must have visited Italy and have seen the works of Raphael and his contemporaries for himself. It is otherwise hard to see how he should have had an understanding of them so much in advance of his fellow countrymen.

Apart from the 'Apocalypse', the most famous engravings by Duvet are the Unicorn series, which may be tentatively dated to the 1540s.[77] Stylistically they show a further approach to-

93. Jean Duvet: Illustration to the Apocalypse. Before 1561. *London, British Museum*

wards the manner of the 'Apocalypse'. The compositions are crowded, space is no longer clearly defined; the heads tend more towards the grotesque; elements, such as *putti*, borrowed from Italy, are transformed more and more into a personal idiom.

In one of the set, 'The Unicorn purifies a spring with his horn' (R.D.59), a quite different spirit appears, and the composition is filled with animals rendered with a naturalism which is sometimes naïve, as in the almost heraldic lions, and sometimes reveals a startlingly close observation, as in the foreshortened poses of the beasts.

One other engraving by Duvet probably dates from the same period [92]. It is usually called, not quite accurately, 'Moses surrounded by the Patriarchs'. Its theme is a variant of one common in medieval cathedral porches, the ances-

tors and antitypes of Christ, and the arrangement of the figures on truncated columns against a vaulted recess is also a direct echo of the practice of the Middle Ages. In certain details, moreover, the figures seem to go back to medieval models. The Abraham and Isaac group, and the Melchizedek, are both types best known in the north porch of Chartres, and some of the other figures with their cross-legged dancing poses almost suggest that Duvet had in mind models such as the sculptures of Moissac and Souillac.

It is, however, in the twenty-four engravings illustrating the 'Apocalypse' that Duvet's full imaginative power is seen [93]. The set was published at Lyons in 1561, but the first plate, with a self-portrait of the artist, bears the date 1555, and others may well have been executed before this time. In these compositions Duvet borrows extensively from Dürer's woodcuts of 1498, and it could even be said that his whole project is based on that of his predecessor. But it is the variations from Dürer rather than the resemblances that are interesting.

The approach of the two artists is entirely different. Dürer aims at the greatest clarity in his designs, at perspicuity in his setting out of the narrative, at making the supernatural stories seem, at least, to conform to the laws of nature. He compresses the spiritual significance of the subjects within this severe framework, and in the process gains the concentration which is one of the most marked characteristics of his engravings. Duvet accepts from the outset the purely visionary nature of his material and plans his compositions on that basis. All attempt to make them plausible is abandoned. Space is not a matter of interest; relative scales of figures or of figures to buildings are arbitrary; the human figure can be distorted to any degree if by so doing it becomes more expressive of the symbolical action it has to perform; clarity is no object in itself in a subject where commotion and turmoil are the central themes. Duvet ac-

cepts the dictation of the text with the utmost literalness. If St John speaks of a voice 'as it were of a trumpet', Duvet shows an actual trumpet blowing into the saint's ear. In the sealing of the hundred and forty-four thousand, whereas Dürer with typical moderation represents those sealed by a group of about a score, Duvet shows an innumerable crowd vanishing in confusion into the far distance. He is completely uncompromising in his methods; he does not shrink from rigid and monotonous symmetry when it is demanded, as in the 'Fountain of Living Water' (R.D.49), nor from the grotesque, as in the 'Fall of Babylon' (R.D.44), where the woman seen in the previous plate seated on the Beast is depicted tumbling down in an attitude which trembles on the borderline of comedy. But in all these designs there is an urgency and a conviction which make us forget the confusion and the technical incompetence. We feel only that here is an artist who has penetrated the visionary world described by St John and has translated his experience into appropriate terms, even if those terms are at variance with all the canons of classical art.

Duvet may seem at first sight an inexplicable phenomenon in French art of the sixteenth century, but this is not the case, if we examine more closely the circumstances in which he lived. Although we know little of his own life, we have some information about the atmosphere of Langres in his time. The religious activity of the town was dominated by the personality of the bishop, Claude de Longwy, Cardinal de Givry, who was appointed to the see in 1529.[78] The Cardinal belonged to the group of churchmen who recognized the abuses in the Catholic Church and wished to reform them, but were passionately opposed to the doctrines of Luther and the Protestants. Although himself a powerful figure in the Church, he was never a politician, and his reforms were aimed at producing a change of heart, not of constitution. In his diocese he inaugurated a movement of real en-

thusiasm, one manifestation of which was the foundation of many new confraternities for charitable and devotional purposes. Of these the most important was that of the Holy Sacrament, founded in 1548, to which we know that Duvet belonged.[79]

It was against the background of this emotional religious movement that Duvet's 'Apocalypse' was produced, and it is this atmosphere that it reflects. His art, therefore, offers a close analogy to some of the early manifestations of Mannerist painting in Italy, particularly to the work of Rosso and Pontormo in Florence in the 1520s, produced in a similar atmosphere of religious excitement.[80] The stylistic analogies with the art of these Florentine painters are obvious: the arbitrary proportions of the figures, the crowding and lack of space, the borrowings from Dürer, the revival of Gothic elements. The last feature is naturally more evident in the work of the Frenchman than in that of the Italians, since France had not yet fully thrown off the habits of medieval art. Duvet is also more specifically mystical than the southerners, who should rather be described as dramatic in their treatment of religious emotion. But in general the parallel is close, and the contrast between Duvet and the art of Fontainebleau is in almost every respect like that between the religious art of Pontormo and the official style of the Medici Court.[81]

Duvet is an appropriate artist with whom to end the chapter on the classical art of the mid sixteenth century, because in a sense he links the periods which precede and follow this classicism. We have already seen that in certain respects he springs from the Middle Ages; in others the mystical and agitated quality of his work foreshadows the art produced in the later part of the sixteenth century during the Wars of Religion.

To the English student the comparison of Duvet with William Blake is inescapable. Both were visionaries; both were uncompromising

in their determination to render exactly what they experienced; both are confused, technically incompetent, provincial even. But both have the supreme conviction of the mystic. One can, however, push the comparison further, for not only were their intentions similar, but also their choice of means for the expression of their ideas. Both have affinities with the artists of the Middle Ages, but both also borrow their idiom in part from the engravings of the High Renaissance, above all those after Raphael and Michelangelo, and both translate these models into Mannerist terms. Blake may have known the engravings by Duvet, for one was reproduced by William Young Ottley in his *Facsimiles of Scarce and Curious Prints* in 1826, which proves that the artist was known in the circle in which Blake moved. There are certain similarities between the designs of the two artists which are hard to explain except by direct influence.

SCULPTURE

Goujon, Bontemps, Domenico del Barbiere

In the field of sculpture, as in that of painting, we find a great Italian playing his part in the development of the art in France; but in this case the exact share of the artist – Benvenuto Cellini – is very hard to define. For of the works which he executed during the five years of his stay – 1540 to 1545 – only two survive: the bronze relief of the Nymph of Fontainebleau and the gold salt-cellar for Francis I (Vienna). We know from his autobiography that he also made models for a series of twelve silver statues of gods and goddesses, of which only the Jupiter was finished;[82] that he began a fountain with a colossal statue; and that he made two bronze busts and a number of silver vases. But of all these nothing survives. Even the 'Nymph of Fontainebleau', as we see it, is only a fragment of a scheme for reconstructing the whole of the Porte Dorée at Fontainebleau with supporting satyrs at the sides and a new disposition of the architectural surround.

There can, however, be no doubt that Cellini's work made a deep impression in France. Local artists must have been first of all struck by his dazzling technical skill; the types of nude to be seen in the salt-cellar probably influenced Primaticcio;[83] and, as we shall see, Cellini's treatment of drapery must have had an effect on Jean Goujon, the artist who dominates French sculpture in the middle of the sixteenth century. Goujon created the style current in Paris and widely imitated in the provinces, and invented a form of Mannerism as exquisite as the finest production of the school of Fontainebleau in painting and decoration, but flavoured with a personal type of classicism.

Goujon's birth and early career are a mystery.[84] The first trace of him is from the year 1540, when he is mentioned as making the columns supporting the organ loft in the church of St Maclou at Rouen. These columns are so remarkable for their date that they lead to two conclusions: first, Goujon must have been a fully formed artist when he designed them, and cannot therefore have been born later than about 1510; and secondly, it is hard to believe that he could have made so pure a classical design without a visit to Italy and first-hand experience of Roman architecture.[85] From this first work and from the payments to him by the authorities of the cathedral of Rouen we know that Goujon was as much an architect as a sculptor at this time, and this is confirmed by a later reference to him as having been 'architecte' to the Constable Anne de Montmorency.

One other work in Rouen has been generally attributed to Goujon, namely the tomb of Louis de Brézé, husband of Diane de Poitiers, in the cathedral [94]. We do not know the exact date of the monument, but Brézé died in 1531, and the tomb is believed to have been put up by his widow, probably in the following years. But from the variation in style of different parts it

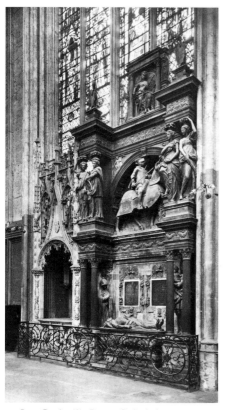

94. Jean Goujon(?): Rouen Cathedral,
tomb of Louis de Brézé. *c.* 1540

seems that its construction took some time.
Two decorative features in the tomb can be
linked directly with works certainly by the sculp-
tor;[86] and it is hard to imagine any other artist
of the time in Rouen, or indeed in Paris, capable
of designing the caryatids, which foreshadow
those later designed by Goujon for the Louvre.

It is not, on the other hand, by any means
certain that Goujon was responsible for the
whole tomb. The panels with inscriptions are
in the style of the school of Fontainebleau, and
though they may possibly represent the manner
of Goujon in the thirties, we have no evidence

to support this view. The equestrian statue is
cruder and more archaic than the rest of the
sculpture, and the coarse but detailed vegetation
behind it recalls the local school which pro-
duced the carvings under the vault of the Grosse
Horloge and the reliefs in the Lady Chapel at
Valmont. As it stands the tomb presents one
puzzling feature. To the right and left of the
gisants are life-size figures of Diane de Poitiers
kneeling and the Virgin standing, holding the
Child, which are squeezed in behind the coupled
columns of the lower Order, a position for
which they cannot have been designed. There
seem to be two possible solutions to this pro-
blem: either Goujon may have planned a second
tomb to have contained the body of Diane, or
the existing tomb may have been designed to
have had a third storey, in which the statues
would have held a central position. If the second
hypothesis is correct, the tomb would have pre-
sented almost exactly the appearance of the
frontispiece at Anet. Those parts of the decora-
tive sculpture which can be attributed to
Goujon are of high quality. The upper frieze is
of ingenious design, with a repeating pattern of
a winged genius crowning two gryphons, for
which no parallel exists in France at this time.
The caryatids are free and vivacious in con-
ception and modelling, far in advance of any-
thing which even the most competent Italians
in France could have invented; and their heads
and drapery both show a greater knowledge of
classical models than was possessed by any con-
temporary sculptor in France.[87]

By 1544 we find Goujon in Paris at work on
the first sculpture in which his mature style is
displayed, the Rood Screen of St Germain
l'Auxerrois. The transition to this major work
may perhaps be formed by the much-disputed
reliefs from the altar of the chapel at Écouen,
now at Chantilly, which show links with the
Brézé tomb and also with the Fontainebleau
decorative style of the 1530s, but which include

bas-reliefs of the four evangelists directly fore-shadowing those on the screen.[88]

The Rood Screen of St Germain l'Auxerrois, of which the principal panels are preserved in the Louvre, was executed in collaboration with Lescot. Its sculptured decoration consists of a central panel of the 'Pietà', flanked by four smaller reliefs of the evangelists. The 'Pietà' [95] is based on various Italian motives; the pose of the dead Christ is from an engraving of Parmigianino, and other elements come from

direction of a greater classicism, especially in that the draperies now reveal the form under them. The panels of the evangelists show the same qualities, above all an exquisite sense of pattern and texture; but here the poses and types derive rather from Michelangelo than Rosso.

Goujon's most celebrated and most mature works date from the years about the middle of the century. They are the decorations on the Fontaine des Innocents and the work executed with Lescot at the Louvre.

95. Jean Goujon: Pietà. 1544–5.
Paris, Louvre

Rosso, particularly the figure of the fainting Virgin and the close-cropped curls with which almost all the characters are equipped. The drama of the theme is expressed in an idiom borrowed from Rosso, but diluted through the emphasis laid by the artist on decorative beauty. The most striking feature of the relief is the patterning of closely repeated parallel folds against the plain ground of the panel, a treatment of drapery inspired partly by Cellini, whose influence seems to be mainly responsible for Goujon's change in style after his arrival in Paris. But his manner has also evolved in the

The Fontaine des Innocents was built and decorated during the years 1547–9. In its original form it was a rectangular building on a corner, presenting façades of two bays on one street and one bay on the other. At the end of the eighteenth century, however, it was reconstructed as a free-standing square block. Its sculptured decoration, most of which is now in the Louvre, consisted of six tall, narrow reliefs of nymphs [96], three long reliefs with nymphs and tritons [97], three more with *putti*, and, finally, Victories filling the spandrels. The long reliefs of nymphs and tritons show more

96. Jean Goujon:
Paris, Fontaine des Innocents, Nymphs. 1547-9

97. Jean Goujon: Naiad from the Fontaine
des Innocents. 1548-9. *Paris, Louvre*

clearly than any other of Goujon's works the influence of Cellini's 'Nymph of Fontainebleau', particularly in the drapery, which is disposed in close parallel folds and floats as a background to the nudes without any functional connexion with them. The figures themselves, however, have a lightness and delicacy far beyond Cellini's, recalling rather the drawings of Primaticcio. Once again, however, Goujon's sense of surface decoration is the source of the real beauty of these panels. Here the patterning of the drapery is supported by new elements, such as the scales of the sea-monsters and the picturesque effect of the shells on which float the nereids.

The upright panels of the nymphs are more restrained in style. The drapery is strictly classical in its manner, but Goujon allows himself a certain richness by adding to the plain classical dress jewelled girdles and patterned borders. The figures show a remarkable variety of poses, each adapted so that the raised arms holding the urns ingeniously fill the corners of the narrow panels. The elongation and the elegant attitudes are reminiscent of Primaticcio's form of Mannerism, but the classicism of the actual drapery gives the figures an entirely different character. For the first time in Goujon's work the artist seems to be in complete command of his medium, and to be able to express within

the restricted formula of the bas-relief the most complicated *contrapposto* of the figures, whereas in the earlier works, notably in the 'Virtues' on the Écouen altar, there was an element of uncertainty in the treatment and an abruptness of transition from the parts shown full face to those which appeared in complete profile.[89]

The work on the Louvre was far more extensive than that on the Fontaine des Innocents, but it was so completely restored in the nineteenth century that it is impossible to judge of more than its general disposition. Apart from purely architectural decoration such as friezes, Goujon's sculpture on the palace consisted externally of standing figures flanking the *œils-de-bœuf* on the ground floor and a series of reliefs on the attic. As regards the date of this work, we know that by 1549 Goujon had executed the figures round the middle *œil-de-bœuf* and signed the contract for the other two pairs. The reliefs on the attics were executed in 1553.

Stylistically the decorations on the ground floor display much the same qualities as those on the Fontaine des Innocents, except that they show a tendency for the draperies to form a broken, fan-like silhouette not to be found in the more classical reliefs of the Fontaine.[90] The reliefs on the attic floor are more remarkable, because they show great freedom in their relation to the architecture. The upper figures break out of the field of the pediment, and those at the side come over the zone of the capitals. Owing to their restored condition, it is unwise to draw any conclusion about their original quality.

The other important work for the Louvre was the decoration of the *Salle* on the ground floor of Lescot's wing. Here Goujon's main contribution is the gallery supported by four caryatids [55]. Compared with those on the Brézé tomb, these are markedly more classical in style, though it is impossible to say how much they may owe this character to the nineteenth-century restoration.[91] In any case, however, the conception of the gallery with caryatids is quite new in French architecture.

Goujon's name continues to appear in the royal accounts till 1562, presumably for work on the Louvre, but after that date it is no longer to be found. According to some critics, the reason is that Goujon left France in 1563 on account of being a Protestant, and took refuge at Bologna and died there in or before 1568. It is not, however, quite certain that the Bolognese documents actually refer to him, and for the present Goujon's last years must remain to some extent a mystery.

<center>★</center>

This is the most convenient point to consider what was for long regarded as one of Goujon's most famous works, the 'Diana of Anet' [98]. Maurice Roy[92] showed conclusively that the attribution to Goujon was of recent origin and without stylistic support, and proposed instead the name of Cellini. But most critics have rejected this view and hold to the old tradition to the extent of maintaining that the sculptor must be a Frenchman, though no new name has been as yet put forward.[93]

The work presents a puzzling problem. The date of its execution is not known, but it is first mentioned in 1554. It is by a sculptor of high quality and individual style, who has one gift which Goujon never possessed, the power to conceive a statue completely in the round. It is less classical than Goujon's mature style, and springs more directly from the art of Primaticcio, though perhaps with some influence from Cellini's Salt for Francis I. It is, however, essentially a product of the late school of Fontainebleau. The head, of exquisite if over-refined accomplishment, is characterized by the elaborate treatment of the hair, the small and delicate features, and the mannered drawing of the eyes.

There is only one group of works in French sculpture of the period in which the same qualities are to be seen, namely some of the

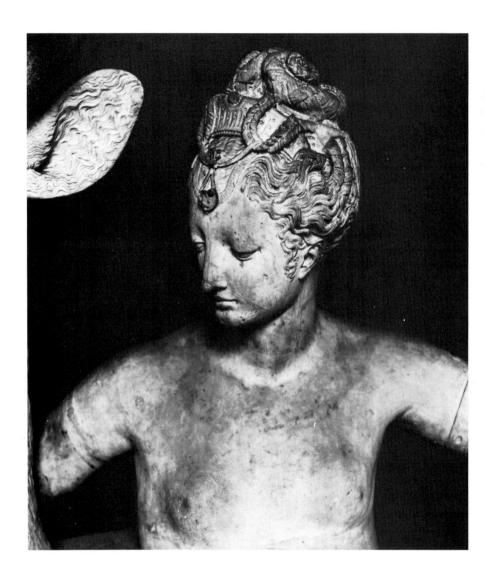

98. The Diana of Anet. Before 1554. *Paris, Louvre*

reliefs on the tomb of Henry II, which are early works of Germain Pilon. In the panel of 'Faith', for instance, the head shows a very close resemblance to that of the 'Diana', and the drawing and pose of the figure have the same origin in Primaticcio. The mannered drawing of the eyes is typical of most of Pilon's mature works and the fluent modelling of the hair can be paralleled even in so improbable a context as the *gisant* of Valentine Balbiani [117].[94]

These similarities are not strong enough to justify a firm attribution of the 'Diana' to Pilon,[95] but they indicate that the statue should be placed in the circle in which his early work was produced rather than in the group round Goujon or Cellini.[96]

The only other sculptor of note among the contemporaries of Jean Goujon in Paris is Pierre Bontemps, a master of decoration rather than of monumental sculpture. He was probably born about 1505-10 and died in 1568.[97] He is first traceable working on decorative sculpture at Fontainebleau under Primaticcio in 1536. From 1540 onwards he was engaged on making casts from the moulds after Roman statues which Primaticcio had brought back from Rome. By 1550 he was established in Paris, and about this time was given by Philibert de l'Orme important commissions in connexion with the tomb of Francis I at St Denis. The documents prove that he was responsible for the greater part of the work on the *gisants*,[98] and executed the whole of the bas-reliefs round the base of the tomb, the contracts for which date from 1551 and 1552.

That Bontemps' real talent was for decoration is evident from his monument for the heart of Francis I, also now at St Denis [99]. Here he worked under the close direction of Philibert de l'Orme, with whom he signed a contract for the monument in 1550; but there is every reason to believe that the real invention of the decoration is due to the sculptor rather than the architect. The round urn standing on a tall rect-

angular base is one of the finest examples of the decorative style of the Fontainebleau school. The reliefs[99] representing the arts and sciences, which the King had so generously patronized, are of far more sophisticated design than those on the tomb. The round panels on the urn bear witness to the influence of Primaticcio on Bontemps, for the nymphs on them have the elongated forms of his figures; but the more masculine style of those on the pedestal recalls the manner of Rosso, while certain heads remind

99. Pierre Bontemps:
St Denis, monument for the heart of Francis I. 1550

us that Bontemps had been engaged on the casts of ancient sculpture. Some of the details, such as the design of skulls and bones at the base of the whole monument, reveal real decorative invention.

The one other known work by Bontemps is the curious tomb of Charles de Maigny now in

the Louvre, executed in 1557. Maigny, who was captain of Francis I's guards, is represented seated, in full armour, holding a pike, but sleeping the sleep of the just. The monument is again principally remarkable for its decorative charm, as displayed in the rendering of the armour and the stool on which Maigny sits.[100]

*

Outside Paris great activity existed in decorative and religious sculpture in the middle decades of the sixteenth century. Many town houses and châteaux still show fine roundels with busts in full relief which derive in many ways from the Italian lower relief medallions of the earlier parts of the century, but have a refinement and delicacy which is peculiarly French. The museum of Lyons contains a fine example [100],

100. Head of a woman from Vienne. c. 1540–50.
Lyons, Museum

which comes from the façade of a house at Vienne. It probably dates from just before the middle of the century but still shows traces of the manner of Francesco Laurana, who had worked in Provence at the end of the fifteenth century. Tombs, Easter Sepulchres, and carved

screens were set up in many churches; but it is only in the eastern provinces that we can at present identify individual artists of importance, though there may well be others still awaiting discovery. The first of these was an Italian, Domenico del Barbiere, called in France Dominique Florentin. He was born in Florence in 1506, and came to France with Rosso in 1530. He worked on stuccos at Fontainebleau and elsewhere under both Rosso and Primaticcio, but in 1541 settled in Troyes, where he enjoyed great success as a sculptor for churches. His style is based on a mixture of the Florentine classicism of Sansovino and certain Mannerist devices. In general, the types of heads and the style of the drapery come from Sansovino, but in figures such as the 'Charity' in St Pantaléon at Troyes[101] there is a *contrapposto* which implies a knowledge of the work of Michelangelo, and a relief from the tomb of Claude de Lorraine, Duc de Guise (d. 1550), now at Chaumont,[102] suggests in its composition the influence of Rosso and even of Salviati. Domenico's last work was the base of the monument for the heart of Henry II, of which the whole design was commissioned from Primaticcio about 1560 and the figures executed by Pilon.[103] He died at an unknown date between 1565 and 1575.

The second figure of importance is the Lorraine sculptor, Ligier Richier, who was born at St Mihiel about 1500 and spent the greater part of his life in the service of the Dukes of Lorraine. The Easter Sepulchre in the church of St Étienne in his native town[104] shows a mixture of Gothic naturalism and Italianate treatment of the draperies which is characteristic of much French sculpture at this period. Much more personal is the recumbent effigy of Philippe de Gueldres, Duchess of Lorraine (d. 1547), from her tomb, now in the church of the Cordeliers at Nancy.[105] Here the Italian elements are scarcely visible and are replaced by a grim naturalism in the rendering of the wrinkled face. This grimness rises to the macabre in the

101. Ligier Richier: Bar-le-Duc (Meuse),
St Pierre, tomb of René de Châlons (from a cast).
After 1544

famous skeleton on the tomb of René de Châlons now in the church of St Pierre at Bar-le-Duc [101].[106] The attribution to Richier is not based on documents and is by no means certain, but the statue is evidently the work of an artist of Lorraine, and other examples of the same manner are to be found in the eastern provinces.[107] The revival of the Late Gothic love of skeletons is here evident, but the treatment is different. The edge is taken off the horror by the manner in which the shreds of flesh and skin which partly clothe the bones are made into decorative patterns like torn parchment; and the virtuosity of the performance distracts one from the grisly theme. Richier was evidently much affected by the disturbed religious atmosphere of the eastern provinces at this time, and he ended by becoming a convert to Protestantism and flying to Geneva where he died in 1566 or 1567.

French sculpture of the middle of the sixteenth century did not show the same range and inventiveness as the architecture of the period, nor did it produce any single personality of the calibre of Philibert de l'Orme; but it can claim to display more completely than contemporary painting the ideals of French society. Painting remained till long after the death of Henry II dominated by the Italians, whereas sculpture freed itself more rapidly; and Goujon is as emphatically a French artist as any produced in the whole century.[108]

THE WARS OF RELIGION

1560-1598

HISTORICAL BACKGROUND

The last forty years of the sixteenth century nearly witnessed the complete destruction of all that had been achieved by Francis I and Henry II during the first half of the century. The centralized and autocratic system of government which they had built up was almost submerged in the civil and religious wars with which France was torn during the reigns of the three sons of Henry II, Francis II (1559-60), Charles IX (1560-74), and Henry III (1574-89), and the first years of their successor, Henry IV (1589-1610).

The history of the Wars of Religion is confused, but the general issues which emerge are clear. Above all, it must be realized that the conflict was social as much as religious. Ostensibly the struggle was between the Calvinists and the Catholics; but the motives which led individuals and families to take part in it and to support one party rather than the other were often more political than theological. The great noble families saw in the wars a means of regaining the position and power which they had lost under the previous reigns. In the anarchy which inevitably accompanies civil strife they saw a chance of making their own advantage against the Crown, whose position was naturally weakened by the situation. Certain families joined one faction because their traditional enemies and rivals had joined the other. The house of Lorraine identified itself early with the cause of Catholicism, and this must undoubtedly have

been an incentive to their rivals, the Bourbons, to favour the Protestant cause.

The manifestos of the two sides are often phrased in curiously similar terms. It is particularly significant that both parties refer to the reign of Clovis as a sort of Golden Age which they would like to revive. In fact, they look back nostalgically to the limited monarchy of medieval France with the throne supported by a strong nobility and a powerful clergy.

The religious struggle had not always had this aristocratic character, and in the early days the Protestant movement was mainly supported by the artisan classes in the towns, but by the second half of the century the nobles had taken charge of the conflict, and both parties, Catholic and Protestant, were dominated by their aristocratic leaders. It is, for instance, typical that by the Edict of Amboise (1563) Condé, the Protestant leader, extracted from his opponents terms which amounted to the right for the seigneur to worship as he liked – and for his dependants to worship in the same way – with no equivalent right of the Protestant dependant of a Catholic seigneur and only the most limited rights for the Protestant in a town.

It is, of course, true that the towns played an important part in the struggle. In the early stages they saw a hope of regaining their ancient liberties which had been encroached upon by Francis I and Henry II, and they were therefore willing to engage in the struggle against the Crown. Later, however, the richer *bourgeoisie* gradually realized that they stood to lose more

than they would gain by the weakening of the Crown, since it would involve the strengthening of the feudal nobility.

In the last stages the issues became even clearer. The succession of the Protestant King of Navarre as Henry IV gave the Catholic party, now organized under the Guises as the League, their finest opportunity. They were able to capture Catholic opinion in the towns, notably in Paris, and even to make the Parisians accept the help of Spain and a Spanish garrison. But when the King declared his conversion to the Catholic faith they found their position weakened. Generally speaking the *bourgeoisie*, represented by the Parlement, turned against the League, on the grounds that Henry IV was the legitimate successor to the throne and that his conversion had removed the last obstacle to acknowledging him. Mayenne, the brother of the murdered Duc de Guise, was determined to continue the struggle, and attempted to do so with the support of a few fanatical preachers who were still able to influence the people of Paris in favour of his cause. But eventually the feelings of patriotism and royalism triumphed, and the gates of Paris were opened to the King by members of the Parlement. The party of the moderates, of the *Politiques*, who put peace above religious fanaticism, had triumphed.

It is only to be expected that this atmosphere of violence should be reflected in the literature and the art of the period. The religious feeling is to be seen directly in the writings of the Protestant poets, Agrippa d'Aubigné and du Bartas, who deal with explicitly theological subjects. The long philosophical poem of du Bartas, the *Semaines*, contains a complete view of the universe according to the Calvinist doctrine, written in turgid but forceful verse which moved Milton to approval. D'Aubigné's *Tragiques* shares with the *Semaines* the element of violence, but contains vivid descriptions of the state of France during the Wars of Religion

which have real dramatic qualities. Both poets, however, are far removed in style from the classical principles of Ronsard; both indulge in complex allegory, in an uncontrolled use of metaphor, and in descriptions of immoderate length. The Catholic party did not produce anything comparable to these poets, and the only important religious poems which expressed their views are the last works of Ronsard, in which, with much more restraint and in nobler form, he sets forth his own deep faith in the Catholic Church. But Ronsard was a man of the previous age, whose voice sounds like that of an elder statesman to whom no one has time to pay attention in the fury of civil war.

In spite of the almost ceaseless disturbance of the period, the court of the last Valois Kings continued to be a centre of cultural activity. In fact, Henry III was as great an enthusiast for letters as any of his predecessors. The atmosphere of his Court was, however, very different from that of Francis I or Henry II. Henry III was a neurotic whose sensibility was heightened to an unhealthy degree. He demanded pleasures of the most sophisticated kind. Elaborate court ballets were succeeded by religious exercises of great severity, and the King's appetite was evidently excited by the contrast between the sumptuous ball dress worn one evening and the hair shirt put on the next day. His religion was perfectly sincere; but it was of a kind which revelled self-indulgently in mortification without precluding any forms of sensual indulgence.[1]

The life of the Court is best reflected in the painting of Antoine Caron, which we shall consider later, and in the poetry of Philippe Desportes, the secretary of Henry III, and the most popular court-writer. His poems are almost a foretaste of *Précieux* verse of the next century, ingenious, *alambiqué*, full of conceits and antitheses, with only the thinnest of ideas to hold the structure together – exquisite nothings gratifying to a jaded palate.

The visual arts were affected as much as literature by this curious and strained atmosphere. The mood of the time appears in many different forms, but all the art of the period has in common the feeling of strain and conflict, the desertion of the principles of rationalism and classicism which had predominated in the previous decades, the preference for the ingenious and complex over the simple and direct; in fact all the elements which we regard as making up the more advanced forms of Mannerism.

ARCHITECTURE

Bullant, Jacques Androuet du Cerceau the Elder

The architecture of the period covered by the Wars of Religion is dominated by two figures, Jean Bullant and Jacques Androuet du Cerceau the Elder, very different in the character of their work.

The date of Bullant's birth is unknown, but the first mention of him is the registration of his daughter's baptism in Paris in 1550.[2] As an architect he does not appear till 1556, when he is referred to as being in the service of the Constable Anne de Montmorency at Écouen. These two dates indicate that he was probably born about 1520 or 1525 rather than in the years 1510-15, as is usually stated. The difference is significant, because in one case he would be the contemporary of Philibert de l'Orme, whereas the whole character of his work confirms the view that he belonged to a younger generation. He died in 1578.

He himself tells us in the preface to his *Reigle générale d'Architecture* that he visited Rome, where he made drawings after ancient buildings of which he made use in the details of his own works. This visit took place in 1541-3.

The first part of Bullant's career is closely linked with the Constable Montmorency, for whom he worked at Écouen, Fère-en-Tardenois,

and Chantilly. Of his two published works, one, the *Petit Traicté de Géometrie et d'Horologiographie* (written in 1561 and printed in 1564), was dedicated to the Constable, and the other, the *Reigle générale d'Architecture des cinq Manières de Colonnes* (1564, republished 1568), to his son.

The exact share of Bullant in the construction of Écouen is by no means easy to define, but he had nothing to do with the west and south wings, which were built from about 1538 onwards by Pierre Tâcheron.[3] He is, however, recorded at Écouen in 1553 and was probably responsible for the north wing, the outer façade of which is decorated with two superimposed Orders, Tuscan and Doric, and with dormers of a more classical design than in the earlier wings. This wing, which bears the cipher of Henry II, was probably Bullant's first work at Écouen, and can be tentatively dated about the middle of the 1550s. To the last years of the same reign can be assigned the portico on the court side of the same front which still bears the King's insignia, and probably also the entrance wing now destroyed but known from engravings of du Cerceau [102]. Both these works show the dependence of Bullant on de l'Orme at this stage of his career. The entrance pavilion is a variant on de l'Orme's central motive at Anet [59]; but Bullant has made the whole effect bolder by the insertion of an arched opening on the middle floor which gives his design something of the character of the Porte Dorée at Fontainebleau. His principal object seems to have been to create a worthy setting for the equestrian statue of the Constable which was to fill a second arched opening at the top, an arrangement recalling Louis XII's entrance to Blois. From du Cerceau's engraving the statue seems to reproduce one of Leonardo's early *modelli* for the Sforza monument.[4]

By far the most original part of Bullant's work at Écouen is the pavilion added to the

court side of the south wing [103].[5] The essential novelty here is the use of the colossal Order instead of the two superimposed Orders of the other pavilions. This appears to be the earliest surviving example of its use in France, though we know that de l'Orme planned to introduce it in his scheme for the Cour du Cheval Blanc at Fontainebleau.[6] Its use had already been authorized in Italy by Michelangelo in the Capitol palaces; but Bullant's application of the device is quite different. In the Capitol palaces the emphasis is on the horizontal, which is brought out both by the proportions of the building and by the strong lines of the entablatures. At Écouen the shape enclosed by the Order is nearly square and the vertical lines dominate almost unchallenged. It was perhaps because of this strong vertical tendency that the colossal Order soon became popular in France, whereas in Italy it was little used, except by Palladio, till the time of Bernini.[7]

The impressive effect of this Écouen pavilion depends to a great extent on the fine quality of its detail. Bullant has copied his Order from the portico of the Pantheon, which he reproduces in his *Reigle générale* after drawings made in Rome. It is characteristic of him that he should in a single building combine two apparently contradictory tendencies: almost pedantically accurate classical detail, and a clearly anti-classical use of the colossal Order.

The feeling for grand scale is seen even more clearly in the bridge and gallery which Bullant built for Montmorency at Fère-en-Tardenois

102. Jean Bullant: Écouen (Seine-et-Oise), château, entrance. *c.* 1555–60. Engraving by du Cerceau

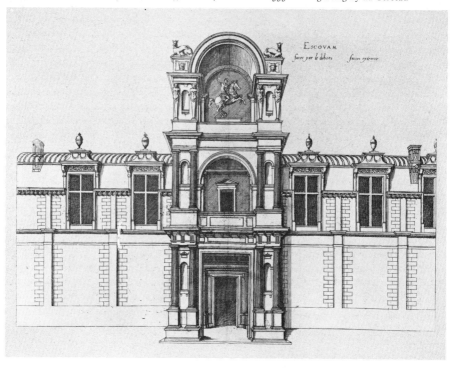

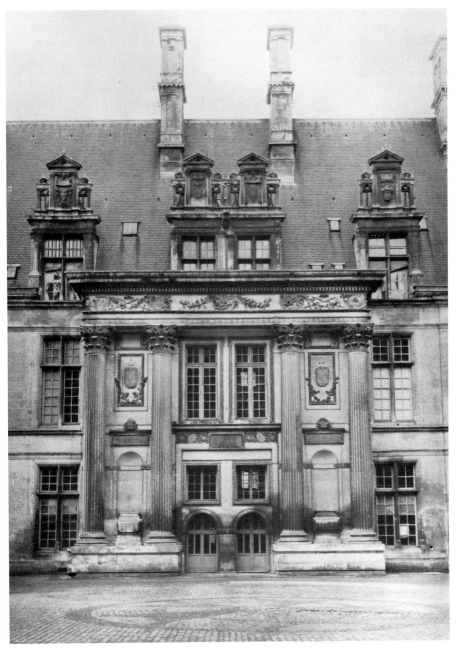

103. Jean Bullant: Écouen, château, south wing. *c.* 1560

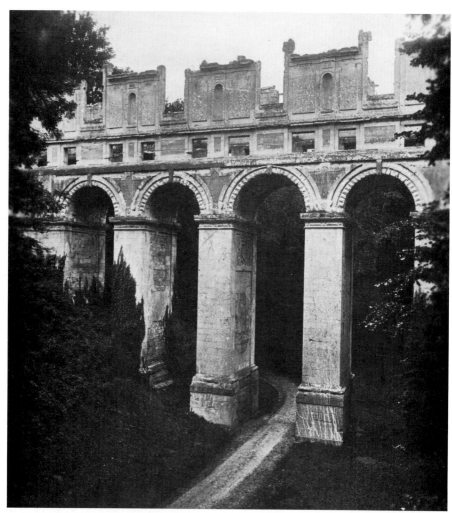

104. Jean Bullant: La Fère-en-Tardenois (Aisne),
château, gallery. Between 1552 and 1562

[104]. The date of its construction is not known, but it must lie between 1552 and 1562.[8] Bullant has here taken advantage of an unusual site as skilfully as de l'Orme had used the position of Chenonceau to construct his bridge across the Cher. The deep valley is spanned by a row of simple monumental arches of enormous height, over which runs a gallery. The ornament is limited to flat mouldings on the gallery and to slight rustication on the voussoirs; and the whole effect is of a Roman aqueduct thrown across a gorge. The entrance to the gallery[9] is composed of Doric columns with a rich entablature.[10] An unusual feature is that the win-

dow over the main door cuts through the entablature and into the pediment, thereby foreshadowing the design of the Petit Château at Chantilly and showing a form of Mannerism typical of the architect.

Bullant also built the Petit Château for Montmorency's castle at Chantilly about 1560 [105]. It shows a different aspect of his style. Seen from outside it consists of a long, rather low building linking two higher pavilions at right angles to it. Structurally it consists of two equal floors but their existence is in part masked by the arrangement of the pilasters which form a single Order, higher than the lower storey, but

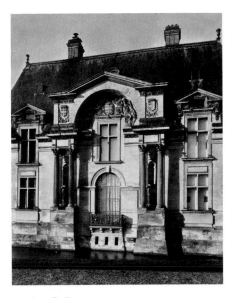

105. Jean Bullant:
Chantilly, Le Petit Château. *c.* 1560

not so high as the two storeys together. The result is that the windows of the upper storey cut through the entablature, and there is set up a sort of syncopation, with the two small storeys playing against the single large Order.[11] On the end façades the arrangement is even more complicated. The middle bay is like that at La Fère,

and at the sides the windows of the two floors are linked into a single vertical strip cutting through the entablature. This syncopation, which is characteristic of Bullant's style, can be regarded as a French form of Mannerism, analogous in certain respects to Palladio's use of interlocking Orders, as, for instance, on the façade of the Palazzo Valmarana at Vicenza or of S. Francesco della Vigna, Venice.[12] In his arrangement of the windows at Chantilly, however, Bullant is taking up again, perhaps unconsciously, a Late Gothic tradition, of which an example can be seen in the château of Josselin, in which the windows and dormers form vertical panels which are cut across at the middle of a window by the balustrade round the roof. Here we see the same kind of syncopation as at Chantilly; but with Bullant the state of mind is different, because he must have been consciously breaking rules governing the use of the Orders, of which the architect of Josselin would not have been aware. In the case of the later architect, therefore, the device can properly be called Mannerist.

We know almost nothing of Bullant's activities during the second half of the 1560s, when his work for the Constable seems to have been finished.[13] On the death of de l'Orme in 1570, however, he was appointed to succeed him as architect to Catherine de' Medici, and his last works were all connected with her. As has already been said, his contribution to the Chapelle des Valois cannot be exactly determined,[14] and the same is true of the wing which was added to the Tuileries to the south of de l'Orme's construction; for the decoration on it seems to have been added later.[15]

In 1572 Bullant was commissioned by the Queen Mother to build a house for her, later called the Hôtel de Soissons. This hôtel, known from engravings of Silvestre, belonged to a type to be found earlier in du Cerceau's *Livre d'Architecture*, published in 1559. Its one remarkable feature was the tall column used by Catherine

as an observatory, which still stands beside the Halle au Blé.[16]

In the very last years of his life Bullant seems to have produced for the Queen Mother two vast schemes, of which only small parts were executed. At a date between 1575 and 1579[17] Catherine decided to enlarge the château of St Maur, for which de l'Orme had, as we have seen, produced a grand design. It is to be supposed that the new design was commissioned from Bullant, who was her regular architect. The scheme, known from du Cerceau's engraving, consisted of an enlargement of de l'Orme's plan by the addition of a further storey. On the park front there was now to be a grotesquely wide pediment, crushingly heavy in comparison with the nine bays of the *logge* below it. In these last years Bullant's desire for the colossal seems to have grown greater, and in this case it could not be happily harmonized with the existing building.[18]

Catherine's passion for building, however, was not assuaged by this plan, and in 1576 she decided to enlarge her château of Chenonceau,[19] which she had forced Diane de Poitiers to give up to her after the death of Henry II. Diane had built the bridge over the Cher to the designs of Philibert de l'Orme,[20] and Bullant added a gallery to it, which in its general conception recalls that of La Fère. In the decoration of the upper floor it shows yet another variant of Bullant's Mannerism, for the pediments which cover the windows overlap the panels filling the spaces between them, thus forming a horizontal interlocking system reminiscent of the vertical disposition at Chantilly and probably derived from Daniele da Volterra's stucco frames in the Sala Regia of the Vatican, begun in 1547. In the interior two remarkable mantelpieces survive which show the same kind of complexity in design combined with Bullant's love of rich classical detail.[21] Jacques du Cerceau reproduces a vast scheme for the extension of Chenon-

ceau [106], which probably incorporated Bullant's ideas, since one of the slanting wings of the forecourt was actually begun.

Bullant's main contribution to French architecture was made when he was working for Montmorency. His style was formed on the lessons he had learned from antiquity and from the study of de l'Orme; but he soon moved away from the classicism which he had thus acquired and evolved a Mannerism which lasted to the end of his career. In his last works, however, designed for Catherine de' Medici, he shows a new fantasy of invention which brings him nearer in feeling to his rival du Cerceau.

★

Jacques Androuet du Cerceau the Elder was the first of a dynasty of architects and decorators which lasted almost till the mid eighteenth century. He was probably born about 1520.[22] According to his eighteenth-century biographer, Dézallier d'Argenville,[23] he was enabled to go to Italy by Georges d'Armagnac,[23] who was ambassador in Rome from 1539 to 1544, but this is probably incorrect. The earliest trace of du Cerceau is supplied by a permission to publish volumes of engravings which was granted to him in 1545 by Francis I. One such volume was brought out at Orléans in 1549. Du Cerceau was apparently still in Orléans in 1551, but his first book of architecture, which appeared in 1559, was printed in Paris and dedicated to Henry II. From this time onwards he seems to have enjoyed considerable favour at Court. For some years after 1560 he worked for Renée de France, Duchess of Ferrara, for whom he made alterations to the castle of Montargis, and who appears to have saved him from persecution on account of his Protestantism. In the 1570s he was employed by Charles IX, and was supported by Catherine de' Medici, to whom he dedicated several of his books. He is last recorded in 1584 but was dead by 1586.

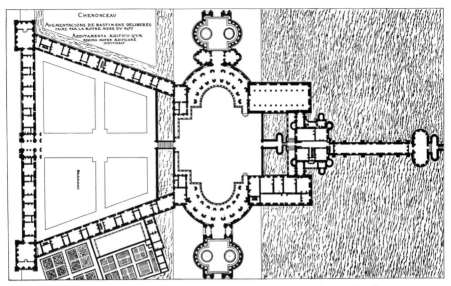

CHENONCEAV

AVGMENTACIONS DE BASTIMENS DELIBERES
FAIRE PAR LA ROYNE MERE DV ROY

ADDITAMENTA ÆDIFICII QVÆ
REGINA MATER ÆDIFICARE
INSTITVERAT

106. Chenonceau, château. Plan, probably by Bullant, from du Cerceau, *Les plus excellents Bastiments*

Even in his lifetime he was more famous for his engravings than as a practising architect, and nothing now survives of the little he is known to have built. By far the greater part of his engravings are of decoration, in the form either of grotesques or of designs for furniture or architectural detail. In these he was mainly inspired by Italian sources, and many of them are copies of traceable originals.[24] They show a high degree of fantasy in the treatment both of decorative detail and of architectural elements, and to this extent form part of the generally anti-classical tendency of French art at this time.

In his purely architectural designs a clear development can be followed. In the early works of about 1550 we see a variety of influences. The *Arcs* of 1549 contain free interpretations of Roman triumphal arches in the idiom of Lescot; the *Temples* of 1550 are more fantastic, and reveal north Italian influence, apparently both Milanese and Venetian; and the *Vues d'Optique* of 1551 consist of compositions in the manner of Jean de Gourmont. Within the following ten years, however, du Cerceau seems to have gained freedom and established a personal style. The result is apparent in the first *Livre d'Architecture* published in 1559.

This book is concerned with the design of town houses, a problem which had rarely been treated before this time, except in the unpublished sixth book of Serlio, which du Cerceau must have known and on which he seems to have drawn extensively. The full title of du Cerceau's book contains the following significant phrase: 'pour instruire ceux que désirent bastir, soyent de petit, moyen, ou grand estat', and in fact the book presents plans for houses of all sizes, from one suitable to a merchant, to the grandest hôtel of a noble family. The smaller houses consist of a single block, usually of only one storey, but with great variety in the eleva-

107. Jacques du Cerceau the Elder: Design for a town house. 1559

XXXVIII

Hic oculis subiicitur ex alto in frontem
despicientibvs totvm ædificivm ·

tions. The surface is varied by stone quoins and window surrounds; the openings are of different forms; and the front is often broken by small pavilions containing *cabinets* and covered by separate roofs, so that the sky-line also is discontinuous. The basic element out of which the houses are made up is the *appartement*, which we first saw early in the century at Chambord. In du Cerceau's town houses it usually consists of the *chambre* accompanied by a *cabinet* and *garde-robe*, the luxury of an *antichambre* not being necessary in a small hôtel; and generally there are two *appartements* linked together by a *salle* or living-room.

Later in the book du Cerceau shows more splendid houses, and in these he uses plans which are based more on the country château, usually with a *corps-de-logis* flanked by pavilions

and preceded by a court enclosed by galleries and a screen [107]. This arrangement is also related to Serlio's 'Grand Ferrare', but the form with separate pavilions at the corners makes it more like a château in the final effect. In some plans du Cerceau gives free rein to his fantasy, and designs houses round triangular or circular cores with radiating wings. But generally speaking the plans seem to be very practical, and there is reason to believe that they were widely copied in houses built in Paris during the later sixteenth century.[25] Very few of these survive, but some are known from engravings. The biggest must have been the Hôtel de Nevers, begun after 1572 for the Duc de Nevers on the site of the Hôtel de Nesle. Only the pavilion near the river and half the main *corps-de-logis* were completed (by 1580), but from Chastillon's engrav-

ings, and from views of it in its unfinished state by Silvestre and Stefano della Bella, it seems to have followed the disposition suggested by du Cerceau in his thirty-eighth design; and many of its details can be paralleled in others of his schemes. In fact so close is the resemblance that it seems not unreasonable to suggest that he was actually the architect.[26]

Du Cerceau's last years must have been largely occupied with the preparation of the two volumes by which he is best known, *Les plus excellents Bastiments de France*, published in 1576 and 1579. They are our best source of information for many sixteenth-century houses that have since been altered or destroyed, although du Cerceau is often unreliable in completing unfinished buildings according to his own fancy[27] and in adding ornament of his own invention to existing structures. This beautiful publication, which was dedicated to the Queen Mother, was highly influential over a long period. The original drawings for it, carefully executed on vellum, are in the British Museum.

The book illustrates a number of earlier châteaux, including even medieval monuments like Vincennes and Creil, but its chief importance lies in recording sixteenth-century buildings which were later altered or never built. To these categories belong two schemes for Charleval and Verneuil.[28] Charleval was begun for Charles IX as a 'Maison de chasse' in 1570, but almost nothing was actually built; Verneuil was begun by Philippe de Boulainvilliers, perhaps on his own design, about 1560 but was actually mainly built by the Duc de Nemours to a plan revised by du Cerceau himself. It was finished by de Brosse for Henry IV who presented it to Henriette d'Entraigues in 1600.

In plan Charleval is the more remarkable [108]. The château itself was to be built round a square cloistered courtyard. In front stretched a vast forecourt flanked by wings which concealed two further pairs of courts. The outer lines of the area covered by these five courts were continued by porticos enclosing two gardens, and the whole square thus formed was surrounded by a moat.

108. Jacques du Cerceau the Elder: Charleval, château. Begun 1570.
Plan, from du Cerceau, *Les plus excellents Bastiments*

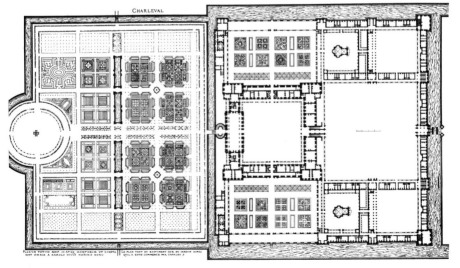

In certain respects this is a derivation from Serlio's plan for the completion of the Louvre, and it must have been thought of as a rival to de l'Orme's scheme for the Tuileries and Bullant's for Chenonceau. The plan of Verneuil is relatively simple, a square court enclosed by three wings and a screen with a circular entrance in the middle.[29] Its principal merit was the advantage which the architect took of the sloping ground to introduce a semicircular grotto below the terrace outside the garden front.

The elevations of both Verneuil and Charleval are in the highest degree fantastic [109, 110].

Classical forms are used in the most wanton manner. Windows or niches interrupt entablatures, pediments are broken in varied ways, voussoirs are twisted, rustication spreads over pilasters, and the whole surface is covered with grotesque ornament. The architects of these buildings are as anti-classical as Bullant, but they destroy classical principles mainly by breaking up smaller architectural features and by covering the surface of the building with his uncontrolled ornament. Compared with Bullant's subtle infringement of the rules, this kind of Mannerism seems almost barbarous.

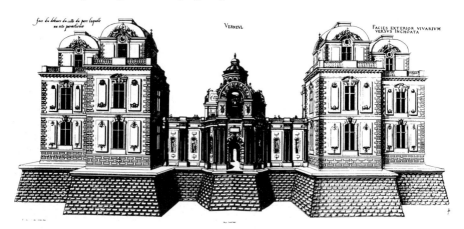

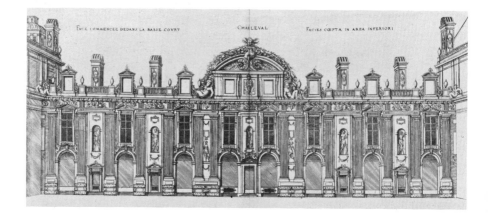

One other important Paris house of the late sixteenth century must be mentioned. This is the Hôtel d'Angoulême, later the Hôtel de Lamoignon, built by Diane de France, illegitimate daughter of Henry II [111]. It is attributed in the old guide-books to Baptiste du Cerceau, the eldest son of Jacques, but is now thought to be by Louis Métezeau, who was on Diane de France's payroll as an architect.[29] In style this house seems to derive rather from Bullant than the elder du Cerceau, particularly in the use of the colossal Order of pilasters and the break-ing of the entablature by the dormers. It has been restored by the City of Paris and is now the best preserved late sixteenth-century house in Paris.

In the provinces again we find movements parallel with those taking place in the capital, but with local variations. In the north-east of France, Flemish influence is naturally strong, for instance in the wing added by Tesson in 1572 to the town hall of Arras,[30] or in the Halle Échevinale at Lille, built in 1593 by Fayet.[31] Generally speaking, provincial architects of this

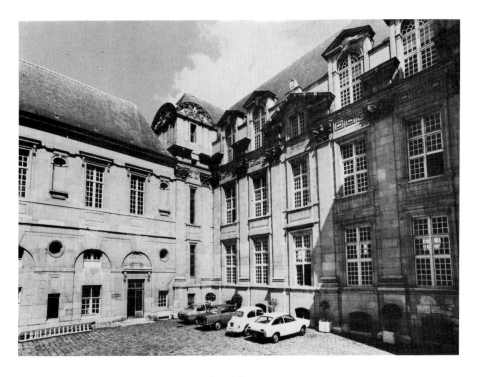

109 *(opposite, above)*. Verneuil, château (first scheme). Begun *c.* 1559.
Engraving, from du Cerceau, *Les plus excellents Bastiments*

110 *(opposite, below)*. Charleval, château. Designed *c.* 1570.
Engraving, from du Cerceau, *Les plus excellents Bastiments*

111 *(above)*. Attributed to Louis Métezeau: Paris, Hôtel de Lamoignon. 1584. The wing on the left was added in the first half of the seventeenth century

period indulge in a great variety of surface effects, particularly through rustication and high relief sculpture. This can be seen in buildings such as the château of Pailly in the Haute Marne, attributed traditionally to Nicolas Ribonnier of Langres.[32] It reached its finest expression in Burgundy in the hands of Hugues Sambin (1515/20-1601/2) and his school. The most famous example of this manner is the Maison Milsand at Dijon (c. 1561) [112], which shows admirably

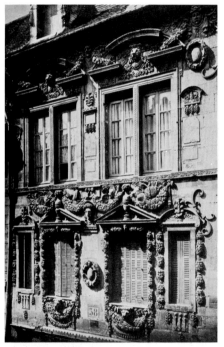

112. Hugues Sambin:
Dijon, Maison Milsand. c. 1561

the free use of fanciful sculpture on a small façade.[33] Rustication was carried to its highest point in the Petit Château at Tanlay begun in 1568, on the ground floor of which every stone is cut into a sort of lace-work pattern of vermicular rustication.[34]

One of the most astonishing documents about provincial Mannerism at this period is Joseph Boillot's *Nouveaux Pourtraitz et figures de termes pour user en l'architecture, composez et enrichiz de diversité d'animaulx, representez au vray selon l'antipathie et contrarieté naturelle de chacun d'iceux*, printed at Langres in 1592. It consists of a series of fantastic designs for herms, in which the entablatures are supported not by human figures, but by animals, grouped in pairs according to the 'antipathy' between them as indicated by the Natural History of Pliny and other ancient authors. One herm, for instance, is formed of an elephant and a dragon, another of a bull, a lion, and a crocodile, and so on.

SCULPTURE

Germain Pilon

After the disappearance of Goujon about 1563 his place was taken by an artist of very different type, Germain Pilon. Pilon was born in Paris c. 1525 and died there in 1596.[35] In 1558 he is mentioned as receiving payment for statues for the tomb of Francis I, which have since disappeared. Two years later, in 1560, he is found working for Primaticcio on the monument for the heart of Henry II, the base of which was executed by Domenico del Barbiere.

These two documents are of importance, because they point to the influences under which Pilon developed. One would expect him to have been strongly affected by his great predecessor Goujon, but there is hardly a trace of his style to be seen in Pilon's work. His first manner seems to be formed on quite different models: the stucco-work of Primaticcio at Fontainebleau [77], the figure-sculpture of Domenico del Barbiere, and the reliefs of Bontemps, the sculptor of the monument for the heart of Francis I [99].

The effects of the first two of these models can be seen in the monument for the heart of Henry II (1561-2), of which Pilon's figures of the

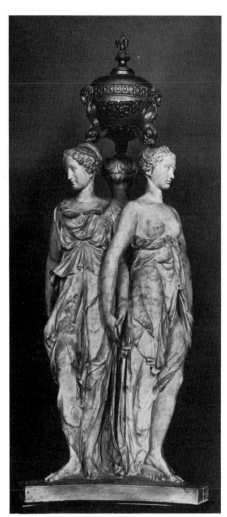

113. Germain Pilon: Monument
for the heart of Henry II. 1561-2. *Paris, Louvre*

Graces and Barbiere's base are in the Louvre, the urn itself being a nineteenth-century restoration [113]. In its general scheme this monument is a direct imitation of the incense-burner designed for Francis I, known to us from the engraving by Marc' Antonio.[36] But Marc'

Antonio's three classically proportioned figures with their Roman draperies are translated into Fontainebleau nymphs with the long necks and small heads of Primaticcio's stuccos in the Chambre de la Duchesse d'Étampes [77]. The fluent drapery suggests the influence of Domenico del Barbiere,[37] and in no way recalls either the engraving or the much more linear idiom of Goujon.

The transition to Pilon's later style can be seen in the tomb of Henry II and Catherine de' Medici, executed under the direction of Primaticcio between 1561 and 1570 [68]. The four bronze figures of Virtues at the corners of the monument, of which the models were ready for casting in 1565, still have much the same character as the Graces on the earlier work, though the movements of torso and limbs are freer and the forms of the drapery more plastic. The reliefs round the base are exquisite variations on the types of figures used by Primaticcio in the decorations of the Ballroom at Fontainebleau, and recall in general character the Bontemps panels on the monument for the heart of Francis I [99].

When, however, we come to the kneeling figures of the King and Queen on the top of the tomb and the *gisants* under the canopy, we find Pilon in a quite different mood. The kneeling figures are in a sense bronze versions of the stone statues of Louis XII and Francis I and their families on their tombs nearby, and they conform to the French tradition of realism in such works. But they also embody new qualities, greater freedom of movement in the poses, strong feeling for the material used and, in the figure of the Queen, skill in the rendering of details of dress and jewellery. This was no doubt mainly due to the example of Cellini, whose Nymph must have constituted a spur to rivalry for any French sculptor in bronze. But Pilon never allows himself to be distracted by virtuosity from his main purpose.[38]

In the two *gisants* [114] the naturalistic element has been intensified. For these statues

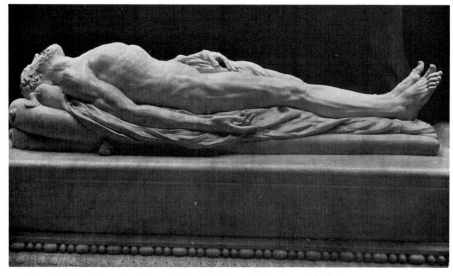

114. Germain Pilon: Recumbent figure of Henry II (from a cast). 1563-70. *St Denis*

Pilon had several models available. He clearly studied the *gisants* on the tombs of Louis XII and Francis I and, in the case of the Queen, he had before him a marble statue which Girolamo della Robbia had been commissioned to prepare for the tomb.[39] Pilon has, however, provided a very personal solution to the problem. He has avoided the grim details, such as the embalming stitches in the Louis XII or the protruding ribs of della Robbia's statue, but he has rendered the complete relaxation of death with great poignancy. The modelling of the two figures is surprisingly different, the Queen's rounded and generalized, the King's fluid and very sensitive. Most striking of all is Henry's head, thrown back and seen in profile, his coarse features here acquiring a fineness which makes one think that the sculptor had been studying the St Peter's 'Pietà' of Michelangelo, of which a cast existed at Fontainebleau.[40]

During the 1570s Pilon was mainly active in making portrait busts and medals. The marble busts of Henry II, Francis II, and Charles IX

now in the Louvre,[41] probably executed about the middle of the decade, are less interesting than the bronze of Charles IX in the Wallace Collection, London,[42] which reveals again Pilon's broad treatment of the metal. These busts suggest that the artist was well acquainted with contemporary Italian sculpture, the closest parallel being with Leone Leoni. The bronze bust of Jean de Morvilliers (after 1577) prepares the way for the more dramatic style of the 1580s.[43] In the same years Pilon made a set of large portrait medals representing Henry II and his three sons, which are remarkable for their psychological insight as much as for their technical brilliance.[44]

The most impressive of Pilon's late works are the groups for the Valois Chapel, and the tombs of the Birague family.

When Catherine de' Medici commissioned the tomb of Henry II, her plan was to set it up in the central space of the chapel which Primaticcio was to build for her at St Denis.[45] At the same time she instructed Pilon to prepare for the

smaller chapels various other groups which were not begun till about 1583. One of these groups was to represent the Resurrection, and fragments of it are in the Louvre and the church of St Paul-St Louis.[46] It shows more than any other work of Pilon a debt to Michelangelo. The two soldiers have his full *contrapposto*, and the Christ is based on his cartoon of the 'Noli me tangere' of 1531. The 'Virgin of Pity' [115],[47] also for the chapel, is the first instance of Pilon's late style, which we shall see fully illustrated in the Birague statues, while the 'St Francis in ecstasy', now in the church of St Jean-St François,[48] almost foreshadows the Baroque in the relaxed open gesture of the arms and hands, very different from the tension usual in Mannerist renderings of religious feeling.

Even more impressive is the group of works from the chapel of René de Birague in the church of Ste Catherine du Val-des-Écoliers in Paris.

Birague, a Milanese by birth, was chancellor of France from 1573 to 1578. After the death of his wife in 1572 he took orders and was made a cardinal; he himself died in 1583. About 1574 he commissioned from Pilon the tomb of his wife, Valentine Balbiani, and his own monument was executed in 1584 at the expense of his heirs. The tombs were much damaged in the eighteenth century and at the Revolution, but the Louvre has preserved the kneeling bronze figure of Birague himself [116], the recumbent marble statue of his wife,[49] and her *gisant* in bas-relief [117].[50]

The statue of Birague [116] is a development from the bronzes on the tomb of Henry II, but the conception is grander and the treatment broader. Pilon has placed the figure in profile kneeling at a prie-Dieu with his robes hanging in heavy folds and forming a long train behind him.[51] All decorative detail has been eliminated,

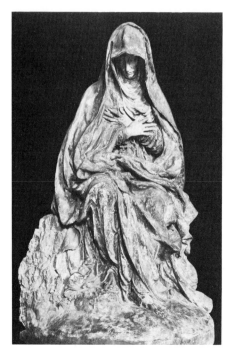

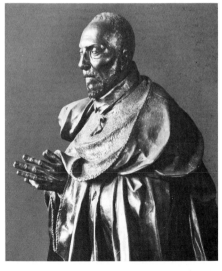

115 *(left)*. Germain Pilon: The Virgin. *c.* 1580–5. *Paris, Louvre*

116 *(above)*. Germain Pilon: Head of Cardinal Birague. After 1583. *Paris, Louvre*

except for the indications of fur on the hood, which are sharply incised in the clay. Pilon has here exploited to the full the heavy monumentality of bronze, and has deliberately left the surface rough and unpolished. The head and the hands show intense observation and great directness of rendering. The tomb of Valentine Balbiani is altogether different. The marble recumbent effigy shows that Pilon was still capable of virtuosity in the carving of detail, and its very richness heightens the contrast with the grim *gisant* on the sarcophagus below. Here for the first time we see Pilon using naturalism to stimu-

the phenomenon common in Mannerism, a return to the Middle Ages. The treatment of the figure, however, is far from being Gothic. On the contrary, the modelling shows Pilon's fluid conception of form carried even farther than in his earlier works. The relief is very low, and the forms seem to flow loosely over the ground. This is the same conception of modelling which we saw in the *gisant* of Henry II, but developed and applied to the different problem of low relief.

The bronze relief of the Deposition [118] now in the Louvre comes from the same church as the Birague tombs and probably formed part of the

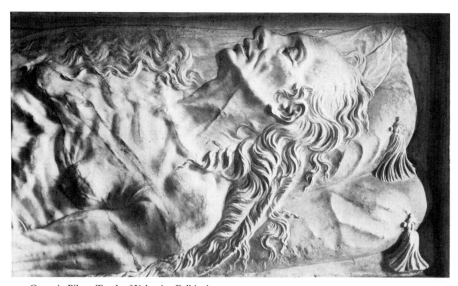

117. Germain Pilon: Tomb of Valentine Balbiani.
Before 1583. *Paris, Louvre*

late emotion. In this relief [117] he has sought all the effects which he deliberately avoided in the *gisant* of Catherine de' Medici. The figure is emaciated, the bones stick through the flesh, the hands are those of a skeleton, as in the work of the naturalistic sculptors of the Late Gothic period. This is the first instance in French sculpture of

same decorative scheme. There is no evidence about its date, but its style is so close to that of the *gisant* of Valentine Balbiani that it must have been executed within a year or two of the tomb. It has not the same grimness of detail, but it comes close to it in its dramatic intensity and in the treatment of relief. There are strong traces of

Italian influence here, principally of Michelangelo and his school.[52] The closest parallels are to be found in Bandinelli's reliefs of the same subject in the Louvre and the Victoria and Albert Museum.[53] But the treatment is entirely personal. It is interesting to compare this relief with Goujon's treatment of the same subject [95]. The comparison not only shows up the difference in the technical methods of the two artists and their opposed conceptions of modelling, but it also reminds us that the whole feeling of the period had changed. In Goujon the emotion is there but it is expressed in symbols which con-

It is not suprising that the personal and emotional qualities of Pilon's art were not copied by his successors. But most French sculptors of the last decades of the sixteenth century were much influenced by his earlier manner. The most interesting of these followers was Barthélemy Prieur (active 1573-1611), who made the sculptures on the monument for the heart of Constable Montmorency, now in the Louvre, of which the architectural parts were designed by Bullant.[54] The central part of the composition is a twisted or 'Salomonic' column, probably the earliest imitation in French architecture of the

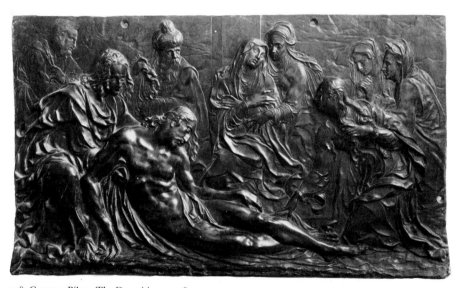

118. Germain Pilon: The Deposition. *c.* 1580-5.
Paris, Louvre

form to canons of classical beauty. Pilon does not hesitate to use gestures and features that are almost grotesque in order to heighten his effect. Goujon is typical of the classical period in the middle of the century; Pilon embodies the emotional state of mind which marked the decades of the Wars of Religion.

columns in St Peter's said to come from the Temple of Jerusalem, popularized through engravings after Raphael's cartoon of 'Elymas'.[55] Round the foot of this column stand three life-size bronze Virtues which are variants of Pilon's corner figures on the tomb of Henry II.[56] Other examples could be found all over France of alle-

gorical sculpture in the same style, and also of kneeling tomb figures deriving from Pilon's Henry II, Catherine de' Medici, and Birague, which may be said to have set a fashion lasting well into the seventeenth century.[57]

PAINTING

Antoine Caron, Jean Cousin the Younger, and the Portrait Painters

There are few periods at which French painting was at a lower ebb than the last quarter of the sixteenth century and the first quarter of the seventeenth, and few periods about which we are more ignorant. In the reigns of Charles IX and Henry III only two painters, Antoine Caron and Jean Cousin the Younger, stand out as recognizable personalities; a few portrait painters, hardly above the level of mediocrity, can be isolated; and for the rest we know some names of artists to whom no works can be assigned and a vast number of works – mainly portrait drawings – to which no names of artists can be attached, at least with any certainty.

Antoine Caron,[58] who has recently enjoyed a rather exaggerated popularity, is of interest in that he reflects vividly the peculiar atmosphere of the Valois Court during the Wars of Religion. He is first recorded as working under Primaticcio at Fontainebleau before 1550, and he later became painter to Catherine de' Medici. We know, further, that Caron was closely connected with the Catholic League, and a friend of its poet and pamphleteer, Louis d'Orléans.

Caron's themes fall into three main categories. The first are allegorical subjects which in presentation recall the festivities for which the Court of the last Valois was famous. His paintings of the 'Triumphs of the Seasons' and the drawings for the Valois tapestries, for instance, include *fêtes galantes*, water-parties, picnics, and orchestras with an allegorical procession in the foreground illustrating the season in question,

apparently based on the ballets which had become a favourite pastime of the court. The two large sets of drawings – the 'Histoire des Rois de France' and the Artémise series – belong to the same category. They reflect court ceremonial rather than court ballets, but the spirit is the same; in the latter the allusion to Catherine de' Medici in the person of Artemisia is quite unmistakable.

In the drawings the theme of battles also occurs, and provides a link with the next type of subject treated by Caron, that of the Massacre. A painting in the Louvre, dated 1566, represents the relatively rare subject of the 'Massacres under the Triumvirate', and it has often been pointed out that this must be understood as a direct reference to the bloodshed which characterized the Wars of Religion during which the picture was executed. The violence of this painting reflects an aspect of life as typical of the period as the court ballets of the first group.

Finally two paintings show a more fantastic approach: the 'Astrologers Studying an Eclipse' and 'Augustus and the Sibyl' [119] bring out the love of predictions, horoscopes, and anything on the borderline of magic which was current in the late sixteenth century, and particularly in the circle round Catherine de' Medici. His only painting to represent a traditional religious subject is the 'Resurrection' at Beauvais.

In his subjects, therefore, Caron is typical of the most sophisticated Court Mannerism, with its emphasis on external ceremonial and elaborate allegory and its love of the fantastic or irrational. In treatment this Mannerism is even more apparent. The most obvious characteristic of Caron's style is the elongation of his figures, a device which he learnt from Nicolò dell'Abate, but which he greatly exaggerated.[59] From him also he learnt their strange twisted attitudes and tapering limbs.[60] His long, pin-headed figures are then placed in a space which is intentionally too large for them, so that they seem lost and insignificant in it. This space is usually defined

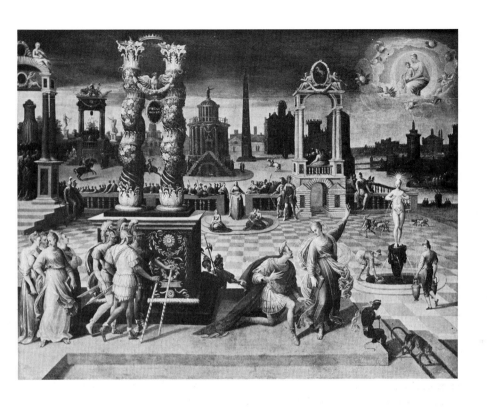

119. Antoine Caron: Augustus and the Sibyl. *Paris, Louvre*

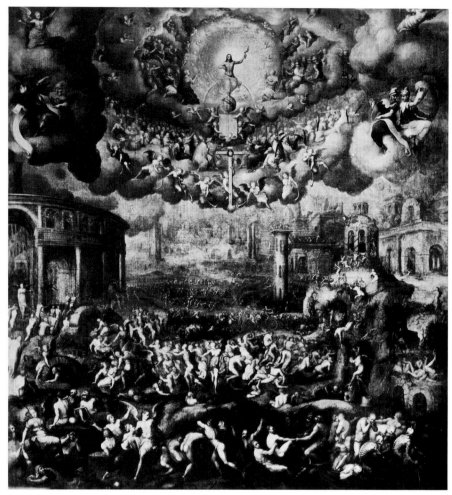

120. Jean Cousin the Younger: The Last Judgement.
Paris, Louvre

by architecture, drawn in sharply exaggerated perspective and composed of the most fantastic fragments which Caron could find in the designs of du Cerceau, combined with schematic versions of Roman ruins or sometimes with a landscape, again based on Nicolò. To this must be added a colouring dominated by unexpected rainbow contrasts, often against an almost white ground in the architecture. The sum total of these elements of content and form is to produce what is perhaps the purest known type of Mannerism in its elegant form, appropriate to an exquisite but neurotic aristocratic society.

In his own time Jean Cousin the Younger must have enjoyed a great reputation, since his

name is mentioned with reverence by contemporary writers; but his work has mostly disappeared. He was the son of Jean Cousin the Elder, was born in Sens about 1522, lived most of his life in Paris, and probably died about 1594. His *Livre de Fortune* (1568), a series of emblem drawings, shows him as a continuer of Rosso's decorative style.[61] Two engraved designs of the 'Brazen Serpent' and the 'Conversion of St Paul' indicate that he was influenced by Florentine Mannerism. In particular the 'St Paul' belongs to a type of composition used by Salviati in his painting in the Doria Gallery[62] and his fresco in the Cancelleria.[63] Cousin's most important surviving work is the 'Last Judgement' in the Louvre, engraved under his name in 1615 [120]. Here he is playing, like Caron, on the theme of the puniness of humanity, which is made to swarm over the earth like worms. But his formula is a Florentine one, and seems to be derived from Bronzino's 'Descent into Limbo' in the Colonna Gallery,[64] although the actual types of figures suggest a Flemish influence. Cousin's main field of activity may have lain outside painting properly speaking, as he is known to have designed widely for book illustrations and for stained glass.[65]

One series of drawings must be mentioned here as throwing an interesting light on the taste of the time. These represent the tournament held at Sandricourt in the year 1493. The drawings which are in the Louvre are probably by Jérôme Bollery (died soon after 1600).[66] It is unexpected to find an artist commissioned at the end of the sixteenth century to make drawings of a famous feat of chivalry of a century earlier,[67] but the subject may well have appealed to a certain section of the aristocracy which looked back with nostalgia to the days of feudalism.[68]

Portraiture continued to be one of the most popular forms of art in France in the later sixteenth century, and in particular the vogue of portrait-drawings grew even greater. In this genre the two eldest members of the Dumonstier family, Étienne and Pierre the Elder, were among the most distinguished, but they hardly did more than carry on the tradition of François Clouet. The same may be said of Benjamin Foulon and François Quesnel, whose drawings are more polished, but less vigorous than those of the two Dumonstiers. Among the few painted portraits of the period which can be attributed to named artists one of the most interesting is that of Mary Ann Waltham, signed with the initials of François Quesnel and dated 1572 [121]. This is typical of the last phase of French sixteenth-century portraiture, when the natural-

121. François Quesnel: Mary Ann Waltham. 1572.
Althorp, Northamptonshire, Earl Spencer

ism of François Clouet has been stylized so that the modelling almost disappears and the portrait is dominated by the flat linear pattern. Marc Duval showed greater boldness in his full-length life-size portrait of the three Coligny brothers, known from copies and an engraving. To the same category belongs the anonymous portrait of Catherine de' Medici and her children which

122. Anonymous artist: Woman choosing
between Youth and Age. Late sixteenth century.
Broomhall, Fife, Earl of Elgin

was unfortunately burnt in the fire at Castle
Howard.[69]

One novelty was introduced into French
painting in the last decades of the sixteenth cen-
tury, namely the treatment of domestic subjects,
or at any rate subjects which were neither reli-
gious nor classical.[70] The favourite themes of
artists in this field are scenes from the Com-
media dell'Arte, such as the 'Woman choosing
between Youth and Age' [122], or court balls,
such as those of the Duc de Joyeuse, at Versailles,
and of the Duc d'Alençon in the Louvre.[71] All
these paintings show strong Flemish influence,
and it is quite possible that they were the work
of Flemish painters living in France. Composi-
tions of the same type, but usually with a more
satirical tendency, are to be found in the engrav-
ings of the period, many of which were devoted
to political satire by both factions in the time of
the League. Here again Flemish influence is evi-
dent, and engravers seize on the idiom of Bruegel
to satirize their religious and political oppo-
nents in the same spirit as he had used it in
Flanders.[72]

HENRY IV AND THE REGENCY OF MARIE DE' MEDICI

1598-1630

HISTORICAL BACKGROUND

When Henry IV entered Paris in 1594 and was acknowledged king by the great majority of his subjects, he found a country worn out with a civil war which had been intensified by religious fanaticism and confused by foreign intervention. The trade and industry of France were almost ruined, her administration was dislocated, and her population impoverished. During the first few years of his reign Henry devoted himself to driving out the Spaniards, coming to terms with the remaining rebels, and finding a religious settlement. These aims had been achieved by 1598, when the Peace of Vervins brought freedom from the invaders, and the Edict of Nantes gave the world the first proof that religious toleration could be the basis of sound state policy. As regards the rebels, even Mayenne, the most recalcitrant Leaguer, had made his peace with the King well before this date.

From 1598 onwards, therefore, Henry and his minister Sully were able to devote their whole attention to the problem of internal reconstruction. The situation could hardly have been more serious. In the country the peasantry had, as always, suffered more than any other section of the community from the civil war and the increased taxation. The nobility were greatly impoverished, partly owing to the expenses of the war and partly through the alteration in the value of money, which lowered the effective value of rent-rolls. The inhabitants of the towns had suffered from the interruption of trade due to the

general insecurity of the kingdom. The *bourgeoisie* was, however, in a much better position to recover than the aristocracy, whose income depended entirely on their land, who were forbidden to engage in any kind of trade, and who, incidentally, had tasted the pleasures of court life during the latter part of the sixteenth century and were reluctant to go back and look after their estates.

The reforms of Henry and Sully were mainly directed towards improving the catastrophic financial position of the Crown and restoring the general prosperity of the kingdom by the revival of agriculture, trade, and industry. To attain the first of these objects Sully tried to free the Crown lands from mortgage and to bring some order into the system of taxation. He could do no more, however, than remove some of the grosser abuses in the system of farming out taxes, so that the actual yield to the Crown was increased; but he never tried to change the system itself. His encouragement to agriculture was more effective; and his attempt to break down the rigidity of the guild system did something to free small-scale industry. Trade was helped by his improvement of communications, but was still hindered by internal customs barriers.

Henry IV's most effective reforms were probably in the field of administration; for he was able to restore to the Crown the power which it had held under Henry II, but which it had almost entirely lost during the Wars of Religion. Learning from the experience of his predecessors he refrained from calling the States General

and did everything to strengthen the administration which depended directly on the Crown. The Council, which in effect governed the kingdom, was reduced to twelve members appointed by the King, and as a matter of policy the Princes of the Blood and the great nobles were excluded from it. Realizing that the provincial governors had now become dangerously powerful and capable of using their power in their own interests rather than in those of the Crown, Henry limited their authority by removing from them the control of taxation and justice, and by appointing his own nominees as governors of the provincial fortresses. With regard to the towns his policy was like that of Francis I, a mixture of cajolery and bullying which extracted from them important concessions and decreased their separatist potentialities.

The policy of Henry IV and Sully was notable more for its solid common sense than for any profound theoretical doctrines about government. But the result of this practical régime was that at the time of Henry's assassination in 1610, France was once more in a position to take her part in the affairs of Europe as one of the great powers. Unfortunately, however, during the minority of his son Louis XIII, who was only nine when he came to the throne, the regency was in the hands of Henry's widow Marie de' Medici, who handled the affairs of state with such indecision that the work of her husband was greatly jeopardized. Seeing the weakness of her Government, largely directed by her unscrupulous and incompetent favourite Concini, the Princes of the Blood and the nobles, led by Condé, Soissons, and Bouillon, did their utmost to regain the position which they had lost under the previous reign. At the same time the Parlement challenged the Crown on every possible issue, above all on the recurrent problem of the *Paulette*, the arrangement which enabled the members of the Parlement to hand on their posts to their children, and so establish the hierarchies which gave them social position and freedom from taxation. This double opposition to the central power might have proved fatal, but for the appearance of a new figure capable of dealing with both. Richelieu, who had been made a Secretary of State in 1616 and had risen by 1624 to be the head of the Council, was to be the continuer of the policy of Henry IV and the final consolidator of the centralized autocracy of France.

In the intellectual field the first three decades of the seventeenth century were a time of considerable activity. They witnessed a religious revival of which the leading representatives were Cardinal de Bérulle, St François de Sales, and St Vincent de Paul. The particular character of this revival gave the tone for religious thought through almost the whole century in France. It was profoundly sincere, but lacked the ecstatic and mystical quality of contemporary movements in Italy and Spain with their love of self-mortification. Instead these French enthusiasts taught a practical doctrine which could easily be harmonized with ordinary social existence. The movement led to a general raising of the religious life of the community, and, in the case of St Vincent, to the first great charitable undertakings.

At the same time the development of a purely secular morality was fostered by the revival of Stoicism due to Guillaume du Vair, one of the leaders of the moderate party or *Politiques* at the time of the League, and Pierre Charron. The latter's famous treatise *De la Sagesse*, published in 1601, was used as a handbook by the sceptics of the next generation, but also influenced the stream of Stoicism which was ultimately to unite with Christianity in the thought of Pascal.

In literature two strongly conflicting tendencies are apparent. On the one hand, a very fantastic style flourished, which appealed primarily to the aristocratic taste of which the law-giver was Mme de Rambouillet with her circle of

Précieux. This public enjoyed the long pastoral novels, such as d'Urfé's *Astrée*, deriving from Italian and Spanish models, and a brand of Mannerist poetry which specialized in epigrams, madrigals, anagrammatic verses and tortured sonnets. On the other hand, Malherbe introduced his reform, and so laid the foundations of French classical verse. His rational approach to literature, his common-sense purification of the language, his demand that poetry should be clear, easily intelligible, and carefully chiselled, put him in complete opposition to the fantastic school of Maynard, Racan, and Voiture, the poets admired by the *Précieux*. These qualities also explain why he was the favourite poet of Henry IV.

ARCHITECTURE

The King's Works,
Le Muet, Salomon de Brosse

The buildings for which Henry IV was directly responsible must be considered in two groups: the additions to the royal palaces, and the improvements to the city of Paris.

Of the former the finest example is the Stable Court at Fontainebleau [123], built by Rémy Collin round a square court open on one side towards the Cour de l'Ovale.[1] The great entrance, of between 1606 and 1609, is a translation into French terms of Bramante's Belvedere niche. The architect has relied for a great part of his effect on the variety of surface produced by the rustication and by the different colours of the hard local *grès*, which Serlio had used in a similar spirit in the door of the 'Grand Ferrare'. The niche form of entrance is echoed in the semicircular bay in the middle of the opposite side of the court.

At St Germain Henry IV transformed the Château-Neuf begun by Philibert de l'Orme for Henry II into an imaginative scheme of terraced

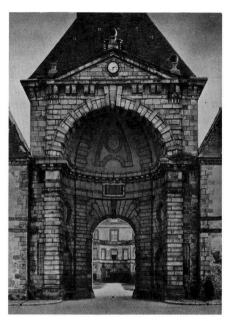

123. Rémy Collin:
Fontainebleau, château, stables. 1606-9

gardens leading from the river to a casino, the whole design being strongly reminiscent of Italian gardens such as the Villa d'Este at Tivoli. The similarity to southern originals confirms the attribution of the design to Étienne du Pérac, the one architect of the time who was well acquainted with the gardens of Rome and its neighbourhood.[2]

Far more revolutionary are Henry IV's improvements to the city of Paris. It was in accordance with his general policy that he should want to embellish his capital, and in keeping with his character that his improvements should be of a very practical kind. In the short space of twelve years he completed the Pont Neuf, built the Place Royale and the Place Dauphine and began the Place de France, created the Hôpital St Louis and laid the foundations of the

Collège Royal. In these works Henry IV brought town-planning to a new stage and established certain principles which were to influence the development of Paris for several centuries. In some cases we shall find that he was taking up ideas which had been suggested in the sixteenth century, but the manner in which they were carried out bears the clear stamp not only of the later period, but also of the character of the King himself. For many of these buildings we do not even know the names of the architects who seem to disappear behind the personality of the King. We know that Henry took a close personal interest in these schemes, and they all have so much in common that we must suppose Claude Chastillon or Louis Métezeau, whose names appear in some confusion in the accounts, to have been above all builders acting under the direction of a single mind, that of the King himself.

In 1598 Henry IV took up the building of the Pont Neuf which had been begun under Henry III in 1578, but interrupted by the civil war. As originally planned, the bridge was to be a somewhat fanciful affair with houses on it, and at each end triumphal arches, which were to serve purposes of defence as well as of ornament. Henry IV simplified the scheme, and eliminated the houses and the triumphal arches. The purpose of the bridge was to link the southern part of Paris, containing the university, with the business and administrative quarters on the Cité and the right bank. In order to deal with the traffic which this new communication would create, Henry further planned the rue Dauphine cutting through the maze of small streets on the left bank. In this way traffic coming from the north bank could communicate not only with the university quarter but with the Faubourg St Germain, which as a result of this scheme became more accessible and was later to be developed as a rich quarter.

In 1604 Marie de' Medici offered to present to the city of Paris an equestrian statue of the

124. Paris, Place Dauphine. Begun 1607.
Plan, based on
L'Entrée triomphale de leurs Majestez
(Paris, 1662)

King to be set up at the point where the Pont Neuf cut the end of the Cité. The statue, commissioned from Giovanni da Bologna and completed by Tacca, was not set up till 1614, but the project evidently influenced the development of the site; for in 1607 Henry IV decided to build the Place Dauphine to cover the triangular space at the end of the island, facing the point where the statue was to be set up [124]. The Place consisted of two ranges of buildings on the equal sides of an isosceles triangle, leaving openings at the apex and in the middle of the base. The houses were of standard design, with pairs of arched openings for shops on the ground floor, separated by narrow doors leading through a passage to the small court at the back, from which a steep staircase led to the living quarters above. The outside was of simple design, very similar to the Place Royale [125], and of cheap materials, brick decorated with quoins and *chaînes* in stucco. Henry IV was here following up an idea suggested in the previous century and recorded in an engraving showing façades erected in 1554 between the Petit Pont and the Hôtel Dieu, which in their exact regularity and their general disposition with arcaded shops separated by doors on the ground floor are exactly like those of the Place Dauphine. But it is characteristic of the more advanced thought of Henry IV that, whereas his predecessors had planned a single block of such buildings, he should have extended the idea to a whole square which in its turn was part of a larger scheme of town-planning.

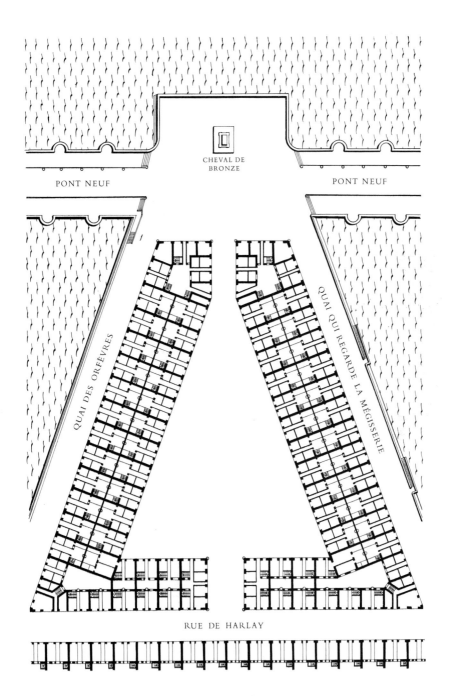

PONT NEUF

CHEVAL DE
BRONZE

PONT NEUF

QUAI DES ORFÈVRES

QUAI QUI REGARDE LA MÉGISSERIE

RUE DE HARLAY

125 *(below)*. Paris, Place des Vosges (Place Royale). Begun 1605

126 *(opposite)*. Paris, Place des Vosges (Place Royale). Begun 1605. From an engraving

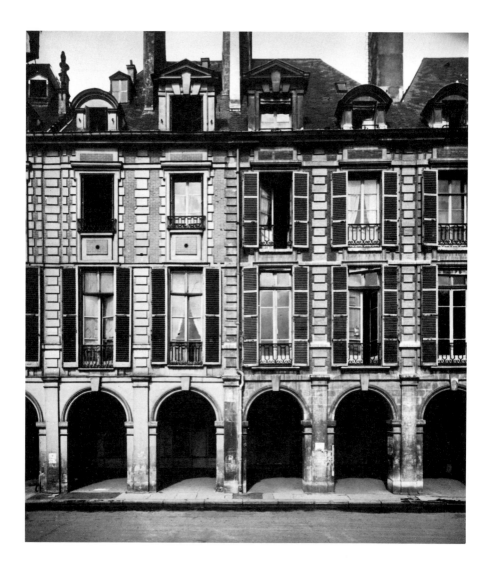

The Place Royale, or Place des Vosges as it is now called [125, 126], was conceived in 1603 and carried out from 1605 onwards. It was built on the site of the old royal palace of the Tournelles, which was abandoned by Catherine de' Medici after the death of Henry II in the tournament held there. In 1563 she put forward a plan to make on the site a square surrounded by than the rest of the houses and more elaborately decorated. The normal plot sold consisted of four bays, which made a house of respectable, but not excessive size. The result was that, though the great noble families continued to build private houses on larger and freer sites, the less rich members of the aristocracy and the wealthier *bourgeois* flocked to the Place Royale,

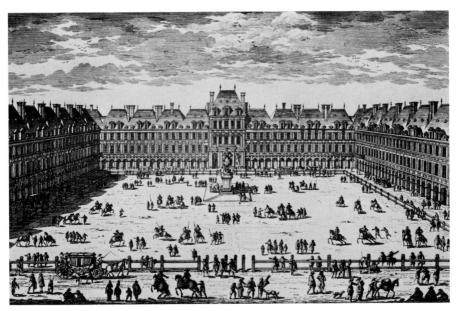

houses of standard form designed by Jean de l'Orme, but the Wars of Religion interrupted the project. The idea in Henry IV's mind is clearly expressed in the instrument drawn up for the execution of the project. The square was to provide a *promenoir* for the people of Paris and a place for them to assemble on occasions of public rejoicing. At the same time it was to contain houses suitable for the well-to-do. The King let the plots round the square at a nominal rate on condition that the buyer built according to the agreed plan. Henry himself built the two central pavilions on the north and south sides, called the Pavillons du Roi et de la Reine, which are taller and made it the centre of a quarter, called the Marais, which remained fashionable for the rest of the seventeenth century, till it was gradually displaced by the Faubourg St Germain.

The style of the houses was of the same simplicity as in the Place Dauphine. Instead of the shops on the ground floor of the latter we find here an arcaded cloister which was an essential part of the King's plan; but in the upper storeys the elevation is similar, with stucco *chaînes* against the brick, and very simple dormers. On the two main floors the architect has used French windows, opening right down to the floor, which were apparently a novelty. The middle of the

square was decorated in 1639 with the equestrian statue of Louis XIII, of which the horse was that made by Daniele da Volterra for the monument of Henry II and the figure was added by Pierre Biard the Younger. The whole statue was melted down at the time of the Revolution.[3]

In the last of Henry IV's great town-planning projects, the Place de France (designed in 1610) [127], the practical and symbolical sides were both clearly emphasized. Only a small part of

some distance behind the market buildings. Each street bore the name of a French Province, so that the whole plan was a symbol of national as well as civic pride. Stylistically the buildings are like those of the Place Royale and the Place Dauphine in their simplicity, but they are more archaic in one detail, namely in having turrets at the corners of the pavilions which thus look almost like Flemish town-halls of the later Middle Ages.

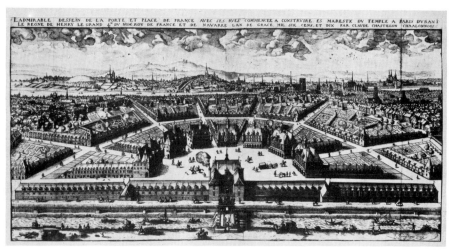

127. Claude Chastillon and Jacques Alleaume: Paris, Place de France. 1610. Engraving by Chastillon

the scheme was carried out, but we know the whole from the engraving prepared by Claude Chastillon, who in the legend tells us that he and the engineer Jacques Alleaume were responsible for the design. It consisted of a semicircular space closed along the diameter by the walls of Paris between the Porte St Antoine and the Porte du Temple. In the middle of this diameter was a new gate, the Porte de France. Round the circumference were seven buildings for markets and other public services, separated by roads leading radially from the Place itself. These roads were cut by an outer ring of streets,

Two other public buildings undertaken by Henry IV must be mentioned: the Hôpital St Louis and the Collège de France. The former, an isolation hospital outside the walls of Paris, begun in 1607, still survives almost unaltered. The main wards of the hospital are symmetrically disposed round a square court while other buildings, for the staff of the hospital, form the corners of an outer square and are linked by covered ways with the wards.[4]

The Collège Royal was only begun in the year of Henry IV's death, probably from designs by the King himself. It was completely altered in

the eighteenth century. Here the type of building demanded a slightly different style, and Chastillon's engraving shows a work in the late-sixteenth-century manner.

It would be hard to over-estimate the importance of Henry IV's public works in Paris for the history of town development, so advanced were they for their time. Italy had produced open spaces such as the Capitol and the Piazza of St Mark's surrounded by some of the great public buildings of the city symmetrically disposed; and in Flanders and north-eastern France towns like Antwerp, Brussels, or Arras could show squares on which stood houses of the guilds or the richest citizens. But Henry's *places* were the first to combine the regularity of design of Italy with the Flemish grouping of small houses. They were the first examples of that most characteristic expression of *bourgeois* pride and practical sense, the regularly designed series of living houses disposed on a geometrical plan and carried out in simple materials, unostentatious but comfortable.[5] The idea was soon copied. Elsewhere in France examples are to be found built at Charleville (1608) by Charles de Gonzague, Duc de Nevers, at Henrichemont by Sully (1608), at Montauban (1616) by the municipality and at Richelieu (*c.* 1632) by the cardinal.[6] But the idea was soon to spread outside France. In England Covent Garden (*c.* 1630) is a direct imitation of the Place Royale, which may therefore be regarded as the ultimate ancestor of the square development in London, Bath, and elsewhere. And in other forms the idea took root in Holland, Germany and, later, even in Italy.

In Paris itself, as has already been indicated, Henry IV's improvements led to the development of several new quarters. It became fashionable to build round the Place Royale, and the bolder spirits soon began to take advantage of the new bridge to buy sites in the almost deserted Faubourg St Germain. In 1608 the contractor Marie acquired the right to let off the whole of the Île Notre-Dame, now the Île St Louis, to which he agreed to build the bridge bearing his name. During the following decades some of the finest private houses in Paris sprang up on this island, which still preserves its rigid layout with one street from end to end, crossed by three at right angles to it. At about the same time a further area north of the Louvre and the Tuileries gardens was enclosed within the walls of Paris. There Richelieu built the Palais Royal, and a little later Mazarin his house, now the Bibliothèque Nationale, and round this nucleus sprang up yet another quarter.[7]

In all these newly developed areas those who could afford the larger free-standing type of hôtel gave to the architects of the time an opportunity to display their skill in planning and decoration.

In 1605 Charles, Duc de Mayenne, reconciled with the King after his activities in the League, began an hôtel in the rue St Antoine, not far from the Place Royale.[8] The house, which still stands, though much altered and suffering from being used as a school, is a variant of the type known in the sixteenth century in the Hôtel Carnavalet, consisting of a main *corps-de-logis* and wings leading to a street façade of two pavilions joined by a lower section containing the entrance.[9]

During the regency of Marie de' Medici many hôtels were put up particularly in the Marais of which the finest surviving examples are the Hôtel Châlons-Luxembourg and the Hôtel de Sully. The Hôtel Châlons-Luxembourg, probably built about 1623,[10] consists of a narrow building in brick and stone standing behind a court, the entrance to which is formed by a magnificent door [128], originally free-standing. This is a fine example of the more fantastic style which was current in Paris in the period after 1620.

The Hôtel de Sully, in the rue St Antoine, was built *c.* 1624-9, possibly to the design of Jean du Cerceau, for a rich financier, Mesme

Gallet, who sold it in 1634 to Sully, the minister of Henry IV. It has been brilliantly restored and now gives a better impression than any other surviving building of what a great Paris hôtel of the 1620s must have looked like.[11]

The plan follows the traditional form with a central *corps-de-logis* flanked by wings, leading to pavilions which are joined by a lower bay containing the *porte-cochère*. About 1660 the main building was slightly altered by the addition of a pavilion at one end of the garden façade, but otherwise it is externally in almost exactly the same state as in 1630, even to the Orangery at the bottom of the garden.

If the plan is traditional, the external decoration is novel. The façades on the court are ornamented with allegorical figures in niches which are an echo of Goujon's decorations on the Hôtel Carnavalet [129]. All the windows are covered by sculptured friezes and pediments containing masks or shells. The dormers are also of unusually elaborate form with carved scrolls at the sides and friezes and masks over them. The style of these carved decorations is one which does not seem to be traceable in Paris at an earlier date, but it is remarkably like that practised by Hugues Sambin in Dijon almost half a century earlier, and may be a derivation from it.

Internally the building has suffered extensively, but a number of painted beamed ceilings – *plafonds à la française* – were uncovered in the restoration.

The principles on which private houses were built during this period are laid down in two books. The first is the *Architecture Françoise* of Louis Savot, first published in 1624, in which the author discusses the practical conditions of building in Paris, including the various laws and regulations governing private houses, and the nature and price of materials. The second is the *Manière de bien bastir pour toutes sortes de personnes*, published by Pierre Le Muet in 1623. This treatise is an up-to-date version of Serlio's

sixth book and du Cerceau's first book of architecture, in that it provides designs of houses for different categories of owners. But Le Muet goes even farther down the social scale than his predecessors. His smallest houses are for a street frontage of only twelve feet, with just enough room on the ground floor for one small room and a narrow passage leading through to the staircase and the tiny court.[12] From this smallest model, built almost without ornament and in the simplest materials, Le Muet takes the reader on to larger houses, mainly in the current brick-and-stone manner. In the second half of the book, which was only added in the second edition of 1647, he is more ambitious and gives plans and elevations of a few very grand hôtels which he actually built.

128 *(opposite)*. Paris, Hôtel Châlons-Luxembourg. 1623(?)
129 *(below)*. Attributed to Jean du Cerceau: Paris, Hôtel de Sully. 1624–9

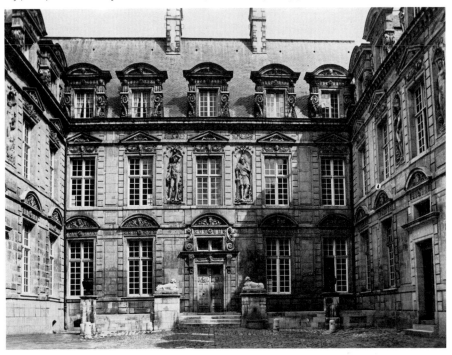

These include the Hôtel d'Avaux in the rue du Temple [131] which has emerged from its recent restoration as one of the finest seventeenth-century houses surviving in Paris. The visitor enters through a door set in a lightly rusticated concave bay and finds himself in a large court articulated on all four sides by giant Corinthian pilasters. The idea of using such pilasters goes back through Métezeau at the Hôtel d'Angoulême to Bullant in the south frontispiece at Écouen, but they had never been applied before to the complete façade of a court. The effect is one of extreme grandeur, foreshadowing the work of the architects of the next generation.

Le Muet also built the smaller Hôtel de l'Aigle in the rue St Guillaume, which is almost *Mansardien* in its purity, and the Hôtel Comans d'Astry on the quai de Béthune which has a beautifully refined door [130].[13]

Another typical house of this period of which the exterior has survived more or less intact is the Hôtel Duret de Chevry, built by Jean Thiriot in 1635, enlarged in 1641, later sold to Mazarin, and now forming part of the Bibliothèque Nationale.[14] This building shows the architect's love of complicated rustication, of stone *chaînes* and quoins and of unusually shaped pediments filled with low reliefs.

In the château building of the early years of the seventeenth century we find the same conflict of styles. In the reign of Henry IV the greater part of the castles and country houses built conform in materials and manner to the

130. Pierre Le Muet: Paris,
Hôtel Comans d'Astry. 1647

131. Pierre Le Muet: Paris,
Hôtel d'Avaux. Engraving

132 (opposite). Grosbois (Seine-et-Marne),
château. 1597–1617

133 (opposite below). Rosny (Seine-et-Oise),
château. c. 1610-20

brick-and-stone work of the Place Royale, but in the years after 1610, and even in some cases earlier, architects make an even greater display of fantasy here than in the Paris hôtel.

Of the simple style a fine example is Grosbois [132]. It was begun by Nicolas de Harlay in 1597, but work on the side wings was still continuing in 1617, when the estate had passed to the Duc d'Angoulême, natural son of Charles IX.[15] There is no record of the original designer, but, in view of the great semicircular bay in the middle of the main block, which is a grander enlargement of the niche in the Stable Court at Fontainebleau, it is quite likely that Collin was the architect responsible.[16] The château is traditional in its materials and is composed of the brick and stone or plaster current in the reign of Henry IV and the regency of Marie de' Medici, but whereas normally, as at Rosny [133], the surface is of brick and the quoins white, here the walls are of white plaster which is relieved with quoins and chaînes, but in this case the quoins are of stone, whereas the chaînes are of brick, an arrangement which gives an effect of variety to the elevation without any use of ornament.[17]

The same simple manner can be found all over the country, but on the whole the provinces favoured a more fantastic style. When, for instance, in 1606 Charles de Cossé, Duc de Brissac, decided to rebuild the château of Brissac, near Angers, he used the foundations of the medieval castle and began to build on them a structure

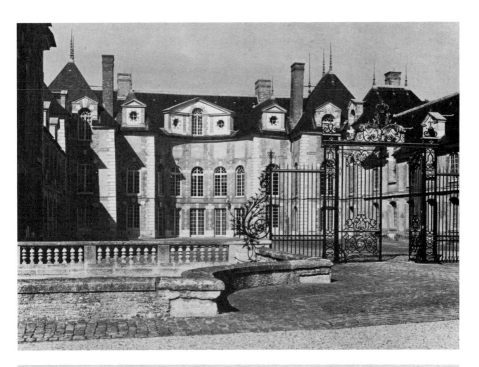

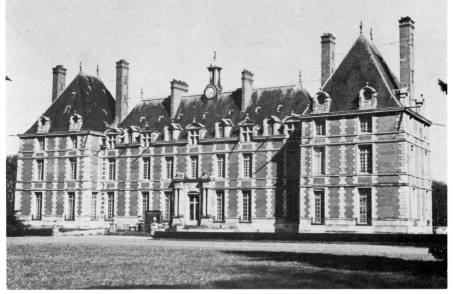

which in its proportions and its details is a complete contrast to all that had been put up in the Île-de-France [134]. As it stands to-day the château is only a fragment, and the main façade is still squeezed between two medieval towers, windows, rusticated *voussoirs* and pilasters, and in the central pavilion elaborate Late Mannerist carved decoration. In many details, too, the arrangement is Mannerist in feeling. Notice, for instance, the double dormers with curved pedi-

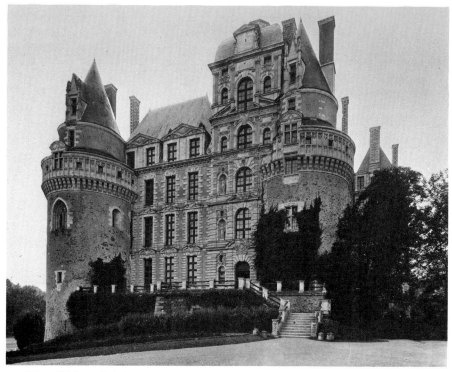

134. Brissac (Maine-et-Loire),
château. 1606

which were to have been pulled down so that the front could be made symmetrical. Its enormous height – on the north side where the ground falls away it rises to six storeys – and its unusual, compact plan make it look more like a castle than the house of a country gentleman; but we must remember that the Wars of Religion were only just over and that Brissac had taken an active part in them. The surface of the building is restlessly broken with long-and-short borders to the

ments enclosed under a single straight one, and on the same floor in the middle pavilion the two pediments interrupted by the intrusion of the window of the floor above.[18]

So far no mention has been made of the most distinguished architect of the period, Salomon de Brosse, but he is conveniently considered at the end of this section because more than any of his contemporaries he prepares the way for the next generation and the introduction of clas-

sicism.[19] His father was an architect of some distinction, and his mother was the daughter of the elder Jacques du Cerceau. He was born in 1571 at Verneuil, and presumably brought up in the circle of late du Cerceau activities there. After

1618 de Brosse began his two major public commissions, the rebuilding of the *Salle* in the Palais of the Paris Parlement, and the construction of the palace for the Parlement of Brittany at Rennes [139]. In 1623 he rebuilt the Protestant

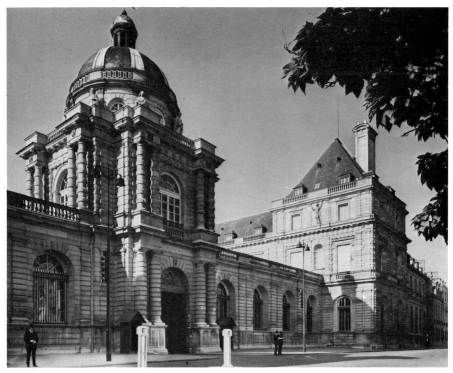

135. Salomon de Brosse:
Paris, Luxembourg Palace. Begun 1615

the Edict of Nantes his family, who were Protestants, moved to Paris, and from about 1610 onwards he seems to have enjoyed considerable success as an architect. During the next few years he was commissioned to build three great châteaux: Coulommiers in 1613 for Catherine de Gonzague, Duchesse de Longueville; Bléran-court [137, 138], begun by 1612 and finished before 1619 for Bernard Potier;[20] and the Luxembourg [135] in 1615 for Marie de' Medici.[21] In

Temple at Charenton, after the first Temple built in 1606 – perhaps also after his design – had been burnt.[22] He died in 1626.

Of the three châteaux the Luxembourg and Coulommiers are in many ways traditional. In plan they are variants of the well-established form with *corps-de-logis*, two wings and a screen enclosing a court. The Luxembourg [135, 136] is the more mature with its double pavilions at the corners of the main block, each pavilion pro-

viding a complete *appartement* on every floor. On the other hand, this plan has the disadvantage that its side elevation is asymmetrical.[23] At Coulommiers[24] de Brosse gets over this difficulty by doubling the pavilions at the ends of the wings as well as those on the *corps-de-logis*. This arrangement, it may be noted, is an exact reproduction of the first plan for Verneuil, which de Brosse must have known from childhood.

The essential contribution of de Brosse to the development of French architecture at this moment lies in the fact that he was the first architect since Philibert de l'Orme to think in terms of mass, and not of decoration of surface. Most architects of the late sixteenth century were essentially inventors of ornament, and even Bullant, though a more intellectual artist,

136. Salomon de Brosse: Paris,
Luxembourg Palace. Begun 1615. Plan, from Hustin,
Le Palais du Luxembourg (Paris, 1904)

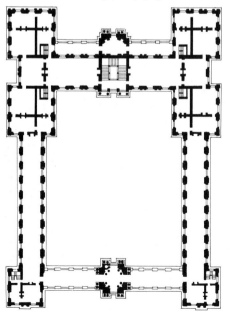

designed primarily patterns playing on the surface or porticos applied to a building.

De Brosse's sense of mass can be seen most clearly in the two later works, the Luxembourg and Blérancourt. In Coulommiers it is less in evidence, partly because the more elaborate dormers, still in the du Cerceau manner, blur the edges of the roof, and partly because the walls facing the court are articulated with a system of coupled full columns on each floor, based on Lescot's design for the Louvre. In the Luxembourg the dormers are replaced by an attic floor under a cornice which leaves an almost unbroken edge at the spring of the roof. Much greater emphasis is also placed on the *corps-de-logis* itself, conceived as a complete symmetrical unit, to which the wings, being lower and narrower, are clearly subordinated. The articulation with columns used at Coulommiers is also given up, and both the court and the exterior façades are now covered with a uniform and rather light rustication, which does not break the clarity of outline of the blocks. This rustication seems to be the only element which survived in the finished building of Marie de' Medici's original project of constructing a palace in imitation of the Pitti. We know that she sent Métezeau to make drawings of the latter in 1611, but Salomon de Brosse certainly did not follow them in any important features of his design.[25]

In one respect the Luxembourg follows the design for Coulommiers, and even the earlier example of Verneuil, namely in the design of the entrance front which has as its central element a sort of rotunda. It is noticeable, however, that de Brosse's design is more restrained than that of Verneuil. His rotunda goes back to the Valois Chapel and Bramante's Tempietto as models rather than to the Mannerist fantasies of the 1560s and 1570s.

At Blérancourt de Brosse's plastic conception is even more apparent, because the château has no wings, but is reduced to a single block with four flanking pavilions [137]. This is an im-

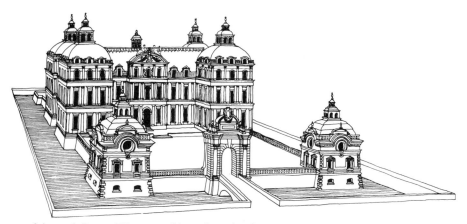

137. Salomon de Brosse: Blérancourt, château. Begun by 1612, finished before 1619. Reconstruction by Peter Smith

138. Salomon de Brosse: Blérancourt, château, entrance pavilions. Before 1619

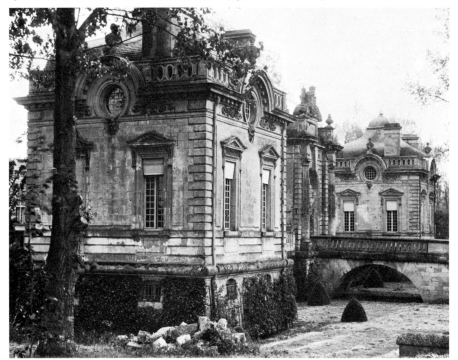

portant step, leading up to the classical conception of the château as it was evolved by François Mansart, and bearing a closer relation to the ideals of the Italian Renaissance than any earlier buildings in France. This free-standing symmetrical block, designed to be seen from all sides, is of the same family as Bramante's House of Raphael or Peruzzi's Farnesina, but, apart from de l'Orme's Château-Neuf at St Germain, it was a novelty in France, where up to this time the château had either been built round a court or on a straight plan with pavilions and wings. De Brosse introduces at Blérancourt another feature which adds to the compactness of the whole. In his two other châteaux he had used the traditional high-pitched roof, though at the Luxembourg he had altered it to the extent of cutting off the apex; but at Blérancourt he adopts for the pavilions the square domes used in the design for Verneuil, though he makes them even

lower, so that they bring the roof into easy relation with the main mass of the pavilions below.

As far as we can judge from the drawings, Blérancourt was a revolutionary building in another respect. Its application of the Orders was far more correct than in the other works of de Brosse or the buildings of his contemporaries. The Orders chosen were the two most severe, Doric and Ionic, and the walls were decorated by them alone without any further ornament. In the pavilions which still stand at the corners of the forecourt [138] we can see how fine but severe was the design of the windows, far in advance of anything else which was being done in France at this time. The interlacing pattern of the balustrade was one copied by François Mansart and used in France at any rate till the generation of Jacques-Ange Gabriel. The same purity is to be seen in the façade of the Palais du Parlement at Rennes [139],[26] which was unfor-

139. Salomon de Brosse:
Rennes, Palais de Justice. 1618

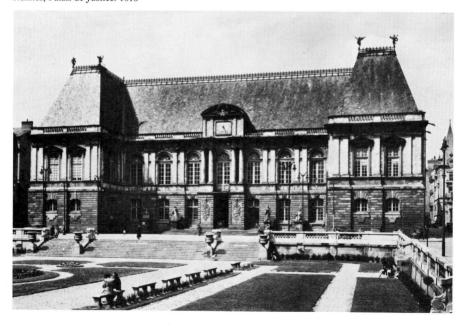

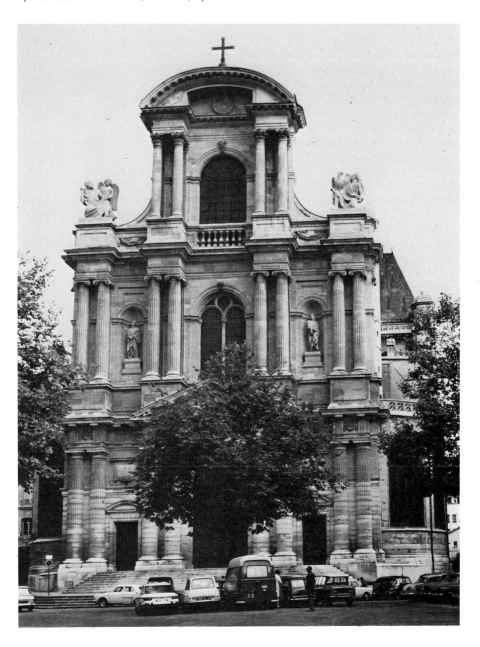

tunately altered in the eighteenth century, when the open staircase and the terrace were removed and the middle bays of the ground floor altered. Here de Brosse's feeling for sharply defined mass, for the simplicity of the wall and for delicacy of detail appears at its clearest, anticipating many of the features to be developed later by François Mansart.

The name of de Brosse is also traditionally associated with the most important piece of church architecture of the period, the façade of St Gervais (1616) [140].[27] This design is a novelty in ecclesiastical architecture, for it is the application to a church façade of the three superimposed Orders regularly used for the entrance to a château. The closest model is de l'Orme's frontispiece at Anet, to which de Brosse has simply added a straight pediment over the main door and a curved one at the top of the whole structure. In this way de Brosse has invented a French form of the current Roman church façade. His problem is different, however, because in the case of St Gervais the church to which the façade was being added was a tall Late Gothic building, and this necessitated the use of three floors instead of the two usual in Roman fronts of the same type. In the case of St Paul–St Louis by Derand [141] the church was of the same date as the façade, but the Gothic feeling for height survives in the proportions of the interior and forces the architect to adopt the three-storey type of façade.[28]

The chapel of the Trinité at Fontainebleau supplies a good example of the interior decoration of the period. The main ornamentation of the ceiling dates from the reign of Henry IV, and consists of a combination of stucco frames and painted panels in the manner to be seen in all parts of the palace, though with rather more advanced details of ornament. Over the altar and the royal gallery, however, Marie de' Medici added two big stucco groups of angels supporting her coat of arms [142] in the new style which was to be current in France during the period

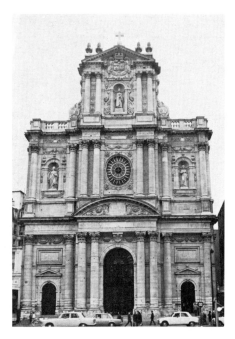

141. François Derand: Paris, St Paul-St Louis. 1634

c. 1615–35. This is a variant of the strapwork invented by Rosso at Fontainebleau, which had in the interval been imitated and transformed by Florentine architects such as Buontalenti, who had given it a more curvilinear and three-dimensional quality. Instead of curving over like pieces of cut leather, its forms are now more like a shell or even the lobe of an ear.[29] This form of decoration was widely used during the regency of Marie de' Medici, in stone or wood work, as for instance in the door of the Hôtel Châlons-Luxembourg [128], and can even be traced in the early work of architects of the next generation - for instance, in Mansart's Church of the Visitation and in private houses by Le Vau.

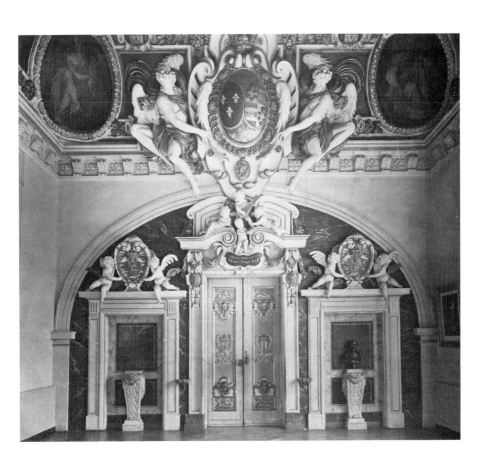

142. Fontainebleau, château, chapel. *c.* 1615–25

French architecture during the reign of Henry IV and the regency of Marie de' Medici reflects the conflicting tendencies visible in all fields of French culture at this time. Henry IV himself was responsible for works revolutionary in their rational conception and their simple execution. On the other hand, private patrons were still indulging in the fantasies of Late Mannerism, not, it is true, quite as wild as those of the previous decades, but still ignoring the logical style encouraged by the King. Salomon de Brosse alone understood the simplicity of the great royal ventures and added to it a monumental sense which prepared the way for the greatest figure of the next generation, François Mansart.

PAINTING AND SCULPTURE

The Second School of Fontainebleau –
The Mannerists of Nancy : Bellange and Callot –
Late Mannerism in Paris – Vignon – Biard

Henry IV devoted considerable energy to the decoration of the royal palaces, but unfortunately few of the paintings which he commissioned survive, and we are therefore badly informed about the so-called Second School of Fontainebleau, which was responsible for them.

The name is generally applied to three painters: Ambroise Dubois (1542/3–1614), Toussaint Dubreuil (1561–1602), and Martin Fréminet (1567–1619), who may be said to have revived the function of their predecessors at Fontainebleau – Rosso, Primaticcio, and Nicolò dell'Abate – after the Wars of Religion had interrupted large-scale painting in France; but there were other painters of importance active, such as Jacob Bunel who worked on the Petite Galerie of the Louvre which was destroyed by fire in 1661.[30]

The oldest of the three members of the school, Ambroise Dubois, was born in Antwerp, and apparently came to France as a youth. Before leaving his native town he seems to have ac-

quired the international Mannerism current there, based on a mixture of local Flemish elements with a variety of Italian styles introduced mainly by the great engraving firms, such as that of Jerome Cock.

His most important work in France, the decoration of the Gallery of Diana at Fontainebleau, was destroyed in the nineteenth century and is now mainly known from descriptions and copies. But many paintings survive from the other cycles executed in the same palace, illustrating the story of Clorinda from Tasso, and Heliodorus' novel, *Theagenes and Chariclea* [143]. Of the former series, painted for the Queen, three are known, of which the 'Baptism of Clorinda' in the Louvre is typical; of the latter almost all escaped destruction and are still to be seen in the Salle Ovale at Fontainebleau.[31]

143. Ambroise Dubois: Sacrifice at the tomb of Neoptolemus. *Fontainebleau*

Toussaint Dubreuil,[32] who died at the age of forty-one in 1602, seems to have been an artist of greater sensibility whose style was formed more on French models. His paintings in the Petite Galerie of the Louvre, now the Galerie d'Apollon, were destroyed in the fire of 1661, and his decorations at Fontainebleau have also disappeared without trace. From the series of compositions at St Germain three survive [cf. 144] while others are known from copies and drawings; and further several tapestries of the history of Diana are known from his designs. In these his manner is based primarily on Primaticcio. He makes use of certain Italian Mannerist devices, such as the cut-off half-figures in the foreground, but in general the style is of great restraint and lacks the extremes of elongation usual in the generation of Caron.

144. Toussaint Dubreuil: A Sacrifice. *Paris, Louvre*

In fact, Dubreuil forms a link between Primaticcio and the classicism of Poussin in the following century.[33]

On the death of Dubreuil in 1602 Henry IV summoned to Paris Martin Fréminet,[34] who had spent the previous fifteen or sixteen years in Italy, first in Rome and later in Venice and Turin. In Rome he had been in close contact with the Cavaliere d'Arpino, by whose style he was much influenced. Of his few surviving works the most impressive is the ceiling, begun in 1608, of the chapel of the Trinité at Fontainebleau, for which he also designed the architecture of the high altar.

While painting in Paris was in this state of general mediocrity, Nancy was the scene of a remarkable revival of artistic activity and produced a group of artists celebrated in their own time far beyond the frontiers of Lorraine: Jacques Bellange, Jacques Callot, and Claude Deruet, who represent in their several ways the last stage of Mannerism in Europe.

Bellange is an artist who has only been disinterred from neglect during the last half century, and we still know very few facts about him.[35] He is recorded in Nancy between 1600 and 1617 as painting portraits, executing wall decorations in the ducal palace, and preparing scenery and machines for theatrical performances, but little survives from his hand except drawings and engravings.[36] It is generally supposed that he visited Italy, and although there is no external testimony for such a visit, the internal evidence points strongly to his presence in Rome in the last decade of the sixteenth century.

The etchings of Bellange are the last in a long evolution of that particular type of Mannerism in which a private mystical form of religious emotion is expressed in terms which appear at first sight to be merely those of empty aristocratic elegance. The founder of this tradition was Parmigianino, who invented many of the formulas used by his successors, such as the elongation of the figures, the small heads on

long necks, the sweeping draperies, the strained, nervous poses of the hands, and the sweet ecstatic smile which those of Protestant upbringing find it hard not to think of as sickly and insincere, but which incorporates a particular kind of mystical feeling. This type of Mannerism, which flourished in the smaller towns of Italy in the sixteenth century and expressed a religious mood very different from that of official religious circles in Rome, came to Bellange through its exponents in the last decade of the century, Barocci and his two Sienese followers, Francesco Vanni and Ventura Salimbeni. If he visited Rome he would have known their works through his compatriot, the engraver and publisher Philippe Thomassin, but many of them were in any case accessible through engravings. Vanni and Salimbeni added to what they learnt from Barocci certain stylistic elements which are strictly Sienese and derive ultimately from Beccafumi. To these Italian sources must be added that of Flemish engraving which would have been known to Bellange in Nancy.[37] Out of these varied elements Bellange created a style which is intensely personal and which can be seen at its best in the etching of the 'Three Marys at the Sepulchre' [145]. The most immediately striking characteristics of the etching are the strange poses and forms of the three women, their long, sweeping draperies,[38] their swan necks and tiny heads with hair strained up from the nape of the neck, and their elongated nervous fingers. At first one is tempted to feel that they are merely ladies of the court walking in the ducal garden, but such an interpretation would miss the essential point of the work. True, the forms are those of a hyper-sophisticated court society, but the neuroticism which they display has taken a religious form, as it often did at the time of the Counter-Reformation. This state of mind may be complex and remote from modes of religious feeling current to-day, but it is not for that reason any the less sincere; and it would be as false to call Bellange unreligious as it was when, fifty

years ago, critics made the same accusation against El Greco.

To create the mysterious atmosphere of his compositions Bellange uses every trick known to his predecessors. His distortions in attitude and feature have already been mentioned, but he has many other shots in his locker. In the 'Three Marys', for instance, he places the three principal figures in the very foreground, but turns them round so that they all face away from the spectator and into the composition. Almost

145. Jacques Bellange: The Three Marys. Etching. *London, British Museum*

the same device is used with great effect in the 'Carrying of the Cross'. The composition is based on Schongauer's engraving of the same subject, but the two soldiers on either side of Christ in his design are brought forward and made into huge *repoussoirs*, leading the eye into the picture and towards the central figure which

146. Jacques Bellange: The Annunciation.
Etching. *London, British Museum*

appears between them. In this case Bellange uses another familiar trick, for between the two soldiers there projects into the composition the figure of a woman cut off at the waist by the edge of the picture. This device goes back to some of the earliest works of Italian Mannerism, the Certosa frescoes of Pontormo, who, perhaps like

Bellange, borrowed it from Dürer. In the etching of the 'Three Marys' Bellange has shown a typically cavalier attitude towards the question of space. Sometimes he deliberately makes the space vague, as in the great 'Annunciation' [146], but in the case of the 'Three Marys' he chooses a viewpoint so high that the ground is tipped up,

147. Jacques Bellange: The Hurdy-Gurdy Player. Etching. *Windsor, Royal Library*

and the spectator seems to be looking down on the principal figures. Bellange has sought other effects of surprise in a spirit very typical of a Mannerist; for instance, he has chosen the unusual course of representing the action as seen from the inside of the cave, and has broken the unity of time by showing the Marys twice over, once in the foreground and again in the mouth of the cave in the background.

Bellange's most important works all deal with religious themes [cf. 145, 146]; but he also designed a few *genre* compositions of which the most remarkable is the 'Hurdy-Gurdy Player' [147]. Here Bellange shows an interest, excep-

tional for him, in the ugliness and deformity of the blind beggar; but, as we shall see with Callot, there is nothing unusual in this simultaneous inclination towards the opposite extremes of elegance and repulsiveness.

Jacques Callot was born at Nancy in 1592 or 1593.[39] His family had been connected with the ducal court for several generations and his father was King-at-Arms to Duke Charles III. In 1607 Jacques was apprenticed to a Nancy goldsmith, Demange Crocq. At some time between 1608 and 1611 he left Nancy for Rome, where he joined the studio of his compatriot, the engraver Philippe Thomassin, who has already been mentioned in connexion with Bellange. There he learnt the current technique of line engraving and practised his hand at copying compositions by Flemish artists such as Sadeler, and Late Mannerist works in Roman churches. At the end of 1611 he moved to Florence, where his real artistic career begins. He was immediately attached to the court of the Grand Duke, Cosimo II, who was a patron of the arts and above all a lover of every kind of festival and celebration. In 1612 Callot was commissioned to engrave a series of plates recording the memorial ceremonies for the death of the Queen of Spain, and soon afterwards another on the life of Ferdinand I of Tuscany, the latter mainly after the designs of Florentine painters. But he was to achieve his greatest success in engraving those public festivities with which the Grand Dukes sometimes amused the people of Florence, and of which the invention was usually due to Giulio Parigi. Parigi provided the fantastic cars and allegorical figures of the *Guerra d'Amore* or the *Intermezzi*, but it was Callot who found the brilliant idiom for rendering the action of those taking part. The idiom can be seen applied to a slightly different subject in the background of the etching of the 'Two Pantaloons' [148], which dates from this period. In this case the people represented are not the members of a pageant, but the ladies and gentlemen of Florence out walking. In the so-

phisticated Medici Court, however, the border-line between *festa* and daily life was very vague, and here the courtiers are behaving almost as if they were taking part in a ballet. It is this swaggering, dance-like action that Callot renders easy; but in the huge plates like the 'Florentine Fête' [149] the actors taking part in the scene run into hundreds, and Callot displays incredible skill in forcing them into a coherent pattern.

148. Jacques Callot: The two Pantaloons. 1616.
Etching. *London, British Museum*

with such vividness, adopting for the figures poses which go back to Late Gothic models, seen through the eyes of Flemish Mannerists such as Goltzius. But affected though their movements are, Callot's figures are based on close and witty observation; they combine artificiality with naturalism in a manner only excelled by Watteau. Some of them even take up the poses of the little figures in the fantastic engravings after Bosch and Bruegel which were common in Italy.[40] Callot seems to have been influenced by these artists in the way in which he builds up his innumerable figures into a single composition. In the 'Two Pantaloons' the problem is relatively

The 'Two Pantaloons' shows another important aspect of Callot's work, namely his love of the grotesque. Even in Rome he had begun to imitate the engravings of beggars and deformities by artists like Villamena and Agostino Carracci, who in their turn had derived the idea of such studies from Flemish artists of the sixteenth century. Callot made a speciality of this kind of subject, and his *Gobbi* (hunchbacks) and *Beggars* are still among his most popular works. In the 'Pantaloons' he borrows his grotesque characters from a source to which he often turned, the *Commedia dell'Arte* or Italian Comedy. In the 'Two Pantaloons', however, Callot not only de-

149. Jacques Callot: Florentine Fête. 1619. Etching. *London, British Museum*

150. Jacques Callot: The Agony in the Garden. 1625. Wash drawing. *Chatsworth, Derbyshire*

picts these grotesque figures, but shows them side by side with his elegant courtiers. It is typical of the Mannerist state of mind that the artist should turn, in his reaction against the norm of classical beauty, towards the two extremes of affected elegance and sheer ugliness, and should find a further piquancy in the juxtaposition of the two. Callot's technique in etching is highly personal. He found the current soft varnish inadequate to the delicacy which he sought and replaced it by the hard varnish employed by lute-makers, a habit in which etchers have followed him to the present day.

In 1621 the Grand Duke died and his widow, who became regent, introduced economies, which included the cancellation of Callot's pension. The artist therefore left Florence and returned to Nancy, where he soon became one of the leading figures in the artistic life of Lorraine.

In Nancy he carried on the various types of etching with which he had established his reputation in Florence. In 1627, in continuation of his *fêtes* series, he engraved the celebrations in honour of the visit of the Duchesse de Longue-ville during her exile from Paris; in 1622 he produced the finest of his studies in the grotesque, the 'Gipsies'; and in the 'Fair of Gondreville' (1624) he repeated the Italian 'Impruneta'. These last two etchings show signs, however, of a new tendency in his art which appears after his return to Nancy, an interest in the objective rendering of everyday scenes which are neither swaggeringly elegant nor grotesquely ugly. In the 'Gipsies' he still shows his interest in the grotesque though much less than in the 'Hunchbacks', and in other etchings his rendering is much more objective.

This difference of tone is part of a general change of attitude, which can be described roughly as an increasing seriousness. The old elements of Court Mannerism still occur, but parallel with them others gain ground. For the first time, for instance, Callot makes drawings and etchings of landscape for its own sake. Illustration 150 of the 'Agony in the Garden' shows his feeling for the rendering of natural scenery, though here it is used as a setting for a religious subject; but there are many dozens of drawings

151. Jacques Callot: Landscape. Pen drawing.
Chatsworth, Derbyshire

and etchings executed by Callot at Nancy in which the landscape is the real theme. Generally speaking, these follow the Mannerist tradition as it had developed in the Low Countries from the inventions of Bruegel, whose engraved landscapes Callot must certainly have known. The convention is fairly rigid and can be seen in illustration 151: a dark tree in the very foreground, the recession based on an alternation of light and dark passages, arranged in wings as on a stage, aided by an exaggerated perspective established either by the sharply converging lines of buildings or the sudden diminution in the scale of the figures, as in the 'Agony'. The stage properties which Callot employs are arbitrary and often repeated – fantastic rocks, broken-down cottages, decaying châteaux – but he uses them with such skill and variety that their artificiality is not disturbing.

A marked change can be seen in the religious etchings of Callot during the Nancy period. In Florence he had designed many compositions of religious subjects in the current style of the Late Florentine Mannerists without any personal addition, and without great depth of feeling. But in the Nancy designs such as the 'Great Passion', for which illustration 150 is one of the preparatory drawings, a real sense of drama appears. Here Callot uses the devices of Mannerism to give poignancy to the story. The artist brings out the sense of tragedy by isolating the tiny figure of Christ in one of the suddenly lit passages in the middle distance; by contrast the approaching soldiers appear in the shadow, half cut off by the edge of the hill. That is to say, the tricks of scale and of lighting are used for dramatic and not for purely formal purposes.

In 1625 Callot was called to Brussels to collect material for his huge 'Siege of Breda', commissioned by the Infanta Clara Eugenia, and in about 1629 Richelieu invited him to come to Paris in order that he might celebrate the capture of La Rochelle and the island of Ré in a similar manner. These three siege compositions are among his most dazzling performances from the technical point of view, in the brilliant grouping of their hundreds of small figures and the inventiveness of their decorative borders. While in Paris he also made some of his most celebrated topographical landscapes, including the two views of the Seine.

He returned to Nancy about 1631, and the remaining four years of his life were marked by Richelieu's invasion of Lorraine in 1633, the capture of Nancy and the ignominious surrender of the Duke. We do not know how far Callot was directly involved by these events, but they must have affected his life, and his reaction is to be seen in his last great work, the 'Grandes Misères de la Guerre', executed in 1633.

It has frequently been pointed out that these etchings must not be connected too closely with the actual campaign in Lorraine because some of the scenes which they contain had already been introduced by Callot into earlier works, notably the 'Siege of Breda', and that some of the 'Misères' themselves were begun before the attack on Nancy. But this does not affect the real point. Lorraine was near enough to the Empire to have been in contact with the horrors of the Thirty Years War for fifteen years; Callot himself had been forced to study the sieges of Breda and La Rochelle, even if only after the event; and the 'Grandes Misères' may therefore be regarded as a precipitation of his general feelings about war, brought to a head by the invasion of Lorraine.

In the manner of presentation Callot brings all his previous experiments to bear on intensifying the horror of the story which he has to tell. In the etching in which the bandits are hanged [152], the traditional dark tree in the foreground is replaced by a group of the priest giving absolution to a man about to join the row of gallows-birds in the centre of the composition. The tree from which they hang is isolated in the middle of a wide circle of soldiers, reduced by distance to minute scale. On the figures of the hanged

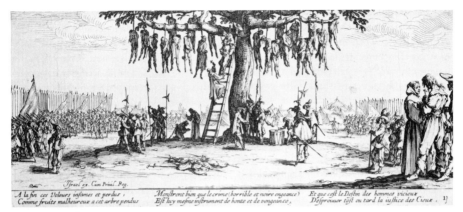

152. Jacques Callot:
Scene from the *Grandes Misères de la Guerre*. 1633.
Etching. *London, British Museum*

men Callot has expended as much observation and as much finesse as in all his sketches of the courtiers of Florence. The result is strangely grim, and gives the lie to those who maintain that Callot was a purely detached observer, recording the scene of hanging without emotion as if it had been the Fair of Gondreville.

The third member of the Lorraine trio, Claude Deruet, was in his day even more suc-

cessful than the other two and was for many years official painter to the Duke of Lorraine and director of his court festivities. His style, as it can be seen in the 'Four Elements' painted for the château of Richelieu [153], is an extension of the methods of Callot to a larger scale, but in the process of enlargement all the finer qualities of the original disappear. Deruet is an interesting phenomenon in that he went on working till his

153. Claude Deruet: Fire.
Orléans, Museum

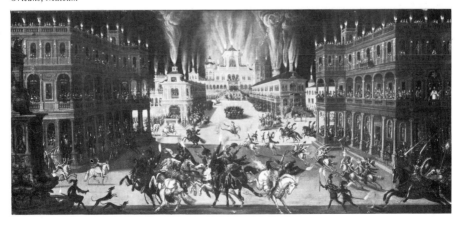

death in 1660 in a style that was already out of date by nearly thirty years.[41]

Deruet's compatriot and contemporary, Georges Lallemant, was more important in that he moved from Nancy to Paris about 1601 and set up a highly successful studio through which passed many of the major artists of the next generation, including Poussin and Philippe de Champaigne. Few of his works have survived, but his style is known from the engravings made after his designs by Businck. These show that he brought with him to Paris the manner of Bellange, who was presumably his master in Nancy.[42]

One painter active in Paris before the return of Vouet in 1627 must be mentioned, namely Claude Vignon (1593-1670), who represents a phase of European art which otherwise hardly penetrated to Paris.[43] He was born in Tours, and

154. Claude Vignon: The Death of a Hermit. *Paris, Louvre*

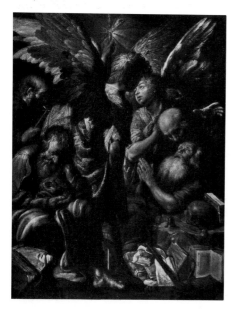

probably began his artistic education in Paris in the current Late Mannerist style of Lallemant and Fréminet. But his style was really formed in Rome, where he seems to have spent roughly the years 1616-24. There he seems to have come under all sorts of influences, including that of the followers of Caravaggio; but the artist to whom he owed most was Elsheimer. He must have studied his works directly, but he no doubt also knew those of Elsheimer's younger followers such as Lastman. The composite nature of his style is well seen in the 'Death of a Hermit' (painted after 1620) [154]. Here marked traces of Late Mannerism can be seen in the heads of the angels and of Caravaggesque naturalism in the still-life, but the most noticeable feature of all is Vignon's use of that rich and almost tortured quality of paint which Lastman learnt from Elsheimer and transmitted to the young Rembrandt. In colour the same mixture exists: the subdued grey-browns in the monk's habit – recalling Zurbaran – are strikingly interrupted by the almost rainbow sequences in the wings and robes of the angels. In certain works of the 1620s, such as the 'Queen of Sheba' in the Louvre, the closeness to the early Rembrandt is even greater. Nor is it entirely accidental, because we know from a letter that the two artists were at any rate acquainted and that Vignon, who seems to have been a dealer and valuer of pictures as well as a painter, sold works of Rembrandt in France. On his return to Paris he seems also to have come under the influence of Rubens, as in the 'St Jerome' of 1626 (Stockholm), but in his later works he returns to his earlier more minute handling, and certain paintings, such as 'Christ washing the Apostles' feet' (Nantes), composed with little figures scattered in large empty spaces, seem almost like Callot. Vignon lived long enough to become a foundation member of the Academy, but like his contemporary Le Muet in architecture he never fully understood the new classicism, and his later style is

only a dilution of his earlier manner with the Mannerist features somewhat reduced.

Mention must also be made here of the first group of imitators of Caravaggio connected with France. The first, Valentin de Boulogne (1591–1632),[44] hardly concerns the history of French painting since he spent the whole of his active life in Rome. The second is a Fleming, Louis Finson (c. 1580–1617), who lived for a number of years in Provence painting altarpieces in a style combining elements that he borrowed from Caravaggio, Elsheimer, and Late Mannerism.[45]

One other provincial painter of the period deserves mention. Jean Boucher of Bourges (1568–after 1628) painted altarpieces for churches in Berri, several of which, ranging in date from 1604 to 1628, survive in the Musée Cujas at Bourges. His manner is composed of a mixture of Italian and Flemish Late Mannerist elements.

Throughout the regency of Marie de' Medici and largely owing to her activities contacts were maintained with artists of various other countries. Objectively the most important artistic event in Paris during the period which we are considering was the decoration of the gallery of the Luxembourg for Marie de' Medici by Rubens in the years 1622–5, though it is a fact, frequently commented upon, that these masterpieces of Baroque painting exercised almost no influence on French art till the end of the seventeenth century, so contrary were they to the current conventions of Late Mannerism and to the new canons of classicism which were about to be imposed.

The other artists involved in the decoration of the Luxembourg probably give a more accurate impression of her real taste. The Cabinet Doré was decorated with a series of canvases illustrating the history of the Medici family, above all in terms of the successful marriages which allied it to the Imperial and French and Spanish royal families. These paintings were commissioned by the Grand Duke of Tuscany and executed by the not very brilliant artists attached to his Court.[46] In the Cabinet des Muses hung a series of paintings by Giovanni Baglione, sent by the Duke of Mantua and now in the museum of Arras. The Queen was luckier in obtaining the services of Orazio Gentileschi, who apparently worked at the Luxembourg for a few years before going to England at the invitation of Charles I. One of his paintings for the palace has been identified, and it is clear that his work exercised a considerable influence on certain French artists of the next generation.[47] In the decoration of the Luxembourg Gentileschi was succeeded by a French painter, Jean Mosnier of Blois, most of whose work there has, however, disappeared, although one panel survives in the ceiling of the Chambre du Livre d'Or.

Portraiture during the reign of Henry IV and the regency of Marie de' Medici was entirely dominated by the Flemish artist, Frans Pourbus the Younger (1569–1622).[48] Trained by his father, Frans the Elder, he achieved European reputation as a court portrait painter, first in Brussels and then, from 1600 to 1609, in Mantua. In the latter year, after passing through various other cities, he was called by Marie de' Medici to Paris, which he had visited for a short time in 1606, and where he was to remain till his death in 1622.

Pourbus brought to France the tradition of portraiture of which Mor had been the founder and greatest exponent in the Low Countries, but which had evolved since his death towards a greater degree of formalism, with more emphasis on outward show and on the depiction of rich dresses and jewels. By the turn of the century this manner had become almost universal and is to be found as much in Spanish painters, such as Coello and Pantoja de la Cruz, as in the earliest works of Rubens.

The most important commissions which Pourbus received in Paris were for state por-

traits of Henry IV, Marie de' Medici, and the Dauphin, later Louis XIII. The portrait reproduced as illustration 155 shows the impressive quality which he was able to give to his sitters, though in this case he has left out many of the enrichments which he uses for the portraits of the royal family. On the other hand his representation of the Duc de Chevreuse reveals a different side of Pourbus's talent, namely his naturalism in the painting of both the head and of

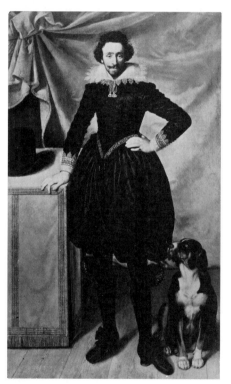

155. Frans Pourbus the Younger:
The Duc de Chevreuse. 1612.
Althorp, Northamptonshire, Earl Spencer

the stuff, a quality which is frequently obscured under the formality of the state portraits.[49] This type of portrait was to be the basis of the style of

Philippe de Champaigne, and is therefore important for the whole later development of the *genre* in France.

Pourbus also painted a few religious pictures while in Paris, of which one, the 'Last Supper', now in the Louvre, is of great interest in that it seems to have given Poussin his first taste of the grand manner of designing in the Venetian style, which Pourbus had learnt while in Mantua, and the influence of this composition can be traced in relatively late paintings by Poussin, such as the 'Eucharist' from the second series of Sacraments dating from 1647 [237].[50]

French sculpture produced little that was notable during this period. The most important monuments were erected by foreigners and have since been destroyed, namely the equestrian statues of Henry IV on the Pont Neuf and of Louis XIII in the Place Royale. Of the former, begun by Giovanni da Bologna and completed by his pupils, the only parts surviving are a fragment of the horse's foreleg and the slaves round the pedestal by Pierre Franqueville, a Fleming influenced by Adriaen de Vries.[51]

The most important French sculptors of the period were Pierre Biard (1559-1609) and Mathieu Jacquet (d. 1610).[52] Biard's 'Fame' from the tomb of the Duc d'Épernon, now in the Louvre, shows him to have been a robust if somewhat insensitive follower of Giovanni da Bologna, but in his figures on the screen of St Étienne-du-Mont the influence of Goujon is more apparent. Jacquet's reputation was based on the Belle Cheminée at Fontainebleau, of which the central feature was a life-size equestrian portrait of Henry IV in high relief [156]. This has been much altered, but from the remaining fragments and from old drawings it was evidently an impressive piece of sculptural decoration. Barthélemy Tremblay (1568-1629) specialized in portraiture and decorative sculpture, in which he carried on the tradition of Pilon.

156. Mathieu Jacquet: Equestrian portrait of Henry IV. *Fontainebleau, Château*

RICHELIEU AND MAZARIN

1630-1661

During the ministries of Richelieu and Mazarin - that is to say, roughly between 1630 and 1660 - France finally established her position as a great power in Europe. In foreign policy these years mark her victory in the struggle with Spain and the Empire, and internally during the same period the last forces of discord, social and religious, were crushed. The outward glory of France was greater in the decades which followed, when Louis XIV laid down the law to Europe, but there is something more heroic in the preceding phase, which is the age of achievement as compared with that of enjoyment.

In external affairs Richelieu and Mazarin did little more than follow the lines of policy which had become traditional in France since the time of Francis I, but, with a richer and more united country behind them, they were able to follow them with greater success. Richelieu managed to inflict serious wounds on Spain and the Empire, while at the same time exposing France as little as possible to the horrors of war. His practice of subsidizing the enemies of the Habsburgs - even when, as in the case of Gustavus Adolphus, they happened to be Protestant - proved extremely profitable, and his diplomatic skill often caused serious defeats to the enemy without costing France a single man. Mazarin had only to continue along the same lines, although he was forced to come into the open and declare war on Spain. However, his diplomatic skill enabled him to extract at the Peace of Westphalia (1648) advantages out of all proportion to the sacrifices France had made. The same tech-

nique led to the final humiliation of Spain at the Peace of the Pyrenees in 1659.

Of even greater importance were the internal reforms carried out by the two ministers. Here their techniques were wholly different, Richelieu using open and ruthless methods, Mazarin going about his work in a more subtle and indirect manner; but the results were the same.

To Richelieu goes the credit for solving the problem of religious unity. After defeating an open rebellion of the Protestants in 1629, he had the wisdom to leave them complete liberty of conscience, while at the same time destroying them as a political force. His attitude towards Rome was equally skilful, though somewhat surprising in a cardinal. By playing ingeniously on the Gallican tendencies of the Parlement he managed to restrict Papal interference to the minimum. At the end of his life he could reasonably have said that, although there might be differences of doctrine in the field of religion in France, there was unity of loyalty.

His struggle with the socially dissident elements was far more difficult. The Wars of Religion had weakened and impoverished the feudal nobility, but had by no means destroyed their power. They soon realized that Richelieu intended to finish the work and, led by the princes and princesses of the blood, organized a series of plots, all of which failed owing to their habit of including in each conspiracy Gaston d'Orléans, the King's brother, who invariably betrayed it. These plots were seized on by Richelieu as opportunities to strike at the nobility, and were followed by executions and the razing of castles. Even when not engaged in such violent attacks,

Richelieu continued his policy of weakening the nobility by other methods, such as steadily undermining the position of the provincial governors and transferring as much as possible of their power to the central authority. In the same way he continued the old policy of reducing the Parlements and the provincial États, but here he was not always successful, as he was dependent on them for a part of the state income.

The death of Richelieu at the end of 1642, followed by that of Louis XIII himself early in 1643, seemed for a moment to endanger the whole of the work that had been achieved. The nobility were quick to realize the weakness of the Crown, owing to the fact that the King was a minor, and they were deceived by the apparent benignity of the new minister, Mazarin. Instantly the old plots began again and it was evident long before the outbreak of the Fronde in 1648 that Mazarin would have trouble with these traditional enemies of the Crown.

The great blunder made by Mazarin was his estrangement of the *bourgeoisie*. Like Richelieu, Mazarin had somewhat primitive ideas about finance, and, provided that money was available for present needs, he did not enquire too closely into the methods by which it was obtained or the possible implications for the future. This lack of foresight, combined with the corruption of the financiers who worked for him, created a series of grievances in the minds of the *bourgeoisie*. New taxes were added which hit them particularly; the sale of offices was increased, which lowered the effective value of those already in existence; and, most serious of all, the payment of *rentes* became extremely irregular and the rate of interest insecure. The result was that the middle classes were, almost against their will, forced into hostility towards the Crown as it was represented by Mazarin, and, when the nobles came into the open against the minister, they could count on support from this unexpected quarter.

The story of the Fronde (1648–53) is one of confusion, but the main implications of it are clear and important. The nobility went into it hoping to regain the power which they had seen slipping from them. The *bourgeoisie* took part, as has just been said, for much more temporary reasons, and they soon realized that they stood to lose more by the victory of their allies, the nobility, than by the triumph of their nominal enemy, the Crown. The situation was fundamentally the same as that during the Siege of Paris under the League, and the evolution of thought was the same. The *bourgeoisie* gradually came to its senses, and the basic differences which separated it from the nobility were given greater prominence by the injudicious use which the latter made of a powerful but dangerous weapon: their ability to rouse the Paris mob against the *bourgeoisie* when the latter was recalcitrant. After the people of Paris had burnt the Hôtel de Ville at the incitement of Beaufort, the *bourgeoisie* realized that they had chosen the wrong allies. The Fronde collapsed partly because of the futility, internal quarrels, and lack of policy of the nobles, and partly because the *bourgeoisie* saw where their real interests lay.

The Fronde is of immense significance because it led to a re-alignment of parties within the kingdom which lasted for more than a century. The power of the nobility was finally and completely broken, and the way was open for Louis XIV to distract them from noticing that they no longer performed any function by giving them that most expensive of toys, the Court of Versailles. The middle classes finally accepted the fact that they could best achieve their aims by submitting to the wise dictation of a central authority. Luckily Colbert was sufficiently intelligent to conduct autocratic government so that the middle classes really obtained the benefits for which they had hoped.

One feature of this period, which is of particular importance for the development of the arts, is the enormous increase in the wealth and power of the middle classes. We have seen that throughout the sixteenth century they had been

establishing their position, but it was under Richelieu and Mazarin that their rise took a steeper upward curve. The methods by which they attained their wealth were mainly disreputable, largely through the exploitation of the loose financial administration of the Government, but the result was remarkable in many ways. It is hardly an exaggeration to say that during this period, apart from works ordered by the Crown, the first minister, or by one or two princes of the blood, such as Gaston d'Orléans, every commission of importance comes from a *bourgeois*. Whereas in the late sixteenth and the early seventeenth centuries the names of the great French families occur frequently in art history, if we list those who employed François Mansart or Le Vau, Poussin or Vouet, we shall hardly find one name belonging to the *noblesse d'épée*. The period ends characteristically and spectacularly with the career of one of the greatest of all *bourgeois* patrons, the Surintendant Nicolas Fouquet. Fouquet gained immense wealth by methods no more corrupt than those of his colleagues, and he used his money with exceptional taste. He collected round him a team of architects, sculptors, painters, poets, dramatists, and musicians, who made of Vaux-le-Vicomte the greatest art centre of its period and who after his disgrace were to become the nucleus of the culture of Versailles.

During the period of Richelieu and Mazarin there flourished one of the most brilliant groups of Frenchmen ever to have appeared at one time. In philosophy it was the age of Descartes, in religious thought that of Pascal, in drama that of Corneille, in painting that of Poussin and Claude, in architecture that of François Mansart, and in the world of action it was the time of Condé and Turenne as well as François de Sales and Vincent de Paul.

French culture of the time was far from uniform. While some sections of the Paris public were applauding the tragedies of Corneille, Rotrou was still scoring a success with his tortuous tragi-comedies, and Mme de Rambouillet and her circle of *Précieux* were playing elegant games with madrigals and epigrammatic verses and reading the *Astrée*.[1] While Jansenists and Jesuits were feuding in the field of religious activity and thought, the *libertins – érudits* or otherwise – were also making progress. French prose reached a new crispness in Pascal's *Provinciales*, but Mlle de Scudéry was still writing her endless romantic-heroic novels.

In the visual arts the variety is equally great and the situation is further complicated by outside influences. Many French artists visited Italy, where Rome was their principal goal, but they were also more deeply affected than is generally realized by Venetian art. At the same time Paris was open to influences from Flanders and even Holland, which led some painters in the direction of naturalism. Fortunately French artists were able, out of all these disparate elements, to create a new and independent style, which, for better or worse, was taken by French artists as a standard, to imitate or to reject, for at least two hundred years.

ARCHITECTURE

Lemercier, François Mansart,
the early work of Le Vau

French architecture of this great age was the creation of three men: Jacques Lemercier, François Mansart, and Louis Le Vau. Of very different character, of talent varying in degree and kind, they yet each made a distinct contribution to the evolution of the style and were to influence their successors for more than a century.

Jacques Lemercier was the eldest and perhaps the least talented of the three.[2] He was probably born about 1580–5, the son of a master mason who worked on the church of St Eustache. It may be assumed that he obtained his first training in his father's workshop till, at a

date before 1607, he went to Rome, where he seems to have stayed till about 1614. In 1615 he is mentioned in the royal accounts, but we have no record of any work by him till 1624, when he was commissioned to carry out Louis XIII's new plans for extending the Louvre. His career

157 and 158. Jacques Lemercier:
Paris, church of the Sorbonne. Begun 1635.
Plan, from the *Petit Marot*, and façade

was, however, to depend above all on the favour of Richelieu, for whom he built the Palais Cardinal, later called the Palais Royal (begun 1633),[3] the Sorbonne (begun 1626),[4] the château and church at Rueil,[5] and the château and new town at Richelieu (begun 1631). In addition to these buildings for the Cardinal, he enlarged the Hôtel de Liancourt[6] and probably built the Hôtel d'Effiat,[7] and he was involved in the building of three great Paris churches, the Oratoire, St Roch, and the Val-de-Grâce [159], but his precise contribution to them is impossible to determine.[8]

Lemercier's style is composed of two elements which he never succeeded in completely fusing: the first is the current French manner of the first years of the seventeenth century, the second the idiom which he learnt in Rome.

It will be convenient to consider the second aspect first, because it can be found in isolation in Lemercier's church designs. The three churches for which he was responsible were two small buildings at Rueil and Richelieu and the more ambitious church of the Sorbonne begun in 1635 [157, 158].[9] All three show a Roman form of front with two superimposed Orders facing the nave, this higher central part being linked by volutes to the lower sections closing the aisles. This Roman front had only been seen once before in Paris in the Novitiate of the Jesuits built by Martellange in 1630,[10] which was an almost exact copy of Giacomo della Porta's S. Maria dei Monti.[11] From the general character of Lemercier's three façades it is clear that he has studied the same type of model, and has followed Giacomo's method of articulating the wall principally with pilasters.[12] The alternating rhythm of wide bays with doors or windows and narrow ones with niches could also be paralleled in the churches of Giacomo and the other members of this academic late sixteenth-century group.

The Sorbonne, however, leads us to a more precise source and even to a possible master for

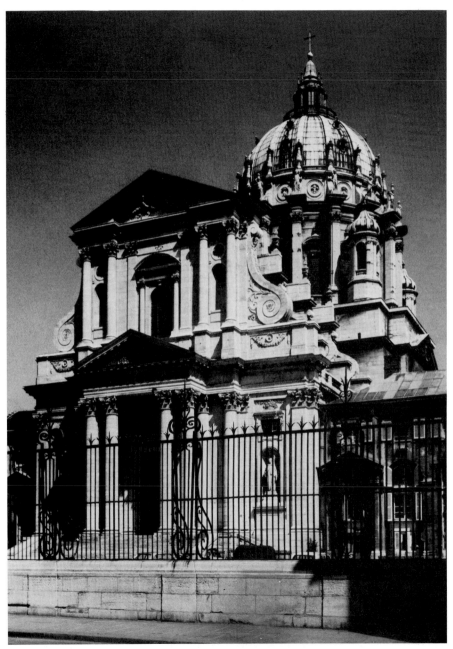

159. François Mansart and others: Paris, Val-de-Grâce. Begun 1645

Lemercier in Rome. The plan [157] is an un-
usual one, consisting of a central dome, round
which are grouped a nave and choir of equal size
and two shallow transepts, the corners between
the arms of the cross being filled with four rec-
tangular chapels each of two bays. The only
asymmetrical element in the plan – apart from
the north porch, to be considered later – is the
shallow bay containing the altar. Now, this plan
is a close imitation of Rosato Rosati's church of
S. Carlo ai Catinari in Rome, which was begun
in 1612; that is to say at a time when Lemercier
was in Rome.[13] Even more striking, however, is
the resemblance of the two domes. The drum of
the Sorbonne dome differs from the conven-
tional Roman design of the late sixteenth or early
seventeenth centuries in that it is articulated
with clustered pilasters, between which are
round-headed windows; and both these features
occur in S. Carlo, but, as far as I know, in no
other dome of the period.[14]

Now, the dome of S. Carlo was not completed
till 1620, that is to say, about six years after Le-
mercier left Rome, and one is forced to the con-
clusion that he must have known Rosati's plans;
hence that he must have had access to his studio;
and therefore that possibly this architect may
have been his master. In any case, Lemercier's
relation to Roman architecture can be precisely
defined; he brought back to France the aca-
demic style inaugurated by Giacomo della
Porta and continued after his death by a few
architects, of whom Rosati was one, who re-
sisted the movement of Maderno towards the
Baroque. In this way his function in relation to
the development of French art is analogous to
that of Vouet, who brought back the idiom of
painting current in Italy just before the flower-
ing of the Baroque.

There is, however, one original feature in the
Sorbonne. The church had to present two im-
portant façades: the main front towards the
street, and another on the north towards the

court of the college. To make the latter front
impressive Lemercier added to the north tran-
sept a free-standing classical portico[15] with a
triangular pediment enclosing a cartouche with
the arms of the Cardinal, which makes a striking
and unusual end to the courtyard.[16]

The buildings which Lemercier designed for
the university were swept away in the nine-
teenth century but the main façade, executed
by Cottard in 1648, is recorded in a drawing. The
Palais-Royal has suffered almost as much. It
was so much modified in the late eighteenth and
nineteenth centuries that only the reliefs from
the Galerie des Proues survive, but the old n-
gravings confirm what contemporaries said of
it, namely that it was inconvenient and con-
fused in design.[17]

Lemercier received his most important royal
commission in 1624, when he was ordered to
continue the Square Court of the Louvre ac-
cording to the scheme conceived in the sixteenth
century. This involved doubling the existing
wing on the west side of the court and inventing
a centre for the now enlarged building. For this
centre Lemercier built the Pavillon de l'Hor-
loge, of which the three lower stages are simply
an adaptation of Lescot's design. Over the lat-
ter's attic, however, Lemercier adds a full storey
of his own invention with caryatids supporting a
complex pediment, above which rises a square
dome of the kind used by J. A. du Cerceau the
Elder and de Brosse, which Lemercier was to re-
peat constantly, for instance at Richelieu.[18] The
only trace of Roman feeling in this design is in
the curious repetition of the pediments, a
straight within a curved within a straight pedi-
ment, which is an extension of the method used
by della Porta on the façade of the Gesù. The
caryatids after the designs of Sarrazin are an in-
genious solution to the problem which faced
later architects in continuing the court;[19] that is
to say, the difficulty of knowing what Order to
use in the top floor, since the lower floors are

decorated with Corinthian and Composite, above which, according to classical precept, no proper Order of columns may be placed.[20]

Of Lemercier's domestic works in Paris only one need be mentioned in detail, the Hôtel de Liancourt.[21] In 1623 the Duc de Liancourt bought the Hôtel de Bouillon, built by de Brosse in 1613, and enlarged it to almost double its size on the designs of Lemercier.[22] The enlargement of the site gave the architect the opportunity of an ingenious piece of planning [160]. Seen from the street, the left half of the site was occupied

160. Salomon de Brosse and Jacques Lemercier: Paris, Hôtel de Liancourt. Plan, from the *Petit Marot*

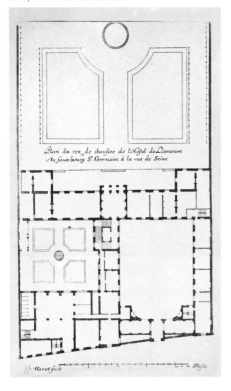

by a base-court and a small garden, and the right half by a court forming the main approach to the house. The *porte-cochère* was flanked on the court side by two quadrant wings with niches, an arrangement probably surviving from de Brosse's building which was to be much imitated by later architects. More remarkable, however, was the disposition of the principal *corps-de-logis* which ran along the whole width of both courts, presenting on the garden side a front of fifteen bays, with pavilions at the ends and a portico with three openings in the middle. From the court the entrance to the house lay in the corner; it opened on the staircase and led through it to the vestibule on the garden.[23] In this way Lemercier managed to produce the maximum grandeur on the garden side while leaving ample room for the stables and offices, and at the same time concealing the difference of axis between the court and garden fronts. This type of solution was to be widely used by later architects in Paris.

Of the two country houses, Rueil and Richelieu, built by Lemercier, practically nothing remains. Rueil was a modest house principally famous for its elaborate gardens which contained many rare plants and were ornamented with a rusticated grotto, cascades, *pièces d'eau*, and a triumphal arch painted by Jean Lemaire on a wall which formed the end of a vista. The gardens, including the vista with the triumphal arch, are recorded in engravings by Israël Silvestre.

The château of Richelieu [161] was designed on a scale that was quite different from Rueil.[24] In conception it is reminiscent of Charleval. The château itself was of the usual form round three sides of a square court, with a low closing wall on the fourth; but in front of this spread a forecourt enclosed by two lines of offices. This forecourt opened out again into a still wider space, of which the middle zone formed the approach to the house, while on each

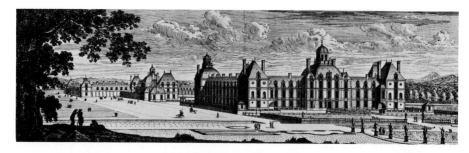

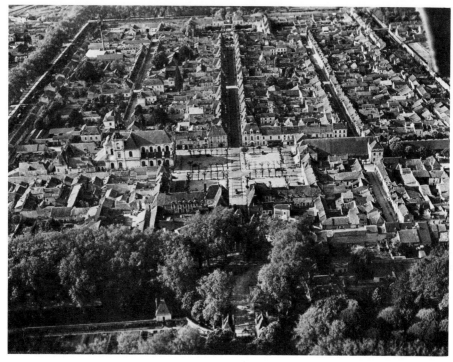

161 and 162. Jacques Lemercier: Richelieu (Indre-et-Loire).
Begun 1631. Engraving of château by Marot and air view of town

side was a base-court concealed behind a rusticated wall. Finally came the entrance gate itself, set in a semicircular wall with pavilions at the ends. The main lines of the design were carried on into parterres behind and on the north side of the château. Of all this there remain only two small garden grottos, the entrance gate, and one domed pavilion of the office block. Illustration 161, which represents the château from the garden side, gives an idea of the general character of the ensemble, with the buildings of the office block and one base-court disappearing into the distance on the left. It also shows, however, that Lemercier was ill at ease when designing on this scale. In particular, the garden front is composed of a series of almost unrelated sections: a heavy central pavilion and two smaller end pavilions, against which nestle, as it were, four mean little turrets, in two cases supported on *trompes*. In this additive method of designing a façade, Lemercier has made no advance on the architects of the previous generation; and much of the decoration is also archaic, particularly the elaborate dormers. From contemporary descriptions we learn that the effect of the exterior depended largely on the statues and busts which filled niches all round the court and a few on the garden front. These were nearly all antiques, except for the two Michelangelo Slaves which were moved here from Écouen. The interior was richly decorated with paintings and tapestries.[25]

The Cardinal's ambition was not, however, limited to the building of a château at Richelieu. He wished also to found a town which should bear his name, and he therefore ordered Lemercier to prepare a completely new scheme according to which the village of Richelieu would be enlarged to a township planned and executed according to the most rational principles. This project was carried out, and Richelieu still stands to-day [162] as one of the most consistent examples of town-planning on a small scale. The town forms a rectangular grid with a main street forming the long axis and connecting two squares, and the houses are of uniform design, built of brick with stone quoins. The project is in fact an extension of Henry IV's ideas for the Paris *Places*. But Richelieu lacked the common sense of Henry; he overlooked the fact that there was no good economic reason why there should be a town on that particular site, and though he used every means to persuade people from neighbouring districts to migrate to Richelieu, he had little success, and the town seems always to have been as deserted as it is to-day.

<center>★</center>

François Mansart was in almost every way a complete contrast to Lemercier. Lemercier was a competent designer, whose chief importance lies in his introduction of a new foreign idiom. Mansart was an architect of almost unparalleled subtlety and ingenuity who learnt little from his contemporaries abroad, but brought a genuinely French tradition to a high level of perfection.

We know surprisingly little about Mansart's life.[26] He was born in Paris in 1598. His father was a master carpenter who died when he was quite young, and François was trained by his brother-in-law, Germain Gaultier, who had collaborated with de Brosse at Rennes. Although it is practically certain that Mansart never visited Italy, he instinctively understood some of the essential qualities of Italian classical architecture more profoundly than some of his contemporaries who mastered the Italian idiom of detail.

If 1598 is the correct date for his birth, Mansart must have been unusually precocious, because he appears in 1623 as a well-established architect, and by 1635 his reputation must have equalled that of any rival, since he was called on to plan the château of Blois for Gaston d'Orléans, the King's brother, as well as to build several important private houses in Paris. In 1646 he suffered a severe setback over the

building of the Val-de-Grâce, a commission given to him in 1645 by Anne of Austria. As a result of his difficult character, his recklessness with regard to expense, and his habit of changing his plans as he went along, he was deprived of the job, which was given instead to Lemercier. The same difficulties continued to surround him, and towards the end of his life prevented him from obtaining important commissions, such as the construction of the east front of the Louvre, so that when he died in 1666 he had grown to be somewhat neglected in favour of younger and more flexible men.

As far as we can judge his character, he was arrogant, obstinate, intolerant, difficult, and probably dishonest, but these qualities were only the unattractive reverse of his high feeling for his own calling and his justifiable confidence in his ability as an architect. He made many enemies, who attacked him during his lifetime on all scores, charging him with incompetence as well as corruption. The latter charge may be true, but posterity has not ratified the former.

Before 1630 Mansart had executed or modified three important buildings from which we can form some opinion of his early style and its sources. These are the façade of the church of the Feuillants in Paris (1623), and the châteaux of Berny (designed in 1623) and Balleroy (begun in the late 1620s).

The façade of the Feuillants, as it is known to us through the engraving in Blondel, brings out clearly Mansart's relation to de Brosse in his early years. It is basically a copy of the two upper storeys of St Gervais [140], but with certain variations. The volutes recall sixteenth-century Roman churches, but the obelisks seem to derive from Jacques Androuet du Cerceau. Above the rounded pediment Mansart has added a panel, the top of which consists of a straight entablature breaking into an arch in the middle, a form which he was to use regularly and which he derived from sixteenth-century models (cf., for instance, the entrance at Fleury-en-Bière). The

door has three heavy voussoirs, a device which the architect frequently uses at this time (Berny and Balleroy) and which, like the obelisks, comes from the elder du Cerceau. That is to say, Mansart's façade is less classical than the model on which it is based, so that his position can be defined by saying that, though he based his style on de Brosse, he had not yet understood the significance of his last classical phase, as it is shown at Blérancourt and Rennes, but dilutes his borrowings with decorative elements from the tradition of the du Cerceau. Yet Mansart already shows a subtlety all his own in the treatment of the surfaces into which the wall is broken up, particularly in the central niche and door.

A somewhat similar mixture of elements can be seen in the château of Berny, of which only one wall still survives [163] but of which the general lay-out is recorded in the original drawing attached to the contract [164] and in seventeenth-century engravings.[27] Here Mansart did not have a free hand but was called upon to remodel an existing house which consisted of an I-shaped building preceded by a court closed on the opposite side by a canal, and joined to a base-court on an axis at right angles to the main building. Mansart pulled down the central block of the château and rebuilt it further back, so that the building took on the form of an E rather than an I, with an almost unbroken garden façade. To the right of the main block he added a pavilion containing the staircase, a highly unusual arrangement, designed to link the main building to the offices. He emphasized the central element of his design by giving it an extra floor and a high-pitched roof, and he joined it to the side wings by means of curved arcades. The effect of these changes was to produce an agglomeration of almost independent units, which shows that Mansart was trying to conceive the château as a free-standing unit but that he had not yet mastered the method of so doing which de Brosse had used with such success at Blérancourt. The surviving fragment shows, however, that he

163 and 164. François Mansart: Berny (Seine), château. Begun 1623. Remaining fragment and contract drawing

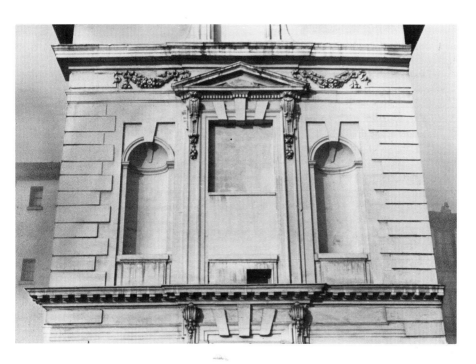

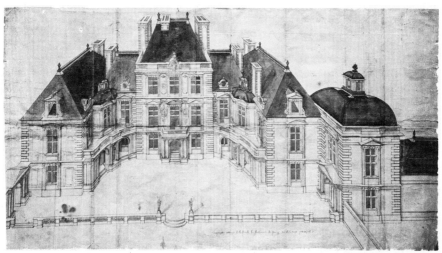

was already evolving a personal style. There are still many traditional Mannerist passages, such as the consoles of the window and door, but certain details, such as the tongue-like voussoirs which cling to the half-domes of the niches, are highly original, and others, like the niches and the palms at the top of the ground-floor panels, foreshadow Mansart's mature classicism.

In Balleroy [165], near Bayeux, built for Jean de Choisy, Mansart has overcome the immaturity visible in the design of Berny. In general character and materials the château is like the country houses of Henry IV's time, and depends for its effect on its massive blocks, built of the rough, brownish-yellow local stone, with quoins and window-surrounds of dressed white stone. The main design of the court side is like the middle of Berny, but Mansart has omitted the wings, and ends the building with low one-storey blocks. The grouping of the main masses is much clearer and more harmonious than at Berny. On the court side it depends on the simple relation of the three main blocks, which are almost in the same alignment, while on the garden side the central block breaks forward more markedly, leaving room for small terraces on either side.

One of the most striking features of the whole design of Balleroy is the forecourt. This is surrounded by a low terrace on which stand two small pavilions, as at Blérancourt. The court itself is raised above the approach, from which it is reached by a flight of steps copied from Philibert de l'Orme's oval flights on the terrace at Anet. This staircase is echoed in three other oval flights, of which two lead from the forecourt to

165. François Mansart:
Balleroy (Calvados), château. *c.* 1626

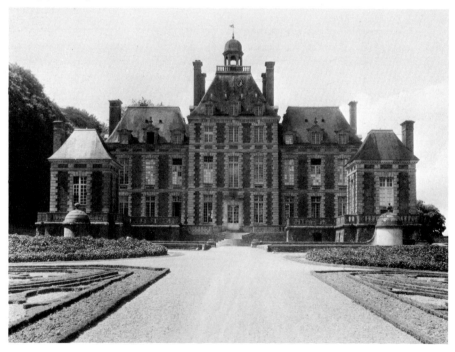

the terrace and the third to the front door. One result of this series of rises in level is that the simple masses of the château seem to tower over the visitor arriving from the village and crossing the moat. At Balleroy, in fact, we may say that Mansart appears for the first time as an independent artist. He has now realized the implications of the classicism of de Brosse in his last phase, and has combined the manner of his master with another tradition which can also in a sense be called classical, namely the brick-and-stone style of Henry IV.

The two patrons who commissioned the châteaux just discussed must have prepared the way for contact with those who were to employ the architect during the rest of his career. Jean de Choisy, son of the owner of Balleroy, was chancellor to Gaston, Duc d'Orléans, brother of Louis XIII, and it was no doubt he who obtained for Mansart the commission for the rebuilding of Blois for the Duke. Nicolas Brulart de Sillery, who began Berny, was chancellor of France, and therefore belonged to the class which was to provide Mansart's best patrons, the great officers of the Crown, particularly those who were connected with the Treasury. La Vrillière, Longueil, Duplessis-Guénégaud, La Basinière, the men whose names recur most frequently in the career of the architect, all belonged to this class of *bourgeois* who had enriched themselves, often with suspicious rapidity, in the service of the State and the collection of taxes. Not once do we come upon the name of a great noble family on Mansart's books; and although he was occasionally to receive commissions from the King and the Queen Mother, he was never successful in these, and his achievement was entirely fostered by the *parvenus* – 'avortons de fortune', as Sauval calls them – who were intelligent enough to understand his sophisticated but luxurious classicism, and rich enough to indulge his extravagant whims.

During the years from 1630 to the beginning of the construction of Maisons in 1642 Man-

sart's personality continues to affirm itself more and more clearly. This is the period of the purest classical works, such as the new wing at Blois, in which the subtlety of the architect's methods reaches its fullest expression and his treatment of detail its greatest refinement. The characteristics of his style during these years are the pursuit of clearly defined forms in plan and in elevation the increasingly correct use of the Orders and a great respect for the flat surface of the wall.

In the earliest of the works now to be considered these features are only partially apparent. The church of Ste Marie de la Visitation in the rue St Antoine was built in 1632–3 at the expense of Noël Brulart, a relation of the builder of Berny. The plan [166], strictly central in conception, consists of a domed circle

166. François Mansart:
Paris, Visitation. 1632–3. Plan, from the *Petit Marot*

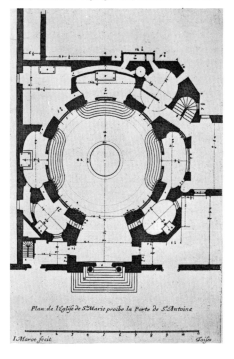

round which are grouped three curved chapels, recalling de l'Orme's design for Anet. The central chapel, forming the choir, is covered with an oval dome into which strong light falls from a tall lantern, producing an effect which anticipates that of the cut-off domes used by Mansart later in his career. The decoration of the interior shows the transition through which the architect was passing. The main Order of the pilasters and the decoration up to the cornice are strictly classical and conceived in terms of flat panels which hardly disturb the surface of the walls, and the same method can be seen in the panelled design on the dome of the choir [167], but in the latter case there is superimposed on this panelling fantastic Late Mannerist high-relief decoration of scrolls and cherubs' heads, which seems in comparison a pure archaism.

In 1635 Mansart received his first recorded commission for a private house in Paris from Louis Phélypeaux de la Vrillière, and designed for him what was to be a model for the Parisian hôtel for many decades [168, 169]. The main part of the building follows the usual form, and consists of three wings round a court closed by a wall, but Mansart has given a classical sim-

plicity and harmony to the whole design. All the elements – the main *corps-de-logis*, the central pavilion, and the wings – are clearly defined masses, almost unbroken by ornament, and each harmoniously related to its neighbours. The windows are rectangular openings surrounded by the simplest mouldings. The division into floors is the same the whole way round the court, but monotony is avoided by subtle variations in the pitches of the roofs, all of which incidentally are lower than was normal at the time, and therefore more easily brought into harmony with the masses which they cover. The garden front was of about double the width of the court side, and was not coaxial with it, but Mansart has disposed his rooms with great ingenuity to conceal this irregularity. The façade was flanked on one side by a long wing running at right angles along the side of the garden and containing on the ground floor an orangery and on the first a gallery. This is an early example of an arrangement which was used by many French architects of Mansart's generation – for instance by Le Vau at the Hôtel de Bautru – but Mansart's gallery struck his contemporaries as peculiarly impressive. As if in protest against the rich gilded decoration of the period, the walls were entirely of stone-coloured stucco, broken only by a series of large canvases by Guercino, Guido Reni, Poussin, and others. The vault was frescoed by François Perrier with allegorical scenes set in imitation stucco frames.

In the Hôtel de la Vrillière, Mansart showed how his new style could be applied to a town

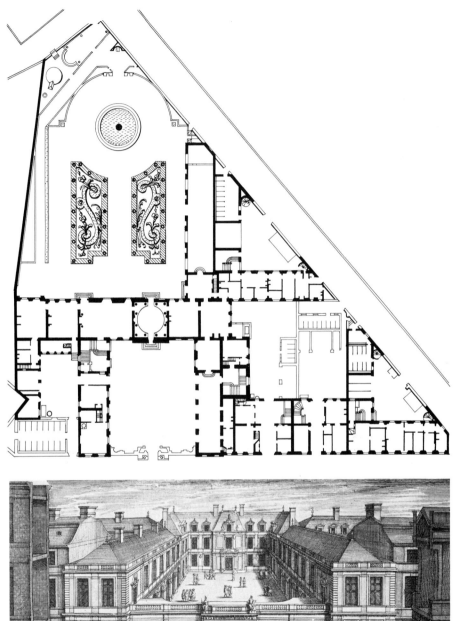

house; at Blois [170] he had an even finer opportunity of showing its potentialities in a great château.

Had it been completed Blois would have been a grander and more monumental version of the Luxembourg. It was to consist, like the latter, of a court with main *corps-de-logis*, double pavilions, wings, and closing side with a rotunda entrance. But it was to have been extended beyond this by a forecourt leading down towards the town on the east and by terraced gardens stretching over the sunk road to the west. The main door of the *corps-de-logis* was approached by two quadrant colonnades, a more classical version of the arcades at Coulommiers and Berny. The plan was full of the kind of ingenuity which has already been noticed in the Hôtel de la Vrillière. Not only were the axes of the court and the garden façades different, but the latter was on a higher level than the former. Mansart, however, has skilfully masked these differences by his disposition of the staircase in the central pavilion. The two wings were to contain long galleries, which were no doubt designed to house the Duke's collections, including his antiques and his natural history specimens, and on the north-west side the gallery was to be doubled by a huge *salle des fêtes*, which would have projected some thirty feet beyond the wing of Francis I on the cliff overhanging the town.

Of all this vast project only the central block and the quadrant colonnades were built, but this fragment is one of Mansart's purest works. Blois is the direct descendant of de Brosse's designs for Blérancourt and the Luxembourg. The masses have the same grand simplicity, and Mansart follows his master's use of the superimposed Orders to articulate them. In this case, however, the problem is less easy because of the difference of level between the two sides of the

170. François Mansart:
Blois, château, Orléans Wing. 1635–8

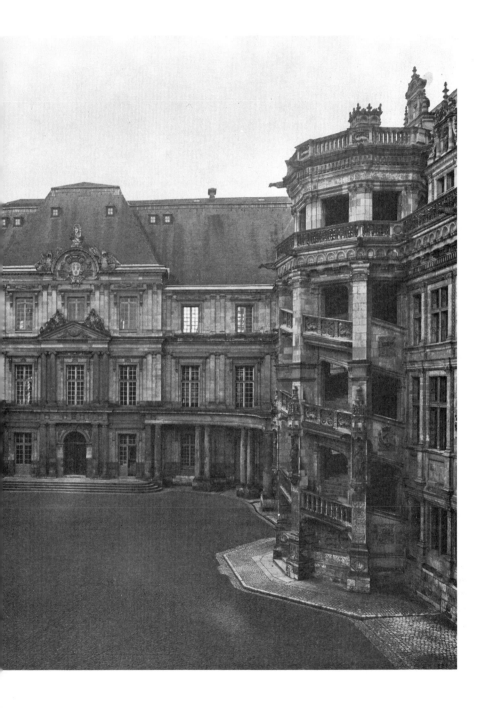

171. François Mansart: Blois, château, staircase. 1635-8. From a drawing by Sir Reginald Blomfield

block. Mansart, however, gets over this by using on the court side the Doric for the ground floor, Ionic for the main storey, and a truncated Corinthian for the attic, while on the other front he replaces the Doric by a low, unarticulated basement. In this way a particular Order is always to be found on the same level on both fronts of the block, a fact which shows that Mansart, unlike most of his French contemporaries, thought of his buildings in the round, and not merely as composed of a series of disconnected fronts. But Mansart eliminates the curved roofs of Blérancourt and substitutes for them a continuous high-pitched broken roof of the kind which bears his name. He has further sharpened the definition of the edges of his buildings by eliminating all rustication and bringing the pilasters right to the corners of the block, whereas de Brosse always sets them slightly back. This clarity of disposition, the harmonious proportions of the masses, and the restrained details

which hardly break the surface of the walls combine to make this one of Mansart's most completely satisfying designs. His style was to become more plastic and more dramatic later in his career, but never again was it to be so placid.

Very different qualities are, however, revealed by the one part of the interior to be actually executed, the grand staircase. Even this was not completed in Mansart's time. The panels on the walls still await their decorative sculpture, and the steps themselves, based on those at Maisons, were put up in this century. In plan the staircase follows the type which Mansart had used at Balleroy and at the Hôtel de la Vrillière, with three flights round the sides of a square. But it is in the treatment of the upper part of the space that Mansart's boldness appears [171]. The staircase itself only leads to the first floor, but the cage runs through the whole height of the building. At the top of the first floor it is covered by a coved ceiling, which supports a gal-

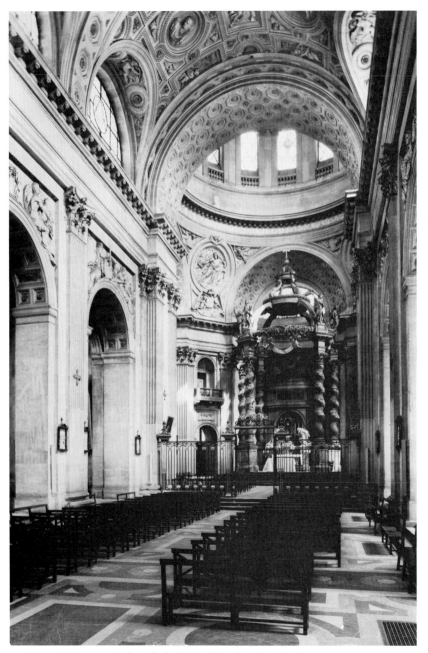

172. François Mansart and others: Paris, Val-de-Grâce, interior. 1645-67

lery allowing communication between the top floor rooms on either side of the stairs. The central panel of the ceiling, however, is open, so that the eye passes right through to the upper storey, which is covered by a dome supported on pendentives and ending in a low lantern. This arrangement is in a sense a development of the device used in the smaller domes in the Visitation. There the rim of the cut-off dome stands out dark against the strongly lit lantern, but in the staircase at Blois this effect of contrast is much intensified by the fact that there are windows on the second floor which are not visible from the staircase itself, but which throw light on the dome above. In this way a practical necessity – the communication between two parts of the château – is made the excuse for an arrangement which is almost Baroque in its use of directed light.

The decoration of the staircase is also in some ways related to that of the Visitation. The dome is panelled in much the same way; above the panels and in the shallow lantern is decoration composed of Mannerist scroll-work and masks mixed with more classical garlands. The classical tendency is more apparent in the low reliefs on the panels, in the *putti* and trophies below the cornice, and in the panels, again with arms, on the cove below, though in the last there appear again Mannerist elements in the form of masks. The whole of this decoration seems to be in the manner of Simon Guillain, who is known to have been working in Blois in 1637-8, and to whom the groups which once stood on the colonnade on the court side have always been attributed.

During the 1640s a change comes over Mansart's style. His buildings become freer in planning, more plastic in conception, and more classical in decoration. This is also the period when he seems to approach most closely the ideals of High Renaissance architecture in Italy, sometimes through direct borrowing, but sometimes apparently unconsciously.

In this decade Mansart embarked on two of his most important undertakings in church architecture, the Val-de-Grâce [159, 172] and the chapel in the château of Fresnes [173]. The Val-

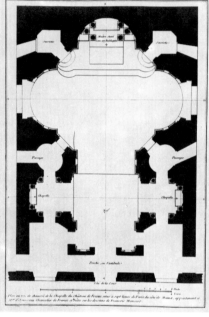

173. François Mansart: Fresnes, château, chapel. Soon after 1645(?).
Plan, from Mariette, *Architecture Française*

de-Grâce was begun in 1645 by Anne of Austria in fulfilment of a vow made before the birth of the Dauphin, later Louis XIV. Mansart's original project consisted of a church flanked on one side by a convent and on the other by a palace, a conception which went back directly to the Escorial and ultimately to the Temple of Solomon. His drawing for this magnificent scheme survives, but unhappily, as has already been said, after little more than a year's work he was dismissed. He was, however, responsible for the plan of the church and for its construction up to the entablatures of the nave and for the lower storey of the façade. The building was

finished by Lemercier, Le Muet, and Le Duc –
their exact shares being difficult to determine[28]
– and the decoration of the interior was carried
out by Michel Anguier between 1662 and 1667
and the dome was painted by Pierre Mignard
in 1663.

The exact date of the chapel of Fresnes is not
known, but it was probably built soon after the
Val-de-Grâce to which its plan [173] is closely
related, though on a miniature scale.

The essential feature which the two plans
have in common is the dominant central domed
space, surrounded by three equal apses for the
choir and transepts. This arrangement is quite
unlike anything that had been built in France up
to this time, and seems to derive from Palladio's
Il Redentore in Venice. The source is impor-
tant, for the plan of the Redentore is one in which
Palladio applies most strictly the principles of
the High Renaissance, particularly in the play on
circular forms and the repetition of the same ele-
ment three times in the choir and the transepts.
In plan, therefore, the Val-de-Grâce and Fres-
nes provide evidence of the way in which Man-
sart seems to approach the methods of Italian
High Renaissance architects at this stage in his
career. The treatment of the interior of the Val-
de-Grâce is highly classical, though less Italian-
ate than the plan. The main Order of Corinthian
pilasters and the fine but severe entablature are
due to Mansart, and although the decorative re-
liefs in the spandrels and pendentives on the
vaulting were only executed after his retirement
they carry on perfectly the combination of rich-
ness and severity which is characteristic of the
whole design. Externally the lower storey of the
façade with its massive portico is an instance of
Mansart's fully plastic style in the 1640s. In the
Feuillants he had used columns against the wall
of the façade, and in the Visitation they are to be
found flanking the door. But at the Val-de-
Grâce the whole portico projects, supported by
half-columns against the walls and full columns
standing some feet in front of them. This por-

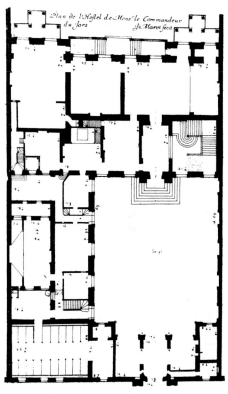

174. François Mansart:
Paris, Hôtel de Jars. Begun 1648.
Plan, from the *Petit Marot*

tico is perhaps an adaptation of Lemercier's on
the north side of the Sorbonne, but it is a novelty
in Mansart's work, and its simpler arrangement
of the heavy columns in pairs gives it a grandeur
and monumentality lacking in Lemercier's
portico, just as it makes his upper storey above
look light and almost over-delicate by compari-
son.

During the period 1640-55 Mansart built a
series of private houses in Paris, some of which
survive and some of which are known from en-
gravings. In the Hôtel de Jars, begun in 1648, he
made an important innovation in planning [174].
The site was narrow, and in order to take full

175. François Mansart: Paris, Hôtel Carnavalet, façade. 1655

advantage of it he arranged the principal rooms in two parallel ranges, with the staircase at the right-hand end of that on the court side. This freer disposition in depth enables him to give greater variety of shape and size to the rooms and at the same time to arrange convenient access to all of them. It was to be followed in most of the later developments of the hôtel design. In the Hôtel Carnavalet, which he remodelled in 1655, he made a further unusual disposition by carrying the principal rooms on the first floor round all four sides of the court, instead of interrupting them on the street front as was normally done. This meant that the façade on the street was all of the same height, instead of consisting, as usual, of two high pavilions joined by a lower central section. In the side pavilions [175] Mansart has produced one of his subtlest designs, a delicate arrangement of Ionic pilasters above a rusticated ground floor, with detail of the greatest restraint.

The château of Maisons, or Maisons-Laffitte, as it has been called since the nineteenth cen-tury, is the most complete work surviving from the hand of Mansart and gives a better idea than any other of his genius as an architect. In 1642 René de Longueil, later to be called the Prési-dent de Maisons, decided to build a new château on his estate and, having called in Mansart, ap-pears to have given him a completely free hand. The main structure seems to have been finished in 1646, but the decoration may have extended over many years.

The plan is a variant on themes with which Mansart had played in his earlier châteaux. It consists of a free-standing block, like Berny, with a prominent central frontispiece, flanked by two short wings of the same height as the main block which are continued in two project-ing blocks of one floor only [176]. Each part of the building is composed of rectangular masses, which are as clearly defined as at Blois but more complex. The relations of the main blocks are simplified by the elimination of the quadrant colonnades used at Blois, so that the two wings project in unbroken rectangular sections from

176. François Mansart: Maisons (Seine-et-Oise), château, entrance side. 1642-6

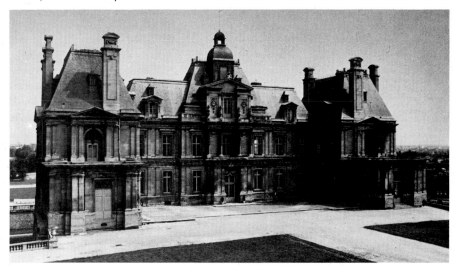

the main front. The same principle can be seen in the design of the frontispiece on the entrance side [177], which grows out of the main wall in a series of shallow layers. The plane of the main wall of the façade is carried on upwards in the top storey of the frontispiece which is decorated with Corinthian pilasters only. In front of this stands a layer constructed with columns – Doric below, Ionic above – and on the ground floor there projects from this yet another block, slightly narrower than the other panels and articulated with Doric pilasters. Behind this frontispiece and behind the wall of the main façade stands an attic supporting a high-pitched roof. The central part of the frontispiece is broken in varying ways on different floors. The entablature over the Corinthian pilasters at the top is completely interrupted; that over the Ionic columns breaks back over the central window, and that over the Doric pilasters on the ground floor is continuous. In this way there is built up a structure of blocks each clearly defined, each different from its neighbour and each seeming to grow logically out of the whole setting. This is perhaps the purest example of the plasticity of Mansart's architecture in the 1640s.

Maisons is the only building by Mansart in which the decoration of the interior survives. The entrance vestibule [178] is a magnificent example of his severe richness – a design of Doric columns and pilasters, with allegorical reliefs on the vault and eagles on the entablature, but all kept in restraint by being executed in stone without either gilt or colour. Most splendid of all, however, is the staircase [179], the finest surviving specimen of Mansart's work in this field. It mounts in four flights round the sides of a square of which the central part is open, following in this way the plan which he had already used at Balleroy and Blois. The whole space is covered with a dome, below which runs a narrow oval gallery serving the same purpose as the coved open ceiling at Blois, namely to allow communication between the two

ends of the building on the second floor. But the gallery at Maisons, having no window above it, does not produce the light contrasts so carefully calculated at Blois, and, being narrower, it interrupts less sharply the continuity of the space. In fact in its spacing and lighting the staircase at Maisons is more classical than that at Blois.

Its decoration is particularly fine. As at Blois, the walls are ornamented with panels, on which sit groups of *putti* representing the arts and sciences. Even more remarkable, however, is the balustrade, which is composed of interlocking curved blocks of great complexity, topped by a rich bunch of acanthus decoration.

These are all examples of the more playful and freer type of decoration at Maisons. In other parts it takes on a restrained and delicate character which almost reminds one of the style of Louis XVI, particularly in the sphinxes on the side pavilions, in the draperies over the main entrance, and in the flaming urns flanking the classical medallions on the top sections of the frontispiece.

As it stands today Maisons is an isolated beautiful building, surrounded by nineteenth-century villas, but as originally created by Mansart it was the centre of a vast ensemble. To the east it extended over a parterre running down to the river, and across it to an island on which the axis of the château was continued in a double avenue. To the west the forecourt was continued by a further space flanked by stables which led on to an avenue running several miles into the Forêt de Saint-Germain and crossed by another, of equal length, at right angles – a conception as Baroque in its scale as that of Mansart's full project for Blois.

The alterations to the Hôtel Carnavalet are the latest surviving work by Mansart, but there are records during the last ten years of his life of

177. François Mansart: Maisons, château, frontispiece. 1642–6

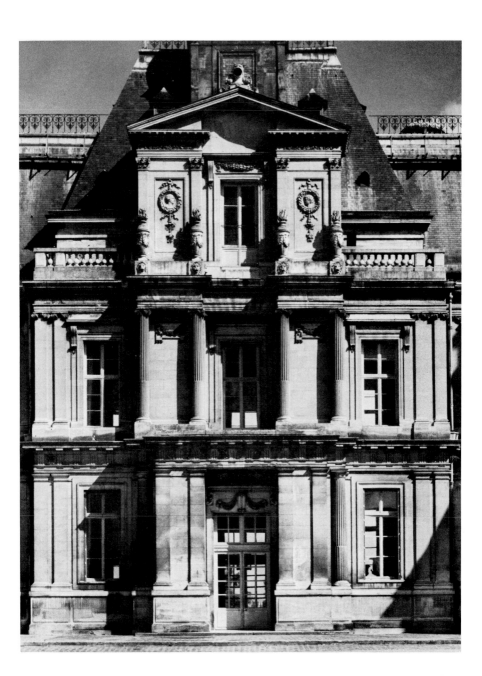

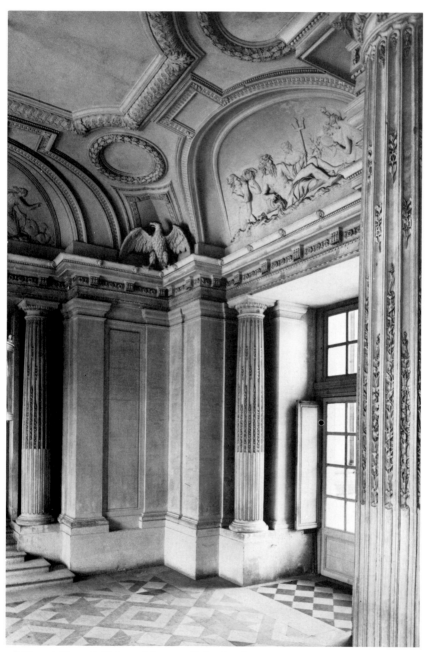

178. François Mansart: Maisons, château, vestibule. 1642–6

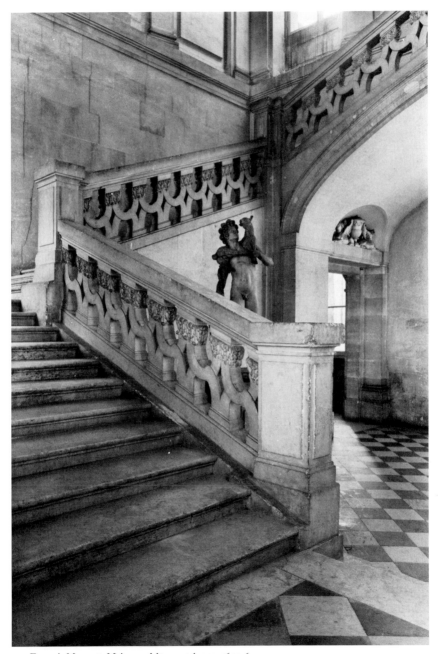

179. François Mansart: Maisons, château, staircase. 1642–6

other projects, of which the two most important were not even begun. We are left therefore with the impression that Mansart was somewhat neglected during his last years, owing, no doubt, partly to changes in taste but partly also to his difficult character. The drawings of these last years themselves confirm what we are told by his contemporaries, that he was incapable of producing and keeping to any final plan for a building, and in the case of the projects for the Louvre, we know that it was for this reason that he finally lost the commission.

In 1664 Colbert, who was considering the completion of the Square Court of the Louvre by the building of its eastern wing, asked Mansart to produce designs for the work. Even a cursory examination of Mansart's drawings, which are preserved in the Bibliothèque Nationale, brings out the immense fertility of his invention at this time. There are only about half a dozen sheets of plans, but to each of them is attached a series of flaps incorporating variants, these flaps again having other flaps, so that for certain parts of the buildings there may be two, four, eight, or even sixteen possible combinations. In some the façade is planned with Orders on each floor, in some with a colossal Order, in some with no Order at all. Sometimes Mansart uses pilasters, sometimes half-columns, sometimes full columns, and often a combination of all these forms. In the arrangement of the interior also there is great variety: oval, octagonal, or square vestibules, with or without columns; and staircases in single flights round a square, in two flights which lead to one, or of one flight dividing into two [180]. In some Mansart uses features which were typical of High Roman Baroque architects. In one scheme – actually for

180. François Mansart: Design for the east wing of the Louvre. 1664.
Paris, Bibliothèque Nationale

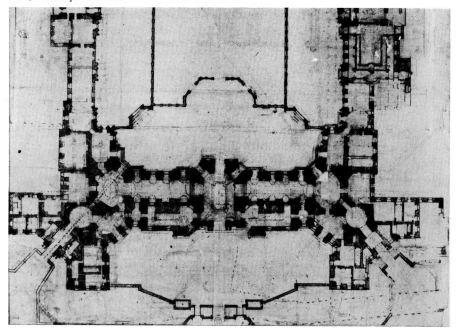

the west wing of the court – he introduces an oval concave bay in the centre exactly like that planned by Borromini for S. Agnese in Piazza Navona but rejected as being too bold, and in another he designed a *place*, incorporating the awkwardly placed church of St Germain-l'Auxerrois, which would have done honour to Pietro da Cortona.

In 1665, Colbert evolved another scheme to the glory of Louis XIV for which he again asked Mansart to produce designs. This was to be a chapel for the tombs of the Bourbon dynasty at St Denis to outshine the unfinished Valois Chapel there.[29] The chapel, which was to be of vast dimensions – its diameter was about half the length of the whole church – represents Mansart's last researches into the problem of the centralized building. But it is conceived on very different lines from the Visitation. The central domed space was to be supported on full columns, and round it were to be grouped chapels which in the plans take on a confusing variety of forms, so that evidently Mansart was here 'thinking aloud', as he was in the Louvre sketches. One of the designs has an unexpected feature, namely that each chapel is covered by a separate dome visible from the outside, which produces an effect of small independent units clustering round a large one reminiscent of the church projects of Leonardo. Mansart also makes use here of a device which we have found several times in his domestic architecture: the cut-off dome. In this case the principal dome of the chapel is truncated, so that the eye can see through to an outer shell, on which presumably there was to be frescoed decoration.

In 1665 Mansart designed a staircase for the Hôtel d'Aumont, of which the main part had been built more than twenty-five years earlier, probably by Le Vau. The staircase, which is known from the engraving in Daviler, is an interesting example of Mansart's ingenuity in his last period. He has exploited brilliantly the possibilities of the limited available space by putting the bottom steps of the flight in the middle of the opening leading to the staircase, and then moving the succeeding steps to one side, at the same time narrowing them, so that when they turn round for the last part of the flight they are only of half the width of the whole space. However, this transformation is so subtly done that it would hardly have disturbed anyone going up the stairs. The staircase is preceded by a shallow vestibule with full Doric columns and a deep niche on each side, which provides a dramatic and plastically conceived approach to the main flight. The balustrade seems to have been as ingenious as that of Maisons.

Mansart was the most accomplished architect of his generation in France. His works show a rare combination of qualities: clarity combined with subtlety, restraint with richness; obedience to a strict code of rules coupled with flexibility within them; and concentration by the elimination of inessentials. His style has not the heroic quality which is to be found in the more classical paintings of Poussin and in the great tragedies of Corneille, but he worked for patrons who demanded luxurious settings for their lives and would not altogether have appreciated the stoical grimness of Poussin's most severe works. Voltaire has summed up the qualities of his art in lines which are believed to refer to Maisons:

> Simple en était la noble architecture;
> Chaque ornement en sa place arrêté
> Y semblait mis par la nécessité:
> L'art s'y cachait sous l'air de la nature,
> L'œil satisfait embrassait sa structure,
> Jamais surpris et toujours enchanté.

Voltaire clearly saw Mansart as embodying the ideal of French classicism to which his generation looked back with reverence.

François Mansart may have been the most subtle architect of his generation, but he was not the most successful. Louis Le Vau seems to have

been temperamentally much better suited to the demands of his patrons and, whereas Mansart threw away commissions owing to his obstinacy and arrogance, Le Vau was adaptable enough to fit in with what was demanded of him. He seems to have lacked the scrupulous artistic conscience which was the most marked quality of Mansart. Le Vau is, on the contrary, an artist careless of detail and thinking always of a general effect, inconsistent in his use of the Orders, but brilliant in decoration. Mansart walked alone; Le Vau was the head of a team of craftsmen – painters, sculptors, stucco-workers, gilders – who combined to produce effects which come nearer to the Baroque than any other architectural work in France during this generation. He was a great *metteur-en-scène* rather than an intellectual artist.

We know almost nothing of his life.[30] He was born in Paris in 1612, and his father was a master-mason also called Louis. From about 1639 onwards he seems to have been financially interested in the development of the Île-St-Louis. He built a house there, where he lived with his father, and it was there that his most important private commissions in Paris were carried out: houses for Lambert, Hesselin, Gruyn des Bordes, Sainctot, Gillier, and other wealthy patrons.[31] He and his father seem to have done a little speculation in buying and selling plots as well as being concerned with the actual building. His first patrons come from a class closely related to those who employed Mansart, but with a slight difference. Both architects worked for the recently enriched financiers, but whereas Mansart also built for the great officers of the Crown, Le Vau was more favoured by the members of the Parlement. It was not till he was noticed by Fouquet about 1655 that he moved into the higher circle, but he made much better use than Mansart of his newly gained position and managed after the fall of Fouquet to obtain the favour of his rival, Colbert, and through him that of Louis XIV. His works at the Louvre and

Versailles, executed between 1661 and his death in 1670, belong therefore to the next phase in French history, and will be considered in a later chapter. For the moment we are only concerned with his buildings for private patrons, almost all of which date from before 1661, and which may be conveniently considered under the two headings of Paris houses and country châteaux.

We have no information about Le Vau's early training, but it is safe to assume that it was begun under the instruction of his father. The earliest work attributed to him is the Hôtel de Bautru, built between 1634 and 1637. Though the house was destroyed in the nineteenth century, its general plan can be reconstructed and its external appearance is recorded in engravings by Marot. In plan it is advanced for its time, having a gallery running along the side of the garden – a feature also to be found at Mansart's Hôtel de la Vrillière – and an ingenious placing of the staircase in the right wing, next to the main block, so that it leads up to the end of a long enfilade of rooms on the first floor. Externally it was much more traditional, with a high-pitched roof over each section, dormers breaking the line of the roof, and a rusticated arch rising above the middle of the wall which separated the court from the street.

The Hôtel d'Aumont and the Hôtel de Miramion, probably built about 1635, can be ascribed with reasonable certainty to Le Vau. In plan they are of no great interest, but they are remarkable for the refinement of their external decoration, which is far simpler than the ornament at Bautru and entirely free of the du Cerceau tradition.

The next step in Le Vau's development as a planner can be seen in the Hôtel de Bretonvilliers [181]. The hôtel was begun in 1635, probably to the design of Jean du Cerceau, but at this stage only the left wing of the court was built. In 1638 a new contract was made for a building on a grander scale, and, although the architect's name is not given, there are strong stylistic rea-

181. Jean du Cerceau and Louis Le Vau:
Paris, Hôtel de Bretonvilliers. Begun 1635.
Plan, from the *Petit Marot*

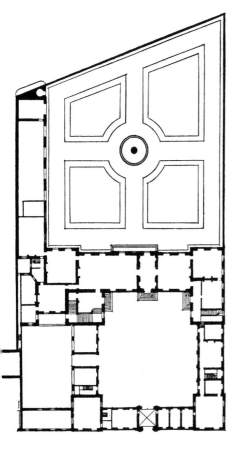

sons for thinking that in fact Le Vau was respon-
sible for the new design. Basically this follows
the scheme of Bautru, but with the staircase
moved over to the left, as at La Vrillière, and
with a small flight of steps inserted in the right
pavilion to balance it. An unusual feature is
the presence of yet a third entrance in the
middle of the main *corps-de-logis* leading to a ves-
tibule which cuts right through the block and
leads to the garden. The garden front is much
longer than at Bautru, covering a quite con-
siderable base-court on the left, and causing a
dislocation of axis which Le Vau solves by an
adjustment based on Mansart's solution at La
Vrillière, even to the detail of having a solid in-
stead of a void in the central bay of the façade.[32]

Le Vau's lay-out of the Hôtel de Bretonvil-
liers must have been largely conditioned by the
position of the house on the eastern point of the
Île-Saint-Louis. Since the house was pulled
down in the middle of the nineteenth century,
we can only guess at what the views must have
been, but in the case of the Hôtel Lambert, built
on the adjacent site, it is still possible to-day to
enjoy the vista up the river, though it needs an
effort of the imagination to picture it as open
country, with the Arsenal and the Salpêtrière
standing in isolation among trees and fields.[33]

The plot on which the Hôtel Lambert stands
was bought by Jean Baptiste Lambert in 1639,
and the house itself was begun in 1640. In 1644
the building was far enough advanced for the
owner to move in, but the decoration of the in-
terior continued for many years.

The site was curious in shape [182], and Le
Vau made brilliant use of its possibilities. The
entrance from the street leads to a court of which
the curved end facing the visitor [183] contains
the staircase. The wings on each side of the
court are composed of two sets of private rooms,
which are approached from the staircase through
an oval and a circular vestibule respectively. The
right-hand vestibule also gives access to a wing
which runs parallel with the street towards the

point of the island. On the upper floor this contains a long gallery with windows on one side looking over the garden and ending in a bow with a view up the river. In a sense this is an adaptation of the scheme used at Bautru and Bretonvilliers, with the difference that, owing to the shape of the site, the gallery has been turned round and continues the line of the principal *corps-de-logis* instead of running at right angles to it along the side of the garden. This re-arrangement gives Le Vau the opportunity for a brilliant and dramatic disposition of the staircase and the gallery.

The staircase is a highly personal invention, conceived on almost theatrical principles entirely opposed to those applied by Mansart in his staircase at Maisons. There the visitor realizes at first glance the whole plan and spacing of the staircase; at the Hôtel Lambert these are only gradually revealed as he goes up the steps,

encountering as he does so a series of surprises. After going up a few steps from the court the staircase divides into two flights, of which that on the left leads only to the lower of the two main floors, while that on the right, after taking the visitor to this level, doubles back and leads him to the upper floor. Gradually, as he goes up this second stage, he moves from the narrow confined flight into the main cage of the staircase, three times the width of the flight, lit by big windows on the next floor and continued upwards past a gallery through the whole height of the building.[34] The effect of emerging from a dark tunnel into a well-lit, open space is deliberately prepared and ingeniously carried out in an almost Baroque spirit.[35] However, this is not the end, because as the visitor turns on to the upper landing he will see – if the doors are open – a long vista through the oval vestibule, along the gallery, and out on the river landscape beyond. This

182. Louis Le Vau: Paris, Hôtel Lambert. Begun 1640.
Plan of second floor, from Blondel, *Architecture Françoise*

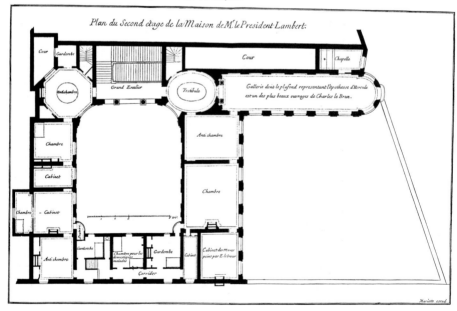

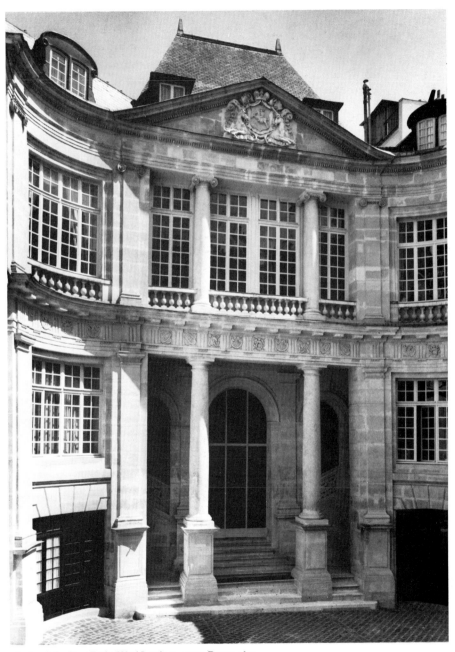

183. Louis Le Vau: Paris, Hôtel Lambert, court. Begun 1640

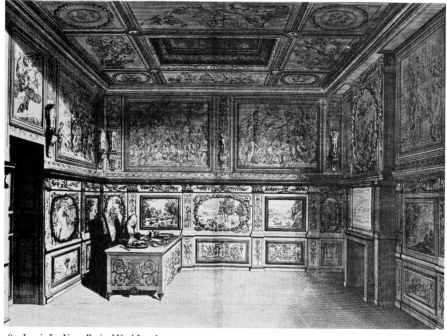

184. Louis Le Vau: Paris, Hôtel Lambert,
Cabinet de l'Amour. *c.* 1646–7. Engraving by Picart

is the kind of dramatic effect of which Le Vau is a master.

Externally the Hôtel Lambert is dominated by the use of the classical Orders, which do not appear in this position in Le Vau's earlier works. The central feature of the court is a triple opening running through two storeys and covered by a straight pediment, the two floors being articulated by Doric and Ionic columns. The detail is correct, but the columns are unevenly spaced and the proportions of the Doric Order are disguised by the enormously high pedestals on which the columns stand. A further irregularity is that the entablature of the lower Order is carried on all round the court, although in large parts of its course it is entirely unsupported by columns or pilasters. The façade to the street is severe, al-most fortress-like, but the gallery and the wing facing the garden are decorated with giant Ionic pilasters, a device which at first sight seems a contradiction to the use of superimposed Orders in the court – Mansart never allows himself this freedom – but which is appropriate because this part of the house is calculated to be seen at a considerable distance, from across the river, and the large scale of the Order makes it tell at such a distance.

Much of the decoration of the interior survives.[36] The Cabinet de l'Amour, decorated *c.* 1646–7, has suffered most severely, for it has been stripped of its panelling and its paintings, which are now for the greater part in the Louvre. Its original appearance, however, is preserved in an engraving by Picart [184]. The walls were

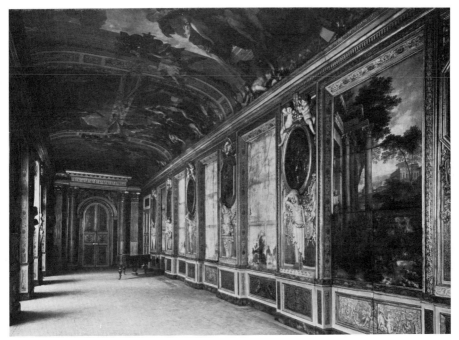

185. Louis Le Vau and Charles Lebrun:
Paris, Hôtel Lambert, gallery. *c.* 1650

divided into almost equal parts, consisting of a
dado and frieze, as in sixteenth-century French
rooms. The dado was decorated with landscape
panels by the elder Patel, Swanevelt, and Jan
Asselyn, and the frieze with mythological sub-
jects by Perrier, Romanelli, and Le Sueur, who
was also responsible for the figure panels in the
ceiling. The Cabinet des Muses survives in
better condition, though it was altered in the
eighteenth century[37] and its paintings have been
removed to the Louvre. It is probably a few
years later, though it must have been begun be-
fore 1650, the year of Perrier's death, since he
painted the decorations on the cove of the ceil-
ing. It presents an advance on the Cabinet de
l'Amour in the general disposition of the decora-
tion, since the walls are no longer divided into

equal dado and frieze, but are treated as wholes
with a single central painting by Le Sueur, above
and below which are narrow decorative panels of
grotesques.

The gallery is even more striking [185]. Men-
tion has already been made of the skill with
which the architect has designed it with an eye
to the view which it overlooks, and his abilities
are no less apparent in its decoration. It is by far
the finest room of this period to survive, and al-
though many Paris houses had galleries of this
type, the enthusiasm of early writers justifies us
in assuming that this must always have been an
exceptional example. The walls are decorated
with a series of stucco reliefs, bronze and gold in
colour, by van Obstal, representing the Labours
of Hercules, to whom the room is dedicated. On

186 *(below)*. Louis Le Vau: Paris, Hôtel Tambonneau. Begun 1642. Engraving by Marot

187 *(opposite)*. Manner of Louis Le Vau: Paris, Hôtel Aubert de Fontenay, staircase. 1656-61

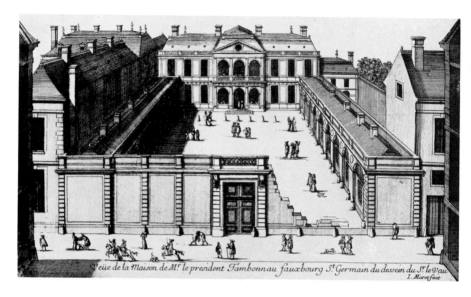

Veüe de la Maison de M. le president Tambonnau fauxbourg St Germain du dessein du St le Vau
I. Marot fecit

the side opposite the windows these reliefs alternate with landscapes by Rousseau. The ceiling was painted by Lebrun, who continued the story of the hero in a huge decoration which was in its time the most ambitious piece of Baroque illusionism to be executed in France.[38] Le Vau was presumably the controlling mind behind this magnificent scheme, and it shows his real qualities at their best. As a purveyor of this kind of grand and highly coloured setting Mansart could not hold a candle to him; his ambitions lay in other fields.

Of Le Vau's other private houses the most interesting are the Hôtel Tambonneau, begun in 1642,[39] and the Hôtel de Lionne, begun in 1662. Like the Hôtel Lambert, the former has in the middle of the main block a triple entrance, but at Tambonneau the openings are arched so that the effect is like *logge* to be found on many Roman churches of the early seventeenth century [186]. At Lionne Le Vau uses two superimposed Orders in the court and a giant Order on the garden front which, as at Lambert, would usually have been seen at a distance. The great novelty in this house lay in the arrangement of the vestibule and the staircase. On entering the house the visitor found himself in an impressive vestibule, which ran along the line of the buildings instead of cutting through it. At the end of this vestibule and on the same axis Le Vau placed the staircase, which was approached through a triple-arched opening, the whole producing a theatrical build-up of a type hitherto unknown in French architecture.[40] The Hôtel de Lionne has unhappily been destroyed, but the effect it produced can be to some extent judged from the Hôtel Aubert de Fontenay (or Hôtel Salé, as it was called after the source of the owner's wealth, the Gabelle), built in the years 1656-66, very much in the style of Le Vau

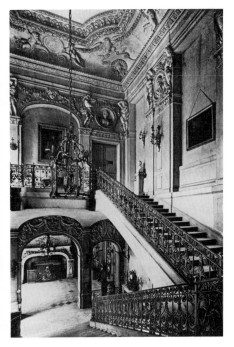

[187].[41] Both these houses follow the scheme used by Mansart at the Hôtel de Jars and the main *corps-de-logis* has been made of greater thickness, so that it can include two parallel flights of rooms.

Le Vau's most important building before he gained royal favour was the château of Vaux-le-Vicomte, but before he undertook this task he had already built at least one other major country house, Le Raincy, designed before 1645 for Jacques Bordier, Intendant des Finances.[42] The plan was a usual one: a main block with slightly projecting pavilions at the end of the forecourt; but the novelty was the introduction of a great oval vestibule in the centre which made a curved projection in the middle of both garden and court façades.[43]

It was, however, in 1657 that Le Vau had his great opportunity, when he was commissioned by the Surintendant des Finances, Nicolas Fouquet, to plan for him on his estate at Vaux-le-Vicomte the most splendid château and gardens to be found at that time in France [189].

188 *(below)*. Louis Le Vau:
Vaux-le-Vicomte, château.
1657–61.
Plan, from the *Grand Marot*

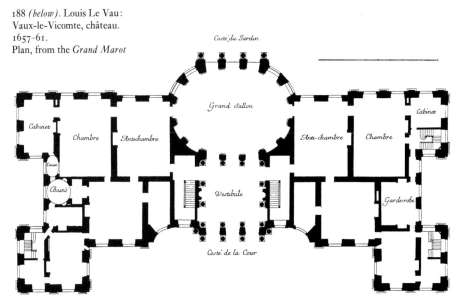

189. Louis Le Vau:
Vaux-le-Vicomte (Seine-et-Marne),
château. 1657-61

The building was carried out at unparalleled speed; the roof was already being put on before the end of 1658, and the decoration of the interior was almost complete by the time of the *fête* of 1661.

The plan of the château [188] was an adaptation of that of Le Raincy, varying externally only in that it has double pavilions and no forecourt. It is, therefore, a completely free-standing block in the tradition of Blérancourt and Maisons. As at Le Raincy, there is a projection in the centre of each façade, but with a slight difference. Instead of a single oval vestibule, the middle of the block is occupied by a rectangular vestibule which leads to an oval salon lying across the main axis of the building. The staircases are fitted into the spaces at the sides of the vestibule,[44] and the two wings each contain a splendid *appartement*, one on the east side for the King and one on the west for the owner of the house.

The vestibule itself is of an unusually masculine style for Le Vau, and its sole ornament is a row of detached Doric stone columns. His favourite motive of the triple opening is here carried right through the building, for the transitions from court to vestibule, from vestibule to salon, and from salon to garden are all made through three arches. The salon is again relatively staid in its ornament, white stucco

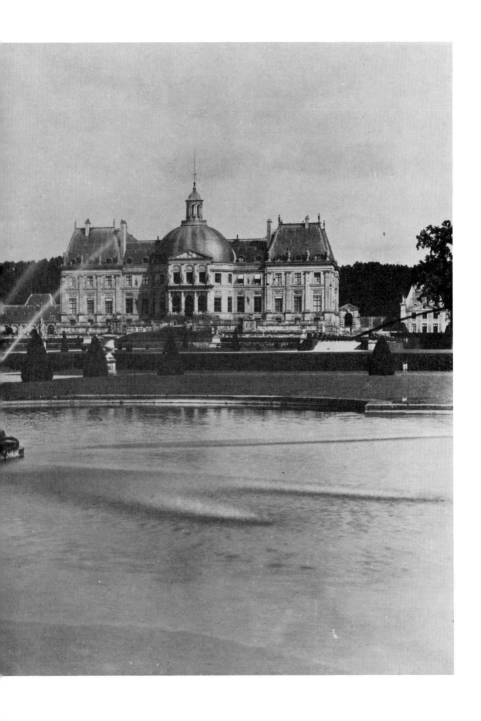

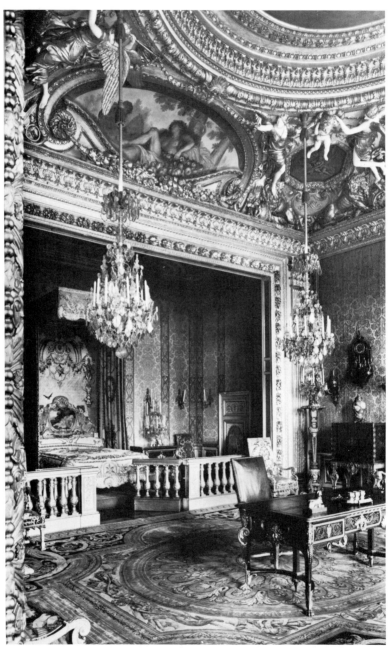

190. Louis Le Vau and Charles Lebrun: Vaux-le-Vicomte, château, Chambre du Roi. 1657-61

composite pilasters below and stucco caryatids above; but the ceiling was to have had frescoes by Lebrun which would have added greater richness.[45] The other rooms are elaborately decorated, some with painted grotesque panels, others, like the King's bedroom [190], in a style new to France which Lebrun had brought from Italy. This is based on a combination of stucco, gilding and painting, which Lebrun seems to have learnt from studying Pietro da Cortona's rooms in the Palazzo Pitti. In the King's *appartement* Le Vau and his team of collaborators, Lebrun for painting, Guérin and Thibault Poissant for sculpture, invented the style which was to be used in the decoration of Louis XIV's first rooms at Versailles, that style which at first sight seems to be Baroque, but which is always more restrained than its counterpart in Italy.[46] It uses the Baroque combination of all the arts in one striking general effect, but it eschews the more ingenious tricks of illusionism and foreshortening which the Roman Baroque decorators loved. The line of demarcation between painting and sculpture is kept clear, and figures are not allowed to wander from one into the other. It is, in fact, a compromise, a Baroque tamed to suit a northern taste.

Externally the architecture of Vaux shows only too clearly Le Vau's weaknesses as a designer. There is the looseness in the use of the Orders which we have found in almost all his works; but there is also a great indecision in the grouping of the main masses. On the garden side the projection made by the oval salon is not brought into any relation with the remainder of the façade, and to it is applied, as the centre for the whole design, what is in effect the frontispiece of the Hôtel Tambonneau. It may be said in defence of Le Vau that he must have been working under great pressure of time and that he could not work out details such as these as carefully as he may have wished; but the fact remains that his artistic conscience did not prevent him from producing these ill-digested features.

It is, however, unfair to cavil at details, because the general impression of Vaux is triumphantly successful, and this was certainly what mattered to Le Vau and to Fouquet. The combination of château and gardens has hardly its peer in France, and although this must be largely attributed to the skill of Le Nôtre, who here appears for the first time as an independent garden designer,[47] there can be little doubt that Le Vau had the main direction of the lay-out, and that the admirable relation of the buildings to the whole must be due to him. The approach to the house from the road slopes slightly down, flanked by the two base-courts, built of brick and stone, in contrast to the milky stone of the château itself. As the visitor walks down he is able gradually to see the gardens stretching away beyond the house itself. The terraced parterre slopes slowly down again till, half a mile away, it reaches the canal and the grotto, beyond which the ground rises again in a long grass stretch between trees. Fountains, terraces, grottos, canal, *tapis-vert*, all the elements of Versailles are already there, and on a scale which might well have made the King jealous when he saw it.

The last chapter in the story of Vaux is well known. On 17 August 1661, Fouquet entertained there the King, the Queen, Mlle de la Vallière, and the whole Court. After a supper prepared by Vatel, they were offered a new comedy-ballet, *Les Fâcheux*, composed for the occasion by Molière, with décor by Lebrun and music by Lully. La Fontaine, Fouquet's poet, was in the audience, and wrote a description of the evening, which ended with a splendid firework display. Three weeks later Fouquet was arrested for embezzlement; all his property was confiscated; and his enemy and destroyer, Colbert, took over his artists to work for the King. In the most literal sense, therefore, Vaux was the preparation for Versailles. Colbert needed only to transport to Paris the team of architects, sculptors, painters, composers, and poets to have, ready-made, a means of flattering the

191 and 192. Antoine Le Pautre:
Paris, Hôtel de Beauvais.
1652-5. Plans of ground and first floors,
from the *Grand Marot*

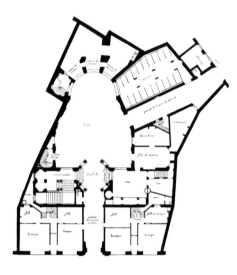

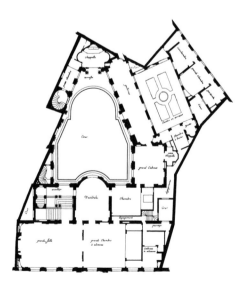

King's taste for splendour. Colbert was not the
man to miss such an opportunity because of any
of the scruples which a more sensitive character
might have felt. It may, however, be thought
that he went unnecessarily far in actually trans-
porting to Versailles the best statues and the
rarest trees with which Fouquet had orna-
mented his park.

From 1661 onwards Le Vau becomes the ser-
vant of Colbert and the King, and his work for
them will be considered in the next chapter.[48]

French architectural style of the mid seven-
teenth century was formed by Mansart and Le
Vau, but among their contemporaries were
many artists of considerable talent, who pro-
duced work with individual characteristics.

The most original of these was Antoine Le
Pautre (1621-79).[49] Before 1650 he had already
built the monastery of Port-Royal, which still
stands, and at least one private house, the Hôtel
de Fontenay-Mareuil.[50] But his reputation rests
on the Hôtel de Beauvais, erected between 1652
and 1655, on the rue St Antoine, which survives
to-day, though in sad condition. This house is
the most ingenious of all the solutions found by
French architects for the problems presented by
difficult and irregular sites [191, 192]. In this
case Mme de Beauvais had bought two plots,
one facing the rue St Antoine and the other the
rue de Jouy. Though contiguous, the two sites
formed together an area with re-entrant angles
and with no side parallel to any other side. Le
Pautre has planned a deep *corps-de-logis* on the
rue St Antoine, with shops on the ground floor
and a *porte-cochère* in the middle leading to a cir-
cular vestibule[51] where the visitor got out of his
coach and walked into the staircase on the left.
Beyond this main block the architect has con-
trived to fit in a court which is symmetrical in
spite of the small amount of space available on
the left. The court ends in a sort of apse, from
which the coach-house opens, while to the right
a covered way leads out beside the stables to the
rue de Jouy. If we compare the plan of the first

193. Antoine Le Pautre:
Paris, Hôtel de Beauvais, staircase. 1652-5

floor with this disposition of the space below we shall see yet further proofs of Le Pautre's boldness. In the main *corps-de-logis* the rooms correspond very roughly to those below them: but in the rest of the plan they go their own way without consideration for what is underneath. Over the stables and the passage to the rue de Jouy, and at right angles to them, Le Pautre contrives a long gallery, a hanging garden, and an *appartement*, while over the coach-house there is a terrace and a chapel. The detail of the Hôtel de Beauvais is disappointing in comparison with the general plan, though the staircase is skilfully designed and richly decorated with stuccos by Martin Desjardins [193].[52]

Of Le Pautre's other executed works we know little,[53] but more light is thrown on his methods by the volume of engravings which he published in 1652. In these he presented to the public the designs for country and town houses which he had not been able to execute. That he had found no patrons bold enough to undertake them need not surprise us, if we look at their vast scale and fantastic qualities [194]. In these plates, unrestrained by the ties of practical considerations – which, however, as we have seen in the Hôtel de Beauvais, he was well able to deal with – Le Pautre gives free rein to his imagination, and creates a series of designs which have hardly any parallel in French architecture. Some depict vast rusticated châteaux; others show villas almost Palladian in plan, but with porticos supported by huge figures totally foreign to the spirit of Palladio; yet others derive their inspira-

194. Antoine Le Pautre:
Design for a château. 1652. Engraving

tion from nearer home and are adaptations of designs by Le Vau. The château of illustration 194, for instance, recalls Le Raincy in its use of the colossal Order intermingled with rusticated wall surfaces. But in its general conception it is far freer than anything that Le Vau created. Le Pautre alone among French architects could have thought of the semicircular concave bays which link the end pavilions to the centre and to which the drum over the middle section forms a contrast of convex curves.[54] Internally the plan is wholly fantastic. The middle three sections of the building are occupied by the vestibule and the staircase, and only the two wings contain living-rooms; but even here half of each wing is taken up with a huge columned salon. It was a splendid invention, and one from which later theatrically-minded architects[55] were able to derive useful ideas, but hardly, as it stands, a practical design for a country house.

Pierre Cottard (d. 1701) was a more practical architect. In 1660 he published a set of engravings illustrating the façades of Paris churches, but he is principally remembered for one building, the Hôtel Amelot de Bisseuil, better known as the Hôtel des Ambassadeurs de Hollande, on which he worked from 1657 to 1660. Here the decoration, both internal and external, rather than any skill in planning, is the most striking feature. The house presents to the street one of the finest of Parisian *portes cochères* [195], and within it has a richly decorated and painted gallery, now restored to its original state after severe alterations in the nineteenth century.[56] In the court are the remains of a painted false perspective.

Adam Robelin, of whom nothing is known, built the Hôtel de Léon in the rue Garancière, which is unusual in having on the street façade an Order of colossal Ionic pilasters with rams'

195. Pierre Cottard: Paris, Hôtel Amelot de Bisseuil. 1657-60

heads in the capitals. Jean Richer enjoyed some reputation in his day and three of his houses are engraved in the *Grand Marot*, but they show little originality.

A more puzzling figure, of whom too little is known as an architect, is Gérard Desargues (1593–1661), who worked at Lyons as well as in Paris. He was a mathematician and engineer, and his achievement lies in the field of construction. In the rue de Cléry he built for M. Roland a house with a staircase of great originality [196].[57] The staircase is placed in the corner of the court and set diagonally. A few steps lead to an oval vestibule from which the first flight goes straight up, to divide into two flights, each at an angle of 45° with the first flight. Desargues was probably led to this unexpected plan by his interest in structural problems, but the result was a type of staircase which was taken up again by architects of the early eighteenth century when they were seeking original forms and trying to break away from the strictly rectangular plans of the seventeenth century.

196. Gérard Desargues: Paris, house of Monsieur Roland. Plan, from the *Grand Marot*

Jean Marot fecit

Mention must also be made here of Jean Marot (*c.* 1619–79), since he was also a designer of private houses, though he is chiefly remembered for his volumes of architectural engravings, notably the *Grand Marot* and the *Petit Marot*, which have often been referred to in these pages. The only works which he is known to have carried out are the Hôtels de Pussort, de Mortemart, and de Monceaux, all of which are engraved by him, but we can also learn something of his style from his plates after his own unexecuted projects. These show him to have been an eclectic with little originality and with a rather dry manner. He picked up ideas from all his major contemporaries, particularly Mansart and Le Vau, and on the whole added little to them. He is more personal when he is designing decoration or triumphal arches or working in any field which is not strictly architectural.[58]

One of the few public buildings put up in Paris during this period is the Hall of the Marchands-Drapiers [197], designed in about 1655–60 by Jacques Bruant, the elder brother of Libéral, the builder of the Invalides. The only part which survives is the façade which was transported in the nineteenth century to the Carnavalet museum. In certain respects the design derives from Mansart's frontispieces at Blois and Maisons, particularly in its application of the three Orders, with a truncated Corinthian for the attic. But the general character is entirely different, since Bruant's frontispiece is conceived primarily as a setting for sculptured decoration, which centres on the arms of Paris flanked by two caryatids.[59]

The middle decades of the seventeenth century were also a period of activity, though not of great progress, in church-building. We have already considered the major works produced – Mansart's Visitation, Lemercier's Sorbonne, and the Val-de-Grâce – but besides these a number of other churches of quite different character were erected. In most cases they were long in building and there were several changes

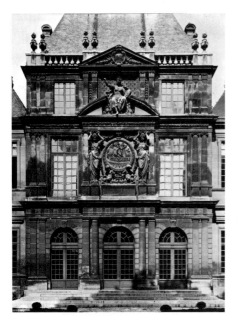

197. Jacques Bruant: Façade of the
Hall of the Marchands-Drapiers. *c.* 1655–60.
Paris, Carnavalet Museum

du-Chardonnet and St Sulpice, present what
can almost be described as a *chevet* with but-
tresses, classical in their moulding but Gothic
in their structure.[61]

The period of Richelieu and Mazarin was in
French architecture, as in other fields, one of
great individualism. François Mansart, Louis
Le Vau, Antoine Le Pautre were personalities
who left their mark on the art of their time and
on that of succeeding generations. They all
contributed to the art of this great period,
but their contributions were distinct, marked
by the idiosyncrasies of their makers. Colbert
and Lebrun had not yet imposed the uni-
form excellence which marked all the visual
arts under the personal reign of Louis XIV.
Architects could still be difficult, even prepos-
terous; they were not and could not be courtiers.
They still had the calibre of the men who fought,
however futilely, in the Fronde. Life at Ver-
sailles under Louis XIV may have been much
more polished than it had been in Paris in the
time of Retz and Mlle de Montpensier, but it
must have been much duller. The same is true
of the art of the two periods.

of architect, so that it is difficult to determine
the real authorship of any part of the design.
But they all have one feature in common: they
represent an attempt to reconcile the new clas-
sical forms with traditional church-planning.
Notre-Dame des Victoires (begun 1629), St
Jacques-du-Haut-Pas (begun 1630), St Sulpice
(begun 1645),[60] St Roch (begun 1653), St
Nicolas-du-Chardonnet (begun 1656), St
Louis-en-l'Île (begun 1664) are all built on a
Latin cross plan with aisles and ambulatory like
Gothic churches. In some there are even more
curious reminiscences of medieval architecture.
In St Sulpice, for instance, the curve of the vault
is so much higher than the semicircle that it
looks almost like pointed groining, and many of
these churches have a rib along the ridge of the
vault which again produces a Gothic effect.
Externally some of them, for instance St Nicolas-

PAINTING

Simon Vouet

French painting was dominated by a form of
Late Mannerism throughout the first quarter of
the seventeenth century and the event which
inaugurated the new movement was the arrival
in 1627 of Vouet, who had been in Italy for four-
teen years and brought back a style of Italian
painting till then unknown in France.

Vouet was born in 1590.[62] At the age of four-
teen he is said to have come to England to paint
the portrait of a French lady, and in 1611 he ac-
companied the French ambassador to Constan-
tinople. From there he made his way to Italy,
arriving in Venice in 1613. By 1614 he had
moved to Rome, which seems to have remained

198 *(below)*. Simon Vouet: The Birth of the Virgin. *c.* 1620. *Rome, S. Francesco a Ripa*

199 *(opposite)*. Simon Vouet: Appearance of the Virgin to St Bruno. 1626(?). *Naples, S. Martino*

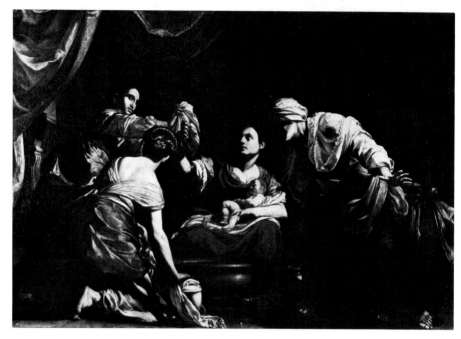

his headquarters till his return to France in 1627, though he may have visited Naples in the early 1620s and certainly spent a period during 1621-2 in Genoa, visiting Modena and Bologna on his way back. In 1624 he was elected President of the Roman Academy of St Luke. He is again traceable in Venice in 1627, presumably en route for France. On his arrival in Paris he immediately scored a great success, receiving commissions for the decoration of private houses and churches on a great scale. The arrival of Poussin in 1640 was a threat to his monopoly, but when he returned to Rome in 1642 Vouet was left again in almost unchallenged supremacy, though in his last years advanced opinion probably began to turn against him and in favour of a more classical style. But he seems to

have enjoyed wide popularity till his death in 1649.

During his first years in Rome Vouet seems to have produced many paintings in a picturesque sub-Caravaggesque style, either of swaggering *bravo* figures, as in the Brunswick painting, or portraits in the same guise. Later he was to take up Caravaggio's use of *chiaroscuro*, but in a very personal manner, particularly in the 'Birth of the Virgin' in the church of S. Francesco a Ripa [198], and in the scenes from the life of St Francis in S. Lorenzo in Lucina of 1624. The 'Birth of the Virgin' is an unusually original version of Caravaggio's style, novel in its broad, low composition, bold in its foreshortenings, and striking in its handling of drapery. In fact it shows a vitality which Vouet

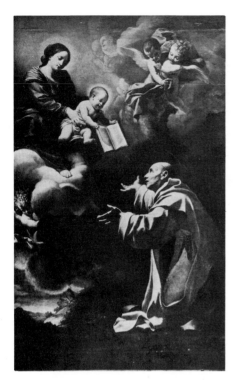

for the Certosa di San Martino at Naples, probably a little later, and in the 'Adoration of the True Cross', commissioned for St Peter's in 1624, but now only known from a *bozzetto* and a fragment of the original.[64] In the 'St Bruno' [199] the sentiment, marked above all by the atmosphere of ecstasy, is already Baroque, though it is still restrained; in the same way the composition, with its strong diagonal, probably deriving from a design by Guido Reni in the Cappella Paolina in S. Maria Maggiore,[65] is typical of the transitional stage towards the full Baroque movement of a Pietro da Cortona. On the other hand, the firm modelling and the almost Domenichinesque type of the Madonna show that the artist has not altogether thrown off the classical tradition. The influence of Reni is visible in many of the compositions engraved after Vouet by Mellan, such as the 'Lucretia'.[66] At the same time he painted portraits of a swaggering, bohemian type which in the treatment of light and colour remind one that he had also passed through Venice.

On his arrival in Paris, Vouet seems at first to have been mainly occupied with painting religious subjects, and in this field the style which he brought from Rome was bound to be successful with the French public. The Mannerist upbringing of Parisian connoisseurs would have prevented them from appreciating the naturalism of the Caravaggesques, and the religious atmosphere was not sufficiently enthusiastic and emotional for them to have stomached the full Baroque. But Vouet's compromise manner, Baroque still qualified by a classical tradition, was exactly in tune with the needs of a society whose religion was that of St François de Sales, of Bérulle, and of Olier. For the rest of his career Vouet was overwhelmed with commissions for altarpieces in the churches of Paris, whether for the various orders – the Jesuits at St Paul-St Louis and at their Novitiate, the Minims, the Carmelites, and the Oratorians – or for the

was soon to lose. It reveals a curious feature of the artist's style at this period, for one detail, the head of the maidservant in the middle, is taken directly from Michelangelo.[63] An analogous point occurs in the 'Temptation of St Francis' in S. Lorenzo, where the figure of the saint is borrowed from Michelangelo's model of a river-god in the Accademia. This combination of Michelangelesque and Caravaggesque elements gives an unusual flavour to Vouet's luminist work.

In his last years in Italy, however, he developed towards a more Baroque style. The 'Crucifixion' in S. Ambrogio at Genoa, painted in 1622, damaged though it is, shows the first signs of this evolution which is fully realized in the 'Appearance of the Virgin to St Bruno', painted

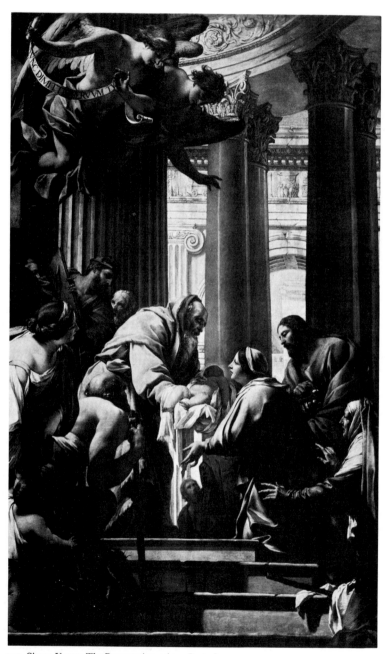

200. Simon Vouet: The Presentation. 1641. *Paris, Louvre*

parish churches such as St Eustache and St Merri. One of his most successful altarpieces was the 'Presentation in the Temple', commissioned in 1641 by Richelieu for the high altar of the Novitiate of the Jesuits [200]. The general principles of design are still the same as in the early painting at S. Martino, with the strong diagonal emphasis. But the space is now more carefully defined by means of the architecture, which also gives stability to the pattern by its strong verticals. That is to say, the composition is slightly more classical than in the S. Martino painting, whether it is considered in two or three dimensions. In the same way the modelling is firmer and the drapery more statuesque. The colour is colder, and perhaps shows the influence of Philippe de Champaigne. In the treatment of the subject there is also a change. The presentation is more rational, with less emphasis on the supernatural and emotional sides of the theme. The figures swoon less, and the angels appear in more human guise without the aid of clouds and mystical light. In fact in both form and content this altarpiece shows that Vouet after his return to France moved farther away from the Baroque and nearer to the type of classical painting of which Poussin was beginning to set the standard.[67]

At the same time he began to try his hand at poetical and allegorical composition. The first large series in this genre is one illustrating Tasso, executed for Bullion about 1630, in which the artist applies his Roman style to this new kind of subject. More personal are the allegorical panels executed for the various royal palaces, of which a series is in the Louvre and a fine 'Allegory of Peace' at Chatsworth [201]. This work, which is probably very late,[68] shows that Vouet did not always carry on the classical tendencies visible in the 'Presentation'. The design is freer, the modelling looser, and the whole picture is conceived more in terms of light and colour, reminding us of the fact that Vouet in his youth studied not only in Rome but also in Venice,

where he must have learnt the style of colouring which he here displays, a rather pallid version of Veronese's tones.

Vouet's most important innovations, however, lie in the field of decorative painting, in which he founded a tradition destined to dominate French painting for a century.

His earliest decorative schemes were carried out in conjunction with the sculptor Jacques Sarrazin, and consisted of painted panels surrounded by stucco. In the ceilings each panel was depicted in steep perspective, but there was no attempt to create a consistent illusion linking up the different parts of the decoration. A second group of decorations is mainly made up of panels of grotesques with landscapes and small figure groups set among them. The most important of these were two for Anne of Austria at Fontainebleau (1644) and the Palais Royal (between 1643 and 1647), now destroyed and only known from engravings, but a similar series, probably by Vouet and his pupils, survives, though much restored, at the Arsenal, where it was executed for the Maréchal de la Meilleraye about 1637.[69]

It was, however, at the Hôtel Séguier that Vouet received his greatest opportunity. There

201. Simon Vouet: Allegory of Peace. *c.* 1648. *Chatsworth, Derbyshire*

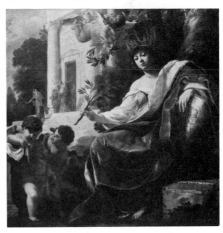

he painted the chapel (1638), the library (finished by 1640), and the lower gallery, which was left incomplete at his death in 1649. In the first two of these Vouet introduced methods of decoration which were up till then unknown in France; or rather, to put it more precisely, he grafted new wood on an old tree, and revived with fresh ideas a tradition which had been founded by the school of Fontainebleau, but had died out in the early seventeenth century.

It will be remembered that in the Galerie d'Ulysse at Fontainebleau, Primaticcio and Nicolò dell'Abate had included illusionist panels in steep perspective and that the method had been carried even further in the chapel at the Hôtel de Guise. The second school of Fontainebleau had not continued the tradition, but Vouet took it up, adding to it the methods which

he had learnt in Italy. In the library at the Hôtel Séguier the ceiling seems to have been completely painted, without stucco but with a background imitating gold mosaic. The individual compositions are in steep perspective, some of them based on Guercino's 'Aurora', but others showing Vouet's debt to Venetian painters. Some of the big oval designs have architectural backgrounds which derive directly from the ceilings of Veronese, whose works, we are told, Vouet had particularly studied while he was in Venice.

In the chapel ceiling he went a step further, and decorated it with a fresco of consistent illusionism. The subject was the Adoration of the Magi [202], and Vouet disposed the procession of the Kings and their attendants in a sort of frieze round the cove of the vaulting, so that

202. Simon Vouet: Ceiling of the chapel in the Hôtel Séguier, Paris. 1638. Engraving by M. Dorigny

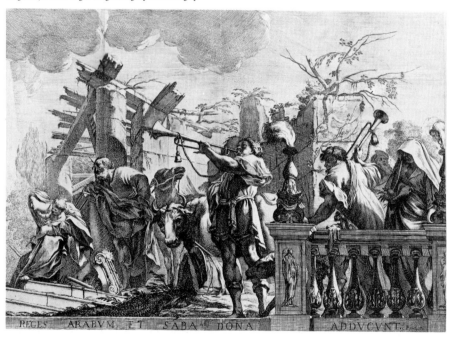

the figures seem to stand on the cornice. As Sauval points out, he has followed the example of Primaticcio and Nicolò, who used the same arrangement in the Guise Chapel. But, whereas the sixteenth-century artists organize their figures into a continuous bas-relief, Vouet is far freer in his disposition. All but the central figures of the Kings and the Holy Family are arranged behind a balustrade, which must have looked like a continuation of the wall architecture into the ceiling, and behind the groups are indications of further architecture, carrying the composition into depth. In details the figures again recall Veronese, but the general scheme of the fresco is closer to the two first examples of this type of illusionism, Correggio's dome in the cathedral of Parma and Giulio Romano's ceiling of the Sala di Troia in the Palazzo del Tè.[70]

In this fresco Vouet introduced a form of illusionist decoration which was not to be followed up in France till almost the end of the century,[71] for the ceiling decorations of the next decades are based on the illusion created by means of painted architecture, and therefore derive from a different tradition, that of the Farnese Gallery.

Vouet's influence on French painting was greater than his real quality as an artist might lead one to expect. His success depended on his bringing in a suitable new Italian idiom at the moment when it was needed, and on his skill in undertaking all sorts of tasks. Historically his position is parallel to that of Lemercier, but in temperament he reminds one more of Le Vau. He was supple, brilliant, rapid, adaptable. Like Le Vau's, his artistic conscience was not very sensitive, and his works suffer from a certain superficiality. But he brought new life to French painting when it was at a very low ebb; he introduced a solid tradition of competence; and he managed to inspire a generation of pupils who were to carry on his work in a remarkable way. Almost all the artists of the middle of the century – François Perrier, Le Sueur, and Pierre

and Nicolas Mignard – passed through his studio, and his influence was felt even farther through the most important of them all, Charles Lebrun. Theoretically Poussin represented the ideal which the Academy set itself to follow in the later seventeenth century, but all its members, starting with Lebrun, sacrificed as often, though with less ostentation, at the altar of Vouet.[72]

The Minor Painters of the 1630s and 1640s

Among Vouet's contemporaries were several artists who, like him, drew their inspiration from Italy and who evolved a kind of classical style independent of Poussin and before his work became generally known in Paris.

Vouet's collaborator, François Perrier, is still a somewhat hazy figure. Born, according to Dézallier d'Argenville,[73] in 1590, he went young to Rome, and returned to France in 1629, painting for the Charterhouse at Lyons in that year and joining Vouet at Chilly in 1630. He then settled in Paris and executed a number of works, including a series for Bordier at Le Raincy. He made a further journey to Rome, returning in 1645. During the five years after his return he carried out a number of important decorative commissions: for Mansart in the gallery of the Hôtel de la Vrillière and the chapel at Fresnes, and for Le Vau in parts of the Hôtel Lambert. He became a foundation member of the Academy and died two years later.

Perrier's style seems to have been formed in Rome on the study of the Carracci and of Lanfranco, in whose studio he actually worked. His 'Acis, Galatea, and Polyphemus' [203] in the Louvre is based on Lanfranco's treatment of the subject in the Palazzo Doria Pamphili, but is treated in a much more picturesque and less classical manner. Unfortunately almost all his decorative work in France, on which his reputation rested, has been destroyed or altered.

The decoration at the Hôtel Lambert is a slight work,[74] and the vault of the Hôtel de la Vrillière was completely reconstructed in the late nineteenth century, though the new version seems to have followed fairly accurately the original division into panels by fictive bands of stucco decoration, as recorded in a drawing.[75]

Jacques Blanchard is a more easily intelligible figure.[76] He was born in 1600 and was brought up, presumably in the Late Mannerist tradition, by his uncle, the painter Nicolas Bollery. In 1620 he went to Lyons, where he worked for a time under Horace Le Blanc,[77] and in 1624 attained what was no doubt his original goal, Rome. Here he stayed for eighteen months, and in 1626 moved to Venice, where he spent two years, mainly studying Veronese. About

1628 he returned to Paris, stopping on the way to carry out commissions in Turin and Lyons. In the remaining years till his death in 1638 he seems to have achieved a success in painting small religious and mythological subjects, though he also undertook the decoration of a gallery for Bullion, in whose house Vouet was also working.

The dominant influence on his formation was certainly the painting which he saw in Venice. For his figure types he looked at the followers of the Carracci, but in colour he was inspired by Veronese, whose cool tones and silvery light he imitated more successfully than Vouet. On his return to Paris he was probably also influenced, both in his colour and in his figure drawing, by the works of Gentileschi in the Luxembourg.

203. François Perrier: Acis and Galatea. 1645-50.
Paris, Louvre

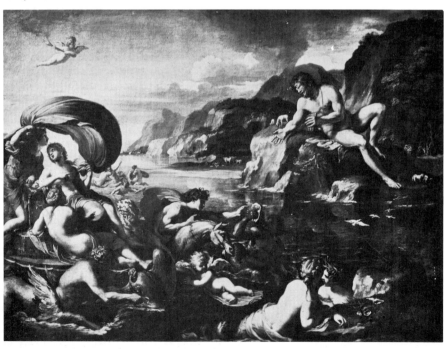

He seems to have specialized in painting such subjects as 'Charity' [204], of which many different versions exist, all showing the particular type of rather delicate sentiment which appears in almost all his work. In this painting the influence of Veronese is visible not only in the light and colour, but also in the architectural background and in the clear building-up of the group. In other probably earlier paintings, such as the 'Medor and Angelica' in the Metropolitan Museum, New York, he is more Mannerist, borrowing his compositional method from Tintoretto and his treatment of trees from Paul Brill. In yet other paintings, notably the so-called 'Cimon and Iphigenia' in the Louvre, his model is evidently Rubens, whose late nudes he must have known. It would be wrong, however, to think of Blanchard as a mere eclectic, for out of his borrowings he composed a style of his own which makes him one of the most attractive painters of his generation. He was less ambitious than Vouet, but his small, rather intimate canvases have a delicacy lacking in the great decorators.

A painter of greater range though perhaps less charm than Blanchard is Laurent de La Hyre. He was born in Paris in 1606,[78] and worked for a short time in the studio of Lallemant. His main training, however, consisted of studying the works at Fontainebleau, particularly, his biographers say, those of Primaticcio, but no doubt also those of Dubois and the other painters of Henry IV's time. The effect of this training can be seen in his earliest surviving

204. Jacques Blanchard: Charity. *c*. 1630–8.
Toledo (Ohio), Museum

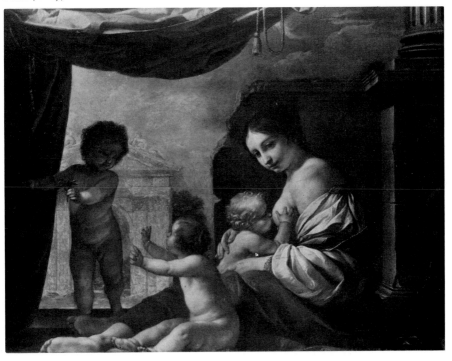

works, the two altarpieces painted for the Capuchins in the Marais, representing the 'Adoration of the Shepherds' (now at Rouen) and 'Nicholas V before the body of St Francis', dated 1630

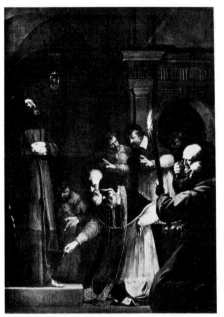

205. Laurent de La Hyre: Pope Nicholas V before the body of St Francis. 1630. *Paris, Louvre*

[205], in which the architectural setting, seen in sharp perspective, is used very much as it had been in the ceiling panels of the Galerie d'Ulysse at Fontainebleau. On the other hand, his figures have none of the characteristics of Mannerism, but are, on the contrary, staid and realistic, unlike the work of any other religious artist active in Paris at that time. We must therefore suppose that La Hyre had also seen more naturalistic models. We know that he did not visit Italy, but he could have found inspiration for his style in the Venetian paintings in the royal collection and in certain private collections in Paris, particularly those of Cardinal Riche-

lieu and the Duc de Liancourt, who had important paintings by Titian and Veronese.[79] In La Hyre's works of about 1635-7[80] this Venetian influence is even more apparent, both in the classical arrangement of the space defined by the architecture and in the treatment of light and colour. About 1638 La Hyre appears to have come under the influence of Poussin's earlier style, of which he produced a personal variant. The 'Mercury giving the Infant Bacchus to the Nymphs' in the Hermitage at Leningrad [206], dated 1638, is typical of this phase. The romantic treatment of the ruins is close, for instance, to Poussin's 'Adoration of the Magi' at Dresden, but La Hyre adds to the architecture broken fragments of sculptured heads and bas-reliefs, a device which he frequently uses at this time.[81] The figures, moreover, are in a personal style, independent of Poussin, and the landscape, with its romantic view on a river valley, is one of the earliest examples in La Hyre's art of his individual contribution in this field.

In his last years, from about 1648 till his death in 1656, La Hyre's paintings fall into two categories. His figure compositions become colder and more classical, under the influence apparently of Poussin and of Philippe de Champaigne.[82] In these works the artist seems to be adapting himself not altogether happily to the new fashion, and the result is something impersonal and not deeply felt. At the same time, however, he continued to develop his interest in landscape, and it was in these years that he produced his most original works in this field. Sometimes he models himself on Flemish masters, such as Foucquier, who was then working in Paris,[83] though modifying their naturalism into a slightly more generalized formula. At other times, as in the 'Landscape with the Arcadian Shepherds' at Orléans, he adopts the luminous qualities of the early Claude and uses them to create a poetical setting for a nostalgic classical theme.

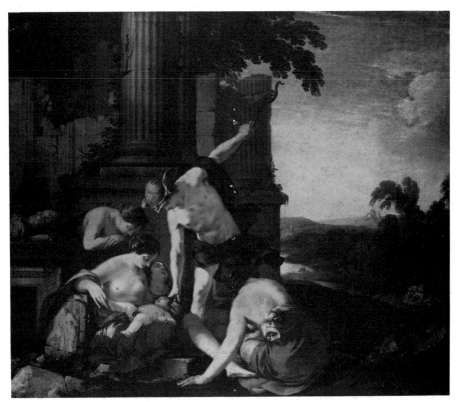

206. Laurent de La Hyre: The Birth of Bacchus.
1638. *Leningrad, Hermitage*

La Hyre is far from being a great master, and his influence was never considerable; but he is typical of a phenomenon which was to become increasingly common in France from this time onwards, namely the artist with minor talent who managed to make a personal contribution to a school of painting more notable for its steady level of quality than for the giants which it has produced. La Hyre embodies in a small way the good sense and the good taste of French seventeenth-century culture.

A number of minor contemporaries of the painters discussed above deserve mention. Lubin Baugin (*c.* 1610–63), called 'Le Petit Guide', specialized in small Holy Families based on the designs of Parmigianino but incorporating also some of the sentiment of Guido Reni [cf. 207].[84] Nicolas Chapron (1612–56),[85] mainly known as an engraver, also painted small pictures of Bacchanals in a manner which he probably learnt in Rome, where he went in 1642, from Poussin and Castiglione. Michel Corneille the Elder (1602–64) started by working with something of the naturalism and the cool colouring of the Le Nain brothers, particularly Louis, as in his 'Jacob and Esau' at Orléans, but later he was influenced by Raphael and Poussin.[86]

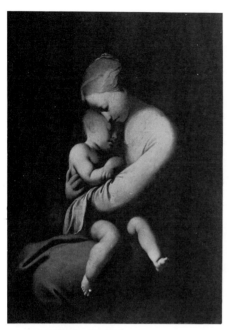

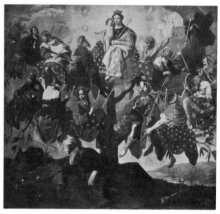

the church.[90] In the same district a rather charming, but provincial, style was practised by Jean Tassel of Langres, whose Madonnas are apt to be little more than languorous adaptations of not quite up-to-date Italian models, except when, as in the 'Tree of Jesse' [208], they are

207. Lubin Baugin: Madonna.
Private collection

208. Jean Tassel: The Tree of Jesse.
Troyes, Museum

To these must be added certain provincial painters who established various forms of Italianism in their districts. In the south Guy François of Le Puy (1580–1650) and in the north-east Philippe Quentin (*c.* 1600–36) painted large altarpieces in a semi-Baroque manner.[87] At Toulouse Hilaire Pader (1607–77) executed huge religious and allegorical compositions for the town and wrote a long poem on painting.[88] At Aix-en-Provence a Fleming, Jean Daret (1613–68), settled and decorated the houses and churches of the town.[89] At Troyes Jacques de Lestin (1597–1661), a pupil of Vouet, added a vigorous note of naturalism to his master's style. His works are mainly preserved in the museum and the churches of Troyes, but a large composition of 'The Death of St Louis', painted for St Paul-St Louis, Paris, has been reinstalled in

fortified by being grafted on an older but still lively local iconographical tradition. His few portraits and genre paintings show him to have had an instinct for naturalistic observation rare in France in his day.[91]

There are a few painters of French origin who spent the whole of their active lives in Italy and belong to the history of Italian art. From Burgundy came the two Courtois brothers, Jacques and Guillaume, who settled in Rome, where they were known as Cortese or Borgognone. Jacques became a member of the Jesuit Order and specialized primarily in battle pictures; Guillaume painted religious compositions.[92] Charles Mellin (*c.* 1587–1649), born in Lorraine, is principally interesting as the successful rival to Poussin in the competition for frescoes in S. Luigi dei Francesi in 1631.[93]

Conversely there were certain Italian artists who visited France for shorter or longer periods, sometimes exercising a considerable influence there.

One of these, the engraver Stefano della Bella (1610–64), spent the years 1639 to 1650 in Paris. He was a pupil of Callot, and benefited from the popularity of Callot's work in France. His extremely delicate topographical and decorative etchings had much success in Paris, and the latter probably exercised some influence on engravers of the next generation, like Jean Le Pautre.[94]

The appearance in Paris of the celebrated Roman decorative painter, Giovanni Francesco Romanelli, the ablest pupil of Pietro da Cortona, was part of a general move by Cardinal Mazarin to introduce the Baroque to France. His first visit to Paris was in 1646-7, when he painted for Mazarin the Galerie Mazarine which survives in the Bibliothèque Nationale, and also for the Président Lambert in the Cabinet de l'Amour. The second was in 1655-7, when he decorated the rooms of the Queen Mother, which also survive, though radically altered, on the ground floor of the Louvre.[95]

In the Galerie Mazarine Romanelli created a type of decoration blending in a novel manner classical and Baroque elements. The painted mythological scenes are enclosed in well-defined stucco frames, partly gilt, the panels themselves being mainly treated without illusionist foreshortening. This is a method which had been frequently used in both countries, but with the difference that the panels here are much larger than usual and their forms simpler and more rectilinear, producing therefore a less broken and more unified effect. Romanelli may be said to have combined the sober pattern of the Farnese ceiling with the rich stucco effects achieved by Pietro da Cortona in the Palazzo Pitti, the Baroque character of the latter being thus adapted to a more classical canon, which,

as Romanelli no doubt realized, would be palatable to a French public.[96] The scheme was to have its influence on the most important decorations of the next generation, particularly on Lebrun's Galerie d'Apollon in the Louvre.[97]

Philippe de Champaigne and Flemish Influence

Although French artists turned more regularly to Italian art for inspiration than to any other school during the seventeenth century, there were always certain groups whose interests were directed northwards to Flanders[98] and one artist of Flemish origin, Philippe de Champaigne, established an important position for himself in Paris as a painter of portraits and religious subjects.[99] He was born in Brussels in 1602 and trained there, mainly as a landscape painter under Jacques Foucquier or Foucquières.[100] In 1621 he came to Paris, perhaps with his master, who arrived in the same year. He worked with various painters, including Lallemant, on whose designs he executed a portrait group of the aldermen of the city of Paris.[101] At about the same time he met the young Poussin, with whom he collaborated on decoration for Marie de' Medici in the Luxembourg under the landscape painter, Nicolas Duchesne.[102] In 1627 he paid a short visit to Brussels, but returned at the beginning of the next year to Paris to succeed Duchesne as painter to the Queen Mother. In 1628 he began for her a series of paintings in the convent of the Carmelites in the rue St Jacques. At the same time he seems to have gained the favour of Louis XIII, for whom he painted the portrait in the Louvre showing the King crowned by Victory with a background composed of a view of La Rochelle, where the Protestants had been besieged and defeated in 1628. Six years later, in 1634, he executed a picture for Notre-Dame showing Louis XIII offering his crown to Christ at the foot of the Cross, and a composition to celebrate the reception of the

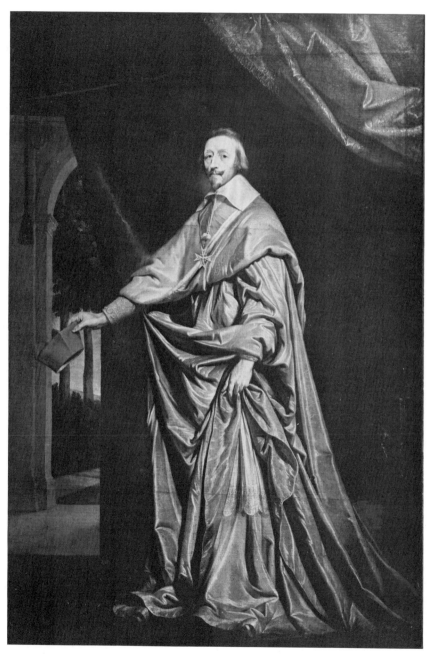

209. Philippe de Champaigne: Richelieu, 1635-40. *London, National Gallery*

Duc de Longueville into the Order of the Saint-Esprit, a huge formal design now at Toulouse.[103] In 1636 Champaigne was commissioned by one of the canons to design two tapestry cartoons of the Life of the Virgin for the cathedral.

Before 1635 Champaigne had also attracted the attention of Richelieu, for whom he decorated one gallery at the Palais Royal and painted a series of portraits of great men for another.[104] The Cardinal also commissioned him to execute the frescoes in the dome of the Sorbonne and to paint his own portrait [209].

The official paintings of Champaigne's early period show him as an artist still involved – not altogether happily – in the hieratic style imposed by tradition on this type of composition, but in his religious paintings he gives freer play to his

210. Philippe de Champaigne:
Adoration of the Shepherds. *c.* 1630.
London, Wallace Collection

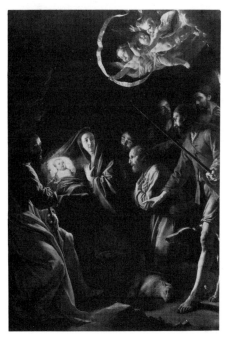

skill in depicting individual types, many of which defy the canons of classical beauty. The 'Adoration of the Shepherds' in the Wallace Collection [210], which is almost certainly an early work, shows him in this mood. The handling and the lighting have been learnt from the early Rubens,[105] and even the colour and the composition are derived from him, but they have been transformed in the borrowing. Champaigne has checked the strong movement which Rubens would have introduced into the group, and he has modified the colour in the direction of cold and strong local colour, almost unblended. There are still Baroque traces in the conception of the subject, particularly in the miraculous lighting and in the *putti* which fly in at the top, but Champaigne's personal style is already apparent in the naturalistic treatment of the shepherds, who are unlike Rubens' figures and at the same time quite unclassical.

The only portraits of this period about which we have any certain knowledge are those of Louis XIII and Richelieu. The allegorical portrait of the King after the siege of La Rochelle (1628) is probably the earliest of the series, and embodies the type used in all the later portraits, but Champaigne has evidently not felt at home in the rendering of the Victory, a piece of Baroque machinery which does not harmonize with the straightforward rendering of the King. In a fine version of Louis XIII belonging to the Comte de Paris Champaigne has borrowed the pattern used by Pourbus for his state portrait of Henry IV in the Louvre and also for that of the Duc de Chevreuse, except that he has modified the perspective, presumably because the picture was intended to be seen from below.

The portraits of Richelieu show, on the other hand, his links with Rubens and van Dyck. The full-length [209] is based on a pose much used by van Dyck in his Genoese portraits, and borrowed by him from Rubens. On the other hand, the modelling of the robes is much more massive and even sculpturesque, a fact which suggests

that Champaigne had been studying Roman statues and that he was moving towards the imitation of them at the same time as Poussin, but independently of him.[106]

About the middle of the 1640s there occurred the most important event in Champaigne's life: he came in contact with Port Royal and the doctrines of Jansenism. Like so many serious men of his time, he was evidently attracted by the sincerity of the Jansenists, their severe way of life, their devotion to their beliefs, and their complete rejection of everything that was worldly. For the rest of his life Champaigne was in close relation with the convent, for which he painted several of his most important works. But the effect of their teaching can be seen in everything that he produced, whether religious or secular.

In the religious works of his later period Champaigne rejects the elements of the Baroque which he had retained in the earlier. There are no radiances, no *putti*, no ecstasies; everything is carefully stated in clear and intelligible terms which appeal to the reason as much as to the emotions. In the big compositions, such as the series illustrating the lives and martyrdoms of St Protasius and St Gervasius (1655),[107] the result is sometimes cold and uncomfortable. Champaigne here abandons his near-Baroque energy, but never quite attains the classicism of Poussin, at which he seems to be aiming. The compositions are cold rather than lucid, and the figures rigid rather than statuesque. But in the scenes which admit of more restrained treatment the effect is of real intensity. Among the finest is the 'Crucifixion' in the Louvre [215], painted by Champaigne in 1674, the year of his death, and bequeathed by him to the Charterhouse of Paris. Here the simplicity of the presentation is dramatically effective – the cross in isolation, seen frontally with a classically constructed view of Jerusalem in the background.[108]

The most important works of this later period, however, are the portraits, in which Champaigne attains to real originality. He occasionally continues to produce the more or less showpieces, such as the portrait of the Président de Mesme (1653) in the Louvre, in which he still uses a modification of the Rubens-van Dyck formula. But his real invention is the half-length portrait of a much simpler type [211]. Basically the formula is a simple one, showing the sitter at half length, with his hand on a ledge, a pattern which Champaigne could have known from Flemish fifteenth-century or Venetian sixteenth-century models, but in the example here illustrated he has modified the pattern by showing the model sitting in a window and leaning his hand on the sill. He may have had in mind models in Dutch painting, but it is possible that he was thinking of Rembrandt's etching of Jan

211. Philippe de Champaigne: Unknown man. 1650. *Paris, Louvre*

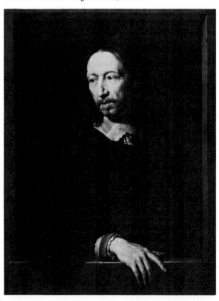

Uytenbogaert, which shows the dead preacher addressing us from the tomb. Champaigne's window is curiously like the niche-tomb from which Bernini's Fonseca prays towards the altar

in S. Lorenzo in Lucina. Bernini's figure cannot have been the model for the portrait, because it is in fact later in date, but there may have been a common source. In any case, Champaigne's unknown sitter seems to gaze out of the picture as if at something – either an altar, if the picture was to be placed in a private chapel, or conceivably at a holy image painted on another panel which, joined to the portrait, would have formed a diptych of a type familiar in Flemish art since the fifteenth century. The treatment of the portraits is highly personal; their sharp observation, their severe naturalism, and their restrained colour are all Champaigne's own. In colour one can almost say that these portraits are Jansenist in their extreme restraint. Champaigne's sitters usually wear black, and there is

little to relieve the severity of the whole, since they are shown against a grey background and behind a stone-coloured parapet. In pose they are again as classical as possible, with the head and body almost frontal, and no suggestion of movement or *contrapposto*.

On three occasions Champaigne was also commissioned to paint the official portrait group of the mayor and aldermen of the city of Paris. One of these groups, for the year 1648, exists in the Louvre [212]. As in the case of the Saint-Esprit commemorative pictures, the artist here had to follow a rigidly established formula. The individual heads are painted with great naturalism, but the figures kneel in hieratic poses on either side of a small altar, supporting a crucifix, on the base of which is the figure of St Gene-

212. Philippe de Champaigne: The Échevins of the City of Paris. 1648. *Paris, Louvre*

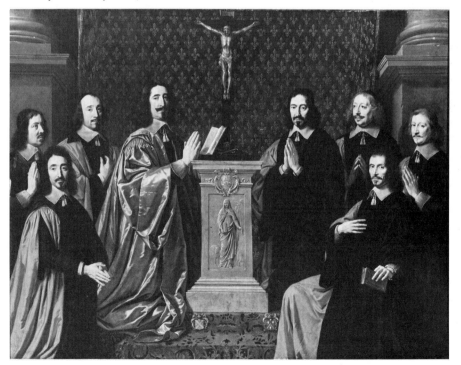

viève, the patron saint of Paris. The severity and rigidity of the design are in keeping with the dignity of those who ruled over the city at this time, who took their duties seriously and proudly maintained the independence of their municipality.

Champaigne also executed a few portraits of the great figures connected with the Jansenist movement, though not so many as is often said, because the names of Pascal and of the various members of the Arnauld family have been arbitrarily and wrongly attached to many of his sitters. Those portraits, however, which are certainly Jansenist in origin, such as the busts of the two Abbés de Saint-Cyran (at Grenoble and in an English private collection), raise an interesting problem, because it is legitimate to wonder why two priests representative of a movement which so aggressively disapproved of any kind of outward show, should be recorded in painting at all. The answer seems to be that these portraits and the few others of the same kind, such as that of Jansenius himself, of which the original is lost, were posthumous and were regarded as holy images of the 'saints' of the movement; and it is probably no accident that the portraits of the two Saint-Cyrans should have taken a form which is immediately reminiscent of a medieval *chef* reliquary. This formula would have been precisely appropriate to the needs of the case.

Although Champaigne was originally trained as a landscape painter, the only surviving examples of his work in this field date from the end of his career, probably from the 1650s. They belong to a series painted for the apartments of Anne of Austria in the Val-de-Grâce illustrating the lives of the hermits and probably based on the *Vies des Saints Pères des déserts* by the great Jansenist Antoine Arnauld. They show the artist following the formula used by Poussin in his classical landscapes of the years 1648-51, though with stronger blue distances

still recalling Champaigne's Flemish origin. In one he even adapts Poussin's figure group, and the two men carrying the body of Phocion appear bearing a sick woman to be cured by one of the anchorites. Champaigne's landscapes have a more serene atmosphere than Poussin's heroic compositions, but he may well have been inspired by the atmosphere of Poussin's 'Landscape with St Francis', usually called 'Landscape with three Monks' (Belgrade), which has the same calm remoteness.

All Champaigne's qualities are concentrated in the masterpiece of his later period, the votive picture for the curing of his daughter [213]. The story of the miraculous cure is well known. Champaigne's daughter, who was a nun at Port-Royal, was attacked in 1660 by paralysis, which by the end of 1661 had made it impossible for her to walk at all. The prioress, la Mère Agnès Arnauld, then declared a *novena* in the hope that she might be cured, and at the end of it she found that she was suddenly and miraculously enabled to walk. In thanksgiving for this cure Champaigne painted the votive picture of the miracle, which he presented to the convent. In it he depicted his daughter stretched on a chair in her cell, while the prioress kneels in prayer beside her. The composition is of the simplest, with the two figures set in almost geometrically related poses at right angles to each other against the plain background of grey walls. The colour is limited to greys and blacks, with only two strong notes of red in the crosses on the nuns' habits – and even one of those is partly obscured. The indication of the miraculous event is limited to the ray of light which falls between the two figures. In its restraint and simplicity this painting is as typical of the Jansenist approach to a miracle as Bernini's 'St Theresa' is of the Jesuit.

One lost painting must have presented almost the same dignity and simplicity in a different form. This is the 'Memento Mori' still-life

213. Philippe de Champaigne: Two Nuns of Port Royal. 1662. *Paris, Louvre*

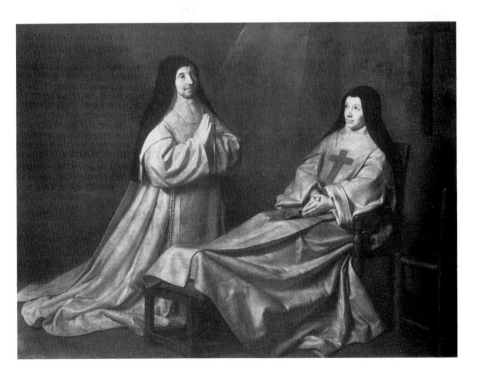

Quid terra cinisque Superbis,
Hora fugit, marcescit Honor; Mors imminet atra.

P. Champaigne Pin. Morin Scul. Cum Priuil. R.

214. Philippe de Champaigne: Memento Mori.
Engraving by Morin

engraved by Morin [214]: in the middle a skull, seen frontally, on the right a vase of roses with one petal fallen, on the left a watch – the perfectly classical still-life, as impressive in its direct symbolism as those of Zurbaran.

Philippe de Champaigne is important not only as an original artist but also as summing up one aspect of French art in the middle of the seventeenth century. His portraits and his later religious works [215] are as true a reflexion of the rationalism of French thought as the classical compositions of Poussin in the 1640s. One uses the formula of Roman republican virtue to express his beliefs, and the other that of Jansenism, the most severe of all forms of Catholicism in the seventeenth century.

It is a considerable drop from Champaigne to the remaining portrait painters of this period, but some of them must be mentioned. In their own day the cousins Henri (1603–77) and Charles Beaubrun (1604–92) enjoyed a great success, especially among the society of the *Précieux*. Their style was a continuation of the Late Mannerist formula of Pourbus in a less sensitive manner, and their portraits have little value except as records. Louis Elle (1612–89), son of Ferdinand, was of the same type, though he sometimes enlivened his portraits by a pose borrowed from van Dyck. Justus van Egmont (1601–74), a pupil of Rubens, spent the years *c.* 1628–48 in Paris, where he painted many of the most important members of the Court, using a moderated version of Rubens' style.[109]

The only member of the group to attain distinction was the draughtsman and engraver, Robert Nanteuil.[110] He is in engraving what Philippe de Champaigne was in painting, and it is no chance that he should have engraved so many heads after his Flemish contemporary. Technically he was a master of his craft, and his original engraved portraits reveal an acute power of observation [216]. His works provide the most complete view which remains to us of the great figures of the middle of the seventeenth century.

215 *(left)*. Philippe de Champaigne: The Crucifixion. 1674. *Paris, Louvre*

216 *(above)*. Robert Nanteuil: Louis XIV. 1664. Engraving. *London, British Museum*

The Caravaggesques

The influence of Caravaggio never penetrated as far as Paris, but in the provinces his style enjoyed a considerable vogue. In Toulouse Nicolas Tournier (1590–after 1660)[111] painted religious pictures in the idiom of Caravaggio [217]

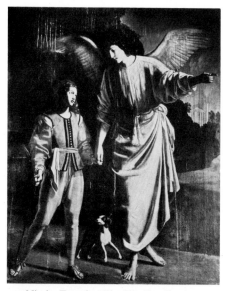

217. Nicolas Tournier: The Guardian Angel.
Narbonne Cathedral

and genre compositions in the manner of his pupil Manfredi, but he also executed a vast 'Victory of Constantine', now in the museum at Toulouse, more in emulation of Giulio Romano. His naturalism is always qualified by a slightly Mannerist elegance in the poses of his figures and by his preference for rather refined types, as opposed to the coarse peasant heads of most Caravaggesques.

Provence produced a particularly charming painter of nocturnal subjects in Trophime Bigot who was born at Arles but worked mainly in Rome, where he was influenced by the Dutch painters, such as Honthorst and Stomer, and Italians such as Manfredi and Saraceni. In some of his later works he comes very near to Georges de la Tour, though it is not clear how he could have seen his paintings, since he is not known to have visited Lorraine or indeed to have returned to Provence.[112]

It was, however, in Lorraine that the influence of Caravaggio produced its most interesting results, and in Georges de La Tour we find a personal interpretation of the convention not to be paralleled elsewhere.

La Tour was born at Vic-sur-Seille in 1593.[113] By 1620 he was established as a master in Lunéville, one of the most prosperous towns of the duchy, which he seems to have made his headquarters for the rest of his life and where he died in 1652. Records show him to have been successful in his career and to have accumulated enough wealth to arouse jealousy among his fellow townsmen. Quite early in his career, in 1623–4, he received commissions for two works from the Duke of Lorraine, but there is no evidence that the favour of the Prince was continued. In 1639 he is mentioned as having the title of *Peintre du Roi*, and it is known that Louis XIII owned a painting by him of St Sebastian. Some five years later he caught the attention of the Duc de La Ferté-Senecterre, who had been made French governor of Lorraine in 1643, and who managed to persuade the town of Nancy to present him with several works by the artist. In fact La Tour's links seem to have been not with the Court of Lorraine itself, but with a *bourgeois* circle in Lunéville and with members of the French administration at Nancy. It is, therefore, to be expected that his style should not be like the court Mannerism of his immediate predecessors and contemporaries at Nancy, Bellange, Callot, and Deruet, but should strike out on quite different lines. We know further that he was connected with the religious revival which took place at this time in Lorraine, and it has been suggested that his painting reflects the feeling of the Franciscans who were the leaders of this movement.

La Tour's artistic education has been the cause of much speculation. What appear to be the artist's earliest works, 'The Cheat', in the Louvre, and the 'Fortune Teller' in the Metropolitan Museum, show no direct evidence of Caravaggesque influence, but are exercises in a manner which had been practised in Nancy by

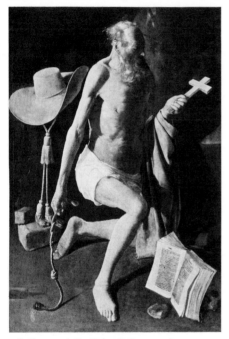

218. Georges de La Tour: St Jerome. 1620-5.
Stockholm, National Museum

Callot and by Jean Leclerc.[114] But a series of paintings which can probably be assigned to the 1620s, including the 'St Jerome' [218],[115] shows that La Tour soon came into contact with the style of Caravaggio. Most writers have assumed that he went to Italy and picked up the tradition as it was continued in Rome by Manfredi and Valentin, but the particular form of naturalism in the 'St Jerome' seems rather to suggest an acquaintance with Caravaggio's Dutch followers. The closest parallel is to be found in

Terbrugghen's works, such as the 'Four Evangelists' at Deventer painted in 1621, a time when La Tour might well have visited Utrecht. In these one finds the curious clay-like handling of the flesh and the emphasis on the dry wrinkles which are so characteristic of the 'St Jerome'. In this phase La Tour is naturalistic in the sense that he describes minutely the incidents on the surface of the bodies which he paints. Only in the cardinal's hat in the background is there a trace of the generalized treatment which was to be the hallmark of his later style. The other works which are probably of the same date all have the same picturesque, rugged, descriptive quality, for instance the 'Hurdy-Gurdy Player' in the museum at Nantes, the equivalent in a modern subject to the 'St Jerome', and moreover painted from a very similar model.

A painting, representing 'Job and his Wife', at Épinal marks the transition to the next phase. It is still conceived in the same spirit of descriptive naturalism, but it has one important difference: it represents a night scene, illuminated by an unshaded candle held by Job's wife. This is yet another link with the Dutch followers of Caravaggio who were the real exponents of this treatment of light. This method is used with great originality in almost all La Tour's later works, but in various different ways. In the 'Penitence of St Peter' at Cleveland, dated 1645, and in the 'Christ and St Joseph in the Carpenter's Shop' [219], in the Louvre, the warm, almost coppery tones suggest the influence of Honthorst's work, which La Tour may have seen if he made a journey to the Low Countries or to Rome, as is possible, in the years 1639-42, when he is not recorded in Lunéville. But in another group, the latest of all, the use of candle-light effects is far more personal, and it is here that La Tour shows his true qualities. These can be grouped round the 'Denial of St Peter' at Nantes, dated 1650, and include the 'St Sebastian' [220] at Bois-Anzeray (copy (?) in Berlin) and the Rennes 'Nativity'

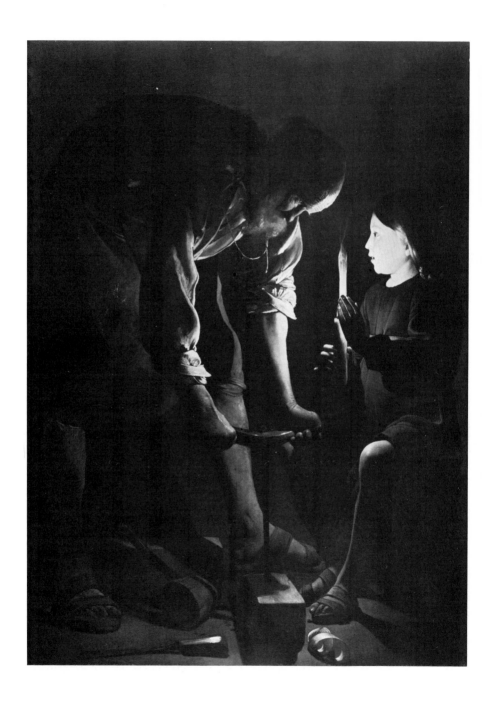

219 *(opposite)*. Georges de La Tour: Christ and St Joseph. *c*. 1645. *Paris, Louvre*

220. Georges de La Tour (copy ?): St Sebastian. *c*. 1650. *Berlin-Dahlem, Staatliche Museen*

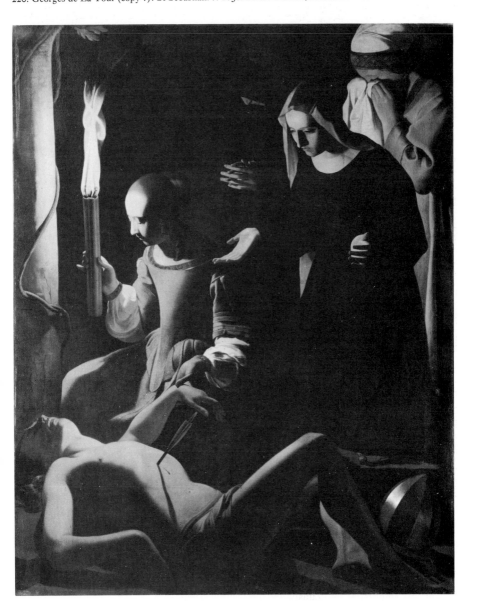

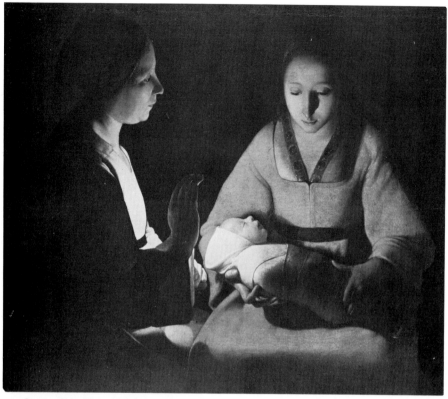

221. Georges de La Tour: Nativity. *c.* 1650.
Rennes, Museum

[221]. Here La Tour has broken away from the descriptive style of his earlier period and, avoiding all disturbing detail, reduces individual forms to almost geometrical terms, and relates them to each other in compositions of equally mathematical clarity. The result is a monumentality which has no parallel among the other followers of Caravaggio, an impressive simplicity which converts the formula of naturalism into something classical.

The style of Caravaggio admits of two different, one can almost say opposite interpretations. Some of his followers, particularly the Neapolitans, emphasized the dramatic and hor-

rific qualities in his painting, and adapted the manner to gruesome renderings of martyrdoms in which every unpleasant detail is recorded with fidelity and heightened by *chiaroscuro*. La Tour in his mature works seeks in Caravaggio exactly the opposite qualities. He does not imitate his rendering of detail, and he avoids the depiction of the disagreeable details. Notice, for instance, that in the 'St Sebastian' there is no blood and no anguish; the saint lies motionless and apparently dead, but with hardly a trace of his martyrdom. The forms are generalized to their greatest simplicity, and all violence, all movement even, are eliminated, so that the

THE LE NAINS · 265

picture takes on a quality of stillness and of silence rarely to be found in the visual arts. In this calm, detached interpretation of Caravaggesque naturalism La Tour comes near to the classicism of Poussin and to the nobility of the finest compositions of Champaigne. The art of La Tour is as far removed as it can be from the Mannerism of the Court of Nancy, but it has qualities in common with the style which was being evolved in Paris at the same time.

The Le Nains

More ink has been spilt over the 'Le Nain problem' than over any other question in French seventeenth-century art, and the process will assuredly continue, because, though at certain moments a solution has seemed to be near, new evidence has always been produced which has necessitated a re-examination of the whole problem.[116]

The facts known about the Le Nains are very few. There were three brothers, Antoine, Louis, and Mathieu. Mathieu, the youngest, was born in 1607, but the dates of birth of the other two are uncertain. The old authorities give 1588 for Antoine and 1593 for Louis, but there are strong reasons for thinking that these dates may be wrong and that Antoine may have been born shortly before 1600 and Louis shortly after. In this case all three brothers would belong more nearly to the same artistic generation than was previously thought. They were born at Laon, sons of an Isaac Le Nain, who was a man of some means and owned houses in the town and land near it. The brothers seem to have been established in Paris by the late twenties.

Antoine became master-painter in 1629 and was commissioned to paint the traditional group-portrait of the Échevins in 1632. Mathieu was made painter to the City of Paris in 1633. All three brothers became foundation members of the Academy in 1648, but the two elder died the same year. Mathieu lived till 1677 and seems to have established himself as a successful – and fairly wealthy – figure in the Paris art-world. In 1652 he is referred to as *peintre du roi*; at some date before 1658 he brought a farm near Laon, on the basis of which transaction he called himself Seigneur de la Jumelle; and he became a lieutenant in the Paris militia. In 1662 he was made a Chevalier de Saint-Michel, an honour very rare for a painter, which was apparently awarded to him for his services to the army. In the next year, however, he was deprived of the dignity because he was unable to prove his nobility. He apparently refused to accept the decision of the commission appointed by the king to reform the Order, and in 1666 was imprisoned for a short time and heavily fined. In 1673, however, he was still describing himself as 'Le Chevalier Le Nain'.

The question of attributing particular pictures to individual members of the Le Nain family has greatly exercised the minds of historians. Unfortunately those paintings that are signed simply bear the surname without any Christian name attached, and those that are dated belong to the years 1641-8, when all three brothers were active. There is therefore no firm starting point in the pictures and we are compelled to refer to external sources.

The novelist du Bail in his *Galanteries de la Cour*, published in 1644, describes three brothers who are painters and have always been taken to represent the three Le Nains. He characterizes them as follows: Antoine excelled in 'miniatures and portraits in small'; Louis made 'little pictures in which a thousand different attitudes which he copies from nature attract the eye'; Mathieu was a specialist in 'portraits and big pictures'; and Claude Leleu, the earliest biographer of the brothers, writing in 1726, adds that Mathieu painted 'big pictures, such as mysteries, martyrdoms of saints and battles'.

In a list of early members of the Academy drawn up in about 1753 Louis is described as

'Le Romain', which would imply at least a visit to Rome, and as 'Peintre de Bambochades' (a phrase used earlier by Félibien of all the brothers), that is to say paintings in the manner of Pieter van Laer, called in Rome *Bamboccio*, who specialized in 'low' subjects, or what we should call 'genre paintings'. Till the middle of the present century the three brothers were all thought of as mainly producing works of this kind, but the discovery of du Bail's text (which was only published in 1934) and the inventory of Mathieu's studio drawn up after his death (published in 1955) made it clear that in their day they were esteemed more for their religious paintings and their portraits than for their peasant-pieces. This fact was substantiated by the discovery of a number of large religious paintings and two of classical subjects, which were ascribed to the brothers.

The discovery of these large religious and secular paintings has led to much discussion on the questions of attribution which they raise: how many hands are involved? Are painters other than the three brothers involved? When were they painted? It was fortunately possible to see nearly all these canvases beside the genre paintings at the exhibition held in the Grand Palais in 1978, but no unanimity was reached on the problems involved. Two of the classical paintings – 'Venus in the Forge of Vulcan' and the 'Victory' (both in the Louvre) – are signed, and the 'Bacchus and Ariadne' at Orléans goes very closely with them, but the case of the religious paintings is different, and I suggested at the time that only two of them – the 'St Michael' at Nevers and the 'Birth of the Virgin' in Notre-Dame – were really from the studio of the Le Nain brothers. I was not supported in my

222. 'Antoine' Le Nain: Family Group. 1647. *Paris, Louvre*

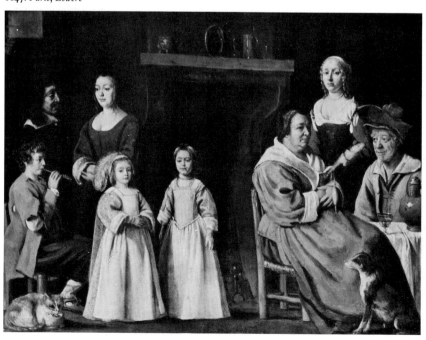

suggestion, but whether I was right or wrong the fact remains that the real contribution of the brothers to the art of their time lay in their genre paintings.

Even before the discovery of du Bail's text critics had distinguished three main groups in these works which they had associated with the names of the three brothers. To Antoine was attributed a series of small pictures mainly on copper, depicting groups of diminutive figures, painted in strong and rich colours, and naïvely placed with no great care for calculated composition. Most of these groups are portraits of *bourgeois* families shown in the surroundings of their own houses [222], but some of Antoine's compositions – for instance, the small picture in the National Gallery – represent peasant families. The origins of Antoine's style are obscure but he may have known the works of some late sixteenth-century Flemish naturalist, such as Adriaen Pietersz. van der Venne, or Hendrik Averkamp.

To Louis the second brother was attributed a group of paintings quite different from Antoine's little compositions [223]. They are larger in scale, impressive, and almost classical in composition, and subdued in colour, mainly in a narrow range of cool greys, grey-browns, and grey-greens. In the case of the paintings ascribed to Louis it seems possible to explain the origin of the manner more fully than for Antoine. The artist could have learnt something from Bamboccio – either in Rome, if he went there, or in Paris when Bamboccio passed through in 1626 on his way to Italy – not only the type of composition that he painted but something of his colouring, for Bamboccio, too, based his palette on a limited range of colours

223. Louis Le Nain: Peasants at Supper.
c. 1645–8. *Paris, Louvre*

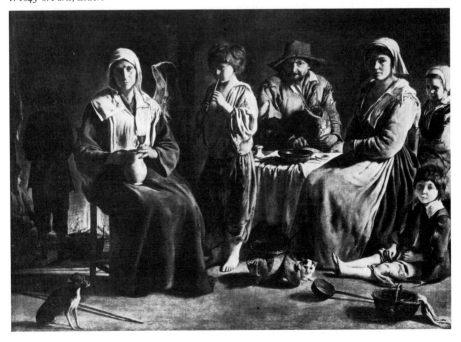

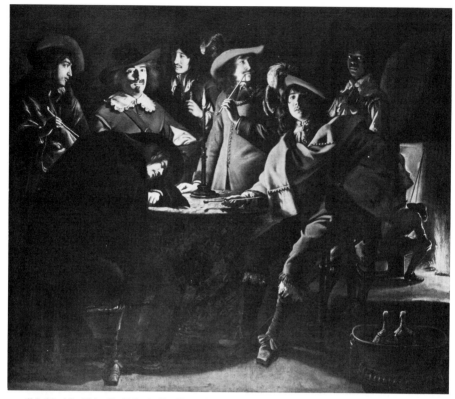

224. 'Mathieu' Le Nain: La Tabagie (Le Corps de garde). 1643.
Paris, Louvre

near to grey, though they are in general cooler than those of the French artist.

The genre paintings connected with the name of Mathieu are different again. Among the earliest is probably the 'Tabagie', formerly called the 'Corps de garde' [224], dated 1643, which is also perhaps his masterpiece. It represents a party of officers sitting round a table, drinking and attended by a Negro servant. The scene is lit by a candle standing on the table, and the effect is therefore immediately reminiscent of the Dutch Caravaggesques, whose works the artist must have known. Essentially his style is made up of elements learnt from his brother

Louis, to which is added a finish of handling which again suggests contacts with the Dutch school. Appropriately to his swaggering subjects, Mathieu makes his compositions more lively and more Baroque than those of Louis.

The attribution of these groups of paintings to the three brothers was based partly on the belief that Antoine was considerably older than the other two and that he was therefore likely to be the author of the most archaic series. When it was shown that he was of nearly the same age as the others this argument fell to the ground, and, as was pointed out by Thuillier in the catalogue of the exhibition, there was no logical

reason for attaching the name of any brother to any one group. Yet the three groups originally distinguished remain, in my opinion, coherent, and although it might be more correct to label them A, B, and C, the old appellation has its advantages though it might be wise to put the Christian names in inverted commas.

The most impressive of the three groups is unquestionably that ascribed to Louis; indeed it is because of these paintings that the family deserves all the attention that it has received.

By the early 1640s 'Louis' Le Nain had mastered a style which enabled him to paint his remarkable genre scenes [223]. In a sense these pictures belong to the tradition of Dutch *bamboccianti*, but with the very important difference that the artist never satirizes his sitters, nor draws out their grotesque or amusing qualities. He paints them with complete sympathy, but at the same time he resists the desire to idealize them. He steers, that is to say, a course midway between the boors of Brouwer and the pious simpletons of Millet's 'Angelus'. This detached observation is coupled with a mastery of a classical type of composition, which intensifies the calmness of the presentation. The figures are grouped without obvious thought, but in fact on a carefully worked-out method of frontal positions and balancing half-views, strangely like that used by Philippe de Champaigne in the votive picture for the cure of his daughter [213]. There is no action in the pictures and the figures are either absorbed in what they are doing, like the little boy playing a pipe in illustration 223, or gaze fixedly out of the picture. Here we find again that recurrent phenomenon in French art of this period, a classicism which does not use the outward forms of Greek or Roman formulas, but attains to the clarity and calm which are the more fundamental qualities of the style. Louis Le Nain is classical in his approach to life and to painting, even though he never turned to mythology for his themes.

The genre paintings of the Le Nain brothers raise one further – and fundamental – problem: who commissioned them, who bought them, and exactly what types of subject do they represent? There are unfortunately no records of collectors owning paintings by any of the brothers in the seventeenth century and very few before the middle of the eighteenth, and we are obliged to set about answering these questions from the evidence of the pictures themselves and from what we know about the circumstances of the artists and the circles in which they moved. The portrait groups by 'Antoine' represent people – presumably *bourgeois* – of moderate means who probably commissioned and paid for the pictures. 'Mathieu' we may suppose had a regular clientèle of a slightly richer bourgeois class who would have enjoyed paintings like the 'Tabagie'. The difficult problems arise over the groups of paintings ascribed to Louis. These are generally said to represent 'peasants', but Neil Macgregor[117] has pointed out that the figures in, for instance, 'La Charrette' (Louvre) and the so-called 'Resting Peasants' (Victoria and Albert Museum) [225] are too well-dressed to be true peasants, who in the 1640s had been reduced to a very low level of existence. They probably represent the members of the bourgeoisie who had begun to buy land near their native town which they either looked after themselves or entrusted to a farmer, who appears on the right of the Victoria and Albert painting, with his horse, which was almost a mark of his office. Fortunately we know that Isaac Le Nain, the father of the artists, who was an officer of the Grenier à Sel at Laon, belonged exactly to this class, and Mathieu followed his example in buying his 'farm' of La Jumelle – which consisted of half an acre – and no doubt other parcels of land near Laon. The ideals of this new class of landowner were set out by two writers, Charles Estienne and Olivier de Serres, who, in 1564 and 1600 respectively, published treatises on agriculture which were

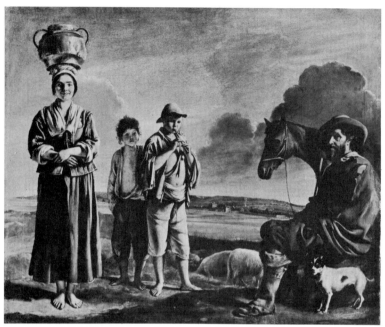

225. 'Louis' Le Nain: 'Resting Peasants'. 1640s.
London, Victoria and Albert Museum

frequently reprinted during the seventeenth century. Their description of the new type of landowner and his paternalistic attitude towards his servants whom he treats well, almost as part of his family, corresponds exactly to the dignity which is such a conspicuous feature of 'Louis'' characters.

In some cases the pictures probably represent urban rather than country scenes. This is the case with the so-called 'Repas des Paysans' in the Louvre which has a strange, almost sacramental atmosphere, an impression heightened by the fact that nothing but bread and wine are to be seen on the table. It has been suggested[118] that pictures of this type are connected with the charitable movement organized in the 1640s by bodies such as the Compagnie du Saint-Sacrement and individuals such as the Jesuit Jean Labadie, who later became a Protestant, and

the Jansenist Saint-Cyran. According to these men of good-will the poor were the chosen of God – like the sick and the mad – and it was a privilege as well as a duty to help them. Indeed the 'Repas des Paysans' seems to represent such a scene; the central figure, though simply dressed, is evidently of a different class from either the robust drinker on the left or the man who sits bare-foot on the right to whom he offers the glass. The central figure even gives the impression of being a portrait – perhaps of one of those engaged in the good work described above.

If this connection is a real one it has some bearing on the identity of the patrons for whom these pictures may have been painted, because the charitable movement was encouraged by members of a number of great families, including Condé and Conti and their sister, Mme de

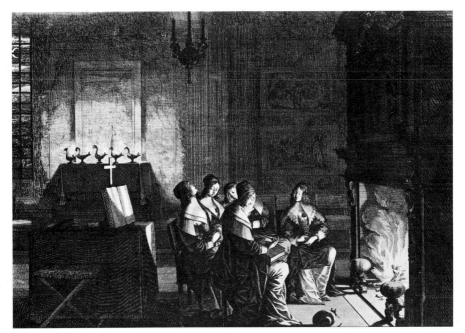

226. Abraham Bosse: The Wise Virgins. *c.* 1635.
London, British Museum

Longueville, and there are reasons for thinking that the Le Nain brothers had links with this particular family, who were the largest land-owners in Picardy. But, one may ask, if pictures by the Le Nains of this particular type were bought by Condé and his family, why do they not appear in their inventories? The answer seems to be that the movement of private charity fell into disrepute owing to its increasingly close connection with Jansenism and was replaced by a different policy which led the state to shut up the poor in newly founded institutions such as the Salpêtrière. Pictures illustrating the earlier charitable activities would therefore have been dangerous and might well have been disposed of.[119]

Naturalism produced one other remarkable artist in this period, the engraver Abraham Bosse (1602-76).[120] Bosse is generally studied purely as a recorder of life and manners, but he is also an artist of high quality. He began as an illustrator of novels and religious works and as a copier of the Late Mannerists. But in the 1630s he developed an independent and very personal style. His subjects are either taken from contemporary life, as in the 'Mariage à la Ville' and the 'Mariage à la Campagne' series (1633), or are clothed in the forms of his own period as in the 'Wise and Foolish Virgins' (*c.* 1635) [226]. Bosse always gives a clear idea of the life of his day; but the kind of life which he describes is a limited one, that, namely, of the well-to-do *bourgeoisie*. In the 'Mariage à la Ville' this is particularly clear. The characters are all the dignified members of the *noblesse de robe* and their families. The scenes illustrated are the practical events associated with a *bourgeois* marriage - the signing of the contract, the

return from the baptism, and so on. The artist takes no stock in the personal aspect of the theme, nor in the romantic – or falsely romantic – love-making whicn played so important a rôle in the aristocratic-intellectual life of the Hôtel de Rambouillet and the circle of the *Précieux*. In most of the engravings the lovers play a quite minor part and always behave with un-emotional decorum. When aristocratic figures appear in Bosse, as they do on occasions, they are usually slightly caricatured as in the 'Noblesse Française à l'Église', or made to symbolize the morally less respectable part of society. For instance, in the engravings illustrating the Parable of Lazarus the 'Rich Man's Feast' is shown attended by over-dressed fashionable figures, whereas in the 'Prodigal Son' the father wears the clothes and has the appearance of a respectable magistrate.

When Bosse renders a biblical subject such as the 'Wise and Foolish Virgins' he makes the parable the means of conveying a moral dear to the serious hearts of his audience, and at the same time gives yet another series of scenes from *bourgeois* life. In the engravings of the 'Wise Virgins' [226] we see his narrative and descriptive skill, but at the same time his mastery of technique. His detached naturalism in the rendering of the subject brings him close to Louis Le Nain, and he has further in common with him a fine grasp of classical composition, coupled in this case with a Caravaggesque use of lighting. His qualities are the opposite to those of Callot – solid technical ability and clear composition, as opposed to wit and brilliance of touch – so that to a certain extent he represents the classical phase of French engraving just as Callot embodies the Mannerist stage.

In the middle of the seventeenth century naturalism also manifested itself in France in the painting of still-life, a *genre* which later, under the influence of the doctrines of the Academy, became a much despised art. Unfortunately little is known about the practitioners of this art, except their names and a few signed works. The most remarkable is an artist who signs himself Baugin but is almost certainly not the same as Lubin Baugin, the painter of religious pictures (cf. page 249). Baugin's still-lifes are remarkable for a combination of minute attention to natural appearances with carefully planned compositions built up of very simple forms, which brings them nearer to the Spanish still-life painters, such as Sanchez Cotán, than to their contemporaries in the Low Countries. Linard and Louise Moillon have the charm of precision but lack the almost grand quality which sets Baugin apart from his competitors in France.[121]

Nicolas Poussin

By a curious freak, French painting of the seventeenth century produced its most remarkable and its most typical works not in Paris but in Rome, since it was in Rome that Poussin and Claude spent almost the whole of their active lives. In one sense these artists belong not to the French school, but to that of Rome or the Mediterranean. Seen from another point of view, however, Poussin at least is the key to the whole later evolution of French art. In him are summed up all the qualities traditionally associated with French classicism; and his influence was to be predominant in French art from his own time up to our own, in the sense that many artists took him as their ideal, and an almost equal number reacted against him with a violence which was in itself a tribute to his importance.[122]

Nicolas Poussin was born in 1593 or 1594 of a peasant family in a hamlet near Les Andelys in Normandy.[123] In 1611 he had his first taste of painting when Quentin Varin came to Les Andelys to execute a series of altarpieces for the church there. Varin (*c.* 1570-1634) was a minor Late Mannerist who worked mainly in the north-east provinces of France. As his sur-

viving paintings at Les Andelys and elsewhere show, he was an eclectic of mediocre quality, combining some knowledge of late sixteenth-century Roman painting with an inherited Flemish style. He can have done little more than whet Poussin's appetite, but he did this to such a degree that the boy left home in the next year, apparently going first to Rouen, where he worked under Noël Jouvenet, and then to Paris. We know almost nothing of his activities between his arrival in Paris about 1612 and his arrival in Rome in 1624, although some writers have filled the gap with great ingenuity by invention. He studied for a short time with the Flemish portrait painter Ferdinand Elle and probably also with Lallemant. We know too little of these artists to be able to deduce what he would have learnt from them, but it is safe to guess that he would have absorbed a style close to that of the Second School of Fontainebleau. In addition to these models, however, he had access to others better suited to his taste. He was able to work in the Royal Library, where he studied engravings after Raphael and Giulio Romano, and in the collection of sculpture, where he formed his first acquaintance with Roman statues and reliefs. It is to be supposed that he also had access to the royal collection of paintings, and so began to know Raphael and Titian. He made several attempts to reach Rome, the first two being abortive and taking him only as far as Florence and Lyons respectively. He also travelled about France executing works of which little trace remains.

In Paris he met Philippe de Champaigne, as we have seen, and worked with him for the Queen Mother at the Luxembourg. It was perhaps at her Court that he found his first real patron, the Italian poet Marino, who was attached to Marie de' Medici as her laureate. During the years 1615–23 Marino enjoyed a great success in Paris, particularly at the Hôtel de Rambouillet, where we may picture him reading parts of the *Adone,* his most important

work, published in Paris in 1622. He may even have introduced Poussin to this circle, and we know at any rate that he commissioned from the young artist a series of drawings illustrating Ovid's *Metamorphoses,* which are the only works before 1624 certainly attributable to him. They confirm the view suggested above that Poussin started as a follower of the Second School of Fontainebleau, and as a not very distinguished member of that school. They are coarse and vigorous, full of Mannerist tricks of drawing and composition, and of borrowings from the approved authorities. They give no indication that their author was to become a great artist.

In 1624 Poussin succeeded, at the third attempt, in reaching Rome, spending a few months in Venice on the way. Unfortunately for him, his one friend in Rome, Marino, left within a few months for Naples, where he died in the next year. But before leaving he had introduced Poussin to Marcello Sacchetti, through whom he met Cardinal Francesco Barberini, nephew of the recently elected Pope Urban VIII.

Poussin's first five years in Rome were a time of experiment. After a period of real poverty he obtained several important commissions, some for the Cardinal personally and one for an altarpiece in St Peter's, and he seemed set for a successful career as a painter of large altarpieces and classical compositions. It is difficult to define his style at this stage, because he tried his hand at so many different things, changing his manner with each new type of commission. His very first works in Rome – two battle-scenes from the Old Testament [227] – still show the influence of his study in Paris of engravings after Giulio Romano and Polidoro, although his imagination had been refreshed by contact with the antique sarcophagi which he would have seen in Rome. These two battle-pieces are, however, still Mannerist, in that their composition is constructed in terms of high relief, without any real space in which the figures can exist and move.

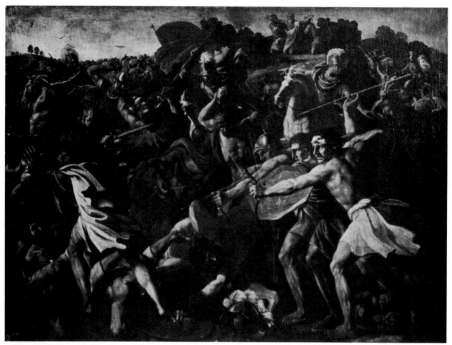

227. Nicolas Poussin:
Victory of Moses, 1624-6.
Leningrad, Hermitage

Soon after his arrival in Rome, Poussin is known to have worked in the studio of Domenichino, and to have copied his 'Martyrdom of St Andrew' in S. Gregorio al Celio. The influence of this artist is more apparent in his work of the 1630s, but it can be traced in the general design and the cool colouring of paintings such as the 'Triumph of David' at Dulwich and the 'Parnassus' in the Prado.

In the last years of the 1620s Poussin carried out several large-scale compositions, mainly, we may suppose, on commission. The most important was the altarpiece of the 'Martyrdom of St Erasmus' [228] for St Peter's, for which he

obtained the commission in 1628 through Cardinal Barberini. This was, of course, the chance for which every young artist in Rome longed, but there is some reason to think that Poussin did not profit much by it from the point of view of his own career. In any case, it remained his only public picture painted in Rome, and we can feel in Sandrart's account of its reception that many critics disapproved of it, and preferred its pendant, Valentin's 'Martyrdom of St Processus and St Martinianus', for its colour, its naturalism, and its vigour. The truth seems to be that Poussin already felt ill at ease in these big compositions in which the Baroque painters

scored their great successes, and his attempt to produce a design which should be in accordance with his own principles and yet fulfil the needs of an altarpiece for St Peter's led to a compromise which satisfied neither condition.

In one other painting of this period, the 'Madonna del Pilar' in the Louvre, Poussin is more frankly Baroque. In others, such as the 'Massacre of the Innocents' at Chantilly, painted for Giustiniani, he is more Caravaggesque. In the 'Marriage of St Catherine' he adapts a Venetian type, derived from Veronese, to the solution of the same problem. In the 'Inspiration of the Poet' in the Louvre [229], Poussin attains complete originality. Here the classicism is so marked that many critics have dated it much later, but although in the pose of the Muse the artist uses an ancient model with a directness unusual at this period, the pale, cool colour, the luminous modelling, and the free handling, which are Venetian in origin and recall Veronese, point to this short phase in Poussin's career.

About 1629 or 1630 a crisis seems to have occurred in Poussin's life. One cause may have been the relative failure of the St Peter's picture; another may have been the severe illness from which he suffered at this time. But whatever the reason, he seems suddenly to have changed direction. He abandoned the arena in which the artists of Rome were competing for the public commissions for churches and palaces, and from now onwards painted only relatively small pictures. His patrons, moreover, were no longer the princes of the Church or members of the wealthy Roman families. He seems to have been dependent for the next ten years on a small circle of *cognoscenti*, of whom the most important was the Commendatore Cassiano dal Pozzo. This attractive character was secretary to Cardinal Francesco Barberini, and Poussin no doubt knew him from his first years in Rome. Cassiano was a serious patron of the arts and the friend

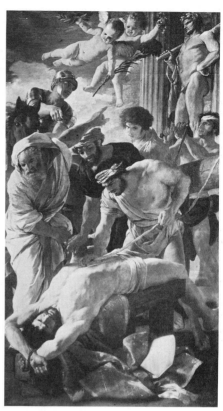

228. Nicolas Poussin:
The Martyrdom of St Erasmus.
1628–9. *Rome, Vatican*

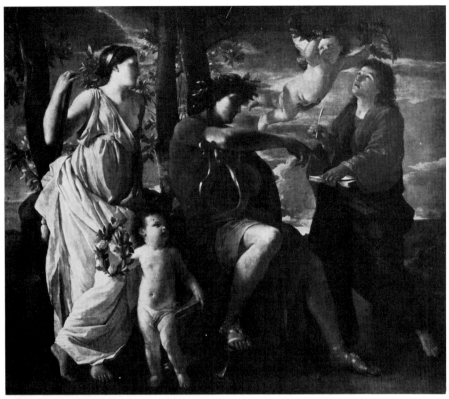

229. Nicolas Poussin: The Inspiration of the Poet.
c. 1628-9. Paris, Louvre

of Pietro da Cortona, Lanfranco, Testa, Mola, and many other artists. But his dominating passion was the study of antiquity. With apparently limited means, he brought together a collection of material designed to illustrate every aspect of life in ancient Rome. Original ancient marbles were for the most part beyond his purse, but he made up for this by commissioning a team of artists to draw for him every fragment of classical sculpture, every piece of ancient architecture, and every relic of Imperial Rome that was dug up. The volumes containing this collection are now at Windsor, and they give one a singularly vivid idea of the atmosphere in which Poussin moved at this time. Cassiano was evidently not a man who took advantage of his position to intrigue for promotion in the political world, and we can rather imagine him surrounded by his friends and collaborators, poring over his drawings and documents illustrating the ancient world.

It was in this backwater of scholarly and sensitive archaeological study that Poussin produced his paintings in the 1630s. In those dating from the years 1629-33 a complete change of subject and style is visible [230, 235]. During

these years Poussin rarely treats religious subjects; his themes are taken from ancient mythology, and from Tasso. The stories of Bacchus, Echo and Narcissus, Apollo and Daphne, Mars, Venus and Adonis, Mercury, Rinaldo and Armida – these are the stock-in-trade of the artist at this time.

One of the earliest of these *poesie* must be the 'Rinaldo and Armida' at Dulwich [231]. The colouring and the juicy handling of the pigment are Venetian and close to the 'Marriage of St Catherine'; the closed sculptural oval of the figures recalls the 'Massacre of the Innocents'; but the feeling is new in Poussin. His intention here is to render the dramatic moment in the romantic story: the *coup de foudre* as Armida falls in love with Rinaldo just as she

is about to kill him. Even the usually artificial *putto* here plays a real part, as he holds back the arm which is about to raise the dagger. Poussin's rendering is effective by its very literalness.

Among the classical compositions, the 'Arcadian Shepherds' at Chatsworth [235] is exceptional, since it is not taken directly from an ancient author, but its theme – the presence of death even in Arcadian happiness – is based on classical ideas. It shows clearly the change in Poussin's approach. The picture derives in its conception and its execution from models quite other than those on which Poussin had hitherto drawn. Above all, the influence of Titian is manifest. Poussin must have seen the works of Titian when he passed through Venice in 1624,

230. Nicolas Poussin: Diana and Endymion.
c. 1631–3. *Detroit, The Art Institute*

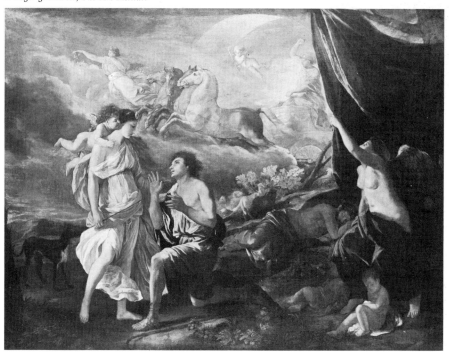

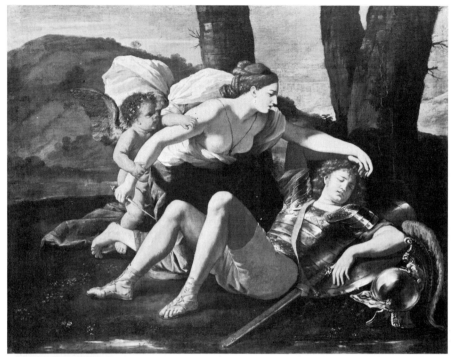

231. Nicolas Poussin: Rinaldo and Armida.
c. 1629. *Dulwich Gallery, London*

but, as far as we can judge from his works, he was not deeply influenced by him at that time. We know, however, that in Rome he studied attentively the Este 'Bacchanals', which were at that time in the Villa Ludovisi, and it is these *poesie* that we find reflected in Poussin's paintings of this time.

In a few instances Poussin actually borrows figures direct from Titian, but generally speaking he imitates the atmosphere, the colour, and the light of his model. In the 'Arcadian Shepherds' the most obviously Titianesque element is the treatment of the trees and the sky. Poussin has taken over Titian's play of dark tree-trunks and light leaves against the stormy sky, and has caught the romantic atmosphere created by

these means. Unlike Poussin's works of the mid twenties, it has a warmth and a richness of colour which are again due to Titian, for whom in this respect he has forsaken Domenichino and even Veronese. Above all, however, it is in his attitude towards antiquity that Poussin has learnt from the great Venetian. His approach is poetical, and not archaeological; there are none of the outward signs of classicism which were favoured in Rome at that time, and which were later to be much used by Poussin himself. The painter has sunk himself in the atmosphere of Ovid and his mythology, and has produced this personal version of it in paint.

The 'Arcadian Shepherds' was painted as one of a pair, the pendant being a picture rep-

resenting Midas washing in the Pactolus to rid himself of the gift which he had begged of Bacchus that everything he touched might turn to gold. These two pictures are typical in their rather melancholy, disillusioned themes of the tone of Poussin's painting at this time. Even his love-stories are usually sad – Narcissus, Apollo and Daphne, Venus and Adonis – and entirely lacking in any sensual quality. They are treated as themes for elegiac meditation rather than for romantic emotion. It is interesting to notice that, when Poussin treats religious subjects at this time, he does so in almost exactly the same spirit; the dead Christ in the Munich 'Lamentation' is hardly distinguishable from the young hunter in the 'Death of Adonis' at Caen.

One of the few firmly datable pictures in this phase is the 'Kingdom of Flora' at Dresden, painted in 1631 [232], and it provides striking evidence of Poussin's mastery of his art. In no other picture did he attain to such light-hearted delicacy. The design is built up of a complex play of diagonals, all in planes parallel with the picture, so that the whole group occupies a shallow stage, behind which the pergola and the rocks form a sort of drop-scene. The poise of the composition is exquisite but never too obvious. Echo and Narcissus form a closed oval group in the foreground, while Ajax on their left balances in his death-movement Flora scattering flowers on the right. Clytie follows Apollo with her eyes – the only movement in depth in the whole composition – and on the right the

232. Nicolas Poussin: The Kingdom of Flora. 1631. *Dresden Gallery*

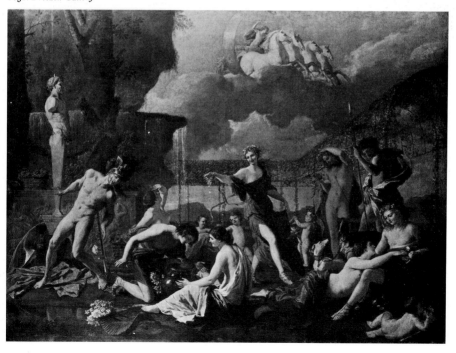

233 *(below)*. Nicolas Poussin: The Adoration of the Golden Calf. 1635-7. *London, National Gallery*

234 *(opposite)*. Nicolas Poussin: The Nurture of Jupiter. 1636-7. *Dulwich Gallery, London*

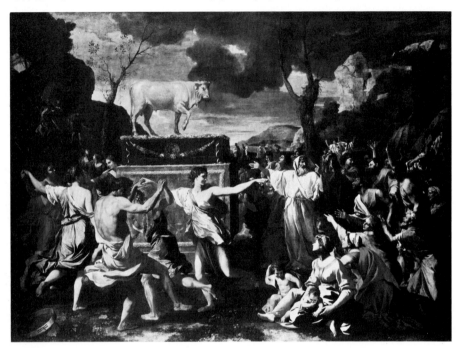

other pairs of lovers give stability by their vertical and horizontal poses to what might otherwise be a too lively whole.

About 1633 another change begins to take place in Poussin's style. The turning point is marked by the 'Adoration of the Magi' in Dresden, dated 1633, which provides a basis for distinguishing a group of paintings and assigning them to the years 1633-7. In these Poussin no longer concentrates on poetical and mythological themes; his preference is rather for subjects which offer a good pageant. From the Old Testament, for instance, he likes scenes from the wanderings of the Children of Israel, the 'Golden Calf' [233], or the 'Crossing of the Red Sea'; from ancient history the 'Rape of the Sabines' or the 'Saving of Pyrrhus'. This is also

the time of the great Bacchanals, notably those painted for Richelieu, which are more elaborate and spectacular than the earlier paintings of the same kind.

The 'Golden Calf' shows clearly the qualities of Poussin's painting at this period. Certain elements remain of the earlier manner. The landscape is still Titianesque, the colour is warm, and the small figures in the background are still treated with the rough free handling of the 'Arcadian Shepherds'. But the feeling has changed. The influence of Titian has been to a great extent replaced by that of Roman sculpture and of the late Raphael and Giulio Romano. The group of dancing figures, for instance, can be traced from Roman reliefs through paintings by Mantegna, Giulio Romano, and Taddeo

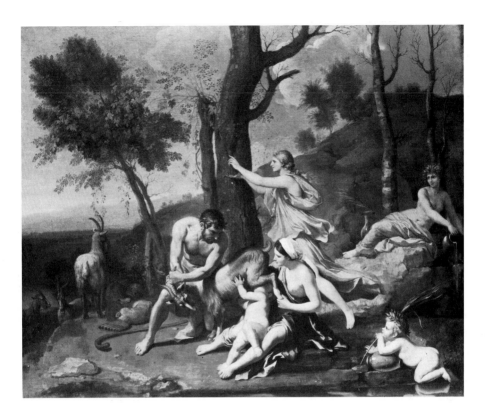

Zuccaro to Poussin, that is to say, through a linear and sculptural tradition quite different from that of Titian. Poussin has, moreover, arranged this group strictly in the form of a bas-relief. As far as possible each figure is turned so that its whole movement is in a single plane, parallel with that of the picture, and in almost every case the head is seen in profile. For the first time in Poussin's work the figures have that frozen appearance which is often to be seen in marble figures of dancers, as if they had been turned to stone in the middle of their action; and this quality is yet further evidence for the fact that Poussin was now studying ancient reliefs more and more closely.

A similar change can be seen in the modelling of individual figures. It is perhaps clearest in the foreground group of a mother with two children. Ultimately this group is derived from one in Raphael's 'Mass of Bolsena', and Poussin has attempted here to imitate to some extent the generalized modelling of Raphael, though he has emphasized more than his predecessor the sharp edges of the folds in the drapery. But he is now evidently thinking in plastic terms, and no longer in the colourist idiom of Titian.

One further point must be noticed. Poussin has here taken great pains to make the various actors in the scene show their emotions and explain the part which they are playing by means of their gestures and their facial expression. This was later to be for him a point of cardinal importance, but even at this stage he exploits it to a considerable extent.

The rejection of Venetian colouring, the sharper modelling, and the evolution of a composition based on carefully balanced movements are more apparent in a small group of works which must be dated about 1637, of which the exquisite 'Nurture of Jupiter' at Dulwich [234] is typical, and in the paintings of the very last years of the thirties these tendencies are intensified. The influence of Titian disappears, while that of Raphael and of antiquity increases. The compositions become more carefully planned; forms are more plastically modelled; colour is more local and less broken. Generally speaking, Poussin shows a leaning towards a psychological interpretation of his themes, and the emphasis on gesture and expression becomes increasingly marked. This is made very clear in the letter with which he accompanied the painting of the 'Israelites collecting the Manna' when he sent it in 1639 to the patron in Paris who had ordered it. He explains that his intention is to 'represent the misery and hunger to which the Jews had been reduced, and at the same time their joy and delight, the astonishment with which they are struck, the respect and reverence which they feel for their law-giver; with figures of women, children, and men of different ages and temperaments, all which things, if I am not mistaken, will not be displeasing to those who can read them'. Notice his use of the verb *read* in the last sentence. This brings out his real intention, that the spectator should study every group in the composition and be able to decipher the exact feelings of each figure and his function in the action as a whole. This is, of course, carrying the psychological and literary conception of painting very far, and the dangers of the method were to become only too obvious in the next generation when the Academy transformed it into a system.

At the same period, although Poussin continued to paint subjects from the *Metamorphoses*, he turned also to classical allegory and executed for instance the 'Dance of Time', now in the Wallace Collection in London, which foreshadows to some extent the more philosophical classical paintings of the next decade. It was also in these years that he painted for Cassiano dal Pozzo the series of the 'Seven Sacraments', which came to England in the eighteenth century, and of which five are still in the collection of the Duke of Rutland. In the 'Ordination' [238] the influence of Raphael is once again apparent, since the design and the types are taken closely from the tapestry 'Feed my Sheep'. But it is important to notice that Poussin is now turning to the more classical Raphael of 1515 and not to the style of the master's very last years.

In 1640 Poussin set out for Paris. For nearly two years the Surintendant des Bâtiments, Sublet de Noyers, had, at the command of the King and Richelieu, been trying to persuade the artist to return to his native country. The offers made to him were in many ways tempting: good salary, honourable position, lodgings in the Louvre, and so on. But Poussin clearly did not want to give up his quiet existence in Rome, where he could devote all his energy to his work. However, the pressure became too great to resist, and eventually he had to give in.

His first letters from Paris were cheerful. He was well received by Sublet de Noyers, Richelieu, and the King, who, on his being presented, made the not very generous comment: 'Voilà Vouet bien attrapé', which Poussin, with even less generosity, retailed to his correspondent, Cassiano dal Pozzo, in Rome. But very soon the trouble began. He was commissioned to carry out two altarpieces, two large allegories for Richelieu, and to plan the decoration of the Long Gallery of the Louvre. It would have been hard to find tasks worse suited to Poussin's talent and method of working. He was used to painting small canvases on which he could work at his leisure and without the help of assistants. Here he was being made to work in a hurry and on a scale which made it

inevitable that the execution should be mainly left to assistants. In addition, he had to face the intrigues of artists whose position in Paris had been threatened by his arrival, above all Vouet, but also men like Foucquier, who had been commissioned to decorate the Long Gallery with landscapes, and saw a dangerous rival in Poussin. He made a further enemy in Lemercier, whose decorations for the Gallery he criticized mercilessly in a letter to de Noyers.

The paintings which Poussin actually executed during this visit to Paris are among the least satisfactory that came from his brush. The altarpieces and the allegories are cold and empty. Poussin had never been addicted to such compositions, and he had lost whatever skill he may once have had for them. We can only form a partial idea of the decoration of the Long Gallery, but although it was much admired in its day and exercised considerable influence for half a century in France, Poussin's real gifts did not lie in this field. In fact, the most successful works produced on the visit were probably the designs for three frontispieces for books to be printed by the royal press: a Bible, a Virgil, and a Horace. These are all competent, classically conceived compositions, which to some extent lead on to the work of the next years.

In September 1642, having been in Paris just over eighteen months, Poussin set out again for Rome, nominally to fetch his wife, but quite certainly with the determination not to return. He reached his real home before the end of the year, and never left it again till he died in 1665.

From the point of view of his official mission, therefore, Poussin's visit to Paris was a failure. But in other ways it had consequences of the greatest importance for his development. While in Paris he established contact with a circle of friends whom he had begun to know during the last years of the 1630s, when some of them had visited him in Rome. Not only were these men to be his best patrons for the latter part of his life, but they were to influence his whole intel-

lectual outlook, and so to have an important bearing on his evolution as an artist.

Poussin's new friends belonged to a clearly defined class, and, as we have come to expect in this period, it is from the *bourgeoisie* that they sprang. But they were not the same as those who commissioned their houses from Mansart or Le Vau. They came of more modest but more solid stock. They were not so rich as the Lamberts nor so powerful as the Longueils, but their money had been gained by more honest means, and they were less ostentatious in spending it. Poussin's most regular patrons and most intimate friends were merchants, minor civil servants, and small bankers. The circle extended into the legal world, but on the whole only to the more modest sections of the Parlement, and although one or two names occur which are already familiar to the reader as among the richest men in Paris – La Vrillière, Jabach – they stand out as exceptions.

One of Poussin's Paris friends must be mentioned more specifically, because after 1640 he played a part as important as Cassiano dal Pozzo's had been before that date. This was Paul Fréart de Chantelou, a civil servant, secretary to de Noyers. He seems to have been the first Frenchman to 'discover' Poussin, and it was for him that the artist painted the 'Manna' despatched to Paris in 1639. In the next year Chantelou was sent by de Noyers to Rome to bring Poussin to Paris, and in Paris it was he who looked after the artist during his stay. After Poussin's return to Rome the two friends continued to write to each other regularly, and this correspondence, of which luckily Chantelou kept the part which he received, gives us the most interesting details which we have about Poussin's life and works in the last twenty years of his life. Chantelou was probably not as intelligent a man as Cassiano, but he was devoted and patient, and it is clear from Poussin's last letters to him that the artist felt a deep debt of gratitude towards him. Other members of this circle also

corresponded with Poussin and visited him on their business journeys to Rome, but our knowledge of their relations with the artist is fragmentary.

For these Paris intellectuals Poussin produced during the ten years after his return to Rome the paintings which were regarded in his own time as his most perfect, and which are now considered to be among the purest embodiments of French classicism [237, 239, 240, 241].

In treatment of subject and in formal conception they reveal the fact that a revolution had taken place in the artist's outlook. Poussin's choice of theme is significant. He continues to treat religious and classical subjects, but in both his attention is differently directed. In the field of religious painting his preference is now for the New Testament rather than the Old, and in the New he turns to the central themes, to those which have always occupied great religious artists – the Holy Family, the Crucifixion, the Entombment. He again takes up the theme of the Seven Sacraments, but he treats it with a quite new solemnity. When he uses Old Testament stories, it is no longer the pageant scenes from the book of Exodus that he selects, but those which admit of more dramatic or psychological interpretation: the Judgement of Solomon, Rebecca and Eliezer, Esther before Ahasuerus, the Finding of Moses. In the classical field he completely abandons Ovid and the loves of the gods, and turns instead to the Stoical historians for his matter. Coriolanus, Scipio, Diogenes, Phocion are his heroes. In all these he expounds moral themes in accordance with Stoical philosophy, all variations on the central problem of the victory of the will over the passions: Coriolanus sacrificing himself for his country; Scipio overcoming his sexual desires out of generosity; Diogenes giving up his last tie with material things; Phocion suffering death for his refusal to conceal the truth. We have already seen that the revival of Stoicism in France was fostered by the middle classes, and

no doubt Poussin's *bourgeois* friends found these stories exactly to their taste. It is also important to notice that in certain respects they correspond to the stories of Corneille's classical tragedies of the same decade: in *Horace* the sacrifice of personal interests to the safety of the state; in *Cinna* the victory of moderation over the desire of vengeance; in *Polyeucte* the sacrifice of one's life for religious beliefs; in the earlier and more romantic *Le Cid*, the willingness to sacrifice love to a code of honour.

On the other hand, the parallel between Poussin and Corneille must not be pressed too closely, for there is an essential difference between their approaches. Poussin's conception of his stories is fundamentally human and rational; Corneille's heroes are superhuman, and often defy the dictates of reason. They pursue *la gloire* with an enthusiasm which takes on the character of a pure and uncontrolled passion, and actions such as the murder of Camille by her brother in *Horace* have an almost monstrous quality which sets them apart from the moderate behaviour of Poussin's Greeks and Romans. In this respect Corneille is more Baroque than classical.

Poussin's presentation of his themes is, however, curiously like Corneille's. Both aim at perfect clarity, at an exposition which states everything essential and leaves out everything incidental. Both work within very strict rules – in the one case the Unities, in the other a canon of classical forms – but both derive extreme subtlety from this very limitation. Both aim at concentration rather than richness, and both may be said to limit their vocabulary to the minimum. Each, we are led to feel, could have explained exactly why he used a particular phrase or selected a particular pose. Neither ever gives his audience the unexplained shock of revelation which is the characteristic of the opposite Shakespearian type of art; but both lead the spectator by an infallibly calculated series of steps to the exact point at which they aim.

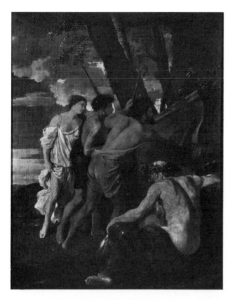

In order to see how Poussin achieves these effects, it is necessary to examine some of the paintings of the period in greater detail. The method becomes apparent if we set paintings of this time beside those of similar subjects from Poussin's earlier years. Compare the two versions of the 'Arcadian Shepherds' [235, 236], the first painted, as we have already seen, about 1630, and the second probably executed in the 1650s. One is immediately struck by what Poussin has sacrificed in the second version – warmth of colour, freedom of handling, dramatic effect as expressed both in the action and in the set-

235 *(left)*. Nicolas Poussin:
The Arcadian Shepherds. *c.* 1629–30.
Chatsworth, Devonshire Collection

236. Nicolas Poussin:
The Arcadian Shepherds. *c.* 1650. *Paris, Louvre*

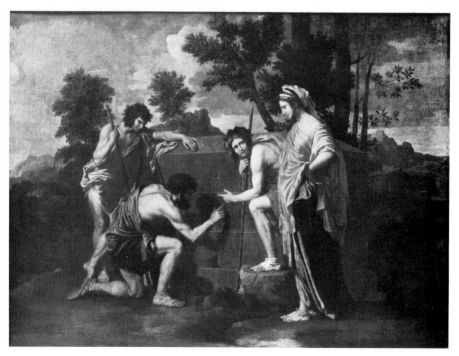

ting. All sense of urgency has gone, and, instead of rushing forward to decipher the inscription, the shepherds stand motionless in contemplation of what they have read, absorbed by the thoughts which it arouses. As befits this new conception of the subject, Poussin has eliminated all movement, and has changed the diagonal arrangement of the figures of the earlier version for a nearly frontal disposition. The figures themselves are more strictly classical in

The same change of feeling can be seen in the religious paintings. The second series of Sacraments executed for Chantelou between 1644 and 1648 [237, 239] have a solemnity wholly lacking in the more picturesque first series. This is perhaps most apparent in the 'Eucharist' [237], one of Poussin's most severe compositions. The scene is set in a room of the utmost simplicity, without ornament, and articulated only with plain Doric pilasters. The apostles are shown

237 (above, and detail, opposite). Nicolas Poussin: The Eucharist. 1647.
The Duke of Sutherland (on loan to the National Gallery of Scotland, Edinburgh)

their poses, types, and drapery, and Poussin has clearly been studying ancient sculpture with renewed interest and with the intention of imitating it more closely than before. The landscape is calm and without the contrasts which give its particular character to the Devonshire version. In fact, where one version is spontaneous, lively, and poetical, the other is calculated, calm, contemplative, and philosophical.

lying on couches round the table – a point of archaeological accuracy to which Poussin attached great importance – and are dressed in Roman togas. The artist has chosen a moment which enables him to combine the two main themes which the subject involves: the dramatic and the sacramental. Christ has given the bread to the apostles and is about to bless the cup, but on the left of the composition we see the figure of

Judas leaving the room. That is to say, Poussin represents primarily the institution of the Eucharist, but at the same time reminds the spectator of Christ's words: 'One of you shall betray me'. The double theme is made even clearer in the actions of the apostles, which are defined with great precision. Some are engaged in eating the bread, others show their realization of the significance of what is taking place by gestures of astonishment, while St John's ex-pression of sorrow shows that he is thinking of Christ's words about Judas. It is typical of Poussin's humanist religious belief at this time that he should combine in this way the transcendental and the dramatic elements of the story.

Formally Poussin has concentrated his group into a symmetrical relief pattern. His choice of a low view-point has enabled him to foreshorten the front apostles, so that they form a compact group with those on the other side of the table.

238 *(above)*. Nicolas Poussin: Ordination. 1636–40. *Belvoir, Rutland, The Duke of Rutland*

239 *(opposite)*. Nicolas Poussin: Ordination. 1647.
The Duke of Sutherland (on loan to the National Gallery of Scotland, Edinburgh)

In this respect, however, we can see Poussin's new method even more clearly by a comparison of the two versions of the Sacrament of Ordination [238, 239]. In the first the apostles are temple surrounded by smaller buildings. These two blocks, defining the middle distance, are joined by a bridge, which runs parallel with the picture plane and almost closes the composition.

arranged in a long row in the very front of the composition with the principal group, consisting of Christ and St Peter, on the extreme left. Behind them the landscape closes the picture like a backcloth. In the second version Poussin has used a quite different compositional method. Christ stands in the middle of the picture with St Peter kneeling at his feet and facing into the composition. The apostles are arranged in two groups at the sides and form a sort of avenue, leading up to the central group and also establishing a much greater depth in the composition than in the earlier version. Behind them is a landscape which is no longer a backcloth, but is planned in three dimensions. To the left is a hill crowned with buildings, and on the right a

Not completely, however, for over it the eye can see two rows of buildings stretching still farther back. That is to say, the landscape, punctuated by architectural features, is a three-dimensional space, analogous in its form to the groups of the apostles in the foreground. This more spatial conception of composition is a method regularly used by Poussin during this period, and is one of the indications that his mind was turning not only to classical antiquity but also to the most classical works of the High Renaissance in Rome, Raphael's frescoes in the Stanza della Segnatura of the Vatican. For this is merely an extension of the principles of composition which had been displayed by Raphael in the 'School of Athens'.

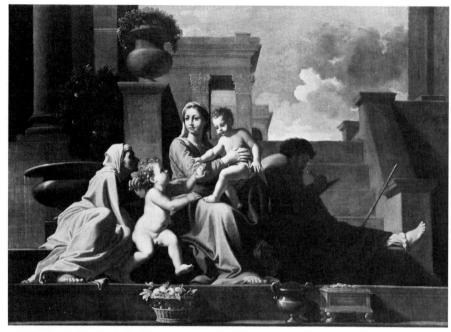

240. Nicolas Poussin: The Holy Family on the Steps.
1648. *Washington, National Gallery*

Another example of this method of space composition, and one which further illustrates Poussin's link with High Renaissance art at this time, is the 'Holy Family on the Steps' [240] of 1648. The Madonna and the Child are based on Raphael's 'Madonna with the Fish', and the pyramidal formation of the whole group was perhaps suggested to Poussin by Andrea del Sarto's 'Madonna del Sacco'. But the essential features of the composition are of Poussin's own invention. The whole space of the picture is organized in purely geometrical terms. The figures are placed in a setting defined by the simplest planes: the wall, the side of the temple, and the steps themselves, which carve out the space into a series of rectangular blocks. This obvious emphasis on the mathematical structure of the space composition reminds one that

Descartes was a contemporary of Poussin, and that he conceived the physical universe as being subject to the laws of mathematics. It is by no means certain that Poussin actually read Descartes, but it is still true to say that his conception of space composition is based on the same mathematically rational principles which governed Descartes' view of the material world.

The same fact is apparent in another group of Poussin's paintings. In the second half of the 1640s he began, rather unexpectedly, to turn his attention to landscape, a field in which he had hitherto shown little interest. In doing so, however, he applied the same method which he had used for his figure compositions. The most impressive examples are the pair of landscapes illustrating the story of Phocion, a theme taken from Plutarch [241]. Round the story of the col-

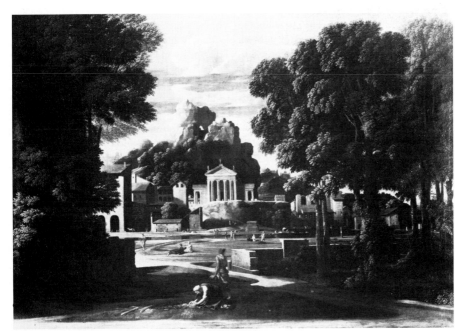

241. Nicolas Poussin: The Ashes of Phocion. 1648.
Knowsley, Lancashire, The Earl of Derby

lecting of the hero's ashes by his wife after his unjust condemnation to death Poussin has built up a landscape of the greatest solemnity, suitable to the subject with which he is dealing. The calm and sombre scene, with the city of Megara in the background, has just the heroic character which the story demands. But the most interesting feature of the picture is that Poussin has managed to apply to the confusion of inanimate nature the same principles of mathematical order which he introduced into, say, the 'Holy Family on the Steps'. The space composition is as carefully planned and as mathematically lucid as the architectural setting of the latter. Poussin has achieved this by a judicious introduction of architecture into the landscape and by treating the natural features with a monumental simplicity which reduces them to the same clarity. In the foreground the line of the wall crossed by that of the path leads the eye into the middle distance, fixed by the line of the river, which runs parallel with the plane of the picture. Behind this rises the city in which houses, temples, and rocks all conform to the same principles of clarity and parallelism. Even the sky falls into the same scheme: it does not lead the eye off to infinity, but is closed by layers of clouds, which recede one behind the other like the more tangible elements in the foreground and middle distance.

How complete was the identity of his treatment of animate and inanimate nature can be seen from the remarkable 'Finding of Moses' painted for Raynon in 1651. Here the figure groups in the foreground and the rocks and buildings in the middle distance are all handled

as masses to be fused into a single spatial scheme almost without distinction. The caesura in the middle of the figures is echoed in a break through the landscape, which leads the eye to the distant vista of the town. This picture also illustrates a feature which was to become more important in Poussin's last period. Up to this time he had always made his figures express their meaning by gesture or facial expression. Here he manages to produce the sensation of excitement at the discovery of the child to a great extent by the fluttering effect of the draperies in the left-hand figures, contrasted with the static quality of those on the right.

Since it was in the period 1643–53 that Poussin's art attained its greatest maturity, and his ideas their greatest clarity, it may be worth while to consider for a moment what we know of his method of work and the principles which underlay it. In his letters he often emphasizes points which have been made in the foregoing pages. Painting, he says, deals with human action, and above all with the most noble and serious human actions. It must present these according to the principles of reason; that is to say, it must show them in a logical and orderly manner, as nature would produce them if she were perfect. The artist must seek the typical, and the general. Painting should appeal to the mind and not to the eye; hence it must not bother with trivialities, such as glowing colour, which is only a sensuous attraction, but must only use colour and light as means of expressing the action of the picture.

One form which this doctrine took with Poussin was the well-known theory of Modes. According to this, each subject demands a particular kind of treatment, just as, according to the ancients, different Modes in music expressed different characters of themes, the Dorian heroic, the Lydian melancholy, and so on. The principal result of this view was that if the artist was treating a harsh and solemn subject his painting would also have to be harsh and solemn,

and it would be wrong for him to introduce into it any sweetness or charm. Poussin was consistent in applying this doctrine, with the result that many of his paintings of this period are remarkably lacking in attraction to the eye, and appeal to the emotions only through the mind and the reason.

Of Poussin's method of work we have some knowledge from accounts left by his contemporaries. When a subject was suggested to him, he began by reading carefully all that he could find about it. Then he made a rough sketch of the projected design. For the next stage in the evolution of the design he made small wax figures, which he dressed with linen draperies and put into a sort of peep-show, or miniature stage, of which he could control the lighting and in which he could put a backcloth to represent the landscape. Then, having arranged the figures to his satisfaction, he would make another sketch. If that did not seem right he would again move his puppets and make a new sketch; and so on, till he found the grouping which satisfied both his desire for harmony and his principle of the greatest clarity of exposition. We can actually watch this process taking place, for in some cases – for instance the 'Baptism' belonging to the second series of Sacraments – enough drawings survive to show us half-a-dozen stages in the game.

When the figure composition was fixed in this way, Poussin made bigger models, and again covered them with draperies. From these he executed the actual picture, never painting direct from life, but going to look at real figures when he felt the need to do so. The proportions and types of the lay figures from which he actually painted were based on his long study and intimate knowledge of ancient statues, and it was to these that he looked as the ideal for his own compositions. He felt that if he painted from life he would lose his image of this ideal. This unusual method explains many of the features of Poussin's style: its classicism, its

marble-like detachment, and also its coldness, which at some moments comes near to lack of life.

In the last twelve years of his life (1653–65) Poussin's style changes again, and in a rather curious way. By this time his position in Rome was unique. His reputation was European, but he had never played an active part in the official artistic activities of the city. He had become something of a hermit, revered by many, but seeing only a small circle of intimate friends. We have the impression that he now worked more to satisfy his need to paint, and less to please anyone else. His last works are, therefore, highly personal, and represent the researches of the old artist in the privacy of his studio rather than his reaction to any outside impulse.

In the figure compositions of his last phase certain features present in the previous years are intensified, such as the almost puritanical simplicity and severity of the compositions, and the elimination of all picturesque ornament. But there are new qualities. In the 'Holy Family in Egypt', painted in about 1655–7 [242], for instance, the calmness has been carried to a much higher pitch. Action and gesture have disappeared, and even facial expression is reduced to the minimum. The composition is as clear as in the works of the 1640s, but even simpler in that it is based entirely on horizontals and verticals, with hardly a diagonal movement. The whole painting is typical of the method of expressive understatement which Poussin uses so much in the last period.

242. Nicolas Poussin: The Holy Family in Egypt. *c.* 1655–7. *Leningrad, Hermitage*

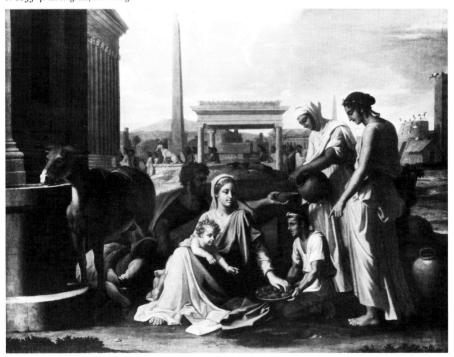

The 'Holy Family' also contains another typical feature. The details of Egyptian architecture and customs in the background were taken, as Poussin himself indicates in a letter, from the Roman mosaic at Palestrina which represents scenes from Egyptian life. We have seen that in earlier periods Poussin paid attention to details of classical archaeology, but he is here doing more. Up till now he had been content with a generally antique setting for such a subject, but now he seeks greater precision and wants the details to be correctly Egyptian.

The same motionless quality which we have noticed in this composition is to be found in the few classical paintings of the last years, such as the 'Achilles on Scyros', painted in 1656, and now only known from engravings, and even more clearly in the 'Holy Families'. The most striking of these is one with almost life-size figures in the Hermitage, probably finished in 1655 [243]. The last vestiges of action and ex-

243. Nicolas Poussin: The Holy Family. 1653–5. *Leningrad, Hermitage*

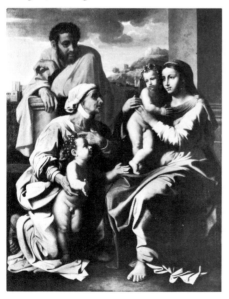

pression have gone. The only figure to make any gesture at all is the infant St John, who holds out his hands. The other figures are lost in a marble stillness, which gives a sort of abstract grandeur to the composition.

Poussin also returned in his last years to the painting of mythological stories, but in a spirit entirely different from that in which he had treated them in his early years. Now he makes the stories in Ovid symbols for some general truth which he wishes to convey. His gods and goddesses have the same abstract qualities as the figures in the 'Holy Family'. Moreover, they are usually placed in a landscape, and the two together are used to convey the allegory. The 'Landscape with Orion' [244] in the Metropolitan Museum is an allegory on the origin of clouds, and the 'Birth of Bacchus' in the Fogg Museum symbolizes the contrast between the forces of life and death. In these paintings it is noticeable that nature itself takes on a character new in Poussin. Instead of being orderly and subject to the laws of reason, it has a grand wildness unknown in his earlier work. Even in the 'Apollo and Daphne' [245], left unfinished at his death, we feel that nature has this character. This picture sums up all the strange features of his last phase: the wildness and grandeur of inanimate nature, the impassive calm of the human actors, here more than ever like wax images, and the other-worldly atmosphere in which they live. These are no longer the gods and goddesses of Ovid, subject to the passions of the flesh. They are symbols created by the mind of the artist, existing in a world of pure intellect.

Curiously enough the key to this strange world is to be found in a late form of Stoicism, a philosophy of which the ethics had influenced Poussin so profoundly in his middle years. In late antiquity certain Stoics, of whom the most important is the fourth-century writer Macrobius, interpreted the myths surrounding the gods of Greece and Rome as cosmological allegories, that is to say, as allegories for the cyclical

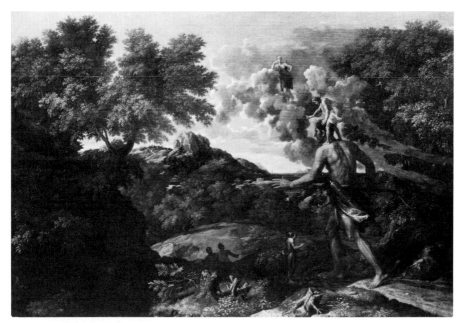

244. Nicolas Poussin: Landscape with Orion.
New York, Metropolitan Museum

processes of nature – the alternation of day and night, the procession of the seasons – and for the power of the sun as the source of life conquering the inertia of dead matter, and these ideas lie behind many of Poussin's late mythological paintings, such as the Orion', the 'Birth of Bacchus', and the 'Four Seasons', painted in his very last years and now in the Louvre.[124] The Stoic doctrine explains the iconography of these works, which does not conform to any normal tradition, but it also accounts for the atmosphere of remote contemplation which permeates them.[125]

In his last phase Poussin goes beyond the principles which had inspired him in his middle years. Then he worked on the belief that the processes involved in the creation of a work of art were wholly rational. The business of the artist, according to him, was to mould his imaginative conceptions into forms of perfect clarity, which should, further, conform to certain canons derived from classical art and should produce an internal harmony almost musical in quality. These were the conscious aims of the artist and they could be attained by Reason. In concentrating so exclusively on this aspect of art Poussin was inevitably led to sacrifice certain opposite qualities: spontaneity of design, freedom of handling, richness of colour, beauty of *matière*; and he ran the risk of inhibiting the free working of his imagination. But if Poussin worked at this time within these limitations, he attained other qualities of almost equal importance: the invention of visual forms perfectly adapted to their purpose, a concentrated pointedness in expression, an integrity which seems both intellectual and moral, a high seriousness and a harmonious calm which are hardly excelled save in the frescoes of Raphael and the sculptures of fifth-century Greece.

245. Nicolas Poussin: Apollo and Daphne. 1664. *Paris, Louvre*

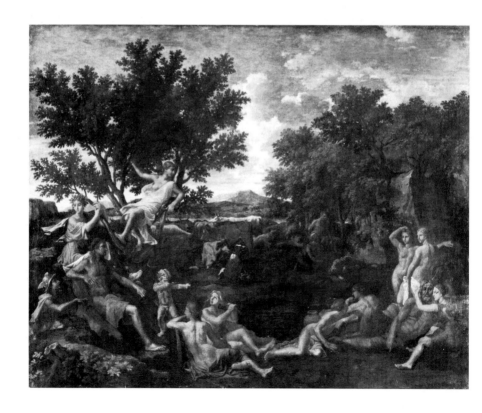

In his last years he broke through the barriers of reason, or rather, conceiving of reason, like the Stoics, as a positive and creative faculty, he was enabled by it to produce paintings which, paradoxically, must rank with the highest creations of the human imagination.

Landscape Painting: Claude Lorraine and Gaspar Dughet

As we have seen, Poussin, following the example of Annibale Carracci and Domenichino, experimented in classical landscape, but it was Claude Lorraine who did for Roman and French painting what, much earlier, Altdorfer had done for Germany, and Patinir and Bruegel for Flanders, that is to say, established landscape as a means of artistic expression as subtle and varied as the older genres of religious and historical painting.

Claude Gellée, known to the French as Le Lorrain, and to the English as Claude Lorraine, was born in the village of Chamagne, not far from Nancy, in 1600.[126] At a very early age, probably when he was about twelve, he went to Freiburg-im-Breisgau and thence to Rome, to follow the favourite trade of the Lorrainers, that of a pastry-cook. In this capacity he obtained employment in the house of the landscape painter Agostino Tassi and, gradually turning himself from cook into apprentice, learnt from him the rudiments of painting. At an uncertain date, probably about 1623, he made a visit to Naples, to study under the Flemish artist known in Italy as Goffredo Wals. We know too little of the work of this painter to be able to estimate his influence on the young Claude, but the visit to Naples produced one result which affected Claude for the rest of his life. He was haunted by the beauty of the Gulf of Naples, and to the very end of his life we find him reproducing the coastline from Sorrento to Pozzuoli and the islands of Capri and Ischia.

In 1625 he left Rome and, passing through Loreto, Venice, Tyrol, and Bavaria, returned to Nancy. There he worked for a time with Claude Deruet, painting architectural backgrounds to his ceiling paintings for the Carmelite church, now destroyed. By the end of 1627, however, he had again abandoned his native country and returned to Rome, travelling this time through Marseilles and Civita Vecchia. As far as the records tell us, he never again left the city, though it is hard to believe that he did not revisit Naples to revive in his mind the image of the bay.

By the end of the 1630s he had established a considerable reputation as a painter of landscape. We know that about 1634 another artist, Sébastien Bourdon, thought it worth while to imitate his style and pass off a painting of his own as a work of Claude; and before the end of the decade he had attracted the attention of Béthune, the French ambassador, Cardinals Crescenzio and Bentivoglio, and finally Urban VIII, all of whom had commissioned paintings from him. From that time onwards patrons were never lacking, and the measure of Claude's success in later life is the fact that he felt it necessary to record his compositions in drawings, forming the *Liber Veritatis* (now British Museum), to guard against imitations and forgeries. He died in 1682, a respected member of the colony of foreign artists in Rome.

Whereas the landscape of Poussin derives from the line of Bellini, Titian, Annibale Carracci, and Domenichino, Claude's roots are in a quite different tradition, that of the Northerners established in Rome. Apart from his master Tassi he learnt his art in the first instance from studying the works of Paul Brill and Elsheimer. Brill and Tassi had implanted and developed in Rome the style of Late Mannerist landscape, with its artificial disposition of dark-brown foreground, lighter-green middle distance, and blue hills on the horizon, each stage being marked by wings as in a theatre, starting from a dark tree in the foreground. This artificiality of design was coupled with a stylized treatment of

the detail, the trees in particular being painted in a set formula of frond-like branches. Elsheimer had used this Mannerist idiom of landscape, but in a wholly different spirit; for he had understood the poetical possibilities of light enveloping the whole of a landscape, of an infinite vista contrasted with a filled foreground, and of the evanescent effects of dawn and twilight.

In his earliest paintings Claude imitates the more prosaic of these models, and, for instance, in the 'Mill', dated 1631 [246], he follows closely the example of Brill. There on the left is the regulation dark tree; the foreground is filled with incidents of the kind which Brill loved – boats in construction, fragments of ancient columns, and small figures, in this case artists

sketching; on the right is a picturesque tower; behind it the trees form the next stage, and the hills close in the background. The Mannerist scheme is carried out even to the formula for the tree silhouettes. Of Elsheimer we can see little, except that there is some feeling for the enveloping quality of light, which gives a more definite mood to the picture than would be found in Brill. This is the only foretaste of the poetical qualities of Claude's mature style. In the etchings of the same period the influence of Elsheimer is more evident, and through their technical incompetence there shines a glimmer of real imagination.

During the years 1640–60 Claude developed his full mastery in every type of landscape painting, and we may therefore consider the general

246. Claude: The Mill. 1631.
Boston, Mass., Museum of Fine Arts

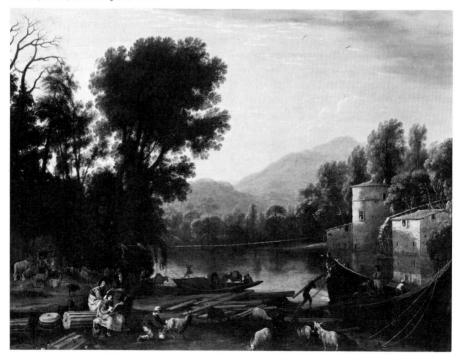

characteristics of his style as it is manifested in those years.

The first problem to be considered is the actual content of his paintings. I say *content* rather than *subject* because it has long been realized that it was not of primary importance to Claude whether he depicted in a painting the Flight into Egypt or Cephalus and Procris. He did not, like Poussin, evolve his composition logically from the particular theme of the painting. On the other hand, it is quite wrong to jump from this argument, as some have done, to the conclusion that Claude was not concerned with subject, but merely painted light or pursued some abstract quality in his art. He was, on the contrary, deeply interested in the content of his paintings, but this content was something other than the theme set him for any particular work.

As a first approximation we may say that the content of his painting was the beauty of the countryside round Rome. This was actually in itself a novelty in landscape painting. The south German and Austrian painters had discovered the beauty of the Danube valley; the Umbrians had realized the pure clarity of their hills; the Venetians had rendered the romantic quality of the plains of the Veneto and foothills of the Alps. But before Claude the Roman Campagna had generally been an object of interest rather than of aesthetic admiration to artists. Many Northerners had drawn it for the ruins which covered it: none had noticed its pictorial possibilities. It had been studied with the eyes of curiosity; Claude saw it with the eyes of wonder.

We know from the artist's early biographers of his constant excursions from Rome, wandering over the whole range of the country, sketching it with the pen, in wash, and even, we are told, in oils. His surviving drawings confirm the extent and the subtlety of his observation. But even in the finished pictures we can see his knowledge incorporated, though in more generalized form. Sometimes he paints the Tiber valley with Soracte in the distance, sometimes

the more deserted Campagna south of the capital. He is equally at home in the olive-groves of the Sabines, and among the vines and lakes of the Albans. Pines, oaks, and feathery poplars all take their place in his scenes; and sometimes he fills the middle distance with the citadel of an Etruscan town [249]. Always there recur the memories of the bay of Naples, the rock arch of the School of Virgil [253], the caves in the cliffs of Capri, the coastline leading out to Ischia [253], or the harbour itself [247], though here no doubt he fused with Naples reminiscences of Civita Vecchia and Genoa also seen in youth.

But it is not only the topographical appearance of the Roman country that Claude paints. The scenes which he chooses are given significance and poetical quality by his understanding of the light which bathes them. Here he follows Elsheimer, though with a difference. Generally speaking, the German artist preferred the exceptional light effects – moonlight, or a dark twilight. Claude sometimes selects these, but his normal tendency is towards the more typical effects, a cool early-morning light, the hot noonday, or the warm glow of evening. To our northern eyes his light often appears artificial and exaggerated, but in reality he renders effects which can be seen daily in the country which he painted. Like Elsheimer, he uses light to impose imaginative and visual unity on his compositions; but whereas Elsheimer tends to work with a dramatic intention and to seek strong chiaroscuro, Claude aims rather at serenity, and therefore avoids contrasts. This is a tendency which becomes more marked in his later period, but it is also true of his maturity. Even when he paints ships and buildings directly against the light of the setting sun [247], he minimizes the contrasts of value in order to preserve the calm unity of the whole.

For Claude, however, the Roman countryside was not empty. It was filled with associations and memories of antiquity. But the

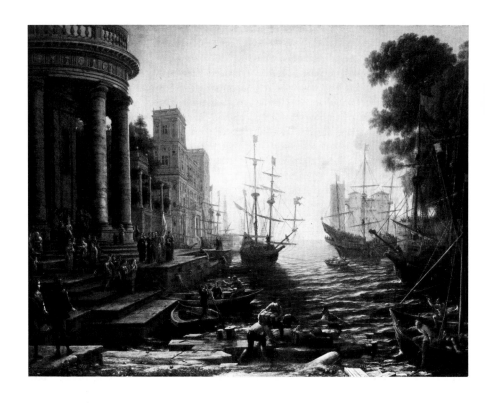

247. Claude: The Embarkation of St Ursula. 1641. *London, National Gallery*

aspect of antiquity which fascinated Claude was very different from that which inspired Poussin. He had no mind to revive the virtues of Republican Rome or the splendours of the Imperial city. His antiquity was the pastoral life described in the bucolic poems of Virgil, the first poet to record the beauty of Italian landscape. Claude loved first of all the life which Virgil and his contemporaries led on their villas, and secondly he was inspired by the earlier epoch which the poet described, the Golden Age of the time when Aeneas landed and founded Rome. Some of his paintings actually illustrate themes from those passages in the *Aeneid* which describe this part of the hero's life, and many are filled with the same atmosphere. Claude's Campagna is peopled with the shades of Aeneas and his companions, and with the gods which Virgil describes in the *Georgics,* not the great gods but the little ones, 'Pan and old Sylvanus and the Sisterhood of Nymphs', and 'the tutelary spirits of country folk'.

The poems of Virgil were evidently Claude's main source of inspiration in these paintings, but from all accounts he was not himself a Latin scholar. He is more likely to have absorbed the atmosphere of the pastorals through Italian translations and through the conversation of his more learned friends, such as Cardinal Massimi. I believe, however, that he also derived ideas – and this time directly – from visual sources in ancient art. We know that the Vatican Virgil was much studied in the circles in which Claude moved, and it is quite likely that some of the illustrations of pastoral subjects in it may have suggested ideas for his compositions. He no doubt also knew Roman frescoes of landscape subjects in which architecture and country scenes are mingled, in a form of composition which he used extensively, for instance in the paintings entitled 'The Decline of the Roman Empire' in which the arches and aqueducts of ancient Rome rise from the Cam-

pagna. But Claude differs from his ancient models in one important respect: his buildings in these cases are in ruins, and it is an essential part of his intention to create a feeling of nostalgia for past greatness.

We may say, in short, that the content of Claude's paintings is a poetic rendering of the atmosphere of the Roman countryside, with its changing lights and its complex associations. This is as different as could be from the content of Poussin's heroic landscapes, which, as we have seen, are built up round a Stoical theme according to a series of logical calculations. It follows that the means of expression chosen by Claude must also differ radically from those of Poussin.

In certain very rare cases the two artists seem to approach each other. In paintings like 'The Mill' in the National Gallery, London, or even in the 'Port Scene' [247], Claude uses a symmetrical composition in which the clear recession by stages reminds one of the method of Poussin. But this is the exception, and in general it is the contrast and not the similarity between the two artists that strikes one. Instead of Poussin's hollow box-like space filled with solid objects which recede in well-defined steps, Claude creates a much looser space, almost always leading the eye to infinity at some point, and often with a wide line of horizon. This space is filled with atmosphere which penetrates the trees standing in it and forms the continuum of the picture [cf. 248]. Recession is established often without the use of linear perspective, by the subtle degradation of colour, usually in objects such as trees which have no sharp outline. Moreover, these objects may be disposed on a horizontal plane, as are, for instance, the trees covering the valley in the 'Erminia' [248], in which the eye is led from the river to the extreme distance simply by the change in colour of the groves. When he paints water, Claude can be even bolder, and in the

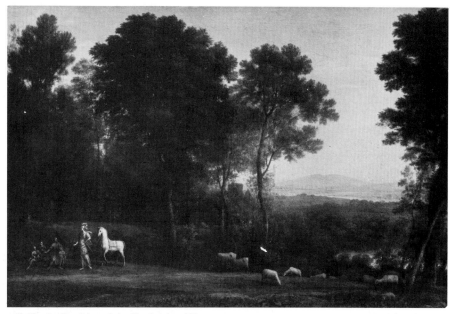

248. Claude: Erminia and the Shepherds. 1666.
Holkham, Norfolk, The Earl of Leicester

late 'Perseus' [253] we see at its most daring a method which he uses frequently in the works of the middle years. Here Claude carries the eye over the unbroken surface of the sea right to the horizon, with no external aids, by means of colour and tone changes, coupled with the slight variations in the frequency of the waves which pattern the surface. In the early works he makes use of the *repoussoir* trees in the foreground which we have noted in 'The Mill', but in the paintings of the middle and later years he frequently throws away this too obvious help, and for instance in the 'Apollo' of 1654 [249] the composition consists of two masses of trees and a town all rising like blocks from a composition primarily planned on the horizontal plane.

This freely invented atmospheric space is then filled with trees and buildings through which the air flows so that they hardly seem to interrupt its continuity. Claude's branches have none of the marble solidity of Poussin's. They wave in the moving air and reflect the flickering light. Nothing in Claude is fixed; everything is about to change. Compare, for instance, his treatment of water with that of Poussin. The latter rarely represents water at all, but when he does it is the unruffled surface of a river which reflects as steadily as possible the surrounding scene. Claude, on the other hand, prefers the sea, and in the sea he loves to render the perpetual movement of the waves – or rather ripples, because they never take on the romantic grandeur of waves. Like his trees, their primary function is to reflect the changing light.

Even in their use of architecture the methods of Poussin and Claude are different. Poussin gives us structures of the simplest cubical forms, every detail of which could be justified on archaeological grounds. Claude chooses build-

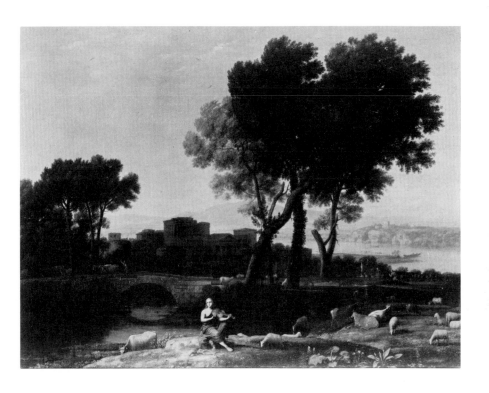

249. Claude: Apollo guarding the herds of Admetus. 1654. *Holkham, Norfolk, The Earl of Leicester*

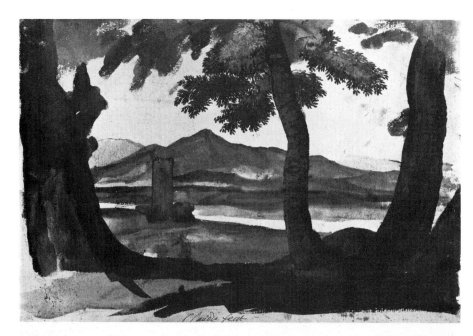

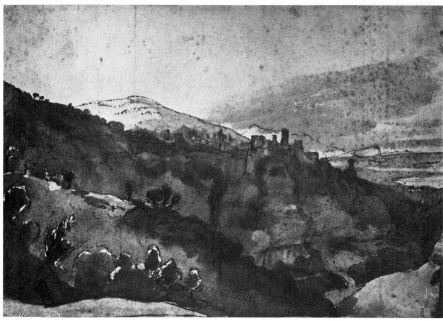

ings with varied and picturesque surfaces, preferably ruined, sometimes Gothic, and almost always fanciful and mixed in their styles. Poussin's buildings are solid blocks of masonry; Claude loves open porticos seen against the sun, or towers that lose their substance in the mist [247].

We can learn as much about Claude from his drawings as from his paintings. Turning through the boxes of sketches in the British Museum, we realize the range and intensity of his observation. Here we have the first records of those wanderings over the Campagna of which San-

drart and Baldinucci tell us. The variety of the drawings is endless. Some are prosaic notes of a building or a prospect, put down in a hard pen outline. Others are more carefully studied descriptions of a section of the landscape. Others are the immediate record of a suddenly perceived *contre-jour* effect [250]. In some [251] all these qualities are combined, and we have the poetical rendering of a startling visual impression – the hillside of Tivoli seen against the light. Before Claude no one had ventured to tackle such a subject, and since his time few have done so with success. In order to render precisely the complexity of the light effects with the echoing reflexions in the valley, Claude has allowed the solidity of the hills to disappear, so that the town seems almost to float in the air. How completely he was prepared to make this sacrifice can be seen in the drawing of trees [252], which, as has frequently been said, has an almost Chinese appearance.

250 *(opposite, above)*. Claude: View of the Campagna. Wash drawing. *London, British Museum*

251 *(opposite, below)*. Claude: View of Tivoli. Wash drawing. *London, British Museum*

252 *(above)*. Claude: Tree and Hills. Wash drawing. *London, British Museum*

253. Claude: Perseus and Medusa. 1674.
Holkham, Norfolk, The Earl of Leicester

In addition to these magically fresh notes, Claude also used drawing as a means of preparing his compositions. Many finished preparations for painted compositions exist, and in some cases we can follow the artist in the evolution of a design. For the 'Apulian Shepherd', for instance, there are several preliminary sketches which show that Claude played about with his trees and hills in the same calculating spirit that Poussin moved his puppets on his toy stage.

In the last fifteen or twenty years of his life Claude's style changed, and he produced some of his most remarkable and daring compositions. In certain respects the tendencies visible earlier were simply intensified. The boldness of asymmetrical composition, the modulation in the horizontal plane, the emphasis on the open and the infinite can all be seen in their finest form in paintings such as the 'Perseus' of 1674 [253]. Never did Claude invent a more unconventional composition: a flat surface from which rise a tree and a rock arch. Never was he bolder in his light effects with the dark arch against the pale moonlight.

One new tendency can be seen in this picture. The human figure is now reduced to insignificance. Naturally human beings had never played an important part in Claude's conception of painting, but in the earlier works they had held

254. Claude: Ascanius and the Stag. 1682.
Oxford, Ashmolean Museum

their place with some dignity. Now they have become puppets, completely dominated by the natural scenery which surrounds them. In some cases, for instance in the 'Ascanius' painted in the year of his death [254], this puniness of men is emphasized by placing the figures beside a huge piece of architecture. This painting reveals all the qualities of the artist's last phase. Claude has now entered a dream-world comparable with Poussin's realm in the 'Apollo and Daphne'. All the obvious methods which he had used in his earlier periods are rejected. The range of colour is reduced to its utmost limits: silvery green trees, pale grey-blue sky, grey architecture, and neutral-coloured dresses for the figures. The trees are now so diaphanous and the portico is so open that they hardly interrupt the continuity of the air. The figures are thin and elongated, so that they, too, have the immaterial quality suited to this fairyland. All the elements of Claude's poetry are here in their most naked form, but combined in a magical way which defies analysis.

Claude's position in European painting is clear. At the moment when Dutch painters were applying to nature their principles of realism, Claude showed that the methods of French classicism can also be used to extract the poetry of inanimate nature. Just as Poussin is the last stage in the rational treatment of landscape, so

Claude, starting from a different tradition, carried to its furthest point the study of light and atmosphere as a means of creating both pictorial and imaginative unity. In this sense he represents the end of a development which reached its first peak in Umbria in the person of Perugino. But Claude is bolder; he confined the infinity of nature within the rigid boundaries of classical composition.

*

Claude and Poussin represent the two great tendencies in French classical landscape in the seventeenth century, but there were among their contemporaries several painters who enjoyed not unmerited success in this field.

The most distinguished of them was Poussin's brother-in-law, Gaspar Dughet (1615-75),

who took to calling himself Gaspar Poussin. We know singularly little about his life and the chronology of his works is still a matter of speculation.[127] He was trained in the studio of his brother-in-law in the years 1630-5, and his early works are coloured by the Venetian manner which Poussin was then practising, but very soon he established a quite individual style. He studied the country round Rome with passionate intensity and took houses both in Tivoli and Frascati so as to be within easy reach of *le motif*. In 1647 he was given his first major public commission, for the church of S. Martino ai Monti, where he painted a series of landscapes in which he set the histories of those connected with the Carmelite Order. In these his awareness of his brother-in-law's painting of the preceding years is apparent, but Gaspar

255. Gaspar Dughet: Landscape.
Private Collection

has exploited the possibilities of the fresco medium to give his compositions a breadth necessarily lacking in easel paintings. In his last phase he seems to turn back to Poussin's later works and to build up his landscapes with a logic which does not, however, conflict with his direct observation of nature.

His formula here is a synthesis of the methods of Poussin and Claude [255]. His space composition is less rigidly geometrical than Poussin's, but more finite than Claude's; he lacks Claude's fine perception of light, but is more generous in his treatment of it than Poussin. He conveys vividly the bare and rugged character of certain parts of the more mountainous country round Rome, which neither Poussin nor Claude seems to have appreciated. After his death his style was widely imitated in Rome till

well after 1700, but his real importance historically is that in the later part of the eighteenth century he was greatly admired by English painters, such as Richard Wilson, and by the supporters of the Picturesque Movement, and his compositions were taken up by them as models for landscape gardens and parks, thus inspiring a vogue which affected the whole of European taste.

The other landscape painters of the period are of less originality, but several of them produced personal variations on the styles established by Poussin, Claude, and Gaspar Dughet.

Jean François Millet (1642-79), also called Francisque, a Fleming who lived the greater part of his life in Paris, applied competently but a little heavily the principles of Poussin's landscapes of the 1640s, and occasionally, as in

256. Pierre Patel the Elder: Landscape. 1652.
Leningrad, Hermitage

'The Storm' in the National Gallery, London, showed real originality.[128] Jean Lemaire (1598–1659), who was a pupil of Poussin and called himself Lemaire-Poussin, specialized in architectural fantasies.[129] Pierre Patel the Elder (c. 1620–c. 1676) was principally famous for his landscape panels, which were incorporated into the decoration of rooms, as in the Cabinet de l'Amour at the Hôtel Lambert. His compositions [cf. 256] contain a mixture of architecture and pure landscape, and show that he had some understanding of Claude. Jacques Rousseau (1630–93) painted a vast landscape decoration, now lost, in the Orangery at Saint-Cloud[130] and a series of smaller ones in the gallery at the Hôtel Lambert. In 1690 he settled in England, where he painted decorative landscapes at Hampton Court and Montagu House. This period also produced one draughtsman and engraver of great distinction in landscape, Israël Silvestre (1621–91); his topographical views are among the most sensitive works of the time.[131]

The Minor Classical Painters:
Le Sueur and Bourdon

To complete the account of painting before the reorganization of the Academy by Colbert and Lebrun in 1663 something must be said of a group of painters who either died before this event or remained little affected by it.

The most important of them is Eustache Le Sueur, who was born in 1616 and died young in 1655.[132] At an early age, probably about 1632, the boy entered the studio of Vouet. His first recorded works are a series of designs for tapestries illustrating the *Hypnerotomachia Poliphili*, for which Vouet received the commission about 1637, but passed it on to his pupil.[133] These paintings show that Le Sueur had fully learnt the manner of his master, but had as yet established no independence. The 'Presentation of the Virgin' in the Hermitage [257], probably painted in the early 1640s, is still full of

reminiscences of Vouet, but it has also features which are more individual. The types are still those of the master, but the modelling is firmer and the design slightly more rigid and classical.

About 1646-7 Le Sueur embarked on his first major work, the Cabinet de l'Amour at the Hôtel Lambert. The importance of this room as a decorative whole has already been discussed in connexion with the architecture of Le Vau. Le Sueur's share was a series of panels illustrating the story of Cupid which ornamented spaces in the ceiling and on two sections of the walls. The influence of Vouet is still visible, though there is a certain lightness in the drawing and a calmness in the composition which distinguish these works from the decorations of the older artist. The second series of paintings for Lambert, in the Cabinet des Muses, shows

257 (above). Eustache Le Sueur:
The Presentation of the Virgin. c. 1640-5.
Leningrad, Hermitage

258 (opposite). Eustache Le Sueur:
Three Muses. c. 1647-9. *Paris, Louvre*

greater independence [258]. They were probably carried out about 1647-9, and they reveal for the first time the influence of the two painters who were to dominate Le Sueur's last years, Poussin and Raphael. In this case the influence of Raphael is the more marked, though he is seen through the eyes of Romanelli. Le Sueur presumably studied his work in engravings since he never went to Rome - a fact which all his early biographers deplore, while at the same time quoting him as an example of how successful an artist can be without making such a journey. The poses and types of the Muses in the principal panels tell us that Le Sueur has had before his eyes the 'Parnassus' and perhaps the roundels from the ceiling of the Stanza della Segnatura, from which he has learnt a fullness of form lacking in his earlier figures.

In his later years Le Sueur's style was profoundly affected by the study of Poussin's compositions of the 1640s. The works in which this influence appears most clearly are those illustrating the life of St Bruno, painted for the Charterhouse of Paris, probably about 1648,[134] and now in the Louvre. The 'St Bruno in his Cell' from this series [259] shows very clearly the characteristics of Le Sueur's religious composition in his mature period. From Poussin Le Sueur learnt a new interest in the psychological aspect of his subjects and also a new classicism of composition and modelling. But here, and in all Le Sueur's best paintings of this time, there is a reflective religious atmosphere, a tone of *recueillement*, which is not to be found in Poussin. It is personal to Le Sueur, but it seems also

259. Eustache Le Sueur and assistants: St Bruno.
c. 1650. *Paris, Louvre*

to be the direct expression of the cloistered way of life which the Carthusians were among the few religious houses in Paris to follow in the seventeenth century. We know nothing of Le Sueur's own religious views, but it is hard to doubt that there existed a real sympathy between him and the monastery for which he painted the St Bruno series.

In the last years of his life Le Sueur's style underwent yet another change. The certain works of this period[135] indicate that the artist had been deeply impressed by Raphael's tapestry designs. In fact the 'St Paul at Ephesus' of 1649 (Louvre) is little more than a series of quotations from them. In the works of the 1650s, however, the interpretation is freer though hardly more successful. Le Sueur caricatures the plastic grandeur of Raphael's forms and turns them into inflated and sometimes almost meaningless shapes.[136]

In his own day Le Sueur was much admired, and throughout the eighteenth century his reputation in France was almost as great as that of Poussin. A certain *tendresse* distinguishing his work from that of his more heroic rival appealed to an age when sensibility was the fashion.

Sébastien Bourdon (1616-71), the exact contemporary of Le Sueur, was capable of imitating almost any style, and giving it a personal flavour, but he never evolved one of his own. Born at Montpellier, he moved at the age of seven to Paris, at fourteen to Bordeaux, and in 1634 reached Rome. There he spent three years imitating the work of the *bamboccianti* and Castiglione.[137] In 1637 he returned to Paris, spending some time in Venice on the journey. In 1643 he was commissioned to paint the *Mai* for Notre-Dame, which was to represent the 'Martyrdom of St Peter'. This is an ambitious Baroque composition with a Venetian looseness of handling. A series of lively compositions of the same type, such as the 'Caesar before the tomb of Alexander' in the Louvre, probably dates from about this time.

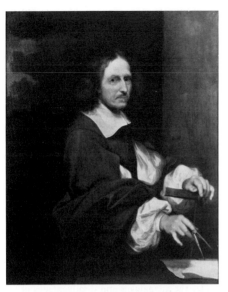

In 1652 Bourdon was invited by Queen Christina to come to Sweden as her court painter. During the two years which elapsed before her abdication in 1654 he painted portraits of the Queen and various members of her Court,[138] but apparently no history paintings. In 1654 he returned to Paris, where he continued to enjoy great success as a portrait painter [cf. 260]. Soon after his return he executed a 'Martyrdom of St Andrew' for the church of that name at Chartres,[139] in which the energy of his earlier Baroque style has been restrained under the influence of Poussin.[140] About 1659 he went to

260 *(left)*. Sébastien Bourdon: An Architect. 1657. *Boughton, Northamptonshire, The Duke of Buccleuch*

261. Sébastien Bourdon: The Holy Family. *c.* 1660-70. *Saltwood, Kent, Lord Clark*

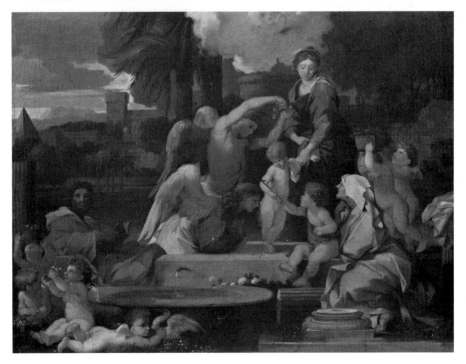

Montpellier, where he painted for the cathedral a vast 'Fall of Simon Magus' in the same style. He was violently attacked by rival local painters and returned to Paris in 1663 after having executed a series of tapestry cartoons and seven canvases of the 'Acts of Mercy' in an increasingly Poussinesque manner.[141] On his return to the capital he undertook the decoration of the gallery of the Hôtel de Bretonvilliers, which as far as one can judge from surviving drawings was again in the manner of Poussin.[142] It was no doubt during his last years in Paris that he carried out his most characteristic works, which show the strong influence of Poussin, but yet have a certain rather sweet charm, which seems to have appealed to his contemporaries. The 'Holy Family', reproduced as illustration 261, is an unusually fine example of what must be considered his best and most personal manner. In it elements from Poussin's 'Holy Families' are translated into a more elegant form and treated with a cool colour which is entirely Bourdon's own.

Certain other painters of the same generation as Bourdon and Le Sueur deserve mention. Charles Alphonse Dufresnoy (1611–68),[143] who spent the greater part of his life in Italy, combined a taste for Venetian painting with an admiration for Poussin. He is chiefly remembered for a Latin poem which embodied in epigrammatic form the doctrine of the classical school and which enjoyed a great success. It was translated into French immediately after his death by his friend, Roger de Piles, and into English by Dryden, and it was later annotated by Reynolds. Louis de Boullogne the Elder (1609–74)[144] and Nicolas Loir (1624–79) combined elements from the traditions of both Poussin and Vouet. Jacques Stella (1596–1657)[145] of Lyons began his career as an engraver in Florence in 1619, but in 1623 he moved to Rome, where he became one of Poussin's few intimate friends. He went through a series of stages in which he practised different styles. His early

engravings are in the manner of Callot; but his later work was dominated by his admiration for Poussin. Rémy Vuibert was also a friend of Poussin, whose style he imitated in his most important work, the decoration of the chapel in the Visitation at Moulins.[146] Nicolas Mignard (1606–68), although born at Troyes, spent most of his active life at Avignon.[147] He has been completely overshadowed by his younger brother Pierre but was in fact an original artist who learnt much from what he saw in Rome – particularly from the work of Lanfranco – and painted a number of remarkable altarpieces in a near-Baroque style for Avignon and other towns in Provence.

The artists just discussed still belong to the group of individualists who followed their own inclinations in painting. The next generation was to take a different course and was to work under the advantages and disadvantages of an intelligent dictatorship.

SCULPTURE

Sarrazin, François and Michel Anguier

French sculpture in the middle of the seventeenth century has neither the quality nor the range of the architecture and painting of the same period. It produced no artist of the first rank, but a number of craftsmen of high ability, whose work is worth studying as being typical of the artistic taste of the period and as preparing the way for the movement in the following decades. Stylistically sculpture presents much the same problems as contemporary painting. A local tradition survives from the end of the sixteenth century, and on this are grafted influences from Italy and Flanders. The result is a series of works which vary in their mixture of classical, naturalistic, and Baroque elements. The scale of variation is not so great as in painting, and there is nothing comparable to the gap which separates say Poussin from Vouet,

or La Tour from Le Sueur; but the constituents are the same in the two arts.

The two artists who were least affected by foreign influences were Simon Guillain (c. 1581–1658) and Jean Warin (1604–72). Guillain[148] spent a short time in Italy, returning in 1612, but his style was probably more deeply affected by the work of his father, Nicolas Guillain (d. 1639),[149] and by the bronze sculpture of Pilon. His only important surviving work in sculpture properly speaking is the monument erected on the Pont-au-Change in 1647, of which a relief and the three bronze figures of Louis XIII,

Anne of Austria, and the young Louis XIV are in the Louvre [262]. In their treatment of the metal they are a direct continuation of the method of Pilon, though the vitality of the Mannerist has given place to a rather conventional academic treatment of the drapery, analogous to that of Vouet. In the same way, the heads lack the earlier artist's psychological insight and are conceived in a dull semi-classical formula.[150]

Warin is a more subtle artist, and in a work such as the bust of Richelieu [263] he is not entirely unworthy to bear the comparison with

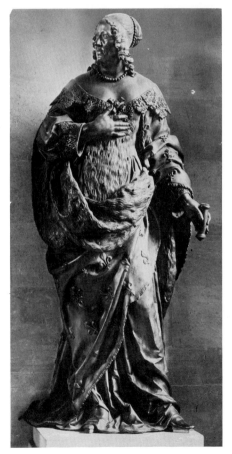

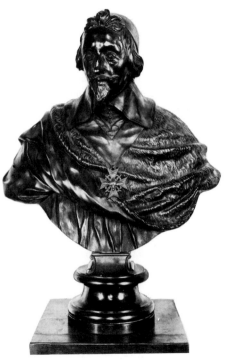

262 (left). Simon Guillain:
Anne of Austria. 1647. Paris, Louvre

263 (above). Jean Warin: Richelieu. c. 1640.
Paris, Bibliothèque Mazarine

the portraits of the same sitter by Philippe de Champaigne. He combines with the traditional methods of Pilon some knowledge of Baroque busts, such as those by Bernini and Algardi, although he never seems to have visited Italy. He was the most brilliant medallist of the century, and reorganized the French Mint, of which he was appointed head in 1646.[151]

The most important figure of the period is Jacques Sarrazin (1588–1660),[152] who created the style which dominated the middle of the century, and through whose studio most of the sculptors of the next generation passed. After a preliminary training under Nicolas Guillain, Sarrazin went to Rome, where he spent the years 1610–c. 1627. His personal and stylistic contacts in Rome were with the group of artists who immediately precede the rise of the Baroque: Maderno, for whom he worked at Frascati in 1620–1,[153] Domenichino, and in sculpture Francesco Mochi, Pietro Bernini, and François Duquesnoy.[154]

The influence of his Roman training can be seen in the first works which Sarrazin executed on his return to Paris, such as the altar in St Nicolas-des-Champs and the sculpture for the château and nymphaeum at Wideville. But a more personal manner appears in his first royal commission, the decoration of Lemercier's Pavillon de l'Horloge at the Louvre (1641) [264].[155] Sarrazin's caryatids may claim to be the first works of French classicism in sculpture, and are thus the exact parallel to the work of Poussin and François Mansart at the same moment in the other two arts. From the frontal poses, the archaeological accuracy of the dress, and the treatment of the draperies we can see that Sarrazin has not taken his classicism entirely second-hand through the artists he had known in Italy but has also looked directly at ancient Roman statues.[156]

Between 1642 and 1650 Sarrazin directed the decoration of Maisons for Mansart [178, 179]. Here a great variety in style is displayed, pro-

264 (below). Jacques Sarrazin and Gilles Guérin: Paris, Louvre, caryatids. 1641

265 (right). Jacques Sarrazin: Chantilly, tomb of Henri de Bourbon, Prince de Condé. 1648–63

266 (far right). François Anguier and assistants: Moulins (Allier), Chapel of the Lycée, Montmorency tomb. 1649–52

bably because Sarrazin only supplied small models and exercised a general supervision of the decorations which were carried out by his pupils Guérin, Buyster, and van Obstal.

Sarrazin's last work was the monument erected to Henri de Bourbon, Prince de Condé, father of the great Condé, in the church of St Paul-St Louis. It was begun in 1648, interrupted by the Fronde and only taken up again after the Peace of the Pyrenees, so that the

was to dominate the sculpture of Versailles for the next two decades. It was Sarrazin who invented in sculpture the peculiar mixture of classicism and Baroque which was to fit with the doctrine of Lebrun and to play its part in the style of Louis XIV. The iconography is classical, though embellished with later Italian glosses. The sentiment lies between the cold rationalism of the purely classical artists of the time and the ecstasy of the Baroque. The poses

monument was not finished till 1663, three years after the artist's death.

In the nineteenth century it was moved by the Duc d'Aumale to Chantilly and reconstructed in a wholly new setting, with the result that in its present form only the individual groups and not the general arrangement represent the original intention of Sarrazin.[157] The groups, however [265], reveal the importance of this late stage in Sarrazin's evolution; for here we see in fully developed form the style which

are clear and almost frontal, but the movement is free. The drapery is based on ancient Roman models, but not interpreted in the almost puritanical spirit with which Poussin viewed them. The bronze is not fretted as it would have been by a Mannerist, but flows in agreeably ample folds. The features are classical, but there are reminiscences of the School of Fontainebleau in the columnar elongation of the neck. These figures could be transferred to the parterre of Versailles, and not look out of place; and it is

only appropriate that Sarrazin should figure among the artists who took part in the first decoration of the gardens there, even though his 'Sphinx and Children' was only carried out from his designs after his death.[158]

The brothers François and Michel Anguier represent a tendency in French sculpture of the middle of the seventeenth century which is independent of the Sarrazin group. Both brothers were born at Eu in Normandy, François probably in 1604 and Michel in 1613.[159] François Anguier is said to have worked in his youth in Abbeville, Paris, and England; Michel moved to Paris in 1627 or 1629 and worked under Simon Guillain on the altarpiece of the Carmelite church near the Luxembourg. The two brothers seem to have gone together to Rome about 1641 and to have joined the studio of Algardi. François returned to France in 1643, but Michel stayed in Italy till 1651. On his return he joined François who was engaged on the Montmorency tomb at Moulins (1649–52) [266]. This tomb reveals the new Roman influence which the Anguiers introduced into France. The model for the monument as a whole is to be sought early in the century in Giacomo della Porta's Aldobrandini tombs in S. Maria sopra Minerva, although Anguier has enriched the design by sculptured decoration. The style of the figure sculpture is a variation of that which the artists would have learnt in the studio of Algardi in the 1640s, that is to say, a form of Baroque less extreme than Bernini's, and therefore more easily acceptable than his to a French public. The reclining figure of the Duke shows clearly the combination of influences present here. The pose is one traditional in France since the early seventeenth century, but the twist on the body, the undercut curls of the hair, and the lively treatment of the drapery all betray a Roman origin. In the figure of the Duchess classical influence is more visible, and this is even more clearly the case with the allegorical statues at the side of the main group

which were executed by pupils. Michel Anguier's share seems to be limited to the seated Hercules below on the left, antique in conception but with some Baroque movement in the pose of torso and head.

In their later periods the paths of the two brothers diverge. François continues along the lines indicated in the Montmorency monument,[160] while Michel on the whole tends more towards classicism. In the years 1655–8 he decorated the rooms of the Queen Mother in the Louvre in collaboration with Romanelli.[161] Here his immediate model was the decoration of the Palazzo Pitti by Romanelli's master, Pietro da Cortona, which he could have seen on his return journey from Rome; but he translates the heavy Baroque stucco figures of his original into more elegant classical terms. His works at the Val-de-Grâce show the last form which the struggle of Baroque and classical tendencies took in him. The reliefs in the spandrels and on the vault of the nave [172] are as classical as any work of the time, but in the group of the 'Nativity' for the high altar, now in St Roch [267],[162] Baroque movement asserts itself. The mood which it expresses, however, is not the ecstasy of the Roman Baroque but a sort of pathos which is purely French and, like Le Sueur's religious sentiment, seems to prepare the way for the eighteenth century.[163]

His only important official commission after 1661 was the decoration of the Porte St Denis (1674), which came to him because Girardon to whom it had been entrusted was called back for more important jobs at Versailles.[164] His work on the arch must have seemed almost archaic to the public of the 1670s in spite of his attempt to add richness by effects of high relief to his severely designed classical trophies.

The secondary figures of the period in sculpture fluctuate between the various styles employed by Sarrazin and the two Anguiers. Gilles Guérin (1606–78)[165] began as a pupil of Sarrazin for whom he worked on the Louvre and at

267. Michel Anguier:
Paris, St Roch, Nativity. 1665

Maisons, where he carved the 'Four Elements' in the vestibule and the mantelpieces in the two principal *salles*. His tomb for the Prince de Condé (d. 1648) at Vallery includes an adaptation of Sarrazin's caryatids. But later he developed a more Baroque manner, as in the altar at Ferrières-en-Gâtinais (1650), the statue of Louis XIV for the Hôtel de Ville (1654) in the Carnavalet, and the tombs of the Duc de la Vieuville and his wife (after 1666, Louvre).

Two of Sarrazin's most successful pupils were Flemings by birth. One, Philippe de Buyster (1595-1688),[166] was principally active in large-scale sculpture for the decoration of churches, e.g. on the dome of the Val-de-Grâce [159]. Several of his tombs survive, one for Claude de Rueil in the cathedral of Angers (1650), and one for the Aubespine family in the cathedral of

Bourges (1653). He is probably responsible for the groups of children over the panels on the staircase at Maisons. Gérard van Obstal (1605-1668) also came from Flanders and worked for Sarrazin on the Louvre. His mature works in France, e.g. the medallions on the staircase at Maisons and the reliefs in the gallery at the Hôtel Lambert [185], show a consistently classical manner. His last important works were a series of reliefs on the Hôtel Carnavalet (after 1655), often, but wrongly, said to have been destroyed. Two other artists represent the classical tendency of this generation, but in a less distinguished manner. Thibault Poissant (1605-68)[167] was responsible for the angels and coat of arms at the top of the Montmorency tomb [266], as well as for the 'Fame' in the pediment of the garden front of Vaux [189]; but his work is

coarse and clumsy. Louis Lerambert (*c.* 1620–70) appears to have been a sculptor of greater ability, as can be seen from the reliefs in the cathedral of Blois, dated 1660.[168]

Many sculptors of this generation survived long after the beginning of the personal reign of Louis XIV and were given work in minor capacities on statues in the gardens of Versailles, but they found themselves, like Michel Anguier, pushed aside in favour of the younger generation. It is a curious fact that, whereas the period which we have been studying excelled in the arts of architecture and painting and was weakest in sculpture, the next phase, the era of Versailles, was to shine most conspicuously in that field. Poussin and François Mansart were never forgotten, even during the later years of Louis XIV, but the reputations of Sarrazin and the Anguiers disappeared under the glory of Girardon and Coysevox.

LOUIS XIV AND COLBERT

1660-1685

On 9 March 1661 Cardinal Mazarin died, and the next day, to the surprise and even the amusement of his courtiers, the young King announced that he would not take another First Minister, but would himself govern France. This decision opens the most spectacular period in French history. In two decades a series of successful wars gave France the most powerful position among European countries; skilful development of her natural resources supplied her with apparently inexhaustible wealth, and the whole nation united to glorify the King, who believed himself to be the greatest monarch of the century, and was determined to demonstrate the fact to any who might doubt it.

Louis was fortunate – or perhaps wise – in his choice of the man who was to carry out his policy. Jean-Baptiste Colbert, whom Mazarin had bequeathed to the King as his ablest assistant, was to be till his death in 1683 Louis' adviser on all matters of importance, whether political, economic, religious, or artistic, and the engineer of the State machine on which the greatness of the King was based.

Under the inspiration of the King, and with the skilful organization of Colbert, the finishing touches were given to the centralized autocracy for which the way had been prepared by Henry IV, Richelieu, and Mazarin. Internally the last vestiges of opposition to the central power were destroyed. The administration was a pyramid of which the apex was in reality as well as in theory the King, whose power was exercised through a hierarchy of Secretaries of State and councils at the centre and an efficient body of *Intendants* in the provinces. In this way an almost uniform system, dependent on the central authority, was imposed on all activities throughout France.

This direction from above was carried by Louis XIV and Colbert into all fields. In industry, for instance, which the latter was particularly successful in fostering, strict regulations were imposed on each trade and the authority of the guilds replaced by that of the State. This reorganization, which was coupled with improvements in agriculture and internal communications and with the building up of a merchant fleet, greatly increased the national wealth, and brought prosperity to the industrial and trading sections of the middle classes, who heartily supported Colbert's régime, except on those occasions when their particular privileges were threatened.

Colbert's achievements were, however, restricted by two factors: his inability to put real order into the finances of the kingdom, and his limited economic outlook. His ideas in the latter field were based on the principle that France should aim at being self-supporting, should import as little and export as much as possible, and should destroy by tariffs and if necessary by war all rivals to her commerce and industry, and so accumulate herself the greatest reserves of bullion, for him the only measure of wealth. This rigid mercantilist point of view prevented Colbert from making the best use of the material resources of France which he so ably developed. At the same time it involved him in wars, for

instance with Holland, which, though practical in their aims, led in fact to the weakening of France rather than to her real profit.

Louis XIV and Colbert carried their principles of national power and unity into the intellectual as well as the practical field. The thought as well as the actions of all Frenchmen must follow the State plan. In religion, for instance, the independence of the Gallican Church was fiercely and successfully upheld against the demands of the Pope, who was also deliberately humiliated by the King over the affair of the Corsican guards. At the same time tendencies towards internal disunity, such as the Jansenist movement, were severely suppressed.[1]

Naturally the fine arts were not exempt from this universal direction, and their history in this period is that of the closest and most complete State control ever exercised before the present century. Colbert managed to get into his own hands all the key positions in relation to the arts. In 1664 he became Surintendant des Bâtiments; in the Academy he held successively the posts of Vice-Protector (1661) and Protector (1672); and as Controller-General of Finance all important projects had ultimately to be dependent on his goodwill.

Colbert believed that, like all other activities, the arts should serve the glory of France. To do this their practice had to be organized on the same basis as industry and their theory established in a body of dogma. The practical side of this scheme was secured by the foundation of the Gobelins and the Savonnerie,[1] and the theoretical by the establishment of the various academies. Just as Louis XIV had need of Colbert to find the means of executing his plans for the State, so Colbert had to find a pro-consul who would act for him in the field of the arts. Once again exactly the right man was to hand in the person of Charles Lebrun (1619-90), who was to be, till the death of Colbert in 1683, dictator of the arts in France. Lebrun was not a great imaginative artist, but he had exactly the talents required for the particular situation: flexibility, power of organizing, the ability to inspire and control a team of artists, untiring energy, and patience in the face of a changeable and difficult patron. His range of knowledge was vast. He could design a painting, a piece of garden sculpture, a tapestry, all with equal ease, and all in a style which made them suit their function and harmonize with each other.

This was, of course, what Colbert needed; for the end to which the arts had to be applied was the glorification of the King and the creation of a suitable setting for him. Louis' conception of himself as the greatest monarch in Europe naturally led him to demand the most magnificent surroundings for himself and his Court, which was also designed to serve a political purpose and to be a distraction for his nobles. The elaborate hierarchy and complicated etiquette of the Court itself had to be reflected in a palace which by grandeur of scale and richness of decoration was to be the visible embodiment of the power of the Sun-King.

The organization of the Gobelins factory was typical of Colbert's methods. It was housed in the buildings of an old tapestry factory, but the scope of Colbert's scheme was far wider than the mere weaving of wall-hangings. The official title of the factory was *Manufacture royale des meubles de la Couronne*, and, as this implies, it was planned to produce everything necessary to the furnishing of a royal palace, everything except carpets, and they were woven at the Savonnerie factory established just outside Paris at Chaillot. It was here that the magnificent carpets for the Galerie d'Apollon and the Long Gallery of the Louvre and for the chapel at Versailles were woven during Louis XIV's reign.

Under Lebrun there worked an army of painters, sculptors, engravers, weavers, dyers, embroiderers, goldsmiths, cabinet-makers, wood-carvers, marble-workers, and even mosaicists. The entire production, which involved some two hundred and fifty workmen, was con-

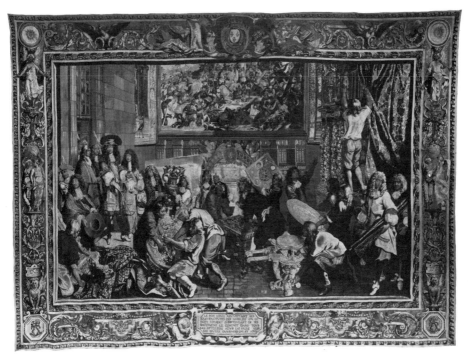

268. Tapestry after Charles Lebrun:
Louis XIV visiting the Gobelins.
Between 1663 and 1675. *Paris, Gobelins Museum*

trolled by Lebrun, who supplied the designs for every section. These were worked up into cartoons or models by assistants, and were then translated into their final form; but at each stage Lebrun kept a close eye on the work. The well-known tapestry showing the visit of the King to the factory [268] gives some idea of the variety of its productions. Curtains, silver basins, inlaid tables, and a hundred other articles of luxury are being brought out for the King to inspect, and on the wall in the background hangs one of Lebrun's own cartoons for the tapestries illustrating the life of Alexander the Great.

The Gobelins was, however, more than a universal factory, it was also a school, and in its constitution, drawn up in 1667, much attention

was paid to the training of apprentices. It is interesting to notice that they were first of all to be given a grounding in drawing, and only when they were competent in this field could they begin the study of any particular craft. In this, as in many other details, Colbert's regulations differ markedly from the old-fashioned methods of the guilds which were still organized on almost medieval principles. Moreover, all artists connected with the Gobelins were given exemption from the demands of the guilds, and enjoyed the same freedom as the artists who had lodgings in the Louvre and were directly employed by the King.

The system of production set up at the Gobelins created the high level of technical skill and

the uniformity of style which were requisites of the products demanded by Colbert and Louis XIV for the royal palaces. Individual inventiveness was at a discount, but it was Lebrun's great achievement to canalize the energies of so many craftsmen into a single channel. Versailles is one of the supreme examples of what team-work can do in the arts.

For the theoretical organization of the arts Colbert naturally turned to the system of academies which had already been successfully used for this purpose in Italy and which had been introduced into France during the previous régimes. In 1635 the French Academy had been founded to establish the true doctrine in the field of literature, and thirteen years later a similar organization had been set up for the visual arts. In its original form the Royal Academy of Painting and Sculpture was a means used by artists employed by the King to gain independence from the guild and to establish their social position. In Italy the principle had been laid down that the liberal arts, including painting, sculpture, and architecture, should be organized into academies, leaving the guilds to handle the mechanical arts only. French artists were therefore only following an Italian precedent in claiming to practise a liberal art, and therefore to have a right to an academy. As in earlier academies, the foundation members of the French Academy of Painting asserted the principle that their art should be taught on a theoretical basis, and not by mere practice, like the manual crafts. For this reason they insisted that, in addition to the life-class for the students, lectures should be held in which the truth about the arts should be expounded. In practice, however, it was found that the artists were reluctant to lay down the law in this way, and at first the lectures seem rarely to have taken place.

The Academy, however, offered to Colbert and Lebrun just the weapon which they needed, and after a thorough reorganization in 1663 it was turned into another part of the State art-machine. A hierarchy was established descending from the Protector through the Director (Lebrun) to professors, members, associates, and students. Teaching was carried out according to rigidly laid down principles; theory was expounded by the now compulsory lectures followed by discussion. In due course the system was extended. In 1666 a French Academy was founded in Rome under the directorship of Charles Errard for the training of young artists sent there from Paris. Academies were also established for the other arts: dance in 1661, science in 1666, music in 1669, and architecture in 1671.

The teaching and doctrine of these academies naturally varied according to the particular art concerned, but certain principles underlay the work of them all. In the case of the visual arts there was much in common between the practice of the Academy of Painting and Sculpture on the one hand and that of Architecture on the other. In each case it was assumed that the practice of the art could be learnt by the application of certain precepts, and that these precepts could be discovered by a process of rational analysis, that they could be exactly expressed in words and that they could be conveyed to any intelligent person. We shall examine later the methods used in the two academies; for the moment it will be enough to notice that their theory and practice represent the most fully developed form of academic training known in Europe, and the most thorough application of the principle that the arts can be learnt by taking thought.

The position with regard to literature was somewhat different. Racine, Molière, and La Fontaine all enjoyed great favour at Court, but were not entirely dependent on it. For them the Paris public was as important as that of Versailles, and they were therefore saved from being absorbed into the machine. Boileau, it is true, laid down the law as rigidly as Lebrun, but he did not have the economic control over

writers which the latter could exercise over artists. Consequently we find in literature a far higher degree of individual talent than prevailed in the visual arts. With the possible exception of Bossuet none of the great writers of the period devoted the best of their talent to the glorification of Louis XIV or the success of his arms and policy. It is true that Racine wrote, under royal command, the *Précis des Campagnes de Louis XIV*, but no one would maintain that either this piece of historical eulogy or Charles Perrault's *Siècle de Louis le Grand* ranks as one of the masterpieces of the period. It is not for works such as these that the reign of Louis XIV is remembered as one of the high points in the history of French literature, but rather for *Phèdre* or *Le Misanthrope*, both works produced in Paris and admired at Versailles less than the tragedies of Quinault.[2]

The style produced in the visual arts under the dictatorship of Colbert is a curious compromise. Naturally the Baroque appealed to Louis XIV by its richness and its command of grand scale. On the other hand, he could not take over, lock, stock, and barrel, a style which had been developed so largely to satisfy religious needs. The more dramatic qualities of Roman Baroque – its use of directed light in architecture, its rendering of swooning ecstasy in painting and sculpture – could not be employed in the Versailles of the great period, which required a more secular and a more rational style. Moreover a tradition of classicism was by now ingrained in the French and made them naturally opposed to the more bizarre qualities of the Italian Baroque. Consequently French artists produced during this period a series of compromises in which the lessons of the Italian Baroque were tempered by *le bon goût*.

Owing to the dictatorship of Colbert and Lebrun this style was imposed uniformly all over France. In the period which we are now considering everyone accepted the official doctrine about the arts; all were orthodox, and

there were no heretics.[3] All the great commissions emanated from the Crown, and any artist who aspired to success had to obtain such a commission, which generally speaking only came through the official channels of the Academy or the Gobelins. The standards of Paris and Versailles were accepted all over France, and we find little independent initiative in the provinces during this period. When great cities wanted to carry out any important work they usually tried to get a design from the capital, and, if they failed, they compelled their own craftsmen to follow the Parisian models as closely as possible.

But the domination of the taste of Versailles spread further than the borders of France. All western Europe began to imitate the Court of Louis XIV in its manners, its etiquette, and its art, and even countries like England and Holland, which were politically opposed to France, were influenced by her taste. Significantly the artistic relations between France and Italy began to change. Up till this time Rome had been the unchallenged capital of the artistic world, looked up to by all countries, including France. Students were sent to Rome to study, and the aim of most French kings and ministers was to attract to their own country the best available Italian artists. The first indication that this situation was changing was the failure of Bernini's grandiose visit to Paris to design the new Louvre. The rejection of his plans by the King may have been partly due to the intrigues of Charles Perrault, but it was fundamentally the expression of a new fact: that French architects could now supply what was demanded, and that there was no need to call in a foreigner, even if he was the most celebrated Roman artist of the day.[4] Other small indications point in the same direction. Poussin and Vouet had held or been offered the post of President of the Academy of St Luke in Rome, but they were both Romans by adoption; and it was a far more significant event when in 1675 Lebrun was

awarded this privilege, the highest artistic honour in Rome, although he had not been there for thirty years. Moreover, Italian writers on art began at this time to dedicate their works to French patrons. For instance, Malvasia's *Felsina Pittrice* (1678) has on its title-page the name of Louis XIV, and Bellori's *Vite de' Pittori* (1672) that of Colbert. Such a tribute might have been paid to Francis I, but it would be hard to parallel in the intervening period. Before the end of the century the rising position of France in the arts was to be demonstrated in a more positive manner. There is clear evidence of influence going from Paris to Rome instead of only in the other direction. In what one may call the International Late Baroque of Maratta and Carlo Fontana there are elements which can only be accounted for by a conscious imitation of French models. In fact it was due to the work of Louis XIV, Colbert, and Lebrun that in the eighteenth century Paris replaced Rome as the artistic capital of Europe and attained the peculiar eminence which she kept till the twentieth century.

ARCHITECTURE
AND THE DECORATIVE ARTS

The Louvre and Versailles - Bernini,
Le Vau, Perrault, J. H. Mansart, Le Nôtre -
Blondel and the Academy -
L. Bruant - the Decorators

Versailles is the great monument of Louis XIV's reign, but he did not at once decide to make it the seat of his Court. Colbert did his utmost to persuade the King not to desert Paris, and during the 1660s he devoted his energies to completing the Louvre in the hope that it would remain the principal royal palace.

Before Colbert's accession to power work had been continued steadily on the Square Court, first by Lemercier and then after his death in 1654 by Le Vau, who carried on the building to the east side.

In the 1660s Le Vau had designed for the executors of Mazarin's will the Collège des Quatre Nations [269], for the foundation of which the Cardinal had left a large sum. The building, now the Institut de France, was placed on the south side of the Seine on the axis of the Square Court of the Louvre and was conceived as part of the same grand scheme. It is of importance in French architecture of this period as being one of the few buildings to embody some of the principles of Roman Baroque architecture. The domed church flanked with wings curving forward combines motives from Pietro da Cortona[5] and Borromini,[6] and presents a dramatically effective ensemble not to be paralleled in French architecture of the seventeenth century. Le Vau's plan included a bridge which was to link the college with the Louvre. This was not built till the nineteenth century, and then only as the meagre Pont des Arts; but even this allows one to appreciate the effect which the architect intended to be produced on the visitor as he walks across the river towards the college with its semicircle spread symmetrically before him.

This bold piece of planning, together with his other public works, the château of Vincennes,[7] and the hospital of the Salpêtrière,[8] clearly designated Le Vau as the architect best suited to construct the great front facing St Germain l'Auxerrois which was to close the Louvre on the east. He had already prepared several plans for this part of the palace; but he was prevented from carrying them out by the appointment of Colbert as Surintendant des Bâtiments in January 1664. The exact reasons for Colbert's animosity towards Le Vau are obscure,[9] but whatever the cause, he immediately set about finding an alternative architect.

He first applied to François Mansart, who had apparently been engaged on plans for the

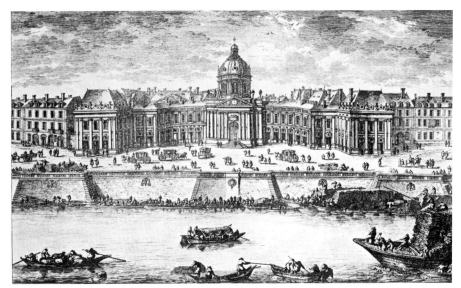

269. Louis Le Vau: Paris, Collège des
Quatre Nations. Begun 1662. Engraving by Pérelle

scheme since 1662, but who failed to get the commission because he refused to be tied down to an agreed design.[10] Foiled here, Colbert submitted Le Vau's plans to the criticism of all the architects of Paris and then asked them to propose their own designs. As a result projects were sent in by various architects which are known to us from engravings.[11] Still dissatisfied, Colbert decided to appeal to Italy. At first he planned to ask the best Roman architects to criticize Le Vau's projects, and then, changing his mind, determined to ask them to make their own designs.

Of the four projects originally submitted one, by an otherwise unrecorded figure, probably an amateur, called Candiani, does not appear ever to have been taken very seriously, and two, by Pietro da Cortona and Carlo Rainaldi, were turned down immediately. Both these architects seem to have been given instructions to incor-

porate in their designs a reference to the French crown, which accounts for the strange curved roofs which they gave to the central pavilion of the east front. Cortona's design,[12] of which unfortunately no plan survives, contains some fine passages of designing in curves contrasting with flat surfaces – as on the almost contemporary façade of S. Maria della Pace, Rome – but it was much too fantastic for the taste of Louis XIV and Colbert.

The same was true of Bernini's first design, of which he sent drawings from Rome [271].[13] This would have been a Baroque palace, as free in its forms as Cortona's, with an oval pavilion in the middle from which projected two elliptical wings ending in corner pavillions, the whole front being decorated with colossal pilasters.[14] Colbert sent his comments and criticisms of this project to Bernini, who prepared a second design much in the same spirit. At this stage he

270-2. Designs for the East Front of the Louvre

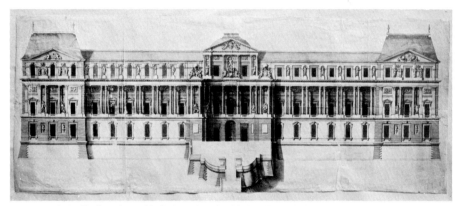

270. François Le Vau's project. 1664(?). Drawing. *Stockholm, National Museum*

271. Bernini's first project. 1664. Drawing. *London, Anthony Blunt*

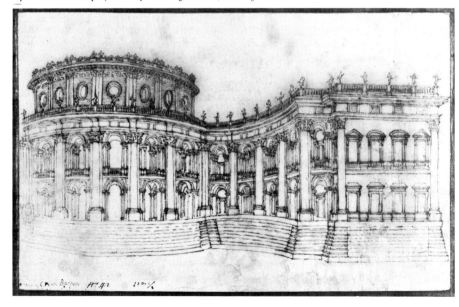

was called to Paris, and arrived in June 1665, after an almost royal progress through France.[15] Once arrived, he prepared yet a third scheme, much wider in its scope, since it involved re-modelling or encasing the whole of the Square Court and not merely completing the east wing.

vided admirable space for ballrooms, staircases, and grand approaches, it left the King no better housed than before.

The arrogant attitude towards French traditions implied in Bernini's design was maintained by the artist in his personal relations with

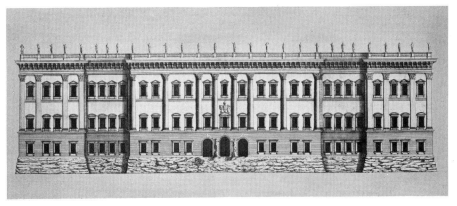

272. Bernini's third scheme. 1665.
Engraving by Marot

This third scheme is preserved in the engravings of Marot [272, 273]. It shows a colossal block-like palace, with a flat roof and a balustrade ornamented with statues, the walls being again articulated with a colossal Order, this time of half-columns and pilasters. In this design Bernini made no concessions to French taste, but presented a vast mass of plastically conceived masonry in the tradition of Caprarola or his own Montecitorio. On the river front its height – a whole storey greater than Le Vau's façade – would have crushed the two existing galleries. Inside the court nothing would have remained visible of the buildings of Lescot, Lemercier, or Le Vau which would have been hidden behind double *logge*, with staircases in the corners. Most important of all, the plan was open to very serious criticism on the score of convenience in its internal arrangement. Colbert's final comment was that although it pro-

French artists and administrators. He very soon made himself unpopular by criticizing everything and by always making unfavourable comparisons with Rome. It was easy, therefore, for Charles Perrault, Colbert's main assistant in the Surintendance des Bâtiments, to organize feeling against Bernini, and before the latter left for Rome in October 1665 there were many in France who realized that his plans would never be carried out.[16]

Not only, however, was his project never realized, but his visit exercised no serious influence in France. The only work which he actually executed while in Paris was the bust of the King;[17] but his opinion was also asked by a number of individuals in connexion with works of architecture which they had in hand.[18] In some of these cases we know positively that his advice was rejected,[19] and nowhere was any visible mark left to show that it was followed.

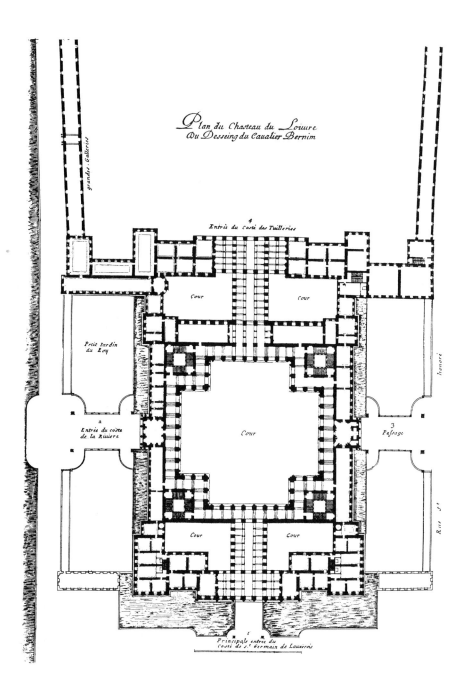

Plan du Chasteau du Loüure
Du Desseing du Caualier Bernim

grands Galleries

Entrée du costé des Tuilleries
4

Cour Cour

Petit Jardin
du Roy

honoré

2
Entrée du costé
de la Riuiere

Cour

3
Passage

Rue St

Cour Cour

1
Principale entrée du
costé de st Germain de Lauxerois

273 *(left)*. Bernini: Final project for the Louvre, 1665. Plan, from the *Grand Marot*

274 *(below)*. Louis Le Vau, Claude Perrault, and Charles Lebrun: Paris, Louvre, East Front. 1667-70

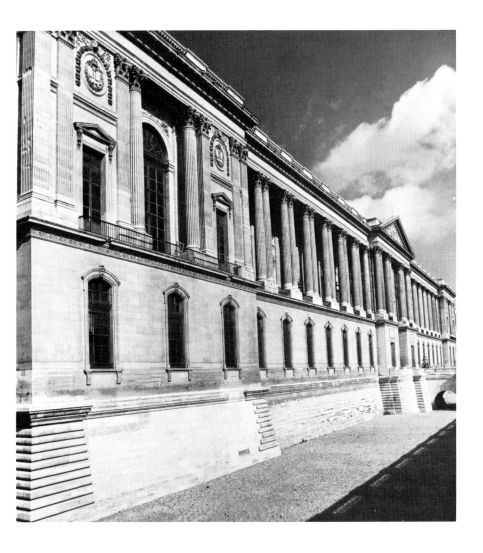

At the most it may be said that in a few altarpieces his Baldacchino in St Peter's was an inspiration to French artists, but this was already well known. It was truly a meagre result for so pompous and much-heralded a visit.

In the spring of 1667 Louis XIV, having finally decided to abandon Bernini's plans, created a council of three men who were to collaborate in preparing an alternative project. The team consisted of Le Vau, who was still First Architect and enjoyed the confidence of the King, if not that of Colbert, Lebrun as First Painter, and Claude Perrault, brother of Charles. The choice of Perrault seems at first sight curious. He was a doctor by profession whose interest in architecture was purely amateur. That his qualifications were serious, however, is proved by his edition of Vitruvius,[20] and his scientific training, which extended to the study of engineering, was to be of great use in the Louvre project.

In April 1667 this commission presented two alternative schemes of which the King selected one for execution, and within three years the Colonnade was more or less complete [274]. The cleaning of the east façade in the 1960s brought back to the Colonnade its original splendour, which had been much obscured by dirt. At the same time the bold step was taken of digging out the moat, which was certainly planned but was never actually made. In this way the effect originally intended has been reconstructed and the true proportions can be seen for the first time.[21]

Since the time of its erection arguments have raged about the real authorship of this building, some claiming that the essential contribution was made by Perrault, others that it was due to Le Vau. No doubt all three artists involved made their contribution to the scheme, but the weight of evidence points to Perrault as having played the dominant part.[22]

Stylistically the building is complicated. The flat skyline and the continuous tall Order on a high stylobate derive from an Italian tradition, going back to Michelangelo's design for the Palazzo dei Senatori, and perhaps taken over directly from Pietro da Cortona.[23] The coupling of the columns can perhaps be linked with the name of Le Vau, who had used coupled colossal pilasters in the garden front of the Hôtel de Lionne.[24] On the other hand, the strictly Roman details of the Orders and the conception of the colonnade as the peristyle of a Roman temple are features not to be found in either Italian architecture or the work of Le Vau. They are probably due to Perrault, who was the one member of the commission with pronounced archaeological leanings. It was no doubt his engineering skill which made it possible to solve the practical difficulties involved in bridging the wide intercolumniation and the distance between the colonnade and the back wall.[25]

The Colonnade has no exact parallel in French architecture, but it is the first example in this art of the style of Louis XIV. In certain respects it is Baroque: the scale of the Order, the depth given by the free-standing colonnade, the variety of rhythm due to the coupling of the columns. In other ways it is more strictly classical than earlier French work: the clear and simple definition of the masses, the straight line of the front (in contrast to the curves of most of the Italian designs and even Le Vau's first scheme),[26] the severe and almost unbroken entablatures, and the purity of detail in the Order and the mouldings.[27]

Before the Colonnade of the Louvre was completed Louis XIV had made it clear to Colbert and to the world that he intended to transfer his Court from Paris to the palace which he had begun to build at Versailles, and which was to become the symbol of his greatness.

The history of Versailles is long and complicated.[28] In 1624 Louis XIII had built there to

the design of Philibert Le Roy a small château, enlarged in 1631, consisting of a court surrounded by three wings, the inner façades of which still survive, though somewhat altered, in the existing Cour de Marbre [275]. Louis XIV had early developed an affection for Versailles, and soon after taking over the reins of government had ordered Le Vau to make some small alterations in it and to enlarge it by the addition of two wings of *communs* in the forecourt. In 1668, however, after the Peace of Aix-la-Chapelle, he began to plan much more serious changes, and for a time intended to pull down the existing buildings and begin on an entirely new plan.[29] In 1669, however, it was finally decided to carry out Le Vau's scheme for enveloping the old château in a new building which completely hid it on the garden side but left the original court fronts exposed. As seen from the gardens the new building [276, 277] presented a vast block of twenty-five bays, of which the middle eleven on the first floor were set back behind a terrace. The articulation of the building was almost Bramantesque, the ground floor being treated as a rusticated base, the first being decorated with an Order of Ionic pilasters and columns, above which came an attic forming a straight skyline broken only by statues. More than any other building by Le Vau Versailles shows a real grasp of the principles of classical architecture and at the same time a feeling for grand scale. The blocks are clearly defined and conceived in cubical terms, the two side sections standing out from the recessed centre in the simplest manner, their surfaces being broken only by the projecting central frontispieces with

275. Philibert Le Roy and Louis Le Vau: Versailles, Cour de Marbre in 1676. Engraving by Silvestre

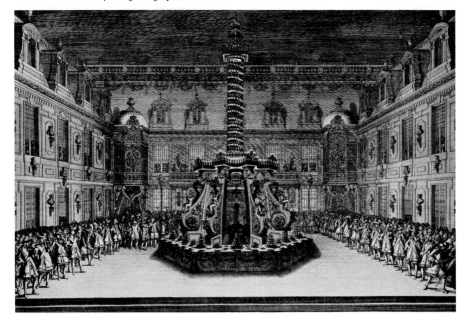

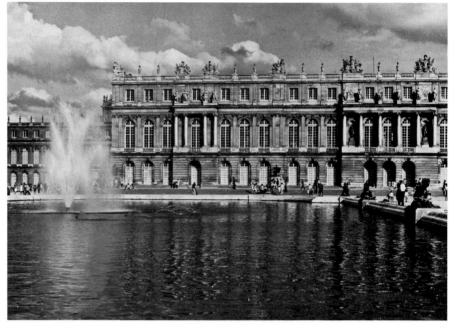

276. Louis Le Vau and J. H. Mansart: Versailles, garden front. 1669-85

coupled columns. It is hard for us to judge the real quality of the building because the effect of varied depth was destroyed by the filling in of the terrace in the middle of the façade when J. H. Mansart made the Galerie des Glaces, and the scale was ruined by the addition of Mansart's vast wings to north and south. But, as far as we can imagine it from the existing building and from engravings of its original state, it proves that Le Vau rose finely to an opportunity far beyond anything which had confronted him earlier in his career.

The effect of the outside depends, of course, to a great extent on the setting and on the gardens which were planned and made by Le Nôtre during the 1660s.[30] Silvestre's engraving [277] gives a good idea of the main terrace which led from the palace downwards towards the gardens on the west side. It shows Le Nôtre's skill in taking advantage of the accidents of the ground and yet at the same time forcing them into a coherent and clearly comprehensible design. As at Vaux-le-Vicomte nature was the raw material from which he was to make his effects, but nature had to be tamed and forced into a pattern suitable to man's use and to the ideas of order on which man's whole existence depended in this most highly regulated of societies. The rationalism which underlay Boileau's poetry, Colbert's economic plans, or Bossuet's theology was also the basis of Le Nôtre's garden designs. The symmetry and order of the palace were extended to the gardens, which were planned with hedges cut to regular shapes, paths following geometrical patterns, and fountains flowing along prearranged channels. In this formal layout statues and pieces of architecture take their place with perfect ease.[31] This concep-

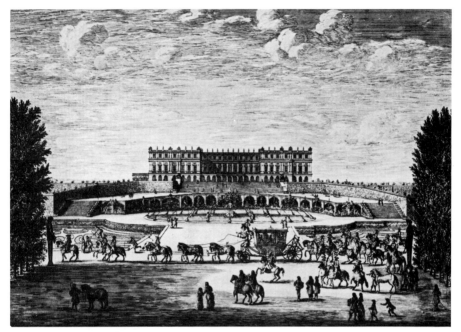

277. Louis Le Vau: Versailles, garden front. 1669. Engraving by Silvestre

tion of a garden is the exact reverse of that with which the Englishman is now familiar, and it requires as much effort for us to recognize its qualities as to see the beauties of Racine if we have been wholly brought up on Shakespeare.

The gardens and courts of the palace were the scene of the great out-of-doors *fêtes* given by Louis XIV. In 1664 the 'Plaisirs de l'Île Enchantée', lasting three days, were given in honour of Mlle de la Vallière, and in 1674 even more splendid celebrations were prepared to celebrate the reconquest of the Franche-Comté.[32] On these occasions all the arts combined, and the achievements of Fouquet at Vaux were imitated and excelled. Quinault and Molière collaborated with Lully in the writing of ballet-comedies and operas, for which Gissey and Berain supplied the settings and dresses. Temporary theatres were set up in the gardens; fire-work displays were given round the fountains; and torchlight suppers were prepared in the Cour de Marbre [275].

But, however grand the outside and the gardens of Versailles may be, it was on the interior that Louis XIV lavished his chief care. It was here that he had to appear on the most important ceremonial occasions; it was here that he received the ambassadors of foreign Powers; and it was here that the full complexity of court life was displayed.

The new style of interior decoration was actually first used not at Versailles, but in the Galerie d'Apollon at the Louvre. After the fire of 1661 the gallery was rebuilt by Le Vau, and Lebrun was commissioned to decorate it in 1663.[33] The decoration is based on the mixture of stucco decoration and painted figure compositions and arabesques which the artist had used at Vaux,

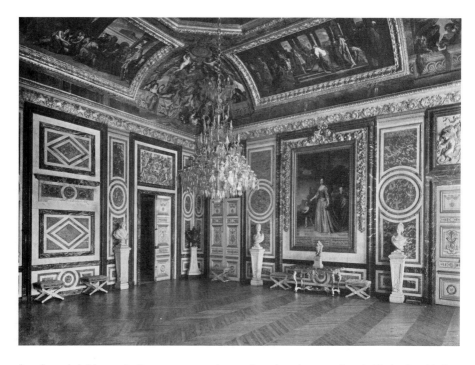

but the scale is bigger, the forms more complex, and the reliefs richer. It is an altogether royal gallery and is the first instance of Lebrun's use for the King of the teamwork which he had inaugurated at Vaux. He himself made the sketches for all parts of the decoration, but in the execution he was assisted by a host of artists and craftsmen.[34]

The first rooms decorated at Versailles were probably in the same style, but they have all disappeared. However, those forming the *Grands Appartements* of the King and Queen, decorated under the direction of Lebrun between 1671 and 1681, survive, though not in their original splendour [278]. The ceilings of these rooms are decorated with the same combination of stucco and paint as in the Galerie d'Apollon, but in some cases there are illusionist panels in the corners, most effectively in the Salle des Gardes de la Reine, where groups of spectators look down into the room from behind painted balustrades, a device much loved by Baroque architects, which had been widely used in Italy since it had been introduced by Veronese in the Villa Maser.[35]

The decoration of the walls was entirely different from the traditional type based on painted panelling which had been used at Vaux and in the Louvre. In some rooms the walls were covered with patterned velvet, usually crimson or green, on which were hung Italian paintings from the royal collection. In others, such as the Salon de Vénus and the Salon de Diane, they were panelled in different-coloured marbles, a material much favoured by Italian Baroque architects, but here disposed in classical, rectilinear patterns.

At the time of their greatest splendour the effect of these rooms must have been even more remarkable than it is at present. The floors were

278 *(opposite)*. Charles Lebrun: Versailles, Salle des Gardes de la Reine. 1679-81

279. Louis Le Vau and Charles Lebrun:
Versailles, Escalier des Ambassadeurs. Begun 1671. Engraving by Surugue

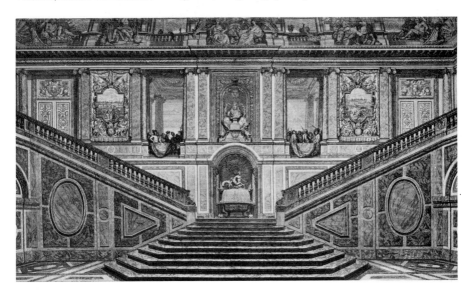

paved with different-coloured marbles, and the furniture consisted of inlaid tables and cabinets, stools covered with cut velvet or tapestry, and gilt-bronze *girandoles*. In the Salon de Mercure, which was the state bedroom, there was in addition a complete set of silver furniture, including a balustrade round the alcove,[36] eight candlesticks, each two feet high, four silver basins, three feet high, two pedestals with perfume burners, a pair of fire-dogs, and a chandelier. All this luxury was of short duration, for the marble floors had to be removed in 1684 for practical reasons and the silver furniture was sent to the Mint in 1689 to be melted up during the financial crisis of the war of the League of Augsburg.

The iconography of these rooms was based on the theme of Apollo or the Sun, with whom Louis had by now identified himself.[37] The seven rooms of the King's *Appartement* were named after the seven planets, culminating in

the Salon d'Apollon, which was, appropriately enough, the Throne Room. In each Salon the particular attributes of the planet in question were set forth in fables or allegories alluding to the great kings of the past. In the Salon de Vénus the influence of love on kings was expounded; in the Salon de Mercure the theme is the wisdom of kings; in the Salon de Mars the great warrior kings of antiquity.

These rooms, in which all the festivities of the Court took place, were approached by the most spectacular of all the inventions of this period at Versailles, the great staircase or Escalier des Ambassadeurs [279]. This was designed by Le Vau, but was only begun in 1671, the year after his death, by his collaborator d'Orbay, who was undoubtedly an important figure in his studio during the period that he worked at Versailles.[38] The form of the staircase was novel and filled a long, narrow space. A short, broad flight led to a

landing, where it divided into two flights following the long wall of the cage. The whole staircase was lit by an opening in the middle of the coved ceiling. The decoration, planned by Lebrun, was of the greatest splendour. The lower parts of the walls were panelled with marble, and the upper areas were painted with sham architecture, composed of an Order of Ionic columns, the gaps between which were filled with imitation tapestries illustrating the victories of Louis XIV and open *logge* in which stood allegorical figures of the four continents. The ceiling was covered with a huge fresco in which the symbolism of the continents was carried on, combined with allegories in praise of the virtues and achievements of the King.

This staircase was the finest example of the co-operation between Le Vau and Lebrun, and proved how brilliantly these two artists could adapt themselves to the needs of the new epoch. It opened the way for the second stage in the creation of Versailles, in which the name of Le Vau is replaced by that of Hardouin Mansart.

Jules Hardouin, to call him by his proper name, was born in 1646, and was a great-nephew of François Mansart. In his early years he collaborated with his great-uncle and learnt his style so well that his first independent buildings, such as the Petit Hôtel de Conti, could well pass as the work of the older architect,[39] whose name he later added to his own. When he was only twenty-eight he was commissioned by the King to rebuild the little Château du Val in the forest of St Germain. Two years later he received a more important commission, the reconstruction of Clagny, near Versailles, for Mme de Montespan, the King's mistress (begun by Antoine Le Pautre), and before 1670 he had built several private houses, including the Hôtel de Noailles at St Germain.[40] These buildings show that the architect had learnt more from Le Vau than from his great-uncle. They have in common with the former many details of planning and elevation,[41] and in some cases a similar sense of the *mise-en-scène*.[42] They also reveal certain qualities which were not to be typical of Mansart's mature works, notably ingenuity in planning and inventiveness in the shape of rooms. In the Château du Val, for instance [280], the right wing consists of four rooms of different and un-

280. J. H. Mansart: Château du Val. 1674. Plan, from Mariette, *Architecture Française*

usual shapes, grouped so that they can all be heated by a single stove fitted into the space left in the middle of the group.[43] This tendency is of importance, since it foreshadows the development of architecture in the first years of the eighteenth century, when Mansart's pupils were responsible for introducing the more comfortable type of private house which we associate with the rise of the Rococo style. Another feature in Mansart's houses indicates a similar tendency. All the early buildings mentioned above show an emphasis on the horizontal quite unusual at the time. Both the Hôtel de Noailles and the Château du Val have only one full floor, and, though Clagny has two storeys, its length is so huge that the effect of the horizontal is even greater there than in the other houses. This is again a tendency which was taken up in the early eighteenth century.

Mansart was already working at Versailles in 1673, but in a quite minor capacity. It was not till after the Peace of Nijmegen in 1678 that he was put in charge of the vast extension of the palace which the King planned. The project consisted of the construction of the Galerie des Glaces and the two salons adjacent to it, the addition of the wings to the north and south of the central block, and certain modifications to the Cour de Marbre.

Externally these alterations were disastrous. The construction of the Galerie des Glaces involved filling in the terrace in the middle of Le Vau's garden façade, thereby destroying, as has already been said, an essential part of the design. The addition of the two wings more than trebled the length of the garden front; but Mansart simply repeated the existing elevation along his addition, with the result that Le Vau's Ionic Order on the principal storey, which was rightly proportioned to his short façade, looks mean when repeated over the six hundred yards of the extended front [cf. 276].[44]

Internally, however, Mansart and Lebrun created the most effective ensemble in the whole palace and the work in which the style of Louis XIV is most completely summed up, the Galerie des Glaces [281] and the two rooms which led to it: the Salon de la Guerre [282] and the Salon de la Paix.[45] There is nothing essentially new in the design or decoration of these rooms. In form and decoration the Gallery is basically a repetition of the Galerie d'Apollon, except for the mirrors from which it takes its name and the marbling which has a parallel in the earlier rooms of the *Grand Appartement*. The Salon de la Guerre is more original in being decorated almost entirely in terms of sculpture. The centre of interest is the white plaster panel by Coysevox of the King triumphing over his enemies, round which are reliefs in gilt bronze and bronzed stucco.

But if the principles are not original, the application of them is so brilliant as to produce quite new results. The scale, the richness of the materials, the delicacy of the detail, the ingenious relation of the three rooms to each other, all make this suite something far more impressive than any earlier work in the style. But once again we must remember that what we now see is only a fragment. Here, even more than in the *Grand Appartement*, the effect depended on the silver furniture which was on a yet grander scale – tables, standing candlesticks, and hanging candelabra – all alas! melted down in 1689.

In relation to the earlier rooms there is a significant change in the iconographical scheme. It was at first proposed to devote the room to Apollo, but this deity was soon abandoned in favour of Hercules, whose achievements were to symbolize those of Louis himself. But finally he also was dismissed, and Lebrun was ordered to paint on the ceilings the life of the King himself. The taste of the time compelled the use of allegory for such representations, and the result is a mixture somewhat confusing to the modern mind. Louis appears dressed as a Roman Emperor, performing the acts of his reign surrounded by the gods and goddesses of antiquity, and by figures symbolizing his enemies.[46] In

281. J. H. Mansart and Charles Lebrun: Versailles, Galerie des Glaces. Begun 1678

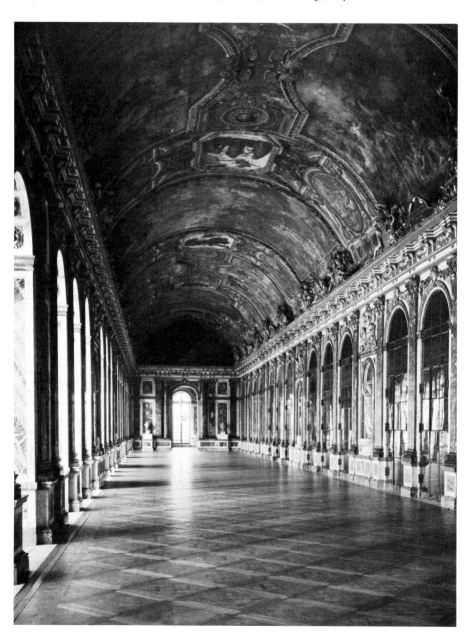

spite of this indirect method of representing contemporary events it is typical of the confidence and pride of the high period of the reign that Louis XIV should have chosen such themes.

Once again these rooms present a compromise between the principles of the Baroque and of classicism typical of the art of Louis XIV. The general disposition of the suite, and particularly the approach through the arches joining the gallery to the two Salons, has a parallel in the Salone of the Palazzo Colonna, the type of High Roman Baroque interior.[47] But in all details the French gallery is the more restrained: the ceiling is less illusionistic, the compartments of the walls are more rectilinear, the carved trophies more classical. This is as far as the French could go towards the Baroque at this period.

Apart from these modifications to the palace itself, Mansart was responsible for certain other buildings of importance connected with it. The stables, built between 1679 and 1686, formed part of the extension of the palace towards the east. They filled the gaps between the three avenues which spread fan-wise from the open space in front of the palace. On the garden side Mansart replaced Le Vau's Orangery by a larger and grander building (1681-6). In 1687 he again replaced a building of Le Vau's, the Trianon de Porcelaine, by a new and more extensive structure, the Trianon as we know it to-day, a curious one-storeyed building of which the most original feature is the open colonnade in the middle linking the two wings.[48] The Trianon was a retreat where Louis could take refuge from the publi-

282. J. H. Mansart, Charles Lebrun, and Antoine Coysevox: Versailles, Salon de la Guerre. Begun 1678

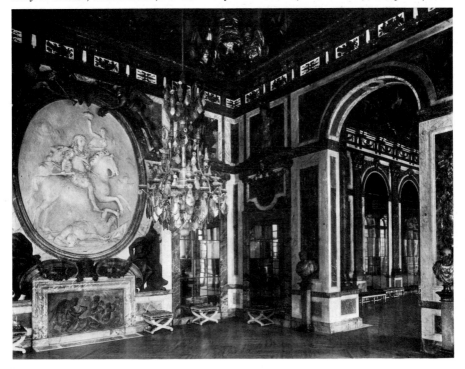

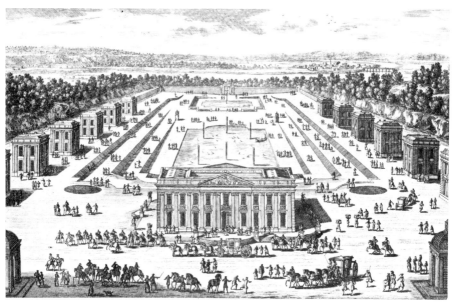

283. J. H. Mansart: Marly, château.
Begun 1679. Engraving by Pérelle

city of official court life. For the same purpose
he began in 1679 the château of Marly, now
destroyed, but known from drawings and en-
gravings [283].[49] It was planned by Mansart on
a completely novel principle. The central fea-
ture of the design was a square block for the
King, in front of which, flanking the parterre,
stretched a double row of smaller pavilions for
the courtiers, separated from the main build-
ing.[50] The great charm of Marly evidently lay in
its skilful lay-out and in the intimate relation
which was created between these relatively
small buildings and the fountains, parterres, and
canal which surrounded them. It was a colony
of gazebos rather than a palace.

In this respect Marly shows in exaggerated
form the characteristics of the art of Louis XIV.
As pure architecture even Versailles cannot
rank high. The story of its building, with the
many changes of plan, in part accounts for this;

but there is a more fundamental reason. The
interests of Le Vau and J. H. Mansart, and
above all those of the King, lay in other direc-
tions. What Louis XIV wanted, and what the
two artists so brilliantly supplied, was a setting
for the Court. In the previous generation archi-
tects such as François Mansart were devoted to
the abstract qualities of the art, and his patrons
were sufficiently sensitive to encourage him to
develop these interests. To Louis XIV fine
points of proportion, subtleties in the use of the
Orders, or the exact quality of moulding were
matters of indifference; and neither Le Vau nor
J. H. Mansart was sufficiently devoted to them
to pursue them without encouragement. The
result is that Versailles with its splendour intern-
ally, its vast size externally, its magnificent park
and its enchanting garden pavilions, presents a
whole of unparalleled richness and impressive-
ness; but it offers little in either painting, sculp-

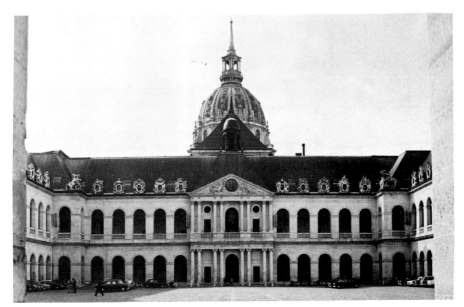

284. Libéral Bruant and J. H. Mansart:
Paris, Invalides. Court, 1670-7; dome, 1680-9

ture, or architecture which is of the first quality in itself. Louis XIV aimed first and foremost at a striking whole, and to produce it his artists sacrificed the parts.

Mansart's other additions to Versailles belong to the end of the reign, and will be considered in the next chapter. But there are some less prominent figures among his contemporaries who must receive notice here.

The most distinguished of these was Libéral Bruant (c. 1635-97), younger brother of Jacques.[51] He never attained the success which his talent merited, and only secured one of the many public commissions of the day, namely the building of the Invalides [284].[52] The vast construction, planned to house disabled soldiers, was begun in 1670 and finished in 1677, apart from the domed church added later by J. H. Mansart. It was designed in the form of a grid, like the Escorial or Serlio's scheme for extend-

ing the Louvre. The external elevations are undistinguished, but the arcaded courts have a severe gravity reminiscent of a Roman aqueduct. The same impressive simplicity is evident in an even higher degree in the chapel which Bruant designed about 1670 for the Salpêtrière, the hospital founded by Mazarin for the sick and destitute of Paris [285]. Here Bruant has shown great inventiveness in planning a building with a number of almost separate compartments to accommodate the various sections of the community occupying the hospital, while producing at the same time a highly original variant of the centralized church plan. Round the central octagon are grouped four identical rectangular members and in the spaces between them four smaller octagonal chapels. All these subsidiary parts are connected with the central octagon by small bays, almost like apses cut off in the middle, so as to leave a narrow arched opening. The un-

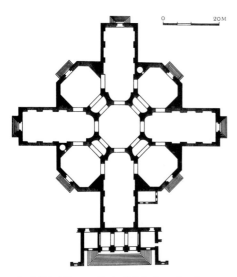

0 ____ 20 M

285. Libéral Bruant: Paris, Salpêtrière, chapel.
c. 1670. Plan from Dumolin and
Outardel, *Les Églises de France, Paris et la Seine*

usual forms so created are treated with extreme simplicity as regards decoration, and the result is an interior which shows a feeling for hollow enclosed space almost unique in French architecture of the seventeenth century. To twentieth-century eyes Bruant had the qualities essential to an architect in a higher degree than J. H. Mansart, but he lacked entirely the sense of the spectacular without which none could achieve success at Versailles.[53]

Most of the other architects of the day were little more than reflexions of Le Vau or J. H. Mansart. Charles Errard (*c.* 1606-89) was mainly active as a painter of arabesques, of which some examples remain in the Palais de Justice at Rennes and in the Luxembourg, but he also built the church of the Assomption in the rue St Honoré (1670-6), a clumsy and pedantic attempt to make a design consisting only of a dome raised on a high drum.[54] Daniel Gittard (1625-86) was concerned in the construction of a number of churches, and in 1671

built Lully's house in Paris, of unusual design with a colossal Order of pilasters on a rusticated ground floor. Charles Chamois (active after 1659), Thomas Gobert (1630-*c.* 1708), Gabriel Le Duc (1625/30-1704), and many others built hôtels and châteaux which reveal competence rather than originality.[55]

The architects properly speaking were greatly helped by the inventors of decorative themes, such as Jean Bérain (1640-1711) and Jean Le Pautre (1618-82), who showed brilliant originality in the designing of arabesques and other fantasies for wall panels or tapestries.[56]

While all this activity was taking place in the field of architecture, the Academy was keeping an eye on theory. Its doctrine is to be found set out in the minutes of the weekly meetings held by this body[57] and also in certain full-dress treatises of which the most important is the *Cours d'Architecture* of François Blondel, originally given as lectures to the students, but published in volume form between 1675 and 1698.[58]

Blondel expounds a strictly classical and rationalist doctrine. Architecture must follow the laws of nature and reason rather than fantasy. One of the manifestations of reason is orderliness, which alone makes architecture apprehensible to the human mind. From reason certain rules can be deduced, which are of absolute validity. They apply in particular to proportions; for instance, the proportions of the five Orders are deduced from those of the human body, and must never be altered. The student can shorten the process of learning these principles by studying and imitating those works in which they have been most perfectly embodied, that is to say, in the first place the buildings of classical antiquity,[59] and secondly those of the great masters of the Italian Renaissance. In short, the old academic doctrine: reason, rules, and the best masters.

This rigid doctrine corresponded exactly to Colbert's desire for orthodoxy, and it was generally accepted, till the whole system of values on

which it was based was challenged in the Quarrel of the Ancients and Moderns. But it cannot be said that it was precisely in conformity with the practice of architects such as J. H. Mansart, whose style showed a greater degree of richness and less attention to the rules of Vitruvius than would have pleased Blondel.[60] We shall find the same phenomenon in the painting of the period, for not even Lebrun could carry into his work at Versailles the strict classicism which he preached in the Academy. It would, however, be wrong to suppose that there was any sense of conflict over the difference; the fact is simply that it is easier to be strictly rational in theory than in practice.

PAINTING AND THEORY

Lebrun and the Academy – Mignard

The great achievements of painting during this period lay in the large-scale decoration already considered; but French artists naturally continued to produce easel pictures, and the theoretical teaching of the Academy was more appropriate to small-scale classical composition than to heroic frescoes.[61]

The views of the Academy of Painting and Sculpture are in essence closely related to those of their architectural colleagues and can be summed up in the same formula: reason, rules, and the best masters. But naturally the application to the representational arts involves many differences of detail.

The foundation of their doctrine is the proposition that painting[62] appeals to reason or the mind, and not primarily to the eye. It is therefore an intellectual and a learned art, intended for educated people. The Academicians accept the traditional definition that painting is an imitation of nature, but this imitation must only be carried out according to the laws of reason. The artist must choose from the variety and disordered richness of nature the most beautiful parts, that is to say, those parts which accord with reason.[63] In other words, the artist must reduce nature to the laws of reason, i.e. the rules of proportion, perspective, and composition. Further, he must concentrate on the permanent aspects of nature – form and outline – and not devote too much attention to those elements, such as colour, which are ephemeral and which appeal to the eye and not to the mind.[64]

On this basis the Academy worked out in its lectures a system of rules as complicated as any that have ever been devised to govern the art of painting. The painter must only choose noble subjects. Like the dramatist, he must observe the unities of time, place, and action, though he may be allowed certain liberties in the matter of time to suggest what immediately precedes and succeeds the actual moment depicted. He must observe the proprieties; there must be nothing 'low' in his compositions, and everything must be suitable to the theme chosen.

The Academicians, however, were not content with such general indications, but set out their decisions in rigid form. Lebrun produced his famous treatise on the expression of the passions[65] in which he gives the student exact instructions how to represent any particular state of emotion, and, lest the written word should not be explicit enough, accompanies each chapter with a diagrammatic drawing. Henri Testelin, the secretary of the Academy, extended this method, and in his *Sentiments des plus habiles peintres*, published in 1680, tabulated the agreed views of the Academy on the subjects of drawing, expression, proportion, *chiaroscuro*, composition, and colour.

To these rules were added equally strict instructions on the suitability of different artists as models for the young student. The Academy arranged its hierarchy of merit as follows: first, the Ancients;[66] secondly, Raphael and his Roman followers; thirdly, Poussin. The student was specifically warned against the Venetians, since they led to a too great interest in

colour, and against the Flemish and Dutch artists, since they imitated nature too slavishly, without discrimination.[67]

These precepts were naturally supplemented by practical instruction, which followed the same principles. On arrival at the Academy's school the young student was set to copy the works of the approved old masters, first in drawing and then in painting. Next he was made to copy casts from the antique. After this preliminary training he was allowed to draw from life, since by then, it was believed, his taste would have been sufficiently formed by his study of the masters for him to be able to select from the model before him according to taste and reason.

The reader will not be surprised to learn that this restrictive teaching did not produce remarkable or individual artists. The painters trained in the Academy under the direction of Lebrun are uniformly competent, but rarely more; and when they show character it is usually by breaking the rules which had been inculcated into them.

Lebrun himself was an artist of great natural talent.[68] Born in 1619, he was first trained under Perrier and Vouet, and while still in the studio of the latter produced a painting of Hercules and the horses of Diomedes [286] which reveals a vigour of design and handling astonishing in so young an artist. In 1642 he went to Rome, where he worked for four years, partly under the instruction of Poussin, and partly studying contemporary Roman art. Returning to Paris in 1646, he at once obtained commissions for decorative and religious paintings. His reputation was established by his decorations in the Hôtel Lambert and at Vaux in the later 1650s.[69] In 1661 he was given his first commission by the King, for 'The Family of Darius before Alexander' [290], in which the qualities of the artist's mature style appear fully developed. The traces of Poussin's influence are still visible in the classical detail and in the attention paid to ges-

286 (above). Charles Lebrun: Hercules and the horses of Diomedes. c. 1640. Nottingham, Art Gallery

287 (opposite). Charles Lebrun: The Nativity. c. 1689. Paris, Louvre

ture and facial expression, but Lebrun has taken the edge off Poussin's style. The composition is freer and more picturesque; the setting is richer and more striking;[70] the subject is pathetic rather than heroic.[71] Finally, the hero is Alexander, with whom Louis XIV admitted some similarity, and who was to be the theme of the next series of works commissioned by him from Lebrun immediately after the 'Tent of Darius'. This consists of four vast canvases – three of them are more than forty feet long – illustrating the victories of Alexander, which reveal Le Brun as a master in the control of compositions involving great numbers of figures, a master equal to his obvious models, Giulio Romano and Pietro da Cortona.[72] In a scheme of this scale Lebrun inevitably made use of assistants, but it is clear from the surviving drawings that he worked out every part himself, and many of

the details are certainly not by the hands of hacks. The Alexander compositions are particularly enlivened by brilliant passages of animal painting, and it is customary to give the credit for such passages to Adam van der Meulen, who was trained in the Flemish naturalist tradition; but Lebrun himself had given proof of astonishing talent in this field in his early works, for instance the horses of the 'Diomedes' and the dog in the foreground of the 'Martyrdom of St John' (St Nicolas-du-Chardonnet), and he may well be responsible for these parts of the later compositions.

The Alexander series established Lebrun's position with the King. From this moment he obtained, as we have seen, every post of importance in the arts, and supplied designs for all the great decorative schemes in the royal palaces. We have already noticed that in these

288. Charles Lebrun: Louis XIV
adoring the Risen Christ. 1674. *Lyons, Museum*

works he was compelled by the nature of the task to be less strictly classical than in his theories, and the same phenomenon appears in the few easel pictures which he produced during the period of his success. A typical example of his style is the painting of 'Louis XIV adoring the Risen Christ', painted for the chapel of the Mercers' Company in 1674, and now in the museum of Lyons [288]. The first impression is of a lively Baroque composition, such as Pietro da Cortona might have produced for a Roman church; and it is only on careful examination

that we notice the other elements. The types are more Raphaelesque and the presentation of the figures is more frontal than would be the case in a contemporary Roman composition. But the fact remains that the altarpiece is closer in its general effect to the Baroque artists whom Lebrun condemned than to Poussin, whom he set up as the ideal model.[73]

In the bottom right-hand corner of this painting we see the figure of Colbert, modestly placed and realistically painted, which may serve to remind us of the fact that Lebrun was also a portrait painter of distinction. His portrait of his first protector, the chancellor Séguier, at the entry of Louis XIV and Marie-Thérèse into Paris in 1661 is a fine solution to the problem of producing a classical version of the life-size equestrian portrait [289]. The group is treated like a frieze with the horse seen exactly from the side and the pages arranged in a row, the one on the extreme right turning back to close the composition. This is the French classical answer to the challenge of Rubens' 'Buckingham' or van Dyck's 'Charles I', the great Baroque models for this kind of composition, and, though it lacks their vigour, it has a stateliness suitable to its time and place. But even here Lebrun is not entirely true to his own principles; for, though the composition is classical, the naturalistic treatment of the embroidered dresses and the warm colouring of the whole picture show that he had borrowed from the Flemish tradition of van Dyck, which in his lectures he was so strongly to condemn.

Lebrun's dictatorship lasted till the death of Colbert in 1683; but the latter's successor, Louvois, had for many years been a supporter of Lebrun's rival, Pierre Mignard, by whom the first painter found himself gradually displaced. Till his death in 1690 he continued to receive marks of favour from the King himself, but they were in reality consolation prizes; the important commissions went elsewhere. It is, however, a remarkable proof of Lebrun's inte-

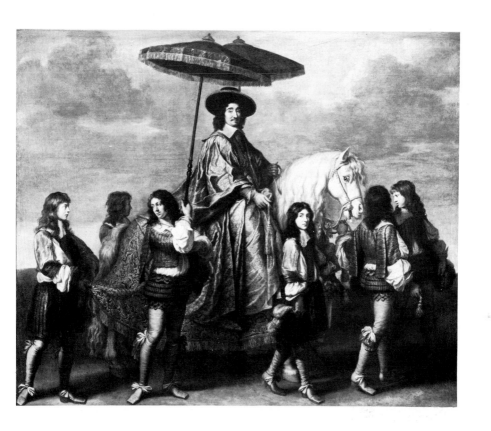

289. Charles Lebrun: The Chancellor Séguier. 1661. *Paris, Louvre*

grity as an artist that he should have devoted his enforced leisure to painting a number of relatively small pictures which reveal qualities which he had been unable to cultivate during his years of success. The 'Nativity' [287], for instance, probably painted in 1689, has a sincerity and a poetic quality which would hardly have been suspected in the artist who conceived the 'History of Alexander' or designed the ceiling of the Galerie des Glaces. The degree to which Lebrun had freed himself from his own chains is brought out by the fact that, in defiance of every convention accepted in France at the time, he uses in these paintings an almost Caravaggesque lighting; but he uses it to create a personal and intimate emotional atmosphere, more akin to the luminism of certain Dutch painters than to Caravaggio or La Tour.[74]

The personal rivalry between Lebrun and Mignard must not lead us to assume that they represented opposing styles. On the contrary, the paintings of Mignard fit in with the teaching of the Academy even more fully than those of Lebrun. Born at Troyes in 1612, Mignard studied first under Jean Boucher of Bourges and then in the studio of Vouet in Paris. In 1636 he reached Rome, where he lived till 1657 with only a short interruption in 1654–5 for a visit to Venice and other towns in the north of Italy. In Rome he formed his style mainly on the study of Annibale Carracci, Domenichino, and Poussin, and although he later supported the claims of the Venetians in the quarrel about drawing and colour, he seems to have done so from a desire to oppose Lebrun rather than from any real admiration, for it is hard to see any trace of

290. Charles Lebrun: The Family of Darius before Alexander. From an engraving. 1661. *Paris, Louvre*

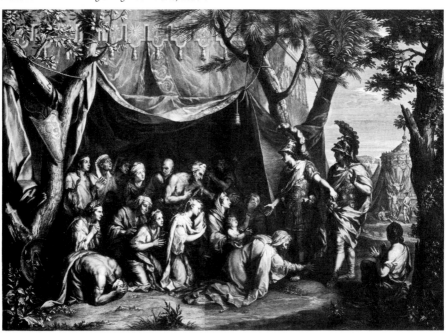

Venetian influence in the colour or handling of his own work.[75]

In 1657 he was summoned back to France at the command of Louis XIV and attained considerable success primarily as a portrait painter, but also in the execution of decorations for private houses and churches.[76] In the latter field his two most important commissions were the painting of the dome of the Val-de-Grâce for Anne of Austria in 1663 and the decoration, now destroyed, of the gallery and salon at St Cloud for Monsieur, the King's brother, in 1677. Neither work shows great originality, the dome being a direct imitation of the type originated by Correggio and re-introduced in the seventeenth century by Lanfranco, and the St Cloud decorations being hardly distinguishable in design and conception from the works of

Mignard's rival at Versailles. In all his historical and religious paintings the most striking feature is the coldness of colour and handling derived from the tradition of Domenichino and Poussin. In 1689 Louvois brought to a head the rivalry between his favourite and Lebrun by commissioning from the former a 'Tent of Darius' [291] in direct competition with the latter's acknowledged masterpiece. Mignard's painting was at the time much admired, though to us it seems tired and hollow, lacking the gusto of Lebrun's design and missing equally the classical poise and harmony of Domenichino and Poussin, the two models whom Mignard seems to have followed. And once again the 'colourist' Mignard turns out in practice to be more classical and more linear than the official leader of the party in support of drawing.

291. Pierre Mignard: The Tent of Darius. 1689.
Leningrad, Hermitage

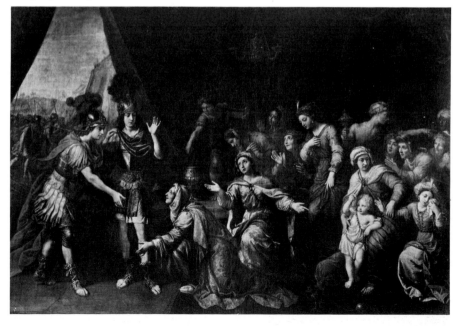

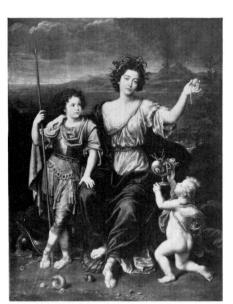

292. Pierre Mignard: The Marquise de Seignelay as Thetis. 1691. *London, National Gallery*

293. Pierre Mignard: Louis XIV. 1673. *Turin, Gallery*

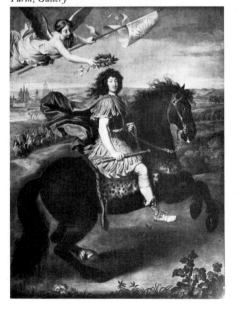

The only field in which Mignard shows any originality is that of portraiture.[77] This art had almost ceased to exist in its own right, owing to the importance which the Academy attached to history painting. The general run of portrait painters, such as Claude Lefèvre (1632–75)[78] or Laurent Fauchier (1643–72), used a more or less Flemish formula deriving ultimately from van Dyck, but a few attempted allegorical portraiture. A typical if not very satisfactory example is Jean Nocret's portrait-group of Louis XIV and his family, commissioned in 1670, in which each member of the family is painted with the dress and attributes of a classical god or goddess.[79]

Mignard had the skill to give life to this ailing tradition, and his portraits in this vein, such as the 'Comte de Toulouse as Cupid asleep' (Versailles) or the 'Marquise de Seignelay as Thetis' [292], are vastly superior to similar productions by his rivals. In his equestrian portrait of Louis XIV at the siege of Maastricht [293] he is more ambitious. Here the King appears dressed as a Roman Emperor on a prancing horse while a Victory flies down to crown him with laurel. In this case Mignard is competing directly with Baroque artists, with Bernini in the pose of the horse, and with Rubens in the whole conception of the portrait. The result proves how unwise it was for a classically trained painter to attempt the vivacity of movement which was the natural idiom of a Baroque artist. As in many of his works, Mignard has fallen between all the stools; and has failed to achieve what his less ambitious rival, Lebrun, did so well in the Séguier portrait, to find a classical solution to the formal equestrian portrait.

At the end of his life Mignard's ambitions were satisfied, and he obtained the official recognition which he had so long sought. On the death of Lebrun in 1690 the King, at the instigation of Louvois, made him his First Painter and sent word to the Academy that they were to appoint him director and chancellor of their

body. And so, in a single sitting, Mignard was made Associate, Member, Rector, Director, and Chancellor. His triumph over his dead rival was complete.

SCULPTURE

Girardon and Coysevox

The principal rôle assigned to the sculptors of the period was their share in the decoration of the gardens and rooms of Versailles, and their work in this field has already been referred to in considering the general architectural problems of the period. But some of them stand out as individuals of such significance that they call for separate study, in particular François Girardon (1628–1715) and Antoine Coysevox (1640–1720).[80]

Girardon[81] was a close collaborator of Lebrun and embodied in his works the classical theories of the Academy. Like Lebrun, he was a *protégé* of Séguier, who sent him to Rome for a short visit, probably between 1645 and 1650. On his return the artist continued his training in the school of the Academy, of which he became a member in 1657. His few surviving early works[82] show that he learnt the current style based on Sarrazin. From 1663 onwards he played a part in the decoration of the royal palaces, particularly in the Galerie d'Apollon, and in 1666 he received the commission on which his fame

294. François Girardon:
Apollo and the Nymphs of Thetis. 1666. *Versailles*

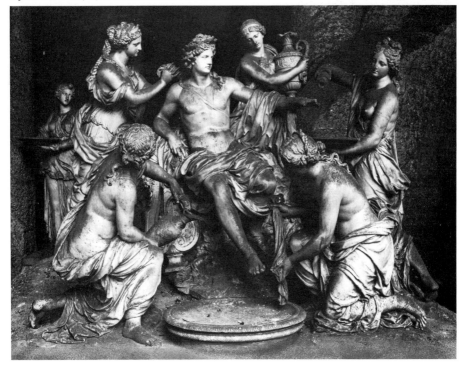

principally rests, the group of 'Apollo tended by the Nymphs' for the grotto of Thetis at Versailles [294]. It is hard now to judge this work because not only was it moved in the late eighteenth century to a new 'picturesque' setting of rocks and ruins designed by Hubert Robert, but the arrangement of the figures in the group was altered.[83] The engraving of illustration 295 shows the original disposition of the group in an enclosed niche, which was flanked

295. François Girardon and others: Versailles, Grotto of Thetis. 1666. Engraving by J. Le Pautre

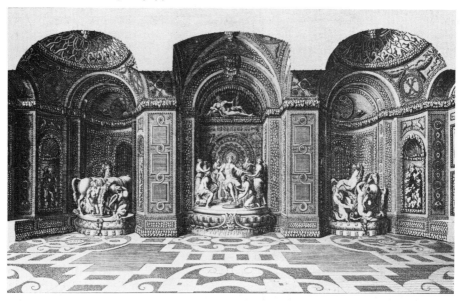

of the nude and the treatment of the draperies, and can be accounted for by the fact that the artist paid a special visit to Rome during the execution of the group in order to refresh his memory of ancient sculpture there.[84] The main problem which faced Girardon, however, was not the treatment of the individual figures, but the manner of linking them into a coherent group. Antiquity provided no model to guide him here,[85] and Girardon was not prepared to

by two other similar niches containing the horses of Apollo carved by Guérin and the Marsy brothers. This idea of continuing the action through several different parts of the building and so linking them up is a Baroque device. It is certainly part of Lebrun's general project; for Girardon's group itself is the most purely classical work in French seventeenth-century sculpture. The direct inspiration of Hellenistic work is strikingly evident in the types, the modelling

use the methods evolved by Baroque sculptors with such success for their fountains or altar-groups. He therefore fell back on a quite different source, the paintings of Poussin. The late classical compositions of this artist are conceived so much in terms of solid objects set up in space that Girardon needed only to translate them into sculpture. In its original form the group must have satisfied in a high degree the canons of classical composition. The central

figure, closely imitated from the Apollo Belvedere, is seen frontally in a classical pose; the nymphs are placed symmetrically round him, but with such variety and contrast in their poses and gestures that monotony is avoided.

Girardon's other sculptures for the gardens of Versailles are not outstanding, except for two: the relief on the 'Bain des Nymphes',[86] which can almost be described as a seventeenth-century version of Goujon's reliefs on the Fon-

296. François Girardon: The Rape of Persephone. 1677-99. *Versailles*

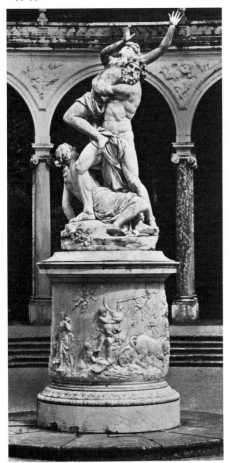

taine des Innocents, and the 'Rape of Persephone' [296].

In the 'Apollo tended by the Nymphs' Girardon had tackled the problem of separate figures forming a group to stand in a niche. The 'Persephone' is a free-standing group, composed of three entwined figures carved out of a single block. Girardon is therefore here directly challenging comparison with Bernini's treatment of the same theme and with Giovanni Bologna's 'Rape of the Sabines'. Once again the statue does not now stand in the position for which it was originally designed. At present we see it standing in the middle of the circular Colonnade, facing the entrance but inviting the spectator to walk round it and view it on all sides. It was planned, however, to form one of a quartet of groups at the four corners of the Parterre d'Eau.[87] We do not know exactly how it was to be placed, but it would certainly have been set on a definite axis, so that it presented one principal aspect. Girardon has taken this fact into account and has designed the group with a marked emphasis on frontality. This feature is brought out most clearly by a comparison with the two Italian groups. Bologna's version presents a satisfactory composition from whatever angle it is seen, but does not finally arrest the spectator at any one point. Bernini's is evidently meant to be studied primarily from one view, with the body of Pluto seen frontally, but there is such a wealth of cross-movement in depth that it can in fact be examined from many sides. Girardon has concentrated everything on one view, to the extent that he has almost designed the statue as a high relief. Pluto stands, stepping forward, so that the plane formed by his two legs defines the main aspect. His head is turned to be seen full face. Persephone, although she writhes into a twisted *contrapposto*, does so in such a way that the main axis of her body remains in a plane parallel to the principal aspect. The same is true of the figure of her sister, Cyane, who appears below

the other two.[88] Once again it is to Poussin that Girardon has turned for inspiration, and in the two versions of the 'Rape of the Sabines' he found the formula that he needed; for in these groups Poussin had solved the problem of forcing figures in violent movement into groups which fitted into his classical scheme of composition in planes parallel with that of the picture.

Apart from these sculptures for Versailles, Girardon received many other commissions, both private and public, in which the same tendencies are visible. In the monument to Richelieu in the church of the Sorbonne (1675–7) [297] he provides the classical type for the free-standing altar-tomb. Like all Girardon's works, it was carefully designed to suit its posi-

tion, which was originally the middle of the choir on the main axis of the church.[89] Here it would have presented two principal aspects, one towards the altar, the other towards the north, from which side it would be approached by those who came into the church from the university. The latter would see the full-length recumbent figure of the Cardinal exactly from the side, except that the upper half of his body is turned so as to face towards the spectator; while the mourning figure at his feet would be seen exactly from behind.[90] From the altar the group is again coherent with the mourning figure leading straight back to the dead man, who turns his head so as to look up at the altar and is supported by the allegorical figure of Piety whose gaze follows his.

297. François Girardon: Paris, Sorbonne, tomb of Richelieu. 1675–7

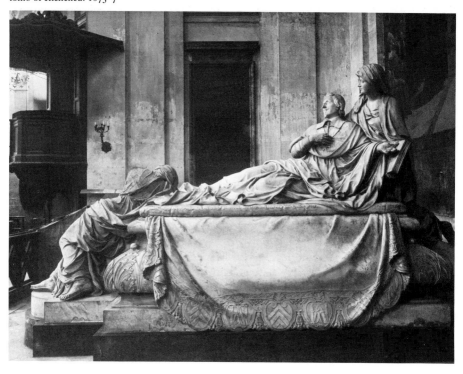

Girardon's one commission for the city of Paris, which was also the most important work of his later period, was the equestrian statue of Louis XIV, prepared in the years 1683–92 for the Place Vendôme, but destroyed at the Revolution. Here again both Girardon's natural tendency and the nature of the problem provoked a classical solution; for the statue was to stand on the axis of the Place facing down the street connecting it with the rue St Honoré. But in this case the artist had no need to turn to Poussin for inspiration. The ancient model lay ready to hand in the statue of Marcus Aurelius, and Girardon made full use of it in his design. The pose of the horse and even the King's outstretched arm are copied almost literally from the Roman model. The artist has only made a few concessions to contemporary taste in the naturalistic treatment of the saddle-cloth and the skirt of the armour.

Girardon did not die till 1715, but his most important work was executed well before the end of the century. There is no direct evidence to show that he lost the favour of the King, but it is certain that by the 1690s the taste of the latter was moving away from the classical manner, of which Girardon was the most distinguished exponent, and beginning to favour a more Baroque style.[91]

It is partly for this reason that the position of Girardon's rival, Coysevox, improved as that of Girardon became weaker. For classicism never came easily to Coysevox, whereas even in his early years leanings towards the Baroque are clearly apparent. He was born in 1640 at Lyons,[92] came to Paris in 1657, and studied at the Academy school and under Lerambert for at least six years. His earliest surviving work, a 'Madonna' in Lyons (c. 1676), shows the influence of Michel Anguier, but he also learnt much from studying Sarrazin. By 1679 he was working at Versailles, which was to be the scene of his most spectacular successes.[93] His sculpture there can be divided into two categories. In the statues

and fountains in the forecourt and gardens he attempts to follow the classical manner of Girardon, but with little success; for they are either heavy and lifeless, like 'La France triomphante', or pure pastiches of the antique, like the 'Nymphe à la Coquille'.[94] Where Coysevox excels is in the decoration of the later rooms in the palace, particularly the Galerie des Glaces [281], the Escalier des Ambassadeurs [279], and the Salon de la Guerre [282]. His free invention, his love of rich materials, and his technical virtuosity make him the ideal counterpart of Mansart, just as Girardon was of Lebrun. The most splendid piece of real sculpture, as opposed to decoration, in these rooms is the stucco relief of the victorious Louis XIV in the Salon de la Guerre. Here Coysevox does brilliantly what Mignard so signally failed to do in his equestrian portrait [293]. The chief reason for the sculptor's success is that he has approached the matter in the spirit of the Baroque. He makes no attempt to restrict the violence of the action in order to conform to classical canons. On the contrary, he emphasizes the movement across

298. Antoine Coysevox: Tomb of Mazarin. 1689–93. *Paris, Louvre*

the surface of the relief and in depth into it. The body and head of the King are boldly turned, his arm projects out into space, and the fallen soldiers below are arranged so as to lead the eye into the composition. Yet another less obvious device is used for the same purpose. Although the horse is seen from the side, the relief becomes higher towards the right, so that the head and forequarters of the animal project farther than the hindquarters and one foreleg is actually free of the relief. This arrangement gives variety to the whole effect, and breaks up any trace that might remain of classical emphasis on the plane of the relief itself. In fact, this panel is the most Baroque piece of sculpture produced by any of the Versailles team up to its date.

The same tendency towards the Baroque can be seen in Coysevox's designs for tombs. In that of Vaubrun at Serrant (1680–1) the figure rests on his elbow, but has the maximum of movement in the pose and of undercutting in the detail. Colbert in St Eustache (1685–7) is in the traditional kneeling pose, but again with deep undercutting and strong shadows. In its original form the allegorical figures would also have started a movement in depth up to the main figure, which is destroyed by the present arrangement of the monument. The latest of the series, the tomb of Mazarin, now in the Louvre (1689–93) [298], is in many ways the most classical, and the allegorical figures are in the manner of Sarrazin. But the movement and the swinging drapery of the kneeling cardinal are marks again of Coysevox's leanings towards a Baroque idiom.

Coysevox's most original works are his busts, but they belong mainly to the later part of his career, and will be dealt with in the next chapter. For the moment it will be enough to notice that even his earlier busts, such as the bronze of Louis XIV, dating from about 1686, in the Wallace Collection [299], are free in their movement and startling in the skill of their modelling.

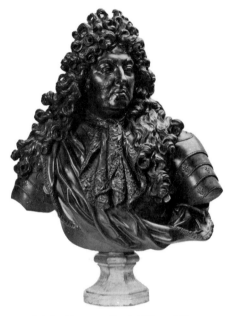

299. Antoine Coysevox: Louis XIV. *c.* 1686. *London, Wallace Collection*

In this field, however, Coysevox had the advantage of knowing one great Baroque original, Bernini's bust of Louis XIV, which stood at Versailles. His own works look calm and almost severe beside the swirling rush of the Roman sculptor's marble, but the existence of Bernini's bust helps in part to explain the curious paradox that whereas Girardon, who twice visited Rome, showed no sign of even being aware of the Baroque, Coysevox, who as far as we know never went to Italy, comes closer in feeling to his Roman contemporaries than any other Frenchman.[95]

THE DECLINE OF LOUIS XIV

1685-1705

HISTORICAL BACKGROUND

The death of Colbert in 1683 is a convenient event from which to date the change in the position of France and the beginning of the decline which marked the last years of Louis XIV's reign. But even before the minister's death his power was declining and he was beginning to be eclipsed by his rival, Louvois, whose personality was to dominate France during the eight years that he survived his predecessor, and whose policy was to be continued in many ways after his own death, partly because it was largely based on a desire to flatter the King and indulge his personal inclinations.

To put it very shortly, the change from the régime of Colbert to that of Louvois was marked by a tendency towards purely aggressive, useless, and ruinous wars, which strained the financial system and brought out the faults inherent in it. The result was increase in taxation, with even greater injustice in its distribution and corruption in its collection; and the more oppressive the taxation grew the more inflexible the administration had to become in order to enforce it. Meanwhile the increased autocracy in the political field was accompanied by a similar movement in religion, of which the Revocation of the Edict of Nantes in 1685 was the most significant example.

Of the various campaigns before the Treaty of Nijmegen in 1678 it could always be said that, though often unjustified in an ethical sense, they were directed towards practical ends, such as the advancement of trade or the strengthening of natural frontiers. But the wars of the last part of the reign were of a quite different kind. That of the League of Augsburg may have been declared to forestall attack, but that attack would have been provoked by Louis XIV's obvious intention to attain domination of the continent of Europe. The War of the Spanish Succession was legally justified, but only a megalomaniac would have taken up the testament of Charles II of Spain, and taken it up in such a provocative manner.

The result of these two wars on the state of France is too well known to need much emphasis. The misery to which the peasantry was reduced is a common theme of writers of the time; the greater nobility were busy ruining themselves at Versailles; the smaller lived in obscurity and relative poverty on their estates; the solid *bourgeoisie* suffered from the irregular payment of *rentes* and from the interruption of trade; and, as usual in such disturbed circumstances, the only section of society which prospered was a small group of financiers who made and often lost again vast fortunes at spectacular speeds.

The power of the King himself became in effect more and more absolute. Although it had always been so in name, under the guidance of Colbert it had been exercised with greater discretion and in a less arbitrary manner. With increasing age the King became less and less able to brook opposition, either from his ministers or his subjects. The function of the latter became to pay and obey blindly, and of the former to endeavour to find out beforehand what advice the King wanted to be given in order to gain favour by giving it. In effect,

therefore, the entire government of the country depended on the personal whim of the King; and the King had become a megalomaniac and a bigot.

The blame for his bigotry is usually placed too exclusively on Mme de Maintenon, for in fact other advisers, such as Louvois, probably had as much to do with it. And in any case his reactionary policy in religion was only the counterpart of his attitude in politics. It could even be said that his reasons for fearing the Huguenots were as much political as religious; for the threat of the 'State within the State' was still a living memory. One thing is certain, that he became much more *dévot*, and that his particular form of religion partook of the pietistic enthusiasm of seventeenth-century Catholicism, as embodied in the doctrines and methods of the Jesuit order, to which his confessor, the Père La Chaise, belonged. That his relations with the Papacy remained strained was due to the political necessity of maintaining as far as possible the privileges of the Gallican Church.

However, as the government became more and more reactionary, there grew up an increasing resistance to it, though this opposition was of necessity more intellectual than practical. The new rationalist and independent thought which led the way to the eighteenth century was born well before the end of the seventeenth. It was not at Versailles but in Paris, or even in exile, that men like Fontenelle and Bayle were preparing the challenge to all authority, whether religious, philosophical, or political, which in the hands of the Encyclopaedists was actively to further the break-up of the old régime.

Within France itself one of the most significant manifestations of the new spirit was the Quarrel of the Ancients and Moderns, to which Fontenelle made a vital contribution by his new doctrine of progress but which in the field of the arts and literature can be said to date in its active form from the publication of Charles Perrault's *Siècle de Louis le Grand* in 1687, which

was followed in the years 1688–96 by the even more explicit *Parallèles des Anciens et des Modernes*. Perrault's thesis was that the blind adoration of the ancients taught by the French Academy and the Academy of Painting was irrational. The moderns, he said, had made great advances on the ancients not only in science but also in the arts. They could draw on new styles and could use methods such as perspective which were unknown to the Greeks and Romans. This view was, of course, a direct attack on one of the cardinal principles of the Academy of Painting, for whom ancient art was the absolute standard by which all contemporary work was to be judged. The issue was confused, because although the doctrine of the moderns was revolutionary and in the end helped to destroy the dictatorship of the Academies associated with the régime of Louis XIV, Perrault, who was a skilful controversialist, pointed to Lebrun and Racine, the two stoutest supporters of the ancients, as the examples of contemporary artists who had excelled these very ancients. In the same way he maintained that Louis XIV was himself a proof that kings were as great in the seventeenth century as they had been in antiquity. Nevertheless, the supporters of the ancients were not deceived by this simple piece of tactical manoeuvring and fully realized the danger of the attack on their position.

Parallel with the Quarrel ran another which affected only the field of painting, but within that sphere was of even greater importance. This was the quarrel of Colour *versus* Drawing.

This quarrel arose out of the gradually increasing admiration of certain French artists for Venetian painting. We have seen that even in the earlier part of the century some painters, such as Vouet and Jacques Blanchard, had profited from the example of Titian and Veronese, but it was not till the publication of C. A. Dufresnoy's poem, *De arte pingendi*, in 1667 that any theoretical defence of the importance of colour and the Venetian conception of paint-

ing was put forward. Dufresnoy was, however, very tentative in his statements, and it was rather in the notes to the poem by Roger de Piles that a real assertion of the value of colour was to be found

The matter came to a head in 1671 in the Academy itself. In that year Gabriel Blanchard, the son of Jacques, read a lecture attacking Philippe de Champaigne, who, in spite of his Flemish origin, had just made a highly doctrinaire statement of the views of Lebrun and the majority of the Academy that colour was altogether inferior to drawing. There followed a violent discussion which was nominally closed by Lebrun in an *ex cathedra* statement of the official doctrine in favour of drawing in a lecture given in January 1672.

But the matter was not to rest there, for Roger de Piles, who, though not a member of the Academy, had been taking an interest and probably an actual part in the discussions, began to publish his views in a series of theoretical pamphlets.[1]

Fundamentally his arguments are much the same as those of Blanchard, and the problem can be summarized as follows. The orthodox Academicians maintained that drawing was superior to colour because the former was a purely intellectual matter and appealed to the mind, whereas colour appealed only to the eye, that is to say to one of the senses.[2] Put otherwise, drawing is to colour as the soul to the body.

To this the defenders of colour replied as follows. The principal aim of painting is to deceive the eye, and colour achieves this more fully than drawing. This doctrine was in many ways revolutionary, for although the Academy would have agreed that the purpose of painting was to imitate nature, they would not have allowed the use of the word *deceive*, and they would immediately have qualified their statement about imitation by saying that the artist must, of course, select from nature and only imitate the most beautiful parts of it. The view

of the colourists was therefore a statement of a much more complete naturalism than had hitherto been formulated in France. But they went even further, and directly attacked the rationalism of academic teaching. Drawing, said the Academy, imitates the real, whereas colour only represents the accidental. On the contrary, said their opponents, colour represents truth, whereas drawing only represents reasonable truth, that is to say truth altered to suit the demands of reason. This was again heretical, because it implied that reason was not the ultimate standard of judgement in the arts. Finally, they said, drawing appeals only to the learned and the expert, but colour appeals to everyone, thereby asserting an almost democratic conception of art and challenging the view generally accepted since the early Renaissance that painting is an art appealing to the mind and only to be enjoyed by intellectuals.

This dispute involved, therefore, attacks on a number of the most important props of the academic position, and, quite as much as the Quarrel of the Ancients and Moderns, served to undermine its authority. For gradually the view of the Colour party came to be accepted, and by the end of the century, though the battle had died down, it was the colourists who were left in possession of the field.

The later stages of the discussions centred round the importance of a single artist, Rubens. It is a fact, on which all historians of French art have commented with surprise, that the great cycle painted by Rubens for Marie de' Medici in the Luxembourg exercised almost no influence in French painting for more than half a century. What is even more curious is that the discovery of his importance was made not by practising artists but by the critic Roger de Piles.[3] By the middle of the 1670s de Piles was already advising the Duc de Richelieu, who was re-forming his collection, to buy Rubens, and in his later theoretical works Rubens plays a more and more prominent part.[4]

For Roger de Piles the first quality in Rubens was that he was a naturalist. This view may seem strange to us, but was reasonable in the context, because Rubens was the means of escaping from the imitation of classical art which Poussin had inaugurated and which the Academy had codified into a soulless system. Rubens, moreover, had all the other qualities necessary to the great artist, such as invention, knowledge of allegory, power of composition, and so on. In one quality only was he deficient, namely drawing – to us also a curious opinion, but we must remember that for even the opponents of the Academy drawing meant the drawing of Raphael and Poussin.[5]

It is not surprising that, with this highly complicated historical background and the break-up of the whole academic structure, we should find in the actual practice of the arts a great variety of tendencies all active at the same time. The changed state of mind of the King and the Court provided the background necessary for the appearance of a strong Baroque movement in France, and this is in fact one of the most striking features of official art of the later 1680s. The rise of La Fosse and a little later of Jouvenet in history painting, the establishment of Largillierre and Rigaud as the most popular portrait painters, the belated success at Versailles of Puget, the gradual supersession of the classical Girardon by Coysevox in sculpture, and the increasingly Baroque elements in the architecture of J. H. Mansart – all these phenomena occur within a few years of 1685 and mark the change in the taste of the Court.

Parallel with this transformation, however, there occurred another, also within the Court, but starting a little later in date. The younger members of the royal family – the Dauphin, the Duc de Chartres (son of Monsieur, the King's brother), and the Duchesse de Bourgogne (the wife of his grandson) – began to grow bored with the formality and pomposity of the academic style, as it was interpreted by the followers of Lebrun, and demanded a gayer type of decorative painting of which the subjects were the lighter themes from classical mythology treated in a more frivolous style. This tendency was one of the main factors which led the way towards the Rococo.

At the same time, however, there grew up in Paris a style independent of Versailles and in many ways opposed to it. Among artists, among their personal friends, and among a small group of *bourgeois* admirers there was developed a real taste for naturalism.[6] Even the portrait painters, such as Largillierre and Rigaud, who for their smart patrons could produce all the tricks of the Baroque, worked in a quite different style when painting for their own pleasure or that of their friends. Formal classical portraiture was superseded by intimate portraits based on the models of Flanders and sometimes of Holland, and even in small religious pictures painted for this circle the old tradition of Poussin and Lebrun began to give way to a more naturalistic and picturesque manner.

These confusing and conflicting tendencies naturally manifested themselves differently in each of the three arts, but basically the same kind of variations of taste can be seen in them all.

ARCHITECTURE

The later work of J. H. Mansart – Bullet

The architecture of the last decades of the seventeenth century must be considered in two parts: public and private buildings. In the public works the tendencies towards the Baroque which we have seen latent in the architecture of the high period of the reign are suddenly given free rein.[7] In the private houses the opposite characteristics come to the fore, and practical convenience rather than a desire to impress is the primary object sought.

Till his death in 1708 Mansart continued to control all the public works, whether executed

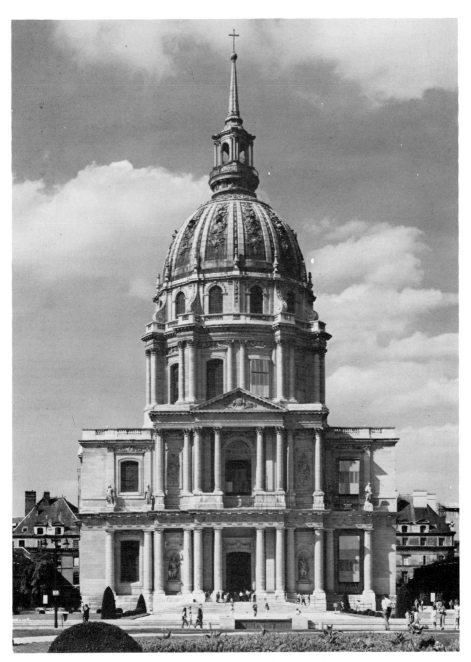

300. J. H. Mansart: Paris, Church of the Invalides, exterior. Before 1679-1691

at the direct order of the King or by some public body in his honour. The most important of these are the two chapels for the Invalides and Versailles, and the two public squares in Paris, the Place Vendôme and the Place des Victoires.

As early as 1676 Louis XIV had decided to build a second chapel at the Invalides, to be linked with the old chapel at the hospital. It is almost certain that his original intention was to make this chapel a burial place for himself and for the Bourbon dynasty, but for some reason this plan was abandoned.[8] The existing church [300, 301] was begun before 1679 and was com-

301. J. H. Mansart: Paris,
Church of the Invalides, section. Before 1679–1691

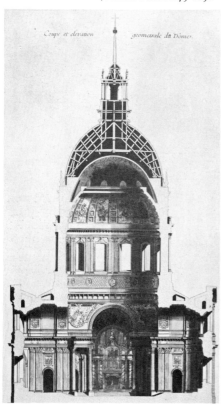

pleted, after some modification of the design, in 1691, but the decoration of the interior lasted until after Mansart's death in 1708.

In certain respects the chapel springs from the French seventeenth-century tradition. Its plan, a Greek cross with circular chapels in the corners connected with the central space by low, narrow openings, is taken directly from François Mansart's designs for the Bourbon Chapel at St Denis; and the lower part of the façade, constructed in rectangular blocks, recalls the same architect's church of the Minims. But in other respects the design reveals features which could not be found in France before this date. Even the lower part, though classical in its rectilinearity, is Baroque in that it builds up towards the centre by means of a series of breaks forward, culminating in the pedimented frontis-piece. But the design of the dome is even more singular. Ultimately it derives from St Peter's, but with surprising variations. Mansart has broken away in two respects from the usual arrangement with a regular disposition of win-dows each separated from the next by a buttress-ing pier and with a window on the main axis of the church; for he has placed alternately one and two windows between his pairs of piers, and on the main axis he has set neither a window nor even a buttress, but the pier with two half-columns which forms the centre of each two-windowed bay between the buttresses. This unexpected placing of a solid instead of a void on the principal axis is quite unclassical, but it is repeated in the lantern, which is square in plan but is set with a corner on the main axis. Further, there is a greater emphasis on the vertical than in the classical models for this kind of church, the Sorbonne or the Val-de-Grâce. The lines of the columns in the portico are carried up through the piers of the drum, along the consoles and the heavy ribs of the dome, to be interrupted for a moment by the projection at the bottom of the lantern, but to be taken up again strongly through the lantern and so to continue up to the

climax, the three-sided obelisk symbolizing the Trinity. A Baroque richness is given to the whole effect by the gilt trophies which fill the area of the dome between the ribs, so that seen across Paris the Invalides stands out in isolated Baroque splendour between the simplicity of the two earlier domes and the conscious coldness of Soufflot's Panthéon.[9]

The interior is as Baroque as the exterior.[10] Its general character is set by the main Order of vast free-standing columns, supporting a rich and deeply projecting entablature. Compared with the boldness of this conception the Sorbonne seems timid and the Val-de-Grâce modestly classical. Between the columns are openings to the side chapels, above which are stone reliefs of unusually free conception, like Bernini's *Logge* in St Peter's, but in white stone instead of coloured marbles. In the dome itself Mansart has again taken up an idea of his great-uncle for the Bourbon Chapel, for it is cut off so that the spectator looks through it to an outer shell on which is painted a heavenly glory. This is lit by windows concealed in the upper part of the drum.[11] The Baroque character of the interior is completed by the high altar, which consists of a variation of Bernini's St Peter's Baldacchino, with black marble columns, standing out dark against the opening which leads through to the older church.

The chapel of the Invalides demonstrates, therefore, the tendency towards the Baroque which became so strong in religious architecture at the end of the century. The same mood dominates Mansart's other important work in this field, the chapel at Versailles [302].[12] There had been several chapels at Versailles before this one, but all had been regarded as more or less temporary. In 1688 Louis XIV decided to build one worthy of the palace, and commissioned Mansart to prepare plans. Work was started on the building in 1689, but the war of the League of Augsburg interrupted it almost at once, and the project could not receive attention till after

the Peace of Ryswick. In 1698, however, Mansart was ordered to take up the work again, and in the next year building operations were resumed, on slightly modified plans. By 1703 the structure was finished and by 1710 the decoration of the interior was complete.

The chapel presented a special problem, in that it had to consist of two storeys, of which the upper containing the royal pew had to be made the more important. Mansart's solution to this was to make a low arcaded ground floor, for the courtiers and the public, and a high colonnaded first storey, with the royal pew at the west end

302. J. H. Mansart:
Versailles, chapel. 1689–1710

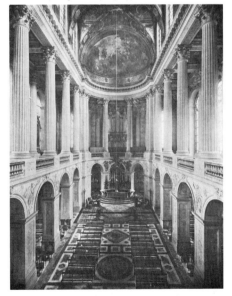

communicating directly with the King's *Appartement*, and a spacious gallery for his immediate suite. The result of this arrangement was to make the chapel of great height in relation to its breadth, so that the proportions of the interior are those of a Gothic chapel rather than of a classical building.[13] Moreover the colon-

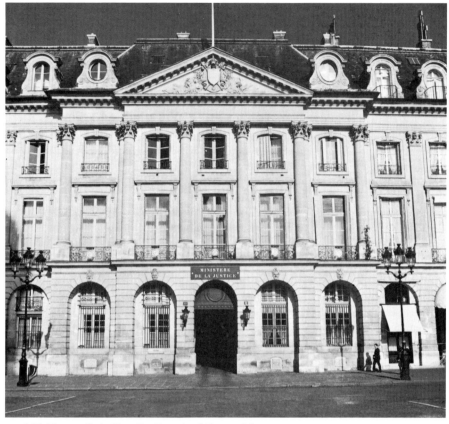

303. J. H. Mansart: Paris, Place Vendôme, detail. Begun 1698

nade on the first storey creates variations in depth and contrasts of light which are quite unclassical in feeling. But the most Baroque part of the whole chapel is the ceiling, which is covered with an illusionist fresco by Antoine Coypel (1708) [326].[14]

It is to be expected that these two chapels should be the most Baroque works produced at the end of Louis XIV's reign, because they embody the two ideas which lead most usually to this style: a heightened religious atmosphere and an autocratic rule, coupled in this case with a strong belief in Divine Right on the part of the ruler. But if, seen in the context of French seventeenth-century architecture, the chapels of Versailles and the Invalides appear Baroque, compared with the Italian churches of the High Baroque they seem very restrained. Walls are never curved, entablatures are rarely broken, pediments are straight, plans are simple. The French did not follow the Baroque principle of fusing the three arts of architecture, sculpture, and painting into one; they never used directed light with the dramatic force of a Bernini; and they rarely employed coloured marbles for decoration.[15] In fact, their tendency towards the

Baroque was always checked by the tradition of classicism, even in these last decades of the seventeenth century.

This fact is even more apparent in the two squares built at the same period in Paris, the Place des Victoires and the Place Vendôme. The former was planned in 1685 by the eccentric Duc now hardly possible to imagine its original appearance.[16]

The Place Vendôme, however, can still give us a true idea of Mansart's ability in this field [303, 304]. In 1685 the King bought the site of the Hôtel de Vendôme from the bankrupt owner, the Duc de Vendôme, with the intention

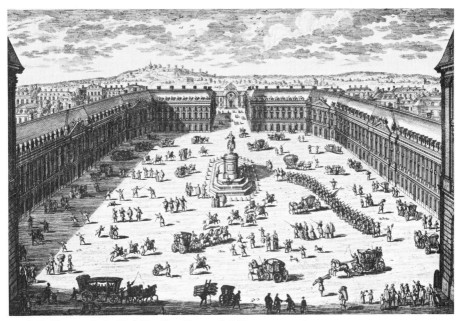

304. J. H. Mansart: Paris, Place Vendôme. Begun 1698. From an engraving

de la Feuillade as a piece of exaggerated flattery to the King. He commissioned Desjardins to make a statue of Louis as the centre of the square; but the statue pleased the King so much that the Duke presented it to him and ordered the artist to make another. Meanwhile Mansart was commissioned to design an appropriate setting, and produced a plan for a circular Place with four huge standard lamps which were to burn always before the statue of the King, as if before a holy image. These were removed in the eighteenth century, and since that time the whole Place has suffered increasing depredations, so that it is of making an arcaded square with buildings to house the royal library and the various academies.[17] Once again, however, financial difficulties necessitated a change of plan, and in 1698 a new project was devised. The idea of housing the library and the academies was dropped, the arcaded ground floor was given up in order to make fuller use of the available space, and the King made over the whole site, together with the buildings which had been begun on it, to the city of Paris, on the following terms: the authorities would erect the façade as planned by Mansart, but they might sell the plots behind

the façade to private individuals to build on as they wished.

As finally completed the Place Vendôme is a square with the corners cut off, closed except for two openings which form its main axis. On the axis stood Girardon's equestrian statue of the King, facing one of the openings.[18] The buildings which surrounded the Place were decorated with a colossal Order of pilasters, broken by frontispieces with half-columns at the centres of each side and at the cut-off corners.[19]

The Place Vendôme must inevitably suggest comparison with the Place Royale (or Place des Vosges) of the first years of the century [126], and the differences are very revealing. The Place Royale was designed by Henry IV for a practical purpose, to provide decent houses for the moderately well-to-do and a covered promenade for the people of Paris. The Place Vendôme, as originally planned, was intended to house the establishments dependent on the King's bounty and to form a suitable setting for the King's statue. That is to say, it was designed for the greater glory of the King and to display his beneficence to the arts. In the form which it ultimately took the nobler part of this scheme was abandoned; the setting for the statue survived; and the houses were handed over not to the useful citizens who inhabited the Place Royale but to the excessively wealthy and somewhat ostentatious financiers who built their hôtels round it.[20]

In its general conception, as a piece of scenic architecture rather than a practically designed domestic scheme, the Place Vendôme is close to Roman Baroque architecture which could offer a brilliant solution to this type of problem in the Piazza of St Peter's. In detail, however, it is restrained and relatively classical, so that once more we find a compromise between the two

305. J. H. Mansart:
Versailles, Salon de l'Œil de Boeuf. 1701

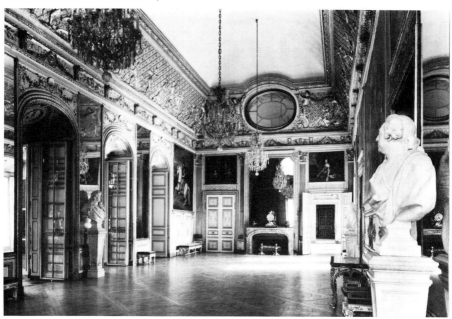

opposites, classicism and Baroque, though here the Baroque element is less marked than in the two chapels discussed above.

It would, however, be wrong to regard Mansart in his last years as entirely a protagonist of Baroque ideas. In the field of domestic architecture his work has a quite different character. During the last decade of the century a number of rooms at Versailles, Trianon, and Marly were redecorated under his direction, and for them a new style was evolved which marks the first stage towards the Rococo.[21] Panelling became lighter, looking-glasses replaced overmantels, cornices became less monumental; in fact, everything was done to make the decorations of the walls lighter and more elegant [cf. 305].

From the same period we know of one project by Mansart for a private house [306].[22] This design is full of unusual features. In addition to

306. J. H. Mansart: Plan of a house, from Mariette, *Architecture Française*

the main door in the middle of the *corps-de-logis*, there is a second entrance in the right-hand corner of the court, which creates an asymmetrical arrangement. Inside the house the staircase and vestibule form a single space, which is again contrary to the usual practice of the time. Mansart also breaks away from the conventional rectangular shapes for his rooms, for the dining-room to the right of the vestibule and the *salle* above it both have rounded ends, and the secondary staircase in the corner of the court is also curved in plan. In elevation there is one surprising and unclassical device; for on the garden front, instead of the usual arrangement of a central projecting pavilion and two others, one at each end, there is a colonnaded portico on the ground floor in the middle with two pedimented frontispieces, one on each side, separated from the portico by one window bay.[23] This disposition completely breaks up the centralized symmetry of the traditional garden façade and foreshadows the less rigid designs of the early Rococo.

From the time of his appointment as first architect to the King, and even more after he became Surintendant des Bâtiments in 1699, Mansart was occupied with so many different jobs that he cannot possibly have attended personally to every detail of each of them. Some of his contemporaries, including Saint-Simon, who hated Mansart, explicitly accuse him of having kept one or more young architects in the back room, who did all the essential work but got none of the credit. Several modern critics have developed this theory, and there is no question that for the decorative side of the work Mansart relied to a great extent on his two ablest assistants, Lassurance and Pierre Le Pautre.[24] Indeed, it would probably be fair to say that they, rather than Mansart himself, were responsible for the steps which led towards the invention of Rococo decoration. On the other hand, no analogous evidence has as yet been produced for the strictly architectural side of the designs.[25]

It is true, as we shall see, that in the buildings which can be certainly attributed to him Lassurance shows skill in design and is at least abreast of the times in this field. But the facts are not enough to prove that Mansart was dependent on him for this side of his work. On the contrary we have already seen that in his very first works, executed in the 1670s, when he certainly did not have an organized office, Mansart showed marked talent as a planner. That these gifts were not particularly displayed in the work at Versailles is due to the nature of the commission rather than to the character of the architect. Versailles called forth Mansart's other

great gift, his sense of the dramatic and of the appropriate setting for the King; ingenuity of planning was not demanded here. When, however, he had occasion towards the end of his life to design once more a private house, then these talents, long buried, manifested themselves again.[26]

Mansart will probably always be the subject of dispute. His meteoric career reasonably aroused jealousy among his contemporaries and less reasonably arouses suspicion among modern critics. He did not have the concentrated intellectual qualities of his great-uncle, and he was always working in a hurry and in circumstances

which prevented him from achieving a particular kind of excellence. But his enemies have gone too far in denying him real ability as an architect. He served the needs of his time perfectly, and applied to them vast talents: an exceptional sense of grandeur, great skill in directing a team of craftsmen, and, when it was called for, considerable mastery of the strictly practical side of the architect's profession.

The crucial steps in the development of decoration were made at Versailles and the other royal palaces, but the revolution in planning was carried out in Paris. Mansart, as we have just seen, played a part in this, but equal impor-

307 *(opposite)*. Pierre Bullet:
Paris, Hôtel d'Évreux. 1707. Plan of first floor,
from Mariette, *Architecture Française*

308 *(above)*. Pierre Bullet:
Paris, Hôtel Crozat. Finished 1702. Plan of first floor,
from Mariette, *Architecture Française*

tance must be attached to the work of an architect who was his exact contemporary, Pierre Bullet (1639-1716).[27] Bullet was a pupil of Blondel and began his career by carrying out some of his designs such as the Porte St Denis (1671). As a result of this work he was himself commissioned to build another gate, the Porte St Martin, for the city of Paris (1674). During the 1680s he was responsible for a number of designs for private houses[28] which show him to be a supporter of the classical tradition of the previous generation, and little affected by the innovations of Mansart at Versailles.[29]

In the very first years of the eighteenth century, however, he built two houses of great novelty. The rich financier Crozat the elder bought two of the sites at the corner of the Place Vendôme and commissioned Bullet to construct on them houses for himself (finished 1702) and for his son-in-law, the Comte d'Évreux (1707) [307-9]. The irregularity of the site of the Hôtel d'Évreux, of which the street frontage consists only of four out of the five bays of the cut-off corner of the Place Vendôme, has provoked a brilliant solution, including a diagonal approach to the courtyard, through a circular *porte-cochère*. With an ingenuity as great as that of Antoine Le Pautre at the Hôtel de Beauvais, Bullet has managed to form a symmetrically disposed court, rounded at one end and closed by a portico at the other [309].[30] The Hôtel Crozat[31] presented a more regular site, but Bullet has been no less clever in using it. The most remarkable feature of this plan, however, is the great variety in the shapes of the rooms. On the first floor the gallery, the *antichambre,* and the front bedroom all have rounded ends; the Cabinet is equipped with a niche-shaped protuberance which allows access from two doors; and the vestibule, squeezed between two spiral staircases, has the shape of a T, with an oval dome at the crossing of the two axes. Here the method which we saw hinted at in Mansart's early design for the Château du Val is fully developed, and

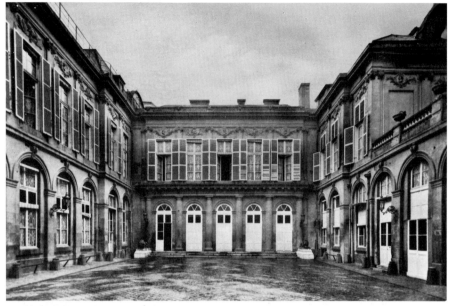

309. Pierre Bullet: Paris, Hôtel d'Évreux. 1707

we are near to the complete freedom and fantasy which the architects of Louis XV show in the shapes of their rooms.

The external architecture of the Hôtel d'Évreux shows the other side of Bullet's style. The ground floor of the court elevation is simple and even monumental, and the first storey is decorated with an elegant motif of a medallion supported by laurels which is taken from François Mansart's façade of the Carnavalet.

The late work of Mansart and that of Bullet lead up directly to the eighteenth century, and the innovations of these two architects are taken up by the younger generation. Pierre Cailleteau, called Lassurance (?-1724), was the most important pupil of Mansart in this field. In the first decade of the century he built a series of houses in which the new tendencies are developed.[32] Several of these have the long low elevations which were first introduced by Mansart at Le Val and Clagny; all have a freedom

of planning, which is derived partly from the same source, and partly from Bullet. Other architects who were not direct pupils of Mansart show the same tendencies: Dulin (c. 1670-1751) in the Hôtels Dunoyer (1708) and Sonning; Jean Sylvain Cartaud (1675-1758) in the house of the younger Crozat (1704); Pierre Alexis Delamair (1676-1745) in the complex of the Soubise and Rohan hôtels (begun 1704);[33] and Claude Mollet (1660-1742) in the Hôtel d'Humières (1700).[34] But with the works of this generation we have left the Grand Siècle and have crossed the threshold of the Rococo.[35]

SCULPTURE

Puget – The later work of Coysevox

If we were to follow the strict order of dates, Pierre Puget would have been treated in the previous chapter, since he was of the same gene-

310. Pierre Puget: Toulon, Town Hall, door. 1656

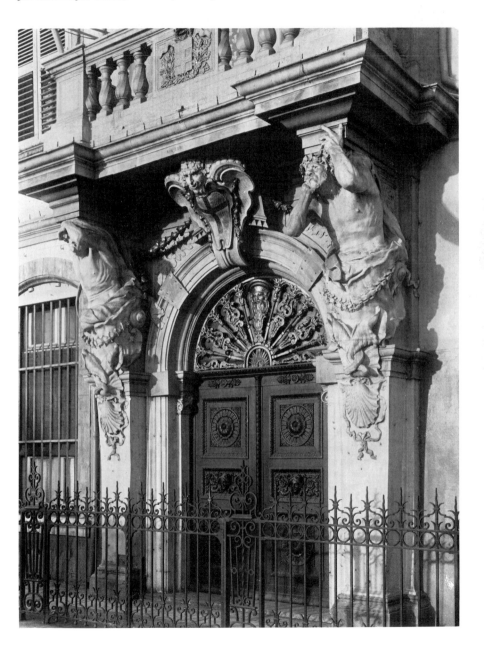

ration as Lebrun and Girardon.[36] Logically,
however, he fits in at this point in the history of
French sculpture, for the first half of his career
belongs to the story of Mediterranean art, and
he does not come into the main stream of French
culture till the middle of the 1680s. Moreover
his sudden if short-lived success at this moment
is one of the most striking examples of the
change of taste in favour of the Baroque.

Puget was born in 1620 in Marseilles, where
he was first trained under a sculptor engaged in
carving the prows of warships. He spent some
years, probably 1638–43, in Rome and Flor-
ence, working partly under Pietro da Cortona.
On his return he continued work in the naval
dockyards and also painted altarpieces for
churches.[37]

In 1656 he received his first important com-
mission, for the door of the Hôtel de Ville at
Toulon [310, 311]. The general scheme of this
door was one already current in Italy, but in
the treatment of the figures Puget shows great
originality. In the freedom of their movement
and in the fluidity of their modelling they are
far more Baroque than anything of the period
in the Parisian tradition. It is usual to say that
in works such as these Puget was imitating the
manner of Bernini; but this is not the whole
truth, nor even the essential point. Puget's style
here springs from the Roman Baroque, but not
in the first place from Bernini. There is no work
of Bernini which attempts to convey the feeling
of anguish, which is the principal characteristic
of Puget's Atlantes.[38] In this way they mark
rather a direct return to the 'Slaves' of Michel-
angelo, who was at all times an important inspi-
ration to the artist. But there are also models for
them to be found nearer at hand, in Puget's own
master, Cortona. One of the novelties of the
latter's ceiling in the Palazzo Barberini is that
in the painted corners the entablatures are sup-
ported not, as in the Farnese Gallery, by non-
chalant athletes in classically calm poses, but by
struggling figures oppressed by their loads.[39]

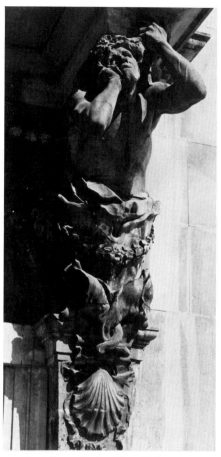

311. Pierre Puget: Toulon, Town Hall,
Atlas. 1656

Puget's figures have, however, a character
quite distinct from any Roman work. The sense
of strain in them is more intense than in Cor-
tona's, and is expressed in a different way. They
display in their faces anguish of mind as well as
of body; in fact they almost remind us of the
damned souls in Michelangelo's 'Last Judge-
ment'. Bernini's figures often express equally
strong emotion, but of another kind – mystical
ecstasy in the 'St Theresa', nervous tension in

the 'David'. They never show this particular mood, which is personal to Puget.

In 1659 Puget was called to Paris on a commission which must have seemed to him the beginning of real success. He was invited by Claude Girardin, one of Fouquet's chief assistants, to make two statues for his château of Vaudreuil in Normandy. As a result of this he came to the notice of Fouquet himself, and received a commission to make for him a Hercules resting.[40] Puget went himself to the Carrara mountains to choose marble for this statue, and settled in Genoa to execute it; but before it was finished he heard of the fall of Fouquet, and his hopes of success collapsed.

For the next twenty years Colbert kept Puget away from Versailles and prevented him from obtaining any really important commissions. This is often said to be due to the fact that the artist had worked for Colbert's enemy Fouquet, but the connexion with the latter did not prevent the minister from taking over all the other artists who had worked at Vaux. There may have been some element of personal feeling in the matter, because Puget was a man of violent temper certainly not made to get on with the sober and calculating Colbert, to whom he probably failed to pay his court.[41] But there is no need to postulate such personal differences. Colbert was quite right in thinking that Puget was not a suitable artist for the work to be carried out at the Court. His leanings were far too clearly towards the Italian Baroque; he was not formed in the classical school; and he was an individualist, who would not have submitted to the tyranny of Lebrun. In the statues produced for Girardin and Fouquet he had tried to moderate his violence and to give them an appearance of classicism, but the effort was too visible and the result was not successful.[42]

On the disgrace of Fouquet Puget decided to stay in Genoa, and within a very short time he had established a reputation there as a sculptor. His most important works in Genoa were

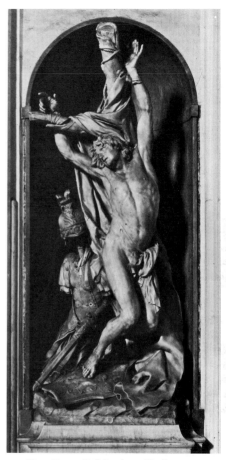

312. Pierre Puget: St Sebastian. 1663-8.
Genoa, S. Maria di Carignano

two statues of St Sebastian [312] and the Blessed Alessandro Sauli, made for the Sauli family to decorate the niches in the crossing piers of S. Maria di Carignano, Genoa.[43] In these works Puget comes nearer than at any other time to the feeling of Roman Baroque sculptors and even to Bernini, particularly to his 'Daniel' in the Chigi Chapel in S. Maria del Popolo which he could have seen if, as seems almost certain, he made a second visit to Rome, probably in

1661-2.[44] However, the differences which exist between the two statues are significant. Bernini's 'Daniel' is more plastic in its conception than Puget's 'Sebastian'. Daniel surges forward in the movement of prayer, right out of the niche; St Sebastian falls in a pose contained by the plane closing the front of the niche. This refusal of the full Baroque three-dimensional movement is typical of Puget and distinguishes his work from that of Bernini.[45]

In 1667 Puget returned to France and apart from an occasional visit to Genoa, and one to Versailles, the rest of his life was spent at Toulon and Marseilles. He was engaged on various tasks, including the decoration of ships and architectural work for both cities.[46] But in spite of difficulties of every kind he continued to produce sculpture.

In 1670 he found in the dockyards at Toulon two blocks of marble which had been abandoned there, and after some difficulty he got Colbert's permission to use them for statues. From them he carved the 'Milo of Crotona' [313] and the relief of 'Alexander and Diogenes' [314].[47]

The 'Milo' is perhaps Puget's most remarkable work [313]. It has the qualities of emotional intensity which were already apparent in the door of the Hôtel de Ville at Toulon and the 'St Sebastian', but in addition it has a concentration and a geometrical regularity which are almost classical. In the 'Milo' Puget invented a truly French Baroque.

The statue is Baroque in its violence of movement, in the sharp twist of the arm and head, in the naturalism of the tree trunk, which indicates that the artist must have known Bernini's 'Apollo and Daphne'. But the movement is so carefully controlled that, seen from the front as it is meant to be seen,[48] the whole statue forms a simple silhouette composed of two sets of parallel axes: the legs and left arm forming one set, and the torso, drapery, and tree trunk forming the other. If this pattern is compared with, say, the 'David' of Bernini, which also depicts

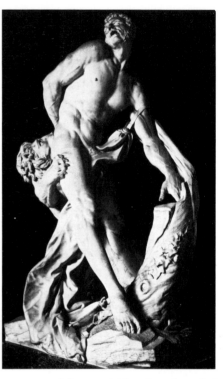

great strain, the difference is evident. In the 'David' there is the maximum of *contrapposto*, so that no straight line or plane survives; in the 'Milo' the whole statue is based on straight lines and planes. And just as the physical strain is concentrated into a rigid and mathematical scheme, so the emotional expression is made to conform to a classical formula. For the head and the mask are based on the 'Laocoon' and have the degree of restraint apparent even in that most Baroque of ancient groups. Again this feature is brought out most clearly by a comparison with the 'David', with its tense lips and down-drawn eyebrows.

The 'Milo' was taken to Versailles by Puget's son, François, and arrived there in 1683. After a moment of doubt it was approved by the King and given a prominent position in the gardens

313 *(opposite)*. Pierre Puget: Milo of Crotona. 1671–82. *Paris, Louvre*

314 *(below)*. Pierre Puget: Alexander and Diogenes. 1671–93. *Paris, Louvre*

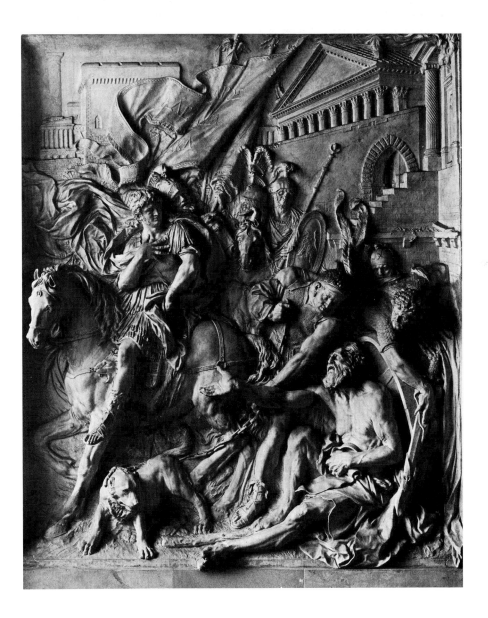

at Versailles. What was almost more important, it was admired by Louvois, and when a few months later Colbert died, Louvois wrote to the artist in the most flattering and encouraging terms. Puget reacted immediately to this display of interest. He continued the 'Alexander and Diogenes' and the 'Perseus and Andromeda', the latter of which was well received at Versailles in 1684;[49] he probably made the 'Triumph of Alexander' at this time,[50] and he planned various other works for Versailles: a colossal 'Apollo' for the canal, an equestrian statue of the King, an 'Apollo and Daphne', an 'Apollo and Marsyas'.[51]

The 'Alexander and Diogenes' [314] is the most important marble relief which came from the hand of Puget.[52] It bears the same relation as the 'Milo' to Roman Baroque. The work with which it most obviously challenges comparison is Algardi's relief of the 'Meeting of Leo I and Attila' in St Peter's. But once again the differences are more striking than the similarities. Whereas Algardi lays the emphasis on movement into depth, Puget keeps everything in a series of planes near the surface of the relief and parallel with it. Algardi breaks into the middle of his composition with a vista leading to an indefinite distance, whereas Puget carefully closes his background with an architectural setting. The movement of Algardi's figures is sinuous and full of *contrapposto*; Puget's figures make a series of straight diagonals across the surface of the marble. In fact he seems to turn back once more to his first master, Pietro da Cortona, and to have translated into high relief the latter's angular, diagonal compositions, such as the 'Bronze Age' and the 'Iron Age' from the Pitti frescoes.[53]

Puget's last years – he died in 1694 – were embittered by renewed failures at Court. The 'Alexander' never reached Versailles; his last work, the relief of 'St Charles Borromeo in the Plague at Milan', was refused by the King; and he had the greatest difficulty in getting payment

for those works which had been accepted. Some part of his failure was due to the intrigues of rivals; but Puget could never have been a successful court artist. With the help of Louvois he was able to come in for a moment on a wave of taste; but when Louvois was gone he could no longer hold his own. The famous and arrogant memorandum, in which he set out to Colbert the terms on which he would work for the King, gives the measure of his discretion as a courtier, for the words *je veux* occur with a frequency and an emphasis unknown at Versailles. His recurrent quarrels with the authorities in the shipyard at Toulon and with the town council of Marseilles confirm that he was headstrong and difficult. In fact he had almost the temperament of a Romantic artist,[54] of which the fine side appears in his enthusiastic letter to Louvois, written at the age of more than sixty in 1683, in which he exposes his plans and which contains the celebrated phrase: 'Je me suis nourri aux grands ouvrages, je nage quand j'y travaille; et le marbre tremble devant moi, pour grosse que soit la pièce'.[55]

We saw in the last chapter that in his work at Versailles under Lebrun and Mansart Coysevox showed a greater tendency towards the Baroque than his collaborators, and in many of his later works, such as the kneeling statue of Louis XIV set up in Notre-Dame in 1715, this tendency persists. In others, notably the 'Duchesse de Bourgogne as Diana' [315], there is a lightness and a delicacy which point towards the Rococo.

But it is in the busts of the later years that the real novelty of Coysevox's style lies. For those of the King and the great dignitaries of the Court Coysevox continued to use the formula which he had evolved as early as 1686 [cf. 299]. But when he came to portray his personal friends he dropped all formality and swagger and replaced them by penetration of character and naturalism of rendering. We find this tendency as early as the 1670s in his busts of Lebrun

[316].[56] Here, beneath the classical drapery, there appears the pleated linen shirt of the day; and in the rendering of the mask itself the sculptor makes no attempt to reduce the features to classical canons.[57] But the last works, such as the bust of Robert de Cotte (1707) [317], are even more revolutionary. This portrait is both more vivid and more intimate than any earlier French sculpture.[58] The bust has been reduced so that there is nothing to distract the eye from the head itself, which is shown in the

action of turning sharply round as if the sitter's attention had suddenly been attracted to his right. Bernini had used this device in a lesser degree to give liveliness and movement to his figures, and Coysevox himself had adopted it in his earlier formal busts. But never before did the gesture have such alertness, never had the twist of the neck and the tilt of the head been so expressive. This seizing of the characteristic movement is supplemented by a minute observation in the rendering of the features, which

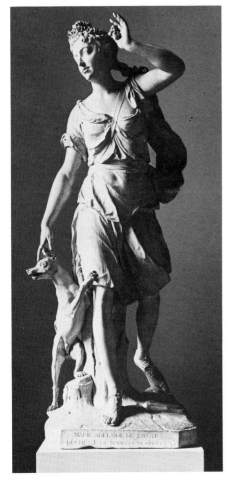

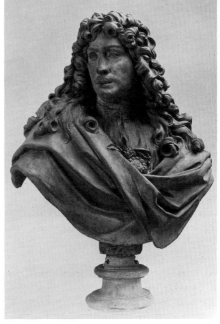

315 *(left)*. Antoine Coysevox:
The Duchesse de Bourgogne. 1710. *Versailles*

316 *(above)*. Antoine Coysevox:
Lebrun. 1676. *London, Wallace Collection*

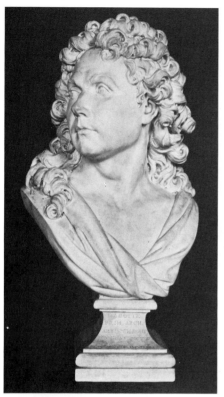

317. Antoine Coysevox: Robert de Cotte. 1707.
Paris, Bibliothèque Ste Geneviève

again convey with great vividness the character of the sitter. In its freshness and spontaneity this bust seems to foreshadow the work of Houdon.

Coysevox's later work is typical of the varied and contradictory tendencies of the period about 1700. His marble groups and busts for Louis XIV are still in the half-classical, half-Baroque convention which he had evolved in the 1680s; for the younger generation at the Court he produced figures which are already *dix-huit-ième*;[59] and for his personal friends, among artists and *bourgeois*, he invented a quite new kind of naturalism.[60]

PAINTING

La Fosse, Jouvenet, Antoine Coypel – The Portrait Painters: François de Troy, Largillierre, and Rigaud – Desportes

The historical complexity of the last decades of the century and the variety of conflicting tendencies in the arts are most clearly visible in the painting of the time. The Baroque invades religious and historical subjects; mythological themes are treated with a freedom from classical rules which eventually turns into a Rococo lightness; portraiture fluctuates between bombastic variations on the methods of Rubens and van Dyck on the one hand and naturalistic experiments in the vein of Rembrandt on the other; landscape is mainly based on the idealization of Claude, but Desportes makes sketches from nature which foreshadow the intimate observation of the English water-colourists.

In the time of Colbert religious painting had taken a quite secondary place, since painters were required above all to celebrate the successes of the King in war and peace. After the middle of the 1680s this situation is reversed. There were fewer victories to celebrate, and the contemporary events which are chosen for record are royal marriages, the reception of ambassadors and other formal incidents of this kind.[61] Generally speaking artists were encouraged by the King to paint allegorical paintings on general rather than topical themes, and the changed attitude of the Court towards religion naturally gave rise to a revival in the painting of altarpieces and decorations for churches. It is typical of the periods before and after 1683 that the representative decorative work of one should be the Galerie des Glaces, and of the other the church of the Invalides.[62]

Of the various artists who were responsible for the transformation of French painting at this time the most original was Charles de la Fosse (1636–1716).[63] He began his training

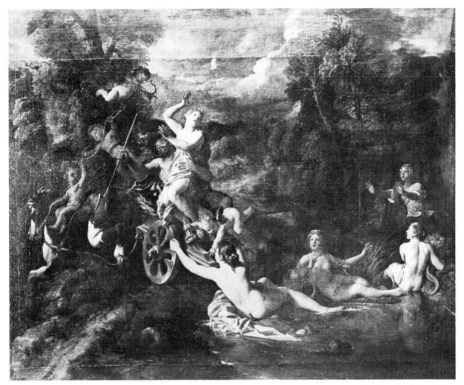

318. Charles de la Fosse: The Rape of Proserpine.
1673. Paris, *École des Beaux-Arts*

under Lebrun, but his evolution was much more deeply affected by his visit to Italy, where he spent the years 1658–60 in Rome and the following three years in Venice, also visiting Modena and Parma. He returned to France armed with a knowledge of the latest Roman manner, that of Pietro da Cortona and his followers, but with a stronger leaning towards north Italian artists, particularly Veronese and Correggio. The results of this training can be seen in his diploma piece, the 'Rape of Proserpine' (1673) [318], in which the landscape is purely Venetian in feeling while the figures show a curious mixture of influences from

Albani and the late Poussin. In the fresco executed in 1676 for the dome of the church of the Assumption, he makes use of Correggio's method of illusion, seen not only through the eyes of Lanfranco but also, to some extent in the figure drawing, of Guido Reni.

During the later 1670s La Fosse was mainly occupied as assistant to Lebrun, first at the Tuileries and then at Versailles, where he was responsible for part of the painted decoration in the Salon de Diane and the whole of that in the Salon d'Apollon. Here his tendencies towards a light and rather free style were held in check by the control of Lebrun, and the panels

which he painted for these rooms are the most classical works which he produced.

In the 1680s, however, his leanings towards the party in favour of colour against drawing, already indicated by his admiration for Venetian

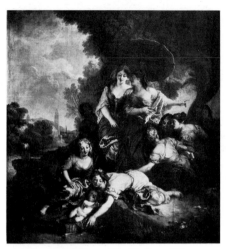

319. Charles de la Fosse: The Finding of Moses. 1675–80. *Paris, Louvre*

painting and Correggio, became stronger, and he suddenly turned to Rubens as a model and an inspiration. The effect of this admiration, no doubt due to the influence of Roger de Piles who was a close friend of La Fosse, is evident in the figures of the 'Sacrifice of Iphigenia' over the mantelpiece of the Salon de Diane at Versailles and in the landscape of the 'Finding of Moses' [319],[64] but it is in the 'Presentation of the Virgin' [320], dated 1682, that the full effects of his new taste appear. This picture is closer to the mature manner of Rubens and more fully Baroque in its conception than anything that had been produced in France up to this date. The pattern is ultimately Venetian and one which had already been imitated in France since the days of Vouet; but it is seen through the

eyes of Rubens, who had invented variants of it which must have been known to La Fosse.[65] Moreover, the types and the swelling draperies are in a spirit unknown in France and directly taken from Rubens.

This sudden irruption of the style of Rubens into French art is somewhat surprising even after the preliminary 'softening up' of de Piles, and it is worth noticing that the 'Presentation' was commissioned by a church in Toulouse and not for either Paris or Versailles. It may be that in this work La Fosse felt free from the trammels of the Academy and therefore able to indulge his enthusiasm for Flemish art to a degree he would not have dared in the metropolis.[66] But the painting was done at the exact moment when Puget was beginning to be accepted at Versailles and when taste at the Court was swinging over towards the Baroque.

In the other two major commissions of his career, La Fosse was only one of a team of artists collaborating on a large scheme of decoration, although he seems to have shown greater invention than his competitors. The first of these was the series of compositions ordered in 1688 by Louis XIV for Trianon. To suit the informal character of this palace the subjects dictated to the artists were chosen from mythology instead of history or allegory, and the style in which they were executed was altogether lighter than anything that had hitherto been usual at the Court. Many of the pictures are now scattered or lost, but a few remain in place and can give us an idea of the conception of the whole. La Fosse's 'Apollo and Thetis' over the mantelpiece of the Chambre du Couchant takes up a theme which had been used in the Grotte de Thétis two decades earlier, but treats it in a much lighter vein. In the Grotto, as we have seen, Girardon made of the story a pure classical group, but La Fosse gives to his nymphs a slender elegance and a rosy flesh-colour which foreshadow Boucher. In fact, this series of paintings, which included also works by Bon and Louis

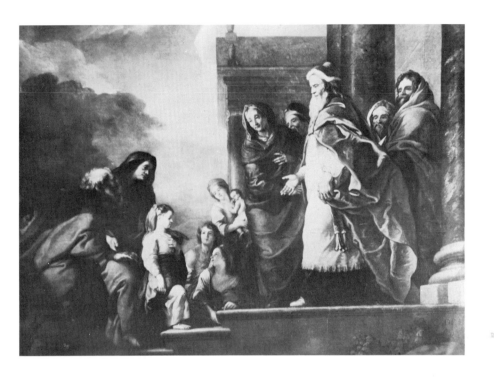

320. Charles de la Fosse: The Presentation of the Virgin. 1682. *Toulouse, Musée des Augustins*

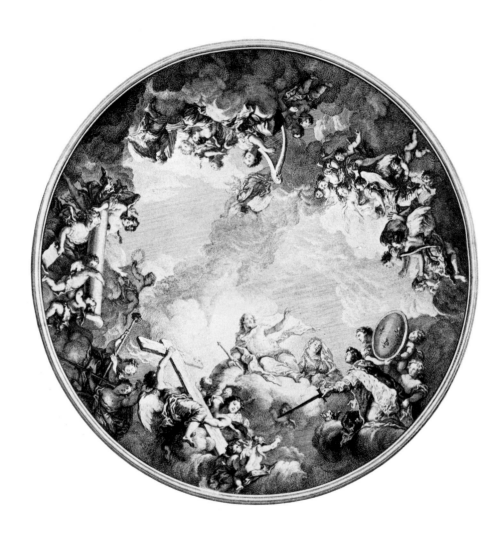

321. Charles de la Fosse: Paris, dome of the Invalides, 1692 (from an engraving)

de Boullogne the Younger, is the first in which something of the lightness of the Rococo can be traced.[67]

But the taste of the King did not long continue to lead him in this direction, and this was the last occasion when any subjects so frivolous were chosen even for the decoration of an informal retreat. The increasing piety of the King and the influence of Madame de Maintenon are more evident in the other great joint commission of the last years of the reign, the decoration of the Invalides.

In 1692 La Fosse, who had been working for the Duke of Montagu in London since 1689,[68] was called back to Paris to undertake the decoration of the church which Mansart had just completed.[69] At first he was commissioned by Mansart to paint the whole building, but gradually other patrons pressed the claims of their favourite artists – Michel Corneille the Younger, Jouvenet, Noël Coypel, Bon and Louis de Boullogne – and the share of La Fosse was reduced to the painting of the outer dome [321] and the four pendentives.

The subject of the dome fresco is 'St Louis presenting to Christ the sword with which he has vanquished the enemies of the Church', a theme which combines Louis XIV's new religious enthusiasm[70] with the veneration for his great ancestor, who is depicted in royal robes and in the likeness of the donor. La Fosse has based his design on Correggio, but he has greatly lightened his model by putting all the figures near the edge of the circle and so leaving the middle of the field for the open sky. In this way he gives a certain Rococo lightness to what is basically a Baroque composition.[71]

In La Fosse are summed up almost all the tendencies of the last decades of the century: interest in Venetian and Flemish colour, a tendency towards Baroque composition, and in his last phase a foreshadowing of the Rococo. And in most cases he seems to have been first in the field with his methods.

Of the artists who collaborated with him at Trianon and the Invalides the most distinguished is Jean Jouvenet.[72] He was born in Rouen in 1644 and joined the studio of Lebrun soon after his removal to Paris in 1661. His decorations in the Salon de Mars at Versailles, dating from 1671–4, are pure imitations of his master, and all his early works seem to have been based on the study of Lebrun and the artists whom he recommended, particularly Poussin, Le Sueur, and the Roman followers of the Carracci. Jouvenet's 'St Bruno in Prayer' [322] illustrates well his relation to Le Sueur.

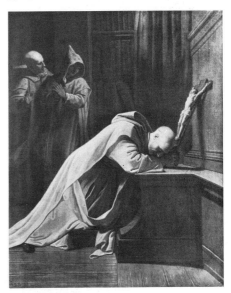

322. Jean Jouvenet: St Bruno.
Lyons, Museum

In type the two figures of the saint are closely similar; but the feeling is different. In Le Sueur's version he kneels in an attitude of *recueillement* before the altar on which are a cross and a skull. In Jouvenet he clutches a crucifix, almost in a swoon. Jouvenet, that is to say, gives to the scene a tone of Baroque emotionalism which Le Sueur has avoided. The pattern is

correspondingly altered. Le Sueur's is static and composed of verticals; Jouvenet's is based on the strong diagonal of the saint's body, crossed by the swaying figures of the two monks in the background.

In his later work the Baroque tendency is even more marked. His most important series of canvases consisted of the four colossal pictures of the 'Miraculous Draught of Fishes' [323], 'The Resurrection of Lazarus', 'Christ driving the Traders out of the Temple', and 'Christ in the House of Simon', painted for St Martin des Champs and put in place in 1706. Most writers attribute the Baroque quality of Jouvenet's later style to the influence of Rubens; but this seems rather wide of the mark. Jouvenet never uses the composition in depth of Rubens, nor does he imitate his types or his Baroque drapery. His manner is rather a free and more lively version of the style which Lebrun had used in his big classical and religious composi-

tions, and is derived ultimately from the late work of Raphael. Jouvenet makes greater use than Lebrun of the Baroque implications in the latter, but his manner is still far from the full Baroque. His relation to it is comparable with that of Puget. His compositions are primarily planned as high reliefs, and the movements are in sharp diagonal straight lines rather than in curves. The drapery is based on the Raphael-esque convention, though it is treated with a greater consideration for deep shadows than was the case with Poussin or even Lebrun. In colour, too, Jouvenet never follows the Flemish manner, but developed a very personal palette, which in his early period combines the cool tones of Lebrun's paintings of the 1650s with a strong ultramarine in many of the draperies, warming later to include coppery reds, but always in unbroken areas, in the tradition of Poussin rather than in a technique deriving from Rubens.

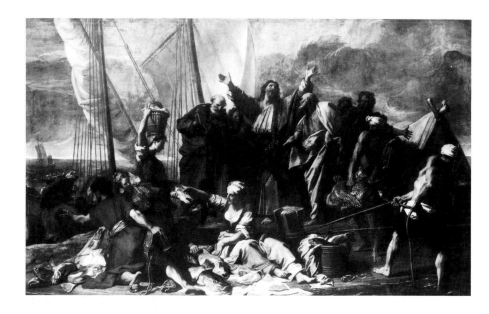

In one respect, however, he differs from most of his rivals in religious painting. There is in his work a strong element of naturalism on which his early biographers comment. In the 'Miraculous Draught', for instance, the piles of dead fish in the foreground are given a prominence and are treated with a relish which would have shocked the Academy in Lebrun's time; and we are told that, in order to paint the picture, Jouvenet made a special journey to Dieppe to study similar scenes on the spot. The same naturalism is to be seen in Jouvenet's choice of types for this picture, in which the apostles are the coarse fishermen which a Caravaggesque might have selected. It is also reflected in his few portraits, of which the most remarkable is that of a doctor, Raymond Finot, a moving study of an old, wrinkled face, and in the unusual 'Mass of the Abbé Delaporte', probably painted in 1709 in honour of the man who paid for the redecoration of the choir of Notre-Dame, in which the figures receiving communion are painted with almost Dutch minuteness.

Jouvenet's relation to the Baroque is therefore somewhat different from that of La Fosse. Whereas the latter's brand of Baroque was essentially taken from Rubens, Jouvenet evolved an indigenous form of the style, based on a blend of French and Raphaelesque elements, to which he added a type of naturalism Flemish in character, but not directly derived from Rubens.[73]

The third important representative of the Baroque in French painting of this period was Antoine Coypel (1661–1722).[74] He was younger than both La Fosse and Jouvenet by half a generation, and comes later into the movement. He was something of an infant prodigy, and at the age of eleven accompanied his father, Noël Coypel, as a student when the latter was appointed director of the French Academy in Rome. After spending three years in Rome,

323 *(opposite)*. Jean Jouvenet: The Miraculous Draught. Before 1706. *Paris, Louvre*

324 *(right)*. Antoine Coypel: Negro with Fruit. *Paris, Louvre*

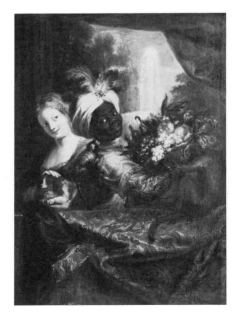

388

where he was commended by Bernini, and one in the north of Italy, where he studied Correggio, the Bolognese, and the Venetians, he returned to Paris in 1676 and was received as a member of the Academy in 1681, giving as his Diploma piece 'Louis XIV resting after the Peace of Nijmegen' [325]. This painting, which has already been referred to as an example of the emptiness of allegorical compositions of this period, is of interest in showing the influence of the later seventeenth-century Bolognese imitators of Albani, partly in the exaggerated sweetness of the expressions and partly in the light and gay colouring, which differs from both the cold classical tones of Poussin and from the

325 *(below)*. Antoine Coypel: The Peace of Nijmegen. 1681. *Montpellier, Musée Fabre*

326 *(opposite)*. Antoine Coypel: Versailles, chapel, ceiling. 1708

warmth of the Venetian key. It is nearer to the gaiety of the Rococo. In others of his early works, however, such as the 'Liberation of St Peter', known from an engraving by Château, he shows a stronger leaning towards the style of Poussin, and it is clear that he began his career with the eclecticism typical of his generation, mixing elements from the classical and the colourist tradition.

Coypel, however, was a close friend of Roger de Piles, and gradually the colourist tendency in him triumphs. By the early 1690s he appears as one of the most wholehearted admirers of Rubens, and his 'Democritus' of 1692 in the Louvre is little more than a pastiche of the master. During the later 1690s he practised a style in which he aimed at combining certain Baroque qualities taken from Rubens with the taste and psychological approach of a Poussin and a Domenichino. The result is the series of vast biblical compositions which were among Coypel's most celebrated works in his own time, but which to us combine the bombast of the Baroque and the pedantry of the classical style without the virtues of either.[75]

At about the same time Coypel was taken up by the Grand Dauphin, by Monsieur (the King's brother), and by his son, the Duc de Chartres, who later succeeded his father as Duc d'Orléans and was Regent during the minority of Louis XV. For the Dauphin Coypel painted at Meudon in about 1700 a series of panels illustrating the story of Cupid and Psyche, in which he did his best to introduce a certain degree of Rococo lightness,[76] but in general he continued to work in a more explicitly Baroque manner.

In 1702 the Duc d'Orléans, who had recently succeeded his father, began extensive alterations to the Palais Royal and commissioned Coypel to decorate the big gallery with scenes illustrating the story of Aeneas. The gallery has been destroyed, but a few of the wall panels and the sketch for the ceiling survive.[77] The former are in Coypel's most bombastic manner, though

with more vitality and less melodrama than in the biblical series; but the ceiling is important as being one of the most completely Baroque schemes to be found in the whole of French art. A huge piece of false perspective architecture opens out in the middle to allow the eye to sweep through to the sky in which the apotheosis of Aeneas is taking place.

Even bolder in the same manner is the ceiling of the chapel of Versailles [326], painted in 1708. It is significant that Roger de Piles disapproved of this work, for in it Coypel turns his back on Rubens and follows a Roman Baroque model, Baciccia's ceiling for the Gesù,[78] with which de Piles would not have been in sympathy. Coypel follows his original closely in the general principles of the design, which depends on the most melodramatic forms of *trompe-l'œil*, and on the creation of the effect that the celestial world is literally bursting through the vault into the chapel itself. Coypel has even extended the *trompe-l'œil* because, whereas in the Gesù the fresco is surrounded with real stucco decoration, at Versailles the architectural setting to the composition is entirely painted, in imitation of real vaulting and relief.

As regards the quality of his work, Antoine Coypel cannot rank high even among artists of his own generation, but his importance historically is considerable, partly as representing a taste which was at first in opposition to that of the King, but which eventually conquered even the Court, at any rate enough to gain for the artist the commission for the ceiling of the chapel. Stylistically he is significant as having produced the two most completely Baroque decorations to be found in French art of this period.

We have already noticed the tendency towards the elegance and lightness of the Rococo in the mythological paintings executed for Trianon in 1688,[79] and the fact that after this date Louis XIV himself could hardly have continued

327. Bon de Boullogne: Hippomenes and Atalanta.
Leningrad, Hermitage

to favour this type of work. He did, however, allow and even encourage it in works not executed for his own use, for instance for the decoration of the Ménagerie, which he ordered to be undertaken in 1699 for the Duchesse de Bourgogne, who had completely won his heart and had brought into the Court of Versailles the only lightness and gaiety to be found there in the King's last years. His comment on the first project shows his aim: 'Il me paroist . . . que les sujets sont trop sérieux . . . il faut qu'il y ait de la jeunesse meslée dans ce que l'on fera'.[80] And it is indeed in the works ordered for the younger members of the royal family that the tradition is carried on.[81]

La Fosse and Antoine Coypel, as we have seen, had a considerable share in the creation of this new style, but other artists such as Bon and Louis de Boullogne the Younger devoted themselves almost exclusively to it.[82] Compositions such as Bon's 'Triumph of Amphitrite' at Tours, probably exhibited in the Salon of 1699, or his 'Hippomenes and Atalanta' in the Hermitage [327] mark the transition between a light Italianism in the manner of the later Bolognese[83] and the full Rococo. It was from this tradition that sprang François Lemoyne (1688–1737), the next link in the chain, and the master of Boucher.

Another artist whose importance has only recently been recognized is Joseph Parrocel (1646–1704). He was famous in his own day as a painter of battle-scenes, but his purely artistic qualities are exceptional. He was trained

328. Joseph Parrocel: St John the Baptist preaching. 1694. *Arras, Museum*

mainly in Venice, where he seems to have studied the works not only of Tintoretto and Veronese, but also of Fetti, Strozzi, and Jan Lys. The 'St John the Baptist preaching' (Museum, Arras) [328], painted as the *Mai* for 1694, shows a vivacity of colour, a brilliance of handling, and a dramatic use of light and shade contrasts which were completely contrary to contemporary French taste and almost foreshadow Delacroix.[84]

A different aspect of the nascent Rococo is to be seen in the work of J. B. Santerre (1651–1717),[85] who was principally known in his own day as a painter of portraits, usually in an allegorical convention, but whose importance historically depends rather on his few religious compositions. In 1709 he painted for the chapel at Versailles a 'St Theresa' which caused a scandal by its almost erotic interpretation of the saint's mystical ecstasy. Very similar is the artist's Diploma piece, the 'Susanna' of 1704, now in the Louvre.[86] This nominally religious painting in fact represents a classical nymph – a devotee of Venus rather than of Diana – in an attitude of provoking coyness, designed for the titillation of the spectator's senses rather than for his edification. Santerre's 'Susanna' foreshadows not only the shepherdesses of Boucher but even more the provocative nudes of Fragonard or Baudouin. Stylistically the 'Susanna' is also interesting in that it marks a revival of Mannerism, which was to be a phenomenon connected with the Rococo in several ways. In this case the return is to Primaticcio, from whom Santerre has taken the delicate, elongated forms of his nude, and the studied affectation of the pose.

Like religious and mythological painting, portraiture enjoyed a considerable success during the last years of the century. During the glorious decades of 1660–80 few painters had devoted themselves exclusively to this genre, which was considered of secondary importance.

The great personages of the time liked if possible to be shown in action, for instance as the victorious general, or at least surrounded by appropriate and allegorical embellishments. The straightforward naturalistic portrait, in which Champaigne excelled, had almost disappeared, except in the hands of Mignard, and even his portraits, though not always allegorical, have usually an element of flattery which takes them out of the category of naturalism.

But after about 1685 several important artists appear who specialized in portraiture and who created a new fashion in this field. The essential novelty of their style is the introduction of the technique and patterns of the Flemish school, particularly of van Dyck. We have already had occasion to notice that Philippe de Champaigne learnt from Rubens and van Dyck; but he radically transformed what he borrowed, stamping it with the mark of his own austere and classical personality. The generation of the end of the century tried, on the contrary, to imitate the very qualities in van Dyck which Champaigne avoided, the Baroque sweep of the draperies and his mixture of impressiveness and intimacy.

The oldest but the least talented of the portrait-painters whom we have to consider was François de Troy (1645–1730), father of the more celebrated Jean François.[87] Some of his portraits, such as that of the lute-player Charles Mouton of 1690 in the Louvre,[88] suggest an awareness of Italian seventeenth-century portraiture, but his more typical portraits of women show him as an imitator of the free movement and the loosely painted drapery of the Flemish tradition [329].[89]

François de Troy was, however, soon outshone by the two more brilliant portrait painters of the same generation, Nicolas de Largillierre (1656–1746)[90] and Hyacinthe Rigaud (1659–1743). Many of the works by these two artists belong in spirit and in date to the eighteenth

394

Private collection

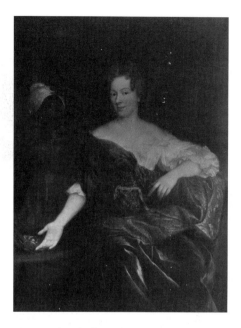

century, but both made important contributions to the development of French painting well before 1700, and they must be considered as helping to create the transition from one century to the other. Both contributed to the elimination of the style of the Grand Siècle, both belonged to the party of Colour; but in certain other respects they are sharply opposed: in their *clientèle*, their naturalism, and in their relation to the painting of the Netherlands.

Largillierre's early life and training were exceptional.[91] He was born in Paris, but his parents moved to Antwerp when he was a child. At an early age he entered the studio of Antoine Goubaud, a painter of still-life and peasant scenes, and in 1672 was received Master in the guild of Antwerp. Soon afterwards he moved to London,[92] where he was encouraged by Lely, for whom he probably worked from about 1674

to 1680. His particular job was the painting of drapery and of still-life accessories, and no doubt many of the elaborate vases of flowers in the backgrounds of Lely's late portraits are from his hand.[93] In 1682 Largillierre settled in Paris, where he remained for the rest of his life, except for a short visit to England in 1685 to paint the portraits of James II and Mary of Modena. Either on this occasion or before his return to France in 1682 he also painted two portraits of members of the Warner family. All these portraits are lost but are known from engravings,[94] which prove that Largillierre had absorbed the style of Lely in his last years, and was not entirely unaffected by other artists working in England, such as Soest, Wissing, and the early Kneller.

That is to say, Largillierre started his career in France with the particular variation of the idiom of the Netherlands which was current in England about 1680, and during the first twenty years after his transfer to Paris we find him adapting it to suit the taste of his country. In some portraits, such as those of three members of the Lambert family,[95] he applies the English convention directly, but in most cases he combines elements from it with other devices. For instance, in the portrait of a tutor and his pupil [330], dated 1685, the angular draperies of the pupil and the schematic drawing of his face belong to the English convention, whereas the head of the tutor is in a quite different vein of naturalism, suggesting rather a knowledge of Dutch painting. The pattern itself, with the two figures cut off at three-quarter-length, is a formula derived from van Dyck and much favoured by his English followers. But the affectation of the boy's pose and the unexpected placing of the dog in the foreground, facing into the composition, distinguish the painting from English models.

In 1684 Largillierre was received into the Academy, and in 1686 he submitted as his Diploma work the portrait of Lebrun, now in the

330. Nicolas de Largillierre: Tutor and Pupil. 1685. *Washington, National Gallery*

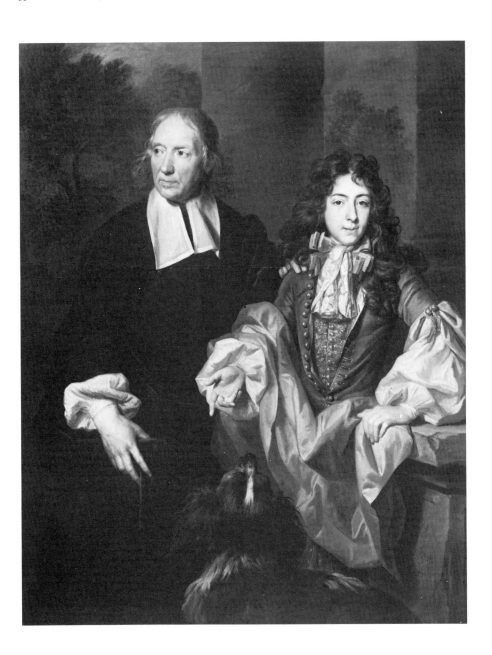

Louvre [331]. In this work he applies his Flemish methods to producing what is one of the most typical portraits of the Grand Siècle. He creates a new genre, the state-portrait of an artist. Up till this time artists had usually painted themselves without any particular setting or apparatus. Some Flemish and Dutch painters are shown at work in their studio, surrounded by the actual furnishings of the place. Poussin had created a unique classical model with a background of mainly blank canvases, a sort of abstraction of a studio. Largillierre depicts Lebrun surrounded not by the actual appurtenances of a studio, but by objects symbolical of his achievement – the classical casts on which he based his style, the sketches for or engravings after his most celebrated works – just as in a royal portrait the King is shown with the attributes of the Monarchy. This is indeed the true portrait of the dictator-artist, appropriate to the régime of Colbert; but it is paradoxical that the spirit of the time should have been so richly presented by an artist who, as

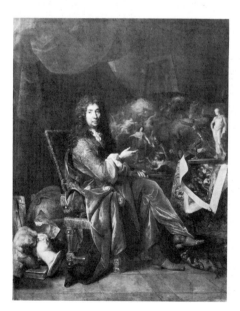

much as anyone, was to help to replace it by a freer and more individual type of painting.

By the end of the 1680s Largillierre had established a considerable reputation among the richer *bourgeois* of Paris from whom he had received regular orders for portraits; but in 1687 he received a new type of commission, for one of the portrait-groups which the City of Paris caused to be executed to commemorate certain solemn occasions. In this case the theme was the banquet given by the Échevins to the King when he made his first formal visit to the Hôtel de Ville, as a gesture of forgiveness to the city for their part in the Fronde. The painting was destroyed at the Revolution, but is known from several sketches.[96] Largillierre shows the Échevins seated in front of a table deliberating on the statue of the King to be erected at the Hôtel de Ville to celebrate their pardon. In the middle of the table is a bust of Louis, and on the wall behind hangs a vast canvas of the banquet itself. The whole is a Baroque version of the Dutch corporation group, with the naturalism and psychological insight of the latter abandoned in favour of freedom in gesture and movement and dramatic effect in grouping.

Nine years later, in 1696, Largillierre executed a second commission of the same kind of which the finished picture happily survives [332]. It was ordered by the city for the church of Ste Geneviève to commemorate the intervention of the patron saint to end a drought in 1694. In this composition the artist has combined northern and southern methods. In the poses and draperies of the lower figures Largillierre follows the portrait convention with

331 *(left)*. Nicolas de Largillierre: Charles Lebrun. 1686. *Paris, Louvre*

332 *(opposite)*. Nicolas de Largillierre: The Échevins of the City of Paris before Ste Geneviève. 1696. *Paris, St Étienne-du-Mont*

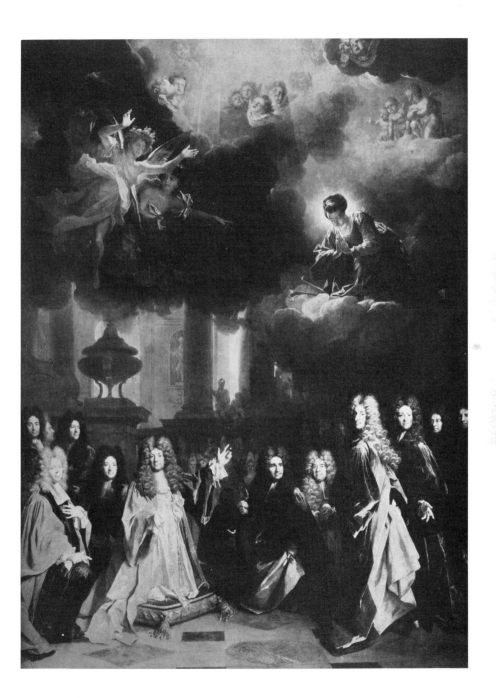

which he had already scored such success; but in its general conception the composition is an adaptation of a much-used formula for Baroque altarpieces in which saints are replaced by the Échevins and the Virgin by Ste Geneviève. In this painting portraiture is blended with religious art, in a whole which is one of the most completely Baroque works of the period. Largillierre achieves what Antoine Coypel attempts with such moderate success in the chapel ceiling and here the heavenly world bursts wonderfully and effectively into the real world, streaming down on the Échevins who might well be kneeling in the setting of Mansart's chapel. In this painting Largillierre looks not only back to Barocci but forward to Tiepolo.[97]

The contrast between this composition and Philippe de Champaigne's Échevin group of 1648 [212] gives the measure of the change in spirit between the two periods. The earlier group is still archaic both in its pattern and in its severe draperies, and it expresses the traditional dignity of the city fathers; in the later version we feel the ostentation of a bourgeoisie no longer independent in its power or its thought but tied to the Court and aping its manners. To such patrons the brilliant Baroque rhetoric and the rich Flemish colouring of Largillierre's composition would appeal instantly.[98]

Although Largillierre's importance depends primarily on his portraits and groups, he also painted religious pictures, though mainly for his own pleasure rather than on commission. Two such paintings, the 'Entry into Jerusalem' (Arras) and the 'Elevation of the Cross' (Private Collection, Genoa), show the influence of both Rubens and Rembrandt.[99]

Rigaud scored his success in a different field and by different means.[100] He was born in Perpignan in 1659 and his artistic training was begun in the south. In 1674 he went to Montpellier, where he studied under the little-known artists Paul Pezet and Antoine Ranc, and later moved to Lyons with Henri Verdier, a fellow-

pupil in the studio of Ranc. We can form little idea of the style which he would have learnt in this way, but we may suppose that it was rather more Baroque than the official manner practised in Paris at the same time.

In 1681 he reached the capital, and for a few years seems to have devoted himself to painting portraits of other artists and members of the bourgeoisie in a manner close to that of François de Troy.[101] But a new field was opened for him by receiving in 1688 a commission to paint the portrait of Monsieur, the King's brother, and in the next year another for that of his son, the Duc de Chartres.[102]

From this time onwards Rigaud dropped his Parisian clients and became almost exclusively a court painter. His sitters in the 1690s and the first year or two of the eighteenth century included most members of the royal family, the great generals (Luxembourg, Villeroy, Vauban), visiting Princes (the Crown Prince of Denmark, the Count Palatine Christian of Zweibrücken), diplomats (Lord Portland, his son, and Matthew Prior and the Polish diplomat Jan Andrzej Morsztyn, known in France as the Comte de Morstin),[103] and more or less everyone of distinction at Versailles.[104]

For this clientèle Rigaud naturally evolved a formula different from that invented by Largillierre for his aldermen and financiers. His patterns are usually based on van Dyck, but he combines with this manner certain features taken from the French tradition, and he gives to the resultant mixture a clearly aristocratic elegance which contrasts with the rather bourgeois bombast of Largillierre.

Perhaps his most typical works are his military portraits [cf. 333]. For these his regular formula is to present the figure in modern armour in three-quarter- or full-length, against a landscape background which usually shows a battle in progress.[105] This is quite different from the convention of the previous generation, when generals preferred to be shown in the dress and

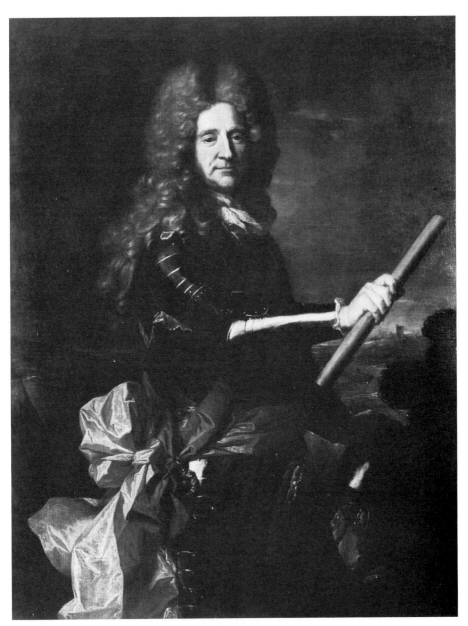

333. Hyacinthe Rigaud: The First Earl of Portland. 1698-9.
Welbeck Abbey, Nottinghamshire, The Duke of Portland

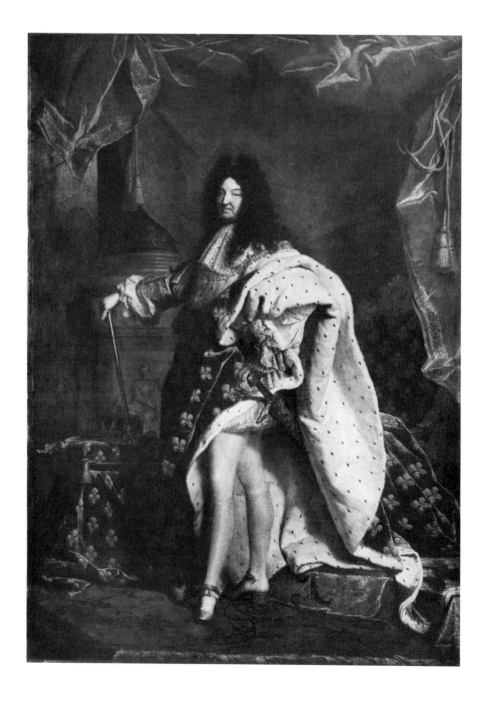

334. Hyacinthe Rigaud: Louis XIV. 1701.
Paris, Louvre

action of a Roman Imperator. Rigaud's por-
traits depend on van Dyck, but in the intro-
duction of the battle scene in the background he
is following a tradition already familiar in
France, for instance in the portraits of Philippe
de Champaigne.[106] Stylistically, too, he com-
bines features from these two sources; for
though the brilliance of the armour painting
and the richness of the floating draperies make
us think of van Dyck, there is in the poses and
gestures a certain stiffness foreign to him and
more akin to the archaism of Champaigne.[107]

The same fusion is to be seen in Rigaud's
state portraits, of which the best known is that
of Louis XIV painted in 1701 [334], the most
Baroque representation of a King of France up
to this time. The general conception follows
the Baroque convention with column and dra-
peries as a background; the figure has a fully
Baroque swagger and *contrapposto;* and the
ermine cloak, thrown nonchalantly back, cuts
through the space in a complexity of Baroque
curves. But there are qualifications to this aban-
don. The pose has affinities with van Dyck's

'Charles I Hunting' in the Louvre; but it is at
least as like Champaigne's 'Louis XIII in
Armour'. Though the cloak swirls about, it does
so in folds which are modelled with a linear
sharpness again nearer to Champaigne than to
van Dyck. The colour is strong and owes much
to the lessons of the Flemings, but it is applied
with a coldness of touch which would have
pleased the followers of Lebrun. In short,
Rigaud has produced a Baroque version of the
French state portrait, combining the severity of
the old tradition with something of the liveliness
of the new, and adding, incidentally, a point of
elegance and affectation - notice the ballet pose
of the feet - which is specifically French and
reminds us that we are on the threshold of the
eighteenth century.[108]

There is, however, in the art of Rigaud as it
was developed by the end of the seventeenth
century the same kind of division which we
noticed in the sculpture of Coysevox. For paral-
lel with the series of Baroque portraits the
artist also produced others of a much more
intimate and naturalistic type. This other style

335. Hyacinthe Rigaud: The Artist's Mother. 1695.
Paris, Louvre

appears to some degree in his family groups, such as that of the printer, Pierre Frédéric Léonard, with his wife and daughter,[109] in which, although the draperies are still Baroque, the figures are painted with a much closer observation of character than is usual in Rigaud's formal portraits. But the new tendency is most clearly apparent in the famous double portrait of his mother, painted in 1695 for the marble bust which the artist commissioned from Coysevox [335]. In this strikingly observed portrait there are echoes of van Dyck and Champaigne, if only in the placing of the two heads on a single canvas; but the real source is a different and a

new one. The whole conception of the portrait, the attention with which the wrinkles of the skin are painted, the meticulous handling of the cap, and the dry painting of the white bodice, all combine to prove that Rigaud was here taking as his model Rembrandt's early portraits of his mother. We know that he admired Rembrandt, since the inventory of his pictures, taken at the time of his wedding in 1703, includes seven paintings by the master and two copies by Rigaud after him.[110] In the eighteenth century the art of Rembrandt was to have a wide success in France, but Rigaud was the first French artist since Vignon to study his works, and the first

without exception to find in him an inspiration towards naturalism and psychological subtlety. It is typical of the contradictions of the period that the same artist should have produced on the one hand some of the most Baroque formal full-lengths and, on the other, the first in a long line of intimate portraits which was to be carried on throughout the eighteenth and even into the nineteenth century.

The naturalism which was latent in so many branches of art in the last decades of the seventeenth century attained its most striking and revolutionary manifestation in the field of land-

painter of animals. After the death of his master Desportes studied at the Academy and for a time seemed to be settling down to a career as a portrait painter, in which capacity he spent the years 1695-6 at the Court of Poland. On his return to Paris he began to devote his attention to the painting of animals, in the form either of hunting-scenes or of still-life compositions with dead game. It was for these works that he was celebrated in his own day, and they were bought by all the most important patrons of the day, headed by Louis XIV, who commissioned hunting-scenes, portraits of his favourite dogs,

336. François Desportes: Landscape.
Château of Compiègne

scape. It did not, however, have a monopoly here any more than in the other genres of painting, and the ideal landscape of Claude was continued by painters such as Étienne Allegrain (1644-1736) and the younger Pierre Patel (1648-1707), who added to it a new type of artificiality almost eighteenth-century in character.

But one artist, François Desportes (1661-1740), breaks entirely new ground. Desportes was the son of a peasant and was born in Champagne. At the age of twelve he was sent by his father to Paris and entered the studio of Nicasius Bernaerts (1620-78), a Fleming and a pupil of Snyders who enjoyed considerable success as a

and pictures of rare animals for Marly and the Ménagerie at Versailles.

But as a preparation for the landscape backgrounds of his hunting scenes Desportes made a series of studies [336] in oil on paper, which reveal an entirely novel approach to nature. They are direct notes of views which he saw in the neighbourhood of Paris and in the Seine valley, put down with sensitiveness and humility, with no desire to improve the actual scene so as to make it fit in with a preconceived idea either of what nature should be or of how a composition should be constructed. In some cases the designs are simple, in others they have unex-

pected features, such as the intrusion of a reed or a tree-trunk into the very foreground, which almost recall the conscious snapshot effects of the Impressionists. In colour they are subdued, painted in the quiet light of the Île-de-France, which no one else rendered so faithfully till the time of Corot.[111]

Desportes' nephew gives the following account of his uncle's method, startling in the late seventeenth century when artists never thought of actually painting in the open air in front of the scene itself:[112] 'He used to take out into the country his brushes and his palette ready loaded with colours, in zinc boxes; he had a walking-stick with a long steel point, which held it firm when stuck in the ground, and on the handle, which opened, there hinged with a screw a little easel of the same metal, to which he fixed the drawing-board and paper. He never visited his friends in the country without carrying this little bundle; with it he was never bored and he never failed to make good use of it.'

Desportes lived till 1743, and many of his works belong to the eighteenth century in character, but these landscape sketches seem to date largely from the years 1690 to 1706. In spirit they look forward beyond the eighteenth century to the methods of the English water-colourists and of the Barbizon school.[113]

POSTSCRIPT

The Transition to the Eighteenth Century

It would be foolish to try in a concluding section to look back over the whole period dealt with in this book and to summarize the already too short and simplified account which has been given of the movements in French art through two hundred years. But it may be worth while to add a word about the transition to the next century.

In the preceding chapters attention has been drawn to various tendencies in artists who were already mature before 1700 which lead on to the Rococo. But about the turn of the century a younger generation sprang up which prepared the way for the next stage even more clearly. In the year 1699 the Academy revived the habit of holding exhibitions of works by its members, which had lapsed since 1683. Five years later, in 1704, the experiment was repeated, and from the catalogues of these two Salons we can learn much about the new atmosphere in painting. The Salon of 1699 contained works in the traditional academic manner, others by the representatives of the Baroque movement, and yet others in the lighter mythological style of the Boullognes. But in 1704 a new tone appears. For the first time the exhibition included playful genre-paintings in the style of the small Dutch masters. This tendency was in a sense an extension of the naturalism which we have seen latent in several artists of the older generation; but it catered for a new *bourgeois* taste for small and intimate works, suitable for the informal rooms of the early eighteenth century rather than for the great galleries of the seventeenth.[114]

At the same time, but outside the Academy, Claude Gillot (1673-1722) was evolving a more fantastic style, and in his scenes from the Italian Comedy was reviving the spirit of Callot, which had been dormant for several generations.

From these ingredients the new style was to be born. The colour of Rubens, the light-heartedness of La Fosse, the naturalistic observation of the followers of the Dutch school, the fancy of Gillot – these were the elements from which the early Rococo was to be made up. It needed only the genius of Watteau to bring them all together into a new synthesis; or rather it needed the genius of Watteau and the care and support of his sensitive Parisian friends, Julienne and Crozat. For it must never be forgotten that Watteau was essentially a product of Parisian society, which in him, as fully as in Voltaire, asserted once again its independence of the Court of Versailles and its determination to follow its own way.

NOTES

Bold numbers indicate page reference

Most of the abbreviated titles used in the notes are, it is hoped, sufficiently clear to guide the reader to the relevant entry in the bibliography. But the following need explanation:

B.S.H.A.F.: *Bulletin de la société de l'histoire de l'art français*
G.B.A.: *Gazette des Beaux-Arts*
J.W.C.I.: *Journal of the Warburg and Courtauld Institutes*
R.D.: Robert-Dumesnil, A. *Le Peintre-graveur français*. Paris, 1835-71.
Grand Marot: Marot, J. *L'Architecture Françoise*. Paris, *c.* 1670.
Petit Marot: Marot, J. *Recueil des plans, profils et élévations de plusieurs palais, chasteaux, églises, sépultures, grotes et hostels bâtis dans Paris*. Paris, *c.* 1660-70.

PREFACE

11. 1. *Mannerism* (Penguin Books, 1967).
2. *Baroque and Rococo Architecture and Decoration* (Elek, 1978).
3. To these writers – and indeed to the whole period – the word 'Baroque' was applied, though the works in question come much nearer to what art-historians would call Mannerist.

CHAPTER I

14. 1. See J. Wilde, 'The Hall of the Great Council of Florence,' *J.W.C.I.*, VII (1944), 76.
15. 2. Cf. John White, *The Birth and Rebirth of Pictorial Space* (London, 1957), 225. Fouquet's followers continued the tradition of using an Italian idiom and transmitted it to miniaturists like Bourdichon (see pp. 45-6), who incorporated it in a wider scheme of Italianization.
3. He was also responsible for the altar now in St Didier, Avignon.
16. 4. All these examples are illustrated in Henry Martin, André Blum, and others, *Le Livre français des origines à la fin du Second Empire* (Paris, 1923).

Italian decorative motifs were also transmitted through German engravings, including those after Dürer and Holbein (cf. E. Billeter-Schulze, *Zum Einfluss der Graphik von Dürer und Holbein in der französischen Kunst des 16. Jahrhunderts* (dissertation) (Basel, 1964).
17. 5. The activities of this group have been conveniently summarized by Maria Luisa Polidori, *Monumenti e mecenati francesi in Roma* (Viterbo, 1969).
6. E. Chirol, *Le Château de Gaillon* (Paris, 1952), 31 ff.
7. S. Luigi was designed by a French architect, Jean de Chènevière (cf. J. Lesellier, 'Jean de Chènevières', *Mélanges d'archéologie et d'histoire*, XLVIII (1931), 233.
8. See below, p. 61.
18. 9. Reproduced in Hautecœur, *Architecture*, I, 95. The frame of the Sepulchre bears the date 1496, but as Pradel (*Michel Colombe*, 32) points out, the arms indicate that the monument must have been begun before 1495. For a discussion of Solesmes see Tonnellier, 'Les Broderies à alphabet et la mise au tombeau de Solesmes', *Bulletin Monumental*, CXX (1962), 37, and CXXI (1963), 21.
10. Cf. P. Vitry, *Michel Colombe*, 276.
11. For the screen in Limoges Cathedral, built between 1533 and 1537, see A. Cloulas-Brousseau, 'Le Jubé de la cathédrale de Limoges', *Bulletin de la Société archéologique et historique du Limousin*, XC (1963), 101.
12. See below, Note 46.
13. Cf. E. Chirol, *Le Château de Gaillon* (Paris, 1952).
14. Cf. M. Dumolin, *Le Château d'Oiron* (Paris, 1931), 12.
15. P. de Cossé Brissac, *Châteaux de France disparus*, 28 ff. Fragments of the sculptured decoration survive in the museum of Poitiers (cf. P. Vitry and G. Brière, *Documents de sculpture française*, plates 30 and 31).
19. 16. Screens similar in form are to be found in S. Petronio, Bologna. The fantastic and endlessly varied columns recall the Cappella Colleoni at Bergamo, and the openwork panels above derive directly from the sacristy of S. Maria presso S. Satiro at Milan by Bramante and ultimately from Donatello's panels in the old sacristy of S. Lorenzo. This is one of the few imitations of Bramante's work to be found in France.

For Viscardi see H. W. Kraft, 'Gerolamo Viscardi, ein genuesischer Bildhauer der Renaissance', *Mitteilungen des Kunsthistorisches Instituts in Florenz*, xv (1971), 273.

A screen similar in type to those closing the chapels at Fécamp but more mature in its imitation of Italian models and perhaps slightly later is to be found in the abbey church of Moissac. Here, however, it runs round the *pourtour* of the choir and leads up to a very unusual projecting aedicule which contains the high altar and also a second altar above it, presumably to house a relic.

20. 17. For a full account of the tomb and the chapel in which it stands see G. Durand, 'Les Lannoy, Folleville et l'art italien dans le nord de la France', *Bulletin Monumental*, LXX (1906), 329. For Tamagnino, see H. W. Kruft, 'Antonio della Porta, gen. Tamagnino', *Pantheon*, XXVIII (1970), 401.

18. Reproduced in Hautecœur, *Architecture*, I, 89. Thomas James was one of the few French patrons of his day to draw inspiration from central Italy rather than from Lombardy. He was for many years governor of the Castel S. Angelo and continued to live in Rome even after his appointment to the See of Léon in 1478 and his translation to that of Dol in 1482 (cf. A. Rhein, *La Cathédrale de Dol* (Caen, 1911), 57). In 1483 he commissioned from the Florentine artist Altavante a superb illuminated missal, now in the municipal library at Lyons (cf. V. Leroquais, *Les Sacrementaires et les missels manuscrits des bibliothèques publiques de France* (Paris, 1924), III, 223, and plates cii ff.).

23. 19. The apse of St Pierre was widely imitated, for instance, at St Sauveur at Caen (1546). Hautecœur (*Architecture*, I, 160) gives a full list of such imitations. The type of pendentive used in the ambulatory is to be found in many churches in Normandy, e.g. Le Grand Andely, Verneuil-sur-Avre, Tillières-sur-Avre.

20. For a full account of Gaillon see E. Chirol, *Le Château de Gaillon* (Paris, 1952). Additional information about the decorative sculpture is given by M. G. La Coste-Messelière, 'Les Médaillons historiques de Gaillon', *Revue des Arts*, VII (1957), 6. Early records of the appearance of the château are given by M. Rosci and A. Chastel, 'Un Château français en Italie. Un portrait de Gaillon à Gaglianico', *Art de France*, III (1963), 103, and by M. Beaulieu, *Sculptures du Musée du Louvre*, II, *La Renaissance française*, 46.

21. Chirol (*op. cit.*, 60) relates this contract to another fountain for the gardens, but the style of the fountain here illustrated points conclusively to Gaggini as its author.

22. For a full account of Pacherot see P. Lesueur,

'Remarques sur Jérôme Pacherot, et sur le château de Gaillon', *B.S.H.A.F.* (1937), 67.

23. A portrait of the Cardinal's brother Charles in the Louvre is traditionally attributed to Solario, though the attribution has been challenged.

25. 24. Reproduced in G. Huard, *L'Art en Normandie* (Paris, 1928), figure 251. The interior of Gaillon is described in the earliest account of the château, written in 1510 by Jacopo Probo d'Atri (cf. R. Weiss, 'The Castle of Gaillon in 1509-10', *J.W.C.I.*, XVI (1953), 351).

27. 25. The best account of Blois is in F. and P. Lesueur, *Le Château de Blois* (Paris, 1914), 21.

30. 26. Cf. p. 208

27. A more regular version of the repeated *logge* motive occurs in the court of the château of La Rochefoucauld, probably built between 1525 and 1533 (cf. Gébelin, *Les Châteaux de la Renaissance*, 125).

28. Letter of 3 September 1633: cf. *Œuvres de J. de La Fontaine*, IX (Paris, 1892), 244.

31. 29. L. H. Heydenreich (*Leonardo da Vinci* (London, 1954), 83, and 'Leonardo da Vinci, Architect of Francis I', *Burl Mag.*, XCIV (1952), 277), following Reymond ('Léonard de Vinci architecte du château de Chambord', *G.B.A.* (1923), I, 337), maintains that Leonardo was responsible for the conception of Chambord, but the arguments in favour of this view are not quite conclusive. On the other hand, it is certain that Leonardo designed the château which Francis I intended to build for his mother at Romorantin, for which drawings survive. See Heydenreich, *loc. cit.*, and the article by C. Baroni, *Leonardo as Architect*, in the commemorative catalogue of the Leonardo exhibition in Milan, 1939 (German edition, 239 ff.). Baroni also reproduces drawings for a double spiral staircase which may be connected with Chambord.

The share of Leonardo in both projects has recently been re-examined and emphasized by J. Guillaume, 'Léonard de Vinci et l'architecture française', *Revue de l'Art*, XXV (1974), 71. For good plates of Chambord see P. Gasseux, *Chambord* (Zürich, 1962).

30. Full details about the dates at which different parts of the château were built are given by L. Lesueur, 'Les dernières étapes de la construction de Chambord', *Bulletin Monumental*, CIX (1951), 7.

31. The nearest parallel is Vincennes.

32. Félibien's drawings are reproduced and the whole problem of Chambord is fully discussed in P. Lesueur, *Dominique de Cortone dit Le Boccador*, chapter 4. Domenico seems to have been active for the greater part of his career in France as a wood-carver rather than as an architect, and the only other

building which he is known to have designed is the Hôtel de Ville in Paris (1532), but here again his plans were altered in the course of execution.

32. 33. Reproduced in Heydenreich and Lotz, *Architecture in Italy 1400-1600* (Harmondsworth, 1974), 134, figure 42.

34. 34. A close imitation of the Orléans town hall was erected more than two decades later (1525) at Beaugency.

35. 35. Illustrated in Martin and Enlart, *La Renaissance en France*, 11, plates 47-57.

36. The old quarter round the cathedral of St Jean in Lyons has been largely restored and many of the original arched openings to shops and doors have been discovered behind the nineteenth-century shopfronts. This quarter probably now gives a more complete idea of an early-sixteenth-century French town than any other surviving. One house, 16 rue du Bœuf, has in its courtyard a circular spiral staircase very similar to that in the Palazzo Minelli, Venice.

37. Even certain much smaller towns have groups of fine sixteenth-century houses, cf. Y. Thiéry, 'Hôtels et maisons de la Renaissance à Riom', *Bulletin Monumental*, XCIII (1935), 63, and Maubourguet, *Sarlat et ses châteaux* (Périgueux, 1970).

38. Cf. J. Laran, *La Cathédrale d'Albi* (Paris, 1931), 61 ff. The sculpture can be dated between 1499 and 1502; the fresco of the 'Last Judgement' on the west wall was probably executed by French artists about 1500, and those in the chapels and on the vault bear dates between 1509 and 1514. They also bear various signatures, none of which can be clearly interpreted but which point to artists coming from the area round Bologna.

36. 39. See René Brimo, 'Le Château et l'église d'Assier', *Bulletin des Musées de France*, no. 8 (1932).

40. For instance, the sculpture of Solesmes and the work deriving from it (cf. P. Vitry, *Michel Colombe*, chapter 8). For eastern France, cf. H. David, *De Sluter à Sambin, La Renaissance*.

41. An important example is the tomb of Charles IV of Anjou (d. 1473) in Le Mans Cathedral, probably a product of the studio of Antonio Rossellino.

37. 42. One of the artists who collaborated in this tomb, Gerolamo Viscardi, also received the commission for the marble sarcophagus and figures in the abbey church at Fécamp (cf. p. 19).

43. Cf. A. Venturi, *Storia*, VI, 768 ff., and A. Petorelli, *Guido Mazzoni da Modena* (Turin, 1925).

44. Reproduced in P. Vitry, *Michel Colombe*, 183.

45. Reproduced in P. Vitry, *op. cit.*, 169.

46. For instance S. Zaccaria, Venice (cf. Venturi, *Storia*, VI, figure 306). The statues and decorative

panels from the chapel of Philippe de Commines in the church of the Grands-Augustins, Paris, now in the Louvre, have also been attributed to Mazzoni (cf. M. Beaulieu, *La Sculpture du Musée du Louvre*, 11, *La Renaissance française*, 114).

47. Cf. Montaiglon, 'La Famille des Juste en France', *G.B.A.* (1875), 2nd period, XII, 401.

38. 48. Erected in 1493-7 by Giovanni Cristoforo Romano. The sarcophagus was only inserted in the sixteenth century. Another possible Milanese source may be found in the designs of Agostino Busti (Il Bambaja) for tombs, including that of Gaston de Foix which would certainly have been known in France.

39. 49. Pradel (*Michel Colombe*, 85 ff.) believes the *gisants* to be definitely French and attributes them as well as the kneeling figures to the atelier of Guillaume Regnault. He tentatively revives the theory that the conception of the whole monument may be due to Perréal.

40. 50. Other examples are the two statues of saints by Gerolamo Viscardi at Fécamp, which also betray the influence of Andrea Sansovino.

41. 51. Of the plans of Perréal and Colombe for the tombs of Brou we know virtually nothing, for there is every reason to think that no part of them was incorporated in the scheme as finally executed by the Flemish sculptors called in by Margaret of Savoy after she had dismissed the French sculptors.

52. Several of these reliefs are reproduced in the *Burl. Mag.*, XVIII (1911), 325 ff. The Gaggini family were closely connected with France, and one member of it at least, Pace, came to the country. It is therefore quite possible that Colombe would have known one of the Genoese prototypes. One of them, indeed, existed on the fountain at Gaillon, sent from Genoa in 1508.

42. 53. It seems to combine features of different Florentine models: Desiderio's Marsuppini tomb, Verrocchio's sarcophagus for Giovanni and Piero de' Medici in S. Lorenzo, and Antonio Pollaiuolo's bronze tomb of Sixtus IV.

54. Cf. Collignon, *La Statuaire funéraire dans l'art grec* (Paris, 1911), 344 f.

55. For a full discussion of this tomb see G. Lanfry, E. Chirol, and J. Bailly, *Le Tombeau des Cardinaux d'Amboise* (Rouen, 1959).

56. The whole group is studied by W. H. Forsyth, *The Entombment of Christ. French Sculptures of the Fifteenth and Sixteenth Centuries* (Cambridge, Mass., 1970). For the Maître de Chaource see Dom Éloi Devaux, *Le Maître de Chaource* (Paris, n.d.).

44. 57. Michel Laclotte has established the existence

of such a school in Burgundy, mainly active between 1515 and 1530 (cf. 'Quelques tableaux bourguignons du XVI^e siècle', *Studies in Renaissance and Baroque Art presented to Anthony Blunt* (London, 1967), 83 ff.). An important aspect of art in the provinces was the revival of the technique of enamel at Limoges in the second half of the fifteenth century after an interruption of nearly a hundred years. The technique of painted enamel made it possible to produce new effects with greater ease than in the old method of *champlevé* enamel, though the results were less brilliant. For a survey of the first phase of the revival which lasted till about 1530 and was dominated by two unidentified artists called the pseudo-Monvaerni and the Aeneid Master see M. M. Gauthier and M. Marcheix, *Les Émaux de Limoges* (Prague, 1962).

45. 58. For Bourdichon see R. Limousin, *Jean Bourdichon* (Lyons, 1954), and L. M. J. Delaissé, J. Marrow, and J. de Wit, *The James A. de Rothschild Collection at Waddesdon Manor, Illuminated Manuscripts* (London, 1977).
Recently Charles Sterling has identified an almost equally talented miniature painter working in France at about the same time whom he has named the Master of Claude, Queen of France, after the daughter of Anne of Brittany and first wife of Francis I for whom he worked; cf. Sterling, *The Master of Claude, Queen of France* (New York, 1975).

59. E.g. the altarpiece from S. Domenico, Fiesole, now in the Uffizi, and the single figure in the Louvre. In the Brunswick *Hours of Henry VIII*, also attributed to Bourdichon, a more complicated borrowing from Perugino occurs. The artist has used for his version of the Pietà the lower figures in Perugino's painting of the subject in the Accademia, Florence (reproduced in W. Bombe, *Perugino* (1914), 26), and has copied the head of the Blessed Giovanni Colombini from the same painting for his St Sebastian in another miniature of the same book. It is interesting to notice that Perugino is placed among the great living Italian artists by Jean Lemaire de Belges in his poem, *La Plainte du Désiré*, 1509 (cf. E. Moreau-Nélaton, *Les Clouet et leurs émules*, I, 48).

46. 60. In Pavia he could have seen one work of Perugino, the altarpiece of which three panels are now in the National Gallery, London, executed in 1498.

61. Some borrowings suggest that he visited Tuscany and Bologna. For instance the miniature of Peter Martyr in the *Hours of Anne of Brittany* recalls a painting by Francia of *c*. 1490, now in the Borghese Gallery (reproduced in A. Venturi, *North Italian Painting of the Quattrocento, Emilia* (Paris, 1931), plate 62), and the St Francis in the *Hours of Henry VIII* is based on Benedetto da Maiano's relief on the

pulpit of S. Croce (reproduced in L. Dussler, *Benedetto da Majano* (Munich, 1925), figure 12). The 'St Mark' in the *Hours of Anne of Brittany* is related to the seated figure in Jacopo della Quercia's tomb of Galeazzo Bentivoglio in Bologna (reproduced in I. B. Supino, *Iacopo della Quercia* (Bologna, 1926), plate 62).

62. Mlle Huillet d'Istria has tried to prove that Perréal executed the frescoes in the cathedral library of Le Puy (*G.B.A.* (1949), I, 313 ff.), but her arguments are not convincing.

63. Reproduced in G. F. Hill, *Medals of the Renaissance* (Oxford, 1920), plate XXV, 2, and G. Ring, *A Century of French Painting, 1400–1500*, 189.

64. Cf. C. Sterling, 'Une Peinture certaine de Perréal enfin retrouvée', *L'Œil*, no. 103–4, 2. The question of large-scale portraits probably still needs examination. M. Sterling accepts the 'Louis XII' at Windsor as being designed by Perréal but believes it to be a copy (but see J. Dupont, 'A Portrait of Louis XII attributed to Jean Perréal', *Burl. Mag.*, LXXXIX (1947), 235), but his arguments about the other portraits are less convincing.

47. 65. See the catalogue by Janet Cox-Rearick and Sylvie Béguin of the exhibition, *La Collection de François I*, held at the Louvre in 1972.

66. For Andrea del Sarto's visit to France see J. Shearman, *Andrea del Sarto* (Oxford, 1965), I, 3. An interesting example of his influence in portraiture is to be seen in the portrait of a lady belonging to the Earl of Normanton (cf. J. Shearman, 'Three Portraits by Andrea del Sarto and his Circle', *Burl. Mag.*, CII (1960), 58 ff.). The sitter is unquestionably French, but the nationality of the artist must remain an open question.

67. This statue was set up in the Cour de la Fontaine at Fontainebleau and can be seen there in seventeenth-century engravings.

CHAPTER 2

50. 1. Villers-Cotterets is not really an example of the new style, but is rather a final flowering of the manner current in the previous period (cf. F. Gébelin, *Les Châteaux de la Renaissance*, figures 118, 126 ff.). For Madrid, see H. G. Duchesne and Henry de Grandsaigne, *Le Château de Madrid* (Paris, 1912).

51. 2. The roof of La Muette was to have been flat, but the design was altered by Philibert de l'Orme.

52. 3. For instance in furniture or stone capitals.

53. 4. *Les plus excellents bastiments de France*, I and II, respectively.

5. Illustrated in Gébelin, *op. cit.*, plate lxiii.

54. 6. For a complete history of Fontainebleau see

F. Herbet, *Le Château de Fontainebleau* (Paris, 1937).
7. For further information about Gilles Le Breton
see P. Vanaise, 'Gilles Le Breton, maître-maçon.
Entrepreneur ou architecte parisien du XVIᵉ siècle'.
G.B.A. (1966), 11, 241 ff. The author convincingly
attributes to this architect the buildings around the
forecourt of Fleury-en-Bière, not far from Fontaine-
bleau. See also L. Grodecki, 'Un Marché de Gilles Le
Breton pour le Château de Fleury-en-Bière', *L'Infor-
mation d'Histoire de l'art* (1974), 37–41. The contract
shows that the *menuiserie* was designed by Lescot.
56. 8. This staircase has had a singularly unhappy
history. Before 1579 the outside steps were removed
and new flights arranged within the building. Henry
IV caused the surviving parts to be taken down and
reconstructed in alignment with the wing to its left,
and at the end of the nineteenth century it was declared
dangerous and completely reconstructed in new
materials.
9. The old attribution to Serlio is ruled out on the
grounds that he did not come to France till 1540, but
recently Professor André Chastel has persuasively
put forward the theory that the design may have been
inspired by Rosso, who had been engaged on work at
Fontainebleau since 1530 and was certainly com-
petent in architecture (cf. 'L'Escalier de la Cour
Ovale à Fontainebleau', *Essays in the History of Archi-
tecture presented to Rudolf Wittkower* (London,
1967), 74).
10. For Montargis, cf. the engravings of du Cerceau
in the *Plus excellents bastiments*, 1.
11. The date of the staircase at Bury is, however,
uncertain.
12. The Italian examples which offer the closest
parallels are actually all later, e.g. Michelangelo's
staircases outside the Belvedere Niche and the
Palazzo dei Senatori, and Vignola's at Caprarola.
Falconetto's in the villa at Luvigliano is contempor-
ary (between 1529 and 1534). It is very unlikely that
Le Breton would have known it, but conceivable that
Rosso should have done so.
58. 13. The arches of the *logge* facing the courts at
Villandry and Valençay have the form used by Le
Breton in the Porte Dorée and elsewhere at Fon-
tainebleau.
14. One group of houses at Orléans presents a
curious problem, to be seen at its clearest in the
Hôtel Toutin, sometimes called the Maison de
François I, built in 1538–40 (cf. *Archives de la Com-
mission des Monuments Historiques*, IV (Paris, 1855–
72), 17, also described and illustrated in *Congrès
Archéologique* (1930), 159 ff.). The house consists of
two *corps-de-logis* linked by a double *loggia* running
along the side of the court. In its arrangement and

in its forms this *loggia* is more Italianate than any-
thing else to be found in France at this date. Other
details of the building, such as the windows and door
on the front *corps-de-logis*, narrow down the source
to Venice or the surrounding territory. On the other
hand, the detail is in many respects too free to be by
an Italian architect (cf., for instance, the irregular
Doric entablature). It seems likely, therefore, that
the building is by a French architect acquainted with
the palaces of Venice and its neighbourhood.
60. 15. It is possible that when complete the abbey
church of Valmont, near Fécamp (before 1540), may
have had something of the character of St Eustache,
though it is broader in its proportions (illustrated in
G. Huard, *L'Art en Normandie* (Paris, 1928), figure 74).
61. 16. The façade of Annecy Cathedral is reproduced
by Hautecœur, *Architecture*, I, 106, and S. Pietro,
Modena, on which it seems to be based, in A. Venturi,
Storia, VIII, I, figure 397.
17. Illustrated in G. Duhem, *Les Églises de France,
Morbihan* (Paris, 1932), plate opposite p. 208.
18. The sculptor Giovanni Francesco Rustici spent
the years *c.* 1528–54 in France, but no trace survives
of his work or influence there.
Much the fullest information about the School of
Fontainebleau is contained in the catalogue of the ex-
hibition *L'École de Fontainebleau* held at the Grand
Palais in 1972, referred to below as *Fontainebleau
(Grand Palais)*. For Rosso in addition to Kusenberg
and Barocchi (see bibliography) see *Fontainebleau
(Grand Palais)*, 175.
19. For a fully documented account of the restoration
of the Galerie François I see 'La Galerie François I au
Château de Fontainebleau', *Revue de l'Art*, XVI–XVII
(1972). For the shares of the different artists see P.
Vanaise, 'Cahier inédit de Tabellion de 1535', *Bulletin
de l'Académie royale de Belgique (Classe des Beaux-
Arts)*, LV (1973), 133. For Nicolas Bellin of Modena,
an artist who later came to England and worked for
Henry VIII, see also Martin Biddle, 'Nicholas Bellin
of Modena', *Journal of the British Archaeological
Association*, XXIX (1966), 106. For the origins of
strapwork see J. Shearman, 'The Galerie François I:
a case in point', *Adelaide Studies in Musicology*, 11
(1980).
20. For the best account of Primaticcio's career see
P. Barocchi, 'Precisioni sul Primaticcio', *Commen-
tari*, 11 (1951), 203.
62. 21. Cf. F. Hartt, *Giulio Romano* (New Haven,
1958), 108, 148 f.
22. The problem is complicated by the fact that
both Rosso and Primaticcio had of necessity many
assistants in works of this scale. Many of their names
are mentioned in the accounts, and many different

hands can be distinguished in the paintings of the Galerie François I since its restoration, but it is rarely possible to connect a name with a group of works. This is the case, however, with Luca Penni, who probably arrived in France soon after 1530 and is recorded in the accounts from 1537 to 1544. He was probably a *protégé* of Rosso and may have gone out of favour at his death, because, although he lived on in France till 1556, he does not appear to have worked for the Crown. He is, however, recorded as working for the Duchesse de Guise in 1549 (cf. L. Golson, 'Luca Penni, a Pupil of Raphael at the Court of Fontainebleau', *G.B.A.* (1957), 11, 17, and *Fontainebleau (Grand Palais)*, 127).

23. Vasari's statement is probably reliable because he was at one period in correspondence with Primaticcio and probably met him in Rome. The evidence of the payments made to the two artists in no way contradicts his assertion, and in fact the earliest records are for schemes which were conducted by Primaticcio and not Rosso, though this is no certain guide since the records are incomplete.

24. Cf. Venturi, *Storia*, XI, I (1938), 221.

25. For Primaticcio, in addition to Dimier (see bibliography) see *Fontainebleau (Grand Palais)*, 130.

63. 26. This drawing was published by F. Hartt (*op. cit.*, II, figure 149), who identified it as a design for the *stalle*, but J. Shearman, who first noticed that the decorative scheme agreed exactly with the surviving copies of the wall-decoration in the Chambre du Roi, believes that it was probably made to be taken to France by Primaticcio as a model for his first work. The drawing shows in the main panels scenes from the story of Cupid and Psyche, whereas the Chambre du Roi had as its principal theme the story of Ulysses, but it is quite possible that this change was demanded by the King after the arrival of the drawing in France (cf. J. Shearman, 'Osservazioni sulla cronologia e l'evoluzione del Palazzo del Te', *Bollettino del Centro di Studi di Architettura Andrea Palladio*, IX (1967), 438).

64. 27. E.g. works by Zoan Andrea, Nicoletto da Modena, and Agostino Veneziano, reproduced in R. Berliner, *Ornamentale Vorlageblätter*, plates 18, 19, and 23. J. Shearman (*Andrea del Sarto* (Oxford, 1965), I, 59) has pointed out that earlier strap-work is to be found in the decoration of the chapel of Leo X in S. Maria Novella, executed by Andrea di Cosimo Feltrini about 1515.

28. Examples of it occur in the last plate of Serlio's fourth book of architecture, published in Venice in 1537.

29. Cf. A. Blunt, 'L'Influence française sur l'archi-

tecture et la sculpture décorative en Angleterre pendant la première moitié du 16e siècle', *Revue de l'Art*, IV (1969), 17 ff.

30. Cf. Panofsky, 'The Iconography of the Galerie François I at Fontainebleau', *G.B.A.* (1958), II, 113. The author has undoubtedly worked out the basic scheme of the iconography of the gallery, but it is not always easy to follow him in some of his more complex interpretations.

65. 31. Hautecœur, *Architecture*, I, 54, lists earlier examples which have disappeared. It was also copied in Italy (cf. the Galleria della Mostra in the Palazzo Ducale at Mantua).

32. He may also have designed the tomb of Alberto Pio, in the Louvre (cf. M. Roy, *Artistes et monuments de la Renaissance française*,138 ff.), but see *Fontainebleau (Grand Palais)*, 127.

33. For these engravings see H. Zerner, *École de Fontainebleau. Gravures* (Paris, 1967), XLI.

66. 34. Reproduced and discussed in *Fontainebleau (Grand Palais)*. This catalogue contains the most up-to-date discussions of other French tapestries, including the St Mammès series (see p. 112) and the Diana series woven for Diane de Poitiers for Anet, but further details will be found about the history of French tapestries, including those of the early sixteenth century, in the catalogue of the exhibition *Le XVIe siècle européen. Tapisseries* (Mobilier National, 1965).

One direct imitation of the Galerie François I can be found in Rome in what is now the Palazzo Spada which was built by Cardinal Girolamo Capodiferro who at some date before 1559 decorated the galleria in a style directly based on Rosso's decoration, which he would have seen on his two missions to France in 1547 and 1553 (cf. Frommel, *Der römische Palastbau der Hochrenaissance* (Tübingen, 1973), 71.

35. For an account of Tory's work see Lieure, *La Gravure dans le livre et l'ornement* (Paris, 1927).

36. See Peter Mellen, *Jean Clouet* (London, 1971). The drawings at Chantilly are discussed and largely reproduced in Dimier, *La Peinture de Portrait*, and Moreau-Nélaton, *Les Clouet et leurs émules*. The drawings are also available in small reproduction in Raoul de Broglie, 'Les Clouet de Chantilly', *G.B.A.* (1971), I, 259, accompanied by a short uncritical text.

70. 37. Little work has been done on French illuminated manuscripts of the mid sixteenth century, many of which are of high quality. A brief summary of their history and character is given by Dominique Bozo in *Fontainebleau (Grand Palais)*, 235. Sylvie Béguin has discussed the *Hours of the Connétable de Montmorency* in *L'École de Fontainebleau*, 47.

CHAPTER 3

73. 1. For the fullest account of Serlio's career see M. N. Rosenfeld's introduction to *Sebastiano Serlio on Domestic Architecture* (Cambridge (Mass.), 1978).

2. Cf. J. Adhémar, 'Aretino: Artistic Adviser to Francis I', *J.W.C.I.*, XVII (1954), 316.

3. Serlio's design for the loggia for Fontainebleau seems to have been for the wing now containing the Salle de Bal, but as Serlio tells us himself it was much altered in the execution by French masons. The château which he calls Rosmarino and of which he gives the plan and elevation at the end of Book 7 has been identified by F. C. James as the château of Lourmarin in the Rhône valley.

M. N. Rosenfeld (*op. cit.*, 23) firmly attributes to Serlio the Grotte des Pins at Fontainebleau [65] on the grounds that he illustrates a design of a grotto for Fontainebleau in Book 6, but this bears no relation to the existing grotto and must be a rejected design. In fact the grotto is more likely to be by Primaticcio (see below, p. 94).

4. The manuscript in the Staatsbibliothek, Munich, was published by M. Rosci, *Il Trattato di Architettura di Sebastiano Serlio* (Milan, 1967); that in the Avery Library, Columbia University, by M. N. Rosenfeld, *op. cit.* (cf. Note 1 above).

In spite of not having been printed, Book 6 had a considerable influence on French architectural designers, including the elder Jacques Androuet du Cerceau, and must have circulated in manuscript. Its importance is discussed by Dr David Thomson in his monograph *Jacques et Baptiste du Cerceau. Recherches sur l'architecture française 1545-1590* (Paris-Geneva, 1980). The manuscript of Book 7 is in the Staatsbibliothek, Vienna (cf. T. Carunchio, 'Dal VII libro di S. Serlio "XXIII case per edificare nella villa"', *Quaderni dell'Istituto di Storia dell'Architettura*, XXII (1976), 95).

75. 5. Cf. C. F. James, 'L'Hôtel du Cardinal de Ferrare à Fontainebleau d'après un document inédit', *Actes du Colloque international sur l'art de Fontainebleau (1972)* (Paris, 1975), 35. For the importance of the hôtel in the history of French domestic architecture, see J. P. Babelon, 'Du "Grand Ferrare" à Carnavalet. Naissance de l'Hôtel Classique', *Revue de l'Art*, XL–XLI (1978), 83.

77. 6. In his seventh book Serlio reproduces, very inaccurately, a work of this architect, the Casino of Luigi Corner at Padua, and other designs in the treatise suggest his influence.

78. 7. Serlio's design for Ancy seems to have been little imitated in France. One adaptation of it, how-

ever, is to be seen in the château of Petit-Bourg, known from the engraving by Pérelle before its rebuilding in the eighteenth century. The garden front seems to be an almost exact copy of one of the Ancy façades, but Petit-Bourg differs from its model in that it consists of three wings only and not of four completely enclosing a court (Blomfield, *A History of French Architecture, 1661-1774*, II, plate 109, reproduces Pérelle's engraving, but attributes the château as shown there to Lassurance, who rebuilt it in the eighteenth century). Ancy was also sometimes imitated in the Lyons district, for instance in the château of the Villeroy family at Neuville-sur-Saône and that of Tours at Crèches-sur-Saône.

8. The doors at the château of Kerjean, most of which are variations on designs by Serlio, are somewhat less provincial.

9. Cf. D. Thomson, 'A Note on Pierre Lescot, the Painter', *Burlington Magazine*, CXX (1978), 666.

79. 10. Of these works, the Carnavalet, the Fontaine des Innocents, and Vallery are not completely documented as being by Lescot, but the reasons for their attribution to him are convincing. For Vallery see R. Planchenault, 'Les Châteaux de Vallery', *Bulletin Monumental*, CXXI (1963), 237. For the Louvre see L. Hautecœur, 'Le Louvre de Pierre Lescot', *G.B.A.* (1927), I, 199; L. Batiffol, 'Les premières constructions de Pierre Lescot au Louvre', *G.B.A.* (1930), II, 276; and C. Aulanier, 'Le Palais du Louvre au 16ᵉ siècle', *B.S.H.A.F.* (1952), 85.

11. The comparison is with the two lower floors only of the Farnese, not with the top one added by Michelangelo.

80. 12. These windows were to become almost standard in France for about two centuries.

13. The extension down to the floor level of the middle window in each side wing is a later alteration.

14. Cf. p. 58.

82. 15. Caryatids occur in Italy in designs for fireplaces, woodwork, etc., but only on a small scale. They are also to be found in painting, for instance in Daniele da Volterra's Cappella Orsini in SS. Trinità dei Monti of 1541, destroyed but known from drawings and engravings (cf. Bernice Davidson, 'Daniele da Volterra and the Orsini Chapel', *Burl. Mag.*, CIX (1967), 553 ff.). In France they are to be found on the tomb of Louis de Brézé in Rouen Cathedral, which is earlier in date and also probably designed by Goujon [94].

16. Delaborde, *Marc-Antoine Raimondi* (Paris, 1888), no. 214.

17. This is perhaps the only design of Lescot which seems to go back directly to an Italian model, for both

in their grouping and in their proportions the columns closely recall those in Giulio Romano's portico on the garden side of the Palazzo del Tè at Mantua.

18. M. Roy, *Artistes et monuments de la Renaissance française*, I, 419.

19. Lescot's name does not appear in the contracts, but there does not seem to be any reason to doubt the traditional attribution.

20. The engravings in Marot show the original state of this wing, and prove that the dormers were of the same type as those on the block over the street (certainly built by 1558) and that therefore the two buildings were probably designed at the same time. For the history of the hôtel and its restoration in the nineteenth century see J. P. Babelon, 'Du "Grand Ferrare" à Carnavalet', *Revue de l'Art*, XL-XLI (1978), 83, who also deals with the general problem of the Paris hôtel in the sixteenth century. Catherine Grodecki and C. F. James have established that Lescot was also responsible for the Hôtel Saint-André in the Quartier St Eustache, now destroyed.

21. For instance, in the Hôtel de Sully.

84. 22. For a fuller account of Philibert de l'Orme's work and ideas see A. Blunt, *Philibert de l'Orme* (London, 1958).

23. De l'Orme was only responsible for building the bridge and not, as is often said, the gallery over it, which was added for Catherine de' Medici between 1570 and 1578, probably from the designs of Bullant. For an account of the château in its earlier form, see J. Guillaume, 'Chenonceaux avant la construction de la galerie', *G.B.A.* (1969), I, 19.

86. 24. Book I, chapter 15, We are reminded of the lines of Joachim du Bellay, nephew of de l'Orme's patron the Cardinal, published in 1558:

Plus me plaist le séjour qu'ont basty mes ayeux,
Que des palais Romains le front audacieux:
Plus que le marbre dur me plaist l'ardoise fine.

87. 25. Book 6, preface. He may have had in mind the work of pedants such as Philander, who was guilty of just this blunder. See pp. 98-9.

89. 26. Built *c*. 1549, the decoration completed in 1552.

27. See p. 61.

91. 28. Echoes of the style of Philibert de l'Orme at Anet are also sometimes to be found in the provinces, for instance in the château of Maillé near Morlaix, built probably after 1577 by a family remotely connected with Diane de Poitiers' husband.

94. 29. It has been generally assumed that the plans shown by du Cerceau in the *Plus excellents Bastiments* and in the drawings in the British Museum represent de l'Orme's scheme for completing the palace, but in my opinion they almost certainly represent du Cer-

ceau's own ideas. This view has recently been challenged by D. A. Chevalley in *Der grosse Tuilerienentwurf in der Ueberlieferung Ducerceaus* (Frankfort, 1973), mainly on the grounds that the plans are too sophisticated for the simple-minded du Cerceau. Dr David Thomson, however, has shown that du Cerceau in fact moved in the most sophisticated intellectual circles and was a man of ideas rather than a builder.

30. The attribution of this grotto to Primaticcio is due to Dimier and, though not certain, is very probable; but see above, Note 3.

97. 31. Dimier, *Le Primatice* (1900), 359, has established Primaticcio's claim in spite of the fact that Félibien and Brice attribute the chapel to Philibert de l'Orme.

98. 32. Its state in that year is known from a drawing made by van Buchel in his diary for September 1585 (cf. *Mémoires de la Société de l'Histoire de Paris*, XXVI (1899), plate opposite p. 128). Silvestre (Faucheux, no. 64, plate 28) shows it in the same condition.

33. It is always stated that some of the columns were taken and re-erected round the lake in the Parc Monceau, but if this is the case their whole arrangement must have been much altered in the process.

99. 34. The château has been attributed by the local historian Gaujal (cf. Gébelin, *Les Châteaux de la Renaissance*, 62) to Guillaume de Lissorgues, who was born in the village of Bournazel and built the nearby château of Graves (reproduced Gébelin, *op. cit.*, figure 67). Gébelin rejects this attribution, but on stylistic grounds it is plausible in connexion with the north wing, which has many features in common with the Graves. The east wing is much more monumental, but there are so many details of decoration common to both wings that it is hard to believe that they are by different hands. The unusual design of the Ionic Order is to be found almost exactly repeated on the entrance gate on the south side of St Sernin at Toulouse. Another example closely related in type is on the choir screen of the cathedral of Rodez, dated 1531, of which the surviving fragments have been moved to a side chapel of the choir. It seems likely that the same team of decorative sculptors worked on these three friezes.

35. Book 4, chapter 12.

100. 36. The following are documented as by him: Hôtel de Bagis, 1538; Hôtel Buet, 1540; parts of Hôtel d'Assézat, 1555. To these can be added on grounds of style the Hôtel du Vieux Raisin or Beringuier-Maynier, after 1547. Outside the town the château of St Jory is certainly by him (1545) and that of Pibrac (*c*. 1540) is plausibly ascribed to him. Cf. H. Gaillot, *Nicolas Bachelier* (Toulouse, 1914). Bachelier is known to have had a pupil named Guiraud Mellot who was responsible for a remarkable door in

the Capitole of Toulouse, now in the Louvre (cf. M. Beaulieu, *La Sculpture du Musée du Louvre*, 11, *La Renaissance française*, 124).

103. 37. *Congrès* (1929), 154.

38. See E. Ulrich and J. Vincent, 'La Chapelle de la Tour d'Aigues', *Revue de l'Art*, IX (1970), 74. The circular chapel was finished by 1566 and the date 1571 is cut on the entrance gate. From a reproduction of a painting dating apparently from the late eighteenth century (available as a postcard published locally) it appears that the central feature of the right façade of the court consisted of a frontispiece of four giant columns like that of the south wing at Écouen. The name of the Piedmontese architect Ercole Nigra or Nigro (1541-1622) has been proposed as that of the architect since he is documented as having worked on the château in 1570-2, but the style of the whole building is so Parisian that it is hard to believe that he was more than the builder. Moreover he was only fourteen when the building was begun. He was primarily a military engineer and his known works are purely Italian (cf. *Mostra del Barocco Piemontese* (Turin, 1963), I, 24).

Another fine and little known house in the south is the château of Marsillargues (Hérault), mainly built in the reign of Henry II on an unusual plan, and with fine carved decoration in the Fontainebleau style.

39. A similar arrangement with a single Order is to be found in Italy in the vestibule of the sacristy of S. Spirito, Florence, by Giuliano da Sangallo and Cronaca. This may also be based on the temple at Nîmes, which was certainly known in Italy by the early sixteenth century.

104. 40. Door to north transept, *c.* 1555-70, illustrated in Hautecœur, *Architecture*, I, 378.

41. The tower at Gisors was built after 1559. Those at St Michel, Dijon, were probably begun about 1560, but were not finished till the seventeenth century (cf. Hautecœur, *Architecture*, I, 390, 392). To these examples can be added three in Brittany, namely the transepts of St Vincent at Saint-Malo, and St Malo at Dinan. A very late survival of the style can be seen in the south transept of St Germain at Rennes, which is said to date from 1606-23.

42. Illustrated in Hautecœur, *Architecture*, I, 406. Its date is not known, but on grounds of style it can be placed soon after the middle of the century.

43. Illustrated in Hautecœur, *Architecture*, I, 403. The author illustrates many other specimens of the church architecture of the period, 374-421.

44. This chapel is illustrated in Hautecœur, *Architecture*, I, 163, who however wrongly describes it as the chapelle des Évêques, an earlier chapel in the same cathedral. The classicism of the chapel, somewhat

unexpected in so remote a centre, may perhaps be connected with the presence there earlier in the century of Jean Pélerin, alias Viator, whose treatise on perspective published in 1505 showed him to have been well versed in classical architecture.

45. For a full account of his work see Pierre Marcel, *Jean Martin* (Paris, 1927).

105. 46. The room has suffered by being transformed into a staircase by Louis XV. For Primaticcio's early work at Fontainebleau, see W. McAllister Johnson, 'Les Débuts de Primatice à Fontainebleau', *Revue de l'Art*, VI (1969), 9.

107. 47. The influence of Parmigianino must have been reinforced by that of Cellini, who was in France from 1540 to 1545 (cf. p. 123). The figures on the saltcellar made for Francis I have many of the same characteristics as Parmigianino's nudes.

108. 48. According to Sauval, Primaticcio also designed the decoration of a gallery in the Paris house of the Constable Anne de Montmorency, known from the engravings by Guérineau. Like the decoration of the Ballroom at Fontainebleau they were actually executed by Nicolò dell'Abate.

A French artist who is recorded as a collaborator of Primaticcio, Michel Rochetel, has recently emerged as an artistic personality by the identification of two drawings by him, one in Dresden, dated 1551, the other in the Pierpont Morgan Library. These were published by Sylvie Béguin (*Master Drawings*, XIX (1981), 157), who suggests that they may be designs for prints, but I wonder whether they are not for enamels, for which it is known that Rochetel made preparatory drawings.

109. 49. Cf. W. M. Johnson, 'Five Drawings for the Palace of Fontainebleau', *Master Drawings*, IV (1966), 25 ff.

110. 50. They even have in common the unusual hexagonal shape for some of the panels.

51. The model for the panel was Giulio Romano's fresco in the Sala del Sole at the Palazzo del Tè (reproduced in Hartt, *Giulio Romano*, II, figure 169). It is traditionally said that Primaticcio designed some of the stuccoes in this room (Hartt, *ibid.*, I, 108).

52. For his Italian works see the catalogue of the *Mostra di Nicolò dell'Abate* (Bologna, 1969) and *Fontainebleau (Grand Palais)*, 5.

53. Both reproduced in the catalogue of the Bologna exhibition (plates 4 and 22).

54. Two drawings by Primaticcio identified by Dimier (*Le Primatice* (1928), plate 32) as designs for the decorations of the Grotte des Pins also show the use of very steep perspective.

55. For a full account see C. Samaran, 'La Chapelle de l'hôtel de Guise', *G.B.A.* (1921), II, 331.

56. Reproduced in A. Venturi, *Storia*, IX, 2, figure 343. Another possible source is one of Tibaldi's frescoes in the Palazzo Poggi at Bologna, begun *c.* 1554, which may have been quickly known in France through the close Bolognese contacts of Primaticcio and Nicolò dell'Abate. Nicolò also painted frescoes in the gallery of the destroyed Hôtel de Montmorency, which are known from engravings published in the seventeenth century by N. Langlois (cf. S. Béguin, 'La Galerie du Connétable de Montmorency à l'Hôtel de la rue Sainte-Avoye. Le Décor de Nicolò dell' Abate', *B.S.H.A.F.* (1979), 47.

57. For a charming but minor follower of Nicolò see S. Béguin, 'Le Maitre de Flore', *Art de France*, I (1961), 301.

111. 58. They may have belonged to the set of four large landscapes for Fontainebleau for which Nicolò was paid in 1557 (cf. Laborde, *Comptes*, II, 195).

59. Mlle Bessard and Mme Béguin have recently identified an important cycle of paintings executed by Nicolò dell'Abate in the Hôtel du Faur, now lost but known from drawings by van Thulden and engravings by Erlinger (cf. 'L'Hôtel du Faur dit Torpanne', *Revue de l'Art* (1968), I, 39 ff.). This house, of which richly carved arches from the loggia survive in the garden of the École des Beaux-Arts, must have been one of the most splendid hôtels of the century.

Francesco Salviati visited France during this period, but his stay lasted less than two years (1554–6). His work at Dampierre has vanished. Bronzino was represented in the royal collection by the Allegory now in the National Gallery, London.

Henry II and Diane de Poitiers seem also to have been interested in the work of Michelangelo, for a small portable altar at Wilton bearing their emblems is based on his 'Pietà' design known from engravings by Bonasone and Beatrizet.

112. 60. For the fullest account of Cousin see *Fontainebleau (Grand Palais)*, 59, 345.

61. Guillaume (*G.B.A.* (1972), II, 185) has shown that the iconography is even more complicated than was previously thought and that there are allusions to Cleopatra as well as to Eve-Pandora.

113. 62. This identification is due to J. Shearman (cf. *Fontainebleau (Grand Palais)*, 78).

114. 63. As the frames of the Sala Regia were not begun till 1546 at the earliest, it seems likely that Jallier visited Rome in the years 1546–9. Another imitation of the same frames is to be found in the outside of the gallery at Chenonceau, built by Bullant (see pp. 138–9). The frescoes are discussed in detail by Jean Guillaume, 'Oiron: Fontainebleau poitevin', *Monuments historiques*, CI (1979), 77.

64. For further information about Mailly see the article in Thieme-Becker, and a short note by G. Frizzoni in *L'Arte*, II (1899), 154.

65. For a full discussion of the Chrétien problem see J. Thuillier, 'L'Énigme de Félix Chrétien', *Art de France*, I (1961), 57.

116. 66. See L. Dimier, *La Peinture de portrait*, and E. Moreau-Nélaton, *Les Clouet et leurs émules*. Both authors record the available facts, but both, and particularly Dimier, allow themselves to speculate with dangerous freedom in the field of attribution. A much more scientific approach is displayed in Irene Adler's article, 'Die Clouet', *Jahrbuch der Kunsthistorischen Sammlungen in Wien*, N.S., III (1929), 201. *Les Clouet et la Cour des Rois de France* (Exhibition at the Bibliothèque Nationale, 1970) is useful for its notes on the sitters.

67. The portrait of Francis I has been more discussed than any other French portrait of this period, with very varying conclusions, but the solution proposed by C. Sterling ('Un Portrait inconnu par Jean Clouet', *Studies in Renaissance and Baroque Art presented to Anthony Blunt* (London, 1967), 86) brilliantly resolves all the problems involved in the attribution of the portrait.

117. 68. We must remember, however, that Salviati's portrait of Aretino, now lost, belonged to Francis I (cf. Vasari, *Vite*, VII, 19).

69. The date now reads 1563, but appears to have been altered from 1569. To fit with the King's age as given, it should be 1570.

70. For instance, the portrait of Archduke Ferdinand in Vienna of 1548.

71. On stylistic analogy with the Charles IX several other portraits can safely be attributed to François Clouet: for instance, the full-length Henry II in the Uffizi (reproduced in Dimier, *La Peinture de portrait*, I, plate 16); the head of Henry II, dated 1559, of which versions exist at Versailles, at Windsor, and in the Pitti (cf. Dimier, *op. cit.*, II, 124, nos 493, 494). On the basis of drawings we may add the Claude de Beaune in the Louvre (Moreau-Nélaton, *op. cit.*, I, figure 29). The Odet de Châtillon, dated 1548, at Chantilly (Moreau-Nélaton, *op. cit.*, figure 27) presents a difficult problem. The drawing (Moreau-Nélaton, *op. cit.*, figure 30) is certainly by François Clouet, but the painting is more Italianate than anything we possess of his. If, however, the hypothesis of a visit to Italy is accepted, then we might expect Italian influence to be stronger in an early work such as this, than in his more mature portraits, and the attribution becomes more acceptable.

119. 72. Cf. M. J. Friedlaender, *Altniederländische Malerei*, IX (1931), plates 53, 63.

73. Friedlaender, *op. cit.*, plates 29, 31, 37, and 38.

The nurse in the Clouet may have been suggested by the St Joseph in the composition shown on plate 38. 74. This composition was imitated several times. At Chantilly is an almost exact copy dating from the end of the century, and perhaps representing Gabrielle d'Estrées (reproduced in Moreau-Nélaton, *op. cit.*, 11, figure 464). Another more individual interpretation at Dijon shows the maidservant in the background taking clothes out of a chest, a direct reminiscence of Titian. A double portrait of the same type exists in several versions and is said to represent Gabrielle d'Estrées and the Duchesse de Villars.

One composition which is in no sense a portrait is also plausibly attributed to François Clouet, namely the 'Diana at her Bath' of which versions exist at Rouen and in the possession of Messrs Wildenstein.

75. See S. Béguin and A. de Groër, 'À propos d'un nouveau Corneille', *Revue du Louvre*, XXVIII (1978), 28. For the background to Corneille see N. Z. Davis, 'Le Milieu social de Corneille de Lyon', *Revue de l'Art*, XLVII (1980), 21.

120. 76. A. E. Popham in his interesting article in Duvet (*Print Collector's Quarterly*, VIII (1921), 123) has pointed out many borrowings of Duvet from Italian sources. He also makes the important point that his engraving after Raphael's Cumaean Sibyl (R.D. 52) agrees with the original and not with any of the Italian engravings after it. Duvet must therefore have worked either from the original or from a drawing brought back by another artist from Rome. For reproduction of all Duvet's engravings and the fullest treatment of Duvet as an artist see C. Eisler, *The Master of the Unicorn. The Life and Work of Jean Duvet* (New York, 1979). The text of this book is, however, open to serious criticism (see the present writer's review to be published in the *Burlington Magazine* in 1980).

77. It is said by most writers that this series refers to the loves of Henry II and Diane de Poitiers, but there seems to be no solid reason for this view.

122. 78. See the excellent account given by L. E. Marcel, *Le Cardinal de Givry* (Dijon, 1926).

79. L. E. Marcel, *op. cit.*, 1, 166.

80. There is also a parallel with the Oratory of Divine Love to which Contarini and Pole belonged. This coloured the later compositions of Michelangelo to which, particularly the 'Last Judgement', Duvet's engravings also owe much.

81. Contemporary with the isolated figure of Duvet there flourished a school of engravers who specialized in the illustration of books, and who, while not attaining the perfection of Geoffroy Tory, yet kept up a good general level of technical competence and of invention. The best of these artists were Bernard

Salomon (active 1540-69), who illustrated Petrarch and Ovid, and the elder Jean de Gourmont (*c.* 1483-after 1551), chiefly notable for his curious architectural and perspective fantasies. For a full account of these engravers see F. Courboin, *Histoire illustrée de la gravure en France*. One painting by Jean de Gourmont, dated 1537, is known (Städelsches Kunstinstitut, Frankfurt).

123. 82. Casts of the Victories designed for the spandrels above the Diana survive, though the originals have disappeared, and a drawing exists for one of the satyrs which were to support the relief. In addition a drawing for the Juno in the series of gods and goddesses exists in the Louvre (cf. *Fontainebleau (Grand Palais)*, 51, 381).

83. Cf. above, Chapter 3, Note 47. The stories of the rivalry between the two artists are probably exaggerated, and in any case would not prevent one from borrowing from the other.

84. For the most up-to-date information about French sculpture in the middle and second half of the sixteenth century see Jacques Thuillier's section in *Fontainebleau (Grand Palais)*, 373, and M. Beaulieu, *La Sculpture du Musée du Louvre*, 11, *La Renaissance française*. For Goujon see P. du Colombier, *Jean Goujon* (Paris, 1949), and M. Beaulieu, *La Sculpture du Musée du Louvre*, 11, *La Renaissance française*, 92.

85. The Corinthian capital is far more correct than any to be found in the illustrated editions of Vitruvius published before that date. It agrees, however, exactly with one illustrated in a plate designed by Goujon for Martin's translation of 1547.

124. 86. The capitals of the Corinthian columns are identical with those in St Maclou; and the very unusual frieze of the upper storey is almost exactly repeated in an engraving by Goujon for the 1547 edition of Vitruvius, in which the Corinthian capital is also engraved (45 v).

87. The allegorical figure at the top of the whole monument, seated between columns, is similar in style to those on the Hôtel d'Écoville at Caen, and suggests that Goujon probably received his first training in Normandy. P. du Colombier also plausibly attributes to the Rouen period of Goujon the general design of the Chapelle de la Fierte de St Romain beside the cathedral, built in 1542-3 (*op. cit.*, 30, and plate 32). Here again links with the Hôtel d'Écoville at Caen can be seen in the circular aedicules on the tops of the two structures.

125. 88. Pierre du Colombier (*op. cit.*, 41 ff.) argues that they date from 1545-7 and were executed by two different pupils after Goujon's design. I find it easier to believe that they were carried out about 1543, probably with the assistance of pupils.

127. 89. Goujon's reliefs on the Hôtel Carnavalet date from about the same period as the Fontaine des Innocents, and show the same stylistic qualities, though on the whole in rather coarser form, owing probably to the collaboration of assistants.

90. The same tendency is to be seen in the relief of a Victory over a mantelpiece at Écouen which is traditionally ascribed to Goujon. The attribution is convincing, but the relief must be much later than the other work at Écouen. It is based on an engraving after Rosso (cf. Kusenberg, *Le Rosso* (Paris, 1931), plate lxii).

91. A description of the room, written just after it was restored by Percier and Fontaine, speaks of the caryatids having been 'extrèmement dégradés' before the restoration. One must assume therefore that they were almost wholly recut, since they are now indistinguishable from the rest of the room, which, according to the same account, was entirely done from the designs of the two nineteenth-century architects. Apart from the caryatids and the balcony which they support, the only part of the room which had been completed in the sixteenth century was the tribune at the other end, and even there the relief over the chimneypiece is largely the work of Percier and Fontaine (cf. Dimier, 'Fragments de l'ancien hôtel d'O dans la décoration de la Salle des Cariatides au Louvre', *B.S.H.A.F.* (1924), 20, and P. du Colombier, *op. cit.*, 98, and plate xxiv).

92. *Op. cit.*, I, 320.

93. Cf. M. Mayer, 'La Fontaine de Diane du château d'Anet n'est pas de Benvenuto Cellini', *Revue de l'art ancien et moderne*, LXVIII (1935), 125. P. du Colombier (*op. cit.*, 132 ff.) believed that the statue is by a painter who made the drawing now in the Louvre (reproduced, P. du Colombier, *op. cit.*, plate 76), but this is not convincing. For a summary of the problem and a full bibliography see M. Beaulieu, *La Sculpture du Musée du Louvre*, II, *La Renaissance française*, 96.

129. 94. One piece of external evidence supports the attribution of the 'Diana' to Pilon. We know that in 1558 he was working with Philibert de l'Orme, to whom he supplied statues for the tomb of Francis I (cf. Babelon, *Germain Pilon*, 33), and therefore collaboration with this architect at Anet is plausible.

95. The dates have been held to present difficulties for this view, because till recently Pilon was supposed to have been born in 1536 or 1537. It is now known however that he was certainly born before 1528, probably about 1525 (cf. E. J. Ciprut, 'Chronologie nouvelle de la vie et des œuvres de Germain Pilon', *G.B.A.* (1969), II, 333).

96. Another work from Anet, a relief of Diana now in the Cluny Museum, is also usually attributed to Goujon (reproduced in P. du Colombier, *op. cit.*, plate 44), but it is more likely to be an early work of Pilon.

97. For Bontemps see M. Roy, *op. cit.* (Note 18), M. Beaulieu, 'Nouvelles Attributions à Pierre Bontemps', *Revue des Arts*, III (1953), 82, and *La Sculpture du Musée du Louvre*, II, *La Renaissance française*, 75.

98. Reproduced in J. F. Noël and P. Jahan, *Les Gisants*, I (1949), plate 20.

99. Reproduced in P. S. Wingert, 'The Funerary Urn of Francis I', *Art Bulletin*, XXI (1939), 383 ff. The themes may have been suggested by the panels on the fountain designed by Cellini for Francis I.

130. 100. Roy, *op. cit.*, I, 113, attributes to Bontemps the tomb of Admiral Chabot in the Louvre, and the monument to Guillaume du Bellay in the cathedral of Le Mans. These works form a complete stylistic unity with the Maigny tomb and there is every reason to accept their attribution to the sculptor, who thus appears as the most important carver of tombs about the middle of the century. In all these monuments the heads suggest the influence of followers of Michelangelo such as Bandinelli. The tomb of Guillaume du Bellay was erected in 1557 at the expense of his brother the Cardinal (cf. Heulhard, *Rabelais, ses voyages en Italie* (1891), 345-7).

There seems also to be a connexion between England and the atelier of Bontemps in the tomb of Sir Philip and Sir Thomas Hoby at Bisham, Berkshire (cf. Margaret Whinney, *Sculpture in Britain: 1530-1830* (Pelican History of Art) (London, 1964), 9.

Mention must also be made of the sculptor Ponce Jacques who in 1560 was given the commission to make forty full-length figures for Verneuil which are known to us from a drawing by du Cerceau in the British Museum.

101. Reproduced in M. Aubert, *La Sculpture française du Moyen-Age et de la Renaissance*, plate 55.

102. Reproduced in P. Vitry and G. Brière, *Documents de sculpture française de la Renaissance*, II, plate cxxix, no. 2.

103. For a recent summary of information about Domenico del Barbiere see *Fontainebleau (Grand Palais)*, 383, and *La Sculpture du Musée du Louvre*, II, *La Renaissance française*, 88.

104. Reproduced in M. Aubert, *op. cit.*, plate 58.

105. Reproduced in Vitry and Brière, *op. cit.*, II, plate cxix, no. 5.

131. 106. The setting, not shown in the illustration, which comes from a cast, and the little heart which the skeleton holds are later additions.

107. For instance, a stone statue in the museum at Dijon and a small bronze of very fine quality in the museum at Strasbourg. The Cimetière des Innocents,

Paris, also contained stone skeletons, one of which survives in the Louvre (no. 319). They must also have been frequent in the provinces (cf. L. Pressouyre, 'Sculptures funéraires du 16ᵉ siècle à Châlons-sur-Marne', *G.B.A.* (1961), I, 143).

108. One other work of sculpture, prepared by Italian sculptors for France in this period, but not actually delivered till much later, must be mentioned here, namely the bronze equestrian statue of Henry II which Catherine de' Medici invited Michelangelo to make in 1560. Michelangelo handed on the commission to Daniele da Volterra, promising to help him with advice. By the time of Daniele's death the horse was cast but not the figure of the King. The Wars of Religion prevented the continuation of the project, and the horse was only sent to France in the seventeenth century, when it was used for the statue of Louis XIII in the Place Royale (cf. pp. 163-4). Vasari gives a full account of the part of this story which concerns Michelangelo and Daniele da Volterra (cf. *Vite*, VII, 66 ff.).

The decorative arts rose to a high level under Henry II, as for instance in the making of ceremonial armour, many of the designs for which were made by Étienne Delaune, a beautiful draughtsman on a small scale (cf. B. Thomas, 'Die Münchner Waffenzeichnungen des Étienne Delaune und die Prunkschilde Heinrichs II von Frankreich', *Jahrbuch der kunsthistorischen Sammlungen in Wien*, LVIII (1962), 101).

The middle of the sixteenth century also saw the flowering of the school of painted enamels at Limoges which in the person of Léonard Limosin produced an artist of a high order. Such works as his portable altar for the Sainte-Chapelle (1553, Louvre) or the Apostles for Anet (1547, Chartres, Musée des Beaux-Arts) are mature and splendid examples of the style of Fontainebleau which, unlike the frescoes, have generally survived in perfect condition. For the latest accounts of Limosin and his contemporaries see *Fontainebleau (Grand Palais)*, 443 ff., and M. Marcheix, 'Les Émaux de Limoges à l'exposition de l'École de Fontainebleau', *Bulletin de la Société archéologique et historique du Limousin*, C (1973), 163 ff. Mlle Marcheix traces a number of engravings used by the artists of Limoges as models for their enamels, and she pursues this theme in her section of the catalogue of the James A. de Rothschild Collection at Waddesdon Manor (*Glass and Enamels* (London, 1977), 317).

CHAPTER 4

134. 1. For a vivid account of the activities of the Court of Henry III see F. Yates, *The French Academies of the Sixteenth Century*.

135. 2. Certain authors have attributed to Bullant the chapel built by Jean d'Amoncourt in the cathedral of Langres, but there is no evidence to support this theory. The inscription over the entrance to the chapel shows that it was begun in 1547, and the date 1549 is inscribed on the vaulting.

3. For the best account of Écouen see Gébelin, *Les Châteaux de la Renaissance*, 87. The monograph by C. Terrasse (Paris, 1925) gives further details and illustrations. The identity of Tâcheron has been established by Ciprut ('Un Architecte inconnu du Connétable Anne de Montmorency', *B.S.H.A.F.* (1956), 205).

4. The pavilion on the court side of the north wing is one of Bullant's clumsiest designs, at any rate in its present relation to the staircase to which it leads, though this may have been inserted later. The pavilion consists of two Orders, Doric and Corinthian, superimposed, the entablature of the upper Order being continuous, that of the lower breaking back over the two entrance doors. Above is a pair of dormer windows with curved pediments, linked by a higher blind panel which has a straight pediment overlapping the two dormers, the whole design being reminiscent of de l'Orme's façade of the Tuileries. The Tuileries, however, is later. Bullant may have known the arrangement in an earlier work of de l'Orme now lost, but it is also possible that the older architect may in this case have been influenced by the younger.

136. 5. The central pavilion on the outside of the north wing, apparently built after 1559, is, like that on the court front, a clumsy design, consisting essentially of two triumphal arch designs standing one above the other and supported on a ground floor pierced with four openings. This seems to be an instance of Bullant's using ideas which he had learned in Rome but not yet fully digested.

6. Cf. Gébelin, *op. cit.*, 101. It is sometimes said that an earlier example is to be found in the Petit Château at Chantilly, but apart from the uncertainty of the dates of the two buildings, the pilasters at Chantilly are not in fact, properly speaking, colossal (see below, p. 139).

7. In certain respects Bullant's use of the colossal Order is closer to Palladio than to Michelangelo. The latter only uses it in the form of pilasters, whereas Palladio in the court of the Palazzo Porto-Colleoni (1552) uses full columns. The Loggia del Capitano provides an even closer parallel, but is too late to have influenced Écouen, since it was not begun till 1571.

138. 8. Cf. Gébelin, *op. cit.*, 95.

9. Cf. a drawing by Blomfield, in his *History of French Architecture, 1494-1661*, I, plate 54.

10. The panels breaking into the entablature recall a

similar arrangement in the portico on the court side of the north wing at Écouen.

139. 11. The ground-floor windows were altered in the eighteenth century, so that they now come regularly below those of the upper floor. For their original arrangement see du Cerceau's engraving.

12. The dates make it impossible that there should have been any direct influence, and, as with the colossal Order at Écouen, this seems to be a case of parallel independent development.

13. In 1568 he was commissioned by the Constable's widow to design his tomb in the church of St Martin at Montmorency, of which fragments survive in the Louvre (cf. R. Baillargeat, 'Étude critique sur les monuments élevés par les seigneurs de Montmorency', B.S.H.A.F. (1952), 107). He also built for Montmorency the château of Offémont of which nothing remains but which is known from an eighteenth-century engraving.

14. Cf. pp. 97-8.

15. Marot's engraving shows the arms and initials of Marie de' Medici on the dormers of this section. The niches with the two halves of a curved pediment interchanged can also hardly date from Bullant's time, since they were first used by Buontalenti in the Porta delle Suppliche in the Uffizi, which can be dated after 1580 (cf. Venturi, Storia, XI, 2, figure 433).

140. 16. Hautecœur (Architecture, I, 543) confuses this Hôtel de Soissons, which he illustrates, with another in the rue de Grenelle near by, which was later bought and remodelled by the Duc de Bellegarde and Séguier (cf. Piganiol de la Force, Description de Paris, III (1742), 58 and 64).

17. Gébelin (op. cit., 169) points out that the design includes the arms of Lorraine and must therefore be later than 1575, the date of Henry III's marriage with Louise de Lorraine; and the scheme is engraved in the second volume of the Plus excellents bastiments, which appeared in 1579.

18. This scheme was executed slowly, as we can see from Silvestre's engraving of the middle of the seventeenth century, which shows the façade half finished.

19. Cf. Gébelin, op. cit., 83.

20. See Blunt, Philibert de l'Orme (London, 1958), 61 ff.

21. Reproduced in Châteaux et manoirs de France, Région de la Loire, III, plate 51. A rather similar mantelpiece is to be found at Écouen (reproduced in Gébelin, op. cit., figure 153). Another piece of decoration certainly inspired by Bullant, and perhaps actually designed by him, is in the farmhouse of La Courtinière, not far from Chenonceau (reproduced in Châteaux et manoirs de France, Région de la Loire, I, plates 82 and 83).

22. For du Cerceau see D. Thomson, Jacques et Baptiste du Cerceau (Paris, 1982).

23. It is often said that he went to Italy with Cardinal d'Armagnac, but there is no solid evidence for this, and Armagnac was in fact accompanied by Philander.

141. 24. It is sometimes said that he was influenced by Flemish decorative engravers such as Vredeman de Vries; but, if influence there was, it seems to have worked in the other direction. Many of du Cerceau's designs can, however, be traced to originals by Italians such as Enea Vico and Nicoletto da Modena (cf. Berliner, Ornamentale Vorlageblätter, 54 and passim). Some of his designs for mantelpieces seem to have been inspired by those in the Château de Madrid.

142. 25. We have already seen that Bullant's Hôtel de Soissons was also related to du Cerceau's projects, and among surviving examples may be quoted the wing built in 1586 by Guillaume Marchant for the Abbot of St Germain-des-Prés as his private residence (cf. Ciprut, 'L'Architecte du Palais abbatial de St Germain-des-Prés', B.S.H.A.F. (1956), 218; the building is engraved in A. Berty, Topographie, Bourg St Germain, plates opposite pp. 118, 120, and 122), and the Hôtel de Sandreville, 26 rue des Francs-Bourgeois (reproduced in G. Pillement, Les Hôtels de Paris, I, plate 2). Among the most important houses of the period must have been the Hôtel de Gondi, later de Condé, north of the Luxembourg, known from engravings by Marot and drawings by Gentilhâtre in the Royal Institute of British Architects volume. It was apparently built shortly before 1584, probably by Claude Villefaux, the author of the Hôpital St Louis (cf. M. Dumolin, Bulletin de la Société historique du 6e Arrondissement, XXVI (1925), 19 ff.). Its style is surprisingly restrained and simple for the period.

143. 26. The second Livre d'Architecture of 1561 is devoted to details such as mantelpieces and dormers, but the third of 1582 gives plans for country houses embodying the same practical spirit as the designs of 1559 for town houses.

27. As with the Tuileries, see above, Chapter 3, Note 29.

28. For Verneuil see R. Coope, 'The History and Architecture of the Château of Verneuil-sur-Oise', G.B.A. (1962), II, 291. For Charleval see R. Lemaire, 'Quelques précisions sur le domaine royal de Charleval', B.S.H.A.F. (1952), 7, and J. Adhémar, 'Sur le château de Charleval', G.B.A. (1961), II, 243. Adhémar shows that Italians were involved in the building of Charleval and in the making of the wooden model. Members of the du Cerceau family were concerned in the building of Montceaux for Gabriel d'Estrées and Marie de' Medici (cf. R. Coope, 'The Château of Montceaux-en-Brie', J.W.C.I., XXII (1959), 71). Here

again Salomon de Brosse was involved in the last stage, working for Marie de' Medici.

145. 29. Dr David Thomson has found documents to support this attribution and also to show that in 1583 Baptiste du Cerceau built the main block of the château of Liancourt, destroyed but known from engravings, and also the château of Fresnes, now called Ecquivilly. Another example of the same 'simple' but sophisticated style as appears at Liancourt is the château de Wideville, near Mantes, built in brick with stone quoins between 1580 and 1584 for a rich financier named Benoît Milon, which is near in plan to plate XXII in du Cerceau's third book (see L. Grodecki, 'La Construction du Château de Wideville et sa place dans l'architecture française du dernier quart du 16e. siècle', *Bulletin Monumental*, CXXXVI (1978), 135).

30. Reproduced in Hautecœur, *Architecture*, I, 319.

31. Reproduced in P. Parent, *L'Architecture civile à Lille* (Lille, 1925), plates 2 and 7.

146. 32. Cf. Hautecœur, *Architecture*, I, 313 and figure 223.

33. Sambin also built the Palais de Justice at Besançon, and published in 1572 a work on the use of caryatids illustrated with brilliant and fanciful engravings. For a full account of his work see H. David, *De Sluter à Sambin*, 401 ff.

34. Reproduced in Hautecœur, *Les Richesses d'art de la France, La Bourgogne, L'Architecture*, I, plate 40.

An astonishing monument of the late sixteenth century is the lighthouse at Cordouan, near the mouth of the Gironde, begun in 1584 on the order of Henry III and finished by Henry IV. As originally built it consisted of three cylindrical storeys, each articulated with an order of pilasters, of which the top one contained a chapel. This disappeared when the upper part of the lighthouse was rebuilt in the nineteenth century, but the original appearance of the building is known from drawings and engravings (cf. J. Guillaume, 'Le Phare de Cordouan, "Merveille du Monde", et monument monarchique', *Revue de l'Art*, VIII (1970), 33. The architect, named as Louis de Foix, is not otherwise known, but the lighthouse shows that he had a fine grasp of the Italianate idiom.

35. For a precise recital of the documents and dates see E. J. Ciprut, 'Chronologie nouvelle de la vie et des œuvres de Germain Pilon', *G.B.A.* (1969), II, 333. See also T. W. Gaehtgens, *Zum frühen und reifen Werk des Germain Pilon* (dissertation) (Bonn, 1967). For his work in the Louvre see M. Beaulieu, *La Sculpture du Musée du Louvre*, II, *La Renaissance française*, 126. His father, André Pilon, was a sculptor of some distinction, and the important 'Entombment' at Verteuil is probably a work from his atelier, perhaps executed with the help of his son (cf. R. Crozet, 'La Mise au

Tombeau de Verteuil', *B.S.H.A.F.* (1953), 19). According to Abel Lefranc ('Philibert de l'Orme, grand architecte du Roy Mégiste', *Revue du Seizième Siècle*, IV (1916), 148), a Germain Pilon *imagier* was recorded as working at Fontainebleau before 1550. Now that the earlier date of birth has been established for the sculptor, this reference may well be the first record of his work.

147. 36. Bartsch, 489. Reproduced in H. Delaborde, *Marc-Antoine Raimondi . . .* (Paris, 1888), 237. The design is traditionally attributed to Raphael and must in any case emanate from his studio. It is always assumed that the engraving represents an incense-burner, but there is no indication of scale, and in view of the adaptation of the design to a larger monument by Pilon it is permissible to wonder whether the original was not also planned to be on a monumental scale.

37. Cf. particularly the statues from the tomb of Claude de Lorraine at Joinville (reproduced in Vitry and Brière, *op. cit.* (Chapter 3, Note 102), II, plate cxxix, nos. 3 and 4).

38. Another possible source of influence on these bronzes is Leone Leoni, whose standing bronze statue of the Empress Isabella of 1553 is in many ways like Pilon's Catherine (reproduced in E. Plon, *Leone Leoni* (1887), plate opposite p. 102). Leoni's relations with France are not clear, but we know from letters that he paid a short visit to Paris in 1549 and that he was in touch with Primaticcio in 1550 (*op. cit.*, 48, 61, 64, etc.). Leone's son Pompeo uses the convention of life-size kneeling bronze figures for the tombs of Charles V and Philip II (reproduced *op. cit.*, plates opposite pp. 230 and 232) in the Escorial, but these are later than Pilon's Henry II.

148. 39. Now in the Louvre; reproduced in Vitry and Brière, *op. cit.*, II, plate cxxxiv, no. 5.

40. Cf. L. Dimier, *Le Primatice* (1900), 332. Some years later, in 1583, Pilon made two marble *gisants* of the King and Queen in coronation robes which are also at St Denis (reproduced in Babelon, *Germain Pilon*, figures 25-7). They have, however, none of the imaginative intensity of the nude *gisants* on the tomb.

41. Reproduced in Babelon, *op. cit.*, figures 42, 43, and 45.

42. *Ibid.*, figure 44.

43. *Ibid.*, figure 46.

44. *Ibid.*, figures 57-60.

45. See p. 95.

149. 46. Babelon, *op. cit.*, figures 28-30.

47. The terracotta is in the Louvre (Babelon, *op. cit.*, figure 31) and the marble in St Paul-St Louis (Babelon, *op. cit.*, figure 32).

48. Babelon, *op. cit.*, figure 34.

49. Reproduced in Babelon, *op. cit.*, figure 38.

50. The appearance of the tomb is known from sketches by Gaignières (Babelon, *op. cit.*, figures 77 and 78).

51. The pose and the relation of the figure to the tomb are reminiscent of the Amboise tomb at Rouen (cf. illustration 23).

151. 52. The head on the extreme left seems to be an idealized portrait of Michelangelo.

53. Venturi, *Storia*, x, 2, figures 166 and 167.

54. The monument is fully described and illustrated in C. Day, 'Le Monument funéraire de Montmorency', *G.B.A.* (1928), 11, 62.

55. Cf. J. B. Ward-Perkins, 'The Shrine of St Peter and its Twelve Spiral Columns', *Journal of Roman Studies*, XLII (1952), 21. In the sixteenth century they are rare even in Italy, though they can be seen in the Cortile della Mostra in the Castello at Mantua and in a grotto at the Villa d'Este at Tivoli. The idea of a central column flanked by figures is derived from Primaticcio's monument for the heart of Francis II, now at St Denis (reproduced in L. Dimier, *Le Primatice* (Paris, 1928), plate 48). Salomonic columns have a long previous history in French painting. They are used by Fouquet and in the sixteenth century by various draughtsmen and designers of tapestry cartoons.

56. For Prieur see M. Beaulieu, *La Sculpture du Musée du Louvre*, 11, *La Renaissance française*, 152; G. Bresa-Gautier, *Revue du Louvre*, XXI (1981), 10.

152. 57. Cf., for instance, Vitry and Brière, *op. cit.*, 11, plates 185-7. Mention must be made of Frémyn Roussel, a talented sculptor and a pupil of Primaticcio, who carved a marble figure of a funerary genius for the monument to the heart of Francis II (1564-5) now in the Louvre (cf. M. Beaulieu, *La Sculpture du Musée du Louvre*, 11, *La Renaissance française*, 167).

58. The fullest summary of information available about Caron is to be found in *Fontainebleau (Grand Palais)*, 31. For a note on his sources see G. Monnier and W. McAllister Johnson, 'Caron antiquaire', *Revue de l'Art*, XIV (1971), 23 (cf. F. Yates, *The Valois Tapestries* (London, 1959), and *Fontainebleau (Grand Palais)*, 354).

Owing to our ignorance of the painting of this time there is at present a danger of attributing to him works displaying what may really be the characteristics of the period rather than the individual painter. It may therefore be useful to set out the relatively certain facts about him.

As a basis for identifying his works we have the following evidence: a painting of the 'Massacres under the Triumvirate' in the Louvre signed and dated 1566; eight engravings after his designs by his sons-in-law, Thomas de Leu and Léonard Gaultier, in

Blaise de Vigenère's translation of Philostratus published in 1609; an equestrian portrait of Henry IV (1600), engraved by G. van Veen; and a drawing in the Louvre (no. 1956) with an early ascription to him. On the grounds of style we may safely add to these the remaining engravings in Philostratus, the drawings made for Houel to illustrate the *Histoire des rois de France*, and the greater part of those for the same author's *Histoire d'Artémise* and the designs of the Valois tapestries. The following paintings show the characteristics displayed in the certain works of Caron: 'Augustus and the Sibyl' in the Louvre; the 'Triumph of Winter' in the René Holzer collection; the 'Triumph of Summer' belonging to Messrs Wildenstein; the 'Astrologers studying an Eclipse' in the possession of W. J. Gaskin, London, and the 'Resurrection' at Beauvais. The 'Triumph of Spring' is known from a copy. Of the other pictures ascribed to Caron by MM. Lebel and Ehrmann I feel that judgement should be reserved till we are better informed about the artist's contemporaries. In the case of the 'Triumph of Semele' and the 'Night Fête with an Elephant', for instance, which do not seem to be by the same hand as those discussed above, it is worth remembering that Nicolas Bollery (active 1585, died 1630) is said by van Mander to have painted 'Night scenes, masquerades, Mardi Gras', and similar festivities (cf. van de Wall's translation (New York, 1936), 407), which would exactly apply to these paintings.

59. Caron is by no means alone in using these proportions. They are to be seen e.g. in the engravings of Bernard Salomon and Étienne Delaune. See *Fontainebleau (Grand Palais)*, 73.

60. In the 'Augustus' the group of the Emperor and the Sibyl is taken almost directly from a composition by Nicolò, but Caron has greatly intensified the affectation of the gestures (cf. A. E. Popham and J. Wilde, *The Italian Drawings of the Fifteenth and Sixteenth Centuries at Windsor Castle* (London, 1949), 185, figure 19).

155. 61. Published in full by L. Lalanne (Paris and London, 1883). For Cousin see *Fontainebleau (Grand Palais)*, 66. It is not always easy to distinguish his drawings from those of his father.

62. Reproduced in H. Voss, *Die Malerei der Spätrenaissance*, I, figure 87.

63. He may have known the pattern through Giulio Clovio's version which was engraved by Cort.

64. Reproduced in Venturi, *Storia*, IX, 6, figure 158.

65. The engravings to Ovid's *Metamorphoses* of 1570 and his *Epistles* of 1571 are attributed to him, and the stained-glass windows in St Gervais are said by Brice to be from his cartoons.

66. They are discussed and illustrated in P. Marcel and J. Guiffrey, 'Une Illustration du Pas d'Armes de Sandricourt', *G.B.A.* (1907), I, 277. The authors there attribute the drawings to the younger Bollery (active 1585, died 1630), but their style suggests an artist of an older generation.

67. The drawings are probably based on illuminated manuscripts of which several are known (see the article quoted above), but they are treated in a more or less Mannerist idiom, with figures unexpectedly cut off in the foreground.

68. Of painting in the provinces at this time it is impossible to give any coherent account. A few isolated names and works can be identified but in most cases we know nothing at all of the artists concerned. For a summary of the available information see S. Béguin, *L'École de Fontainebleau*. For painting in the region of Troyes in the later sixteenth century see M. Mathey, 'La Peinture à Troyes au 16ᵉ siècle', *Combat* (1.ii.1954).

156. 69. Reproduced in Dimier, *La Peinture de portrait*, I, plate 23. The work of all these minor artists is discussed and illustrated in the two works of Dimier and Moreau-Nélaton already quoted, but see also S. M. Percival, 'Les Portraits au crayon en France au XVIᵉ siècle', *G.B.A.* (1962), II, 529.

70. For a summary of this early genre painting see J. Adhémar, 'French Sixteenth-century Genre Painting', *J.W.C.I.*, VIII (1945), 191, and C. Sterling, 'Early Paintings of the Commedia dell'Arte in France', *Metropolitan Museum Bulletin*, N.S., II (1943), 11.

71. See L. Colliard, 'Tableaux représentants des bals à la cour des Valois', *G.B.A.* (1962), II, 146.

72. Owing to lack of space the applied arts have been left out of this and the preceding chapters, but a good account of their development in the sixteenth century will be found in F. Gébelin, *Le Style de la Renaissance en France*, which also has an excellent bibliography. Stained glass of the sixteenth century has been strangely neglected, but a detailed study of it would probably throw much light on the development of figure painting. The only available account is in M. Aubert, *Le Vitrail en France* (Paris, 1946). More upto-date information is given in *Fontainebleau (Grand Palais)*. For enamels see M. Marcheix, 'Limoges Enamels', in R. J. Charleston *et al.*, *Glass and Stained Glass, Limoges and other painted Enamels, The James A. de Rothschild Collection, Waddesdon Manor* (Fribourg, 1977). For furniture, armour, and jewellery, and for Flemish influence on the applied arts, see articles in the *Actes du colloque international sur l'art de Fontainebleau (1972)* (Paris, 1975), 45, 57, 71, 75, 87.

CHAPTER 5

159. 1. Rosalys Coope and François Charles James have carried out important research on the work of Collin which, it is hoped, will be published in the near future.

2. Cf. L. de La Tourasse, 'Le Château-Neuf de St Germain-en-Laye', *G.B.A.* (1924), I, 68. The project to enlarge the Château-Neuf probably went back to the reign of Charles IX, but nothing was done in his time.

164. 3. Cf. above, Chapter 3, Note 108. For these improvements see J. P. Babelon, 'L'Urbanisme d'Henri IV et de Sully à Paris', in *L'Urbanisme de Paris et l'Europe 1600-1800* (Essays in honour of P. Francastel) (Paris, 1969), 47. Babelon discusses in some detail previous schemes of the same type connected with the Pont Notre-Dame, the Palais des Tournelles, etc.

4. Engraved by Chastillon and Pérelle; photographs of it are reproduced in Louis Chéronnet, *Paris imprévu*, plates 64-7.

165. 5. As might be expected the idea was foreshadowed in the most advanced city-state of the early Renaissance, Florence, and is to be found expressed in theoretical form in Alberti (*Architecture*, Book VIII, chapter 6). It was carried out in a nearly systematic form by the Sforzas in the town of Vigevano, near Milan, about 1500.

6. Cf. Hautecœur, *Architecture*, I, 578. The model of Montauban was widely followed in its neighbourhood, for instance at Valence d'Agen and Lisle de Tarn.

7. These new quarters are referred to with wonder by Géronte in Corneille's *Le Menteur* (1643).

8. Cf. Hautecœur, *Architecture*, I, 541. Reproduced in G. Pillement, *Les Hôtels de Paris*, I, plate 8. The middle part of the façade was filled in during the eighteenth century.

9. Cf. F. C. James, 'L'Hôtel de Mayenne avant son acquisition par Charles de Lorraine', *Bulletin de la Société de l'histoire de Paris* (1940). J. A. du Cerceau the Younger was employed by the Duc de Bellegarde to alter the house which he had bought from the Duc de Montpensier in 1612. A few smaller hôtels survive which appear to date from the reign of Henry IV. The Hôtel d'Alméras (reproduced in G. Pillement, *op. cit.*, plate 11) is said to date from 1598; and a house at No. 7 rue des Grands-Augustins, on the site of the Hôtel d'Hercule, seems on stylistic grounds to date from *c.* 1600 though the documentary evidence about its building points to a much later date.

10. In that year it was bought by Guillaume Perro-

chel, *conseiller* and *maître d'hôtel du roi*. His wife was called Françoise Le Buisson, and their initials appear over the windows of the house, surrounded by a sprig of leaves and berries, which might be *gui*, alluding to his Christian name, or *buis*, referring to her surname. Details of the various owners of the house are given by the Abbé Louis Brochard (*Saint Gervais, Histoire de la paroisse* (Paris, 1950), 73). The author connects the monogram with Antoine Le Fève de la Boderie and his wife Jeanne Le Prévost, but they owned the house from 1608 to 1615, a date at which a house of this type could hardly have been built.

166. 11. On the Hôtel de Sully see C. Grodecki, 'Les Fresques d'Antoine Paillet à l'Hôtel de Sully', *Art de France*, III (1963), 91. Jean du Cerceau certainly made the *toisé* of the masonry, but the attribution of the design to him is only based on a statement by Sauval.

12. A house at No. 6 rue de Seine, which can be dated *c*. 1622 (cf. Dumolin, *Études*, I, 187), is very similar to one of these.

167. 13. The Hôtel d'Astry can be safely attributed to Le Muet for its similarity in style to d'Avaux and because the door corresponds almost exactly to an engraving (plate 8) in his *Divers traictez d'architecture* (Amsterdam, 1646). According to Dumolin (*op. cit.*, III, 79) the Hôtel d'Astry was built in 1647. In addition Le Muet built two houses in the rue des Petits Champs, now destroyed, which are engraved in his book, and one for Tubeuf in the rue Vivienne, which survives much altered and is engraved in the *Petit Marot*. For the Hôtel de l'Aigle see Mauban, *Jean Marot*, 246. Le Muet was also involved in the Hôtel de Chevreuse, later de Luynes, in the Faubourg St Germain, destroyed but engraved in the *Grand Marot*. J. P. Babelon has found documents which prove that Le Muet was responsible for building the Hôtel d'Assy, next to the Hôtel de Soubise, in 1656, though little of his work survives (cf. J. P. Babelon, 'L'Hôtel d'Assy, œuvre de Pierre Le Muet', *Paris et Île-de-France*, XVI-XVII (1965-6), 231). M. Claude Mignot is preparing a doctoral thesis on Le Muet.

14. For Thiriot see R. A. Weigert, 'L'Hôtel de Chevry-Tubeuf', *B.S.H.A.F.* (1945-6), 18, 'Jean Thiriot', *B.S.H.A.F.* (1962), 189, and 'Jean Thiriot et le duc d'Angoulême', *B.S.H.A.F.* (1953), 120.

168. 15. Rosalys Coope has kindly allowed me to refer to the unpublished documents about Grosbois in the Minutier Central, on which these statements are based. The builder of the parts of Grosbois carried out for the Duc d'Angoulême was Thiriot, but it is not clear whether he was the designer (cf. R. A. Weigert, 'Jean Thiriot et le duc d'Angoulême', *B.S.H.A.F.* (1953), 120).

16. This feature is very unusual, but it occurs in one of the elder du Cerceau's engraved designs (*Troisième Livre*, plate vi) which may be the origin of both Grosbois and the Fontainebleau stables.

17. There are many other examples of this simple brick-and-stone style in the neighbourhood of Paris, such as Courances, *c*. 1624; Baville (*Châteaux et manoirs de France, Île-de-France*, I, 35); Bombon (*op. cit.*, II, 40); Courquetaine (*op. cit.*, II, 28); Ormesson (*op. cit.*, II, 17); Grignon, between Versailles and Mantes.

170. 18. This provincial style occurs in all parts of France: at the château of Beaumesnil in Normandy (reproduced in H. de Saint-Sauveur, *Châteaux de France, Normandie* (Paris, n.d.), plates 18-23), built between 1633 and 1640; at Cheverny, near Blois (cf. *Châteaux et manoirs de France, Région de la Loire*, IV, 20), built in the same years; at Bussy-Rabutin as late as 1649. Le Muet built three châteaux which show the same manner: Pontz in Champagne and Chavigny in Touraine, both largely destroyed, but known from the engravings in Le Muet's book, and Tanlay, near Tonnerre, which still stands complete (cf. L. Hautecœur, *Les Richesses d'art de la France, La Bourgogne, L'Architecture*, I, plates 41-4).

171. 19. For de Brosse see Rosalys Coope, *Salomon de Brosse and the Development of the Classical Style in French Architecture 1565-1630* (London, 1972).

20. Rosalys Coope has discovered a contract for the beginning of work dated 1612, and the château was described in 1619 in its completed state by a visitor, called Bergeron (cf. Pannier, *Salomon de Brosse* (Paris, 1911), 19). Mme Potier had considerable connexions with Italy, and Mrs Coope has suggested that it may have been through her that de Brosse in his later years seems to have become aware of recent architectural activities in Italy. At Blérancourt, Rennes, and the Luxembourg he moves away from the manner of the last du Cerceau towards a much more monumental Italianate style and many details are based on engravings after Vignola. Further, in the chapel of the Stable Court at Montceaux he seems to have imitated the Vignolesque façade of the church at Capranica.

21. Cf. A. Hustin, *Le Palais du Luxembourg* (1904).

22. Other recorded works by him are as follows: a door for the Hôtel de Soissons, copied from Vignola; work on the Hôtel de Bouillon, later Liancourt, which probably included the principal court (datable 1613; cf. Berty, *Topographie, Bourg St Germain*, 239, note 2). De Brosse's contribution to the building of Montceaux has been defined by R. Coope, 'The Château of Montceaux-en-Brie', *J.W.C.I.*, XXII (1959), 71. For the problem of St Gervais, cf. Note 27 below.

172. 23. In the nineteenth century two more pavilions were added on the garden front, and the whole façade was moved forward.

24. Now destroyed but known from engravings by Marot and Silvestre, the former showing the architect's original scheme, the latter what was actually carried out. A novelty in the plan of Coulommiers is the introduction of curved colonnades linking the *corps-de-logis* with the wings in the court.

25. For the decoration of the interior of the palace see p. 189. The gardens were finished after de Brosse's death in 1626 by Tommaso and Alessandro Francini, who almost certainly designed the Fontaine de Médicis (moved and reconstructed with modifications in the nineteenth century). Alessandro Francini also worked at Fontainebleau and in 1635 designed for Claude de Bullion the grotto at Wideville, the interior of which was decorated by Vouet. His *Livre d'Architecture*, containing designs for fountains, was published in 1631 and exercised a great influence for a century or more. It was translated into English by Robert Pricke (1669), and one of its plates supplied the model for the grotto at the top of the cascade at Chatsworth, built in 1702. The descendants of Tommaso were responsible for many of the waterworks at Versailles. For the Francini see A. Mousset, 'Les Francines', *Mémoires de la société de l'histoire de Paris*, LI (1930).

174. 26. The plans and engravings given by Pannier, *op. cit.*, 76 ff., show that the main façade at least was executed according to de Brosse's design.

176. 27. Brochard (*Saint Gervais*, Paris, 1938) has published documents which prove that the actual builder of the façade was Clément Métezeau, but the early guide books unanimously name de Brosse as the author of the design, and there seems to be every reason to believe their testimony.

28. Generally speaking the church building of the period is *retardataire*, cf. St Étienne-du-Mont (1610) and other examples listed by Hautecœur (*Architecture*, I, 603 ff.). The Jesuits alone, through their leading architect Étienne Martellange (?1569–1641), produced an individual style (cf. Hautecœur, *op. cit.*, I, 558 ff.; Vallery-Radot, 'Le Séjour de Martellange à Rome 1586–87', *Revue des Arts*, XII (1962), 218; P. Moisy, 'Le Recueil des plans jésuites de Quimper', *B.S.H.A.F.* (1950), 70 ff., and 'Martellange, Derand et le conflit du baroque', *Bulletin Monumental*, CX (1952), 237). In many of their chapels, e.g. at Rouen (begun *c.* 1610), pure Gothic structural forms survive combined with classical decoration. In addition St Joseph-des-Carmes, Paris (1615–20), must be mentioned as an early though elementary attempt to in-

troduce a Roman manner in French church architecture (cf. Dumolin and Outardel, *Les Églises de France, Paris et la Seine* (Paris, 1936), 128).

The western parts of Brittany were the scene of great activity in church building during this period, but in a style essentially late sixteenth-century in character. St Thégonnec, Guimiliau, Lampaul, and many other villages in Finistère can show churches, *ossuaires*, and calvaries, astonishingly rich and complex in their carved decoration, but many decades behind the taste of the capital, and coarse and heavy in execution.

An interesting but isolated example of the penetration of up-to-date Italian ideas into France occurs in the chapel of the Pénitents Bleus, now the church of St Jérôme, Toulouse. Its plan is composed of a series of circular and oval curves otherwise hardly to be found in French architecture. It was built between 1622 and 1625 by Pierre Levesville, who came from Orléans and was trained in Italy. He is recorded in Rome, but it is likely that he also knew Milan, since the plan of the chapel is closer to the work of Francesco Maria Ricchino than to anything available at the time in Rome. Cf. Y. Bruand and B. Tollar, 'L'architecture baroque toulousaine', *G.B.A.* (1972), II, 266.

29. Hence the term *Ohrmuschelstil* given to this type of ornament.

178. 30. The best and most recent account of the Second School of Fontainebleau is in S. Béguin, *L'École de Fontainebleau*, but much additional information is to be found in the relevant entries in *Fontainebleau (Grand Palais)*. For Dubois see also S. Béguin, 'Quelques nouveaux dessins d'Ambroise Dubois', *Revue de l'art*, XIV (1971), 31 ff.

31. For Dubois see *Fontainebleau (Grand Palais)*, 81. The water-colour copies by Percier in the library of the Institut de France of the decoration in the Galerie de Diane give some idea of the decorative scheme but falsify the Mannerist character of the paintings. A few much-restored fragments of the originals are preserved in the Galerie des Assiettes at Fontainebleau. For the Theagenes and Chariclea series see W. Stechow, 'Heliodorus' *Aethiopica* in Art', *J.W.C.I.*, XVI (1953), 144.

179. 32. For Dubreuil see *Fontainebleau (Grand Palais)*, 91, and S. Béguin, 'Nouvelles attributions à Toussaint Dubreuil', *Études d'art français offertes à Charles Sterling* (Paris, 1975), 165. Mme Béguin has identified an important pupil of Dubreuil (*ibid.*, 109).

33. Dubreuil's drawings in the Louvre are reproduced in the *Inventaire général, École française*, by Guiffrey and Marcel, V, 33. For the tapestries see Fenaille, *État général des tapisseries*, V, 231 ff.

In 1600 Antoine de Laval, who held the post of Géographe du Roi, produced a pamphlet called *Des peintures convenables aus Basiliques et Palais du Roy, memes à sa Gallerie du Louvre à Paris* in which he proposed a scheme for decorating the Petite Galerie – and perhaps also the Long Gallery – with portraits of the Kings of France, maps of the provinces, and paintings of the great French victories from that of Charles Martel over the Moslems to those of his patron Henry IV. The idea of decorating such a gallery with historical as opposed to mythological themes was new in France and must have influenced later projects, such as the Rubens Gallery at the Luxembourg and the Galerie des Hommes Illustres painted for Richelieu at the Palais Royal by Vouet and Philippe de Champaigne (cf. J. Thuillier, 'Peinture et politique: une théorie de la galerie royale sous Henri IV', in *Études d'art français offertes à Charles Sterling* (Paris, 1975), 217).

An echo of Laval's project may be found in the series of stained-glass windows designed, probably by Linard Gontier, for the Hôtel des Arquebusiers at Troyes about 1620-4, which include battle-scenes, sometimes with allegorical scenes such as Henry IV as Jupiter with Louis XIII as Hercules in the foreground (cf. J. Rigal, 'Deux dessins de Linard Gontier pour des vitraux de l'Hôtel de l'Arquebuse à Troyes', *Revue du Louvre*, XXVII (1977), 70).

34. For Fréminet see *Fontainebleau (Grand Palais)*, 113.

35. The fullest account of his activity is given by F. G. Pariset, 'Jacques de Bellange', *B.S.H.A.F.* (1955), 96. His etchings are listed in R. D. V, 81, and XI, 9. His drawings are reproduced by P. Lavallée, *Le Dessin français du treizième au seizième siècle*, and Kamenskaya, 'Les Dessins inédits de Jacques de Bellange au musée de l'Ermitage', *G.B.A.* (1960), I, 95. For the etchings see N. Walch, *Die Radierungen des Jacques Bellange* (Munich, 1971).

36. Two paintings signed by Bellange, representing the Virgin and the Angel of the Annunciation, are now in the Kunsthalle at Karlsruhe (cf. Anna Maria Ressner, in *Die Kunstinventare der Markgrafen von Baden-Baden* (Bühl, 1941), 62, 120, 187, and plate 14). Dr Grete Ring pointed out that the Virgin is a slightly altered version of Dürer's 'Fürlegerin' in Augsburg. This connexion suggests that Bellange was inspired by earlier German art, and this is confirmed by the use which he made of Schongauer's engraving of the 'Carrying of the Cross' in his own etching of the same subject. Other paintings attributed to Bellange in the museums of Nancy are published by Pariset ('Peintures de Jacques de Bellange', *G.B.A.* (1936), I, 238), but, although all of them must

be works of the Nancy School, their attribution to Bellange must remain in doubt.

180. 37. Some of the figures recall the designs of Goltzius, Bloemart, or Jan Saenredam. In 'Christ carrying the Cross' the crowd pressing into the narrow gully on the left and grouped round a horse seen exactly from behind suggests the influence, probably indirectly, of Bruegel's 'Conversion of St Paul' at Vienna.

38. Reminiscent of Beccafumi; for instance the group in the foreground of the 'Esther' in the National Gallery, London.

182. 39. For Callot's etchings see J. Lieure, *Jacques Callot* (Paris, 1924-7); for his drawings see D. Ternois, *Jacques Callot. Catalogue complet de son œuvre dessiné* (Paris, 1962), and for a general discussion of his artistic career see D. Ternois, *L'Art de Jacques Callot* (Paris, 1962). For further details see P. Marot, 'Jacques Callot. Sa vie, son travail, ses éditions, Nouvelles Recherches', *G.B.A.* (1975), I, 153, and II, 185.

183. 40. Callot's 'Temptation of St Anthony' was an essay in the manner of Bosch.

188. 41. For an account of Deruet see Pariset, 'Claude Deruet', *G.B.A.* (1952), I, 153, and 'La Diane de Deruet au Musée Lorrain', *Revue des Arts*, X (1960), 261. Deruet also practised portraiture in a rigid Late Mannerist style, as in a portrait of a young woman as Astrée in the Musée des Beaux-Arts at Strasbourg, said to represent Julie d'Angennes, the celebrated daughter of Mme de Rambouillet.

42. For Lallemant see A. Blunt, *Nicolas Poussin* (1967), 16 ff., Oliver Millar, 'An Exile in Paris: The Notebooks of Richard Symonds', *Studies in Renaissance and Baroque Art presented to Anthony Blunt* (London, 1967), 157 ff., B. de Montgolfier, 'Georges Lallemant', *B.S.H.A.F.* (1967), 49, and M. Dargaud, 'Un tableau retrouvé de Georges Lallemant', *B.S.H.A.F.* (1974), 17. To the works mentioned by these authors must be added a large altarpiece of 'St Martin dividing his Cloak', almost certainly from the church of Ste Geneviève (cf. Millar, *op. cit.*, 159) (with the Heim Gallery, London, 1979).

43. For Vignon see W. Fischer, 'Claude Vignon', *Nederlands Kunsthistorisk Jaarboek*, XIII (1962), 105, and XIV (1963), 137, P. P. Bassani, 'Claude Vignon', *Storia dell'Arte*, XXVIII (1976), 259, and B. Nicolson, *The International Caravaggesque Movement* (London, 1979), 107.

189. 44. For Valentin, see *Valentin et les caravaggesques français*, exhibition catalogue, Grand Palais (Paris, 1974), Nicolson, *op. cit.*, 103, and J. Bousquet, 'Valentin et ses compagnons', *G.B.A.* (1978), II, 101 (based on the parish archives).

45. For Finson, see Nicolson, *op. cit.*, 47.

46. Cf. A. Blunt, 'A Series of Paintings illustrating the History of the Medici Family executed for Marie de Médicis', *Burl. Mag.*, CIX (1967), 492 ff., 562 ff.

47. Cf. C. Sterling, 'Gentileschi in France', *Burl. Mag.*, C (1958), 112.

48. For Pourbus see J. Wilhelm, 'Pourbus peintre de la municipalité parisienne', *Art de France*, III (1963), 114, 'La Vierge de la famille de Vic', *Revue des Arts*, VIII (1958), 221, 'Le Portrait de Ruzé', *B.S.H.A.F.* (1963), 25.

190. 49. Pourbus also executed portrait groups of Prévôt des Marchands and the Échevins (Lord Mayor and Aldermen) of the city of Paris, probably in 1614 and 1616. Fragments of one picture survive in the Hermitage at Leningrad (cf. Wilhelm, 'Pourbus peintre de la municipalité parisienne', *Art de France*, III (1963), 44). Similar groups were commissioned by other town councils, for instance at Narbonne, and at Toulouse where Jean Chalette (1581-1645) was employed for this purpose. Another popular portrait painter was Ferdinand Elle the Elder (b. before 1585, d. 1637), who painted a portrait of Mme de Châtillon at Hampton Court (reproduced A. Blunt, *Nicolas Poussin* (1967), 17). The sixteenth-century style of portrait drawing continues in Daniel Dumonstier and in a series of highly naturalistic heads traditionally attributed to Lagneau, but certainly by different hands, one of them probably a Lorrainer very close to Georges de La Tour (see A. Blunt, 'Georges de La Tour at the Orangerie', *Burlington Magazine*, CXIV (1972), 524).

For Chalette see the catalogues of two exhibitions held at the Musée Paul Dupuy at Toulouse: *Le Dessin toulousain de 1610 à 1730* (1953), and *Les Miniaturistes du Capitole de 1610 à 1790* (1956).

50. There was a colony of Flemish painters active in Paris in the last decades of the sixteenth century and during the reign of Henry IV, of whom the most interesting is Jerome Francken (1540-1610), who painted a number of religious pictures for Paris churches, including an 'Adoration of the Shepherds' commissioned by Christophe de Thou in 1585 for the Cordeliers and now in Notre-Dame. It is unusual in containing not only the portrait of the donor, kneeling in modern dress, but those of other members of the de Thou family acting the parts of the shepherds; cf. P. M. Auzas, *Hiérosme Francken dit Franco* (Brussels, 1968).

51. For Franqueville see R. de Francqueville, *Pierre de Franqueville* (Paris, 1968).

52. For Jacquet see E. J. Ciprut, *Mathieu Jacquet* (Paris, 1967), M. Beaulieu, *La Sculpture au Musée du Louvre*, II, *La Renaissance française*, 106, J. Ehrmann, 'La Belle Cheminée de Fontainebleau', *Actes du*

Colloque international sur l'art de Fontainebleau (1972) (Paris, 1975), 117, and J. P. Samoyault, 'Le Château de Fontainebleau sous Henry IV', *Revue du Louvre* (1978), 212. For funerary sculpture of the period see P. Chaleix, 'De la sculpture funéraire sous Henri IV et Louis XIII', *G.B.A.* (1973), I, 227, (1977), II, 85

CHAPTER 6

195. 1. The *Précieux* also had a definite taste in the visual arts, and they continued to admire Late Mannerism long after it was outmoded in other Parisian circles (cf. A. Blunt, 'The *Précieux* and French Art', *Fritz Saxl. A Volume of Memorial Essays from his Friends in England* (London, 1957), the catalogue of the exhibition *Les Salons littéraires au XVIIe siècle* (Bibliothèque Nationale, 1968), and E. P. Mayberry Senter, 'Les Cartes allégoriques romanesques du XVIIe siècle', *G.B.A.* (1977), I, 133).

2. For Lemercier see Hautecœur, *Architecture*, I, 507, 528.

196. 3. Cf. T. Sauval, 'De l'hôtel de Rambouillet au Palais Cardinal', *Bulletin Monumental*, CXVIII (1960), 169, 'Le Palais Royal de la mort de Richelieu à l'incendie de 1763', *ibid.*, CXX (1962), 173, and 'L'Appartement de la Reine au Palais-Royal', *B.S.H.A.F.* (1968), 65. A few of the paintings listed in the inventory – including works attributed to Titian and Giulio Romano but also others by more recent artists, for instance Guercino, Cortona, and Sacchi – were sent to Cardinal Richelieu in 1634 and 1638 by Cardinal Antonio Barberini through the agency of Mazarin (cf. M. Laurain-Portemer, 'Mazarin militant de l'art baroque au temps de Richelieu', *B.S.H.A.F.* (1975), 65). The 1638 list of gifts also included a painting by Sacchi for Chavigny, a Cortona for Séguier, and an Orazio Gentileschi for Bullion. Dr Honor Levi has discovered inventories of the Palais Cardinal and Rueil made after Richelieu's death which give full details of his collection there (dissertation) (Edinburgh, 1978).

4. The correct dates are given by L. Batiffol (*Autour de Richelieu* (Paris, 1937), 113 ff.). The college was begun in 1626 and mainly finished by 1629 when the plans for the new church were prepared; but the building of the latter does not seem to have been started till 1635. For the court elevation of the Sorbonne, designed by Lemercier and executed by Cottard in 1648, see Le Moël, 'Archives architecturales parisiennes en Suède', *L'Urbanisme de Paris et de l'Europe 1600-1680* (essays in honour of P. Francastel) (Paris, 1969), 111.

5. For Rueil, which was pulled down in the early nineteenth century, see Cramail, *Le Château de Rueil* (Paris, 1888), and G. Poisson, 'Les Vestiges du do-

maine de Richelieu à Rueil', *B.S.H.A.F.* (1956), 13.

6. The château of Liancourt is often attributed to him, but Dr Thomson has discovered documents which prove that the main block was built by Baptiste du Cerceau.

7. Sauval attributes to Lemercier the Hôtel d'Effiat and the Château de Chilly built by the same patron. Dézallier d'Argenville and Dulaure, however, ascribe the château to Clément Métezeau, and M. Ciprut has discovered documents which prove that he is in fact the designer ('La Construction du château de Chilly-Mazarin', *B.S.H.A.F.* (1961), 205).

8. On the Oratoire, cf. Dumolin and Outardel, *Les Églises de France. Paris et la Seine*, 131, and P. Moisy, 'Le Recueil des plans jésuites de Quimper', *B.S.H.A.F.* (1950), 80.

9. At Rueil he only added a façade to the existing medieval church.

10. Engraved by Marot. An interesting but freer experiment in the same genre was the front of St Laurent, begun in 1621 (destroyed 1862, but reproduced in Dumolin and Outardel, *op. cit.*, 80).

11. Reproduced in Venturi, *Storia*, XI, 2, figure 726.

12. Only in the Sorbonne does he use full columns in the lower storey, and there it may be noticed he follows the sixteenth-century French manner of putting over them an unbroken entablature.

198. 13. For a full account of this church see S. Ortolani, *San Carlo ai Catinari* (Rome, n.d.). The façade was not carried out according to Rosati's design. The similarity between the two churches extends to the interior, where the barrel-vault and the particular Orders used are very alike.

14. The four small turrets round the base of the dome may have been suggested by the small domes on St Peter's.

15. Lemercier may have derived the general idea of the free-standing portico from Michelangelo's design for St Peter's, or he may have adapted it from Palladio's villa designs. There was, however, no actual model for it in Rome at his time. The placing of the cartouche in the field of the pediment was common in Rome, e.g. in della Porta's S. Luigi dei Francesi.

16. Lemercier also designed an altar for his parish church, St Germain l'Auxerrois, executed between 1639 and 1641 by Cottard (cf. Le Moël, *op. cit.*, 131).

17. The façade of the Sorbonne and good elevations of the Palais Royal are recorded in drawings at Stockholm (cf. Le Moël, *op. cit.*, 108, 110).

18. Top storey and dome were certainly not executed and probably not designed till 1641 (cf. A. Blunt, 'Two Unpublished Drawings by Lemercier for the Pavillon de l'Horloge', *Burl. Mag.*, CII (1960), 447).

19. Cf. Chapter 7, Note 60.

199. 20. Their use in this position may possibly have been suggested by the Roman Palais des Tutelles at Bordeaux, which still stood in Lemercier's day, and was engraved in Claude Perrault's *Les dix livres d'architecture de Vitruve*, 219. According to Perrault's description, the Roman caryatids, like those on the Louvre, were unusual in that they supported the entablatures of pilasters, not of columns. Those of Lemercier, however, seem to be unique in one feature: they occur in pairs, one farther back than the other, like stepped-back pairs of pilasters. At an unknown date, but certainly towards the end of his career, Lemercier produced a design for the east front of the Louvre, known from the engraving by Marot.

21. The Palais Cardinal was admitted by all, including Richelieu, to have suffered from being composed of a series of additions and, as far as we can judge from engravings and drawings, it must always have presented a confused appearance. The Hôtel d'Effiat seems to have been a successful small house. It has been destroyed, but is reproduced from an old photograph in G. Pillement, *Les Hôtels du Marais* (Paris, 1945).

22. Cf. Berty, *Topographie, Bourg St Germain*, 239. Evelyn visited the completed house in 1644 (cf. *Diary*, under date I.iii.1644, N.S.). It was pulled down in the first years of the nineteenth century, but is known from engravings by Silvestre and in the *Petit Marot*.

23. This vestibule with its triple opening was to be the basis of a favourite plan of Le Vau.

24. For the Château de Richelieu see H. Wischermann, *Schloss Richelieu* (dissertation) (Freiburg i. B., 1971), and for the town *idem*, 'Ein unveröffentlicher Plan der Stadt Richelieu von 1633', *Zeitschrift für Kunstgeschichte*, XXXV (1972), 302.

201. 25. In one room, for instance, the frieze was decorated with the paintings by Mantegna, Costa, and Perugino from the studio of Isabella d'Este at Mantua, and the three Poussin 'Bacchanals'.

26. For a full account of Mansart's work, with complete publication of documents and drawings and a full bibliography, see A. Braham and P. Smith, *François Mansart* (London, 1973).

202. 27. An old photograph reproduced in P. Jarry, *La Guirlande de Paris* (Paris, 1928), plate 1), not noticed by Smith and Braham, shows the side walls of this pavilion before it was destroyed. It had three windows like that shown on illustration 163 but without pediments and a balcony carried by a heavy console which foreshadows that on the Hôtel Guénégand-des-Brosses.

213. 28. C. Mignot ('L'Église du Val-de-Grâce', *B.S.H.A.F.* (1975), 101 ff.) has shown that, when Lemercier replaced Mansart in 1646, work was almost

suspended till Le Muet, assisted by Le Duc, took charge in 1655 after the Fronde was over.

221. 29. Colbert also invited Bernini to make designs for the chapel (cf. A. Braham, 'Bernini's Design for the Bourbon Chapel', *Burl. Mag.*, CII (1960), 443).

222. 30. For a general account of Le Vau's career see Hautecœur, *Architecture*, II, 76 ff., 248 ff. A more detailed account of the private houses which he built in Paris is given by Constance Tooth, 'The Early Private Houses of Louis Le Vau', *Burl. Mag.*, CIX (1967), 510 (published after her death with modifications by P. Smith).

31. For these houses see D. Feldmann, *Maison Hesselin und andere Bauten von Louis Levau (1612/13–1670) auf der Île Saint-Louis in Paris* (dissertation) (Hamburg, 1976). For Hesselin, see R. de Crèvecoeur, 'Louis Hesselin', *Mémoires de la Société de l'Histoire de Paris*, XXII (1895), 225.

223. 32. The ceiling of the gallery of the Hôtel de Bretonvilliers was decorated by Sébastien Bourdon (cf. Wilhelm, 'La Galerie de l'hôtel de Bretonvilliers', *B.S.H.A.F.* (1956), 137).

33. The facts about the Hôtel Lambert are given in Dumolin, *Études*, III, 90 ff. The house is engraved in Blondel's *Architecture française*, and the painted decorations by Picart in *Les Peintures . . . dans l'Hôtel du Chastelet* (Paris, 1746). Vacquier's *Vieux hôtels de Paris* devotes a whole volume to the house.

224. 34. The use of the gallery recalls Mansart's designs at Blois and Maisons.

35. The gradual change from the narrow and dark lower flight to the open luminous space at the top was developed by German Baroque architects, particularly by Balthasar Neumann at Bruchsal.

226. 36. The interior was brilliantly restored under the direction of the Monuments Historiques (cf. *B.S.H.A.F.* (1946-7), 125). For the Cabinet de l'Amour, see J. P. Babelon *et al.*, *Le Cabinet de l'Amour* (exhibition in the series *Les Dossiers du département des peintures*, Louvre, 1972). For the appearance of French rooms in this period see P. Thornton, *Seventeenth-century Interior Decoration in England, France and Holland* (London, 1978).

227. 37. Cf. L. Dimier, 'Une Erreur corrigée touchant l'Hôtel Lambert', *B.S.H.A.F.* (1927), 30.

228. 38. For a discussion of the ceiling of the gallery see Carl Goldstein, 'Studies in Seventeenth Century French Art Theory and Ceiling Painting', *Art Bulletin*, XLVII (1965), 249.

39. Cf. G. Guillaume, 'Le Lotissement du Moulin de la Butte', *B.S.H.A.F.* (1962), 177.

40. This scheme, with a vestibule running parallel to the façade and leading axially to the staircase, seems to have been introduced at about the same time in

Rome, where it appears in Antonio del Grande's addition to the Palazzo Doria, opposite the Collegio Romano. It is adumbrated in one of Antoine Le Pautre's designs for private houses (the sixth project), but here the vista would have been blocked owing to the fact that the lower stage of the staircase was composed of two side flights which led at the landing to a single central flight, so that from the vestibule the visitor would only have seen a niche under this flight and not an actual view up the staircase.

229. 41. The documents show that the actual builder of the house was Jean Boullier of Bourges (cf. Dumolin, 'Quelques artistes inconnus du 17ᵉ siècle', *B.S.H.A.F.* (1928), 364), but Boullier seems to have been more a mason and a surveyor than an architect, and it is difficult to believe that he could have produced so accomplished a design and not have built anything else of interest.

42. Engraved by Silvestre and in the *Petit Marot*. The upper limit of date is given by the fact that Perrier painted there before 1645 (cf. *Mémoires inédits*, I, 132).

43. Here again Le Vau is untidy in his use of Orders, applying a colossal Order to the end pavilions, the rest of the building being simply rusticated.

230. 44. This arrangement of vestibule, salon and staircase was imitated in England, for instance by Vanbrugh at Castle Howard and Blenheim.

233. 45. Cf. J. Cordey, 'Le grand salon ovale de Vaux-le-Vicomte et sa décoration', *Revue de l'Art*, XLVI (1924), 233.

46. It is in itself typical that Lebrun should have chosen as his model the Pitti decorations and not the much more Baroque Barberini ceiling by the same artist.

47. He had already worked for the Queen Mother in the gardens of the Tuileries and in the Jardin de la Reine (1643) at Fontainebleau in 1645-6 (cf. L. Châtelet-Lange, 'Le Nôtre et ses jardins', *Art de France*, IV (1964), 302, and J. P. Samoyault, 'Le Nôtre et le Jardin de la Reine de Fontainebleau', *B.S.H.A.F.* (1973), 87).

234. 48. In addition to these major works, Le Vau made alterations to Meudon for Servien, who bought it in 1654 (its state after Le Vau's improvements is shown in Hautecœur, *Architecture*, II, 100). He was also involved in the building of several churches, including St Louis-en-l'Île and St Sulpice, but his share is hard to determine (Hautecœur, *op. cit.*, 94 ff.).

His younger brother, François (1613-76), was also an architect of considerable reputation. His certain works include the châteaux of Bercy, Lignières, and St Fargeau (Hautecœur, *op. cit.*, 114 ff.), and two buildings often attributed to Louis may actually be

his, namely the châteaux of St Sépulchre, near Troyes, built for Hesselin (engraved in the *Grand Marot*) and of Sucy-en-Brie (cf. *Châteaux et manoirs de France, Île-de-France*, 11, plates 47-51, and *B.S.H.A.F.* (1925), 32), built for Lambert about 1640. Both these designs have details, such as the breaking of the field of the pediment, which occur regularly in the work of François but are not found in the certain buildings by Louis. The little château of Suisnes (*Châteaux et manoirs de France, Île-de-France*, 11, plates 63-8) seems to be a provincial imitation of the style of Louis Le Vau.

49. For Le Pautre see R. W. Berger, *Antoine Le Pautre* (New York, 1969).

50. Both are engraved in his *Œuvre*.

51. This is in fact built on the foundations of a medieval circular tower which Le Pautre ingeniously incorporated in his design.

235. 52. The house is well illustrated in Vacquier's *Vieux hôtels de Paris, Le Quartier St Paul*.

53. They are listed by Berger in the work quoted above and by Hautecœur, *Architecture*, 11, 145 ff. They include the remodelling of Saint-Cloud for Monsieur, a château at Saint-Ouen (finished before 1674), and a private house for Joachim de Seglier de Boisfranc, and he was involved in the building of Sceaux for Colbert and Clagny for Madame de Montespan (cf. P. Reuterswärd, 'Autour de Saint-Ouen, Sceaux et Clagny', *L'Urbanisme de Paris et l'Europe 1600-1680* (essays presented to P. Francastel) (Paris, 1969), 95).

236. 54. It seems possible that Wren may have had this engraving in mind when he designed the Great Model of St Paul's. The domeless drum was also widely imitated (cf. R. W. Berger, 'A. Le Pautre and the Motif of the Drum without a Dome', *Journal of the Society of Architectural Historians* (1966), 165).

55. In England, for instance, Vanbrugh seems to have been influenced at Blenheim and elsewhere by the massing and rustication of Le Pautre's design.

56. Cottard also built the château of Villacerf (cf. Hautecœur, *Architecture*, 11, 137) and published several series of engraved designs for architecture and decoration.

238. 57. Desargues is named as the author of this house by Lemaire (*Paris ancien et nouveau*, 111, 30), Brice (*Nouvelle description de Paris* (Paris, 1725), 1, 458), and Bosse, who was a personal friend and who engraved this staircase as well as another by the architect in the château of Vizille (1653), in his *Traité des manières de dessiner les Ordres* (cf. G. Gaillard, 'Nouveaux documents sur la construction et la décoration du Château de Vizille', *B.S.H.A.F.* (1951), 19). M. Roland's house is engraved in the *Petit Marot*,

but without the name of the architect. Hautecœur reproduced the plan of this house (*Architecture*, 11, 125, figure 116), but identifies it with a house by Richer in the same street (reproduced *op. cit.*, figure 117).

58. Many buildings, such as the château of Turny and the house of M. de Sainte-Foy, have been attributed to Marot no better reason than that they appear in his engravings without the name of the architect. Stylistically they are quite unlike his documented works. The château of Lavardin, engraved in the *Grand Marot*, was ascribed to him in the eighteenth century (cf. Mauban, *Jean Marot*, 23).

59. Hautecœur (*Architecture*, 11, 130 f.) attributes to Bruant the château of Fayelles and the house of the banker Jabach in Paris, both engraved in the *Petit Marot*. Jabach's house was mainly built by Bullet (Hautecœur, *op. cit.*, 11, 690), although other architects may have had a hand in it earlier; but there is nothing to indicate that Bruant is one of these and the style is not at all like his (cf. Grouchy, 'Everhard Jabach, collectionneur parisien', *Mémoires de la Société de l'Histoire de Paris*, XXI (1894), 225 ff.).

239. 60. For St Sulpice, the rebuilding of which was begun by the great reformer Olier, see G. Lemesle, *L'Église Saint-Sulpice* (Paris, n.d.).

61. An important aspect of vernacular domestic architecture in Paris is illustrated by the history of the Delespine family who for over two hundred years from the reign of Louis XIII to that of Charles X were involved in building small houses for individual owners or to be let off in apartments. Most of the houses which they built in the seventeenth century have been altered or destroyed, but two survive in the rue Richelieu which are documented: No. 14 built by Simon about 1658 and No. 63 by Nicolas the Elder in 1662 (cf. M. Rambaud, 'Une Famille d'architectes. Les Delespine', *N.A.A.F.*, N.S. XXIII (1968), 1).

62. For a full account of Vouet's artistic career see W. R. Crelly, *The Painting of Simon Vouet* (New Haven, 1962). A more detailed analysis of the Italian period is given in Dargent and Thuillier, 'Simon Vouet en Italie', *Saggi e memorie di storia dell'arte*, IV (1965), 25. For the portraits, see J. P. Cuzin, 'Jeunes Gens par Simon Vouet et quelques autres peintres', *Revue du Louvre*, XXIX (1979), 15, A. Bréjon de Lavergnée, 'Simon Vouet à Milan en 1621', *Revue de l'Art*, L (1980), 58, and *idem*, 'Portraits de poètes italiens par Simon Vouet et Claude Mellan', *ibid.*, 51.

241. 63. The head of the Virgin in the Doni Madonna.

64. In the museum at Besançon and at Hovingham, Yorkshire (cf. Schleier, *Burl. Mag.*, CIX (1967), 272, and CX (1968), 573).

65. Cf. Briganti, *Pietro da Cortona* (Florence, 1962), 50.

66. Claude Mellan was one of the most skilful engravers of his day and in addition to copying works by other artists made many original etchings of his own (cf. A. de Montaiglon, *Catalogue raisonné de l'œuvre de Claude Mellan* (Abbeville, 1856)). He also made at least a few paintings (cf. E. Schleier, 'A Proposal for Mellan as a Painter', *Burl. Mag.*, CXX (1978), 511).

243. 67. An important religious painting of the 'Vœu de Louis XIII', signed and dated 1633, was discovered in the church of Neuilly-Saint-Front (Aisne) and published by P. M. Auzas (*Revue du Louvre*, XIV (1964), 85).

68. From the arms it seems to have been painted for Anne of Austria, for whom Vouet worked in 1644-9, and it may even refer to the Peace of Westphalia in 1648.

69. An important series of paintings executed by Vouet for the Château of Colombes before 1634 are now set in the ceiling of the Salle des Mariages in the Mairie of Port-Marly (cf. J. Feray and J. Wilhelm, 'Une Œuvre inédite de Simon Vouet', *B.S.H.A.F.* (1976), 59).

245. 70. This scheme was not apparently used again in Italy till it was taken up afresh by Giordano and Tiepolo.

71. It was applied in a clumsy way by Walther Damery in his dome fresco in the Carmelite church, painted apparently in 1644. In the 1680s it was used by Lebrun and Houasse in the Salon de la Guerre, the Salon de la Paix, and the Salle de l'Abondance at Versailles (cf. p. 336).

72. Vouet's decorative ability appears also in the field of tapestry. Many of his designs were used with success by Comans and La Planche in their factory (cf. Fenaille, *État général des tapisseries . . .*, I, 303-47).

73. *Abrégé*, IV, 19. Félibien (*Entretiens*, IV, 203) gives no date of birth, nor do Caylus and Mariette in their joint life of the artist (*Archives de l'Art Français* (1913), 186; see also W. Vitzthum, 'Zuschreibungen an François Perrier', *Walter Friedlaender zum 90. Geburtstag* (Berlin, 1965), 217, E. Schleier, 'Affreschi di François Perrier a Roma', *Paragone*, XIX (March, 1968), 42, and 'Quelques tableaux inconnus de François Perrier à Rome', *Revue de l'Art*, XVIII (1972), 39, and J. Thuillier, 'Deux Tableaux de F. Perrier', *Revue du Louvre*, XXII (1972), 307).

246. 74. The early lives only mention the paintings in the Cabinet des Muses which still exist, but the author of the introduction to Picart's engravings of the Hôtel Lambert states that Perrier also executed one of the wall panels in the Cabinet de l'Amour, which is gener-

ally assumed to be the painting of 'Aeneas and the Harpies' now in the Louvre.

75. The gallery was remodelled by Robert de Cotte for the Comte de Toulouse in the early eighteenth century. At this time the wall decoration was entirely renewed and the seventeenth-century paintings set in Rococo frames (cf. Braham and Smith, *François Mansart*, 212).

76. For Jacques Blanchard see C. Sterling, 'Les Peintres Jean et Jacques Blanchard', *Art de France*, I (1961), 7, Pierre Rosenberg, 'Quelques nouveaux Blanchard', in *Études d'art français offertes à Charles Sterling* (Paris, 1975), 217, and J. Thuillier, 'Documents sur Jacques Blanchard', *B.S.H.A.F.* (1976), 81). Jean Blanchard was an artist of less distinction than his younger brother, but their works have sometimes been confused.

77. Typical works by Bollery and Le Blanc are reproduced in Sterling's article.

247. 78. The most useful early life is that in the *Mémoires inédits*, I, 104.

248. 79. Cf. Bonnaffé, *Amateurs français au 17ᵉ siècle*, 185.

80. For instance, the *Mai* of 1635 now in the Louvre, of St Peter healing the Sick, and two paintings in the Hermitage at Leningrad, dated 1636 (one reproduced by Weisbach, *Französische Malerei*, 61). The *Mai* of 1637, representing the Conversion of St Paul, now in St Thomas d'Aquin, is La Hyre's most Baroque composition.

For the series of *Mais*, pictures presented to Notre-Dame each year on the first of May, see P. M. Auzas, 'Les grands Mays de Notre-Dame de Paris', *B.S.H.A.F.* (1949), 85, and 'La Décoration intérieure de Notre-Dame de Paris au 17ᵉ siècle', *Art de France*, III (1963), 124.

81. For instance in the 'Holy Family' (Nantes, dated 1641; other versions in the Louvre and Berlin), the little Louvre 'Madonna' of 1641, and in the 'Scene from the Life of Abraham' in the Hermitage, which must date from about the same period.

82. The influence of Poussin can be seen most clearly in a painting of Job (sold at Christie's, 16 March 1945, lot 115), and that of Champaigne in the 'Supper at Emmaus' and the 'Noli me tangere' of 1656, painted for the Grande Chartreuse and now at Grenoble. The coldness is apparent in the 'Allegory on the Peace of Westphalia' (1648) in the Louvre.

83. For instance in the landscape with shepherds of 1648, reproduced in *Les Peintres de la réalité* (Orangerie, 1934), no. 41, and in the 'Landscape with Bathers' in the Louvre.

249. 84. See P. M. Auzas, 'Lubin Baugin, dit le Petit

Guide', *B.S.H.A.F.* (1957), 47, and 'Lubin Baugin à Notre-Dame', *G.B.A.* (1958), I, 129. M. Faré's attempt to identify the two Baugins ('Baugin, peintre de natures mortes', *B.S.H.A.F.* (1955), 15) has not been generally accepted; see C. Sterling, *La Nature morte de l'antiquité à nos jours* (Paris, 1959), 134, note 97a.

85. See C. Sterling, 'Quelques imitateurs et copistes de Poussin', *Actes du Colloque Poussin*, I (1960), 268.

86. See *Les Peintres de la réalité*, no. 23, P. M. Auzas, 'Les quatre Mays des trois Corneille', *Revue des Arts*, XI (1961), 187, and 'Précisions sur Michel Corneille et ses fils', *B.S.H.A.F.* (1961), 45.

250. 87. For Guy François see the catalogue of the exhibition devoted to him at Le Puy and Saint-Étienne in 1974, and *Revue du Louvre*, XXIV (1974), 468, XXIX (1979), 414; for Quentin see B. Nicolson, *The International Caravaggesque Movement*, 79.

88. See the catalogues of two exhibitions held at the Musée Paul-Dupuy, Toulouse: 'Le Dessin toulousain' (1953), 19, and 'Les Miniaturistes du Capitole' (1956), 115.

89. M. C. Gloton in the catalogue of the exhibition *La Peinture en Provence au XVIIe siècle* (Marseilles, 1978), 35.

90. See the catalogue of the 'Trésors d'art des églises de Paris', held in the chapel of the Sorbonne in 1956 (no. 31). At that time it was thought that the artist was called Jacques Ninet de Lestin, but this name is actually the result of a confusion between two artists, Nicolas Ninet and Jacques de Lestin, who both worked at Troyes at about the same time. See the catalogue of the exhibition devoted to Lestin at Troyes in 1976.

91. For Tassel see the exhibition catalogue *Les Tassel, Peintres langrois du XVIIe siècle* (Musée des Beaux-Arts, Dijon, 1955), and P. Rosenberg and S. Laveissière, 'Jean Tassel dans les musées français', *Revue du Louvre*, XXVIII (1978), 122. For artistic activities in Lyons see *Le Rôle de Lyon dans les échanges artistiques*, *Cahier 2* (Lyons, 1976).

92. See F. A. Salvigni, *I Pittori borgognoni Cortesi* (Rome, 1937), and E. L. Holt, 'The British Museum's Phillips-Fenwick Collection of Jacques Courtois Drawings', *Burl. Mag.*, CVIII (1966), 435.

93. Doris Wild has published two long articles on Mellin ('Charles Mellin ou Nicolas Poussin', *G.B.A.* (1966), 11, 177, and (1967), I, 3), in which she attributes to him paintings which appear to be by a variety of different hands and have very little resemblance to Mellin's documented works. They include incidentally several of Poussin's finest works. For a more reliable account of Mellin see J. Bousquet, 'Un Rival inconnu de Poussin: Charles Mellin dit le Lorrain', *Annales de l'Est* (1955), 3, and 'Le Saint Barthélemy

de Charles Mellin', *Revue des Arts*, V (1955), 55; J. Thuillier, 'Poussin et ses premiers compagnons à Rome', *Actes du Colloque Poussin*, I (1960), 79, and P. Rosenberg, 'Quelques tableaux inédits du 17ᵉ siècle français', *Art de France*, IV (1964), 297.

251. 94. For Stefano see F. Viatte, *Musée du Louvre, Cabinet des Dessins. Dessins de Stefano della Bella* (Paris, 1974), and 'Allegorical and Burlesque Subjects by Stefano della Bella', *Master Drawings*, XV (1977), 347. An article by the present writer, 'Stefano della Bella, Jean Valdor and Cardinal Richelieu' (*Master Drawings*, XVI (1978), 156), deals with an allegorical drawing in honour of Richelieu.

95. For Romanelli see B. Kerber, *Giessener Beiträge zur Kunstgeschichte*, II (1971), 133. For his work in Paris see M. Laurain-Portemer, 'Le Palais Mazarin à Paris et l'offensive baroque de 1645-50', *G.B.A.* (1973), I, 151, 'La Politique artistique de Mazarin', *Atti dei Convegni Lincei. Il Cardinale Mazzarino in Francia* (Rome, 1977), 'Mazarin militant de l'art baroque au temps de Richelieu', *B.S.H.A.F.* (1975), 165, and C. Tadgell in *Baroque and Rococo Architecture and Decoration* (ed. A. Blunt) (London, 1978), 110.

96. Particularly after Poussin had set up a new classical model in his decoration of the Long Gallery of the Louvre.

97. The rooms decorated for the Queen Mother on Romanelli's second visit were treated in the same way, though they presented an easier problem, since they were smaller and more compact in form, and so allowed the artist to arrange his panels to follow the lines of the structure. For a contemporary description of these decorations, see D. Bodat, 'Une Description de 1657 des fresques de Giovanni Francesco Romanelli au Louvre', *B.S.H.A.F.* (1974), 43, and for drawings connected with them P. Rosenberg, 'Quelques dessins inédits de Romanelli préparatoires à la décoration du Louvre', *ibid.*, 51.

98. One follower of Rubens, Pieter van Mol (1599-1650), practised the style of his master unchanged in France. Between 1631 and 1635 he decorated the chapel of Jacques d'Étampes in the Carmelite church in the rue de Vaugirard with a series of panels which are perhaps the most purely Baroque works painted in France in this generation (cf. Count A. Doria, 'Les Peintures religieuses de Pierre van Mol aux Carmes', *Revue de l'Art*, LXVII (1935), 77). Another Fleming who worked in Paris in the 1630s and 1640s was Theodor van Thulden, who painted a series of religious works for the church of the Mathurins, including a 'Holy Trinity' (1647) now at Grenoble (cf. A. Roy, 'Un Peintre flamand à Paris au début du XVIIe siècle: Théodore van Thulden', *B.S.H.A.F.* (1977), 67).

99. The fullest early lives of Champaigne are those by Félibien (*Entretiens*, IV, 312) and in the *Mémoires inédits*, I, 239. A detailed and fully illustrated monograph of Champaigne was published by Bernard Dorival in Paris in 1976, but it is in many respects unreliable and should be read with the present writer's review (*Burl. Mag.*, CXIX (1977), 574) in hand.

100. For Foucquier see W. Stechow, 'Drawings and Etchings by Jacques Foucquier', *G.B.A.* (1948), II, 419.

101. Mlle Hériard-Dubreuil identified this with a painting now in the church of Montigny-Lemcoup (cf. *B.S.H.A.F.* (1952), 14). She dates the picture 1625, but there are some reasons for supposing that it might be as late as 1636 (cf. A. Blunt, 'Philippe de Champaigne at the Orangerie, Paris', *Burl. Mag.*, XCIV (1952), 174).

102. Almost nothing is known of Duchesne, whose daughter Champaigne later married.

253. 103. Cf. Vergnet-Ruiz, 'Les Peintures de l'Ordre du Saint-Esprit', *Revue des Arts*, XII (1962), 155. Dorival (*op. cit.*, II, 174) follows the old tradition that the companion picture showing the reception of Philip, Duc d'Orléans, in 1654 is lost and that the version at Grenoble is an eighteenth-century copy made for the Grands Augustins, but Germaine Barnaud ('Note sur un tableau de Philippe de Champaigne du Musée de Grenoble', *Revue du Louvre*, XXIV (1974), 179) shows conclusively that it came from the Bullion family via the Maréchal de Montmorency-Laval and is either the original or a copy from the studio of Champaigne.

104. For the general project and for the choice of people to be represented, see B. Dorival, 'Art et politique en France au XVIIe siècle: la Galerie des Hommes Illustres du Palais Cardinal', *B.S.H.A.F.* (1973), 43, who reproduces ten out of the twenty-five engravings after the paintings, most of which are lost. The commission was shared with Vouet, for whose contribution see P. Rosenberg, 'La Participation de Vouet à la Galerie des Hommes Illustres du Palais Cardinal', *B.S.H.A.F.* (1974), 21.

105. The influence of Rubens is most marked in the 'Adoration of the Magi' at Le Mans, which, though undated, must be an early work. Although this influence grows less marked with the years in the composition of Champaigne's paintings and in the types and poses of his individual figures, his nervous handling of paint, with sharp linear hatching, continues to owe much to the Flemish master even in his latest works, and this feature distinguishes him from his purely French contemporaries.

254. 106. The 'Three Heads' in the National Gallery, painted as a model for a marble bust, is in pattern an imitation of the van Dyck 'Charles I', which at this time was in Bernini's studio in Rome, and would therefore have been known to the maker of the projected bust. The evidence points conclusively to the fact that a bust was made by Bernini and sent to France (cf. Wittkower, *Gianlorenzo Bernini* (London, 1966), 209, and M. Laurain-Portemer, 'Mazarin militant de l'art baroque au temps de Richelieu', *B.S.H.A.F.* (1975), 74), though it is also clear that another bust was made by Mochi. M. Charageat has maintained that this is the marble bust in the Louvre, but Wittkower rejects this suggestion and maintains that the bust is certainly by Bernini, though executed with the help of pupils.

107. In the Louvre and at Lyons. A more successful example is 'Christ nailed to the Cross' at Toulouse.

108. It is typical of his careful attention to literal detail at this stage of his career that he should have copied the Temple of Jerusalem from the reconstruction given by Villalpandus in his commentary on Ezekiel. Dorival has pointed out that he followed the Fleming Molanus, a Jesuit and an important exponent of Tridentine ideas about the arts, in showing the crucified Christ with his back towards Jerusalem, facing west towards Rome, where his church was to be founded and flourish.

259. 109. None of these painters has received or deserves detailed treatment. They are mostly represented in the museum of portraits at Versailles, and the facts about them are in the relevant articles in Thieme-Becker. The Beaubruns are discussed by Weisbach, *Französische Malerei*, 264. See also J. Wilhelm, 'Quelques œuvres oubliées ou inédites des peintres de la famille Beaubrun', *Revue de l'Art*, V (1969), 19.

110. For the engravings of Nanteuil see C. Petitjean and C. Wickert, *L'Œuvre gravé de Robert Nanteuil*; for his drawings see Y. Fromrich, 'Robert Nanteuil dessinateur et pastelliste', *G.B.A.* (1957), I, 209.

260. 111. For Tournier see R. Mesuret, 'L'Œuvre peint de Nicolas Tournier', *G.B.A.* (1957), II, 327, and B. Nicolson, *The International Caravaggesque Movement* (Oxford, 1979), 102.

112. For Bigot see J. Thuillier in the catalogue of the exhibition *La Peinture en Provence au XVIIe. siècle* (Marseilles, 1978), 6, and Nicolson, *The International Caravaggesque Movement* (Oxford, 1979), 21. Owing to a misunderstanding of documents discovered too late for Nicolson to know them directly the words *or 'Maestro Jacopo'* have been inserted after Bigot's name, implying that this could be his real name. In fact 'Maestro Jacopo' is mentioned in early sources only as the author of a 'Lamentation' in S. Maria in Aquiro, Rome, which Nicolson had attributed to Bigot.

In the past Trophime Bigot has been confused with another painter of the same name – possibly his father – who executed altarpieces in a quite different style in Arles and Aix-en-Provence (see Thuillier, *op. cit.*, 4).

113. The literature on La Tour is vast, but much the best general treatment is to be found in B. Nicolson and C. Wright, *Georges de la Tour* (London, 1974). For different approaches to the artist, particularly over the question of chronology, see also J. Thuillier, *Georges de la Tour* (Paris, 1973), and P. Rosenberg and F. Macé de l'Épinay, *Georges de la Tour* (Fribourg, 1973).

261. 114. On Leclerc see Pariset, 'Notes sur Jean Leclerc', *Revue des Arts*, VIII (1958), 67.

115. The inventory of the Palais Cardinal taken at Richelieu's death (cf. above, Note 3) also included a 'St Jerome' which from its dimensions may be the Stockholm picture [218].

265. 116. The fullest account of the Le Nain brothers is contained in J. Thuillier's catalogue of the Le Nain exhibition held at the Grand Palais in 1978-9, which included not only paintings generally accepted as being by the brothers but many works in the 'penumbra', some of which were specifically ascribed to other hands. In the catalogue M. Thuillier reprinted the most important documents, but others are to be found in his article 'Documents pour servir à l'étude des frères Le Nain', *B.S.H.A.F.* (1963), 155. Some writers on the exhibition put forward a more restrictive approach towards the canon of the Le Nain brothers. In the *Burlington Magazine*, CXX (1978), 875, J. P. Cuzin proposed ascribing to a 'Maître des Jeux' a group of pictures traditionally attributed to Mathieu Le Nain, and the present writer (*ibid.*, 870) went so far as to question the idea that the large religious paintings from the Petits-Augustins were produced in the studio of the Le Nains. For an ingenious attempt to distinguish the hands of the three brothers see P. Rosenberg, 'L'Exposition Le Nain: une proposition', *Revue de l'Art*, XLIII (1979), 91. For a new view of Mathieu see J. P. Cuzin, 'Les Frères Le Nain: la part de Mathieu', *Paragone*, 349-51 (1979), 57.

269. 117. 'The Le Nain Brothers and Changes in French Rural Life', *Art History*, II (1979), 401.

270. 118. Cf. Hélène Adhémar, 'Les Frères Le Nain et les personnes charitables à Paris sous Louis XIII', *G.B.A.* (1979), I, 69.

271. 119. The question of portraits by the Le Nains is one of great difficulty, because the only signed original, that of the Marquis de Trévilles (1644), has disappeared and the portrait of an old woman at Avignon is now generally regarded as an old copy. None of the three portraits shown at the Grand Palais exhibition (Le Puy (37) and Stockholm (39) and the miniature

from the Victoria and Albert Museum (38)) seemed to me convincing as works by the Le Nains, and I would propose as a much stronger candidate the portrait of a man in the Musée Longchamp at Marseilles, said to be dated 1634, which in handling and particularly in colour seems to me to correspond to the style of 'Louis'.

Among the imitators of the Le Nains one can be positively identified as Jean Michelin who signed a number of paintings (cf. Le Nain exhibition catalogue, 339) but others are only known by arbitrary names attached to groups of paintings apparently by a single hand: the 'Maître aux Béguins' and the 'Maître aux Cortèges' invented by Thuillier and the 'Maître des Jeux' added by Cuzin.

Wallerand Vaillant (1623-77) is sometimes classified with the French naturalist painters, but wrongly, because he was born in Lille which was not then French, trained in Flanders, and lived mainly in Holland and Germany. The Dutchman Jacob van Loo (*c.* 1614-70), however, should be mentioned, since he spent ten years of his life in Paris and painted *bambochades*.

120. On Bosse see two works by A. Blum, *L'Œuvre gravé d'Abraham Bosse*, and *Abraham Bosse et la Société française au 17e siècle*.

272. 121. For a general history of still-life, including an important chapter on the French seventeenth century, see C. Sterling, *La Nature morte de l'antiquité à nos jours* (Paris, 1959). For a more detailed treatment of French still-life in the seventeenth century see M. Faré, 'Nature et nature-morte au 17e siècle', *G.B.A.* (1958), II, 255; 'Attrait de la nature morte au 17e siècle', *G.B.A.* (1959), I, 129, and 'Jean Michel Picaut (1600-1683), peintre de fleurs et marchand de tableaux', *B.S.H.A.F.* (1957), 91.

122. A Romantic painter of 1830 might well have written a pamphlet entitled *Poussin et Rubens* as a parallel to Stendhal's *Racine et Shakespeare*, except that it had already in effect been done before, at the end of the seventeenth century (cf. p. 361).

123. The account given here of the work of Poussin is of necessity very summary. The evidence on which the conclusions are based is set out in my monograph *Nicolas Poussin* (London, 1967-8), of which the plate volume contains reproductions of all the paintings which I then believed to be by Poussin. For the drawings see W. Friedlaender and A. Blunt, *The Drawings of Nicolas Poussin. A Catalogue raisonné* (London 1939-72), and A. Blunt, *The Drawings of Nicolas Poussin* (New Haven-London, 1979). Jacques Thuillier in *Tout l'œuvre peint de Poussin* (Paris, 1974) gives a different canon of the work of Poussin, rejecting a number of paintings which I accepted and accepting others that I rejected (and still reject, see my re-

view in the *Burlington Magazine*, CXVI (1974), 760). For different approaches to Poussin see Walter Friedlaender, *Nicolas Poussin. A New Approach* (London, 1966), and K. Badt, *Die Kunst des Nicolas Poussin* (Cologne, 1969).

Pierre Rosenberg's catalogue of the exhibition held in Rome and Düsseldorf in 1977-8 contains many new ideas and gives details of the few paintings which have been added to the artist's œuvre since I published my catalogues, namely the 'Virgin and Child in a Wreath of Flowers' at Brighton and the two landscapes 'L'Orage' and 'Le Temps calme' painted for Pointel and now at Rouen and in the Morrison collection respectively. For my own views on the problems of attribution raised by the exhibition see my review in the *Burlington Magazine*, CXX (1978), 421.

295. 124. The evidence for this view, which cannot be summarized, is set out in my monograph on Poussin (particularly in chapters 11 and 12).

125. In the case of Poussin's last works the connexion with these esoteric doctrines is demonstrable, but there is reason to think that similar ideas lay behind the mythological paintings of a much earlier phase. In works of the 1630s there are features which refer to the same category of ideas: recurrent allusions to the cycle of day and night ('Cephalus and Aurora', 'Diana and Endymion' [230]), to the stages of the year ('Phaeton'), or to the story of Adonis, a widespread symbol not only for the return of spring after winter, but for death and resurrection in general. The analogy between this allegory and Christian doctrine, frequently emphasized at the time, may well account for the similarity between the dead Christ and the dead Adonis in the Munich and Caen pictures. It is even likely that Poussin's interest in the subject of metamorphosis is basically connected with the idea of death and rebirth, symbolized in the life of plants.

297. 126. For a catalogue of Claude's paintings and an account of his career see M. Röthlisberger, *Claude Lorrain: The Paintings* (New Haven and London, 1961). For the drawings see Röthlisberger, *Claude Lorrain: The Drawings* (Berkeley and Los Angeles, 1968) and *The Claude Lorrain Album in the Norton Simon, Inc., Museum of Art* (Los Angeles, 1971), and M. Kitson, *Claude Lorrain: Liber Veritatis* (London, 1978). For the etchings see A. Blum, *Les Eaux-fortes de Claude Gellée* (Paris, 1923). For Claude and his influence on later European art see M. Kitson's catalogue of the exhibition *The Art of Claude Lorrain* (Hayward Gallery, London, 1969).

127. The chronology of Dughet's work presents many problems. A firm starting point was provided by Ann Sutherland in 'The Decoration of San Martino ai Monti', *Burlington Magazine*, CVI (1964), 58,

115. Mlle M. N. Boisclair has published the record of his baptism and his will ('Documents relatifs à Gaspard Dughet', *B.S.H.A.F.* (1973), 75) and has added much information in 'Gaspard Dughet: une chronologie révisée', *Revue de l'Art*, XXXIV (1976), 29, but many of her conclusions must be regarded as hypothetical, and her attempt to redate the frescoes in S. Martino is based on a misunderstanding of the documents. For Dughet's drawings see C. Klemm, *Gaspard Dughet und die ideale Landschaft* (catalogue of exhibition at the Kunstmuseum, Düsseldorf, 1981).

In 1950 (*Burlington Magazine*, XCII, 69) I grouped together a number of landscape paintings hitherto ascribed to Nicolas Poussin under the name of 'The Silver Birch Master', who was later identified as the young Dughet. In 1979 ('Poussin's Early Landscapes', *Burlington Magazine*, CXXI, 10) Mr Clovis Whitfield suggested reattributing the whole group to Nicolas. For my qualified acceptance of a part of his hypothesis see *Burlington Magazine*, CXXI (1980), 577.

310. 128. See M. Davies, 'A Note on Francisque Millet', *Société Poussin, Deuxième Bulletin* (1948), 13.

129. Cf. A. Blunt, 'Jean Lemaire, Painter of Architectural Fantasies', *Burl. Mag.*, LXXXIII (1943), 241, and 'Additions to the Work of Jean Lemaire', *Burl. Mag.*, CI (1959), 440.

130. Cf. E. A. Evans, 'A Rousseau Design in England', *Country Life*, CXXXIX (1966), 1668.

131. See L. E. Faucheux, *Catalogue raisonné de toutes les estampes qui forment l'œuvre gravé d'Israël Silvestre* (Paris, 1857).

132. The most important early sources for Le Sueur's life are the biographies in the *Mémoires inédits* and by Félibien. Much important material is brought together by Dussieux in 'Nouvelles recherches sur la vie et les ouvrages de Le Sueur', *Archives de l'Art Français*, II (1852-3), 1. See also G. Rouchès, *Eustache Le Sueur*, and C. Sterling, 'Eustache le Sueur peintre de portraits', *Walter Friedlaender zum 90. Geburtstag* (Berlin, 1965), 181. M. Alain Mérot is preparing a doctoral thesis on Le Sueur for the university of Paris.

133. Four of these cartoons survive (cf. A. Blunt, 'The *Hypnerotomachia Poliphili* in Seventeenth Century France', *J.W.C.I.*, I (1937-8), and *The Age of Louis XIV*, Royal Academy (London, 1958), no. 43).

312. 134. Guillet de Saint-Georges gives the date 1645-8 for the painting of the series, and this is confirmed by the fact that Symonds saw them finished in 1649 (cf. O. Millar, 'An Exile in Paris', *Studies in Renaissance and Baroque Art presented to Anthony Blunt* (London, 1977), 162) and by a document, kindly communicated to me by M. Mérot, which records a final payment in the same year. M. Mérot tells me that in his opinion only the first two canvases ('The Preach-

ing' and 'The Death of the Deacon Raymond') and probably the 'Death of St Bruno' are from Le Sueur's own hand and that the others are the work of studio assistants.

135. 'Christ and the Magdalen' (Louvre), painted for the Charterhouse of Paris in 1651; the 'Adoration of the Shepherds' (La Rochelle, 1653; reproduced in R. Lécuyer, *Regards sur les musées de Province*, I (1949), plate xx); 'St Gervasius and St Protasius' (Louvre); 'The Presentation' (Marseilles, painted for St Sulpice); four paintings for the abbey of Marmoutier (1654–5), namely 'St Sebastian' and 'St Louis' in the museum at Tours, and 'The Appearance of the Virgin and other Saints to St Martin', and the 'Mass of St Martin' in the Louvre.

136. The only exception is the 'Mass of St Martin' in which the style of the St Bruno series is carried on.

137. Examples of his *bambochades* are in the Louvre, and in the Montpellier and Dulwich galleries. Imitations of Castiglione include an etching of 'Jacob's Journey' (R.D.1), 'Rebecca and Eliezer' at Welbeck (*Seventeenth-Century Art*, Royal Academy, London, 1938, no. 327), and the 'Sacrifice of Noah' in the Louvre.

313. 138. Portraits of the Queen are at Stockholm and in the Prado.

139. Now at Montpellier.

140. Other works in this transitional style are the 'St Paul and Barnabas' in the Prado and the 'Adoration of the Shepherds' in the Louvre.

314. 141. The 'Acts of Mercy' are in the Ringling Museum, Sarasota.

142. See above, Note 32.

143. See L. Demonts, 'Deux peintres de la première moitié du 17ᵉ siècle', *G.B.A.* (1925), II, 162 ff.; for his poem see A. Fontaine, *Doctrines d'art en France*, and J. Thuillier, 'Les "Observations sur la peinture" de Charles Alphonse du Fresnoy', *Walter Friedlaender zum 90. Geburtstag* (Berlin, 1965), 193. For his use of drawings by Poussin for his painted compositions, see A. Blunt, *The Drawings of Poussin* (New Haven and London, 1979).

144. See *Mémoires inédits*, I, 195, and Caix de St Aymour, *Les Boullongne* (Paris, 1919).

145. See J. Thuillier, 'Poussin et ses premiers compagnons à Rome', *Actes du Colloque Poussin*, I (1960), 96; G. Chomer, *Revue de l'Art*, XLVII (1980), 85.

146. See J. Thuillier, 'Pour un peintre oublié, Rémy Vuibert', *Paragone*, 97 (January 1958), 22.

147. See the catalogue by A. Schnapper of the exhibition devoted to him at Avignon in 1979 which revealed him for the first time at his full stature. Further information about Nicolas Mignard is given by Antoine Schnapper in 'Après l'exposition Nicolas

Mignard', *Revue de l'Art*, LII (1981), 29. He publishes here a number of paintings and drawings not included in the exhibition.

315. 148. The only early source on Simon Guillain is the biography which appeared in the *Mémoires inédits*, I, 184.

149. The elder Guillain executed a number of tombs in the idiom deriving from Pilon, e.g. that of Louise de Lorraine, reproduced in Michel, *Histoire de l'art*, V, 752, and that of the Laubespines, now in the museum at Poitiers (cf. J. Coural, 'Œuvres inédites des Guillain', *Revue des Arts*, IX (1959), 181).

150. The relief from the Pont-au-Change (reproduced Michel, *ibid.*) suggests that Guillain had studied the engraved trophies of Polidoro da Caravaggio.

316. 151. For further information about Warin see the article in Thieme-Becker.

152. An account of Sarrazin's life and work is to be found in M. Digard, *Jacques Sarrazin*; cf. also J. Thirion, 'Sculptures religieuses de Jacques Sarrazin au Louvre', *Revue du Louvre*, XXII (1972), 145.

153. Payments to Sarrazin are recorded for these years (cf. Cesare d'Onofrio, *La Villa Aldobrandini di Frascati* (Rome, 1963), 141).

154. The parallel with Lemercier's early training in architecture in Rome is close.

155. For the date, see above, Note 18.

156. The original models for these groups are in the Louvre (Digard, *op. cit.*, plate xv). The statues were actually carried out by Sarrazin's pupils Guérin and van Obstal. In the following years Sarrazin seems to have hesitated between the classicism of the caryatids, which he repeats in the monument for the heart of Louis XIII (1643; cf. Digard, *op. cit.*, plate v), and a more Baroque manner as in the 'Enfants à la Chèvre' (*c.* 1640; Digard, *op. cit.*, plate xix) based on Bernini's early group in the Borghese Gallery.

317. 157. In St Paul-St Louis the monument stood in the end of the transept so that there was no circular arrangement as at present. It can be seen in this position in an engraving reproduced by Tapié, *Baroque et classicisme* (Paris, 1957), plate opposite p. 192). The bronze reliefs were actually bent into curves to make them fit the new setting (cf. G. Macon, *Chantilly et le Musée Condé* (Paris, 1925), 262).

318. 158. Long attributed to Lerambert, but proved to be by Sarrazin (cf. Digard, *op. cit.*, 177).

159. The evidence about the dates of their births is conflicting, but these seem the most probable years. The facts about Michel's life are given in detail in two biographies in the *Mémoires inédits*, but about François we are less well informed. The earliest account of him is that in Dézallier d'Argenville's *Vies des plus fameux architectes et sculpteurs* (Paris, 1787), 159. For

the attribution of works to him we are forced mainly to rely on the early guide-books. For a list of the works of both brothers see H. Stein, 'Les Frères Anguier', *Réunion des Sociétés des Beaux-Arts* (1889), 527. See also Jacques Monicat, 'Le Tombeau du duc et de la duchesse de Montmorency dans la chapelle du Lycée de Moulins', *G.B.A.* (1958), ii, 179.

160. In a series of tombs: the Rohan-Chabot tomb now at Versailles (after 1665), the Souvré tomb in the Louvre (before 1667), and the Longueville monument in the Louvre (between 1663 and 1669; reproduced in Planat and Rümler, *Le Style Louis XIV*, plate 202).

161. Cf. Hautecœur, *Le Louvre et les Tuileries de Louis XIV*, 40, reproduced plates viii and ix.

162. For details about the group and the unusual Baroque baldacchino over it by Gabriel Le Duc see M. Beaulieu, 'Gabriel Le Duc, Michel Anguier et le maître-autel du Val-de-Grâce', *B.S.H.A.F.* (1945-6), 150; Lemoine, 'Le Maître-autel de l'église du Val-de-Grâce', *B.S.H.A.F.* (1960), 95, and Chaleix, 'Le Baldaquin de l'église du Val-de-Grâce', *B.S.H.A.F.* (1961), 211.

163. An almost eighteenth-century elegance is also seen in his well-known 'Amphitrite' executed in 1680 for Versailles and now in the Louvre (cf. M. Charageat, 'La Statue d'Amphitrite ... de Michel Anguier', *A.A.F.*, N.S. XXIII (1968), 111).

164. Cf. Souchal, *French Sculptors of the Seventeenth and Eighteenth Centuries*, ii, 35.

165. For Guérin see M. T. Forest, 'Les Sculptures de Gilles Guérin au couvent des Minimes à Paris', *B.S.H.A.F.* (1973), 121.

319. 166. For Buyster see P. Chaleix, *Philippe de Buyster* (Paris, 1967).

167. For Poissant see *Mémoires inédits*, i, 318. For van Obstal see G. Bué-Akar, 'La Vie et l'œuvre de Gérard van Obstal', *B.S.H.A.F.* (1975), 137.

320. 168. Cf. Souchal, ii, 389.

CHAPTER 7

322. 1. For the history of the Gobelins see M. Fenaille, *État général des Tapisseries de la Manufacture des Gobelins* (Paris, 1903-25), and for the Savonnerie, P. Verlet, *The James A. de Rothschild Collection, Waddesdon Manor, The Savonnerie* (Fribourg, 1982). For Louis XIV as a collector of works of art see R. Bacou, catalogue of the exhibition *Collections de Louis XIV* (Orangerie, Paris, 1977-8), and D. Alcouffe, 'La Collection de Gemmes de Louis XIV', *B.S.H.A.F.* (1977), 109.

325. 2. *Athalie* and *Esther* were, of course, produced as specific commissions for Mme de Maintenon, but the circumstances were exceptional.

3. Even artists like Pierre Mignard, who opposed Lebrun and the Academy on grounds of personal ambition, practised a manner scarcely distinguishable from the official style.

4. It is also worth noticing that the Turinese architect Guarini, who designed the Theatine church of Ste Anne-la-Royale (1662-9; reproduced in Guarini, *Architettura Civile* (Turin, 1737), plates 9 ff.), exercised no influence whatsoever on French architecture in spite of his reputation in Italy.

326. 5. The Vigna Sacchetti, S. Maria della Pace, and the reconstruction of the Roman temple at Palestrina.

6. S. Agnese in Piazza Navona.

7. Built at the command of Mazarin, 1654-60 (cf. F. de Fossa, *Le Château historique de Vincennes* (Paris, 1908)).

8. Begun 1660 (cf. M. Dumolin and G. Outardel, *Les Églises de France, Paris*, 182).

9. On the basis of the statements made by Chantelou (*Journal du voyage du Cavalier Bernin en France*, 169), it is usually said (e.g. by Hautecœur, *Le Louvre et les Tuileries de Louis XIV*, 145) that his grievance was due to faults in the structure of the Hôtel Bautru built by Le Vau which Colbert had bought. But he did not acquire the house till 1665, a year after he had turned down Le Vau's Louvre designs (cf. Dumolin, *Études*, ii, 194).

327. 10. Cf. p. 220.

11. The designs of Marot and François Le Vau are reproduced in Hautecœur, *Le Louvre et les Tuileries de Louis XIV*, plates 31 and 32. The same author illustrates (plate 29) the designs of Léonor Houdin, prepared in 1661. These are unique in the series, and indeed almost unique in the whole of seventeenth-century French architecture, in being Palladian in inspiration.

12. Cortona's plans were identified and published by K. Noehles in 'Die Louvre-Projekte von Pietro da Cortona und Carlo Rainaldi', *Zeitschrift für Kunstgeschichte*, XXIV (1961), 40.

13. The facts about Bernini's negotiations over the Louvre are given in Hautecœur, *Le Louvre et les Tuileries de Louis XIV*, 150 ff., where most of the essential plans and elevations are reproduced. Some further drawings are published by R. Josephson, 'Les Maquettes du Bernin pour le Louvre', *G.B.A.* (1928), i, 77. The whole problem is again examined by Brauer and Wittkower in *Die Zeichnungen des Gianlorenzo Bernini*, i (1931), 129, where a further plan is reproduced (ii, plate 175).

14. The plan is given by Brauer and Wittkower, *loc. cit.*, the elevation in Hautecœur, *Le Louvre et les Tuileries de Louis XIV*, plate 33.

329. 15. A day-to-day account of his stay in Paris is

given by Chantelou, *Journal du voyage du Cavalier Bernin en France*. A different view of the story is given by Charles Perrault in *Mémoires de ma vie*.

16. How far Colbert himself had made up his mind is uncertain (cf. E. Esmonin, 'Le Bernin et la construction du Louvre', *B.S.H.A.F.* (1911), 31).

It has recently been suggested, on the basis of a passage in the diary of Cosimo III, Grand Duke of Tuscany, recording his visit to France in 1669, that Bernini had produced a plan for at least the façade of the new palace which Louis XIV was creating at Versailles. It is, however, very curious that this project should not have been mentioned by any other writer, Italian or French (cf. Leonore Pühringen-Zwanowitz, 'Ein Entwurf Berninis für Versailles', *Wiener Jahrbuch für Kunstgeschichte*, XXIX (1976), 101), and it seems likely that the story is due to a confusion with the Louvre.

17. Apart, that is to say, from drawings and a small bas-relief which was mainly executed by an assistant under his direction. For the bust of the King, cf. R. Wittkower, *Bernini's Bust of Louis XIV* (Oxford, 1951).

18. For instance, by Aumont and Lionne about their private houses, and by the Queen Mother and Tubeuf over the altar of the Val-de-Grâce.

19. For instance, the altar of the Val-de-Grâce, cf. M. Beaulieu, 'G. Le Duc, M. Anguier et le maître-autel du Val-de-Grâce', *B.S.H.A.F.* (1945-6), 150. The author proves conclusively that, though Berninesque in style, the altar was not erected on the artist's design, but on one which he explicitly disapproved. **332**. 20. Published in 1673. An enlarged edition appeared in 1684.

21. The decoration remained to be executed and some parts of it (e.g. the relief over the main door) were not completed till the nineteenth century. The opening of the moat revealed part of the foundations laid by Le Vau in 1663-4, but these were later removed. For a survey of the excavations see A. Elande-Brandenburg, 'Les Fouilles du Louvre et les projets de Le Vau', *La Vie urbaine* (1964), 241. A careful study of the whole problem of the Colonnade by M. Whiteley and A. Braham in *Revue de l'Art*, IV (1969), 30 ff.

22. Unfortunately, many of the witnesses best qualified to know were prejudiced: Charles Perrault in favour of his brother, Boileau in favour of Le Vau, because of his quarrel with the Perrault family. For the latest statement of the evidence in favour of Perrault's authorship see C. Tadgell, in *Burlington Magazine*, CXXI (1980; in press); for the evidence in favour of Le Vau see Mary Whiteley and Allan Bra-

ham, 'Louis Le Vau's Projects for the Louvre and the Colonnade', *G.B.A.* (1964), II, 285, 347.

23. Cortona uses such a scheme in a drawing for a fountain for the Piazza Colonna.

24. Cf. above, p. 228.

25. For Claude Perrault's other works see Hautecœur, *Architecture*, II, 452 ff. In 1667 he designed the Observatoire which still stands (cf. M. Petzet, 'Claude Perrault als Architekt der Pariser Observatorium', *Zeitschrift für Kunstgeschichte*, XXX (1967), 1); in 1669 he made a model for a triumphal arch at the Porte St Antoine which was begun but never completed; and in 1673 or 1674 he designed for Colbert the château of Sceaux which stood till the present century. For his theoretical writings see W. Herrmann, *The Theory of Claude Perrault* (London, 1973).

26. Which was broken by the projecting oval vestibule in the middle.

27. During the development of the Colonnade design a change was made in the plan for completing the Square Court. The south wing was doubled in thickness by the addition of a second flight of rooms on the river side to increase the space available for the King's rooms. This involved a slight extension of the Colonnade at both ends and the designing of a new façade towards the river which was prepared by the commission in 1668.

28. The literature on Versailles is vast, but the most useful works are P. Verlet's condensed (but not short) book *Versailles* (Paris, 1961) which gives a reliable account of the history of the building and descriptions of all the rooms and of the principal features of the gardens, and A. Marie's two double volumes *Naissance de Versailles* (Paris, 1968) and *Mansart à Versailles* (Paris, 1972), in which the author gives or summarizes all the documentary evidence and reproduces all the available plans and drawings.

For the sculpture on the outside of the palace see F. Souchal, 'Les Statues aux façades du Château de Versailles', *G.B.A.* (1972), I, 65.

333. 29. The traditional story that Colbert wanted to pull down the existing buildings and start afresh but that Louis XIV refused out of filial piety to destroy his father's château has been shown by the documents to be the exact reverse of the truth. Louis wanted to carry out the grandiose complete scheme but Colbert for reasons of economy opposed the idea and eventually convinced the king.

334. 30. Cf. E. de Ganay, *André Le Nôtre* (Paris, 1962), and H. M. Fox, *André Le Nôtre* (London, 1963).

31. The most important of the buildings set up in the early years at Versailles have all been destroyed. They were the Ménagerie (1662; cf. Mabille, 'La

Ménagerie de Versailles', *G.B.A.* (1974), I, 5), the first Orangery (1663; Hautecœur, *Architecture*, II, 268), and the Trianon de Porcelaine (1668; *ibid.*, 294), all by Le Vau, and the Grotto of Thetis (1665), for the original idea of which Charles Perrault claims the credit (Hautecœur, *op. cit.*, 383), but which was probably designed by Lebrun, and was decorated with sculpture by Girardon and others (cf. L. Lange, 'La Grotte de Thétis', *Art de France*, I (1961), 133).

335. 32. Both *fêtes* were engraved by Silvestre. For the *Île Enchantée* see A. Marie, 'Les Fêtes de plaisirs de l'Isle Enchantée', *B.S.H.A.F.* (1941-4), 118.

33. It was left unfinished when Louis abandoned the Louvre. The painting of the panels on the ceiling was continued till the nineteenth century, when Delacroix added the 'Apollo killing the Python' in 1849. The wall decoration appears to be a complete reconstruction of the nineteenth century, since a water-colour of *c.* 1797 shows the walls plain below the cornice (cf. J. J. Marquet de Vasselot, *Répertoire des vues des salles du musée du Louvre, Archives de l'Art Français*, N.P., XX (1946), plate iii). It is, however, possible that part of the original decoration survived under the plain wall covering.

336. 34. Jacques Gervaise for the painted grisailles, Monnoyer for the flower-pieces, and the brothers Marsy, Girardon, and Régnaudin for the stuccos. The floor was covered with magnificent Savonnerie carpets of which one section is still in place.

35. This particular ceiling was executed by Noël Coypel (cf. A. Schnapper, 'Noël Coypel et le grand décor peint des années 1660', *Antologia di Belle Arti*, I (1977), 7). The other artists involved in the decoration of the rooms were Houasse, J. B. de Champaigne, G. Blanchard, the younger Claude Vignon, Claude Audran II, Michel Corneille the Younger, and, among the younger generation, Jouvenet and La Fosse. But in every case the controller and director of the scheme was Lebrun. One ceiling, in the Salon de l'Abondance, is completely illusionistic, but this room did not originally form part of the *Grand Appartement* and its decoration by Houasse is of a somewhat different character from the rest.

337. 36. The accounts show that it cost 142,000 livres.

37. The idea was not new, for Louis had played with it since the early fifties (cf. Hautecœur, *Le Louvre et les Tuileries de Louis XIV*, 114, and A. Blunt, *French Drawings at Windsor Castle*, 25).

38. François d'Orbay (1631-97) collaborated regularly with Le Vau and completed several of his later works, including the Collège des Quatre Nations. He also designed a number of churches and the Porte du

Peyrou at Montpellier (cf. Hautecœur, *Architecture*, I, 121 ff.). Albert Laprade (cf. *François D'Orbay* (Paris, 1960)) put forward the view that d'Orbay was really responsible for all the fundamental designs of Le Vau's later works; but he seems to overstate his case and certainly attributes to d'Orbay drawings which cannot all be by the same hand.

338. 39. Our knowledge of his earliest phase is derived from a manuscript life published by Peter Smith and Allan Braham in their monograph on François Mansart (London, 1972). Hautecœur (*Architecture*, II, 527 ff.) gives a fairly full account of J. H. Mansart's life. This can be supplemented by the excellent plates and fine appreciation of the architect's qualities by G. Cattaui in P. Bourget and G. Cattaui, *Jules Hardouin Mansart* (Paris, 1960), but the factual notes in the book must be viewed with caution.

40. These houses, except the Château du Val, are destroyed but are known from engravings. For the Château du Val see Bourget and Cattaui, *Jules Hardouin Mansart*, plate XXXVII. For Clagny, see A. Marie, *Mansart à Versailles*, I, 3. The Hôtel de Lorge in Paris is generally said to belong to this period, but B. Jestaz has shown that it was actually built in 1697-8 (cf. 'L'Hôtel de Lorge dans l'œuvre de Jules Hardouin Mansart', *Bulletin Monumental*, CXXIX (1971), 161, and P. Reuterswärd, 'Archives architecturales parisiennes en Suède', *L'Urbanisme de Paris et l'Europe 1600-1680* (essays presented to P. Francastel) (Paris, 1969), 148).

41. Particularly in the Hôtel de Noailles.

42. The Hôtel de Lorge, for instance, where the vestibule and staircase take up about half the entire available space, producing a spectacular entrance but leaving almost no room for the living-quarters.

339. 43. This seems to be an adaptation of an English arrangement which occurs, for instance, in the Queen's House at Greenwich by Inigo Jones.

44. Mansart made some small modifications in Le Vau's design, such as the insertion of round-headed windows.

45. The exact shares of the two artists are established by F. Kimball in 'Mansart and Lebrun in the Genesis of the Grande Galerie de Versailles', *Art Bulletin*, XXII (1940), 1.

46. In the 'Crossing of the Rhine', for instance, he appears in a chariot wielding the thunderbolt, accompanied by Glory, Minerva, and Hercules, while figures representing Spain and Holland (with her lion) fall before the chariot, and the Rhine, astounded, drops his helm.

341. 47. Built by Antonio del Grande between 1654 and 1665 and decorated by Coli and Gherardi in the

438 · NOTES TO CHAPTER 7

years 1675-8 (cf. O. Pollak, 'Antonio del Grande', *Kunstgeschichtliches Jahrbuch der K. K. Zentral- Kommission*, 111 (1909), 139). The scheme is foreshadowed in Mansart's Gallery at Clagny, planned in 1676.

48. A conception, however, which appears before this date in an engraving by J. Marot, reproduced in F. Kimball, 'The Genesis of the Château Neuf at Versailles, 1668–71', *Art Bulletin*, XXXI (1949), 355. For the Trianon cf. A. Marie, 'Trianon de Porcelaine et Grand Trianon', *B.S.H.A.F.* (1945-6), 88, and B. Jestaz, 'Le Trianon de Marbre ou Louis XIV architecte', *G.B.A.* (1969), 11, 259.

342. 49. See A. Marie, *Marly* (Paris, 1947).

50. The plan of the King's block was also unusual in itself, because it was based directly on Palladio's Rotonda.

343. 51. Cf. p. 238. For Libéral Bruant see Hautecœur, *Architecture*, 11, 520 and 724.

52. For the extremely complex history of the Invalides see Patrick Reuterswärd, *The Two Churches of the Hôtel des Invalides* (Stockholm, 1965), and B. Jestaz, 'Jules Hardouin-Mansart et l'église des Invalides', *G.B.A.* (1965), 11, 59.

344. 53. Bruant also built a small house for himself which still stands in the rue de la Perle (reproduced in Vacquier, *Vieux hôtels de Paris, Quartier St Antoine*, plate 1). He also designed a house for the Duke of York, later James II, to be built at Richmond (cf. P. Reuterswärd, 'A French Project for a Castle at Richmond', *Burl. Mag.*, CIV (1962), 533).

54. For the Assomption, see Hautecœur, *Architecture*, 11, 301. For Errard as a designer of book-illustrations see J. Thuillier, 'Charles Errard, peintre', *Revue de l'Art*, XL-XLI (1978), 151. His attribution of certain paintings and drawings to Errard does not seem to be convincing (cf. particularly plates 1, 42-4, 47, 48).

55. Hautecœur, *Architecture*, 11, 168-77. The provincial architects of this phase, who show less independence or originality than at any other period, are also discussed by Hautecœur, *op. cit.*, 11, 205, 702.

56. R. Berliner, *Ornamentale Vorlageblätter des 15. bis 18. Jahrhunderts*; F. Kimball, *The Creation of the Rococo*; Hautecœur, *Architecture*, 11, 297, 653; and R. A. Weigert, *Jean Bérain* (Paris, 1937).

57. *Procès-Verbaux de l'Académie Royale d'Architecture*, particularly 1, 4 ff., 321.

58. For the other treatises of this group, cf. Hautecœur, *Architecture*, 11, 467, who also gives a good summary of the doctrine of the Academy. Blondel (1617-86) was an engineer and a mathematician, but his energies were mainly directed towards theory. The most important of his surviving buildings is the Porte St Denis (1671).

59. In 1682 the most important buildings of ancient Rome were presented in more accurate engravings than had hitherto been available by Antoine Desgodetz in *Les Édifices antiques de Rome*, dedicated to Colbert (cf. W. Hermann, 'Antoine Desgodetz and the Académie Royale d'Architecture', *Art Bulletin*, XL (1958), 23).

345. 60. The difference appears in the discussions over the decorations of the top floor of the Square Court of the Louvre in 1671. Some architects wanted to follow Lemercier's solution and use caryatids (cf. p. 198); but Colbert was attracted by the suggestion that a new French Order should be invented for the occasion. Finally, however, when the designs submitted by Lebrun, Cottard, Perrault, and others were examined by the Academy, they were all condemned as fantastic and licentious and the scheme was abandoned (see Hautecœur, *Le Louvre et les Tuileries de Louis XIV*, 184). It is, however, interesting to notice that the idea of inventing a specifically French Order should arise at two periods of conscious national pride: the middle of the sixteenth century (cf. p. 87) and the most successful moment of Louis XIV's reign.

61. For the teaching of the Academy in respect of decorative painting see C. Goldstein, 'Studies in Seventeenth Century Art Theory and Ceiling Painting', *Art Bulletin*, XLVII (1965), 231.

62. The theory was worked out most fully for painting, and I shall in effect limit myself here to what the Academicians had to say on this art. But, *mutatis mutandis*, much of what they say applies to sculpture equally well.

63. In formulating this part of their theory the Academicians often use the exact phrases which Boileau consecrated for literature: *la belle nature*, and *le choix raisonnable*.

64. Even in the time of Lebrun there were serious differences of opinion within the Academy on the subject of colour; but as they are primarily of importance in connexion with later developments they will be considered in the next chapter. For the moment it will be enough to notice that even the artists like Gabriel Blanchard and Pierre Mignard, who in the time of Lebrun most enthusiastically supported the cause of colour in theory, were, when it came to practice, hardly distinguishable from their opponents.

65. *Méthode pour apprendre à dessiner les passions*.

66. The ancients meant, of course, primarily the Romans, since little was known at this time of Greek sculpture or architecture. It is, however, worth noticing that Poussin and Duquesnoy were in theory firm supporters of Greek as opposed to Roman art, and that Poussin made some use of the Greek statues available in Rome (cf. A. Blunt, *Nicolas Poussin*, 232,

and 'Further Newly Identified Drawings by Poussin and His Followers', *Master Drawings*, XVII (1979), 138). A series of drawings made after the Parthenon sculptures for the Marquis de Nointel in 1673 were in France soon after that date (cf. H. Omont, *Athènes au dix-septième siècle. Dessins des sculptures du Parthénon attribués à J. Carrey* (Paris, 1898)), but there is no evidence to show that they aroused any interest or that they were studied by French artists.

346. 67. André Félibien, who was secretary to the Academy, is in general more liberal in his views. He allows greater importance than the Academy to imagination, a faculty scarcely mentioned in the lectures; and he is more generous in his appreciation of artists, recognizing the merits of the Venetian and Flemish schools.

68. For a full account of Lebrun see the catalogue of the exhibition *Charles Lebrun*, held at Versailles in 1963. The engravings after his compositions are recorded by D. Wildenstein in 'Les Œuvres de Lebrun', *G.B.A.* (1965), II, I. For the artist's early period see also G. Chomer, 'Charles Le Brun avant 1646', *B.S.H.A.F.* (1977), 93.

69. Cf. pp. 228, 233.

347. 70. Notice the reminiscence of Bernini's Baldacchino in the embroidered fringe round the top of the tent.

71. It is worth noticing that Lebrun makes his principal theme a breach of court etiquette, for he shows the moment when the mother of Darius throws herself at the feet of Hephaestion thinking him to be Alexander.

72. In his decorative schemes Lebrun was helped by assistants who specialized in different branches of painting. The most important were Adam van der Meulen (1632-90), a Fleming who executed battle-pieces (cf. G. Brière, 'Van der Meulen, collaborateur de Le Brun', *B.S.H.A.F.* (1930), 150), Jean Cotelle (1607-76), a landscape painter, and Jean Baptiste Monnoyer (1634-99), who produced flower-panels for over-doors.

348. 73. Many of his compositions, for instance those on the ceiling of the Galerie des Glaces, owe much to Cortona's decoration in the Palazzo Pitti and in certain details to Bernini's sculptured groups.

350. 74. Little need be said of the minor Academicians of this period, beyond that they were all imitators of Poussin, Le Sueur, or Lebrun. Noël Coypel (1628-1707) followed strictly in the steps of Poussin; Louis de Boullogne the Elder (1609-74) was also influenced by Le Sueur; Michel Corneille the Younger (1642-1708) and Jean Nocret (1616-71) came nearer to Lebrun. The minor arts of miniature and engraving flourished at this time, the great master in the former

being Jean Petitot the Elder (1607-91), while in the latter field there were a host of artists who reproduced with astonishing sensitiviness and fidelity the works of the painters of the day.

351. 75. We know little of his works executed in Italy, but the following are identifiable: the high altarpiece and an 'Annunciation' in S. Carlo alle Quattro Fontane, Rome; and 'St Charles Borromeo administering the Sacraments', now in the museum at Narbonne, which was a rejected painting for the high altar of S. Carlo ai Catinari, Rome, painted in 1655-7.

76. His earliest recorded altarpiece, painted after his return to France, seems to be the 'Visitation' in the chapel of the Convent of the Visitation at Orléans, painted in 1660 (cf. P. M. Auzas, 'La Visitation de Pierre Mignard', *B.S.H.A.F.* (1959), 23).

352. 77. The most important article on Mignard's portraits is by J. Wilhelm, 'Quelques portraits peints par Pierre Mignard', *Revue des Arts*, XII (1962), 165, in which the author identifies as by Mignard several portraits hitherto ascribed to other artists, and in certain cases reproduces drawings connected with them.

78. See D. Wildenstein, 'Claude Lefèvre restitué par l'estampe', *G.B.A.* (1963), II, 308.

79. The allegory is fully explained by E. Soulié in *Notice du Musée National de Versailles*, II (1881), 198.

353. 80. Pronounced without the final *x* being sounded.

81. On Girardon see Souchal, *French Sculptors*, II, 14.

82. The relief of the Madonna (1657, Louvre; Souchal, 17); tomb of Mme de Lamoignon (after 1659, Troyes, Musée des Beaux-Arts; *ibid.*, 41).

354. 83. The nymphs on the extreme left and immediately to the right of Apollo have been interchanged.

84. In 1668-9.

85. The only groups with many free-standing figures then known were the 'Farnese Bull' and the 'Niobids' in the Villa Medici, neither of which presents a parallel close enough to be useful.

355. 86. 1668-70; Souchal, 30.

87. It was never actually set up in the Parterre because the plans for the latter were changed before its completion, and the marble was left in the sculptor's studio till 1695, when it was put in its present place. At the same time Girardon was commissioned to make the pedestal, which he completed in 1699.

356. 88. How skilfully Girardon could design a statue to be seen from all points of view can be judged from the Fontaine de la Pyramide and the Bassin de Saturne at Versailles (Souchal, 30, 34).

89. It now stands in the transept, so that much of the sculptor's carefully worked out scheme is rendered futile. For earlier projects for this tomb see R. A.

Weigert, 'Deux marchés inédits pour le tombeau de Richelieu', *Bulletin de la Société Poussin*, I (1947), 67.

90. As has often been noticed, this figure is again a borrowing from Poussin, in this case from the 'Extreme Unction'.

357. 91. For Girardon's late work see M. Rambaud, 'Les dernières années de François Girardon', *G.B.A.* (1973), II, 99. For his collection of sculptures see F. Souchal, 'La Collection du sculpteur Girardon d'après son inventaire après décès', *G.B.A.* (1973), II, I.

92. For Coysevox see F. Souchal, *French Sculptors of the Seventeenth and Eighteenth Centuries* (Oxford, 1977-), I, 176.

93. His main work there dates from the years 1679-88. Much of it was done in collaboration with Jean Baptiste Tuby (1635-1700), a sculptor of Italian origin.

94. The bronzes of the rivers Garonne and Dordogne are somewhat in the manner of Sarrazin.

358. 95. The number of sculptors who worked at Versailles at the same time as Girardon and Lebrun is enormous. All of them had superb technical skill and the gift of doing what was needed in the general team-work. They are all being covered by Souchal, *op. cit.*, but so far (1982) only two volumes covering A to L have appeared.

CHAPTER 8

For the later careers of artists mentioned in this chapter see Wend Graf Kalnein and Michael Levey, *Art and Architecture of the Eighteenth Century in France* (Pelican History of Art) (Harmondsworth, 1972).

361. I. For a full account of the ideas of Roger de Piles and of the Quarrel see B. Teyssèdre, *Roger de Piles et les débats sur le coloris au siècle de Louis XIV* (Paris, 1957). The book is full of information but is difficult to use (cf. review by C. Goldstein, *Art Bulletin*, XLIX (1967), 264). J. Thuillier has published a number of texts connected with the Quarrel (cf. 'Doctrines et querelles artistiques en France au début du XVIIe siècle', *A.A.F.*, XXIII (1968), 125).

2. No doubt there was latent in their minds the view of Descartes that outline is superior to colour because we can conceive of the former without the latter, but not *vice versa*.

3. Roger de Piles executed a few portraits, but was in no sense a professional painter. Towards the end of his life he was made a member of the Academy, but as an *amateur* not a painter.

4. It is of some interest that in the dedicatory Epistle to the *Dissertation sur les ouvrages de plus fameux peintres* of 1681 de Piles says that his admiration for Rubens was first aroused by the Duc de Liancourt

and Sir Kenelm Digby, both of whose taste was founded on that of Charles I.

362. 5. The actual influence of Rubens in French painting at this period is complex, because, though he was admired and studied by some artists for his naturalism, his works also gave a strong impetus to the Baroque tendency in artists such as Charles de La Fosse and Antoine Coypel. This problem will be discussed later, cf. pp. 382, 390.

6. The rich *bourgeois*, however, imitated the Court style and, as will appear below, enjoyed the most Baroque forms of portraiture.

7. For the Baroque elements in the architecture of the last years of Louis XIV's reign see C. Tadgell in *Baroque and Rococo Architecture and Decoration* (ed. A. Blunt) (London, 1978), 130.

364. 8. For a full account of the evolution of the design for the church see P. Reuterswärd, *The Two Churches of the Hôtel des Invalides* (Stockholm, 1965); for its origin as a mausoleum see A. Braham, 'L'Église du Dôme', *J.W.C.I.*, XXIII (1960), 216.

365. 9. Mansart planned an approach to the church which would have been even more Baroque. The façade was to be flanked with two domed pavilions from which sprang quadrant-shaped arcaded wings ending in two further pavilions. This scheme was evidently intended as a variant on Bernini's Piazza of St Peter's (cf. the engraving by Le Pautre, reproduced by Hautecœur, *Architecture*, II, 580).

10. The effect of the interior has, of course, been greatly changed by the circular well dug under the dome for the tomb of Napoleon.

11. This arrangement was not in the first design, which is preserved in the engravings in Lejeune de Bellencourt's account of the Invalides published in 1683, made after the original model (cf. *Description*, 18).

12. For the history of the chapel see the books quoted in connexion with the whole palace (cf. above, Chapter 7, Note 28), and also P. Moisy, 'Les Projets de T. Gobert pour la chapelle de Versailles', *G.B.A.* (1962), I, 227, and M. Petzet, 'Quelques projets inédits pour la chapelle de Versailles', *Art de France*, I (1961), 315.

13. Externally this Gothic effect is made even more marked by the console buttresses which run from the roof of the aisles to support the main vault and which produce something like a *chevet*.

366. 14. Cf. p. 390. The sculptured decoration of the lower parts of the chapel is among the earliest manifestations of full Rococo. It is discussed by F. Kimball, *The Creation of the Rococo*, 79 ff.

15. It was originally intended to decorate the chapel of Versailles with coloured marbles, but the scheme was abandoned when the plans were revised in 1698

(cf. Dussieux, *Le Château de Versailles*, 11, 111). Colour would, however, have been added by the Savonnerie carpets which were permanently laid in the king's gallery and were put down in the nave and in front of the high altar on special occasions (cf. P. Verlet, *The James A. de Rothschild Collection, Waddesdon Manor. Savonnerie Carpets* (Fribourg, 1980)).

367. 16. This is recorded in engravings by Pérelle, one of which is reproduced in Hautecœur, *Architecture*, 11, 606. The statue of Louis XIV was destroyed at the Revolution but is recorded in engravings (cf. Hautecœur, *Architecture*, 11, 606), and the statues of the four defeated countries (Turkey, the Empire, Spain, and Holland) which stood round it are preserved in the gardens of the château of Sceaux. Desjardins (1637–94) was by birth a Fleming and his name was Martin van den Bogaert. He worked extensively as a decorative sculptor in Paris (Hôtel Salé, Hôtel de Beauvais, Porte St Martin), and for the king at the Château du Val and at Versailles (cf. Souchal, *French Sculptors of the Seventeenth and Eighteenth Centuries* (Oxford, 1977), 238).

17. Mansart's design embodying this scheme is known from an engraving (reproduced by Hautecœur, *Architecture*, 11, 609).

368. 18. This statue was destroyed at the Revolution, and was replaced under Napoleon with the existing column.

19. Though Mansart was in charge of the whole scheme for the Place Vendôme, it is clear that his assistant, Pierre Bullet, played a considerable part not only in the planning of individual houses (see below, pp. 371 f.) but also in the design for the façade on the Place itself (see R. Strandberg, 'Les Dessins d'architecture de Pierre Bullet pour la Place Vendôme', *G.B.A.* (1965), I, 71).

20. The purchasers of the sites are given in the very full article of Boislisle, 'La Place des Victoires et la Place Vendôme', *Mémoires de la Société de l'Histoire de Paris*, XV (1888), I.

369. 21. This phase is analysed in detail by F. Kimball, *op. cit.*, 59 ff; cf. also C. Tadgell, *op. cit.*, 134.

22. Published by Mariette with the title: 'Maison à bâtir'. It cannot be dated exactly, but it is engraved by Pierre Le Pautre who only joined Mansart's office in 1699, so that it is likely to have been produced between that date and the year of Mansart's death (1708).

23. Shown in the plan by the steps which lead down from them into the garden.

24. F. Kimball (*op. cit.*, 36 ff., etc., and in two articles on the Trianon and the Ménagerie in the *G.B.A.* (1936), 11, 245, and (1938), I, 87) has proved that many of the drawings for decoration are by Lassurance and Pierre Le Pautre, but he goes too far in his attempt to deprive Mansart of almost all the credit for these innovations.

25. Blomfield tentatively attributes the *Maison à bâtir* to Lassurance, but without evidence.

370. 26. Mansart built for himself the Hôtel de Sagonne, rue des Tournelles, which still stands (Pillement, *Hôtels de Paris*, I, plate 25, and Mariette, *Architecture française*, plates 133–5). The exact date is uncertain, but it was finished before 1687 (cf. Hautecœur, *Architecture*, 11, 543). It is more remarkable for its painted decoration than for its planning, which is competent, but straightforward.

371. 27. For Bullet see E. Langenskiold, *Pierre Bullet* (Stockholm, 1959). In the 1670s, in competition with other architects, including Claude Perrault and C. R. de la Marre, he provided designs for a new façade for the medieval church of Ste Geneviève (cf. R. S. Strandberg, 'Projets pour la façade de Sainte-Geneviève et la Place "Qarré Sainte-Geneviève"', *B.S.H.A.F.* (1971), 45). An important collection of drawings by him is in the Tessin-Hårleman Collection in the National Museum at Stockholm; see E. Wettergren and E. Bier, *Från Ludvig XIV's Paris* (Stockholm, 1945) with catalogue and reproductions of the most important drawings, R. Strandberg, *op. cit.*, I, 71, and 'J. B. Bullet de Chamblin architecte du roi', *B.S.H.A.F.* (1962), 193.

28. The archbishop's palace at Bourges (between 1681 and 1686); the Hôtel de Vauvray (Mariette, *Architecture française*, plates 144 and 145) with an unconventional plan designed to suit a difficult site, and arranged so that the axis of the garden front is at right angles to that of the court, a method much used later, e.g. at the Hôtel Amelot, later Tallard, 78 rue des Archives (reproduced in Pillement, *Les Hôtels de Paris*, I, plate 38 and *Les Hôtels du Marais* (1948), plate 55); and the Hôtel de Brancas (reproduced in Pillement, *Les Hôtels de Paris*, 11, plate 8).

29. Between 1681 and 1687 he built the château of Issy for Denis Talon on an unusual compact plan, very nearly square in shape. It is destroyed but known from engravings in Mariette, *op. cit.*, plates 303–31.

30. The Hôtel d'Évreux is engraved in Mariette, *op. cit.*, plates 53–8, and illustrated in Vacquier, *Vieux hôtels de Paris, Place Vendôme*, plates 31–3. The house was begun in 1700, but radically altered in 1707, only the façade surviving from the earlier building. The remodelling may have been partly a work of collaboration between Pierre Bullet and his son, Jean Baptiste Bullet de Chamblin (1665-1726).

31. The Hôtel Crozat as built by Bullet is engraved in Mariette, *op. cit.*, plates 47, 48, 51, and 52. Drawings are in the Tessin-Hårleman Collection (cat. nos. 105-17). A variant solution, slightly simpler in form,

to the same problem is to be seen in a plan for another of the houses in the corners of the Place Vendôme (no. 8) made by Pierre Le Maistre for the financier Delpech (cf. Le Moël, *op. cit.*, 119). The site for this house was bought by Delpech in 1714 (cf. Boislisle, *op. cit.*, 171).

372. 32. Rothelin (*c.* 1700), Desmarets (1704), Auvergne (finished 1708), Béthune (1708), Maisons (1708). On Lassurance see Hautecœur, *Architecture*, II, 649, and F. Kimball, *The Creation of the Rococo*, 39, etc. His most important works are engraved in Mariette, *op. cit.*

33. See J. P. Babelon, *Historique et description des bâtiments des Archives Nationales* (Paris, 1958), 32. According to a *mémoire* by Delamair, J. H. Mansart had offered his services as architect to the Prince de Soubise but he was rejected in favour of his much younger rival.

34. For these architects see F. Kimball, *op. cit.*, 93 ff., and Hautecœur, *Architecture*, III, 106 ff.

35. Robert de Cotte (1656-1735) was also a member of Mansart's workshop, but his independent works all date from 1710 onwards and belong to the early Rococo.

Mention must be made of C. A. Daviler (1653-1700), whose *Cours d'architecture* (1691) is, after Blondel's, the most important manifesto of academic doctrine in the later seventeenth century (cf. Hautecœur, *Architecture*, II, 646 ff.). He worked under Mansart in Paris and for d'Orbay at Montpellier, where he set up a school which produced good imitations of the style practised in Paris (cf. A. Fliche, *Montpellier* (Paris, 1935), 79). A few other provincial architects sprang up, of whom the most important is Pierre Puget, whose career as a sculptor will be discussed in the next section. For his architecture see J. J. Gloton, 'Pierre Puget architecte romain', in *Puget et son temps*. Many of the buildings traditionally ascribed to Puget have been shown by recent research to be by other hands, but he is certainly responsible for the Hospice de la Charité at Marseilles for which he supplied designs in 1671 (cf. Gloton, *op. cit.*, 67). This consists of a huge courtyard surrounded by three storeys of arcaded loggias and in the middle an oval chapel, to which an entirely unsuitable façade was added in 1863. The chapel, which was restored in 1978-9, is impressive in its simple form and undecorated stone dome – a beautiful piece of stone cutting. It contains one very unusual feature: the coupled piers in the lateral chapels do not consist of coupled columns but of one column and one rectangular pier.

374. 36. For Puget see K. Herding, *Pierre Puget (Das bildnerische Werk)* (Berlin, 1970).

37. For Puget's paintings see M. C. Gloton in the catalogue of the exhibition *La Peinture en Provence au XVIIe. siècle* (Marseilles, 1978), 112.

38. The only exception is the early 'Anima dannata' (Wittkower, *Gianlorenzo Bernini* (London, 1966), plate 6), but this is almost a caricature of violent emotion.

39. Cf. Briganti, *Pietro da Cortona* (Florence, 1962), plate 132.

375. 40. The 'Hercules' is now in the Louvre and one of the statues from Vaudreuil, much damaged but still splendid, is in the Musée des Beaux-Arts, Rouen.

41. Colbert may, however, also have felt some grudge against Puget for preferring Fouquet to Mazarin (cf. *G.B.A.* (1865), I, 317).

42. Colbert did not personally dislike this statue, because he later took it for his own park at Sceaux. The garden statues there also included a copy of Bernini's 'Apollo and Daphne', which still survives in a mutilated condition.

43. Cf. Herding, *op. cit.*, 154.

376. 44. *Ibid.*, plate 57.

45. Puget also executed other religious statues in Genoa in the period 1660-70, notably several of the 'Immaculate Conception' (cf. Herding, *op. cit.*, plates 148 and 152). These are close in style to the work of Bernini's pupil, Ercole Ferrata, particularly to those in S. Agnese, Rome, executed in the late 1650s, which Puget might have seen if he went to Rome for a second time.

46. For the work at Toulon see G. Walton, 'Les Dessins d'architecture de Puget pour la reconstruction de l'arsenal de Toulon', *Information d'histoire de l'Art*, x (1965), 162, and Gloton, *op. cit.*

47. Both were designed in 1671. The 'Milo' was finished in 1682, and the 'Alexander' in 1693.

48. Illustration 313, like all available photographs, unfortunately shows the statue slightly from one side.

378. 49. Louvre. By a curious chance the 'Perseus' arrived in the same boat as Bernini's equestrian statue of Louis XIV. A clear light is thrown on French taste at this moment by the fact that, whereas the 'Perseus' was generally (though not universally) admired, Bernini's statue was so widely criticized that the King ordered Girardon to convert it into a Marcus Curtius by making a new head for it and altering other details. That is to say, although the taste of Versailles was nearer than ever before to the Baroque, the King and the courtiers could not swallow the grand and monumental movement of Bernini's late style. Puget's groups were as near as they could go to the Baroque.

50. Louvre.

51. *G.B.A.* (1865), II, 425.

52. It was planned for the vestibule of the chapel at Versailles, but by the time of its arrival Louvois was

dead and intrigue succeeded in preventing Puget's work from ever reaching the King's eyes.

53. Briganti, *op. cit.*, plates 105, 106.

54. It was no chance that he was much admired by Delacroix.

55. Puget had one pupil of some importance, Christophe Veyrier (1637–89); cf. Herding, *op. cit.*

379. 56. The terracotta of 1676 in the Wallace Collection and the marble of 1679 in the Louvre.

57. It is significant that Coysevox's only bust of an Englishman, that of Matthew Prior in Westminster Abbey (1700), is among his most naturalistic works. It depicts the poet in contemporary cap as well as with a shirt and embroidered coat.

58. Except the astonishing terracotta head of Puget at Aix-en-Provence (sometimes attributed to Puget himself, but more usually to his pupil Christophe Veyrier), which has an almost nineteenth-century naturalism (reproduced in Herding, *op. cit.*, frontispiece). The Italian Baroque can offer one parallel in Bernini's bust of his mistress, Costanza Buonarelli (R. Wittkower, *Gianlorenzo Bernini* (London, 1966), plate 61).

380. 59. The tendency towards the Rococo was also visible in the work of other artists active before the end of the reign, particularly in Nicolas Coustou, a nephew of Coysevox (1658–1733), whose figure of France in the Chambre du Roi at Versailles, executed in 1701, marks an important stage towards the freedom of the eighteenth century in decorative sculpture (reproduced in Souchal, *French Sculptors of the Seventeenth and Eighteenth Centuries*, I, 162), and whose statues for Marly (1710–12) are a development from Coysevox's 'Duchesse de Bourgogne' in their lightness of movement. Robert Le Lorrain's (1666–1743) 'Galatea' of 1701 (Kress Collection; Souchal, II, 336) has the same characteristics, and the 'Cupid and Psyche' of C. A. Cayot (1667–1722) in the Wallace Collection, dated 1706, foreshadows Boucher in feeling (cf. Souchal, I, 152). Nicolas Coustou's younger brother, Guillaume (1677–1746), was one of the team of sculptors employed on the decoration of the chapel at Versailles (*ibid.*, 129).

60. Pierre Lepautre (1659/66–1744; first cousin of the architect) carved some of the reliefs in the chapel at Versailles (1707–10; Souchal, II, 379) and made a group of 'Aeneas and Anchises' for Marly (1696–1718, now in the Tuileries Gardens; *ibid.*, 377, 437). Pierre Legros the Younger (1666–1719), Pierre Étienne Monnot (1657–1733), and Théodon (1646–1713) belong to the history of Italian Baroque art (cf. R. Enggass, *Early Eighteenth-Century Sculpture in Rome* (University Park, 1976), 63, 77, 124, and for Legros, Souchal, II, 273).

61. In 1681 Antoine Coypel painted as his diploma picture 'Louis XIV resting after the Peace of Nijmegen' (Montpellier) [325], but the composition is as empty as were the King's claims to victory.

62. For the revival of religious painting at this time and for a complete revaluation of this phase in French painting, see A. Schnapper, *Jean Jouvenet* (Paris, 1974).

63. See M. Suffmann, 'Charles de la Fosse et sa position dans la peinture française à la fin du 17e siècle', *G.B.A.* (1964), II, I.

382. 64. The trees also foreshadow the colour and handling of Watteau, and remind one that La Fosse was almost the only seventeenth-century French artist whom Watteau may have studied with profit.

65. The closest parallels are two engravings by Pontius after the 'Visitation' and the 'Presentation' (Rooses, *L'Œuvre de P. P. Rubens*, I (1886), plates opposite pp. 188, 232) after grisaille sketches which are variants of the wings of the Antwerp 'Descent from the Cross'.

66. The 'Presentation' shows some resemblance to the work of Murillo. This may be due to a common source in Rubens, but it is possible that there may be some direct influence. Murillo was at any rate known in France about 1700, since Grimou copied his 'Infant Saviour' (formerly Ellesmere collection; sold Christie's 18 October 1946, lot 94).

385. 67. See A. Schnapper, *Peintures commandées par Louis XIV pour le Grand Trianon* (The Hague, 1967).

68. He decorated for him Montagu House (cf. *Country Life*, 14 September 1951, 812). On its completion William III tried to induce La Fosse to stay in England to paint at Hampton Court, but the artist had to obey the summons back to Paris.

69. Mansart had originally asked Mignard to design the frescoes, but his great age prevented him from undertaking the work.

70. It is not too much to see in the theme an echo of the Revocation of the Edict of Nantes.

71. The dome fresco was executed in 1700–2.

72. For Jouvenet see A. Schnapper, *Jean Jouvenet* (Paris, 1974).

387. 73. To the same phase belongs Michel Corneille the Younger (1642–1708), who decorated the chapel of St Ambrose at the Invalides and was a prolific draughtsman. For further details about him see the article in Thieme-Becker, and P. Marcel, *La Peinture française, passim.*

74. A fairly full biography of Antoine Coypel, with list of works and bibliography, is to be found in Dimier, *Les Peintres français du 18e siècle*, I, 93. For engravings after his compositions see D. Wildenstein, 'L'Œuvre gravé des Coypel', *G.B.A.* (1964), II, 141.

390. 75. Typical examples are the 'Susanna' and the 'Athalie' (Prado and Louvre; reproduced by Schnapper, *Jean Jouvenet*, plates 258, 259).

76. One survives at Fontainebleau and is reproduced in L. Dimier, *Les Peintres français du 18e siècle*, plate 25.

77. Cf. A. Schnapper, 'La Galerie d'Énée au Palais-Royal', *Revue de l'Art*, v (1969), 33.

78. The vault of the nave was not begun till 1676, the year after Coypel left Rome (cf. R. Enggass, *The Painting of Baciccio* (Pennsylvania State University, 1964), 136), but he may well have known a preliminary sketch for the design.

79. The same tendency can be traced even earlier in one royal commission, the painting by Gabriel Blanchard (1640-1707) of 'Diana and Endymion' in the Salon de Diane at Versailles, finished before 1680. This canvas has a Bolognese lightness and is painted in pastel-like pinks, greys, and blues which are almost *dix-huitième* in character. Little is known of Gabriel Blanchard, who was the son of Jacques, except that he was an active defender of colour in the Academy (cf. p. 361).

391. 80. For the paintings executed for the Ménagerie see G. Mabille, 'Les Tableaux de la Ménagerie de Versailles', *B.S.H.A.F.* (1974), 89.

81. The Dauphin, for instance, ordered a cycle of similar paintings for Meudon in the years 1700-9.

82. For the Boullognes see Caix de Saint-Aymour, *Les Boullongne*, A. Schnapper, *Jean Jouvenet*, C. Goldstein, 'Observations on the Rôle of Rome in the Formation of the French Rococo', *Art Quarterly*, XXXIII (1970), 227, and A. Schnapper, 'Plaidoyer pour un absent: Bon Boullogne (1649-1717)', *Revue de l'Art*, XL-XLI (1978), 121, and 'Esquisses de Louis de Boullogne sur la vie de Saint Augustin', *Revue de l'Art*, IX (1970), 58.

83. Both Bon and Louis de Boullogne the Younger studied in Bologna and North Italy as well as in Rome.

393. 84. For an account of Parrocel's work see the catalogue of the exhibition *Au temps du Roi Soleil*, held at Lille in 1968, and A. Schnapper, 'Deux tableaux de Joseph Parrocel au Musée de Rouen', *Revue du Louvre*, XX (1970), 78.

A curious *retardataire* artist, Nicolas Colombel (1644-1717), continued to paint in the style of Poussin, ignoring all the changes that were taking place around him (cf. A. Blunt, 'Nicolas Colombel', *Revue de l'Art*, IX (1970), 27).

85. For lists of his works see the articles in the dictionaries of Bénézit and Thieme-Becker. Good examples are in the Louvre and at Versailles.

86. Reproduced in L. Réau, *Histoire de la peinture française au 18e siècle*, plate 3.

87. For an account of François de Troy see L. Réau, *op. cit.*, I, 53 ff., with reproductions of typical works.

88. Reproduced in L. Réau, *op. cit.*, I, plate 40.

89. The example shown in illustration 329, dated 1683, was in an anonymous sale at Christie's, 12 May 1939, lot 90.

90. The name is often spelt *Largillière*, but the artist himself regularly signed *Largillierre*.

394. 91. There is a short biography of Largillierre by Georges Pascal (*Largillierre*, Paris, 1928), which also includes a list of his works and a bibliography.

92. With Peter Rysbrack, father of the sculptor (cf. *Vertue MSS*, III, 37).

93. He is recorded as receiving payment for overdoors, no doubt of still-life, at Windsor in 1676-7 (cf. St John Hope, *Windsor Castle*, I (1913), 315). One still-life, dated 1677, survives and passed from the Jersey collection to that of F. Lugt (reproduced in *Maandblad voor beeldende Kunsten*, XXVI (1950), 131). Pascal lists three other still-lifes and reproduces one of them (plate 30), which is in a later and more decorative manner (cf. also P. Grate, 'Largillierre et la nature morte de Grenoble', *Revue du Louvre et des Musées de France*, XI (1961), 23).

94. The engraving of Mrs Anne Warner is reproduced by C. H. Collins Baker, 'The Portrait of Jane Middleton in the National Portrait Gallery', *Burl. Mag.*, XVII (1910), 360. The author's attribution of the portrait of Jane Middleton to Largillierre is not now generally accepted. For further details about Largillierre's portraits painted in England see *Vertue MSS*, IV, 110, 120, and 121, V, 105.

95. Two of Nicolas Lambert and his wife, Marie de Laubespine, and a third of Hélène Lambert, wife of François de Motteville (the last two are in private collections, cf. Pascal, *op. cit.*, nos. 76 and 99) were engraved by Drevet (the first two reproduced by É. Bouvy, *La Gravure de portraits et d'allégories*, figures 82 and 83). Their exact dates are not known, but Lambert died in 1692, and the dress suggests a date nearly a decade earlier. The portrait of Mme de Motteville is based on a Lely pattern, but the other two show also the influence of small Dutch portraits.

396. 96. See G. de Lastic, 'Rigaud, Largillierre et le tableau du Prévôt et des Échevins de la Ville de Paris de 1689', *B.S.H.A.F.* (1975), 147. The author shows that Rigaud made a sketch for the composition, which was presumably rejected in favour of Largillierre's.

398. 97. Largillierre received three other commissions of the same kind from the city of Paris: in 1699 for the marriage of the Duc de Bourgogne, known from an engraving which shows that the artist borrowed freely from Rubens in this composition; in 1702 for the accession of the Duc d'Anjou as Philip V of Spain,

of which two fragments exist in the Musée Carnavalet (cf. Pascal, *op. cit.*, plate 5); in 1722 for the proposed marriage of Louis XV, known from a sketch in the Musée Carnavalet (Pascal, *op. cit.*, plate 2).

98. For an account of Largillierre's views on colour and naturalism see the two lectures by his pupil Oudry in H. Jouin, *Conférences de l'Académie Royale*, 378 ff.

99. F. Maison and P. Rosenberg, 'Largillierre peintre d'histoire et de paysage', *Revue du Louvre*, XXIII (1973), 89.

100. There is no modern monograph on Rigaud, but summaries of his achievement are to be found in Weisbach, *Französische Malerei des XVII. Jahrhunderts*, 285 ff., and L. Réau, *Histoire de la peinture française au 18e siècle*, I, 58 ff. The essential document is the artist's sitters' book published by J. Roman (*Le Livre de Raison du peintre Hyacinthe Rigaud*). Early biographies are to be found in the *Mémoires inédits*, 11, 114, and Dézallier d'Argenville, *Abrégé*, IV, 310.

101. Cf. the portraits of the sculptor Martin Desjardins and his wife, Marie Cadenne, painted in 1683 and 1684 respectively. The latter is in the museum at Caen (reproduced in the *G.B.A.* (1931), I, 106); the former is presumably the painting at Versailles (no. 3583). Other examples are the portraits of Frédéric Léonard (1689; engraved by Edelinck), of Boyer d'Aguilles (1689; engraved by Coelemans), of Mignard (1690; Versailles, reproduced in A. Fontaine, *Académiciens d'autrefois*, plate 10), and La Fontaine (1690; engraved by Edelinck, reproduced in E. Bourgeois, *Le Grand Siècle*, plate opposite p. 302).

102. The portrait of Monsieur seems to have vanished, but that of the Duc de Chartres exists in two versions at Versailles and Toulouse.

103. Cf. Gallenkamp, 'An Early Group Portrait by Hyacinthe Rigaud', *G.B.A.* (1959), I, 45.

104. He did, however, continue to paint portraits of a more personal character, such as the portrait-group at Ottawa, dated 1699, which, as Gallenkamp has shown, represents him with Elisabeth Le Juge, whom he later married (see 'Rigaud's Portrait Group at Ottawa', *J.W.C.I.*, XXIII (1960), 225). Gallenkamp works out ingeniously and convincingly the allegorical implications of this group-portrait. A double-portrait at Melbourne, dated 1697, represents Pierre Cardin Le Bret and his son, who occupied in turn the position of Président in the Parlement of Aix-en-Provence (cf. U. Hoff, 'A New Double Portrait by Rigaud', *Annual Bulletin of the National Gallery of Victoria*, V (1963), 11).

105. The backgrounds, as in the example reproduced, are usually the work of Joseph Parrocel (cf. pp. 391 ff.).

401. 106. E.g. in the portrait of Charles II of England, dated 1653, in Cleveland (cf. N. C. Wixon, 'Charles II, King of England', *Bulletin of the Cleveland Museum of Art*, XLVI (1959), 163).

107. The portrait of the first Earl of Portland here reproduced [333] was painted in 1698-9. Cf. R. W. Goulding (*Catalogue of the Pictures belonging to His Grace the Duke of Portland* (1936), 58), who quotes some caustic comments by Matthew Prior on 'that stuttering rogue Rygault'. (Further references to Rigaud are to be found in Prior's letters published in *Hist. MSS Com. Marquis of Bath*, III (1908), *passim*.) At the same time the artist painted Lord Portland's eldest son (reproduced in C. Fairfax Murray, *Catalogue of the Pictures belonging to His Grace the Duke of Portland* (1894), plate opposite p. 41).

108. Rigaud executed one other state portrait at this time, that of Philip V of Spain at his accession (Prado) (cf. J. J. Luna, 'Hyacinthe Rigaud et l'Espagne', *G.B.A.* (1978), II, 185). The full-length of Bossuet (Louvre, 1699), though not royal, belongs to the same category.

402. 109. Louvre, 1693. Pierre Frédéric was the son of Frédéric Léonard, whom Rigaud had painted in 1689.

110. The inventory is printed in the *Nouvelles Archives de l'Art Français*, third series, VII (1891), 61. The artist's collection also included paintings by Rubens, van Dyck, Jordaens, Titian, and Veronese. One very late work by Rigaud, the 'Presentation', painted in 1743, and now in the Louvre, is a pastiche of Rembrandt's manner in the early 1630s.

For further details about the influence of Rembrandt at the beginning of the eighteenth century, cf. P. Marcel, *La Peinture française*, 71. To this should be added a reference to Robert Levrac de Tournières, who copied Rembrandt at any rate soon after 1700 (cf. L. Dimier, *Les Peintres français du 18e siècle*, I, 231), and Santerre, by whom there is a copy of the Dulwich portrait of a girl at a window (Orléans Museum). Roger de Piles also owned several paintings attributed to Rembrandt, including a 'Girl at a Window', which was probably either that in the Duke of Bedford's collection or that in Stockholm.

404. 111. For a fuller account of Desportes' sketches of landscape and also of animals see L. Hourticq, 'L'Atelier de François Desportes', *G.B.A.* (1920), II, 117, and the catalogue of the exhibition *Paysages de François Desportes* (Compiègne, 1961).

112. Sandrart boasts that he taught Claude to do so, but there is no other case recorded before the time of Desportes.

113. Owing to the increasing centralization under Louis XIV painting in the French provinces was much less important in the second half of the century than in the first. There was however still a great deal

of activity and one or two figures of interest emerged. In Lyons Thomas Blanchet (1614–79) established a considerable career as a painter from 1655, when he settled in the city after his years of training in Paris and Rome (cf. Chou Ling, *Thomas Blanchet*, Lyons, 1941). His principal work was the decoration of the Grande Salle in the Hôtel de Ville, which was unhappily destroyed by fire in 1674, four years after it was completed, but its general design is known from drawings and a painted *modello* (cf. L. Galactéros de Boissier, 'Thomas Blanchet: La Grande Salle de l'Hôtel de Ville de Lyon', *Revue de l'Art*, XLVII (1980), 29; see also the same author's 'Dessins de Thomas Blanchet dans les collections publiques françaises', *Revue du Louvre*, XXV (1971), 25).

In Provence Pierre Puget (1610–94) had a successful career as a painter as well as a sculptor and the tradition was carried on by his son François (1651–1707) (cf. *La Peinture en Provence au XVIIe siècle* (exhibition catalogue), Marseilles, 1978, 112). Michel Serre (1658–1733) painted a number of large religious pictures and two remarkable canvases depicting the plague at Marseilles in 1720.

In Toulouse Jean-Pierre Rivalz (1625–1706) and his son Antoine (1667–1715) created a solid tradition in religious painting and portraiture and also established one of the few provincial Academies of Painting. The tradition of portraiture was linked with Paris by François de Troy, who came of a family of Toulousain painters but moved to the capital (cf. *L'Âge d'Or de la peinture toulousaine* (exhibition catalogue), Toulouse, 1947).

114. Cf. G. Wildenstein, 'Le Goût pour la peinture ... autour de 1700', *G.B.A.* (1956), I, 113.

BIBLIOGRAPHY

The following bibliography is not intended to be complete, but only to include general works and monographs on individual artists. Books and articles on more specialized aspects are referred to in the Notes.

BOOKS COVERING
THE WHOLE PERIOD

A. ALL THREE ARTS

i. Sources

BRACKENHOFFER, E. *Voyage en France, 1643-44.* Paris, 1925.
BRICE, G. *Nouvelle description de Paris.* First edition, Paris, 1684. A facsimile of the 1752 edition was published in 1971. Edition here quoted, Paris, 1725.
DÉZALLIER D'ARGENVILLE, A. J. *Abrégé de la vie des plus fameux peintres.* First edition, Paris, 1745. Second enlarged edition here quoted, Paris, 1762.
DÉZALLIER D'ARGENVILLE, A. N. *Voyage pittoresque de Paris.* First edition, Paris, 1749. Edition here quoted, Paris, 1778.
DÉZALLIER D'ARGENVILLE, A. N. *Voyage pittoresque des environs de Paris.* First edition, Paris, 1755. Edition here quoted, Paris, 1779.
DÉZALLIER D'ARGENVILLE, A. N. *Vies des plus fameux architectes et sculpteurs.* Paris, 1787.
FÉLIBIEN, A. *Entretiens sur les vies et sur les ouvrages des plus excellens peintres anciens et modernes.* First complete edition, Paris, 1685-8. Edition here quoted, Trévoux, 1725. Reproduced in facsimile, London, 1967.
LE COMTE, F. *Cabinet des singularitez d'architecture, peinture, sculpture et graveure.* First edition, Paris, 1699. Edition here quoted, Brussels, 1702.
LEMAIRE, C. *Paris ancien et nouveau.* Paris, 1685.
MARIETTE, P. *Abecedario.* Published by Ph. de Chennevières and A. de Montaiglon. Paris, 1851-60.
PERRAULT, C. *Les Hommes illustres qui ont paru en France pendant ce siècle.* Paris, 1696-1700.
PIGANIOL DE LA FORCE, J. *Description de Paris.* First edition, Paris, 1736. Edition here quoted, Paris, 1742.

SANDRART, J. V. *Teutsche Academie der edlen Bau-, Bild- und Mahlerey-Künste.* First edition, Nuremberg, 1675. Edition here quoted, edited by A. R. Peltzer, Munich, 1925.
SAUVAL, H. *Histoire et recherches des antiquités de la ville de Paris.* Paris, 1724. Reproduced in facsimile, London, 1969, and Paris, 1974.
WILDENSTEIN, G. 'Les Sources d'information sur les artistes provinciaux français', *Gazette des Beaux-Arts* (1958), II, 93 ff.

ii. Reference Books

Dictionnaire des artistes et ouvriers d'art de la France par provinces:
(i) *Franche-Comté* par l'abbé Paul Brune. Paris, 1912.
(ii) *Lyonnais* par M. Audin et E. Vial. Paris, 1918-19.
Inventaire général des richesses d'art de la France. Paris, 1877-1911.
BERLINER, R. *Ornamentale Vorlageblätter des 15. bis 18. Jahrhunderts.* Leipzig, 1925-6.
BONNAFFÉ. E. *Dictionnaire des amateurs français au 17e siécle.* Paris, 1884.
HERLUISON, H. *Actes d'état-civil d'artistes français.* Orléans, 1873.
JAL, A. *Dictionnaire critique de biographie et d'histoire.* Paris, 1867.
THIEME, U., and BECKER, F. *Allgemeines Lexikon der bildenden Künstler.* Leipzig, 1908-50.

B. ARCHITECTURE

i. Sources

BLONDEL, J. F. *Architecture françoise.* Paris, 1752-3. Reprint, Paris, 1904.

CHASTILLON, C. *Topographie françoise.* Paris, 1641.
DU BREUL, J. *Le Théâtre des antiquitez de Paris.* First edition, Paris, 1612. Enlarged edition, Paris, 1639.
FÉLIBIEN, A. *Mémoires pour servir à l'histoire des maisons royales.* Paris, 1681.
FÉLIBIEN, M. *Histoire de la ville de Paris.* Paris, 1725.
LABORDE, L. DE. *Les Comptes des bâtiments du roi (1528-1571).* Paris, 1877-80.
MARIETTE, J. *L'Architecture française.* Paris, 1727. Five volumes. Reprint of volumes 1-3, Paris and Brussels, 1927-9.
MAROT, J. *L'architecture françoise.* Paris, *c.* 1670. Enlarged edition as volume 4 of Mariette's *Architecture française.* Reproduced in facsimile, Paris, 1970.
MAROT, J. *Recueil des plans, profils et élévations de plusieurs palais, chasteaux, églises, sépultures, grotes et hostels bâtis dans Paris.* Paris, *c.* 1660-70. Reproduced in facsimile, Paris, 1970.
MERIAN, M. *Topographia Galliae.* Amsterdam, 1660.

ii. Modern Works

BERTY, A., *et al. Topographie historique du vieux Paris.* Paris, 1866-8.
BLOMFIELD, SIR R. *History of French Architecture, 1494-1661.* London, 1911.
BLOMFIELD, SIR R. *History of French Architecture, 1661-1774.* London, 1921.
BOINET, A. *Les Églises parisiennes.* Paris, 1958-64.
BOUDIN, F., CHASTEL, A., COUSY, H. *Système de l'architecture urbaine. Le Quartier des Halles.* Paris, 1977. The first volume of a systematic, house-by-house survey of Paris.
CHRIST, Y. *Églises parisiennes actuelles et disparues.* Paris, 1947.
CHRIST, Y. *Dictionnaire des châteaux de France.* Paris, 1979—.
COSSÉ BRISSAC, PH. DE. *Châteaux de France disparus.* Paris, 1947.
DUMOLIN, M. *Études de topographie parisienne.* Paris, 1929-31.
DUMOLIN, M., and OUTARDEL, G. *Les Églises de France, Paris et la Seine.* Paris, 1936.
EVANS, JOAN. *Monastic Architecture in France from the Renaissance to the Revolution.* Cambridge, 1964.
GLOTON, J. J. *Renaissance et baroque à Aix-en-Provence.* Paris, 1979.
HAUTECŒUR, L. *Histoire de l'architecture classique en France.* Volumes I-II. Paris, 1943-8. New edition of volume I 1963-7. Generally speaking, references here are to the first edition, but where the second edition is quoted it is referred to as *Architecture (2).*
HAUTECŒUR, L. *Histoire du Louvre,* Paris, 1928.
JARRY, P. *La Guirlande de Paris.* Paris, 1928.

LEFRANÇOIS, P. *Paris à travers les siècles.* Paris, 1948-56.
PILLEMENT, G. *Les Hôtels de Paris.* Paris, 1945.
PILLEMENT, G. *Les Hôtels du Marais.* Paris, 1945. Revised edition, Paris, 1948.
ST SAUVEUR, H. *Châteaux de France.* Paris, n.d.
SAUVAGEOT, C. *Palais, châteaux, hôtels et maisons de France du XVᵉ au XVIIIᵉ siècle.* Paris, 1867.
SELLIER, C. *Les anciens hôtels de Paris.* Paris, 1910.
SOULANGE-BODIN, H. *Châteaux de Normandie.* Paris, 1928-9.
VACQUIER, J. *Les anciens châteaux de France.* Paris, 1914-31.
VACQUIER, J., and others. *Les vieux hôtels de Paris.* Paris, 1909-30.

C. PAINTING, DRAWING AND ENGRAVING

i. Sources

BAILLY, N. *Inventaire des tableaux du Roy rédigé en 1709 et 1710.* Paris, 1899.
FLEURY, M. A. *Documents du minutier central concernant les peintres, les sculpteurs et les graveurs au XVIIᵉ siècle.* Paris, 1969.
RAMBAUD, M. *Documents du minutier central concernant l'histoire de l'art (1700-1750).* Paris, 1964-71.

ii. Modern Works

CHÂTELET, A., and THUILLIER, J. *La Peinture française de Fouquet à Poussin.* Geneva, 1963.
CHENNEVIÈRES-POINTEL, P. DE. *Recherches sur la vie et les ouvrages de quelques peintres provinciaux de l'ancienne France.* Paris, 1847-54.
COURBOIN, F. *Histoire illustrée de la gravure en France.* Paris, 1923-9.
DACIER, E. *La Gravure française.* Paris, 1944.
FONTAINE, A. *Les Doctrines d'art en France.* Paris, 1909.
GUIFFREY, J., and MARCEL, P. *Inventaire général des dessins du musée du Louvre. . . . École française.* Paris, 1906-.
ROBERT-DUMESNIL, A. *Le Peintre-graveur français.* Paris, 1835-71.
THUILLIER, J., and CHÂTELET, A. *La Peinture française de Le Nain à Fragonard.* Geneva, 1964.

D. SCULPTURE

BENOIST, L. *La Sculpture française.* Paris, 1945.
VITRY, P. *La Sculpture française classique de Jean Goujon à Rodin.* Paris, 1934.

E. APPLIED ARTS

i. Textiles

BASCHET, J. *Tapisseries de France*. Paris, 1951.
FENAILLE, M. *État général des tapisseries de la manufacture des Gobelins*. Paris, 1923-.
GUICHARD, E. *Les Tapisseries décoratives du Garde-Meuble*. Paris, n.d.
GUIFFREY, J. *Histoire de la tapisserie depuis le moyen-âge jusqu' à nos jours*. Tours, 1886.
VERLET, P. *The James A. de Rothschild Collection, Waddesdon Manor. The Savonnerie*. Fribourg, 1982.

ii. Other Arts

AUBERT, M. *Le Vitrail en France*. Paris, 1946.
BABELON, J. *L'Orfèvrerie française*. Paris, 1946.
HAVARD, H. *Dictionnaire de l'ameublement et de la décoration depuis le XIIIe siècle jusqu'à nos jours*. Paris, 1887-90.
VERLET, P. *Le Mobilier royal français*. Paris, 1945 and 1955.
VERLET, P. *French Royal Furniture*. London, 1963.

SIXTEENTH CENTURY

A. ALL THREE ARTS

BRION, M. *Lumière de la Renaissance*. Paris, 1948.
L'École de Fontainebleau. Catalogue of the exhibition held in the Grand Palais, Paris, in 1972; referred to as *Fontainebleau (Grand Palais)*.
Fontainebleau. Art in France 1528-1610. Catalogue of the exhibition held at the National Gallery of Canada, Ottawa, 1973.
GÉBELIN, F. *Le Style Renaissance en France*. Paris, 1942.
LABORDE, L. DE. *La Renaissance des arts à la cour de France*. Paris, 1886.
PALUSTRE, L. *La Renaissance en France*. Paris, 1879-85.
ROY, M. *Artistes et monuments de la Renaissance française*. Paris, 1929.
SHEARMAN, J. *Mannerism*. Harmondsworth, 1967.
VASARI, G. *Le Vite de' più eccellenti pittori, scultori, e architettori* . . . First edition, 1550; second edition, 1568. Translation by Gaston du C. de Vere, London, 1912-15.
YATES, F. *The French Academies of the 16th Century*. London, 1949.

B. ARCHITECTURE

i. General

ALBERTI, L. B. *L'Architecture*. Translated by Jean Martin. Paris, 1553.
DU CERCEAU, J. A. *Les plus excellents bastiments de France* . . . Paris, 1576-79. Facsimile reprint, London, 1972.
GÉBELIN, F. *Les Châteaux de la Loire*. Paris, 1927.
GÉBELIN, F. *Les Châteaux de la Renaissance*. Paris, 1927.
LABORDE, L. DE. *Les Comptes des bâtiments du roi (1528-71)*. Paris, 1877-80.
MARIE, A. *Jardins français créés à la Renaissance*. Paris, 1955.
MARTIN, C., and ENLART, C. *La Renaissance en France*. Paris, 1911.
PALUSTRE, L. *L'Architecture de la Renaissance*. Paris, 1902.
VITRUVIUS. *L'Architecture*. Translated by Jean Martin. Paris, 1547. Facsimile reprint, London, 1972.
WARD, H. W. *French Châteaux and Gardens in the Sixteenth Century*. London, 1909. Second edition, London, 1926; reprinted New York, 1976.

ii. Individual Artists

BULLANT, J.
Reigle générale d'architecture. Rouen, 1564 and 1568.
James, F. C. 'Jean Bullant, Recherches sur l'architecture française du XVIe. siècle', *École des Chartes. Positions de Thèses*, 101. Paris, 1968.
DOMINIQUE DE CORTONE
Le Sueur, P. *Dominique de Cortone dit le Boccador*. Paris, 1928.
DU CERCEAU
Livre d'architecture. Paris, 1559.
Second livre d'architecture. Paris, 1561.
Livre d'architecture ... pour ... bastir aux champs. Paris, 1582. Facsimiles of all three books published by the Gregg Press, 1965.
Thomson, D. *Jacques et Baptiste Androuet du Cerceau. Recherches sur l'architecture française 1545-90*. Paris, 1982.
L'ORME, P. DE
L'Architecture. Paris, 1567. Facsimile edition, London, 1967.
Blunt, A. *Philibert de l'Orme*. London, 1958.
SERLIO, S.
Tutte l'opere d'architettura. First complete edition, Venice, 1584. For dates of publication of separate books see p. 73. For the 'true' sixth book see M. Rosci, *Il Trattato di Architettura*, Milan, 1967, and M. N. Rosenfeld, *Sebastiano Serlio on Domestic Architecture*, Cambridge, Mass., 1978.

C. PAINTING, DRAWING, AND ENGRAVING

i. General Works

BÉGUIN, S. *L'École de Fontainebleau.* Paris, 1960.
BLUM, A., and LAUER, P. *La Miniature française aux XVe et XVIe siècles.* Paris, 1930.
DIMIER, L. *La Peinture française au XVIe siècle.* Marseilles, 1942.
LAVALLEÉ, P. *Le Dessin français du XIIIe au XVIe siècle.* Paris, 1930.
MOREAU-NÉLATON, E. *Les Clouet et leurs émules.* Paris, 1924.
RING, G. *A Century of French Painting, 1400–1500.* London, 1949.
ZERNER, H. *École de Fontainebleau. Gravures.* Paris, 1969.

ii. Individual Artists

ABATE
Mostra di Nicolò dell'Abate. Bologna, 1969.
BOURDICHON
MacGibbon, D. *Jean Bourdichon, a Court Painter of the Fifteenth Century.* Glasgow, 1933.
BOYVIN
Levron, J. *René Boyvin, graveur angevin du XVIe siècle.* Paris, 1941.
CARON
Ehrmann, J. *Antoine Caron, peintre à la cour des Valois.* Paris, 1955.
CLOUET, JEAN
Mellen, P. *Jean Clouet.* London, 1971.
DUVET
Eisler, C. *The Master of the Unicorn. The Life and Work of Jean Duvet.* New York, 1979.
PERRÉAL, J.
Maulde la Clavière, M. A. R. de. *Jean Perréal, dit Jean de Paris.* Paris, 1896.
PRIMATICCIO
Dimier, L. *Le Primatice, peintre, sculpteur et architecte des Rois de France.* Paris, 1900.
Dimier, L. *Le Primatice.* Paris, 1928.
ROSSO
Barocchi, P. *Il Rosso Fiorentino.* Rome, 1950.
Kusenberg, K. *Le Rosso.* Paris, 1931.

D. SCULPTURE

i. General Works

ADHÉMAR, J. 'Les Tombeaux de la collection Gaignières', *G.B.A.* (1976–7).

AUBERT, M. *La Sculpture française du moyen-âge et de la Renaissance.* Paris-Brussels, 1926.
BEAULIEU, M. *Description raisonnée des sculptures du Musée du Louvre,* 11, *La Renaissance française.* Paris, 1978.
DAVID, H. *De Sluter à Sambin.* Paris, 1933.
KOECHLIN, R., and MARQUET DE VASSELOT, T. J. *La Sculpture à Troyes et dans la Champagne méridionale au seizième siècle.* Paris, 1966.
VITRY, P., and BRIÈRE, G. *Documents de sculpture française de la Renaissance.* Paris, 1911.

ii. Individual Artists

CELLINI, B.
La Vita scritta da lui medesimo. First edition, Naples, 1728. Translated by John Pope-Hennessy. London, 1949.
COLOMBE
Pradel, P. *Michel Colombe. Le dernier imagier gothique.* Paris, 1953.
Vitry, P. *Michel Colombe.* Paris, 1901.
GOUJON
Du Colombier, P. *Jean Goujon.* Paris, 1949.
PALISSY
Rothschild, G. de. *Bernard Palissy.* Paris, 1956.
PILON
Babelon, J. *Germain Pilon.* Paris, 1927.
RICHIER, L.
Denis, P. *Ligier Richier. L'artiste et son œuvre.* Paris-Nancy, 1911.

SEVENTEENTH CENTURY

A. ALL THREE ARTS

i. Sources

DUSSIEUX, L. and others. *Mémoires inédits sur la vie et les ouvrages des membres de l'académie royale de peinture et de sculpture.* Paris, 1854.
FRÉART DE CHANTELOU, P. *Journal du voyage du Cavalier Bernin en France.* Paris, 1885. Reprint, Paris, 1981.
MAROLLES, M. DE. *Le Livre des peintres et graveurs.* Paris, 1677. Reprint, Paris, 1872.
MONTAIGLON, A. DE. *Procès-verbaux de l'Académie royale de peinture et de sculpture.* Paris, 1875.

ii. General Works

CHAMPIGNEULLE, B. *Le Règne de Louis XIII.* Paris, 1949.

CHAMPIGNEULLE, B. *Le Règne de Louis XIV*. Paris, 1943.

CROZET, R. *La Vie artistique en France au XVII^e siècle*. Paris, 1954.

DU COLOMBIER, P. *Le Style Henri IV–Louis XIII*. Paris, 1941.

FANIEL, S. *Le XVII^e siècle français*. Paris, 1958.

MAURICHEAU-BEAUPRÉ, C. *L'Art au XVII^e siècle en France*. Paris, 1946–7.

ROCHEBLAVE, S. *L'Âge classique de l'art français*. Paris, 1932.

TAPIÉ, V. *The Age of Grandeur. Baroque and Classicism in Europe*. London, 1960.

TEYSSÈDRE, B. *L'Art au siècle de Louis XIV*. Paris, 1967.

WEIGERT, R. A. *Le Style Louis XIV*. Paris, 1941.

B. ARCHITECTURE

i. Sources

BLONDEL, F. *Cours d'architecture enseigné dans l'Académie Royale*. First edition, Paris, 1675. Second edition, Paris, 1698.

DAVILER, A. *Cours d'architecture, qui comprend les ordres de Vignole*. Paris, 1750.

DESGODETZ, A. *Les Édifices antiques de Rome dessinés et mesurés très exactement*. Paris, 1682.

GUIFFREY, J. *Les Comptes des bâtiments du roi sous le règne de Louis XIV*. Paris, 1881–1901.

JOSEPHSON, R. *L'Architecte de Charles XII, Nicodème Tessin à la cour de Louis XIV*. Paris, 1930.

LEMONNIER, H. *Procès-verbaux de l'Académie royale d'architecture*. Paris, 1911–26.

PERRAULT, CH. and CLAUDE. *Mémoires de ma vie par Charles Perrault. Voyage à Bordeaux (1669) par Claude Perrault*. Paris, 1909.

SAVOT, L. *L'Architecture françoise des bastimens particuliers; avec des figures et des notes de M. Blondel*. Paris, 1673.

SIRÉN, O. *Nicodemus Tessin den Ys Studieresor*. Stockholm, 1914.

ii. General Works

ADAMS, W. H. *The French Garden 1500–1800*. New York, 1979.

BABELON, J. P. *Demeures parisiennes sous Henri IV et Louis XIII*. Paris, 1977.

BLUNT, A., et al. *Baroque and Rococo Architecture and Decoration*. London, 1978.

FRANCASTEL, P. (ed.) *L'Urbanisme de Paris et l'Europe 1600–1680*. Paris, 1969.

HAUTECOEUR, L. *Le Louvre et les Tuileries de Louis XIV*. Paris, 1927.

KIMBALL, F. *The Creation of the Rococo*. Philadelphia, 1943.

KIMBALL, F. *Le Style Louis XV*. Paris, 1949.

MARIE, A. *Jardins français classiques*. Paris, 1949.

MARIE, A. *Naissances de Versailles*. Paris, 1968.

MARIE, A. *Mansart à Versailles*. Paris, 1972.

MARIE, A. *Versailles au temps de Louis XIV. Mansart et de Cotte*. Paris, 1976.

NOLHAC, P. DE. *La Création de Versailles*. Versailles, 1901.

NOLHAC, P. DE. *Les grands palais de France: Versailles*. Paris, n.d.

NOLHAC, P. DE. *Les Jardins de Versailles*. Paris, 1906.

PLANAT, P., and RÜMLER, E. *Le Style Louis XIV*. Paris, 1912.

THORNTON, P. *Seventeenth Century Interior Decoration in England, France and Holland*. New Haven and London, 1978.

VERLET, P. *Versailles*. Paris, 1961.

iii. Individual Artists

BÉRAIN
Weigert, R. A. *Jean Bérain*. Paris, 1937.

BROSSE, S. DE
Coope, R. *Salomon de Brosse and the Development of the Classical Style in French Architecture from 1565 to 1630*. London, 1972.

BULLET, P.
Langenskiöld, Eric. *Pierre Bullet, the Royal Architect*. Stockholm, 1959.

LE MUET, P.
Manière de bien bastir pour toutes sortes de personnes. First edition, Paris, 1623. Second enlarged edition, Paris, 1647.

LE NÔTRE
Hazlehurst, F. H. *Gardens of Illusion. The Genius of André Le Nôtre*. Nashville, 1980.

LE PAUTRE, A.
Berger, R. W. *Antoine Le Pautre*. New York, 1969.

MANSART, F.
Smith, P., and Braham, A. *François Mansart*. London, 1973.

MANSART, J. H.
Bourget, P., and Cattaui, G. *Jules Hardouin Mansart*. Paris, 1960.

MAROT, D.
Guérinet, A. *L'Œuvre de Daniel Marot*. Paris, n.d.

ORBAY, F. D'
Laprade, A. *François d'Orbay, architecte de Louis XIV*. Paris, 1960.

PERRAULT, CLAUDE
Ordonnances des cinq espèces de colonnes selon la méthode des anciens. Paris, 1683.
Vitruvius. *Les dix livres d'architecture . . . traduits . . . en François, avec des notes et des figures par M. Perrault.* Paris, 1684.
Hallays, A. *Les Perrault.* Paris, 1926.
Herrmann, W. *The Theory of Claude Perrault.* London, 1973.

C. PAINTING

i. Sources

BELLORI, G. *Le Vite de' pittori, scultori ed architetti moderni . . .* Rome, 1672.
FONTAINE, A. *Conférences inédites de l'Académie royale de peinture et de sculpture.* Paris, n.d.
JOUIN, H. *Conférences de l'Académie royale de peinture et de sculpture.* Paris, 1893.
PASSERI, G. *Vite de' pittori, scultori ed architetti che anno lavorato in Roma, morti del 1641 fino al 1673.* First edition, Rome, 1772. Edition by J. Hess, Leipzig-Vienna, 1934.

ii. General Works

BOUVY, E. *La Gravure de portraits et d'allégories.* Paris, 1929.
DIMIER, L. *Les Peintres français du XVIIIe siècle.* Paris, 1928 and 1930.
FONTAINE, A. *Académiciens d'autrefois.* Paris, 1914.
MARCEL, P. *La Peinture française au début du dix-huitième siècle 1690-1721.* Paris, n.d.
RÉAU, L. *Histoire de la peinture française au XVIIIe siècle.* Paris, 1925-6.
ROSENBERG, P. *I disegni dei maestri. Il seicento francese.* Milan, 1970.
STERLING, C. *Musée de l'Hermitage. La Peinture française de Poussin à nos jours.* Paris, 1957.
TEYSSÈDRE, B. *L'Histoire de l'art vue du grand siècle.* Paris, 1964.
TEYSSÈDRE, B. *Roger de Piles et les débats sur le coloris au siècle de Louis XIV.* Paris, 1957.
WEISBACH, W. *Französische Malerei des XVII. Jahrhunderts.* Berlin, 1932.

iii. Individual Artists

BOSSE
Blum, A. *L'Œuvre gravé d'Abraham Bosse.* Paris, 1924.
Blum, A. *Abraham Bosse et la société française au dix-septième siècle.* Paris, 1924.

BOULLOGNE
Caix de St Aymour, Comte de. *Les Boullongne.* Paris, 1919.
CALLOT
Lieure, J. *Jacques Callot.* Paris, 1924-7.
Ternois, D. *L'Art de Jacques Callot.* Paris, 1962.
Ternois, D. *Jacques Callot. Catalogue complet de son œuvre dessiné.* Paris, 1962.
CHAMPAIGNE, P. DE
Dorival, B. *Philippe de Champaigne.* Paris, 1976.
Rosenberg, P. *Philippe de Champaigne. Classico e realista.* Milan, 1966.
CLAUDE
Blum, A. *Les Eaux-fortes de Claude Gellée dit Le Lorrain.* Paris, 1923.
Kitson, M. *Claude Lorrain: Liber Veritatis.* London, 1978.
Röthlisberger, M. *Claude Lorrain, the Paintings.* London, 1961.
Röthlisberger, M. *Claude Lorrain: The Drawings.* Berkeley and Los Angeles, 1968.
JOUVENET
Schnapper, A. *Jean Jouvenet.* Paris, 1974.
LAFAGE
Whitman, N. T. *The Drawings of Raymond Lafage.* The Hague, 1963.
LARGILLIERRE
Catalogue of the exhibition held at the National Gallery of Canada, Ottawa, 1981.
LA TOUR
Nicolson, B., and Wright, C. *Georges de la Tour.* London, 1974.
Rosenberg, P., and Maré de L'Epinay. *Georges de la Tour.* Fribourg, 1973.
Thuillier, J. *Tout l'œuvre peint de Georges de la Tour.* Paris, 1973.
LEBRUN, CHARLES
Charles Le Brun 1619-1690. Catalogue of the exhibition held at Versailles, 1963.
LE NAIN
Les Frères Le Nain. Catalogue of the exhibition held at the Grand Palais, Paris, 1978.
LE SUEUR
Rouchès, G. *Eustache Le Sueur.* Paris, 1923.
NANTEUIL
Petitjean, C., and Wickert, C. *Catalogue de l'œuvre gravé de Robert Nanteuil.* Paris, 1925.
POUSSIN, N.
Correspondance de Nicolas Poussin. Edited by Ch. Jouanny. Paris, 1911.
Blunt, A. *Nicolas Poussin.* London, 1967-8.
Blunt, A. *The Drawings of Nicolas Poussin.* London, 1979.

Félibien, A. *Life of Poussin*. Translated with an introduction and notes by Claire Pace. London, 1981.

Friedlaender, W. *Nicolas Poussin. A New Approach.* London, 1966.

Friedlaender, W., and Blunt, A. *The Drawings of Nicolas Poussin*. London, 1939-72.

Sterling, C. *Biographie* in the catalogue of the *Exposition Nicolas Poussin*. Paris, 1960.

Thuillier, J. *Tout l'œuvre peint de Poussin*. Paris, 1974.

RIGAUD, H.

Livre de raison du peintre Hyacinthe Rigaud. Edited by J. Roman. Paris, 1919.

TASSEL

Les Tassel, peintres langrois du XVII^e^ siècle. Catalogue of the exhibition held in the Musée des Beaux-Arts, Dijon, 1955.

VOUET

Crelly, W. R. *The Paintings of Simon Vouet*. New Haven and London, 1962.

D. SCULPTURE

i. General Works

FRANCASTEL, P. *La Sculpture de Versailles*. Paris, 1930.

LAMI, S. *Dictionnaire des sculpteurs de l'école française sous le règne de Louis XIV*. Paris, 1906.

SOUCHAL, F. *French Sculptors of the Seventeenth and Eighteenth Centuries*. Oxford, 1977-.

ii. Individual Artists

BUYSTER, PHILIPPE DE

Chaleix, P. *Philippe de Buyster, Sculpteur 1595-1688*. Paris, 1967.

JACQUET, MATHIEU

Ciprut, E. J. *Mathieu Jacquet*. Paris, 1967.

PUGET

Herding, K. *Pierre Puget*. Berlin, 1970.

Puget et son temps. Actes du colloque tenu à l'Université de Provence, 1971, in *Provence historique*, XXII (1972).

SARRAZIN

Digard, M. *Jacques Sarrazin*. Paris, 1934.

INDEX

Entries in *italics* refer to pictures or other works of art; those in CAPITALS to names of owners, museums, galleries, or other indications of location. Galleries and other buildings will generally be found under the town in which they are situated; thus LOUVRE will be found under Paris. Where several references in one entry are given, that in **heavy type** is the principal. References to the notes are given to the page on which the note occurs, followed by the number of the note. Thus 413[48] indicates page 413, note 48.

THE PELICAN HISTORY OF ART

COMPLETE LIST OF TITLES

* Published only in original large hardback format.
† Latest edition in integrated format (hardback and paperback).
‡ Latest edition in integrated format (paperback only).
§ Published only in integrated format (hardback and paperback).
‖ Not yet published.

* Published only in original large hardback format.
† Latest edition in integrated format (hardback and paperback).
‡ Latest edition in integrated format (paperback only).
§ Published only in integrated format (hardback and paperback).
‖ Not yet published.